Fourth Edition

REALITY THROUGH THE ARTS

DENNIS J. SPORRE

Elon College

PRENTICE HALL, UPPER SADDLE RIVER, NJ 07458

2001 North and South American educational editions
published by Prentice Hall
A division of Pearson Education
Upper Saddle River, NJ 07458

10 9 8 7 6 5 4 3 2 1

ISBN 0-13-022565-7

This book was designed and produced by
CALMANN & KING LTD, London
www.calmann-king.com

Designed by Melinda Welch, Design Deluxe, Bath/G & E 2000, Cambridge, UK
Project manager (fourth edition) Elisabeth Ingles
Picture research (fourth edition) Peter Kent
Printed in Hong Kong

Cover: Georges Seurat, *Le Chahut*, 1889–90. Oil on canvas, 66½ x 55¾ ins (169 x 139 cm). Kröller-Müller Museum, Otterlo, The Netherlands.

PICTURE CREDITS

The author, the publisher, and Calmann & King Limited wish to thank the museums, galleries, collectors, and other owners who have kindly allowed their works to be reproduced in this book. Every effort has been made to trace the copyright holders and we apologize in advance for any unintentional omissions. We would be pleased to insert the appropriate acknowledgment in any subsequent edition of this publication. In general, museums have supplied their own photographs; other sources are listed below.

INTRODUCTION
0.1 AKG London
0.2 ©The Andy Warhol Foundation for the Visual Arts/ARS New York/DACS London 2000/Photo: Geoffrey Clements
0.3A+B ©Christo 1997. Photo: Wolfgang Volz
0.10 VAG (UK) Ltd.
0.11 ©British Museum, London
0.12 Alinari

CHAPTER 1
1.1 Photograph ©1997 The Museum of Modern Art, New York
1.6 ©Thomas Hart Benton Trust/VAGA New York/DACS London 2000
1.11 ©ADAGP Paris/DACS London 2000
1.13 Photograph ©1997 The Museum of Modern Art, New York/©ARS New York/DACS London 2000
1.20 Photograph ©1997 The Museum of Modern Art, New York/©Succession Picasso/DACS 2000
1.28 Photograph ©1997 The Museum of Modern Art, New York/©Salvador Dali-Foundation Gala-Salvador Dali/DACS 2000
1.29 ©Succession Picasso/DACS 2000
1.30 RMN
1.33 Photograph ©1997 The Museum of Modern Art, New York/©DACS 2000
1.40 Photograph ©1997 The Museum of Modern Art, New York/©Mondrian/Holzman Trust, c/o Beeldrecht, Amsterdam, Holland/DACS 2000

CHAPTER 2
2.1,2,5,11,17 ©British Museum, London
2.6 Reproduced by kind permission of the Henry Moore Foundation
2.8 RMN
2.9 ©Christo 1997. Photo: Wolfgang Volz
2.12 Photograph ©1997 The Museum of Modern Art, New York/©DACS 2000
2.13 Giraudon, Paris
2.15 Photograph ©1997 The Museum of Modern Art, New York/©ADAGP Paris/DACS London 2000
2.18 ©ADAGP Paris/DACS London 2000
2.20 Rheinisches Bildarchiv, Cologne. Courtesy of Heaton Sessions, Stone Ridge, New York

CHAPTER 3
3.11,13 Trudy Lee Cohen, Philadelphia

CHAPTER 4
4.8,11,13,15 University of Arizona Theatre
4.9,10 Old Globe Theatre, San Diego
4.12 State University, New York
4.14 University of Iowa Theatre
4.16 University of Illinois
4.17 Black Star, New York. Photo: Steve Schapiro

CHAPTER 5
5.1 ©ADAGP Paris/DACS London 2000
5.2 ©Universal Pictures, a Division of Universal Studios Inc. All Rights Reserved
5.3,5 B.F.I., London

CHAPTER 6
6.1-14,18 Linda Rich, Addlestone, U.K.
6.15,16 Roger Greenawalt, Langhorne, PA
6.17 Hulton Deutsch

CHAPTER 7
7.1,23 Britain on View (B.T.A.), London
7.2 A.C. & R. John Donat, London
7.5 Hirmer Fotoarchiv, Munich
7.14,28,35 A.F. Kersting, London
7.20 Library of Congress
7.21 Wayne Andrews/ESTO, Mamaroneck
7.22 Ezra Stoller/ESTO, Mamaroneck/©ARS New York/DACS London 2000
7.27 Ralph Liebermann, North Adams, MA
7.29 Wayne Andrews, Chicago
7.30,31 ©FLC/ADAGP Paris/DACS London 2000
7.33 Norman McGrath, New York
7.34 Giraudon, Paris
7.36,37 Scala, Florence
7.39 Washington Area Convention and Visitors Association
7.40 Solomon R. Guggenheim Museum/Robert E. Mates/©ARS New York/DACS London 2000

CHAPTER 8
8.1 Range Pictures, London/Bettmann Archive, New York/U.P.I.

PART TWO
II.2,4 ©Succession Picasso/DACS 2000
II.3 Photograph ©1997 The Museum of Modern Art, New York
II.5,7,8 Novosti, London

CHAPTER 9
9.2,4 Colorphoto Hans Hinz, Allschwil, Switzerland
9.15,17 A.F. Kersting, London
9.20 Hirmer Fotoarchiv, Munich
9.27 RMN-Hervé Lewandowski

CHAPTER 10
10.2,3,9,10,31,32,34,35,43 Alinari, Florence
10.6,48 Hirmer Fotoarchiv, Munich
10.7,14,41,65 A.F. Kersting, London
10.19 ©British Museum, London
10.20 Courtesy Calmann & King Archives, London
10.21 Ancient Art and Architecture Collection, London
10.29,45 Scala, Florence
10.33 Fototeca Unione, Rome
10.40 Todaiji, Nara
10.46 Sonia Halliday Photographs, Weston Turville, U.K.
10.50 RMN
10.59 Jean Dieuzaide, Toulouse
10.60 Clive Hicks, London
10.61 Bulloz, Paris
10.63 Britain on View (B.T.A.), London
10.66,68 Giraudon, Paris
10.67 Photo: J. Feuille, CNMHS, Paris

CHAPTER 11
11.1,6,8,26 Alinari, Florence
11.4,10,25 Scala, Florence
11.5,34,39,43 RMN
11.9 Hirmer Fotoarchiv, Munich
11.28 A.F. Kersting, London
11.29 Robert Harding Picture Library, London
11.30 Ancient Art and Architecture Collection, London
11.38 Bildarchiv Foto Marburg, Germany
11.42 Weidenfeld & Nicholson Archives, London

CHAPTER 12
12.2,5 ©British Museum, London
12.10,29,32 RMN
12.12 G.E. Kidder-Smith, New York
12.25,27 A.F. Kersting, London
12.28 Bridgeman Art Library, London
12.31,34 Photograph ©1990. Art Institute of Chicago. All rights reserved

CHAPTER 13
13.5 Eric Robertson, Robertson African Arts, New York
13.6,23 ©ADAGP Paris/DACS London 2000
13.8 Photograph ©1997 The Museum of Modern Art, New York. Courtesy of the artist and Francine Seders Gallery, Seattle, WA
13.9 David Redfern Photography, London
13.10 ©DACS 2000
13.12 Photograph ©1997 The Museum of Modern Art, New York/©Succession Picasso/DACS 2000
13.13 ©Succession H. Matisse/DACS 2000
13.14,20 Photograph ©1997 The Museum of Modern Art, New York
13.15,17,21,27 ©ARS New York/DACS London 2000
13.18 André Emmerich, New York
13.19 ©Estate of Roy Lichtenstein/DACS 2000
13.24 Photo: Donald Woodman
13.25 F.R. Yerbury Collection, London
13.26 Architectural Press, London
13.28 Ezra Stoller ©ESTO, Mamaroneck
13.32 Cement and Concrete Association, Slough, U.K.

CONTENTS

CONTENTS

CONTENTS

CONTENTS

PREFACE

The purpose of this book is to teach basic principles and practices of the arts—painting, printmaking, sculpture, music, theatre, dance, literature, and architecture—of Western and other cultures. This text is an introduction to the humanities, and is designed for individuals who have limited experience in the arts. In addition, it attempts to provide the humanities instructor with a helpful textbook for courses that touch upon the arts in an inter- or multi-disciplinary manner, and approach the arts from a world viewpoint. In order to meet those ends, I have been selective in the material included. My treatment of definitions and concepts in Part I is cursory: in order to stay within the bounds of practicality and the limited perspective of the intended audience, they are explained in general terms, making it simpler to apply them to the diverse cultural approaches examined in Part II.

This book is, of course, not a self-contained humanities course. It cannot substitute for the classroom teacher, whose responsibility it is to shape and mold a course according to the needs of local curricula, and to assist the student to focus on what is important for the thrust of that particular course. No textbook can be relied upon to answer all the students' questions and include all key points. A good book can only suggest the breadth of what is available. This text should encourage the use of other source materials. The instructor should develop emphases or foci of his or her own choosing by adding lectures, videos, or field trips, and expansion of particular areas raised in the general overview presented here. I have aimed to provide a convenient one-volume outline, with enough flexibility to serve a variety of purposes.

In Part I we examine the media of the arts—painting and architecture, for example,—define and explain important terminology, discuss how works are composed, and suggest ways in which some art effects responses in viewers and listeners. The compendium approach used in Part I seems useful because it allows us to apply its terms and concepts as tools for perceiving, describing, and understanding the arts of the diverse cultures discussed in Part II.

In discussing works of art, I have for the most part kept to description and compositional analysis. By so doing I hope to assist the readers in polishing their skills of technical observation. By avoiding forays into meanings and relationships, I have left room for the instructor to move discussions in whatever direction is deemed appropriate.

As suggested earlier, the choice of what to include and exclude has been more or less arbitrary. This is not a comprehensive history of the arts; nor is it an introduction to aesthetic theory. Even the media discussed in the various chapters vary—for the simple reason that different cultures have left us different kinds of artifacts, some of which are better examples of the culture than others. In organizing each chapter—particularly in Part II—I have let the nature of the material suggest its own internal structure. In all cases I have tried to keep the focus of the discussion on works of art.

Part II is arranged chronologically. Thus, with what I hope is a reasonably simple format, we are able to glimpse the arts from a variety of cultures that were occurring at roughly the same time in history. We must keep in mind, however, that the focus of Part II is style, not history. In addition, not every culture has been represented—for example, I have not included Oceania, primarily because consultation with humanities instructors suggested priorities for inclusion. Given practical considerations, such as space and accessibility of illustrations, those priorities became imperative.

This book is based on the belief that art from whatever culture is a view of the universe, of human reality, that is expressed in a particular medium and shared with others. Throughout time humans have struggled to understand the universe, and, though separated by centuries or cultures, our concerns and questions, as reflected in our works of art, are alike. By examining art we can enrich our own understanding of our existence. Therefore, as we proceed through the text, try to go beyond the facts and descriptions presented and seek meanings, if only from an individual perspective. Ask questions about what the artist may have been trying to accomplish, and seek to understand how you relate to these creative expressions in terms of your own perception of human reality.

Finally, a work such as this does not spring entirely from the general knowledge or primary source research of its author. Some of it does, because of my long-term and close affiliation with the various arts disciplines. Much is the result of notes accumulated here and there, of travel around the world, and of research specifically directed to this project. In the interest of readability, and in recognition of the generalized purpose of this text, copious footnoting has been avoided. I hope that the method I have chosen for

presentation and documentation of others' works meets the needs of both responsibility and practicality. The bibliography gives a comprehensive list of works used.

This fourth edition contains several major additions. First is a series of feature boxes titled "Profile." These appear throughout the text and introduce the reader to artists of note in fuller biographical detail than would normally occur. Second is a series of feature boxes titled "Masterwork." These appear throughout the second half of the text and draw special attention to several significant works of art, architecture, and literature. The third addition is correlation of the music sections with a compact disc available from Prentice Hall. For the first time, we now have specific illustrations of music that apply both to the descriptive materials in the first half of the text and to the historical materials of the second half. Another addition to this edition is a greatly expanded treatment of music and musicians in the history sections. Also, I have increased the number of literature selections and the number of illustrations.

One final note: in 1977, when I wrote *Perceiving the Arts* (Prentice Hall, 6th edn., 2000), I asked Ellis Grove, my colleague at Penn State University, to prepare a chapter on film. Ten years later that chapter formed the basis for Chapter Five of this book. In twenty years of revisions of these two books, much of Ellis's original work has been altered by additions and editing. Nonetheless, the basics are his, and I am indebted to him, as I am to a score of colleagues whose insights, encouragement, and criticism have, hopefully, made each edition of this book better than its predecessor. I am also deeply indebted to Bud Therien at Prentice Hall, my friend, editor, and publisher for more than twenty years; to Marion Gottlieb for her gentle and pleasant spirit; to the editors and copy-editors at Calmann & King in London; and, most of all, to my wife, Hilda, whose patience, love, and understanding, proofreading, note-taking, and research assistance provided me with a solid foundation from which to generate my own part of the project.

D. J. S.

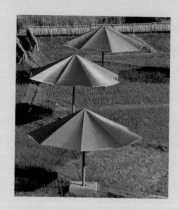

INTRODUCTION

WHAT ARE THE ARTS AND HOW DO WE RESPOND TO AND EVALUATE THEM?

We live in buildings and listen to music constantly. We hang pictures on our walls and react like personal friends to characters in television, film, and live dramas. We escape to parks, engross ourselves in novels, wonder about a statue in front of a public building, and dance the night away. All of these situations involve forms of art in which we engage and are engaged daily. Curiously, as close to us as they are, in many ways they remain mysterious. What are they? How are they put together? How do they stimulate us? What do they mean? In this book we will attempt to answer those and other questions about the arts. We begin with the questions, What *are* the arts? and How do we respond to and evaluate them?

Humans are a creative species. Whether in science, politics, business, technology, or the arts, we depend on our creativity almost as much as anything else to meet the demands of daily life. Any story about the arts is a story about us: our perceptions of the world as we have come to see and respond to it and the ways we have communicated our understandings to each other since the Ice Age, more than

35,000 years ago (Fig. 0.1). At that time, we were already fully human. Since then, we have learned a great deal about our world and how it functions, and we have changed our patterns of existence. However, the fundamental characteristics that make us human—that is, our ability to intuit and to symbolize—have not changed. Art, the major remaining evidence of our earliest times, reflects these unchanging human characteristics in inescapable terms.

Our study will focus on the media of the arts and how artists use those media to reflect human reality: our hopes, dreams, fears, expectations, disappointments, and accomplishments. We begin with an introductory overview about art itself and its place in our world. This Introduction provides us with a foundation. It is more conceptual than the remainder of the book, and the following questions can be used as a guide for reading this material:

- What is meant by the term "humanities"? How do the humanities differ from other ways of knowing?
- What is meant by the statement that 'the arts are processes, products, and experiences?
- Why does a definition of a work of art imply non-restrictiveness, human enterprise, a medium of expression, and communication?
- What is a symbol and in what ways can it communicate?
- What are the major functions of art?
- How is it possible for a work of art to fulfill more than one function?
- How may religious ritual qualify as art?

THE HUMANITIES AND THE ARTS

The humanities, as opposed, for example, to the sciences, can very broadly be defined as those aspects of culture that look into the human spirit. But despite our desire to categorize, there really are few clear boundaries between the humanities and the sciences. The basic difference lies in the approach that separates investigation of the natural universe, technology, and social science from the sweeping search of the arts for human reality and truth.

Within the educational system, the humanities have traditionally included the fine arts, literature, philosophy, and, sometimes, history. These subjects are all oriented toward exploring what it is to be human, what human beings think and feel, and what motivates their actions and shapes their thoughts. Many of the answers lie in the millions of artworks all round the globe, from the earliest sculpted fertility figures to the video arts of today. These artifacts and images are themselves expressions of the humanities, not merely illustrations of past or present ways of life.

Artistic styles, schools, and conventions are the stuff of art history. But change in the arts differs from change in the sciences in one significant way: New technology usually displaces the old; new scientific theory explodes the old; but new art does not invalidate earlier human expression. Obviously, not all artistic styles survive, but the art of Picasso cannot make the art of Rembrandt an idle curiosity of history in the way the theories of Einstein did those of others.

Works of art also remain, in a curious way, always in the present. We react *now* to the sound of a symphony or to the color and composition of a painting. No doubt a historical perspective on the composer or painter and a knowledge of the circumstances in which the art was created enhance understanding and appreciation. But for most of us, today's reaction is most important.

The arts can be approached with all the subtlety we normally apply to human relationships. We learn very young that people cannot simply be categorized as "good" or "bad," as "friends," "acquaintances," or "enemies." We relate in complex ways. Some friendships are pleasant but superficial, some people are easy to work with, and others (but few) are lifelong companions. Similarly, when we have gone beyond textbook categories and learned this sort of sensitivity, we find that art, like friendship, has a major place in our growth and quality of life.

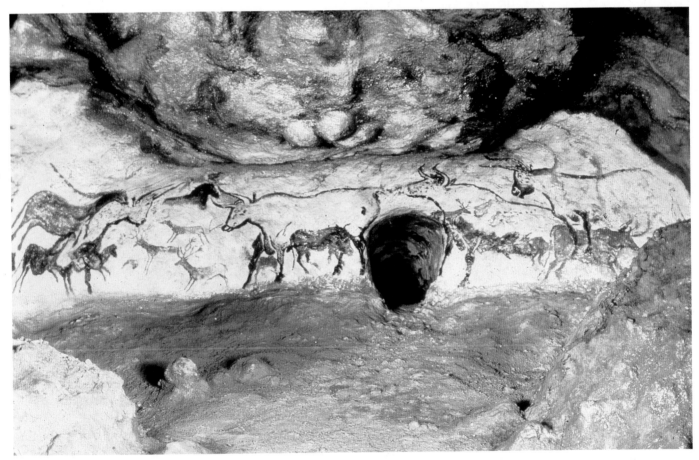

0.1 Cave chamber at Lascaux, France, early Stone Age (c. 15,000 B.C.).

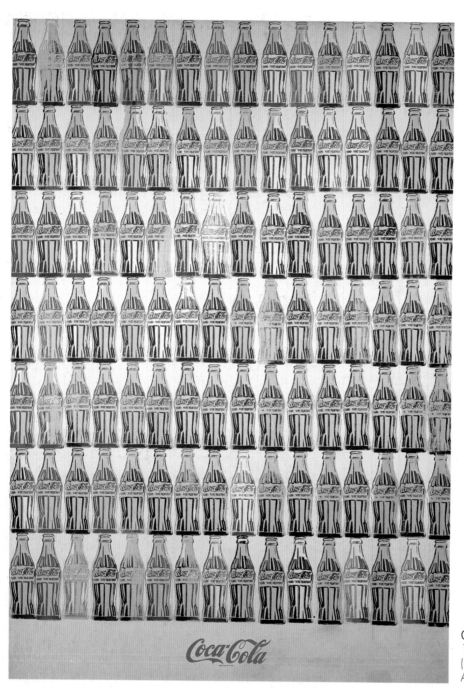

0.2 Andy Warhol, *Green Coca-Cola Bottles*, 1962. Oil on canvas, 6 ft 10 in x 4 ft 9 in (1.97 x 1.37 m). Whitney Museum of American Art, New York.

WHAT IS ART?

We might paraphrase G. K. Chesterton (*The Everlasting Man*) to say that, in one sense, the arts are the "signature" of humankind. In another, broad sense, the arts are *processes*, *products*, and *experiences* that communicate aspects of human living in a variety of ways, many of which do not use words. *Processes* are the creative actions, thoughts, materials, and techniques artists combine to create *products*—that is, artworks. *Experiences* are human interactions and responses that occur when people encounter an artist's vision in an artwork. These are a few of the characteristics that identify the arts—as opposed to science, technology, and social science—as vantage points we use to understand our attitudes, actions, and beliefs.

But what is art? Scholars, philosophers, and aestheticians have attempted to answer this question for centuries without yielding many adequate results. The late pop artist Andy Warhol reportedly said, "Art is anything you can get away with" (Fig. 0.2). Perhaps we should be a little less cynical, and a little more specific. Instead of asking "What is art?", let us ask "What is a work of art?" *A work of art is*

14

one person's vision of human reality (emotions, ideas, values, religions, political beliefs, etc.), expressed in a particular medium and shared with others. (This is not a universally acceptable definition of a work of art. It will, however, serve us in this textbook and should form the basis for classroom discussion and debate.) Now we can explore the terms of this definition.

Nonrestrictiveness

First, the definition is sufficiently nonrestrictive: An artwork is anything that attempts to communicate a vision of human reality through a means traditionally associated with the arts—for example, drawing, painting, printmaking, sculpture, as well as works of music, dance, literature, film, architecture, and theatre. We should note here that when we link the terms "reality" and "art," we are not implying that art is in any way restricted to representing its subject matter representationally (see the Glossary)—as we will see in Part II. If the originator intends it as a work of art, it is one. Whether it is good or bad, sophisticated or naive, profound or inconsequential, matters little to our definition. A child's drawing that expresses some feeling about mother, father, and home is as much an artwork as Michelangelo's Sistine Chapel frescoes. The music of R.E.M. and that by Mozart both qualify as artworks under our definition, even though the qualities we might ascribe to these artworks would probably be different. (We discuss *value judgments* later in this Introduction.)

Human Enterprise

The second implication of our definition is that a work of art is a human enterprise. Whenever we experience a work of art, we come into contact with another human being. We experience human contact because artworks are intended to engage us and to initiate a desire to respond. In the theatre, for example, we are exposed to a variety of visual and aural stimuli that attempt to make us feel, think, or react in harmony with the goals of the artists.

Medium of Expression

Although we can readily accept the traditional media—for example, painting, traditional sculpture, music using traditional instruments, theatre using a script and performed in an auditorium—sometimes when a medium of expression does not conform to our expectations or experiences, we might decide that the work is not art. For example, Figures **0.3A** and **B** show details of two gigantic environ-

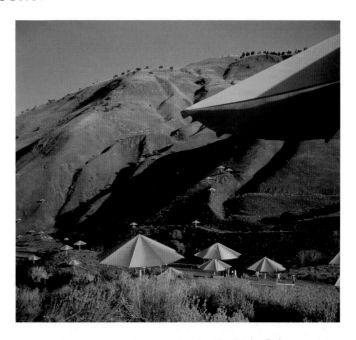

0.3A and **B** Christo and Jeanne-Claude, *The Umbrellas, Japan–USA*, 1984–91. (A) Valley north of Los Angeles, California, detail of 1,760 yellow umbrellas; (B) Valley in prefecture of Ibaraki, Japan, detail of 1,340 blue umbrellas. Nylon and aluminum, height of each umbrella including base, 19 ft 8¼ ins (6 m); combined length 30 miles (48 km).

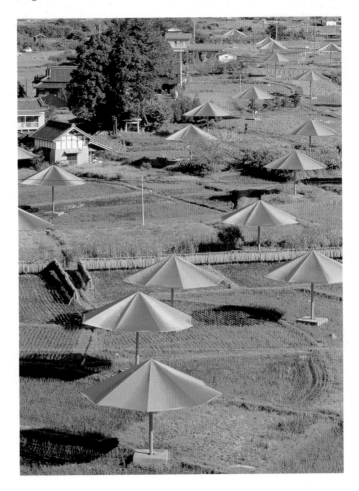

mental installations of blue and yellow umbrellas in Japan and the United States, respectively, created (and financed) by the artists Christo and Jeanne-Claude. For them, the installations (which existed for only a short time) are art. For other people, they most definitely were not. Even though the medium was unconventional and the work transitory, our definition would allow the artwork because the intent of the work was clearly artistic.

Communication

Artworks involve communication and sharing. The common factor in all art is the humanizing experience; artists need other people to whom they can convey their perception of human reality. When artworks and humans interact, many possibilities exist. Interaction may be casual and fleeting, as in the first meeting of two people, when one is not at all interested in the other. Similarly, an artist may not have much to say, or may not say it very well. For example, a poorly written or produced play will probably not excite an audience. Similarly, if an audience member is self-absorbed, distracted, has rigid preconceptions not met by the production, or is so preoccupied by what may have occurred outside the theatre that he or she finds it impossible to perceive what the production offers, then the artistic experience also fizzles out. On the other hand, all conditions may be optimum, and a profoundly exciting and meaningful experience may occur: The play may treat a significant subject in a unique manner; the acting, directing, and design may be excellent; and the audience may be receptive. Or the interaction may fall somewhere between these two extremes. In any case, the experience is a human one, and that is fundamental to art.

In discussing art as communication, we need to note one important term: *symbol*. Symbols are things that represent something else. They often use a material object to suggest something less tangible or less obvious: a wedding ring, for example. Symbols differ from signs, which suggest a fact or condition. Signs are what they denote. Symbols carry deeper, wider, and richer meanings. Look at Figure **0.4**. What do you see? You might identify this illustration as a sign, which looks like a plus in arithmetic. But the shape might be a Greek cross, in which case it becomes a symbol because it suggests many images, meanings, and implications. Artworks use a variety of symbols to convey meaning. By using symbols, artworks can relay meanings that go well beyond the surface of the work and offer glimpses of human reality that cannot be sufficiently described in any other manner. Symbols transform artworks into doorways through which we pass in order to experience, in limited time and space, more of the human condition.

THE FUNCTIONS OF ART

Art can function in many ways: as enjoyment, political and social tool, therapy, or artifact. No one function is more important than the others. Nor are they mutually exclusive; one artwork may fill many functions. Nor are the four categories just mentioned the only ones. Rather, they serve as indicators of how art has functioned in the past and can operate in the present. Like the types and styles of art that have occurred through history, these four functions, and others, are options for artists and the choice depends on what artists wish to do with their artworks.

Enjoyment

Plays, paintings, and concerts can provide escape from everyday cares, treat us to a pleasant time, and engage us in social occasions. Works of art that provide enjoyment may perform other functions as well. The same artworks we enjoy may also create insights into human experience. We can also glimpse the conditions of other cultures, and we can find healing therapy in enjoyment.

An artwork in which one individual finds only enjoyment may function as a profound social and personal com-

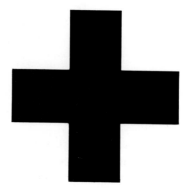

0.4 Greek Cross (?).

ment to another. A Mozart symphony, for example, may relax us and allow us to escape our cares. It may also comment on the life of the composer and/or the conditions of eighteenth-century Austria. Grant Wood's *American Gothic* (Fig. **0.5**) may amuse us, and/or provide a detailed commentary about nineteenth-century America, and/or move us deeply. The result depends on the artist, the artwork, and us. We can note here, as well, that implicit in our discussion of "enjoyment" as a "function" of art is the concept that art can exist for its own sake, alone. That is to say that many people believe that art need not have any "function" at all. "Art for art's sake" is the phrase used to describe their viewpoint, and the issue of whether art should be functional or exist purely for its own sake is worthy of discussion.

Political and Social Commentary

Art that is used to bring about political change or to modify the behavior of large groups of people has political or social functions. In ancient Rome, for example, the authorities used music and theatre to keep masses of unemployed people occupied in order to quell urban unrest. At the same time, Roman playwrights used their public platform to attack incompetent or corrupt officials. The Greek playwright Aristophanes, in such plays as *The Birds*, saw that comedy could be employed as a means of challenging the political ideas of the leaders of ancient Athenian society. In *Lysistrata*, he puts his message over by creating a story in which all the women of Athens go on a sex strike until Athens is rid of war and warmongers.

In nineteenth-century Norway, the playwright Henrik Ibsen used *An Enemy of the People* as a platform for airing the conflict of priorities between pollution control and economic wellbeing. In the United States today, many artworks act as vehicles to advance social and political causes, or to sensitize viewers, listeners, or readers to particular cultural situations like racial prejudice and AIDS.

Therapy

Creating and experiencing works of art can be used therapeutically to provide healing for individuals with a variety of illnesses, both physical and mental. Rôle play, for example, is used frequently as a counseling tool in treating dysfunctional family situations. In this context, often called psychodrama, mentally ill patients act out their personal circumstances in order to find the cause of their illness. The focus of this use of art as therapy is the individual. However, art in a much broader context acts as a healing agent for society's general illnesses as well. In hopes of saving us from disaster, artists use artworks to illustrate the failings and excesses of society. In another vein, the laughter caused by comedy releases endorphins—chemicals produced by the brain—which strengthen the immune system.

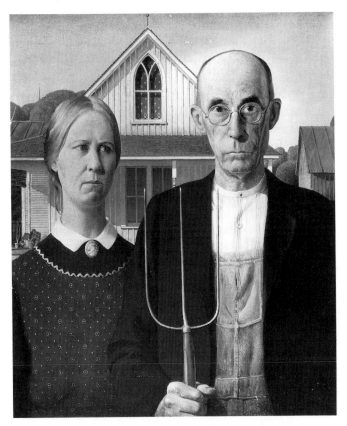

0.5 Grant Wood, *American Gothic*, 1930. Oil on beaver board, 30 x 25 ins (76 x 63 cm). Art Institute of Chicago (Friends of American Art Collection).

Artifact

Art also functions as an artifact: A product of a particular time and place, an artwork represents the ideas and technology of that specific environment. Artworks often provide not only striking examples but occasionally the only tangible records of some peoples. Artifacts like paintings, sculptures, poems, plays, and buildings, enhance our insights into many cultures, including our own. Consider, for example, the many revelations we find in a sophisticated work like the roped pot on a stand from Igbo-Ukwu (Fig. **0.6**). This ritual water pot from a village in eastern Nigeria was cast using the *cire-perdue* or "lost-wax" process and is amazing in its virtuosity. It tells us much about the vision and technical accomplishment of this ninth- and tenth-century African society.

The Igbo-Ukwu pot suggests that when we examine art in the context of cultural artifact, one of the issues we face is the use of artworks in religious *ritual*. We could consider ritual as a separate function of art. In fact, we may not think of religious ritual as art at all; but in the context we have adopted for this text, ritual often meets our definition of human communication using an artistic medium. Music, for example, when part of a religious ceremony, meets the definition, and theatre—if seen as an occasion planned and intended for presentation—would include religious rituals as well as events that take place in theatres. Often, as a survey of art history would confirm, we cannot discern when ritual stops and secular production starts. For example, ancient Greek tragedy seems clearly to have evolved from, and maintained, ritualistic practices. When ritual, planned and intended for presentation, uses traditionally artistic media like music, dance, and theatre, we can legitimately study it as art, and see it also as an artifact of its particular culture.

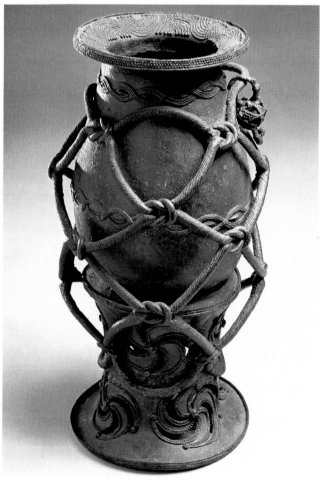

0.6 Roped pot on a stand, from Igbo-Ukwu, eastern Nigeria, 9th–10th century. Leaded bronze, height 12½ ins (32 cm). National Museum, Lagos.

ART CRITICISM

One of the questions we all seem to ask about an artwork is, "Is it any good?" Whether applied to rock music, a film, a play, a painting, or a Classical symphony, judgments about the quality of a work often vary from one extreme to the other, ranging from "I liked it" and "interesting," to specific reasons why the artwork is thought to be effective or ineffective.

Because the word "criticism" implies many things to many people, we must first agree what it does—or does not—mean. Criticism is not necessarily saying negative things about a work of art. All too often we think of critics as people who write or say essentially negative things, giving their opinions on the value of a play, a concert, or an exhibition. Personal judgments may result from criticism, but criticism implies more than passing judgment.

Criticism *should* be a detailed process of analysis to gain understanding and appreciation. Identifying the formal elements of an artwork—learning what to look for or listen to—is the first step. We describe an artwork by examining its many facets and then try to understand how they work together to create meaning or experience. After that we try to state what the meaning or experience is. Only when the process is complete should the critic offer judgment.

The critic, however, also brings to bear a set of standards developed essentially from personal experience. Applying these standards makes value judgment a tricky task. Our knowledge of an art form can be shallow. Our perceptual skills may be faulty, and the range of our experiences may be limited. The application of standards may be especially difficult if we try to judge an artwork as good or bad based on preestablished criteria: If someone believes a plot is the most important element in a film or a play, then any film or play that does not depend heavily on a plot may be judged as faulty despite other qualities it presents. Preestablished criteria often deny critical acclaim to new or experimental approaches in the arts.

History resounds with examples of new artistic attempts that received terrible receptions from so-called experts, whose idea of what an artwork ought to be could not allow for experimentation or departures from accepted practice. In 1912, when Vaslav Nijinsky choreographed the ballet *Rite of Spring* to music by Igor Stravinsky, the unconventional music and choreography actually caused a riot: Audiences and critics could not tolerate that it did not conform to accepted musical and ballet standards. Today, both the music and the choreography are considered masterpieces.

Similarly, Samuel Beckett's *Waiting for Godot* (1953) (Fig. **0.7**) does not have a plot, characters, or ideas that are

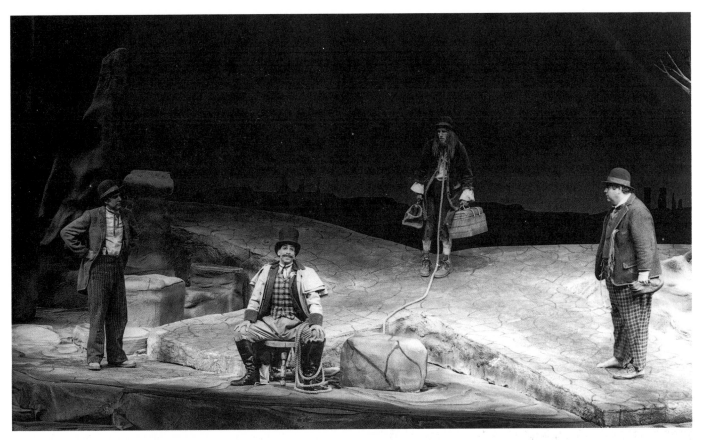

0.7 Samuel Beckett, *Waiting for Godot*, Utah Shakespearean Festival, 1990. Director: Tom Marlens.

expressed in a conventional manner. In this play, two tramps wait beside the road by a withered tree for the arrival of someone named Godot. The tramps tell stories to each other, argue, eat some food, and are interrupted by a character named Pozzo leading a slave, Lucky, by a rope. After a brief conversation, Lucky and Pozzo leave. At the end of the first act, a boy enters to announce that Godot will not come today. In Act 2, much the same sequence of events occurs. Then Lucky leads in a blind Pozzo. The tree has sprouted a few leaves. The play ends as the young boy returns to indicate Godot will not arrive that day either. If your standards require a successful play to have a carefully fashioned plot wrapped around fully developed characters and a clear message, then *Waiting for Godot* cannot possibly be a good play. Some people agree with such an assertion; others disagree vehemently. What, then, are we to conclude? What if my criteria do not match yours? What if two experts disagree on the quality of a movie? Does that make any difference to our experience of it?

Value judgments are intensely personal, but some opinions are more informed than others and represent more authoritative judgment. Sometimes, even knowledgeable people disagree. Disagreements about quality, however, can enhance our experience of a work of art when they lead us to think about why the differences exist. In this way, we gain a deeper understanding of the artwork.

None the less, *criticism* can be exercised without involving any judgment. We can thoroughly dissect any work of art—for example, we can describe and analyze line, color, melody, harmony, texture, plot, character, and/or message. We can observe how all of these factors affect people and their responses. We can spend a significant amount of time doing this and never pass a value judgment at all.

Does this discussion mean all artworks are equal in value? Not at all. It means that in order to understand what criticism involves, we must separate descriptive analysis, which can be satisfying in and of itself, from the act of passing value judgments. We may not like the work we have analyzed, but we may have understood something we did not understand before. Passing judgment may play no role whatsoever in our understanding of an artwork. But we are still involved in criticism. As an exercise in understanding, criticism is necessary. We must investigate and describe. We must experience the need to know enough about the process, product, and experience of art if we are to have perceptions to share.

Now that we have examined briefly what criticism is and why we might try it, what approaches can we use?

TYPES OF CRITICISM

In general, there are two types of criticism. If we examine a single artwork by itself, it is called "formal criticism." If we examine the same work in the context of the events surrounding it or, perhaps, the circumstances of its creation, it is called "contextual criticism."

Formal Criticism

In formal criticism, we are interested primarily in the artwork itself, applying no external conditions or information. We analyze the artwork just as we find it: If it is a painting, we look only within the frame; if it is a play, we analyze only what we see and hear. Formal criticism approaches the artwork as an entity in itself. As an example, consider this brief analysis of Molière's comedy *Tartuffe* (1664) (Fig. **0.8**):

> Orgon, a rich bourgeois, has allowed a religious con man, Tartuffe, to gain complete control over him. Tartuffe has moved into Orgon's house and tries to seduce Orgon's wife while at the same time planning to marry Orgon's

daughter. Tartuffe is unmasked, and Orgon orders him out. Tartuffe seeks his revenge by claiming title to Orgon's house and blackmailing him with some secret papers. At the very last instant, Tartuffe's plans are foiled by the intervention of the king, and the play ends happily.

We have just described a story. Were we to go one step further and analyze the plot, we would look, among other things, for points at which *crises* occur and cause important decisions to be made by the characters; we would also want to know how those decisions moved the play from one point to the next. In addition, we would try to locate the extreme crisis, the *climax*. Meanwhile, we would discover auxiliary parts of the plot such as *reversals*—for example, when Tartuffe is discovered and the characters become aware of the true situation. Depending on how detailed our criticism were to become, we could work our way through each and every aspect of the plot. We might then devote some time to describing and analyzing the driving force—the *character*—of each person in the play and how the characters relate to each other. Has Molière created fully developed characters? Are they types or do they seem to behave more or less like real individuals? In

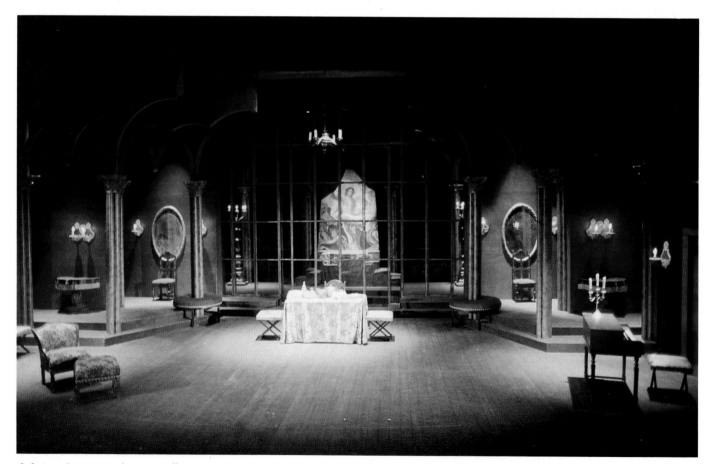

0.8 Jean-Baptiste Molière, *Tartuffe*, University of Arizona Theatre, 1990. Director Charles O'Connor.

examining the *thematic* elements of the play, we would no doubt conclude that the play deals with religious hypocrisy, and that Molière had a particular point of view on that subject.

In this formal approach, information about the playwright, previous performances, historic relationships, and so on, are irrelevant. Thus the formal approach helps us to analyze how an artwork operates and to decide why the artwork produces the responses it does. We can apply this form of criticism to any work of art and come away with a variety of conclusions. Of course, knowledge about how artworks are put together, what they are, and how they stimulate the senses (topics of the first half of this text) enhances the critical process. Knowing the basic elements that comprise these formal and technical elements of the artwork gives us a ready outline on which to begin a formal analysis.

Contextual Criticism

The other general approach, contextual criticism, seeks meaning by adding to formal criticism an examination of related information outside the artwork, such as facts about the artist's life, his or her culture, social and political conditions and philosophies, and public and critical responses to the work. These can be researched and applied to the work in order to enhance perception and understanding. Contextual criticism views the artwork as an artifact generated from particular contextual needs, conditions, and/or attitudes. If we carry our criticism of *Tartuffe* in this direction, we would note that certain historical events help clarify the play. For example, the object of Molière's attention was probably the Company of the Holy Sacrament, a secret, conspiratorial, and influential religious society in France at the time. Like many fanatical religious sects—including those of our own time—the society sought to enforce its own view of morality by spying on the lives of others and seeking out heresies—in this case, in the Roman Catholic Church. Its followers were religious fanatics, and they had considerable impact on the lives of the citizenry at large. If we were to follow this path of criticism, we would pursue any and all contextual matters that might illuminate or clarify what happens in the play. Contextual criticism may also employ the same kind of internal examination followed in the formal approach.

MAKING JUDGMENTS

Now that we have defined criticism and noted two approaches we might take in pursuit of understanding and enjoying a work of art, we can move on to the final step: making value judgments.

There are several approaches to the act of judgment. Two characteristics, however, apply to all artworks: Artworks are crafted and they communicate something to us about our experiences as humans. Making a judgment about the quality of an artwork should address each of these characteristics.

Craftsmanship

Is the work well made? To make this judgment, we first need some understanding of the medium in which the artist works. For example, if the artist proposes to give us a realistic vision of a tree, does the handling of the paint yield a tree that looks like a tree? Of course, if craftsmanship depended only on the ability to portray objects realistically, judgment would be quite simple. However, we must remember that judgments about the craftsmanship of an artwork require some knowledge about the techniques and styles of its medium. Although we may not yet be ready to make judgments about all of the aspects of craftsmanship in any art form, we can apply what we know. Good craftsmanship means the impact of the work will have clarity and not be confusing. It also means the work will hold our interest (given basic understanding and attention on our part). If the artwork does not appear coherent or interesting, we may wish to examine whether the fault lies in the artwork or in ourselves before rendering judgment. Beyond that, we are left to learn the lessons that the rest of this book seeks to teach. Each chapter will give us more tools to evaluate the craftsmanship of a work of art.

Communication

Evaluating what an artwork is trying to say offers more immediate opportunity for judgment and less need for expertise. Johann Wolfgang von Goethe, the nineteenth-century poet, novelist, and playwright, set out a basic, commonsense approach to evaluating communication. Because Goethe's approach provides an organized means for discovering an artwork's communication by progressing from analytical to judgmental functions, it is a helpful way to end our discussion on criticism. Goethe suggests that we approach the critical process by asking three questions: What is the artist trying to say? Does he or she succeed? Was the artwork worth the effort? These questions focus on the artist's communication. The third question, of whether or not the project was worth the effort, raises issues such as uniqueness or profundity (as opposed to the trivial or inane). A well-crafted work of art that merely

restates obvious insights about the human condition lacks quality in its communicative component. One that offers profound and unique insights exhibits quality.

We should think of the arts somewhat as we think of people. An adequate adjustment to the world cannot be made from social responses that simply divide the "good people" from the "bad people." We should be skeptical even of such categories as "the people I like" and "the people I don't like." If we do maintain such divisions, we find individuals constantly moving from one group to the other. Eventually we find human differences too subtle for easy classification, and the web of our relationships becomes too complex for analysis. We try to move toward more and more sensitive discrimination, so that there are those we can learn from, those we can work with, those good for an evening of light talk, those we can depend on for a little affection, and so on—with perhaps those very few with whom we can sustain a relationship for a lifetime. When we have learned this same sensitivity and adjustment to works of art—when we have gone beyond the easy categories of the textbooks and have learned to regard our art relationships as part of our own growth—then we shall have achieved a dimension in living that is as deep and as irreplaceable as friendship.

LIVING WITH THE ARTS

Because of unfamiliarity, many individuals are uncomfortable approaching the arts and literature. That unfamiliarity, perhaps, has been fostered by individuals, both within the disciplines and without, who try to make involvement in the arts and literature elitist, and art galleries, museums, concert halls, theatres, and opera houses open only to the knowledgeable and the sophisticated. Nothing could be further from actuality. The arts are elements of life with which we can and must deal and to which we must respond every day. We live with the arts because the principles of *aesthetics* permeate our existence. Specifically, the aesthetic experience is a way of knowing and communicating in and of itself, separate from other ways of knowing and communicating. It forms a significant part of our experience. Cutting ourselves off from the part of our existence that deals with aesthetic communication and knowledge is like shutting off half of our brain— in effect trying to cope with life with only half of our available tools for survival.

The arts play important roles in making the world around us a more interesting and habitable place. Artistic ideas join with *conventions* to make everyday objects attractive and pleasurable to use. The term "convention" is one we use repeatedly in this text. A convention is a set of rules or mutually accepted conditions. For example, the plug on electrical appliances is a convention. It is a practical convention to which those who have traveled abroad can testify. A more relevant example of a convention might be the keyboard and tuning of a piano. In any case, from these two examples we clearly understand the role that convention plays in our lives.

Figure 0.9, a scale drawing of an eighteenth-century highboy, illustrates how art and convention combine in everyday items. The high chest was conceived to fill a practical purpose—to provide for storage of household objects in an easily accessible, yet hidden, place. However, while designing an object to accommodate that practical need, the cabinetmakers felt the additional need to provide an interesting and attractive object. Our total experience of this piece of furniture can be enlightening and challenging if we perceive it with discrimination and imagination.

First of all, the design is controlled by a convention that dictates a consistent height for tables and desks. So the lower portion of the chest, from point A to point B, designs space within a height that will harmonize with other furniture in the room. If we look carefully, we can also see that the parts of the chest are designed with a sophisticated and interesting series of proportional and progressive relationships. The distance from A to B is twice the distance from A to D and is equal to the distance from B to C. The distances from A to F and C to E bear no recognizable relationship to the previous dimensions but are, however, equal to each other and to the distances from G to H, H to I, and I to J. In addition, the size of the drawers in the upper chest decreases at an even and proportional rate from bottom to top.

A further example might be the Volkswagen shown in Figure 0.10. Here repetition of form reflects a concern for unity, one of the fundamental characteristics of art. The design of the early Volkswagen used strong repetition of the oval. We need only look at the various parts of the Bug to see variation on this theme. Later models differ from this version and reflect the intrusion of conventions, again, into the world of design. As safety standards called for larger bumpers, the oval design of the motor-compartment hood was flattened so a larger bumper could clear it. The rear window was enlarged and squared to accommodate the need for increased rear vision. The intrusion of these conventions changed the design of the Beetle by breaking down the strong unity of the original composition.

Finally, as Edwin J. Delattre states when he compares the purpose for studying technical subjects to the purpose for studying the humanities or the arts, "When a person studies the mechanics of internal combustion engines the intended result is that he should be better able to under-

stand, design, build, or repair such engines, and sometimes he should be better able to find employment because of his skills, and thus better his life. . . . When a person studies the humanities [the arts] the intended result is that he should be better able to understand, design, build, or repair a life—for living is a vocation we have in common despite our differences.

"The humanities provide us with opportunity to become more capable in thought, judgment, communication, appreciation, and action." Delattre goes on to say that these provisions enable us to think more rigorously and to imagine more abundantly. "These activities free us to possibilities that are new, at least to us, and they unbind us from portions of our ignorance about living well. . . . Without exposure to the cultural . . . traditions that are our heritage, we are excluded from a common world that crosses generations."[1] The poet Archibald MacLeish is more succinct: "Without the Arts, how can the university teach the Truth?"

AESTHETIC PERCEPTION AND RESPONSE

In this Introduction we have examined the nature of the arts and something of their relationship to life. The question of how we go about approaching them, or how we study them, is another challenge. This book takes its title from a definition we discussed earlier: A work of art is one person's vision of human reality expressed in a particular medium and shared with others. We have chosen a method of study that can act as a springboard into confident and rewarding engagement with the arts. In the first half of the book, we will examine the various media artists use to transform their visions of human reality into works of art. In the second half of the book we will travel through history and around the world to examine the choices artists make while using their media to give artworks their particular appearance. The first half of the book is more technical than the second, and it deals, basically, with the question, What can we see and hear in works of art? To put that question in different terms, How can we sharpen our aesthetic perception?

- First of all, we must identify those items that can be seen and heard in works of art and literature.
- Second, we must learn some of the terminology relating to those items—just as we learn any subject.
- Third, we must understand why and how what we perceive relates to our response.

It is, after all, our response to an artwork that interests us. We can *perceive* an object. We *choose* to *respond* to it in aesthetic terms.

In Chapters 1–8 we need to employ a consistent method as we pass from one art discipline to another. We will ask three questions: (1) What is it? (2) How is it put together? (3) How does it stimulate the senses? We will study these questions in each of the art disciplines. As we will see, these are also the basic questions we can ask about individual artworks.

0.9 Scale drawing of an 18th-century highboy.

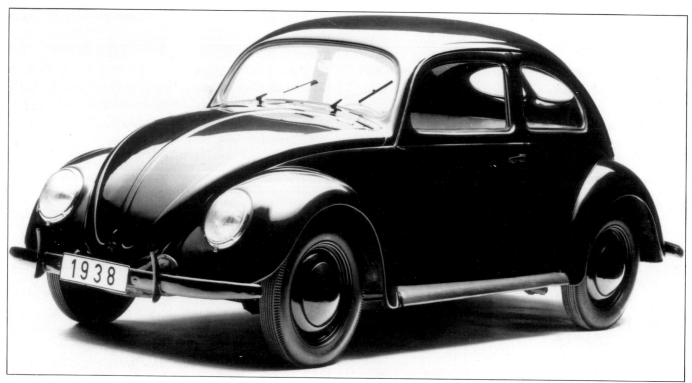

0.10 *Volkswagen Beetle*, 1938.

When we respond to the question, What is it? we make a formal response. We recognize that we are perceiving the two-dimensional space of a picture (Fig. **0.12**), the three-dimensional space of a sculpture or a piece of architecture, or perhaps time and sound, or time and space in dance. We also recognize the form of the item—for example, a still life, a human figure, a tragedy, a ballet, a concerto, a narrative film, or a residence. The term *form* is a broad one: There are art forms, forms of arts, and forms in art.

When we respond to the question, How is it put together? we respond to the technical elements of the artwork. We recognize and respond to, for instance, the fact that the picture has been painted in oil, made by a printmaking technique, or created as a watercolor. We also recognize and respond to the elements that constitute the work, the items of composition—line, form or shape, mass, color, repetition, harmony—and the unity that results from all of these. What devices have been employed, and how does each part relate to the others to make a whole? A concerto is composed of melody, harmony, timbre, tone, and more; a tragedy utilizes language, *mise-en-scène*, exposition, complication, dénouement; a ballet has formalized movement, *mise-en-scène*, line, and idea content.

Moving to the third question, we examine how the work stimulates our senses—and why. In other words, how do the particular formal and technical arrangements (whether conscious or unconscious on the part of the artist) elicit a sense response from us? Here we deal with physical and mental properties. For example, our response to sculpture can be physical. We can touch a piece of sculpture and sense its smoothness or its hardness (Fig. **0.11**). In con-

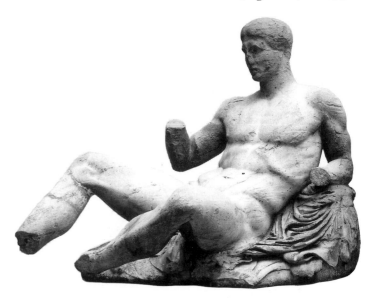

0.11 *Dionysus* (*Heracles?*), from the east pediment of the Parthenon, Athens, c. 438–432 B.C. Marble, over life-size. British Museum, London.

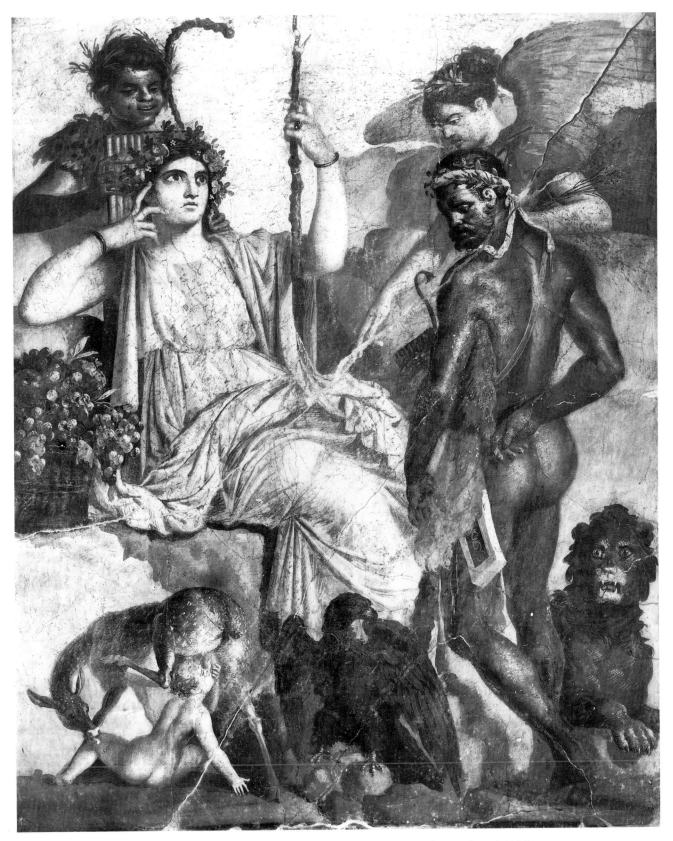

0.12 *Hercules and Telephos,* from Herculaneum, Italy, 2nd century B.C. Roman copy of a Greek work. Wall painting, height 5 ft 7 ins (1.17 m). Museo Archeologico Nazionale, Naples.

trast we experience sense responses that are essentially mental. For example, upright triangles give us a sense of solidity. When we perceive the colors green and blue, we call them "cool"; reds and yellows are "warm" colors. Pictures that are predominantly horizontal or composed of broad curves are said to be "soft" or placid. Angular, diagonal, or short, broken lines stimulate a sense of movement. Music that utilizes undulating melodic contours can be "smooth"; music that is highly consonant can be "warm" or "rich." These and other sense responses tend to be universal; most individuals respond in similar fashion to them.

We can also ask a fourth question about a work of art: What does the work mean? We might answer that question in strictly personal terms, for example, a painting may remind us of some personal experience. However, we cannot dismiss the question, What does it mean? as a reference to purely personal experience, as we will discover in Chapters 9–13. To reiterate, *a work of art is a way of looking at human reality that is expressed in a particular medium and shared with others*. So the ultimate response to an artwork, the ultimate meaning and experience, go beyond opinion to encompass an attempt to understand what the artist may have had in mind and what circumstances may have shaped the work. As we noted earlier, meaning in an artwork can often be enhanced by understanding cultural or historical contexts, including biography.

When we have finished our examination of the two units of this text—*The Media of the Arts: What Artists Use to Express "Reality"* and *The Styles of the Arts: How Artists Portray "Reality"*—our own human reality will have broader horizons and deeper insights.

PART ONE

THE MEDIA OF THE ARTS

What Artists Use to Express "Reality"

THE MEDIA OF THE ARTS

What Artists Use to Express "Reality"

THE MEDIA OF THE ARTS

The arts can be powerful means of expression, and, as we suggested earlier, we live with them on a daily basis, in and out of museums, concert halls, and theatres. We need to understand from the outset that we cannot recognize, understand, or communicate how art affects us without using language. It is important, therefore, that we become *literate* in the languages of the arts. Getting Started, then, means preparing to travel in the land of basic terminology. In other words, we are about to sample some of the things that will help us to identify and communicate important characteristics appropriate to works of art.

In the chapters of Part I of this text, we will meet the traditional art disciplines of painting, printmaking, photography, sculpture, music, theatre, film, dance, architecture, and literature. Each of these disciplines has its own language, and these chapters introduce us to those languages. Thus, Chapters 1–8 comprise mostly a catalogue of terms and definitions. Some are short and sweet, others are more complicated and conceptual. Many of the terms and concepts are recognizable, and you will find yourself thinking, "I know that." At other times you will wonder about the need for the technicality of what is presented. It is at these points that discussion in and out of class will be necessary. Reference to the music CD and careful study of the visual examples will be required. In the end, tremendous satisfaction and confidence will result when, on the street and elsewhere, works of art can be engaged and discussed with accurate terminology and enhanced perception. The ability to do this will result in amazing rewards.

FEATURE BOXES

Inserted at various points in the text are feature boxes. These inserts are intended to supplement the material in the text. They allow for more detailed discussion and analysis, and their purpose is to engage you and make the experience of the arts more personal and rewarding. Because of the way textbooks need to be designed, these boxes do not always appear in the most convenient places. That is to say, you will occasionally encounter a feature box in a place that breaks the flow of the text. Try not to break the flow of your reading when that happens. Continue on with the text until you come to a natural break. Summarize what you have been reading, and then return to the feature box to absorb its message.

PART I: THE MEDIA OF THE ARTS—OUTLINE

Chapter One: Pictures: Painting, Drawing, Printmaking, and Photography
Chapter Two: Sculpture
Chapter Three: Music
Chapter Four: Theatre
Chapter Five: Film
Chapter Six: Dance
Chapter Seven: Architecture
Chapter Eight: Literature

CHAPTER ONE

PICTURES:
PAINTING, DRAWING, PRINTMAKING, AND PHOTOGRAPHY

WHAT ARE THEY?

HOW ARE THEY PUT TOGETHER?

MEDIA
 Paintings and Drawings
 Printmaking
 Photography
COMPOSITION
 Elements
 Principles
Profile: Pablo Picasso
OTHER FACTORS
 Perspective
 Subject Matter

HOW DO THEY STIMULATE THE SENSES?

CONTRASTS
DYNAMICS
Painting and Human Reality: Géricault,
 The Raft of the "Medusa"
TROMPE L'OEIL
JUXTAPOSITION
FOCUS
OBJECTIVITY

IMPORTANT TERMS

Intaglio The printmaking process in which ink is transferred from the grooves of a metal plate to paper by extreme pressure.

Lithography A printmaking technique, based on the principle that oil and water do not mix, in which ink is applied to a piece of paper from a specially prepared stone.

Composition The arrangement of line, form, mass, color, and so forth in a work of art.

Line The basic building block of visual design; for example, a thin mark, a color edge, or implied.

Form The shape of an object within a composition.

Hue The spectrum notation of color.

Value The relationship of lights to darks in a visual composition.

Intensity The degree of purity of a color.

Variation The relationship of repeated items in a composition to each other.

Symmetry The balancing of like forms and colors on opposite sides of the vertical axis of a composition.

Perspective The creation of the illusion of distance in a picture through the use of line, atmosphere, and so on.

Pictures of family, friends, rock and sports stars, copies of artistic masterpieces, and original paintings and prints adorn our personal spaces. Dorm rooms, bedrooms, and living rooms seem coldly empty and depersonalized without pictures of some kind. Pictures have always been important to us. People who lived in caves 20,000 years ago drew pictures on their walls. In this chapter we shall learn about the many ways pictures can be made and how artists use two-dimensional qualities to speak to us.

WHAT ARE THEY?

Paintings, drawings, photographs, and prints are pictures, differing primarily in the technique of their execution. They are all two-dimensional. Our initial response is to their subject matter. A picture might be a landscape, seascape, portrait, or still life; or a religious picture, non-objective (nonrepresentational), or abstract—or something else. So, at the initial encounter, our response is a simple and straightforward matter of observation.

HOW ARE THEY PUT TOGETHER?

MEDIA

Our technical level of response is more complex. Our first response to how a work is put together is to the medium used by the artist to execute it.

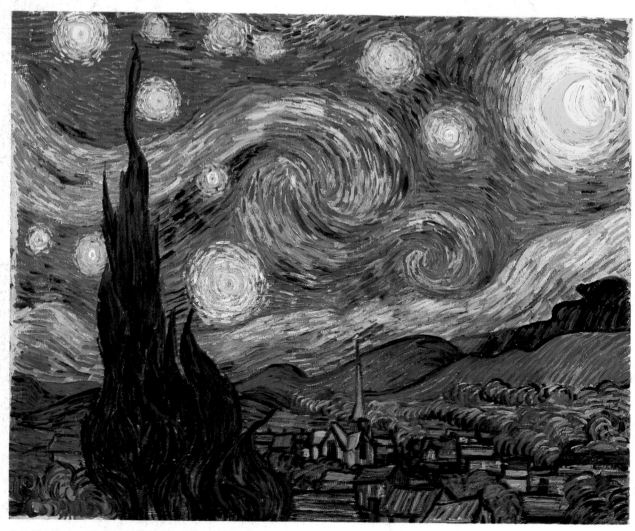

1.1 Vincent van Gogh, *The Starry Night*, 1889. Oil on canvas, 29 x 36¼ ins (73.7 x 92.1 cm). The Museum of Modern Art, New York (Acquired through the Lillie P. Bliss Bequest).

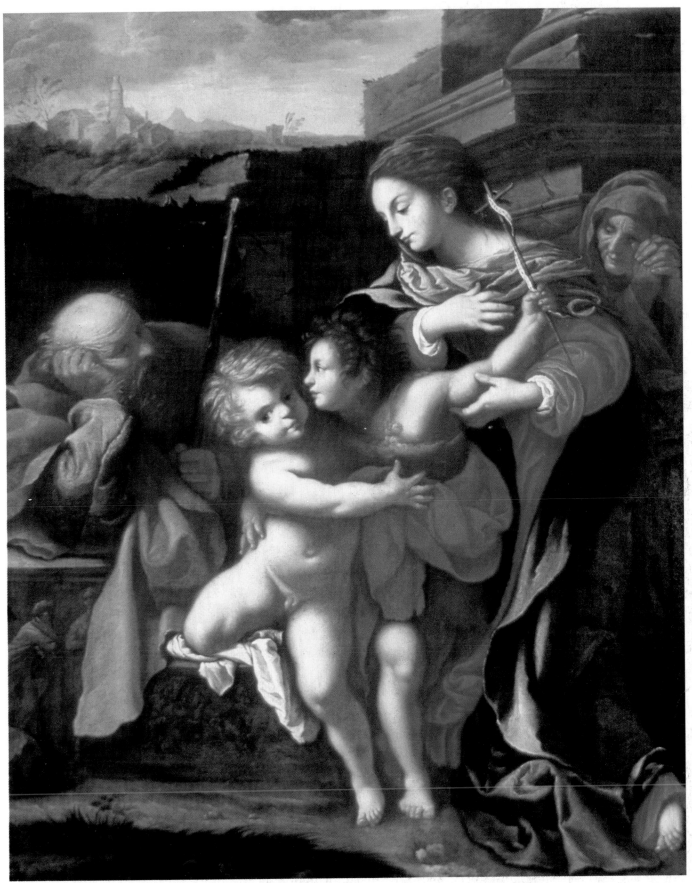

1.2 Giovanni Battista Vanni, *Holy Family with St. John*. Oil on canvas, 5 ft 10 ins x 4 ft 10 ins (1.78 x 1.47 m). Palmer Museum of Art, Pennsylvania State University.

Paintings and Drawings

Paintings and drawings can be executed with oils, water-colors, tempera, acrylics, fresco, gouache (goo-AHSH), ink, pastels, and pencils, to name just a few media. An artist may combine these, and may use some others as well. Each medium has its own characteristics, and to a great extent they dictate what the artist can or cannot achieve.

Oils are perhaps the most popular of the painting media, and have been since their development around the beginning of the fifteenth century. Their popularity stems principally from the fact that they offer a tremendous range of color possibilities; they can be reworked; they present many options for textural manipulation; and they are durable. If we compare two oil paintings, van Gogh's *Starry Night* (Fig. **1.1**) and Giovanni Vanni's *Holy Family with St. John* (Fig. **1.2**), the importance of the medium can be seen. Vanni creates light and shade in the Baroque tradition, and his *chiaroscuro* (key-AR-ohs-SKOO-roh) depends upon the capacity of the medium to blend smoothly among color areas. Van Gogh, on the other hand, requires a medium that will form obvious brushstrokes. Vanni demands the paint to be flesh and cloth. Van Gogh demands the paint to be paint, and to call attention to itself.

Watercolor is a broad category that includes any color medium that uses water as a thinner. The term has traditionally referred to a transparent paint usually applied to paper. Because watercolors are transparent, an artist must be very careful to control them. If one area of color overlaps another, the overlap will show as a third area combining the previous hues. Their transparency gives watercolors a delicacy that cannot be produced in any other medium.

Tempera is an opaque watercolor medium. It was employed by the ancient Egyptians, and is still used today. Tempera refers to ground pigments and their color binders—for example, gum or glue—but is best known in egg tempera form. It is a fast-drying medium that virtually eliminates brushstroke, and gives extremely sharp detail. Colors in tempera paintings appear almost gemlike in their clarity and brilliance.

Acrylics, in contrast with tempera, are modern, synthetic products. Most acrylics can be dissolved in water (but are water-impermeable when dry) and the binding agent for the pigment is an acrylic polymer. Acrylics are flexible media, offering artists a wide range of possibilities in both color and technique. An acrylic paint can be either opaque or transparent, depending upon dilution. It is fast-drying, thin, and resistant to cracking under extremes of temperature and humidity. It is perhaps less permanent than some other media but adheres to a wider variety of surfaces. It does not darken or yellow with age, as does oil.

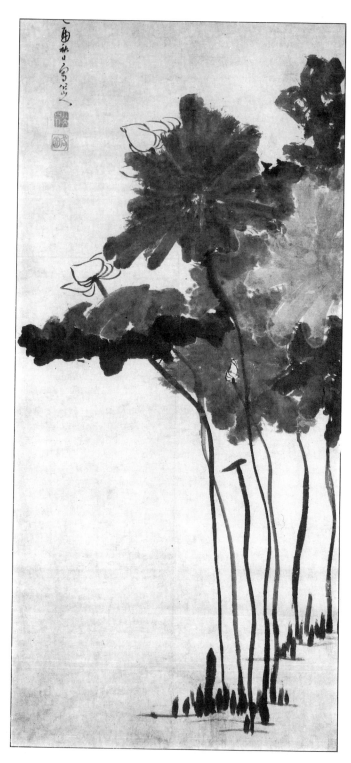

1.3 Chu Ta (Zhu Da) (Pata-shan-jen), *Lotus*, 1705. Brush and ink, 6½ x 28 ins (17 x 71 cm). Palmer Museum of Art, Pennsylvania State University.

Fresco is a wall-painting technique in which pigments suspended in water are applied to fresh wet plaster. Michelangelo's Sistine Chapel frescoes are the best-known examples of this technique. Because the end result

becomes part of the plaster wall rather than being painted on it, fresco is long-lasting. However, it is an extremely difficult process, and once the pigments are applied, no changes can be made without replastering the entire section of the wall.

Gouache is watercolor medium in which gum is added to ground opaque colors mixed with water. Transparent watercolors can be made into gouache by adding Chinese white, which is a special opaque, water-soluble paint. The final product, in contrast to watercolor, is opaque.

Ink as a painting medium has many of the same characteristics as transparent watercolor. It is difficult to control, yet its effects are nearly impossible to achieve in any other medium. Because it must be worked quickly and freely, it has a spontaneous and appealing quality (Fig. **1.3**).

Drawing media such as ink when applied with a pen (as opposed to a brush), pastels (crayon or chalk), and pencils all create an effect through build-up of line. Each has its own characteristics, but all are relatively inflexible in their handling of color and color areas (Fig. **1.8**).

Printmaking

Printmaking falls generally into three main categories, based essentially on the nature of the printing surface. First is *relief printing*, such as woodcut, wood engraving, and linoleum cut. Second is *intaglio* (in-TAH-lyee-oh) including etching, aquatint, and drypoint. Third is the *planographic process*, which includes lithography, silk-screen (serigraphy), and other forms of stenciling. Other combinations and somewhat amorphous processes such as monoprinting are also used by printmakers.

To begin with, we need to ask, What is a print? A print is a hand-produced picture that has been transferred from a printing surface to a piece of paper. The artist prepares the printing surface and directs the printing process. The unique value of a print lies in the fact that the block or surface from which it is made is usually destroyed after the desired number of prints has been made. In contrast, a reproduction is not an original, but a copy of an original painting or other artwork, reproduced usually by a photographic process. As a copy, the reproduction is not the handiwork of an artist.

Every print has a number. On some the number may appear as a fraction—for example, $^{36}/_{100}$. The denominator indicates how many prints were produced from the plate or block. This number is called the issue number, or edition number. The numerator indicates where in the series the individual print was produced. If only a single number, such as 500, appears, it simply indicates the total number

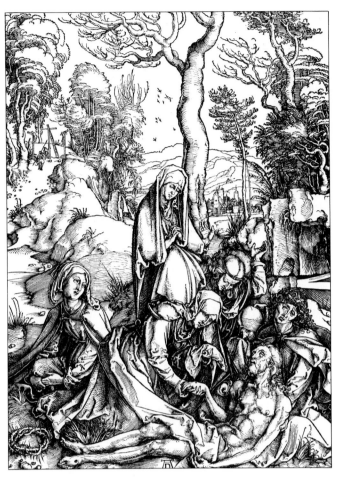

1.4 Albrecht Dürer, *Lamentation*, c. 1497–1500. Woodcut, 15½ x 11¼ ins (39 x 29 cm). Palmer Museum of Art, Pennsylvania State University (Gift of the Friends of the Museum of Art).

of prints in the series; this is also called an edition number. The numerator is an item of curiosity only; it has nothing to do with a print's value, monetarily or qualitatively. The issue number does have some value in comparing, for example, an issue of 25 with one of 500, and is usually reflected in the price of a print. However, the issue number is not the sole factor in determining the value of a print. Its quality and the reputation of the artist are more important considerations.

RELIEF PRINTING In relief printing, the image is transferred to the paper by cutting away nonimage areas and inking the surface that remains. The image protrudes in relief from the block or plate, and produces a picture that is reversed from the image carved by the artist. This reversal is a characteristic of all printmaking media. Figure **1.4** illustrates the linearity of the woodcut, and shows the precision and delicacy possible in the hands of an expert.

INTAGLIO The intaglio process is the opposite of relief printing. Ink is transferred to the paper not from raised areas, but rather from grooves cut into a metal plate. Line engraving, etching, drypoint, and aquatint are some of the methods of intaglio.

Line engraving involves cutting grooves into the metal plate with special sharp tools. It requires great muscular control because the pressure must be continuous and constant if the grooves are to produce the desired image. The print resulting from the line-engraving process is very precise. This form of intaglio is the most difficult and demanding.

In the *etching* process, the artist removes the surface of the plate by exposing it to an acid bath. First the plate is covered with a thin, waxlike, acid-resistant substance called a *ground*. The artist scratches away parts of the ground to produce the desired lines. The plate is then immersed in the acid, which burns away the exposed areas. The longer a plate is left in the acid, the deeper the resulting etches; the deeper the etch, the darker the final image. Artists wishing to produce lines or areas of differing darkness must cover the lines they do not want to be more deeply cut before further immersions in the acid. Repetition of the process yields a plate producing a print with the desired differences in light and dark lines.

Figure **1.5** consists only of individual lines, either single or in combination. The lighter lines required less time in the acid than the darker ones. Because of the precision and clarity of the lines, it is difficult to determine whether this print is an etching or an engraving. Drypoint, on the other hand, can be distinguished because it produces lines with less sharp edges.

Drypoint is a technique in which the surface of the metal plate is scratched with a needle. Unlike line engraving, which gives a clean, sharp line, the drypoint technique leaves a ridge, called a burr, on either side of the groove, resulting in a somewhat fuzzy line.

Aquatint can create a range of values from lightest gray to black and thus is useful for shading. The intaglio methods already noted consist of various means of cutting lines into a metal plate. Sometimes, though, an artist may wish to

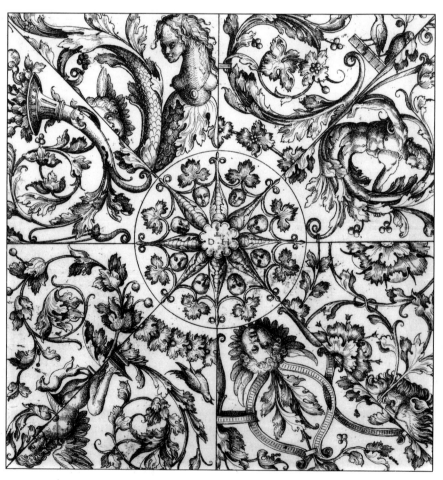

1.5 Daniel Hopfer, *Ceiling Ornament*. Etching, 10 x 8¾ ins (25 x 22 cm). Palmer Museum of Art, Pennsylvania State University.

create large areas of subdued tonality. Such shadowy areas cannot be produced effectively with lines. Therefore, the artist dusts the plate with a resin substance and heats it, which affixes the resin. It is then put into an acid bath. The result is a plate with a rough surface, like sandpaper, and a print with tonal areas that reflect this texture.

Once the plate is prepared, whether by line engraving, etching, drypoint, aquatint, or a combination of methods, it is put in a press and a special dampened paper is laid over it. Padding is placed on the paper, and then a roller is passed over it, forcing the plate and the paper together with great pressure. The ink, which has been carefully applied to the plate, which has been carefully wiped, leaving the ink only in the grooves, transfers as the paper is forced into the grooves by the roller of the press. Even if no ink had been applied to the plate, the paper would still receive an image. This *embossing* effect marks an intaglio process; the three-dimensional *platemark* is very obvious.

PLANOGRAPHIC PROCESSES In a planographic process, the artist prints from a plane surface—neither relief nor intaglio. *Lithography* (the term's literal meaning is "stone writing") rests on the principle that water and grease do not mix. To create a lithograph, artists begin with a stone—usually limestone, as it is porous—and grind one side until absolutely smooth. They then draw an image on the stone with a greasy substance. They can control the darkness of the final image by varying the amount of grease used: The more grease, the darker the image. After drawing the image, the artist treats the stone with gum arabic and nitric acid, and then rinses it with a petrol product that removes the image. However, the water, gum, and acid have impressed

1.7 Charles Sheeler, *Delmonico Building*, 1925. Lithograph, 10 x 7⅛ ins (25 x 18 cm). Palmer Museum of Art, Pennsylvania State University.

1.6 Thomas Hart Benton, *Cradling Wheat*, 1938. Lithograph, 9½ x 12 ins (24 x 30 cm). Palmer Museum of Art, Pennsylvania State University (Gift of Carolyn Wose Hull).

1.8 Hobson Pittman, *Violets No. 1,* 1971. Pastel, 9½ x 10¼ ins (24 x 26 cm). Palmer Museum of Art, Pennsylvania State University.

the grease on the stone, and when it is wetted it absorbs water only in the ungreased areas. Finally, a grease-based ink is applied to the stone. It, in turn, will not adhere to the water-soaked areas, but only where the artist has drawn. As a result, the stone can be placed in a press and the image will be transferred to the waiting paper.

In Figures **1.6** and **1.7** we see the characteristic most attributable to lithography—a crayon-drawing appearance. Because the lithographer usually draws with crayonlike material on the stone, the final print has exactly that quality. Compare these prints with Figure **1.8**, a pastel drawing, and the point is clear.

Silkscreening is the most common of the stenciling processes. Silkscreens are made from a finely meshed silk fabric mounted on a wooden frame. The nonimage areas are blocked out by a variety of methods, including glue or cut paper. The stencil is placed in the frame and ink is applied. By means of a rubber instrument called a squeegee, the ink is forced through the openings of the stencil, through the screen, and onto the paper below. This technique allows the printmaker to achieve large, flat, uniform areas, as in Figure **1.9**. Here the artist has, through successive applications of ink, built up a complex composition, with highly lifelike detail.

Prints reflect recognizable differences in technique. It is not always possible to discern the technique used in executing a print, and some prints reflect a combination of techniques. However, in seeking the method of execution, we add another layer of potential response to a work.

Photography

Photographic images (and images of still photography's subsequent developments—motion pictures and video) are primarily informational. Cameras record the world around us, but, in addition, through editing, a photographer can take the camera's image and change the reality of life as we see it to a reality of the imagination. In one sense, photography is a simplification of reality that substitutes two-dimensional images for the three-dimensional images around us. It also can be an amplification of reality when a photographer takes a snapshot of one moment in time and transforms it, by altering the photographic image and/or artificially emphasizing one of its parts, into something quite different. In some cases, photography is merely a matter of personal record, executed with equipment of varying degrees of expense and sophistication (Fig. **1.10**). Certainly, photography as a matter of pictorial record, or even as *photojournalism*, may lack the qualities we believe are requisite to art. A photograph of a baseball player

1.9 Nancy McIntyre, *Barbershop Mirror*, 1976. Silkscreen, 26½ x 19 ins (67 x 48 cm). Palmer Museum of Art, Pennsylvania State University.

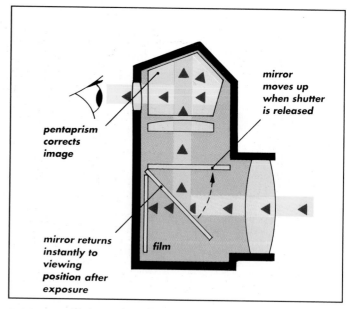

mirror moves up when shutter is released

pentaprism corrects image

mirror returns instantly to viewing position after exposure

film

1.10 The single-lens reflex (SLR) camera.

sliding into second base, or of Aunt Mabel cooking hamburgers at the family reunion, may trigger expressive responses for us, but it is doubtful that the photographers had aesthetic communication or design in mind when they snapped the shutter. On the other hand, a carefully composed and sensitively designed photograph can contain every attribute of human expression possible in any art form.

Ansel Adams believed the photographer to be an interpretative artist: He likened a photographic negative to a musical score, and the print to a performance. Despite all the choices the artist may make in committing an image to film, they are only the beginning of the artistic process. The photographer still has the choice of *size, texture,* and *value contrast (tonality).* A photograph of the grain of a piece of wood, for example, has an enormous range of aesthetic possibilities depending upon how the artist employs and combines these three elements.

Consequently, the question, Is it art? may have a cogent application to photography. However, the quality of our aesthetic repayment from the photographic experience is higher if we view photography in the same way as we do the other arts—as a visualization of reality expressed through a technique and resulting in an aesthetic response or communication.

COMPOSITION

A discussion of how any artwork is put together eventually results in a discussion of how it is composed. The elements and principles of *composition* are basic to all the arts, and we shall return to them time and time again as we proceed.

Elements

The basic building block of a visual design is *line.* To most of us a line is a thin mark: ————. We find that denotation in art as well. Figure 1.11 shows amorphous shapes. Some of them are like cartoon figures—they are identifiable from the background because of their *outline.* Line identifies form, and illustrates the first sentence of this paragraph.

The other shapes also exemplify line. These shapes appear black or white against the background. If we put our finger on the edge of them, we have identified a second

1.11 Joan Miró, *Composition,* 1933. Oil on canvas, 4 ft 3⅜ ins x 5 ft 4 ins (1.31 x 1.65 m). Wadsworth Atheneum, Hartford, Connecticut.

1.12 Outline and implied line.

There is no physical line between the tops of the forms, but their spatial arrangement creates one by implication. A similar use of line occurs in Figure **1.1**, where we can see a definite linear movement from the upper left border through a series of swirls to the right border. That "line" is quite clear although it is composed not of a form edge or outline but of a carefully developed relationship of numerous color areas. This treatment of line is also seen in Figure **1.13**, although here it is much more subtle and sophisticated. By dripping paint onto canvas—a task not as easily executed as it might appear—the artist was able to subordinate form, in the sense of recognizable and distinct areas, and thereby *focal areas*, to form a dynamic network of complex lines. The effect of this technique of execution has a very strong relationship to the actual force and speed with which the pigment was applied.

aspect of line—the *boundary* between areas of color, and between shapes or forms.

There is one further aspect of line, which is implied rather than physical. The three rectangles in Figure **1.12** create a horizontal "line" that extends across the design.

An artist uses line to control our vision, to create unity and emotional value, and ultimately to develop meaning. In pursuing those ends, and by employing the three aspects noted above, the artist finds that line has one of two simple

1.13 Jackson Pollock, *Number 1, 1948*, 1948. Oil and enamel on unprimed canvas, 5 ft 8 ins x 8 ft 8 ins (1.73 x 2.64 m). The Museum of Modern Art, New York (Purchase).

characteristics: It is *curved* or *straight*. Whether expressed as an outline, as a boundary, or by implication, and whether simple or in combination, a line is some derivative of straightness or curvedness.

It is interesting to speculate as to whether line can be thick or thin. Certainly, those qualities are helpful in describing some works of art. People who deny them, however, have a point that is difficult to refute: If line can be thick or thin, at what point does it cease to be a line and become a form?

Form and line are closely related both in definition and in effect. Form is the *shape* of an object within the composition, and "shape" is often used as a synonym for form. Form is the space described by line. In a drawing, a building is a form. So is a tree. We perceive them as buildings or trees, and we also perceive their individual details because of the line by which they are composed. Form cannot be separated from line in two-dimensional design.

Color characteristics differ depending upon whether we are discussing color in light or in pigment. In light, the *primary hues* (those hues that cannot be achieved by mixing other hues) are red, green, and blue; in pigment they are red, yellow, and blue. Mixing equal proportions of yellow and blue pigments creates green. Because green can be achieved by mixing, it cannot be a primary in pigment. Inasmuch as our response to artworks most often deals with colored pigment, the discussion that follows concerns color in pigment. We will not discuss color in light.

Hue is the spectrum notation of color; that is, a hue is a specific, pure color with a measurable wavelength. The visible range of the color spectrum extends from violet at one end to red at the other. The color spectrum consists of three primaries—blue, yellow, and red—and three additional hues that are direct derivatives of them—green, orange, and violet. These six colors are the basic hues of the spectrum (Fig. **1.14**). In total there are from ten to twenty-four perceivably different hues, including these six, depending upon which theory one follows.

For the sake of clarity and illustration, let us assume twelve basic hues. Arranged in a series, they would look like Figure **1.15**. However, turning the color spectrum into a *color wheel* (Fig. **1.16**) illustrates what an artist can do to and with color. First, an artist can take the primary hues of the spectrum, mix them two at a time in varying proportions, and create the other hues of the spectrum. For example, red and yellow in equal proportions make orange, a *secondary* hue. Varying the proportions—adding more red or more yellow—makes yellow-orange or red-orange, which are *tertiary* hues. Yellow and blue make green, and also blue-green and yellow-green; red and blue give us violet, blue-violet, and red-violet. Hues directly opposite

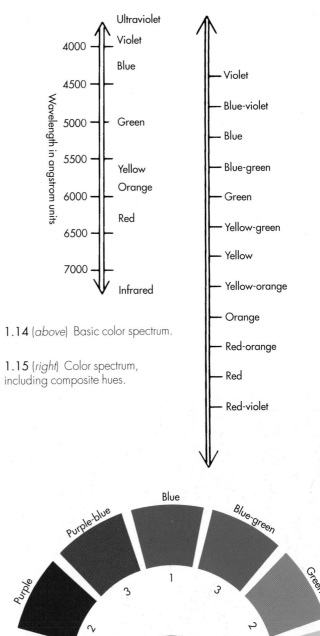

1.14 (*above*) Basic color spectrum.

1.15 (*right*) Color spectrum, including composite hues.

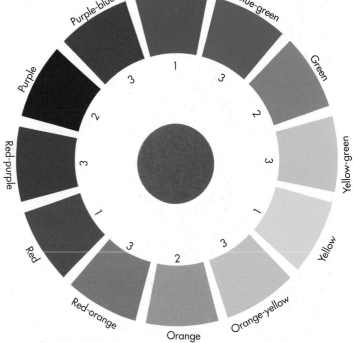

1.16 Color wheel: 1: primary hues; 2: secondary hues; 3: tertiary hues.

each other on the color wheel are known as *complementary*. When they are mixed together in equal proportions, they produce gray. First, therefore, an artist can vary hue.

In discussing photography, we noted the concept of *value contrast*—the relationship of blacks to whites and grays. The range of possibilities from black to white forms the *value scale*, which has black at one end, white at the other, and medium gray in the middle. The perceivable tones between black and white are designated light or dark (Fig. **1.17**).

If we approach the subject of the effects of value on color in terms of what painters can do to color to create a painting that gives the effect they desire, we discover that they may mix primaries to create secondary and tertiary hues, and thereby change hue. Every hue has its own value—that is, in its "pure" state each hue falls somewhere on the value scale in Figure **1.18**. An artist may change the value of a hue by raising or lowering it, that is, by adding white, black, or gray.

In addition, a broad range of color possibilities exists between high-light gray and pure white, or between a pure hue and white. That range of possibilities is described by the term *saturation*. A saturated hue is a pure hue. An unsaturated hue is a hue to which some quantity of white

has been added. Unsaturated hues, such as pink, are known as *tints*.

Some colors are brighter than others. The perceivable difference in brightness between primary yellow and primary blue is due to a difference in value. However, it is possible to have a bright yellow and a dull yellow. The difference in brightness between the two may be a matter of value, as we just observed—a pure yellow versus a grayed yellow. It may also be a matter of surface brilliance, or reflectance, a factor of considerable importance to all visual artists. A highly reflective surface creates a brighter color, and therefore a different response from the observer, than does a surface of lesser reflection, although all other color factors may be the same. This is the difference between high-gloss, semigloss, and flat paints, for example. Probably surface reflectance is more a property of texture than of color. None the less, the term brilliance is often used to describe not only surface gloss, but also characteristics synonymous with value. Some sources also use brilliance as a synonym for saturation, while still others use saturation as a synonym for an additional color-change possibility, intensity.

Intensity is the degree of purity of a hue. It also is sometimes called *chroma*. Returning to the color wheel (Fig.

White

High light

Light

Medium light

Medium (gray)

High dark

Dark

Low dark

Black

1.17 Value scale.

W

HL — Yellow

Yellow-green — L — Yellow-orange

Green — ML — Orange

Blue-green — M — Red-orange

Blue — MD — Red

Blue-violet — D — Red-violet

Violet — LD

B

1.18 Color-value equivalents.

1.16), note that movement around the wheel creates a change in intensity. Moving across the wheel—that is, adding, for example, green to red, also alters intensity. When, as in this case, hues are directly opposite each other on the color wheel, such mixing grays the original hue. Therefore, since graying a hue is a value change, one occasionally finds intensity and value used interchangeably. Some sources use the terms independently but state that changing a color's value automatically changes its intensity. There is a difference between graying a hue by using its complement, and graying a hue by adding black (or gray derived from black and white). A gray derived from complementaries, because it has color, is far livelier than a gray derived from black and white, which are not colors.

The overall use of color by the artist is termed *palette*. An artist's palette can be broad, restricted, or somewhere in between, depending upon whether the artist has utilized the full range of the color spectrum and/or whether he or she explores the full range of *tonalities*—brights and dulls, lights and darks.

As to *mass* (space), only three-dimensional objects take up space and have density. However, two-dimensional objects give the illusion of mass, relative only to the other objects in the picture.

Then there is the *texture* of a picture—its apparent roughness or smoothness. Texture ranges from the smoothness of a glossy photo to the three-dimensionality of *impasto*, a painting technique wherein pigment is applied thickly with a palette knife. The texture of a picture may be anywhere within these two extremes. Texture may be illusory, in that the surface of a picture may be absolutely flat but the image gives the impression of three-dimensionality, so the term can be applied to the pictorial arts either literally or figuratively.

Principles

Probably the essence of any design is repetition: how the basic elements in the picture are repeated or alternated. The three terms used are rhythm, harmony, and variation.

Rhythm is the ordered recurrence of elements in a composition. If the relationships among elements are equal, the rhythm is regular (Fig. **1.12**). If not, the rhythm is irregular. However, one must examine the composition as a whole to discern patterns of relationships, and whether or not the patterns are regular, as they are in Figure **1.19**.

Harmony is the logic of the repetition. Harmonious relationships are those whose components appear to join naturally and comfortably. If the artist employs forms, colors, or other elements that appear incongruous or illogical, then we would use a musical term and say the picture is

dissonant. However, we need to understand that ideas and ideals often reflect cultural conditioning or arbitrary understandings.

Variation is the relationship of repeated items to each other; it is similar to theme and variation in music. How does an artist take a basic element in the composition and use it again with slight or major changes? Picasso, the artist of Figure **1.20**, has used two geometric forms, the diamond and the oval, and created a complex painting via repetition. The diamond with a circle at its center is repeated over and over to form the background. Variation occurs in the color given to these shapes. Similarly, the oval of the mirror is repeated with variations in the composition of the girl. The circular motif is also repeated throughout the painting, with variations in color and size.

The concept of *balance* is very important. It is not difficult to look at a composition and almost intuitively perceive that it does or does not appear balanced. *How artists achieve balance in their pictures is our concern.*

The most mechanical method of achieving balance is *symmetry*, specifically bilateral symmetry—the balancing of like forms, mass, and colors on opposite sides of the vertical axis (Figs. **1.21** and **1.22**). Symmetry is so precise that we can measure it. Pictures employing absolute symmetry tend to be stable, stolid, and without much sense of motion. They are also, probably for that very reason, quite rare. Many works approach symmetry, but nearly all retreat from placing mirror images on opposite sides of the centerline.

Asymmetrical balance, sometimes referred to as psychological balance, is achieved by careful placement of unlike items (Fig. **1.23**). Every painting illustrated in this chapter is asymmetrical. Comparative discussion as to how balance has been achieved is a useful exercise, especially if colors are considered. Often color is used to balance line and form. Because some hues, such as yellow, have great eye attraction, they can counterbalance tremendous mass and activity.

1.19 Repetition of patterns.

41

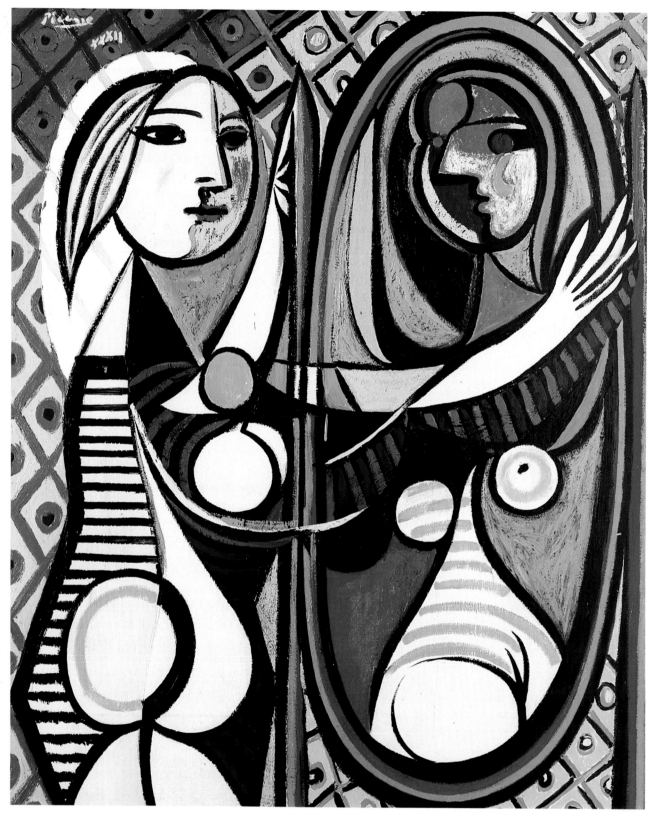

1.20 Pablo Picasso, *Girl Before a Mirror*, Boisgeloup, March 1932. Oil on canvas, 5 ft 4 ins x 4 ft 3 ¼ ins (1.62 x 1.3 m). The Museum of Modern Art, New York (Gift of Mrs. Simon Guggenheim).

PROFILE

Pablo Picasso

Pablo Picasso (1881–1973) was born in Málaga, on the Mediterranean coast of Spain. He studied at the Academy of Fine Arts in Barcelona but had already mastered realistic technique, however, and had little use for school. At sixteen he had his own studio in Barcelona. In 1900 he first visited Paris, and in 1904 he settled there. His personal style began to form in the years from 1901 to 1904, a period often referred to as his Blue Period because of the pervasive blue tones he used in his paintings at that time. In 1905, as he became more successful, Picasso altered his palette, and the blue tones gave way to a terra-cotta color, a shade of deep pinkish red. At the same time his subject matter grew less melancholy and included dancers, acrobats, and harlequins. The paintings he did during the years between 1905 and 1907 are said to belong to his Rose Period.

Picasso played an important part in the sequence of different artistic movements in the twentieth century. He said that to repeat oneself is to go against "the constant flight forward of the spirit." Primarily a painter, he also became a fine sculptor, engraver, and ceramist. In 1917 Picasso went to Rome to design costumes and scenery for Sergei Diaghilev's Ballets Russes. This work stimulated another departure in Picasso's work, and he began to paint the works now referred to as belonging to his Classic Period, which lasted from about 1918 until 1925.

At the same time as he was working on designs for the ballet, Picasso also continued to develop the Cubist technique (see Chapter 13), making it less rigorous and austere.

His painting *Girl Before a Mirror* (**Fig. 1.20**) gives us an opportunity to study his use of color in contrast to form. For example, Picasso chose red and green perhaps because they are complementary colors and perhaps, as art historian H. W. Janson suggests, because Picasso intended the green spot in the middle of the forehead of the mirror's image as a symbol of the girl's psyche, or inner self, which she confronts with apparent anguish.

Guernica (**Fig. 1.29**), his moving vision of the Spanish Civil War, also depends on curved forms. In this painting, however, the forms are intended to be fundamental because Picasso uses no color, only whites, grays, and black. *Guernica*, a huge painting, was Picasso's response to the 1937 bombing by the Fascist forces of the small Basque town of Guernica. In it distortions of form approach Surrealism (see Dali's *The Persistence of Memory*, **Fig. 1.28**), but Picasso never called himself a Surrealist. He continued to work with incredible speed and versatility—as painter, ceramist, sculptor, designer, and graphic artist—into his nineties.

An important characteristic in a work of art is the means by which unity is achieved. All of the elements of composition work together toward meaning. Often, compositional elements are juxtaposed in an unusual fashion to achieve a particular effect. None the less, that effect usually entails a conscious attempt at making a unified statement. Critical analysis of the elements of a painting should lead us to a judgment about whether the total statement comprises a unified one.

With regard to unity, some may speak of *closed composition*, in which use of line and form always directs the eye into the painting (Fig. 1.21), as unified, and *open*

1.21 Closed composition (composition kept within the frame).

1.22 Open composition (composition allowed to escape the frame).

composition, in which the eye is allowed to wander off the canvas, or escape the frame (Fig. **1.22**), as disunified. Such is not the case. Keeping the artwork within the frame is a stylistic device that has an important bearing on the artwork's meaning. For example, painting in the *Classical* style is predominantly within the frame, illustrating a concern for the self-containment of the artwork and for precise structuring. *Anticlassical* design forces the eye to escape the frame, suggesting perhaps the world or universe outside, or the individual's place in an overwhelming cosmos. Unity can be achieved by keeping the composition closed, but it is not a prerequisite.

When we look at a picture for the first time, our eye moves around it, pausing briefly at those areas that seem to be of greatest visual appeal. These are *focal areas*.

A painting may have a single focal area from which the eye will stray only with conscious effort. Or it may have an infinite number of focal points whereby the eye bounces from one point to another on the picture—in this way, the elements vie for our attention.

Focal areas are achieved in a number of ways—through confluence of line, by encirclement (Fig. **1.24**), or by color, to name just a few. To draw attention to a particular point in the picture the artist may make all lines lead to that point. The focal object or area may be placed in the center of a ring of objects, or the object may be of a color that demands our attention more than the other colors in the picture. For example, bright yellows attract our eye more readily than dark blues. The artist uses focal areas to control what we see and when we see.

1.23 (*above*) *St. Mark* and *St. Luke*, from the Gospel Book of Godescale, A.D. 781–3. Vellum, 12¼ × 8¼ ins (31 × 21 cm). Bibliothèque Nationale, Paris.

1.24 (*opposite*) *St. Mark*, from the Gospel Book of St. Médard of Soissons, France, early 9th century. Paint on vellum, 14⅜ × 10¼ ins (37 × 26 cm). Bibliothèque Nationale, Paris.

OTHER FACTORS

Perspective

Perspective is a tool by which the artist indicates the spatial relationships of objects in a picture. It is based on the perceptual phenomenon that causes objects further away from us to appear smaller. If we examine a painting, we can identify the spatial relationships between the objects in the foreground and the background. We can also discern whether or not the relationships of the objects appear as we see them in life. For example, paintings executed prior to the Italian Renaissance, when mechanical procedures for rendering perspective were developed, look rather strange because, while background objects are painted smaller than foreground objects, the positioning does not appear rational. Their composition strikes us as being rather primitive.

Two basic types of perspective are common. The first, *linear perspective*, is characterized by the phenomenon of standing on railroad tracks and watching the two rails apparently come together at the horizon (known as the *vanishing point*, Fig. **1.25**). Very simply, linear perspective is the creation of the illusion of distance in a two-dimensional artwork through the convention of line and foreshortening—that is, the illusion that parallel lines come together in the distance. Linear perspective is also called scientific, mathematical one-point, or Renaissance perspective and was developed in fifteenth-century

Italy (see Chapter 11). Linear perspective is the system most people in Euro-American cultures think of as perspective, because it is the visual code they are accustomed to seeing.

The second, *aerial perspective*, indicates distance through the use of light and atmosphere. For example, mountains in the background of a picture are made to appear distant by being painted in less detail. In the upper left of Figure **1.2**, a castle appears at a great distance. We know it is distant because it is smaller and, more important, because it is indistinct.

Another treatment of perspective can be seen in the painting *Buddhist Monastery by Stream and Mountains* by Chü-jan (Fig. **1.26**). This hanging scroll illustrates a device fairly common in Chinese paintings with a vertical format. The artist divides the picture into two basic units—foreground and background. The foreground of the painting consists of details reaching back toward the middle ground. At that point a division occurs, so that the background and the foreground are separated by an openness in what might have been a deep middle ground. The foreground represents the nearby, and its rich detail causes us to pause and ponder on numerous elements, including the artist's use of brushstroke in creating foliage, rocks, and water. Then there is a break, and the background appears to loom up or be suspended—almost as if it were a separate entity. Although the foreground gives us a sense of dimension—of space receding from the front plane of the painting—the background seems to be flat, a factor that serves to enhance further the sense of height of the mountains.

Subject Matter

We can regard treatment of subject matter as ranging from *verisimilitude* (*representationalism*) to *nonobjectivity*. We will use this continuum again in later chapters, substituting the term *theatricality* for nonobjectivity. Between the two ends of this continuum are many of the "-isms" of the art world: Realism, Impressionism, Expressionism, Cubism, Fauvism, and so forth. Each is a particular method of treatment of subject matter.

Chiaroscuro

Chiaroscuro, whose meaning in Italian is "light and shade," is the suggestion of three-dimensional forms via light and shadow without the use of outline. It is a device used by artists to make their forms appear *plastic*—that is, three-dimensional. Making two-dimensional objects appear three-dimensional depends on the artist's ability to

1.25 Linear perspective.

render highlight and shadow effectively. Without them, all forms are two-dimensional in appearance.

Chiaroscuro gives a picture much of its character. For example, the dynamic and dramatic treatment of light and shade in Figure **1.27** gives this painting a quality quite different from what would have resulted had the artist chosen to give full, flat, front light to the face. The highlights, falling as they do, create not only a dramatic effect but also a compositional triangle extending from shoulder to cheek, down to the hand, and then across the sleeve and back to the shoulder. Consider the substantial change in character had highlight and shadow been executed in a different manner. The treatment of chiaroscuro in a highly verisimilar fashion in Figure **1.28** helps give the painting its strangely real yet dreamlike appearance.

In contrast, works that do not employ chiaroscuro have a two-dimensional quality. This can be seen to a large extent in Figure **1.1** and also in Figures **1.20** and **1.29**.

HOW DO THEY STIMULATE THE SENSES?

We do not touch pictures, and so we cannot feel their roughness or their smoothness, their coolness or their warmth. We cannot hear pictures and we cannot smell them. When we conclude that a picture affects our senses in a particular way, we are responding in terms of visual stimuli that are transposed into mental images of our senses of touch, taste, sound, and so forth.

CONTRASTS

The colors of an artist's palette are referred to as warm or cool depending upon which end of the color spectrum they fall. Reds, oranges, and yellows are said to be warm colors. They are the colors of the sun and therefore call to mind our primary source of heat, so they carry strong implications of warmth. Colors falling at the opposite end of the spectrum—blues and greens—are cool colors because they imply shade, or lack of light and warmth. As we will notice frequently, this is a stimulation that is mental but has a physical basis.

1.26 Chü-jan, *Buddhist Monastery by Stream and Mountains,* c. A.D. 960–85. Ink on silk, 33⅝ x 22⅝ ins (85.5 x 57.5 cm). Cleveland Museum of Art (Gift of Katharine Holden Thayer).

1.27 Jan Vermeer, *The Girl with the Red Hat*, c. 1665. Oil on wood, 9⅛ x 7⅛ ins (23 x 18 cm). National Gallery of Art, Washington, D.C. (Andrew W. Mellon Collection).

Tonality and color contrast also affect our senses. The stark value contrasts of Figure **1.29** contribute significantly to the harsh and dynamic qualities of the work. The colorlessness of this monochromatic black, white, and gray is a horrifying comment on the tragic bombing of Guernica. In the opposite vein, the soft yet dramatic tonal contrasts of Figure **1.27** and the strong warmth and soft texture of the red hat create a completely different set of stimuli.

Many of the sense-affecting stimuli work in concert, and cannot be separated. We have already noted some of the effects of chiaroscuro, but one of the most interesting is its application to the treatment of flesh. Some flesh appears like stone, other flesh appears soft and true to life. Our response to whatever treatment has been given is tactile—we want to touch, or we believe we know what we would feel if we did touch. Chiaroscuro is essential to achieve

1.28 Salvador Dalí, *The Persistence of Memory*, 1931. Oil on canvas, 9½ x 13 ins (24.1 x 33 cm). The Museum of Modern Art, New York (Given anonymously).

1.29 Pablo Picasso, *Guernica*, 1937. Oil on canvas, 11 ft 5 ins x 25 ft 5¾ ins (3.48 x 7.77 m). Museo Nacional Centro de Arte Reina Sofia, Madrid.

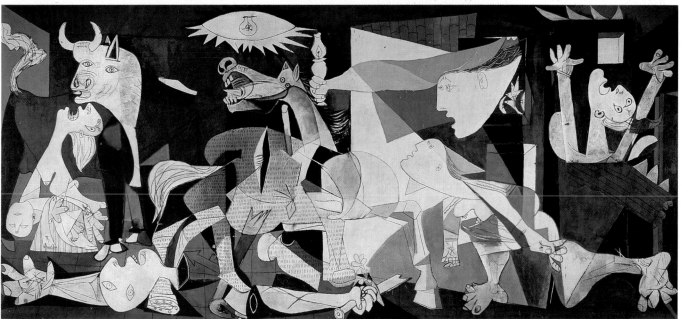

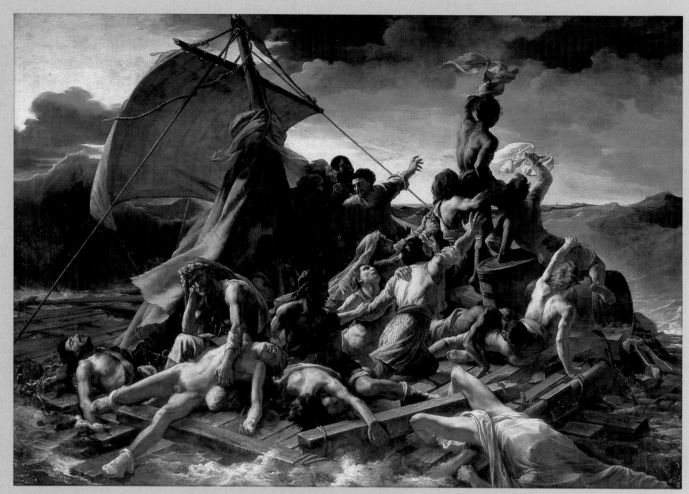

1.30 Théodore Géricault, *The Raft of the "Medusa,"* 1819. Oil on canvas, 16 ft x 23 ft 6 ins (4.91 x 7.16 m). Louvre, Paris.

those effects. Harsh shadow and strong contrasts create one set of responses; diffused shadows and subdued contrasts create another. Rubens's *Rape of the Daughters of Leucippus* (Fig. **1.31**) presents softly modeled flesh whose warmth and softness come from color and chiaroscuro. Highlight and shadow create softness, and predominantly red hues warm the composition; our sensual response is heightened dramatically.

DYNAMICS

Although pictures are static, they can stimulate a sense of movement and activity, and create a sense of stable solidity. The artist stimulates these sensations by using certain conventional devices. Composition that is principally vertical can express, for example, a sense of dignity and grandeur (Fig. **1.33**; see also Fig. **0.5**). A picture that is horizontal can elicit a sense of stability and placidity. The triangle is a most interesting form in engineering because of its structural qualities. It is also interesting in art because of its psychological qualities. If we place a triangle so that its base forms the bottom of a picture, we create a definite sense of solidity and immovability (Fig. **1.34**). If that triangle were a pyramid sitting on a level plane, a great deal of effort would be required to tip it over. If we invert the triangle so that it balances on its apex, a sensation of instability and action results (Figs. **1.35** and **1.38**). Although we can feel clearly the sensations stimulated by these simple geometric forms, we should not conclude that such devices are either explicit or limited in their communication. Nonverbal communication in the arts is not that simple.

PAINTING AND HUMAN REALITY

Géricault, *The Raft of the "Medusa"*

The Raft of the "Medusa" (**Fig. 1.30**) by Théodore Géricault illustrates both an emerging rebellion against Classicism in painting and a growing criticism of social institutions in general. The painting tells a story of governmental incompetence that resulted in tragedy. In 1816, the French government allowed an unseaworthy ship, the *Medusa*, to leave port, and it was wrecked. Aboard a makeshift raft, the survivors endured tremendous suffering, and were eventually driven to cannibalism. In preparing for the work, Géricault interviewed the survivors, read newspaper accounts, and went so far as to paint corpses and the heads of guillotined criminals.

Géricault's painting captures the ordeal in Romantic style, tempered by Classical and even High Renaissance influences (see Chapters 11 and 12). He creates firmly modeled flesh, realistic figures, and a precise play of light and shade (chiaroscuro). In contrast to other paintings of the time, which expressed Classical tendencies and, hence, two-dimensionality and order, Géricault used a complex and fragmented compositional structure. He chose to base the design on two triangles rather than on one strong central triangle. In *The Raft of the "Medusa,"* the left triangle's apex is the makeshift mast, which points back toward despair and death. The other triangle moves up to the right to the figure waving the fabric, pointing toward hope and life as a rescue ship appears in the distance.

Géricault captures the moment that a potential rescue ship is sighted and sails on by. The play of light and shade heightens the dramatic effect and the composition builds upward from the bodies of the dead and dying in the foreground to the dynamic group whose final energies are summoned to support the figure waving to the ship. Thus, the painting surges with unbridled emotional response to the horror of the experience and the heroism of the survivors. It is hope followed by despair.

1.31 Sir Peter Paul Rubens, *Rape of the Daughters of Leucippus*, c. 1616–17. Oil on canvas, 7 ft 3½ ins x 6 ft 10¼ ins (2.22 x 2.09 m). Alte Pinakothek, Munich.

1.32 Juxtaposition.

None the less, the basic compositional devices do influence our response, and impact on our perceptions.

The use of line also affects sense response. Figure **1.36** illustrates how this use of curved line can elicit a sense of relaxation. The broken line in Figure **1.37** creates a much more dynamic and violent sensation. We can also feel that the upright triangle in Figure **1.34**, although solid and stable, is more dynamic than a horizontal composition because it uses strong diagonal line, which tends to stimulate a sense of movement. Precision of linear execution can also create sharply defined forms or soft, fuzzy images. Figure **1.40** shows how straight lines and right angles can create the basic principles of life itself. Vertical lines signify vitality and life; horizontal lines signify tranquillity and death. The intersection of vertical and horizontal lines represents life's tensions.

TROMPE L'OEIL

Trompe l'oeil (tromp-LUH-yuh), or "trick the eye," gives the artist a varied set of stimuli by which to affect our sensory response. It is a form of illusionistic painting that attempts to represent an object as existing in three dimensions at the surface of the painting.

JUXTAPOSITION

We can also receive stimuli from the results of juxtaposing curved and straight lines, which results in linear dissonance or consonance. Figure **1.32** illustrates the juxtaposing of inharmonious forms, which creates instability. Careful use of this device can stimulate some very interesting and specific sense responses.

The metaphysical fantasies of Giorgio de Chirico (1888–1978) have Surrealist associations. Works such as *Nostalgia* (Fig. **1.33**) contain no rational explanation for their juxtaposition of strange objects. They have a dreamlike quality, associating objects that are not normally grouped together. Such works are not rational, and show a world humankind does not control. In them, "there is only what I see with my eyes open, and, even better, closed."

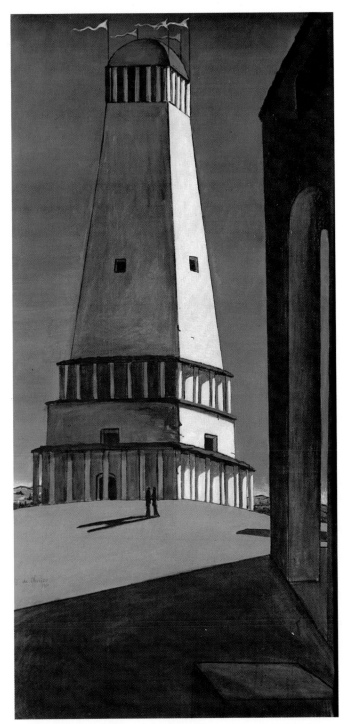

1.33 Giorgio de Chirico, *The Nostalgia of the Infinite*, 1913–14?, dated 1911 on the painting. Oil on canvas, 53¼ x 25½ ins (135.2 x 64.8 cm). The Museum of Modern Art, New York (Purchase).

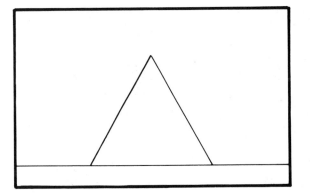

1.34 Upright-triangular composition.

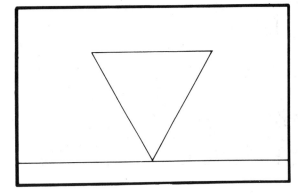

1.35 Inverted-triangular composition.

1.36 Curved line.

1.37 Broken line.

FOCUS

The work of François Boucher (1703–70) in the Rococo tradition gives us a taste of the decorative, mundane, and slightly erotic painting popular in the early and mid-eighteenth century. As a protégé of Madame de Pompadour, mistress of King Louis XV, Boucher enjoyed great popularity. His work has a highly decorative surface, and portrays pastoral and mythological settings such as shown in Figure 1.39. Boucher's figures almost always appear amid exquisitely detailed drapery. His rendering technique is nearly flawless, and his displays of painterly virtuosity provide fussily pretty works whose main subjects compete with their decorative backgrounds for our attention. In comparison with the power and sweep of the Baroque, Boucher appears gentle and shallow. Each detail takes on a separate focus of its own and leads the eye first in one direction and then another.

OBJECTIVITY

Subject matter, which involves any or all of the characteristics we have discussed, is a powerful device for effecting both sensory responses and more intense, subjective responses. The use of verisimilitude or nonobjectivity is a noticeable stimulant of individual response. It would seem logical for individuals to respond intellectually to nonobjective pictures, because the subject matter should be neutral, with no inherent expressive stimuli. However, the opposite tends to occur. When asked whether they feel

1.39 (opposite) François Boucher, *Venus Consoling Love*, 1751. Oil on canvas, 42⅛ x 33⅜ ins (107 x 85 cm). National Gallery of Art, Washington, D.C. (Chester Dale Collection).

1.38 Giotto, *The Lamentation*, 1305–6. Fresco, 7 ft 7 ins x 6 ft 7½ ins (2.31 x 2.02 m). Arena Chapel, Padua.

more comfortable with the subject matter in Figure **1.2** or that in Figure **1.13**, most individuals choose the former.

The works of the Spanish painter and printmaker Francisco de Goya (1746–1828) often reveal humanity and nature at their most malevolent. Figure **1.41** also tells a story of an actual event, when on May 3, 1808 the citizens of Madrid rebelled against Napoleon's army. Many individuals were arbitrarily arrested and executed. The focal attraction of the man in white is one of these. Goya's strong value contrasts force the eye to the victim; only the lantern behind the soldiers keeps the composition in balance.

Does an explicit appeal cause a more profound response? Or does the stimulation provided by the unfamiliar cause us to think more deeply and respond more fully, because our imagination is left free to wander? The answers to these questions are worth considering as we perceive artworks, many of whose keys to response are not immediately obvious.

1.40 Piet Mondrian, *Composition in White, Black, and Red*, 1936. Oil on canvas, 3 ft 4¼ ins x 3 ft 5 ins (1.02 x 1.04 m). The Museum of Modern Art, New York (Gift of the Advisory Committee).

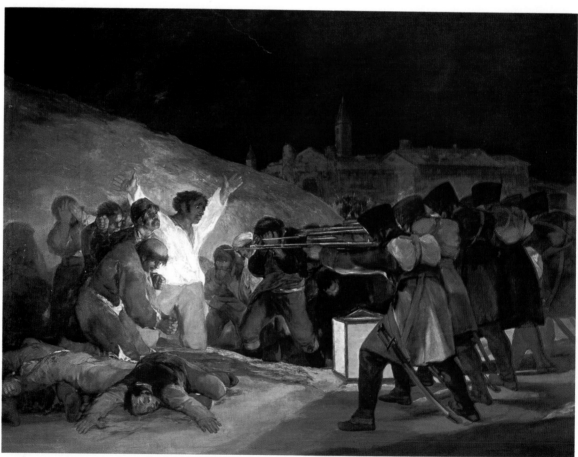

1.41 Francisco Goya, *Execution of the Citizens of Madrid, May 3, 1808*, 1814. Oil on canvas, 8 ft 6 ins x 11 ft 4 ins (2.59 x 3.45 m). Prado, Madrid.

CHAPTER TWO

SCULPTURE

WHAT IS IT?

HOW IS IT PUT TOGETHER?

DIMENSIONALITY
 Full-Round
 Relief
 Linear
METHODS OF EXECUTION
 Subtraction
 Addition
 Substitution
 Manipulation
 Found
 Ephemeral
COMPOSITION
 Elements
 Principles
OTHER FACTORS
 Articulation
 Focal Area
Sculpture and Human Reality:
 Michelangelo, David
Profile: Michelangelo

HOW DOES IT STIMULATE THE SENSES?

TOUCH
TEMPERATURE AND AGE
DYNAMICS
SIZE
LIGHTING AND ENVIRONMENT

IMPORTANT TERMS

Full-Round Sculptural works that explore full three-dimensionality.

Relief Sculptural works attached to a background and seen from one side only.

Subtraction A method of execution in sculpture in which works are carved.

Addition A method of execution in sculpture in which works are constructed, or built, by one element being added to another.

Substitution A method of execution in sculpture in which works are transformed from a molten to a solid state.

Manipulation A method of execution in sculpture in which works are shaped by skilled use of the hands.

Articulation The manner of movement from one element in an artwork to another.

Proportion The relationship of shapes in a work of visual art.

2.1 *Apollo playing the lyre*, from the Temple of Apollo at Cyrene, Libya, 1st century A.D. (Roman copy of a Greek statue). Marble, over life-size. British Museum, London.

Sculpture, in contrast to pictures, seems less personal and more public. In fact, we are likely to finds works of sculpture mostly in public spaces. Outside city halls and in parks and corporate office buildings we find statues of local dignitaries and constructions of wood, stone, and metal that appear to represent nothing at all. We might even wonder why our tax dollars were spent to buy them. Today, as throughout history, sculpture (and other forms of art) are often the subject of public pride and controversy. Because of its permanence, sculpture often represents the only artifact of entire civilizations. In this chapter we see not only how sculpture is made and how it works, but our examples will reveal ideas of artists from ancient history, contemporary times, and many cultures.

WHAT IS IT?

Sculpture is a three-dimensional art. It may take the form of whatever it seeks to represent, from pure, or non-objective, form to lifelike depiction of people or any other entity. Sometimes sculpture, because of its three-dimensionality, comes very close to reality in its depiction. Duane Hanson and John DeAndrea, for example, use plastics to render the human form so realistically that the viewer must approach the artwork and examine it closely to determine that it is not a real person.

2.2 East frieze, from Halicarnassus (modern Bodrum), Turkey. British Museum, London.

How is it Put Together?

DIMENSIONALITY

Sculpture may be *full-round, relief,* or *linear.* Full-round works are freestanding and fully three-dimensional (Fig. **2.1**). A work that can be viewed from only one side—that is, one that projects from a background—is said to be in relief (Fig. **2.2**). A work utilizing materials two-dimensionally is called linear (Fig. **2.18**). A sculptor's choice of full round, relief, or linearity as a mode of expression dictates to a large extent what he or she can and cannot do, aesthetically and practically.

Full-Round

Sculptural works that explore full three-dimensionality and intend viewing from any angle are termed full-round (Fig. **2.3**). Some subjects and styles pose certain constraints in this regard, however. Painters, printmakers, and photographers have virtually unlimited choice of subject matter and compositional arrangements. Full-round sculptures dealing with such subjects as clouds, oceans, and panoramic landscapes are problematic for the sculptor, though. Because sculpture occupies real space, the use of perspective, for example, to increase spatial relationships poses certain obvious problems. In addition, since full-round sculpture is freestanding and three-dimensional, sculptors are forced to concern themselves with the

practicalities of engineering and gravity. They cannot, for example, create a work with great mass at the top unless they can find a way (within the bounds of acceptable composition) to keep the statue from falling over. After we have viewed numerous full-round works, we begin to note the small animals, branches, tree stumps, rocks, and other devices that have been employed to give practical stability to a work.

Relief

The sculptor who creates a work in relief (Fig. **2.2**) does not have quite so many restrictions. Since the work is attached to a background, he or she has freer choice of subjects and need not worry about their positions or supports.

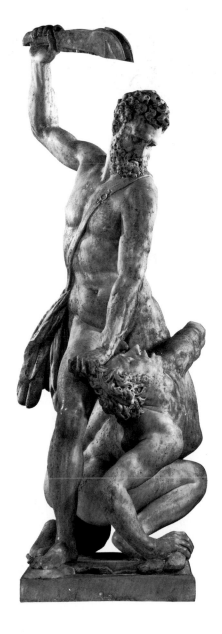

2.4 Giovanni Bologna, *Samson Slaying a Philistine,* c. 1562. Victoria & Albert Museum, London.

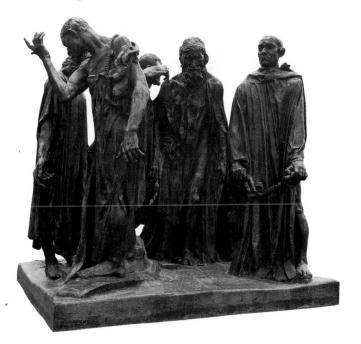

2.3 Auguste Rodin, *The Burghers of Calais,* 1866. Bronze, height 6 ft 10½ ins (2.09 m). Hirshhorn Museum and Sculpture Garden, Smithsonian Institution, Washington, D.C. (Gift of Joseph J. Hirshhorn).

Clouds, seas, and perspective landscapes are within the relief sculptor's reach, since the work needs to be viewed from only one side. Relief sculpture, then, is three-dimensional. However, because it protrudes from a background, it maintains a two-dimensional quality, as compared to full-round sculpture.

Linear

The third category of sculpture, linear sculpture, emphasizes construction with linear items such as wire or neon tubing, as we might see in a mobile like Figure **2.18**. Artworks using linear materials and occupying three-dimensional space will occasionally puzzle us as we try to decide whether they are really linear or full-round. Here again, absolute definition is less important than the process of analysis and aesthetic experience and response.

METHODS OF EXECUTION

In general, we may say that sculpture is executed using additive, subtractive, substitute, or manipulative techniques, or any combination of these. A fifth category, that of found sculpture, may or may not be considered a "method" of execution, as we shall see later.

Subtraction

Carved works are said to be *subtractive*. That is, the sculptor begins with a large block, usually of wood or stone, and cuts away (subtracts) the unwanted material. In previous eras, and to some extent today, sculptors had to work with whatever materials were at hand. Wood carvings emanated from forested regions, soapstone carvings from the Arctic, and great works of marble from the regions surrounding the quarries of the Mediterranean. Anything that can yield to the carver's tools can be formed into a work of sculpture. However, stone, with its promise of immortality, has proven to be the most popular material.

Three types of rock hold potential for the carver. *Igneous* rock, of which granite is an example, is very hard and potentially long-lasting. However, it is difficult to carve and therefore not popular. *Sedimentary* rock such as limestone is relatively long-lasting, easy to carve, and polishable. Beautifully smooth and lustrous surfaces are possible with sedimentary rock. *Metamorphic* rock, including marble, seems to be the sculptor's ideal. It is long-lasting, is "a pleasure to carve," and exists in a broad range of colors. Whatever the artist's choice, one requirement must be met: The material to be carved, whether wood, stone, or a bar of soap, must be free of flaws.

A sculptor who sets about to carve a work does not begin simply by imagining a *Samson Slaying a Philistine* (Fig. **2.4**)

and then attacking the stone. The first step would be to create a model, usually smaller than the intended sculpture. It is made of clay, plaster, wax, or some other material, and is completed in precise detail—a miniature of the final product.

Once the likeness of the model has been enlarged and transferred, the artist begins to rough out the actual image ("knocking away the waste material," as Michelangelo put it). In this stage of the sculpting process, the artist carves to within two or three inches of what is to be the finished area, using specific tools designed for the purpose. Then, using a different set of carving tools, she or he carefully takes the material down to the precise detail. Finishing work and polishing follow.

Addition

In contrast with carving from a large block of material, the sculptor using an additive process starts with a small amount of raw material and adds element to element until the work is finished. The term *built sculpture* is often used

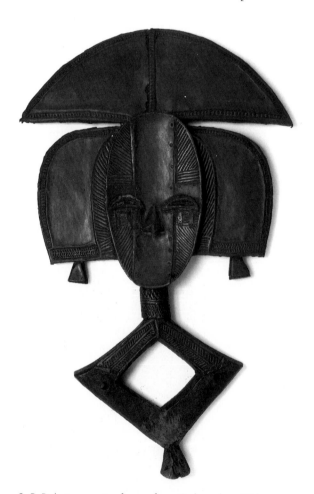

2.5 Bakota ancestor figure, from Gabon, late 19th century. Wood and copper sheeting, height 26¾ ins (68 cm). British Museum, London.

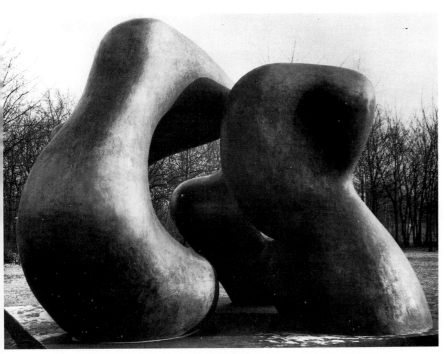

2.6 Henry Moore, *Two Large Forms*, 1969. The Serpentine, Hyde Park, London.

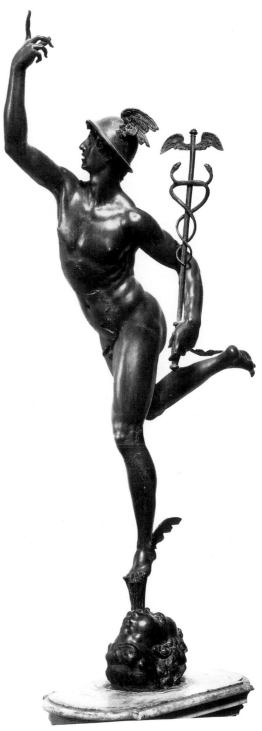

2.7 Giovanni Bologna, *Mercury*, c. 1567. Bronze, height 5 ft 9 ins (1.75 m). Museo Nazionale del Bargello, Florence.

2.8 (*left*) So-called statuette of Charlemagne, c. 860–70. Bronze cast and gilt, height 9½ ins (24 cm). Louvre, Paris.

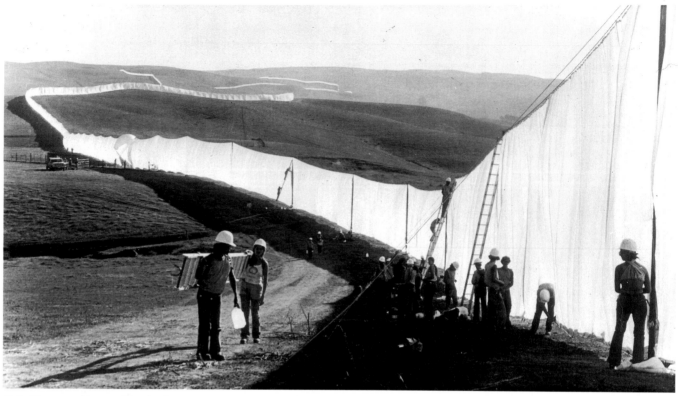

2.9 Christo and Jeanne-Claude, *Running Fence, Sonoma and Marin Counties, California,* 1972–6. Woven nylon fabric and steel cables, height 18 ft (5.49 m), length 24½ miles (39.2 km).

to describe works executed in an additive technique. The materials employed in this process can be plastics, metals such as aluminum or steel, terracottas (clay), epoxy resins, or wood. Many times materials are combined (Fig. **2.5**). It is not uncommon for sculptors to combine methods as well. For example, built sections of metal or plastic may be combined with carved sections of stone.

Substitution

Any material that can be transformed from a plastic, molten, or fluid state into a solid state can be molded or *cast* into a work of sculpture. The creation of a piece of cast sculpture always involves the use of a mold. First, the artist creates an identically sized model of the intended

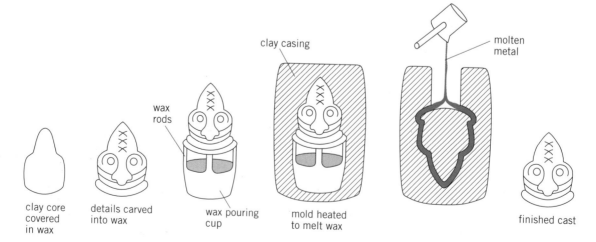

clay casing

molten metal

wax rods

clay core covered in wax

details carved into wax

wax pouring cup

mold heated to melt wax

finished cast

2.10 Lost-wax process.

sculpture. This is called a *positive*. The positive is then covered with a material, such as plaster of Paris, which when hardened and removed will retain the surface configurations of the positive. This form is called a *negative* and becomes the mold for the actual sculpture. The molten or fluid material is poured into the negative and allowed to solidify. When the mold is removed, the work of sculpture emerges. Surface polishing, if desired, brings the work to its final form (Figs. **2.6**, **2.7**, and **2.8**).

One example of substitution is the ancient technique called "lost-wax" or *cire-perdue* (Fig. **2.10**). In this method of casting the basic mold was created by using a wax model, which was then melted to leave the desired space in the mold. A heat-resistant "core" of clay—approximately the shape of the sculpture—was covered by a layer of wax approximately the thickness of the final work. The sculptor carved the details in the wax. Rods and a pouring cup made of wax were attached to the model, and then the model, rods, and cup were covered with thick layers of clay. When the clay was dry, the mold was heated to melt the wax. Molten metal could then be poured into the mold. When the molten metal had dried, the clay mold was broken and removed, which meant that the sculpture could not be duplicated.

Very often sculpture is cast so it is hollow. This saves money, since it requires less material. It also results in a work less prone to crack, since it is less susceptible to expansion and contraction resulting from changes in temperature. Hollow sculpture is, naturally, lighter and thus more easily shipped and handled.

Manipulation

In this technique, materials such as clay are shaped by skilled use of the hands. A term of similar meaning is *modeling*. The difference between this technique and addition is clear when an artist takes a single lump of clay and skillfully transforms it, as it turns on a potter's wheel, into a final shape like the lekythos in Figure **10.1**.

Found

This category of sculpture is exactly what its name implies. Very often natural objects, whether shaped by human hands or not, are discovered which for some reason have taken on characteristics that stimulate aesthetic response. They become *objets d'art* not because an artist puts them together (although an artist may combine found objects to create a work), but because an artist chooses to take them from their original surroundings and hold them up to the rest of us as vehicles for aesthetic communication. In other words, an "artist" decides that such an object says something aesthetically. As a result, it is presented in that vein.

Some may have concern about such a category, however, because it removes skill from the artistic process. As a result, objects such as driftwood and interesting rocks can assume perhaps an unwarranted place as art products or

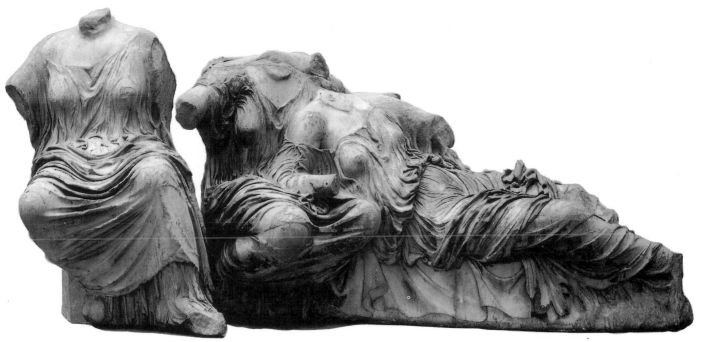

2.11 *Three Goddesses*, from the east pediment of the Parthenon, Athens, c. 438–432 B.C. Marble, over life-size. British Museum, London.

objects. None the less, if a "found" object is altered in some way to produce an artwork, then the process probably falls under one of our previously noted methods, and the product can be termed an artwork in the fullest sense of the word.

Ephemeral

Ephemeral art has many different expressions and includes the works of the conceptualists, who insist that "art is an activity of change, of disorientation and shift, of violent discontinuity and mutability." Designed to be transitory, ephemeral art makes its statement and then, eventually, ceases to exist. Undoubtedly the largest work of sculpture ever designed was based on that concept. Christo and Jeanne-Claude's *Running Fence* (Fig. **2.9**) was an event and a process, as well as a sculptural work. In a sense such works are conceptual in that they call attention to the experience of art in opposition to its actual form. At the end of a two-week viewing period, *Running Fence* was removed entirely and ceased to be.

COMPOSITION

Composition in sculpture comprises the same elements and principles as composition in the pictorial arts—mass, line, form, balance, repetition, color, proportion, and unity. Sculptors' uses of these elements are significantly different, however, since they work in three dimensions.

2.12 Aristide Maillol, *The Mediterranean*, 1902–5. Bronze, 41 x 45 x 29¾ ins (104.1 x 114.3 x 75.6 cm), including base. The Museum of Modern Art, New York (Gift of Stephen C. Clark).

Elements

Unlike a picture, a sculpture has literal *mass*. It takes up three-dimensional *space*, and its materials have *density*. Mass in pictures is relative mass: The mass of forms in a picture has application principally in relation to other forms within the same picture. In sculpture, however, mass is literal and consists of actual volume and density. So, the mass of a sculpture that is 20 ft (6 m) high, 8 ft (2.5 m) wide, and 10 ft (3 m) deep, but made of balsa wood, would seem less than a sculpture 10 ft (3 m) high, 4 ft (1.25 m) wide, and 3 ft (1 m) deep, made of lead. Space and density must both be considered. What if the material of a statue is disguised to look and feel like a different material? We will discuss this later in the chapter, when we look at how a sculpture affects our senses.

As we stated in the previous chapter, *line* and *form* are highly related. We can separate them (with some difficulty) when we discuss pictures, because in two dimensions an artist uses line to define form. In painting, line is a construction tool. In sculpture form draws our interest, and when we discuss line in sculpture, we do so in terms of how it is revealed in form.

When we view a sculpture its elements direct our eye from one point to another, just as focal points do, via line and color, in a picture (Fig. **2.11**). In some works the eye is directed through the piece and then off into space. Such sculptures have an *open* form. In Figure **2.15** the eye is directed outward from the work in the same fashion as composition that escapes the frame in painting. If, on the other hand, the eye is directed continually back into the form, we say the form is *closed*. If we allow our eye to follow the linear detail of Figure **2.12**, we find that we are continually led back into the work. This is similar to composition kept within the frame in painting and to closed forms in music, which we will discuss in Chapter 3. Often it is difficult to fit a work precisely into one or the other of these categories.

Obviously, not all sculptures are completely solid; they may have openings. We call any such holes in a sculpture *negative space*, and we can discuss this characteristic in terms of its role in the overall composition. In some works negative space is inconsequential; in others it is quite significant. It is up to us to decide which, and to determine how negative space contributes to the overall piece. In Figure **2.6** negative space plays a significant role. It could be argued that negative space is as instrumental to the overall concept of the work as is the metal form. On the other hand, in Figure **2.1** negative space is clearly incidental.

Perhaps *color* does not seem particularly important to us as we think of sculpture. We tend to see ancient sculpture as white and modern sculpture as natural wood or rusty

2.13 Jamb statues, west portal, Chartres Cathedral, begun 1145.

2.14 Kouros figure. Metropolitan Museum of Art, New York (Fletcher Fund).

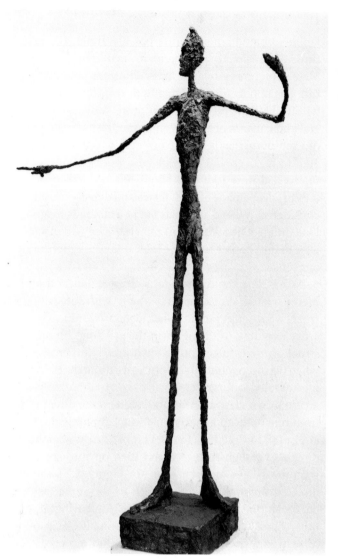

2.15 Alberto Giacometti, *Man Pointing*, 1947. Bronze, 70½ x 40¾ x 16⅜ ins (179 x 103.4 x 41.5 cm), at base 12 x 13¼ ins (30.5 x 33.7 cm). The Museum of Modern Art, New York (Gift of Mrs. John D. Rockefeller 3rd).

iron. But color is as important to the sculptor as it is to the painter. In some cases the material itself may be chosen because of its color; in others, such as terracottas, the sculpture may be painted. The lifelike sculptures of Duane Hanson depend on color for their effect. They are so lifelike that one could easily confuse them with real persons. Finally, still other materials may be chosen or treated so that nature will provide the final color through oxidation or weathering.

Texture, the roughness or smoothness of a surface, is a tangible characteristic of sculpture. Sculpture is unique in that we can perceive its texture through our sense of touch. Even when we cannot touch a work of sculpture, we can perceive and respond to texture, which can be both

physical and suggested. Sculptors go to great lengths to achieve the texture they desire for their works. In fact, much of a sculptor's technical mastery manifests itself in that final ability to impart a surface to the work. We will examine texture more fully in our discussion of sense responses.

Principles

Proportion is the relationship of shapes. Just as we have a seemingly innate sense of balance, so we have a feeling of proportion. That feeling tells us that each form in the sculpture is in proper relationship to the others. As any student of art history will tell us, proportion—or the ideal of relationships—has varied from one civilization or culture to another. For example, such a seemingly obviously

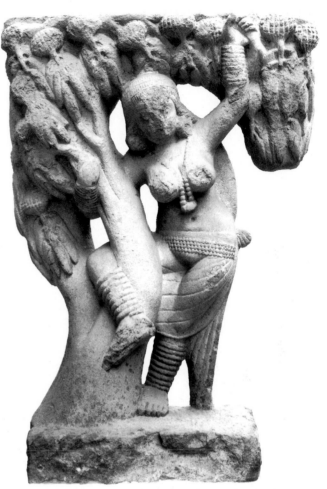

2.17 Tree Spirit, 1st century A.D. Central Indian bracket figure. British Museum, London.

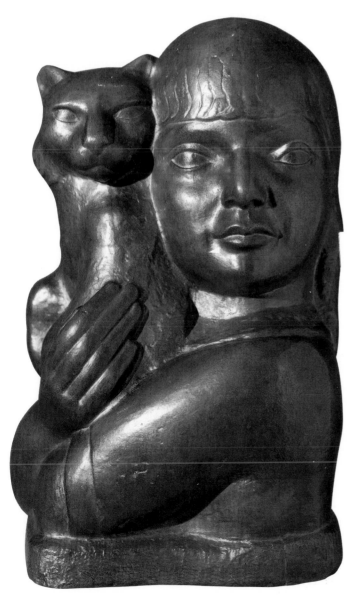

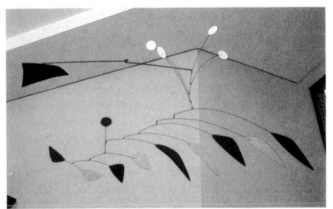

2.18 Alexander Calder, *Spring Blossoms*, 1965. Painted metal and heavy wire, extends 4 ft 4 ins x 8 ft 6 ins (1.35 x 2.59 m). Palmer Museum of Art, Pennsylvania State University (Gift of the class of 1965).

2.16 (*left*) William Zorach, *Child with Cat*, 1926. Bronze, 17½ x 10 x 7½ ins (44 x 25 x 19 cm). Palmer Museum of Art, Pennsylvania State University.

Michelangelo, *David*

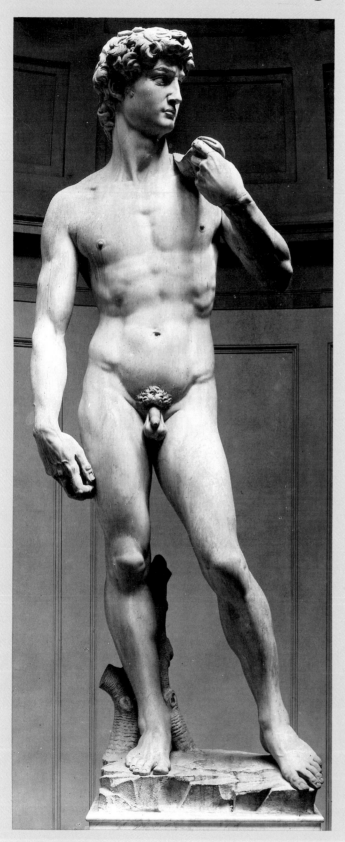

Towering some 18 feet (5.5 m) above the floor on its base, Michelangelo's David (**Fig. 2.19**) awesomely exemplifies *terribilità*, Michelangelo's particular tendency to create awe-inspiring characters. This nude champion exudes a pent-up energy as the body seems to exist merely as an earthly prison for the soul. The upper body moves in opposition to the lower. As the viewer's eye travels downward along the right arm and leg and then up along the left arm, a subtle thrust and counterthrust of movement emerges.

Much of the effect of *David*—the bulging muscles, exaggerated rib cage, heavy hair, undercut eyes, and frowning brow—may be due to the fact that these features were intended to be read from a distance. The work was originally meant to be placed high above the ground on a buttress for Florence Cathedral. Instead, the city leaders put it in front of the Palazzo Vecchio, believing it to be too magnificent to be placed so high.

The political symbolism of the work was recognized from the outset. *David* stood for the valiant Florentine Republic. It also stood for all of humanity, elevated to a new and superhuman power, beauty, and grandeur. However, its "total and triumphant nudity," which reflected Michelangelo's belief in the divinity of the human body, kept it hidden from the public for two months. When it did appear, a brass girdle with twenty-eight copper leaves hung around the waist.

Inspired by the Hellenistic sculptures he had seen in Rome (see pp. 224–227), Michelangelo set out in pursuit of an emotion-charged, heroic ideal. The scale, musculature, emotion, and stunning beauty and power of those earlier works became a part of Michelangelo's style. However, in contrast to the Hellenistic approach, in which the "body 'acts' out the spirit's agony" (compare the *Laocoön*, by Hagesandrus, Polydorus, and Athenodorus, Fig. 10.12), *David* remains controlled, exhibiting action-in-repose for which Michelangelo is famous.

2.19 Michelangelo, *David*, 1501–4. Marble, height 13 ft 5 ins (4.08 m). Accademia, Florence.

2.20 *Gero Crucifix,* Cologne Cathedral, c. 975–1000. Wood, height 6 ft 2 ins (1.87 m).

proportioned entity as the human body has varied greatly in its proportions as sculptors over the centuries have depicted it. Study the differences in proportion in the human body among Michelangelo's *David* (Fig. **2.19**), the Chartres Saints (Fig. **2.13**), an ancient Greek kouros figure (Fig. **2.14**), and Giacometti's *Man Pointing* (Fig. **2.15**). Each depicts the human form, but each utilizes differing proportions. This difference in proportion helps transmit the message the artist wishes to communicate about his or her subject matter.

Rhythm, harmony, and variation constitute *repetition* in sculpture, as they did in the pictorial arts. In sculpture, though, we must look more carefully and closely to determine how the artist has employed these elements because they ocur more subtly. If we reduce a sculpture to its components of line and form, we begin to see how (as in music)

rhythmic patterns—regular and irregular—occur. In Figure **2.2**, for example, a regular rhythmic pattern is established in space as the eye moves from figure to figure and from leg to leg of the figures. We can also see whether the components are consonant or dissonant. For instance, again in Figure **2.2**, a sense of dynamics—that is, action of movement—is created by the dissonance that results from juxtaposing the strong triangles of the stances and groupings with the *biomorphic* lines of the human body. On the other hand, unity of the curves in Figure **2.17** provides us with a consonant series of relationships. Finally, we can see how line and form are used in theme and variation. We noted the repetition of triangles in Figure **2.2**. In contrast, the sculptor of Figure **2.16** varies his motif, the oval, as the eye moves from the child's face to the upper arm, the hand, and finally the cat's face.

PROFILE

Michelangelo

Michelangelo (1475–1564) was a sculptor, painter, and architect and perhaps the greatest artist in a time of greatness. He lived during the Italian Renaissance, a period known for its creative activity, and his contemporaries included Leonardo da Vinci and Raphael. In art, the age's great achievement, Michelangelo led all others. He had a remarkable ability to concentrate his thoughts and energy. Often while working he would eat only a little bread, sleep on the floor or on a cot beside his unfinished painting or statue, and continue to wear the same clothes until his work was finished.

Michelangelo's birthplace, Caprese, Italy, was a tiny village that belonged to the nearby city-state of Florence. He attended school in Florence, but his mind was on art, not on his studies. Even as a young child he was fascinated by painters and sculptors at work.

After gaining the patronage of Lorenzo de' Medici (Lorenzo the Magnificent), the young Michelangelo lived at the Medici Palace. One day Lorenzo saw him carving a marble faun's head and liked it so much that he took Michelangelo to live with him in his palace, treating the boy like a son. Lorenzo died in 1492, and Florence changed almost overnight. Fra Girolamo Savonarola, a Dominican monk, rose to power and held the people under the spell of his sermons. Michelangelo feared Savonarola's influence and his art commissions dried up. Thus, he decided to leave Florence.

In 1496 Michelangelo was in Rome for the first time. There he was commissioned to carve a marble group showing the Virgin Mary supporting the dead Christ on her knees. This superb sculpture, known as the *Pietà*, won him wide fame. One of the few works signed by Michelangelo, it now stands in St. Peter's Basilica in Rome.

When he was twenty-six, Michelangelo returned to Florence. He was given an 18-foot (5.5-m) marble block that another sculptor had already started to carve. The block was nearly ruined. Michelangelo worked on it for more than two years. Out of its huge mass, and in spite of the difficulties caused by the first sculptor's work, he carved his youthful, courageous *David* (Fig. 2.19).

Between 1508 and 1512 Michelangelo painted the vaulted ceiling of the Sistine Chapel in Rome with hundreds of giant figures that made up his vision of the world's creation.

Painting and sculpture, however, did not absorb all Michelangelo's genius. When Florence was in danger of attack, he superintended its fortification. He also wrote many sonnets. In his last years he designed the dome of St. Peter's Basilica in Rome, which has been called the finest architectural achievement of the Italian Renaissance. Michelangelo worked with many of the leaders of his time: the popes and the rulers of the Italian city-states. He knew and competed with Leonardo da Vinci and Raphael. He died in 1564, at the age of eighty-nine, and was buried in the church of Santa Croce in Florence.

OTHER FACTORS

Articulation

Important, also, in viewing sculpture is noting the manner by which we move from one element to the next. That manner of movement is called *articulation*, and it applies to sculpture, painting, photography, and all the other arts. As an example, let us step outside the arts to consider human speech. Sentences, phrases, and individual words are nothing more than sound syllables (vowels) articulated (that is, joined together) by consonants. We understand what someone says because that individual articulates as he or she speaks. Let us put the five vowel sounds side by side: EH–EE–AH–O–OO. As yet we do not have a sentence. Articulate those vowels with consonants, and we have meaning: "Say, she must go too." The nature of an artwork depends on how the artist has repeated, varied, harmonized, and related its parts and how he or she has articulated the movement from one part to another—that is, how he or she indicates where one stops and the other begins.

2.21 Egyptian statuary. Metropolitan Museum of Art, New York (Gift of Edward S. Harkness).

Focal Area (Emphasis)

Sculptors, like painters or any other visual artists, must concern themselves with drawing the viewer's eye to those areas of their work that are central to what they wish to communicate. They must also provide the means by which the eye can move around the work. However, their task is much more complicated, because they deal in three dimensions and they have little control over the direction from which one will first perceive the piece; the entire 360-degree view contributes to the total message communicated by the work.

The devices of convergence of line, encirclement, and color work for sculptors as they do for painters. The encircling line of the tree and body parts in Figure **2.17** causes us, however we proceed to scan the work, to focus ultimately on the torso of this sensuous fertility figure.

One further device is available—movement. Sculptors have the option of placing moving objects in their work. Such an object immediately becomes a focal point of the sculpture. A mobile (Fig. **2.18**) presents many ephemeral patterns of focus as it turns at the whim of the breezes.

HOW DOES IT STIMULATE THE SENSES?

TOUCH

We can touch sculpture and feel its roughness or its smoothness, its coolness or perhaps its warmth. Even if we are prohibited by museum regulations from touching a sculpture, we can see the surface texture and translate the image into an imaginary tactile sensation. Any work of sculpture cries out to be touched.

TEMPERATURE AND AGE

Color in sculpture stimulates our response by utilizing the same universal symbols as it does in paintings, photographs, and prints. Reds, oranges, and yellows stimulate sensations of warmth; blues and greens, sensations of coolness. In sculpture, color can result from the conscious choice of the artist, either in the selection of material or in the selection of the pigment with which the material is painted. Or, as we indicated earlier, color may result from the artist's choice to let nature color the work through wind, water, sun, and so forth.

This weathering effect, of course, creates very interesting patterns, but in addition it gives the sculpture the attribute not only of space but also of time, because the work will change as nature performs its wonders. A copper sculpture early in its existence will be a different work, a different set of stimuli, from what it will be five, ten, or twenty years hence. This is not entirely accidental; artists choose copper knowing what weathering will do to it. They obviously cannot predict the exact nature of the weathering or the exact hues of the sculpture at any given time in the future, but such predictability is irrelevant.

Our response to a work of art may be shaped by the effects of age on it. Ancient objects possess a great deal of charm and character. A wooden icon like Figure 2.20 might have extra emotional impact because of the effects of age on its surfaces.

DYNAMICS

Line, form, and juxtaposition create dynamics in works of sculpture. The activity of a sculpture tends to be heightened because of its three-dimensionality. In addition, we experience a certain sense of dynamics as we move around them. Although we are moving and not the sculpture, we perceive and respond to what seems to be movement in the work itself.

SIZE

Because sculpture has mass—that is, takes up space and has density—our senses respond to the weight and/or the scale of a work. Egyptian sculpture, which is solid, stable, and oversized (Fig. 2.21), has mass and proportion as well as line and form that make it appear heavier than a non-Egyptian work of basically the same size and material, such as Figure 2.7. Moreover, the very same treatment of texture, verisimilitude, and subject elicits a completely different sense response if one work is 3 feet (1 m) and another 130 feet (39.6 m) tall.

Exaggerated size and anatomical form, for symbolic effect, may also be seen in a colossal bust of Emperor Constantine (Fig. 2.22), a gigantic representation—the head is over 8 feet (2.4 m) tall—exhibiting a stark and expressive realism that is countered by caricatured, ill-proportioned intensity. This likeness is not a portrait of Constantine—it is the artist's view both of Constantine's

2.22 Head of Constantine the Great (originally part of a colossal seated statue), A.D. 313. Marble, 8 ft 6⅜ ins (2.61 m) high. Palazzo dei Conservatori, Rome.

presentation of himself as emperor and of the office of emperor itself.

Early in the chapter we mentioned the possibility of an artist's disguising the material from which the work is made. Marble polished to appear like skin, or wood polished to look like fabric, can change the appearance of mass of a sculpture and significantly affect our response to it.

We must also consider the purpose of disguising material. For example, does the detailing of the sculpture reflect a formal concern for design, or does it reflect a concern for the greatest verisimilitude? Examine the cloth represented in Figures **2.1** and **2.13**. In both cases the sculptor has disguised the material by making stone appear to be cloth. In Figure **2.1** the cloth is detailed to reflect reality. It drapes as real cloth would drape, and as a result its effect in the composition depends upon the subtlety of line characteristic of draped cloth. However, in Figure **2.13** the sculptor has depicted cloth in such a way that its effect in the design is not dependent upon how cloth drapes, but rather upon the decorative function of line as the sculptor wishes to use it. Real cloth cannot drape as the sculptor has depicted it. Nor, probably, did the sculptor care. The main concern here was for decoration, for using line (that looks like cloth) to emphasize the rhythm of the work. When sculpture de-emphasizes lifelikeness in order to draw attention to the substance from which it is made, we call it *glyptic*. Glyptic sculpture emphasizes the material from which the work is created and usually retains the fundamental geometric qualities of that material.

LIGHTING AND ENVIRONMENT

One final factor that significantly influences our sense response to a sculpture, a factor that we very often do not consider and that is outside the control of the artist unless he or she personally supervises every exhibition in which the work is displayed, is that of lighting and environment. As we will see in Chapter 4, light plays a seminal role in our perception of and thereby our response to three-dimensional objects. The direction and number of sources of light striking a three-dimensional work can change the entire composition of that work. Whether the work is displayed outdoors or indoors, the method of lighting affects the overall presentation. Diffuse room lighting allows us to see all aspects of a sculpture without external influence. However, if the work is placed in a darkened room and illuminated from particular directions by spotlights, it becomes much more dramatic and our response is affected accordingly.

The question of where and how a work is exhibited also contributes to our response. The response to a sculpture placed in a carefully designed environment that screens our vision from distracting or competing visual stimuli will change if the sculpture is exhibited among other works amid the bustle of a public park, for instance.

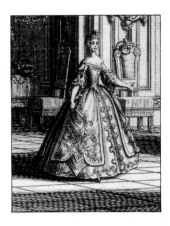

CHAPTER THREE

MUSIC

IMPORTANT TERMS

Concerto A composition for one or more solo instruments, accompanied by an orchestra, typically in three movements.

Fugue A musical composition in a fixed form in which a theme is developed by counterpoint.

Oratorio A large choral work for soloists, chorus, and orchestra, developed in the Baroque period.

Suite A set of dance-inspired movements written in the same key but differing in tempo, meter, and character.

Symphony A lengthy orchestral composition, usually in four movements.

Melody A succession of sounds with rhythmic and tonal organization.

Monophony A type of musical texture using a single musical line without accompaniment

Polyphony A type of musical texture utilizing two or more melodic lines of relatively equal interest performed at the same time.

Homophony A type of musical texture in which chords accompany one main melody.

Sonata form A type of musical structure employing exposition, development, and recapitulation sections.

Opera A staged, musical/theatrical work in which music predominates.

We all have favorite forms of music. They might be tejano, reggae, rock, rhythm and blues, rap, gospel, or Classical. Occasionally we are surprised to find that our favorite tune or musical form was once something else: a rock tune that first was an operatic aria, or an ethnic style that combines styles from other ethnic traditions. Whatever the case, all music comprises rhythms and melodies—they differ only in the ways they are put together. In this chapter we shall concentrate first on some Classical forms, but after that we discuss qualities that apply to all music, whether Classical or popular.

Music has often been described as the purest of the art forms because it is free from the physical restrictions of space that apply to the other arts. However, the freedom enjoyed by the composer becomes a constraint for us listeners because music is an art that places significant responsibility on us. That responsibility is especially critical when we are trying to learn and apply musical terminology, because we have only a fleeting moment to capture many of the characteristics of music. A painting or a sculpture stands still for us; it does not change or disappear, despite the length of time it takes us to examine and appreciate.

We live in a society that is very aural in its perceptions, but these perceptions usually do not require any kind of active listening. We hear music constantly on the radio, the television, and in the movies, but nearly always in a peripheral role. Because we are not expected to pay attention to it, we do not. Therefore we hardly ever undertake the kind of practice we need to be attentive to music and to perceive it in detail. However, like any skill, the ability to hear perceptively is enhanced through repetition and training. If we have had limited experience in responding to music, we will find challenge in the concert hall hearing what there is to hear in a piece of music that passes in just a few seconds.

WHAT IS IT?

At a formal level, our experience of a musical work begins with its type, or form. The basic form of a music composition shapes our initial encounter by providing us with some specific parameters for understanding. Unlike our experience in the theatre, we are likely to find an identification of the musical composition, by type, in the concert program. Here are a few of the more common forms we are likely to encounter. Because many musical forms are period- or style-specific—that is, they grew out of a specific stylistic tradition, some of our descriptions may include brief historical references.

ART SONG

An art song is a setting of a poem for solo voice and piano. Typically, it adapts the poem's mood and imagery into music. Art song is a distinctive form of music growing out of the Romantic style of the nineteenth century. That is to say, it has an emotional tendency, and its themes often encompass lost love, nature, legend, and the far-away and long ago. In this type of composition, the accompaniment is an important part of the composer's interpretation and acts as an equal partner with the voice. In this form, important words are emphasized by stressed tones or melodic climaxes. (Listen to Schubert's "The Erlking," CD track 14.)

CANTATA

A cantata is usually a choral work with one or more soloists and an instrumental ensemble. Written in several movements, it is typified by the church cantata of the Lutheran church of the Baroque period (1600–1750) and often includes chorales and organ accompaniment. The word cantata originally meant a piece that was sung—in contrast to a sonata (see below), which was played. The Lutheran church cantata (exemplified by those of Johann Sebastian Bach) uses a religious text either original or drawn from the Bible or familiar hymns—chorales. In essence, it served as a sermon in music, drawn from the lectionary (prescribed Bible readings for the day and on which the sermon is based). A typical cantata might last twenty-five minutes and include several different movements—choruses, recitatives, arias, and duets. (Listen to Bach's *Cantata No. 80*, final chorale, CD track 9.)

CONCERT OVERTURE

A concert overture is an independent composition for orchestra. It contains one movement, composed in sonata form (see Sonata). The concert overture is modeled after the opera overture, similarly a one-movement work, that establishes the mood of an opera. Unlike the opera overture, the concert overture is not intended as the introduction to anything. It stands on its own as an independent composition.

CONCERTO

A solo concerto is an extended composition for an instrumental soloist and orchestra. Reaching its zenith during the Classical period of the eighteenth century, it typically contains three movements, in which the first is fast, the second, slow, and the third, fast. Concertos join a soloist's virtuosity and interpretive skills with the wide-ranging dynamics and tonal colors of an orchestra. The concerto thus provides a dramatic contrast of musical ideas and sound in which the soloist is the star. Typically, concertos present great challenge to the soloist and great reward to the listener, who can delight in the soloist's meeting of the technical and interpretive challenges of the work. None the less, the concerto is a balanced work in which the orchestra and soloist act as partners. The interplay between orchestra and soloist provides the listener with fertile ground for involvement and discernment. Concertos can last from twenty to forty-five minutes. Typically, during the first movement, and sometimes the third, of a Classical concerto, the soloist has an unaccompanied showpiece called a cadenza.

Common to the late Baroque period, the concerto grosso is a composition for several instrumental soloists and small orchestra (in contrast to the solo concerto—see above). In the Baroque style contrast between loud and soft sounds and large and small groups of performers was typical. In a concerto grosso, a small group of soloists (two to four) contrasts a larger group called the *tutti* consisting of from eight to twenty players. Most often a concerto grosso contains three movements contrasting in tempo and character. The first movement is fast; the second, slow; and the third, fast. The opening movement, usually bold, explores the contrasts between *tutti* and soloists. The slow movement is more lyrical, quiet, and intimate. The final movement is lively, lighthearted, and sometimes dancelike. (Listen to Vivaldi's "Spring" from *The Four Seasons*—first movement, CD track 11.)

FUGUE

The fugue is a polyphonic (two or more melodic lines of relatively equal importance performed at the same time) composition based on one main theme, or subject. It can be written for a group of instruments or voices or for a single instrument like an organ or harpsichord. Throughout the composition, different melodic lines, called "voices," imitate the subject. The top melodic line is the soprano and the bottom line, the bass. A fugue usually includes three, four, or five voices. The composer's exploration of the subject typically passes through different keys and combines with different melodic and rhythmic ideas. Fugal form is

extremely flexible: the only constant feature is the beginning, in which a single, unaccompanied voice states the theme. The listener's task, then, is to remember that subject and follow it through the various manipulations that follow.

MASS

The mass is a sacred choral composition consisting of five sections: Kyrie, Gloria, Credo, Sanctus, and Agnus Dei. These also form the parts of the mass ordinary—that is, the Roman Catholic church texts that remain the same from day to day throughout most of the year. The Kyrie text implores, "Lord, have mercy upon us. Christ, have mercy upon us. Lord, have mercy upon us." The Gloria text begins, "Glory be to God on High, and on earth peace, good will towards men." The Credo states the creed: "We believe in one God, the Father, the Almighty, maker of heaven and earth," and so on. The Sanctus confirms, "Holy, holy, holy, Lord God of Hosts: Heaven and earth are full of thy glory. Glory be to thee, O Lord Most High." The Agnus Dei (Lamb of God), implores, "O Lamb of God, that takest away the sins of the world, have mercy upon us. O Lamb of God, that takest away the sins of the world, have mercy upon us. O Lamb of God, that takest away the sins of the world, grant us thy peace." (Listen to Palestrina's "Kyrie" from the *Pope Marcellus Mass*, CD track 7.) The requiem mass, which often comprises a musical program, is a special mass for the dead.

MOTET

A motet is a polyphonic choral work employing a sacred Latin text other than that of the mass. With, but shorter than, the mass, the motet was one of the two main forms of sacred music during the Renaissance (late fourteenth to sixteenth centuries).

OPERA

We give special treatment to this form of music later in the chapter.

ORATORIO

An oratorio is a large-scale composition using chorus, vocal soloists, and orchestra. Normally an oratorio sets a narrative text (usually biblical), but does not employ acting, scenery, or costumes. The oratorio was a major achievement of the Baroque period. This type of musical composition unfolds through a series of choruses, arias,

duets, recitatives, and orchestral interludes. The chorus of an oratorio is especially important and can comment on or participate in the dramatic exposition. Another feature of the oratorio is the use of a narrator, whose recitatives (vocal lines imitating the rhythms and inflections of normal speech) tell the story and connect the various parts. Like operas, oratorios can last more than two hours. (Listen to Handel's "Hallelujah Chorus" from the oratorio *Messiah*, CD track 10.)

SONATA

An outgrowth of the Baroque period, a sonata is an instrumental composition in several movements written for from one to eight players. After the Baroque period, the sonata changed to a form typically for one or two players. The trio sonata of the Baroque period had three melodic lines (hence its name). It actually uses four players. (Listen to Mozart's *Piano Sonata No. 11 in A, K. 331*—Rondo: alla turca, CD track 12.) This general type of musical composition should not be confused with "sonata form," which is a specific form for a single movement of a musical composition. Sonata form consists of three main sections: the exposition, in which themes are presented; the development, in which themes are treated in new ways; and the recapitulation, in which the themes return. A concluding section, called a "coda," often follows the recapitulation. (Listen to Beethoven's *Symphony No. 5 in C minor*—first movement, CD track 13.)

SUITE

A suite comprises a set of dance-inspired movements written in the same key but differing in tempo, meter, and character. An outgrowth of the Baroque period, a suite can employ solo instruments, small ensembles, or an orchestra. The movements of a suite typically are in two parts, with each section repeated (AABB). The A section opens in the tonic key and modulates to the dominant (the fifth tone of the scale). The B section begins in the dominant and returns to the tonic. Both sections employ the same thematic material and exhibit little by way of contrast.

SYMPHONY

An orchestral composition, usually in four movements, a symphony typically lasts between twenty and forty-five minutes. In this large work, the composer explores the full dynamic and tonal range of the orchestral ensemble. The symphony is a product of the Classical period of the late eighteenth century and evokes a wide range of carefully structured emotions evoked through contrasts of tempo and mood. The sequence of movements usually begins with an active fast movement, changes to a lyrical slow movement, moves to a dancelike movement, and closes with a bold fast movement. The opening movement is almost always in sonata form (see Sonata). In most Classical symphonies, each movement is self-contained with its own set of themes. Unity in a symphony occurs partly from the use of the same key in three of the movements and also from careful emotional and musical complement among the movements. (Listen to Berlioz's *Symphonie Fantastique*—fourth movement ["The March to the Scaffold"], CD track 16; also Beethoven's *Symphony No. 5 in C minor*—first movement, CD track 13.)

HOW IS IT PUT TOGETHER?

Understanding vocabulary and being able to identify its application in a musical work help us to comprehend communication using the musical language, and thereby to understand the creative communicative intent of the composer and the musicians who bring the composition to life. The ways in which musical artists shape the characteristics that follow bring us experiences which can challenge our intellects and excite our emotions. As in all communication, meaning depends upon each of the parties involved; communicators and listeners must assume responsibility for facility in the language utilized.

Among the basic elements by which music is put together, we will identify and discuss seven: 1) Sound; 2) Rhythm; 3) Melody; 4) Harmony; 5) Tonality; 6) Texture; and 7) Form.

SOUND

Music is composed by designing sound and silence. The latter is reasonably clear, but what of the former? What is sound? In the broadest sense, sound is anything that excites the auditory nerve: it can be sirens, speech, crying babies, jet engines, falling trees, and so on. We might even call such sources noise. Musical composition, although it can employ even "noise," usually depends on sound that can be controlled and shaped, sound that can be consistent in quality. We distinguish music from other sounds by recognizing four basic properties: 1) pitch; 2) dynamics; 3) tone color; and 4) duration.

Pitch

Pitch is a physical phenomenon measurable in vibrations per second. So, when we describe differences in pitch we are describing recognizable and measurable differences in sound waves. A pitch has a steady, constant frequency. A faster frequency produces a higher pitch, a slower frequency, a lower pitch. If a sounding body—a vibrating string, for example—is shortened, it vibrates more rapidly. Musical instruments designed to produce high pitches, such as the piccolo, therefore tend to be small. Instruments designed to produce low pitches tend to be large—for instance, bass viols and tubas. In music, a sound that has a definite pitch is called a tone.

In Chapter 1 we discussed color. It comprises a range of light waves within a visible spectrum. Sound also comprises a spectrum, whose audible pitches range from 16 to 38,000 vibrations per second. We can perceive 11,000 different pitches! Obviously that is more than is practical for musical composition. Therefore, by convention the sound spectrum is divided into at least ninety equally spaced frequencies comprising seven and a half *octaves*.

The piano keyboard, consisting of eighty-eight keys (seven octaves plus two additional notes) representing the same number of equally spaced pitches, serves as an illustration (Fig. **3.1**).

A *scale*—an arrangement of pitches played in ascending or descending order—is a conventional organization of the frequencies of the sound spectrum. The thirteen equally spaced pitches in an octave are called a *chromatic scale*. However, the scales that sound most familiar to us are the major and minor scales, each of which consists of an octave of eight pitches. The distance between any two pitches is an *interval*. Intervals between two adjacent pitches are half steps. Intervals of two half steps are whole steps. The major scale—*do re mi fa sol la ti do* (recall the song, "Doe, a deer . . ." from *The Sound of Music*)—has a specific arrangement of whole and half steps (Fig. **3.2**). Lowering the third and sixth notes of the major scale gives us the harmonic (the most common) minor scale.

Not all music conforms to the conventions of Western scales. European music prior to approximately A.D. 1600

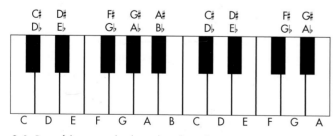

3.1 Part of the piano keyboard, with pitches.

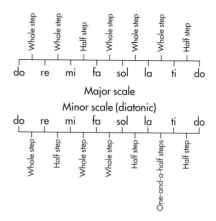

3.2 The major and minor scales.

does not, nor does Eastern music, which makes great use of quarter tones. In addition, some contemporary Western music departs completely from the conventions of *tonality*. Listen to tracks 1–3 on the music CD. These examples are from cultures whose music does not conform to the Western conventions of pitch and scale, or tonality. There are, however, other characteristics that make this music sound different from the music of Bach, for example (track 9). At the end of our discussion of musical elements, identify the additional ways in which these three selections differ from traditional Western music.

Dynamics

Degrees of loudness or softness in music are called dynamics. Any tone can be loud, soft, or anywhere in between. Dynamics is the decibel level of the tones, and depends upon the physical phenomenon of amplitude of vibration. When greater force is employed in the production of a tone, the resulting sound waves are wider and cause greater stimulation of the auditory nerves. The size of the sound wave, not its number of vibrations per second, is changed.

Composers indicate dynamic level, with a series of specific notations:

pp	pianissimo	very soft
p	piano	soft
mp	mezzo piano	moderately soft
mf	mezzo forte	moderately loud
f	forte	loud
ff	fortissimo	very loud

The notations of dynamics that apply to an individual tone, such as *p*, *mp*, and *f*, may also apply to a section of music. Changes in dynamics may be abrupt, gradual, wide, or small. A series of symbols also governs this aspect of music:

≤	crescendo	becoming louder
≥	decrescendo	becoming softer
> ∧ sfz	sforzando	"with force"; a strong accent often followed by *p*

As we listen to and compare musical compositions we can consider the use and breadth of dynamics in the same sense that we consider the use and breadth of palette in painting.

Tone Color

Tone color, or timbre (TAM-ber), is the characteristic of tone that allows us to distinguish a pitch played on a violin, for example, from the same pitch played on a piano. In addition to identifying characteristic differences among sound-producing sources, tone color can also refer to differences in quality of tones produced by the same source. Here the analogy of "tone color" is particularly appropriate. A tone that is produced with an excess of air—for example, by a breathy human voice—is described as "white." Figure 3.4 illustrates some of the various sources that produce musical tone and account for its variety of tone colors.

In the keyboard family, the piano could be considered either a stringed or a percussion instrument since it produces its sound by vibrating strings struck by hammers. The harpsichord's strings are set in motion by plucking, and the organ's sound is made by air.

Electronically produced music, available since the development of the RCA synthesizer at the Columbia-Princeton Electronics Music Center, has become a standard source in assisting contemporary composers. Originally electronic music fell into two categories: (1) the electronic altering of acoustically produced sounds, which came to be labeled as *musique concrète,* and (2) electronically generated sounds. However, advances in technology have blurred those differences over the years.

Duration

Another characteristic of sound is duration: the length of time in which vibration is maintained without interruption. Duration in musical composition is designed with a set of conventions called notation (Fig. 3.3). This system consists of a series of symbols (notes) by which the composer indicates the relative duration of each tone. The system is progressive—that is, each note's duration is either double or half the duration of the adjacent note. Musical notation also includes a series of symbols that denote the duration of silences in a composition. These symbols are called *rests*, and have the same values as the symbols for duration of tone.

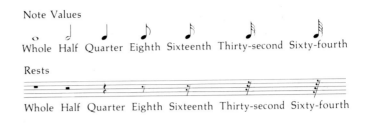

Note Values

Whole Half Quarter Eighth Sixteenth Thirty-second Sixty-fourth

Rests

Whole Half Quarter Eighth Sixteenth Thirty-second Sixty-fourth

3.3 Musical notation.

RHYTHM

Rhythm comprises recurring pulses and accents which create identifiable patterns. Without rhythm we have only an aimless rising and falling of tones. Composing music means placing each tone into a time or rhythmical relationship with every other tone. As with the dots and dashes of the Morse code we can "play" the rhythm of a musical composition without reference to its tones. Each symbol of the musical notation system denotes a duration relative to each other symbol in the system. Rhythm consists of: (1) beat; (2) meter; and (3) tempo.

Beat

The individual pulses we hear are called *beats*. Beats may be grouped into rhythmic patterns by placing accents every few beats. Beats are basic units of time and form the background agains which the composer places notes of various length.

Meter

Normal musical practice is to group clusters of beats into units called *measures*. When these groupings are regular and reasonably equal they comprise *simple* meters. When the number of beats in a measure equals three or two it constitutes *triple* or *duple* meter. We, as listeners, can distinguish between duple and triple meters because of their different *accent* patterns. In triple meter we hear an accent every third beat—ONE two three, ONE two three—and in duple meter the accent is every other beat—ONE two, ONE two. If there are four beats in a measure (sometimes called quadruple meter), the second accent is weaker than the first—ONE two THREE four, ONE two THREE four.

Listen to CD track 15, Chopin's *Nocturne in E-Flat Major,* Op. 9, No. 2, and note the triple meter. Compare that with Louis Armstrong's "Mack the Knife" (CD track 22), which illustrates the martial character of quadruple meter.

When accent occurs on normally unaccented beats, we have *syncopation*, as occurs in Duke Ellington's "It Don't Mean a Thing" (CD track 23). Here the basic meter is

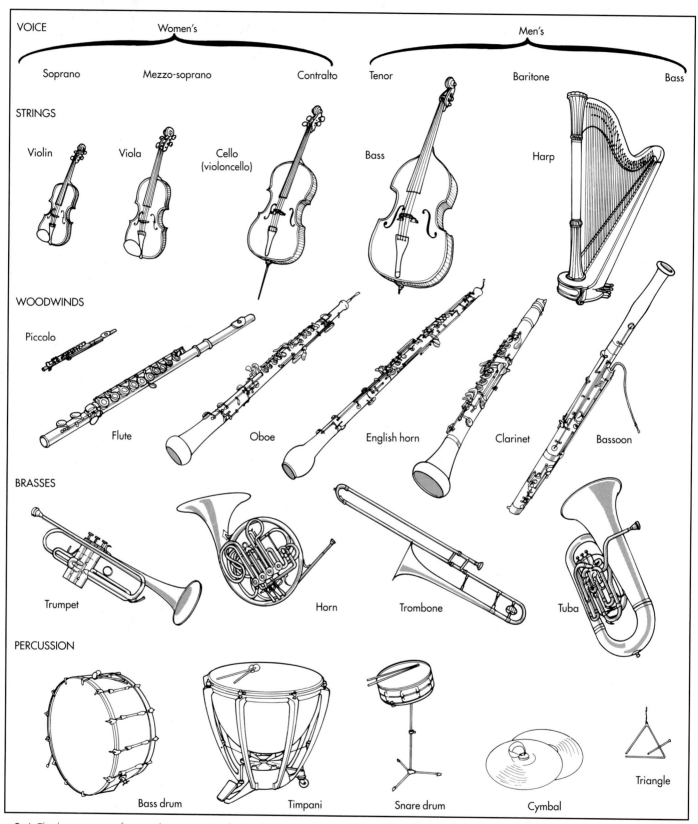

3.4 The key sources of musical tone in an orchestra (instruments not to scale).

Wolfgang Amadeus Mozart

Wolfgang Amadeus Mozart (1756–91) is often considered the greatest musical genius of all time. His output—especially in view of his short life—was enormous and included sixteen operas, forty-one symphonies, twenty-seven piano and five violin concertos, twenty-five string quartets, nineteen masses, and other works in every form popular in his time. Perhaps his greatest single achievement is in the characterization of his operatic figures.

Mozart was born on January 27, 1756, in Salzburg, Austria. His father, Leopold Mozart, held the position of composer to the archbishop and was a well-known violinist and author of a celebrated theoretical treatise on playing the instrument. When Wolfgang was only six years old, his father took him and his older sister, Maria Anna (called Nannerl) on tours throughout Europe during which they performed as harpsichordists and pianists—separately and together. They gave public concerts, played at the various courts, and met the leading musicians of the day. In Paris in 1764, Wolfgang wrote his first published works, four violin sonatas. In London he came under the influence of Johann Christian Bach. In 1768 young Mozart became honorary concertmaster for the archbishop of Salzburg.

In 1772, however, a new archbishop came to power, and the cordial relationship Mozart enjoyed with the previous archbishop came to an end. By 1777 the situation became so strained that the young composer asked to be relieved of his duties, and the archbishop grudgingly agreed.

In 1777 Mozart traveled with his mother to Munich and Mannheim, Germany, and to Paris, where she died. On this trip alone, Mozart composed seven violin sonatas, seven piano sonatas, a ballet, and three symphonic works, including the *Paris Symphony.*

The final break between Mozart and the archbishop occurred in 1781, but before that time Mozart had unsuccessfully sought another position. Six years later, in 1787, Emperor Joseph II finally engaged him as chamber composer—at a salary considerably smaller that that of his predecessor. Mozart's financial situation worsened steadily, and he incurred significant debts that hounded him until his death.

Meanwhile, his opera *The Abduction from the Seraglio* enjoyed great success in 1782; in the same year he married Constanze Weber, the daughter of friends. He composed his great *Mass in C Minor* for her, and she was soprano soloist in its premiere.

During the last ten years of his life, Mozart produced most of his great piano concertos; the four horn concertos; the *Haffner, Prague, Linz,* and *Jupiter* symphonies; the six string quartets dedicated to Haydn; five string quintets; and the major operas, *The Marriage of Figaro, Don Giovanni, Cosi Fan Tutte, La Clemenza di Tito,* and *The Magic Flute.* Mozart was unable to complete his final work, the Requiem, because of illness. He died in Vienna on December 5, 1791, and was buried in a multiple grave. Although the exact nature of his illness is unknown, there is no evidence that Mozart's death was deliberately caused (as the popular movie, *Amadeus,* implies).

duple, but the orchestra provides counterpoint for the vocalist with strong off-beat accents.

Sometimes repetitive patterning or strict metrical development does not occur. Listen to CD tracks 4, 5, 8, and 19 in sequence. In track 4, an example of Gregorian chant, the rhythm is free-flowing with undistinguishable meter. The same is true of track 5, also a composition from the Middle Ages, by Hildegard of Bingen. In contrast, Thomas Morley's "Now is the Month of Maying" (track 8) is written in a strict, lively quadruple meter. Its repetitive pattern of 1, 2, 3, 4 is very obvious. On the other hand, Debussy's *Prelude to the Afternoon of a Faun* (track 19) changes meter so

frequently that patterns virtually disappear (a faun—pronounced fawn—is a mythological creature with the body of a man and the horns, ears, tail, and sometimes legs of a goat).

Tempo

Tempo is the rate of speed of the composition. A composer may notate tempo in two ways. The first is by a *metronome marking,* such as $\quarternote = 60$. This means that the piece is to be played at the rate of sixty quarter notes (\quarternote) per minute. Such notation is precise. The other method is less precise and involves more descriptive terminology in Italian:

Largo (broad) Grave (grave, solemn)	}	Very slow
Lento (slow) Adagio (leisurely)	}	Slow
Andante (at a walking pace) Andantino (somewhat faster than andante) Moderato (moderate)	}	Moderate
Allegretto (briskly) Allegro (cheerful, faster than allegretto)	}	Fast
Vivace (vivacious) Presto (very quick) Prestissimo (as fast as possible)	}	Very fast

The tempo may be quickened or slowed, and the composer indicates this by the words *accelerando* (accelerate) and *ritardando* (retard, slow down). A performer who takes liberties with the tempo is said to use *rubato* (roo-BAH-toh).

MELODY

Melody is a succession of sounds with rhythmic and tonal organization. We can visualize melody as linear and essentially horizontal. Two other terms, *tune* and *theme*, relate to melody as parts to a whole. For example, the tune in Figure 3.5 is a melody—that is, a succession of tones. However, a melody is not always a tune. In general, the term tune implies singability, and there are many melodies that cannot be considered singable. A theme is also a melody. However, in musical composition it specifically means a central musical idea, which may be restated and varied throughout a piece. Thus a melody is not necessarily a theme.

Oh __ say can you see by the dawn's ear - ly light

3.5 "The Star-Spangled Banner" (excerpt).

Related to theme and melody is the *motif*, or *motive*, a short melodic or rhythmic idea around which a composer may design a composition. For example, in Beethoven's *Symphony No. 5 in C minor* (CD track 13) the first movement is developed around a motif of four notes.

In listening for how a composer develops melody, theme, and motif we can use two terms to describe what we hear: *conjunct* and *disjunct*. Conjunct melodies comprise notes close together, stepwise, on the musical scale. For

example, the interval between the opening notes of the soprano line of J. S. Bach's chorale "Jesu Joy of Man's Desiring" from *Cantata 147* (Fig. 3.6) is never more than a whole step. Disjunct melodies contain intervals of two steps or more. However, there is no formula for determining disjunct or conjunct characteristics; there is no line at which a melody ceases to be disjunct and becomes conjunct. These are relative terms which assist us in description. For example, we would say that the opening melody of "The Star-Spangled Banner" (Fig. 3.5) is more disjunct than the opening melody of "Jesu Joy of Man's Desiring"—or that the latter is more conjunct than the former.

Je - su joy of man's de - sir - ing

3.6 "Jesu Joy of Man's Desiring" (excerpt).

HARMONY

When two or more tones sound at the same time, we have harmony. Harmony is essentially a vertical arrangement, in contrast with the horizontal arrangement of melody.

However, as we shall see, harmony also has a horizontal property—movement forward in time. In listening for harmony we are interested in how simultaneous tones sound together.

Two tones played simultaneously are an interval; three or more form a *chord*. When we hear an interval or a chord our first response is to its *consonance* or *dissonance*. Consonant harmonies sound pleasant and stable in their arrangement. Dissonant harmonies are tense and unstable. Consonance and dissonance, however, are not absolute properties. Essentially they are conventional and, to a large extent, cultural. What is dissonant to our ears may not be so to someone else's. What is important in musical response is determining *how* the composer utilizes these two properties. Most Western music is primarily consonant. Dissonance, on the other hand, can be used for contrast, to draw attention to itself, or as a normal part of *harmonic progression*.

As its name implies, harmonic progression involves the movement forward in time of harmonies. In discussing pitch we noted the convention of the major and minor scales—that is, the arrangement of the chromatic scale into a system of *tonality*. When we play or sing a major or minor scale we note a particular phenomenon: Our movement from *do* to *re* to *mi* to *fa* to *sol* to *la* is smooth and seems natural. But when we reach the seventh tone of the scale, *ti*, something strange happens. It seems as though we *must* continue back to *do*, the *tonic* of the scale. Try it! Sing a

major scale and stop at *ti*. You feel uncomfortable. Your mind tells you that you must resolve that discomfort by returning to *do*. That same sense of tonality—that sense of the tonic—applies also to harmony. Within any scale a series of chords may be developed on the basis of the individual tones of the scale. Each of the chords has a subtle relationship to each of the other chords and to the tonic. That relationship creates a sense of progression that leads back to the chord based on the tonic.

The harmonic movement toward, and either resolving or not resolving to, the tonic is called *cadence*. Three different cadences are shown in Figure **3.7**. The use of cadence is one way of articulating sections of a composition or of surprising us by upsetting our expectations. A composer using a full cadence uses a harmonic progression that resolves just as our ear tells us it should. We have a sense of ending, of completeness. However, when a deceptive cadence is used, the expected progression is upset and the musical development moves in an unexpected direction.

As we listen to music of various historical periods we may note that in some compositions tonal centers are blurred because composers frequently *modulate*—that is, change from one *key* to another. In the twentieth century many composers—some using purely mathematical formulas to utilize all tones of the chromatic scale equally—have removed tonality as an arranging factor and have developed *atonal* music, or music without tonality.

TONALITY

Utilization of tonality or key has taken composers in various directions over the centuries. Conventional tonality, employing the major and minor scales and keys discussed previously relative to pitch, forms the basis for most sixteenth- to twentieth-century Western music, as well as traditionally oriented music of the twentieth century.

In the early twentieth century, traditional tonality was abandoned by some composers. Atonal compositions seek the freedom to use any combination of tones without the necessity of having to resolve chordal progressions.

TEXTURE

The aspect of musical relationships known as texture is treated differently by different sources. The term itself has various spatial connotations, and using a spatial term to describe a nonspatial phenomenon creates part of the divergence of treatment. Texture in painting and sculpture denotes surface quality—that is, roughness or smooth-

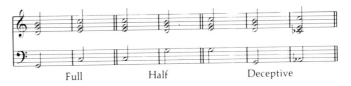

3.7 Full, half, and deceptive cadences.

ness. Texture in weaving denotes the interrelationship of the warp and the woof—that is, the horizontal and vertical threads in fabric. The organization in Figure **3.8** would be described as open or loose texture; that in Figure **3.9**, closed or tight. There really is no single musical arrangement that corresponds to either of these spatial concepts. The characteristic called *sonority* comes the closest. Sonority describes the relationship of tones played at the same time. A chord with large intervals between its members would have a more open, or thinner, sonority (or texture) than a chord with small intervals between its tones; that chord would have a tight, thick, or close sonority or texture. Sonority is a term that does not have universal application; some sources do not mention it at all. Composers can vary textures within their pieces to create contrast and interest. Let's examine the three basic musical textures: monophony, polyphony, and homophony.

Monophony

When we have a single musical line without accompaniment, the texture of the piece is monophonic. There may be many voices or instruments playing at the same time, as in the Gregorian chant illustrated on CD track 4, but as long as they are singing the same notes at the same time—that is, in unison—the texture remains monophonic. In Handel's "Hallelujah Chorus" (CD track 10), there occur instances in which men and women sing the same notes in different octaves. This still represents monophony.

3.8 Open (loose) texture.　**3.9** Closed (tight) texture.

Polyphony

Polyphony means "many-sounding," and it occurs when two or more melodic lines of relatively equal interest are performed at the same time. This combining technique also is called counterpoint. We can hear it in a very simple statement in Josquin Desprez's "Ave Maria ... Virgo Serena" (CD track 6). Palestrina's "Kyrie" from the *Pope Marcellus Mass* (CD track 7) is more complex. When the counterpoint uses an immediate restatement of the musical idea, as in the Desprez, then the composer is utilizing *imitation*.

Homophony

When chords accompany one main melody, we have homophonic texture. Here the purpose of the composer is to focus attention on the melody by supporting it with subordinate sounds. The Bach chorale on CD track 9 illustrates this type of texture very well. In this example all four voices sing together in simultaneous rhythm. The main melody is in the soprano, or top, part. The lower parts sing melodies of their own, which are different from the main melody, but, rather than being independent as would be the case in polyphony, they support the soprano melody and move with it in a progression of chords related to the syllables of the text.

Changes of Texture

Of course, composers may change textures within a piece, as Handel does in the "Hallelujah Chorus" (CD track 10). This creates an even richer fabric of sound for us to respond to.

FORM

Tones and rhythms that proceed without purpose or stop arbitrarily make little sense to the listener. Therefore, just as the painter, sculptor, or any other artist must try to develop design that has focus and meaning, the musician must attempt to create a coherent composition of sounds and silences. The principal means by which artists create coherence is repetition. As we noted in the Introduction, the Volkswagen (Fig. **0.10**) achieved unity through strong geometric repetition which varied only in size. Music achieves coherence or unity through repetition in a similar fashion. However, since music deals with time as opposed to space, repetition in music usually involves recognizable themes.

Form can thus be seen as organization through repetition to create unity. Form may be divided into two categories: *closed form* and *open form*. These terms are somewhat similar to those used in sculpture and painting. Closed form directs the "musical eye" back into the composition by restating music from the beginning of the piece at the end. Open form allows the ear to escape the composition by utilizing repetition of thematic material only as a departure point for further development, and by ending without repetition of the opening. A few of the more common examples of closed and open forms follow.

Closed Forms

Binary form, as the name implies, consists of two parts: the opening section of the composition and a second part which often acts as an answer to the first: AB.

Ternary form is three-part structure in which the opening section is repeated after a different second section: ABA.

Ritornello, which developed in the Baroque period, and *rondo*, which developed in the Classical period, are continuous structures which return repeatedly to the opening theme after statements of additional themes. Ritornello alternates orchestral and solo passages. Rondo alternates a main theme in the tonic key with subordinate themes in contrasting keys: ABACADA.

Sonata form, or *sonata-allegro form*, which we introduced earlier, takes its name from the conventional treatment of the first movement of the sonata. It is also the form of the first movement of many symphonies. The basic pattern is ABA or AABA. The first A section is a statement of two main themes, known as the *exposition*. It starts in the tonic and moves to a related key. To cement the perception of section A, the composer may repeat it: AA. The B section, the *development*, takes the original themes and develops them, usually with fragmentations and key changes. The A section then returns; this final section is called the *recapitulation*. The recapitulation is not an exact repetition of the opening section, because it needs to finish in the tonic key.

Open Forms

The *fugue*, again which we introduced earlier, is a polyphonic development of one, two, or sometimes three short themes. Fugal form, which takes its name from the Latin *fuga* ("flight"), has a traditional, though not a necessary, scheme of development. Two characteristics are common to all fugues: (1) counterpoint and (2) a clear dominant–tonic relationship—that is, imitation of the theme at the fifth above or below the tonic. Each voice in a fugue (as many as five or more) develops the basic subject independent from the other voices, and passes

through as many of the basic elements as the composer deems necessary. Unification is achieved not by return to an opening section, as in closed form, but by the varying recurrences of the subject throughout.

The *canon* is a contrapuntal form based on note-for-note imitation of one voice by another. The voices are separated by a brief time interval—for example (the use of letters here does *not* indicate structure as above):

Voice 1: a b c d e f g
Voice 2: a b c d e f g
Voice 3: a b c d e f g

The interval of separation is not always the same among the voices. The canon is different from a *round* such as "Row, row, row your boat." A round is also an exact melodic repeat; however, the canon develops new material indefinitely, while the round repeats the same phrases over and over. The interval of separation in the round stays constant—one phrase apart.

Theme and variations is a compositional structure in which an initial musical idea, the theme, is repeated over and over and is changed each time through melodic, rhythmic, and harmonic treatments, usually each more elaborate than the last.

HOW DOES IT STIMULATE THE SENSES?

Our Primal Responses

We can find no better means of illustrating the sensual effect of music than to contrast two totally different musical pieces. The Chopin Nocturne we noted earlier (CD track 15) provides us with an example of how musical elements can combine to give us a relaxing and soothing experience. Here, the tone color of the piano, added to the elements of a constant beat in triple meter, consonant harmonies, subtle dynamic contrasts, and extended duration of the tones combine in a richly subdued experience that engages us but lulls us at the same time. In contrast, listen to Stravinsky's "Auguries of Spring: Dances of the Youths and Maidens" from *The Rite of Spring* (CD track 20). Here the driving rhythms, strong syncopation, dissonant harmonies, wildly contrasting dynamics, and the broad tonal palette of the orchestra rivet us and ratchet up our excitement level. It is virtually impossible to listen to this piece without experiencing a rise in

pulse rate. In both cases, our senses have responded at an extremely basic rate over which we have, it would seem, little control.

Music contains a sensual attraction difficult to deny. At every turn it causes us to tap our toes, drum our fingers, or bounce in our seats in a purely physical response. This involuntary motor response is perhaps the most primitive aspect of our sensual involvement—as primitive as the images in Stravinsky's *The Rite of Spring*. If the rhythm is irregular and the beat divided or syncopated, as it is in this piece of music, we may find one part of our body doing one thing and another part doing something else. Having compared the Chopin and Stravinsky pieces, do we have any doubt that a composer's choices have the power to manipulate us sensually?

From time to time throughout this chapter, we have referred to certain historical conventions that permeate the world of music. Some of these have a potential effect on our sense response. Certain notational patterns, such as the ornamental *appoggiatura*, are a kind of musical shorthand, or perhaps mime, that conveys certain kinds of emotion to the listener. This, of course, has little meaning for us unless we take the time and effort to study music history. Some of Mozart's string quartets indulge in exactly this kind of communication—another illustration of how expanded knowledge can increase the depth, value, and enjoyment of the aesthetic experience.

The Musical Performance

A certain part of our sense response to music occurs as a result of the nature of the performance itself. As we suggested earlier in the chapter, the scale of a symphony orchestra gives a composer a tremendously variable canvas on which to paint. Let's pause, momentarily, to familiarize ourselves with this fundamental aspect of the musical equation. As we face the stage in an orchestral concert, we note perhaps as many as one hundred instrumentalists facing back at us. Their arrangement from one concert to another is fairly standard, as illustrated in Figure **3.10**.

A large symphony orchestra can overwhelm us with diverse timbres and volumes; a string quartet cannot. Our expectations and our focus may change as we perceive the performance of one or the other. Because, for example, we know our perceptual experience with a string quartet will not involve the broad possibilities of an orchestra, we tune ourselves to seek the subtler, more personal messages within that particular medium. The difference between listening to an orchestra and listening to a quartet is similar to the difference between viewing a museum painting of monumental scale and the exquisite technique of a miniature.

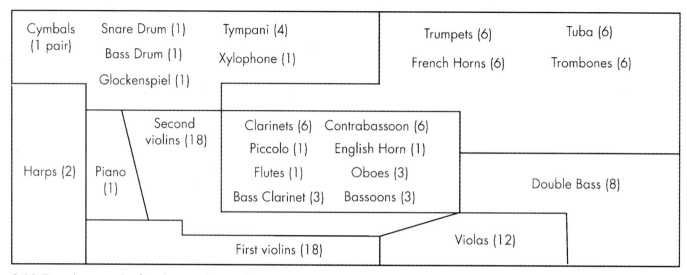

3.10 Typical seating plan for a large orchestra (about 100 instrumentalists), showing the placement of instrumental sections

Textural suggestion can have much to do with sensual response to a musical work. Debussy's *Prelude to the Afternoon of a Faun* (CD track 19) elicits images of Pan frolicking through the woodlands and cavorting with the nymphs on a sunny afternoon. Of course, much of what we imagine has been stimulated by the title of the composition. Our perception is heightened further if we are familiar with the poem by Mallarmé on which the symphonic poem is based. Titles, and especially text, in musical compositions may be the strongest devices a composer has for communicating directly with us. Images are triggered by words, and they can stimulate our imaginations and senses to wander freely "in tune" with the musical development. Johannes Brahms called a movement in his *German Requiem* "All Mortal Flesh is as the Grass"; we certainly receive a philosophical and religious communication from that title. Moreover, when the chorus ceases to sing and the orchestra plays alone, the instrumental melodies stimulate images of fields of grass blowing in the wind.

Harmony and tonality are both of considerable importance in stimulating our senses. Just as paintings and sculpture stimulate sensations of rest and comfort or action and discomfort, so harmonies create a feeling of repose and stability if they are consonant and a sensation of restlessness and instability if they are dissonant. Harmonic progression that leads to a full cadential resolution leaves us feeling fulfilled; unresolved cadences are puzzling and perhaps irritating. Major or minor tonalities have significantly differing effects: Major sounds positive; minor, sad or mysterious. The former seems close to home, and the latter exotic. Atonal music sets us adrift to find the unifying thread of the composition.

Melody, rhythm, and tempo have close parallels to the use of line in painting, and the term "melodic contour" could be seen as a musical analogue to this element of painting. When the tones of a melody are conjunct and undulate slowly and smoothly, they trace a pattern having the same sensual effect as their linear visual counterpart— that is, soft, comfortable, and placid.

When melodic contours are disjunct and tempos rapid, the pattern and response change:

In conclusion, it remains for us as we respond to music to analyze how each of the elements available to the composer has in fact become a part of the channel of communication, and how the composer, consciously or unconsciously, has put together a work that elicits sensory responses from us.

OPERA

The composer Pietro Mascagni reportedly said, "In my operas do not look for melody or beauty ... look only for blood." Mascagni represented a style of late-nineteenth-century opera called *verismo*, a word with the same root as verisimilitude, meaning true to life. *Verismo* opera treated themes, characters, and events from life in a down-to-earth fashion. In Mascagni's operas and the operas of other com-

posers of the *verismo* style, we find plenty of blood, but we also find fine drama and music, and the combination of drama and music into a single artistic form constitutes opera. In basic terms, opera is drama sung to orchestral accompaniment. In opera, music comprises the predominant element, but the addition of a story line, scenery, costumes, and staging make opera significantly different from other forms of music.

In one sense, we could describe opera as the purest integration of all the arts. It contains music, drama, poetry, and visual arts. It even includes architecture, because an opera house constitutes a particular architectural entity with very specific requirements for orchestra, audience, and stage space, as well as stage machinery. In its wide variety of applications, opera ranges from tragedies of spectacular proportions, involving several hundred people, to intimate music dramas and comedies with two or three characters (**Figs. 3.11–3.13**).

In an opera, unlike theatre, the production reveals char-acter and plot through song rather than speech. This convention removes opera from the lifelikeness we might expect in the theatre and asks us to suspend our disbelief so we can enjoy magnificent music and the heightening of dramatic experience that music's contribution to mood, character, and dramatic action affords us.

Central to an opera are performers who can sing and act simultaneously. These include major characters played by star performers as well as secondary solo singers and chorus members plus supernumeraries—"supers" or "extras"—who do not sing but merely flesh out crowd scenes.

Types of Opera

In Italian, the word opera means "work." In Florence, Italy, in the late sixteenth century, artists, writers, and architects eagerly revived the culture of ancient Greece and Rome. Opera was an attempt by a group known as the camerata

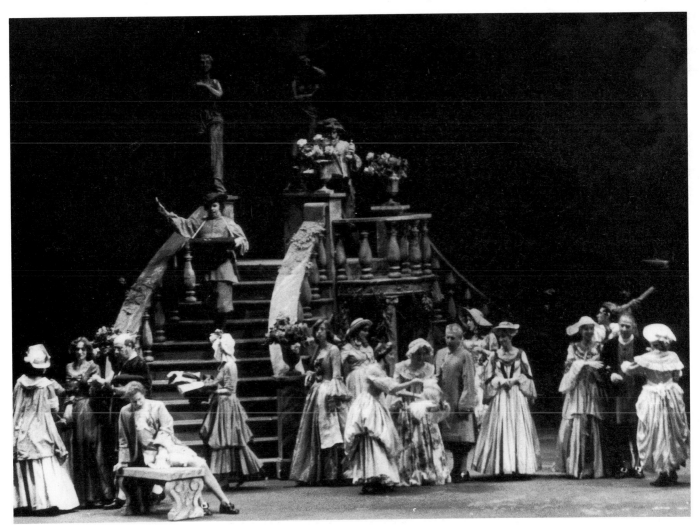

3.11 Giacomo Puccini, *Manon Lescaut.* Opera Company of Philadelphia.

(Italian for "fellowship" or "society") to re-create the effect of ancient Greek drama, in which, scholars believed, the words were chanted or sung as well as spoken. Through succeeding centuries, various applications of the fundamental concept of opera have arisen, and among these applications are four basic types of opera: 1) grand opera; 2) opéra comique; 3) opera buffa; and 4) operetta.

Grand Opera, used synonymously with "opera," refers to serious or tragic opera, usually in five acts. Another name for this type of opera is *opera seria* ("serious opera"), which treats heroic subjects usually in a highly stylized manner—for example, the gods and heroes of ancient times.

Opéra Comique is any opera, regardless of subject matter, that has spoken dialogue. This type of opera must not be confused with comic opera.

Opera Buffa is comic opera (again, not to be confused with opéra comique), which usually does not have spoken dialogue. It usually uses satire to treat a serious topic with humor—for example, Mozart's *The Marriage of Figaro.*

Operetta also has spoken dialogue, but it has come to refer to a light style of opera characterized by popular themes, a romantic mood, and often a humorous tone. It is frequently considered more theatrical than musical, and its story line is usually frivolous and sentimental.

The Opera Production

Like theatre, opera is a collaborative art, joining the efforts of a composer, a dramatist, a stage director, and a musical director. At its beginnings, an opera emerges when a composer sets to music a text, called a *libretto* (and written by a *librettist*). As we suggested earlier, the range of subjects and characters in opera may be extremely broad, from mythological to everyday. All characters come to life through performers who combine singing and acting. Opera includes the basic voice ranges we noted earlier (soprano, alto, tenor, bass), but divides them more precisely. Opposite are some of the categories.

3.12 -Giuseppe Galli da Bibiena, *Scene design for an opera*, 1719. Contemporary engraving. Metropolitan Museum of Art, New York (Elisha Whittelsey Collection).

Coloratura soprano	Very high range; capable of executing rapid scales and trills.
Lyric soprano	Fairly light voice; cast in roles requiring grace and charm.
Dramatic soprano	Full, powerful voice, capable of passionate intensity.
Lyric tenor	Relatively light, bright voice.
Dramatic tenor	Powerful voice, capable of heroic expression.
Basso buffo	Cast in comic roles; can sing very rapidly.
Basso profundo	Extremely low range capable of power; cast in roles requiring great dignity.

Since the large majority of operas in the contemporary repertoire are not of American origin, the American respondent usually has to overcome the language barrier to understand the dialogue and thereby the plot. It is not a desire for snobbery or exclusivity that causes the lack of English-translation performances; much of it is pure practicality. For example, performing operas in their original language makes it possible for the best singers to be heard around the world. Imagine the complications if a great singer had to learn a single opera in the language of every country in which he or she performed it. In addition, opera loses much of its musical character in translation. We spoke of tone color, or timbre, earlier in this chapter. There are timbre characteristics implicit in the Russian, German, and Italian languages that are lost when they are translated into English. In addition, inasmuch as opera is in a sense the Olympic Games of the vocal-music world—that is, the demands made on the human voice by the composers of opera call for the highest degree of skill and training of any vocal medium—tone, placement, and the vowels and consonants requisite to that placement, become very important to the singer. It is one thing for a tenor to sing the vowel "eh" on high B-flat in the original Italian. If the translated word to be sung on the same note employs an "oo" vowel, the technical demand is changed considerably. So, the translation of opera from its original tongue into English is a far more difficult and complex problem than simply providing an accurate translation for a portion of the audience that does not know the text—as

important as that may seem. Translation must concern itself with tone quality, color, and the execution of tones in the *tessitura*, or normal range, of the human voice.

Experienced operagoers may study the score before attending a performance. However, every concert program contains a plot synopsis (even when the production is in English), so that everyone can follow what is happening. Opera plots, unlike mysteries, have few surprise endings, and knowing the plot ahead of time does not diminish the experience of responding to the opera. To assist the audience, often opera companies project the translated lyrics on a screen above the stage, much like subtitles in a foreign film.

The opening element in opera is the *overture*. This orchestral introduction may have two characteristics. First, it may set the mood or tone of the opera. Here the composer works directly with our sense responses, putting us in the proper frame of mind for what is to follow. In his overture to *I Pagliacci*, for example, Ruggiero Leoncavallo creates a tonal story that foretells what we are to experience. Using only the orchestra, he tells us we will see comedy, tragedy, action, and romance. Listening to this overture, we can easily identify these elements, and in so doing understand how relatively unimportant to comprehension it is that the work is in English. Add to the "musical language" the language of body and mime, and we can understand even complex ideas and character relationships—*without* words. In addition to this type of introduction, an overture may provide melodic introductions—passages introducing the *arias* and *recitatives* that will follow.

MUSIC AND HUMAN REALITY

Bizet, *Carmen*

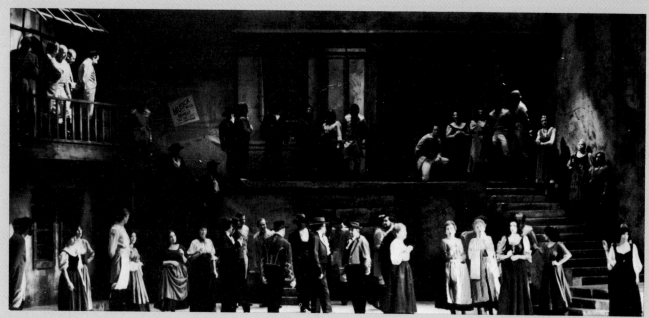

3.13 Georges Bizet, *Carmen*. Opera Company of Philadelphia. Composite photo.

The plot unfolds through recitative, or sung dialogue. Recitative moves the plot along from one section to another; it usually has little emotional content to speak of, and the words are more important than the music. There are two kinds of recitative. The first is *recitativo secco*, for which the singer has very little musical accompaniment, or none at all. If there is accompaniment it is usually in the form of light chording under the voice. The second type is *recitativo stromento*, with full musical accompaniment.

The real emotion and poetry of an opera lie in its arias. Musically and poetically, an aria is the reflection of high dramatic feeling. The great opera songs with which we are likely to be familiar are arias such as "La Donna è Mobile" from *Rigoletto* by Giuseppe Verdi (CD track 17).

Every opera contains ensemble pieces such as duets, trios, and quartets. There are also chorus sections in which everyone gets into the act. In addition, ballet or dance interludes are not uncommon. These may have nothing to do with the development of the plot, but are put in to add more life and interest to the dramatic production, and in some cases to provide a link from one scene into another.

Bel canto, as its name implies, is a style of singing emphasizing the beauty of sound. Its most successful composer, Gioacchino Rossini, had a great sense of melody and sought to develop the *art song* to its highest level. In *bel canto* singing the melody is the focus.

In the nineteenth century Richard Wagner (CD track 18) gave opera and theatre a prototype that still continues to influence theatrical production—organic unity. Every element of his productions was integral and was shaped so as to help create a work of total unity. Wagner was also famous for the use of *leitmotif*, a common element in contemporary film. A leitmotif is a musical theme associated with a particular person or idea. Each time that person appears or is thought of, or each time the idea surfaces, the leitmotif is played.

George Bizet's opera *Carmen* takes its libretto from a literary classic, a story by Prosper Mérimée. Its heroine, Carmen, is a seductive employee in a cigarette factory in nineteenth-century Seville. She flirts with Don Jose, a soldier, and completely enraptures him to the point where he deserts his service to follow her first to her haunt, a disreputable tavern, and then to a mountain pass where gypsy smugglers have made their hideout. But Carmen soon tires of Don Jose and becomes interested in the great toreador Escamillo. On the day of a bullfight in Seville, Carmen arrives with Escamillo, the latter welcomed as a hero. After Escamillo enters the bullring, Don Jose is seen. He is dishevelled and distraught. In vain he pleads with Carmen to return to him. When she refuses, he stabs her fatally with a dagger. Emerging from the bullfight, Escamillo finds Don Jose weeping over Carmen's dead body.

Carmen began as *opéra comique*. When Bizet first wrote his score, he used spoken dialogue, and this is the way *Carmen* was heard at the Opéra Comique in Paris on March 3, 1875. Incidentally, it is still played that way at that house. But elsewhere, dialogue was replaced by recitatives, sung dialogues prepared not by the composer himself but by Ernest Guiraud. There is still another way in which *Carmen*, as we now hear it, differs from the way it was introduced. Today a number of ballet sequences are interpolated (using background music from other Bizet compositions). As an opéra comique in 1875, *Carmen* had no ballets.

As a character and as a woman, Carmen fascinates. Bizet uses her as a symbol of "woman." Every passage Carmen sings is a new mask, mirroring the man she is addressing. Her receptive nature is portrayed with uncanny realism in her change of tone as she addresses the passers-by, Jose, Zuniga, the smugglers, and Escamillo. For each of the men, she alters the sound of her voice, the character of her melody, her mood, her tempo.

There was much in *Carmen* to disturb audiences in 1875. The vivid portrayal of such an immoral character caused shock. Never before had an opera presented women onstage smoking cigarettes. Some listeners objected to the music, thinking it was too much like Wagner, because Bizet assigned such importance to the orchestra and on random occasions used a leading-motif (*leitmotif*) technique. Nevertheless, *Carmen* was by no means the total failure that some of Bizet's early biographers suggested. As a matter of fact, some critics hailed it, a publisher paid a handsome price for the publication rights, and the opera company kept it in its repertory the following season.

CHAPTER FOUR

THEATRE

WHAT IS IT?

TRAGEDY
COMEDY
TRAGICOMEDY
MELODRAMA
PERFORMANCE ART

HOW IS IT PUT TOGETHER?

THE SCRIPT
PLOT
Profile: William Shakespeare
 Exposition
 Complication
 Dénouement
 Foreshadowing
 Discovery
 Reversal
CHARACTER
THE PROTAGONIST
THOUGHT
VISUAL ELEMENTS
 Theatre Types
 Scene Design
 Lighting Design
 Costume Design
 Properties
AURAL ELEMENTS
DYNAMICS
THE ACTOR
VERISIMILITUDE

HOW DOES IT STIMULATE THE SENSES?

Theatre and Human Reality: David Rabe, Hurly-Burly

IMPORTANT TERMS

Tragedy A serious drama or other literary work in which conflict between a protagonist and a superior force (often fate) concludes in disaster for the protagonist.

Comedy A genre of complex qualities involving humor. Comedy may or may not involve laughter and may or may not end "happily."

Melodrama A genre characterized by stereotyped characters, implausible plots, and an emphasis on spectacle.

Performance art A theatrical-type performance that combines elements from fields in the humanities and the arts.

Script A written document containing the words of the play.

Exposition A part of plot containing necessary background information

Complication A part of plot containing a series of conflicts and decisions by the characters.

Dénouement A part of plot containing the final resolution.

Protagonist The main character of a play.

Aesthetic distance The mental and physical separation of the audience from the performance.

Of all the arts, theatre comes the closest to personalizing the love, rejection, disappointment, betrayal, joy, elation, and suffering that we experience in our daily lives. It does so because theatre uses live people acting out situations that very often look and sound like real life. Theatre once functioned in society like television and movies do today. Many of the qualities of all three forms are identical. We shall find in this chapter the ways that theatre, which frequently relies on *drama* (a written script), takes lifelike circumstances and compresses them into organized episodes. The result, although looking like reality, goes far beyond it in order to help us find in its characters pieces of ourselves.

The word "theatre" comes from the Greek *theatron*—the area of the Greek theatre building where the audience sat. Its literal meaning is "a place for seeing." The Greeks' choice of this word suggests that they perceived the essence of theatre as visual. In addition to the words of the script, provided by the playwright, and the treatment of those words by the actors, the theatre artwork—the production—involves visual messages. These include actor movement, costume, setting, lighting, and the physical relationship of the playing space to the audience.

Like the other performing arts, theatre is an interpretive discipline. Between the playwright and the audience stand the director, the designers, and the actors. Although each functions as an individual artist, each also serves to communicate the playwright's vision to the audience. Sometimes the play becomes subordinate to the expressive work of its interpreters; sometimes the concept of director as master artist places the playwright in a subordinate position. None the less, a theatrical production always requires the interpretation of a concept through spectacle and sound by theatre artists.

WHAT IS IT?

Theatre represents an attempt to reveal a vision of human life through time, sound, and space. It gives us flesh-and-blood human beings involved in human action—we must occasionally remind ourselves that the dramatic experience is not reality: It is an imitation of reality, acting as a symbol to communicate something about the human condition. Theatre is make-believe: Through gesture and movement, language, character, thought, and spectacle, it imitates action. However, if this were all theatre consisted of, we would not find it as captivating as we do, and as we have for more than 2,500 years.

At the formal level, theatre comprises *genre*—or type of play—from which the production evolves. Some of the genres of theatre are *tragedy, comedy, tragicomedy, melodrama*, and *performance art*. Some are products of specific periods of history, and illustrate trends that no longer exist; others are still developing and as yet lack definite form. Our response to genre is a bit different from our formal response or identification in music, for example, because we seldom find generic identification in the theatre program. Some plays are well-known examples of a specific genre, for example, the tragedy *Oedipus the King* by Sophocles. In these cases, as with a symphony, we can see how the production develops the conventions of genre. Other plays, however, are not well known or may be open to interpretation. As a result, we can draw our conclusions only after the performance has finished.

TRAGEDY

We commonly describe tragedy as a play with an unhappy ending. The playwright Arthur Miller describes tragedy as "the consequences of a man's total compulsion to evaluate himself justly; his destruction in the attempt posits a wrong or an evil in his environment." In the centuries since its inception, tragedy has undergone many variations as a means by which the playwright makes a statement about human frailty and failing.

Typically, tragic heroes make free choices that bring about suffering, defeat, and, sometimes, triumph as a result of defeat. The protagonist often undergoes a struggle that ends disastrously. In Greek Classical tragedy of the fifth century B.C. (see Chapter 10), the hero or heroine was generally a larger-than-life figure who gained a moral victory amid physical defeat. Classical heroes usually suffer from a tragic flaw or mistake—some defect that causes them to participate in their own downfall. In the typical structure of Classical tragedies, the climax of the play occurs as the hero or heroine recognizes his or her role, and accepts destiny. In the years from ancient Greece to the present, however, writers of tragedy have employed many different approaches. Arthur Miller argues the case for tragic heroes of "common stuff," suggesting that "the tragic right is a condition of life, a condition in which the human personality is able to flower and realize itself."

COMEDY

In many respects, comedy is much more complex than tragedy, and harder to define. Comedy embraces a wide range of theatrical approaches, ranging from the intellectual and dialogue-centered high comedy of the seventeenth century to the slapstick, action-centered low comedy found in a variety of plays from nearly every historical period. Low comedy may include *farce*—typically a wildly

active and hilarious comedy of situation, usually involving a trivial theme. It is the kind of comedy associated with actions such as pies in the face, mistaken identities, and pratfalls. Whatever happens in a farce carries little serious consequence. It perhaps provides an opportunity for the viewer to express unconscious and socially unacceptable desires without having to take responsibility for them. Its differences from other varieties of comedy appear to lie in the method of farcical treatment of material, rather than its intent or purpose.

Between the extremes just noted exist a variety of comic forms. One of these is the popular domestic comedy, in which family situations are the focus of attention, and in which members of a family and their neighbors find themselves in various complicated and amusing situations—for example Neil Simon's plays *Brighton Beach Memoirs* and *Broadway Bound*.

Defined in its broadest terms, comedy may not involve laughter. Many employ stinging *satire*, although we can probably say with some accuracy that humor forms the root of all comedy. In many circumstances comedy treats a serious theme, but remains basically lighthearted in spirit: Characters may be in jeopardy, but not too seriously so. Comedy deals with the world as we find it, focusing on everyday people through an examination of the incongruous aspects of behavior and relationships. The generally held idea that comedy ends happily is probably due to our expectations that in happy endings everyone is left more or less to do what they please. However, happy endings often imply different sets of circumstances in different plays. Comedy appears to defy any such thumbnail definitions.

TRAGICOMEDY

As the name suggests, tragicomedy is a mixed form of theatre, which, like the other types, has been defined in different terms in different periods. Until the nineteenth century, the ending was the criterion for this form. Traditionally, characters reflect diverse social standings—kings (as in tragedy) and common folk (as in comedy)—and reversals go from bad to good and good to bad. The genre also includes language appropriate to both tragedy and comedy. Early tragicomedies were serious plays that ended, if not happily, then at least by avoiding catastrophe. In the past century-and-a-half, the term has been adapted to describe plays in which the mood may shift from light to heavy, or in which endings are neither exclusively tragic nor comic.

MELODRAMA

Melodrama is another mixed form. It takes its name from the terms *melo* (Greek for "music") and "drama."

Melodrama first appeared in the late eighteenth century, when dialogue took place against a musical background. In the nineteenth century, the term was applied to serious plays without music. Melodrama uses stereotypical characters involved in serious situations in which suspense, pathos, terror, and occasionally hatred are aroused. It portrays the forces of good and evil battling in exaggerated circumstances. As a rule, the issues involved are simplified and uncomplicated: Good is good and evil is evil; there are no ambiguities.

Geared largely for a popular audience, the form concerns itself primarily with situation and plot. Conventional in its morality, melodrama tends toward optimism—good always triumphs in the end. Typically, the hero or heroine is placed in life-threatening situations by the acts of a villain and then rescued at the last instant. The forces against which the characters struggle are external ones—caused by an unfriendly world rather than by inner conflicts. Probably because melodrama took root in the nineteenth century, at a time when scenic spectacularism was the vogue, many melodramas depend on sensation scenes for much of their effect. This penchant can be seen in the popular nineteenth-century adaptation of Harriet Beecher Stowe's novel *Uncle Tom's Cabin*, as Eliza and the baby, Little Eva, escape from the plantation and are pursued across a raging, ice-filled river. These effects taxed the technical capacities of contemporary theatres to their maximum, but gave the audience what it desired—spectacle. Not all melodramas use such extreme scenic devices, but their use was so frequent that they have become identified with the type. If we include motion pictures and television as dramatic structures, we could say that melodrama was the most popular dramatic form of the twentieth century.

PERFORMANCE ART

The Postmodern movement of the late twentieth century, which implies a turn away from the qualities that characterized "modern" art, produced a form of theatrical presentation called Performance Art. Performance Art pushes the traditional theatre envelope in a variety of directions, some of which deny traditional concepts of theatrical production itself. It is a type of performance that combines elements from fields in the humanities and arts, from urban anthropology to folklore, and dance to feminism. Performance Art pieces called "Happenings" grew out of the pop-art movement of the 1960s and were designed as critiques of consumer culture. European performance artists were influenced by the early twentieth-century movement of dadaism and tended to be more political than their American counterparts. The central focus of many

"Happenings" was the idea that art and life should be connected (a central concept in Postmodernism in general).

Because of its hybrid and diverse nature, there is no "typical" performance artist or work we can study as an illustration. We can, however, note three brief examples, which, if they do not typify, at least illumine this movement. The Hittite Empire, an all-male performance art group, performs *The Undersiege Stories*, which focuses on nonverbal communication and dance and includes confrontational scenarios. Performance artist Kathy Rose blends dance and film animation in unique ways. In one performance in New York, she creatively combined exotic dances with a wide variety of styles that included German Expressionism and science fiction. The *New York Times* called her performance "visual astonishments." Playwright Rezo Abdoh's *Quotations from a Ruined City*, an intense and kinetic piece, features ten actors who act out outrage in fascinating, energetic fashion. The complicated, overlapping scenes, tableaux, and dances are punctuated by loud but unintelligible prerecorded voices. The piece combines elements depicting brutality, sadism, and sexuality. In the 1990s, Performance Art saw some difficult times because many people viewed it as rebellious and controversial for its own sake.

HOW IS IT PUT TOGETHER?

Theatre consists of a complex combination of elements that form a single entity called a performance or a production. Understanding of the theatre production as a work of art can be enhanced if we have some tools for approaching it. The following come to us from the distant past.

Writing 2,400 years ago in the *Poetics*, Aristotle argued that tragedy consisted of plot, character, diction, music, thought, and spectacle. We can use and expand upon Aristotle's terminology to describe the basic parts of a production. These six parts—and their descriptive terminology—still cover the entire theatrical product. We shall reshape Aristotle's terms into language that is more familiar to us, explain what they mean, and learn how we can use them to understand how a theatrical production is put together—things to look and listen for in a production. First, we will examine the script, and include in that discussion Aristotle's concept of diction, or language. Next, we will examine plot, thought—themes and ideas—character, and spectacle, which we shall call the visual elements. That will be followed by a brief discussion of what

Aristotle called music but which, to avoid confusion, we will call aural elements.

THE SCRIPT

A playwright creates a written document called a script, which contains the dialogue used by the actors. Aristotle called the words written by the playwright diction; we will refer to this part of a production as its language. The playwright's language tells us at least part of what we can expect from the play. For example, if everyday speech has been used, we generally expect the action to resemble everyday truth, or reality. In the play *Fences* (1986), playwright August Wilson uses everyday language to bring the characters to life in the context of the period:

(*Act I, scene iii. Troy is talking to his son.*)

Like you? I go out of here every morning . . . bust my butt . . . putting up with them crackers everyday . . . cause I like you? You about the biggest fool I ever saw.
 (Pause)
 It's my job. It's my responsibility! You understand that? A man got to take care of his family. You live in my house . . . sleep you behind on my bedclothes . . . fill you belly up with my food . . . cause you my son.[1]

Poetic language, on the other hand, usually indicates less realism and perhaps stronger symbolism. Compare the language of *Fences* with the poetry used by Pierre Corneille, a seventeenth-century dramatist, in *Le Cid* to create a mythical hero who is larger than life:

(*Act III, scene iv*)

Rodrigue: I'll do your bidding, yet still do I desire
To end my wretched life, at your dear hand.
But this you must not ask, that I renounce
My worthy act in cowardly repentance.
The fatal outcome of too swift an anger
Disgraced my father, covered me with shame.[2]

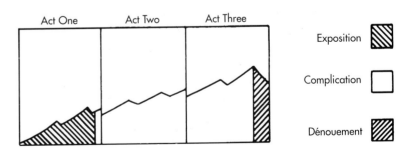

4.1 Hypothetical dynamic and structural development of a three-act play.

95

In both plays, we use language and its tone to aid us in determining the implication of the words. Language helps to create the overall tone and style of the play. It can also reveal character, theme, and historical context.

PLOT

Plot is the structure of the play, the skeleton that gives the play shape, and on which the other elements hang. The nature of the plot determines how a play works: how it moves from one moment to another, how conflicts are structured, and how the experience ultimately comes to an end. We can examine the workings of plot by seeing the play somewhat as a timeline, beginning as the script or production begins, and ending at the final curtain, or the end of the script. In many plays plot tends to operate like a climactic pyramid (Fig. 4.1). In order to keep our attention, the dynamics of the play rise in intensity until they reach the ultimate crisis—the *climax*—after which they relax, through a resolution called the *dénouement*, to the end of the play.

Depending on the playwright's purpose, plot may be shaped with or without some of the features described below. Sometimes plot may be so de-emphasized that it virtually disappears. However, as we try to evaluate a play critically, the elements of plot give us things to look for—if only to note that they do not exist in the play at hand.

PROFILE

William Shakespeare

William Shakespeare (1564–1616) was one of the world's greatest literary geniuses. Most of his work was for the theatre, but he left a remarkable sequence of sonnets in which he pushed the resources of the English language to breathtaking extremes. In his works for the theatre, Shakespeare represents the Elizabethan love of drama, and the theatres of London were patronized by lords and commoners alike. They sought and found, usually in the same play, action, spectacle, comedy, character, and intellectual stimulation deeply reflective of the human condition. Thus it was with Shakespeare, the pre-eminent Elizabethan playwright. His appreciation of the Italian Renaissance—which he shared with his audience—can be seen in the settings of many of his plays. With true Renaissance breadth, Shakespeare went back into history, both British and Classical, and far beyond, to the fantasy world of *The Tempest*. Like most playwrights of his age, Shakespeare wrote for a specific professional company of which he became a partial owner. The need for new plays to keep the company alive from season to season provided much of the impetus for his prolific output.

Although we know only a little of his life, the principal facts are well established. He was baptized in the parish church of Stratford-upon-Avon on April 26, 1564, and probably attended the local grammar school. We next learn of him in his marriage to Ann Hathaway in 1582, when a special action was necessary to allow the marriage without delay. The reason is clear—five months later, Ann gave birth to their first daughter, Susanna. The next public mention comes in 1592, when his reputation as a playwright was sufficient to warrant a malicious comment from another playwright, Robert Greene. From then on, there are many records of his activities as dramatist, actor, and businessman. In addition to his steady output of plays, he also published a narrative poem entitled *Venus and Adonis*, which was popular enough to have nine printings in the next few years. His standing as a lyric poet was established with the publication of 154 Sonnets in 1609.

In 1594 he was a founder of a theatrical company called the Lord Chamberlain's Company, in which he functioned as shareholder, actor, and playwright. In 1599, the company built its own theatre, the Globe, which came directly under the patronage of James I when he assumed the throne in 1603. (A faithful reproduction of Shakespeare's Globe Theatre was completed in London in 1998.) Shakespeare died in 1616, shortly after executing a detailed will. His will, still in existence, bequeathed most of his property to Susanna and her daughter. He left small mementoes to friends. He mentioned his wife only once, leaving her his "second best bed" with its furnishings.

Playwrights were not highly esteemed in England in the sixteenth century, and there was virtually no reason to write about them. We do, however, know more about Shakespeare than we do most of his contemporaries.

Exposition

Exposition provides necessary background information: Through it the playwright introduces the characters—their personalities, relationships, backgrounds, and present situation. Exposition is frequently a recognizable section at the beginning of a play. It can be presented through dialogue, narration, setting, lighting, costume—or any device the playwright or director chooses. The amount of exposition in a play depends very much on where the playwright takes up the story, called the *point of attack*. A play told chronologically may need fairly little expositional material; others require a good bit of prior summary.

Complication

Drama is about conflict. Although not every play fits that definition, conflict of some sort is a fundamental dramatic device in order to interest an audience. At some point in the play, the expected course of events is usually frustrated, giving the audience reason to be interested in what transpires. At a specific moment, an action is taken or a decision made that upsets the current state of affairs. This is sometimes called the *inciting incident* and it opens the middle part of the plot—the complication. The complication is the meat of the play, and it comprises a series of conflicts and decisions, called crises (from the Greek *krisis*, meaning "to decide"), that rise in intensity until they reach a turning point—the climax—that constitutes the end of the complication section.

Dénouement

The dénouement (French for "untangling") is the final resolution of the plot. It is the period of time during which the audience is allowed to sense that the action is ending—a period of adjustment, downward in intensity, from the climax. Ideally, the dénouement brings about a clear and ordered resolution.

Exposition, complication, and dénouement comprise a time-frame in which the remaining parts of the play operate. This structural picture is not always so neat, though. Some plays do not conform to this kind of plot structure, yet that does not make them poorly constructed or of inferior quality. Nor does it mean that these concepts cannot generally be used as a means for describing and analyzing how a play is put together.

Foreshadowing

Preparation for subsequent action—foreshadowing—provides credibility for future action, keeps the plot logical, and avoids confusion. It builds tension and suspense: The audience is allowed to sense that something is about to happen, but because they do not know exactly what or when, anticipation builds suspense and tension. In the movie *Jaws* a rhythmic musical theme foreshadows the presence of the shark. Just as the audience becomes comfortable with that device, the shark suddenly appears—without the music. As a result, uncertainty as to the next shark attack is heightened immensely. Foreshadowing also moves the play forward by pointing toward events that will occur later.

Discovery

Discovery is the revelation of information about characters, their personalities, relationships, and feelings. Hamlet discovers from his father's ghost that his father was murdered by Claudius, and is urged to avenge the killing—a discovery without which the play cannot proceed. The skill of the playwright in structuring the revelation of such information in large part determines the overall impact of the play on the audience.

Reversal

Reversal is any turn of fortune; for example, Oedipus falls from power and prosperity to blindness and exile; King Lear goes from ruler to victim of disaster. In comedy, reversal often changes the roles of social classes, as peasants jump to the upper class, and vice versa.

CHARACTER

Character is the psychological motivation of the people in the play. In most plays, the audience focuses on why individuals do what they do, how they change, and how they interact with other individuals, as the plot unfolds.

Plays reveal a wide variety of characters—both persons and motivating psychological forces. In every play there are characters who fulfill major functions and on whom the playwright wishes to focus. There are also minor characters. They may interact with the major characters, and their actions constitute subordinate plot lines. Much of the interest created by the drama lies in the exploration of how people with specific character motivations react to circumstances. For example, when Rodrigue in *Le Cid* discovers that his father has been humiliated, what is it in his character that makes him decide to avenge the insult, even though it means killing the father of the woman he loves, thereby jeopardizing that love? It is such responses, driven by character, that drive plays forward.

THE PROTAGONIST

Inside the structural pattern of a play some kind of action must take place. We must ask ourselves: How does this play work? How do we get from the beginning to the end? Most of the time, we take that journey via the actions and decisions of the *protagonist*, or central personage. Deciding who is the protagonist of a play is not always easy, even for directors. However, it is important to ascertain whom the play is about if we are to understand it. In Terence Rattigan's *Cause Célèbre* three different responses are possible, depending upon whom the director decided was the protagonist. The problem is this: There are two central female roles. A good case could be made for either as the central personage of the play. Or they could be equal.

THOUGHT

In order to describe the intellectual content of a play, Aristotle uses the term "thought," which we shall adopt to refer to the themes and ideas that the play communicates. In Lanford Wilson's *Burn This* (1987), for example, a young dancer, Anna, lives in a Manhattan loft with two gay roommates, Larry and Robby. As the play opens, we learn that Robby has been killed in a boating accident. Anna has just returned from the funeral and a set of bizarre encounters with Robby's family. Larry, a sardonic advertising executive, and Burton, Anna's boyfriend, maintain a constant animosity. Into the scene bursts Pale, Robby's brother and a

threatening, violent figure. Anna is both afraid and irresistibly attracted to Pale; the conflict of their relationship drives the play forward to its climax.

The above brief description summarizes the *plot* of a play. However, what the play is about—its *thought*—remains for us to discover and develop. Some might say it is about loneliness, anger, and the way not belonging is manifested in human behavior. Others might focus on abusive relationships, and others would see a thought content dealing with hetero- and homosexual conflicts and issues. The process of coming to conclusions about meaning involves several layers of interpretation. One involves the playwright's interpretation of the ideas through the characters, language, and plot. A second lies in the director's decisions about what the playwright has in mind, which is balanced by what the director wishes to communicate because, or in spite, of the playwright. Finally, it is important that we interpret what we actually see and hear in the production, along with what we may perceive independently from the script.

VISUAL ELEMENTS

The director takes the playwright's language, plot, and characters and translates them into action by using, among other things, what Aristotle called "spectacle," or what the French call *mise-en-scène*, but which we can simply call the visual elements. The visual elements of a production include, first of all, the physical relationship established

4.2 Ground plan of an arena theatre.

4.3 Ground plan of a thrust theatre.

between actors and audience. The actor–audience relationship can take any number of shapes. For example, the audience might sit surrounding, or perhaps on only one side of, the stage. The visual elements also include stage settings, lighting, costumes, and properties, as well as the actors and their movements. Whatever the audience can see contributes to this aspect of the theatrical production.

Theatre types

Part of our response to a production is shaped by the design of the space in which the play is produced. The earliest and most natural arrangement is the theatre-in-the-round, or *arena* theatre (Fig. **4.2**), in which the audience surrounds the playing area on all sides. Whether the stage is circular,

4.4 (right) Ground plan of a proscenium theatre.

4.5 Scene design for Aeschylus, *The Eumenides*, c. 1922. Designer: C. Ricketts. Victoria & Albert Museum, London.

4.6 Shakespeare, *Richard II*, Act II, scene ii (entrance into St. Stephen's Chapel). Producer: Charles Kean, London, 1857. Victoria & Albert Museum, London.

square, or rectangular is irrelevant. Some argue that the closeness of the audience to the actors in an arena theatre provides the most intimate kind of theatrical experience. A second possibility is the *thrust*, or three-quarter, theatre (Fig. 4.3), in which the audience surrounds the playing area on three sides. The most familiar example of this type of theatre is what we understand to have been the theatre of the Shakespearean period. The third format, and the one most widely used in the twentieth century, is the *proscenium* theatre, in which the audience sits on only one side and views the action through a frame (Fig. 4.4).

There are also various experimental arrangements of audience and stage space. Sometimes acting areas are placed in the middle of the audience, creating little island stages. In certain circumstances, these small stages create quite an interesting set of responses and relationships between actors and audience.

Common experience indicates that the physical relationship of the acting area to the audience has an effect on the depth of audience involvement. It has also been found that some separation is necessary for certain kinds of emotional responses. This mental and physical separation is called *aesthetic distance*. The proper aesthetic distance allows us to become involved in what we know is fictitious and even unbelievable.

The visual elements may or may not have independent communication with the audience; this is one of the options of the director and designers. Before the nineteenth century, there was no coordination of the various elements of a theatre production. This, of course, had all kinds of curious, and in some cases catastrophic, consequences. However, for the past century, most theatre productions have adhered to what is called the organic theory of play production: Everything, visual and aural, is

4.7 Scene design (probably an alternative design) for Charles Fechter's revival of Shakespeare, *Hamlet*, Lyceum Theatre, London, 1864. Designer: William Telbin. Victoria & Albert Museum, London.

designed with a single purpose. Each production has a specific goal in terms of audience response, and all of the elements in the production attempt to achieve this.

Scene Design

Simply stated, the purpose of scene design in the theatre is to create an environment suitable for achieving the aims of the production. Scene designers use the same tools of composition—line, form, mass, color, repetition, and unity—as painters. In addition, since a stage design occupies three-dimensional space and must allow for the movement of the actors in, on, through, and around the elements of scenery, the scene designer becomes a sculptor as well. Figures 4.5, 4.6, 4.7, and 4.8 illustrate how emphasis on certain elements of design highlights different characteristics in the production. C. Ricketts's design for

The Eumenides (Fig. 4.5) stresses formality, asymmetricality, and symbolism. Thomas Grieve's *Richard II* (Fig. 4.6) is formal, but light and spacious. His regular rhythms and repetition of arches create a completely different feeling from that elicited by Ricketts's design. William Telbin's *Hamlet* (Fig. 4.7), with its strong central triangle and monumental scale, creates an overwhelming weight which, while utilizing diagonal activity in the sides of the triangles, cannot match the action of Robert Burroughs's zigzagging diagonals juxtaposed among verticals in his design for *Peer Gynt* (Fig. 4.8). Scene designers are limited by the stage space, the concepts of the director, the amount of time and budget available for the execution of the design, and elements of practicality—for example, can the design withstand the wear and tear the actors will cause? Scene designers are also limited by the talent and abilities of the staff available to execute the design. A complex setting

4.8 Scenic design for Ibsen, *Peer Gynt*, University of Arizona Theatre.
Director: Peter R. Marroney.
Scene designer: Robert C. Burroughs.

requiring sophisticated painting and delicate carpentry may be impossible if the only staff available are unskilled. These are the constraints, and also the challenges, of scene design.

A *scenic environment* occurs wherever theatre takes place: Any physical surrounding for a production is a scenic design because someone makes an artistic choice in its selection. In the contemporary theatre, scene designers function as creative partners in determining the direction and "look" of a theatre production. Ultimately, scene design must have something of its own to say to the audience. Stage design is first and foremost a visual art, and the fundamental artistic tools of the scene designer are those of the visual artist we studied in Chapter 1: the elements and principles of composition, such as line and color.

Lighting Design

Lighting designers are perhaps the most crucial of all the theatre artists in modern productions. Without their art nothing done by the actors, the costume designer, the property master or mistress, the director, or the scene designer would be seen by the audience. Yet lighting designers work in an ephemeral medium. They must sculpt with light and create shadows that fall where they desire them to fall; they must "paint" over the colors provided by the other designers. In doing so, they use lighting instruments with imperfect optical qualities. They do their work in their minds, unlike scene designers, who can paint a design mock-up and then calculate the end product in feet and inches. Lighting designers must imagine what their light will do to an actor, to a costume, to a set. They must enhance the color of a costume, accent the physique of an actor, and reinforce the plasticity of a setting. They also try to reinforce the dramatic structure and dynamics of the play. They work within the framework of light and shade. Without shadows and highlights, the human face and body become imperceptible: A human face without shadows cannot be seen clearly more than a few feet away. In a theatre, such small movements as the raising of an eyebrow must be seen clearly as much as 100 feet (30.5 m) away. The lighting designer makes this possible.

In summary, lighting design serves four functions or purposes: (1) *selective visibility*; lighting helps us see what the production requires of us, with proper focus on actors and settings, and enhancement of our perception of forms

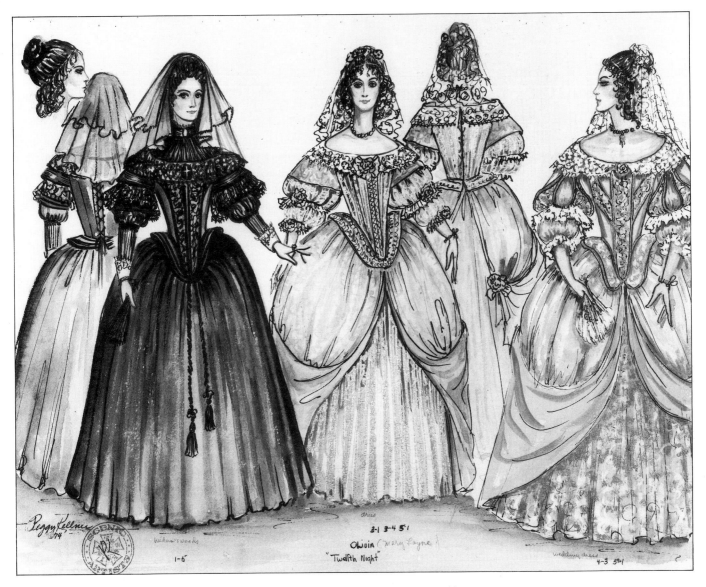

4.9 Costume designs for Shakespeare, *Twelfth Night*, Old Globe Theatre, San Diego, California.
Director: Craig Noel.
Costume designer: Peggy J. Kellner.

and depth; (2) *rhythm and structure*; changes in lighting help move the play and indicate the rises and falls in action from which we perceive the play's meaning; (3) *mood*; lighting is, arguably, our most important clue to the atmosphere of the play; (4) *illusion and motivation*; by creating sunlight, lamplight, moonlight, and other sources of light, lighting helps us experience the time and place of the action.

Costume Design

It is tempting to think of theatrical costumes merely as clothing that has to be researched to reflect a particular historical period and constructed to fit particular actors. But costuming goes beyond that. Costume designers work with the entire body of the actor. They design hair styles and clothing and sometimes makeup to suit a specific person or occasion, a character, a locale.

The function of stage costuming is threefold. First, it *accents*—that is, it shows the audience which personages are the most important in a scene, and it shows the relationship between people.

Second, it *reflects*—a particular era, time of day, climate, season, location, or occasion. The designs in Figure **4.9** reflect a historical period. We recognize different eras primarily through silhouette, or outline. Costume designers may merely suggest full detail or may actually provide it, as in Figure **4.9**. Evident here is the designer's concern not only for the period but also for character in her choice

103

4.10 Costume design for Shakespeare, *King Lear*, Old Globe Theatre, San Diego, California. Director: Edward Payson Call. Costume designer: Peggy J. Kellner.

of details, color, texture, jewelry, and hair style. Notice the length to which the designer goes to indicate detail, providing both front and back views of the costume, and a head study showing the hair without a covering.

Third, stage costuming *reveals* the characters of the personages and their social position, profession, cleanliness, age, physique, and health. In Figure 4.10 the concern of the designer is clearly less with historical period than with production style and character. This costume design reveals the high emotional content of the particular scene, and we see at first glance the deteriorated health and condition of King Lear as he goes mad on the heath. The contrast provided by the king in such a state heightens the effect of the scene, and details such as the bare feet, the winter furs, and the storm-ravaged cape are precise indicators of the pathos we are expected to find and respond to. Costume designers work, as do scene and lighting designers, with the same general elements as painters and sculptors: the elements of composition. A stage costume is an actor's skin: It allows her to move as she must, and occasionally it restricts her from moving as she should not.

Properties

Properties fall into two general groups: *set props* and *hand props*. Set properties are part of the scene design: furniture, pictures, rugs, fireplace accessories, and so on. Along with the larger elements of the set, they identify the mood of the play and the tastes of those who inhabit this world. Hand properties used by the actors in stage business—cigarettes, papers, glasses, and so forth—also help to portray characters. The way properties are used can be significant to our understanding of a play. For example, if at the opening curtain all properties appear to be neat and in order, but as the play develops the actors disrupt them, so that at the end the entire scene is in disarray, that simple transition illustrates and enhances what has happened in the play.

AURAL ELEMENTS

What we hear contributes to understanding and enjoyment of our production. Aristotle's term for the aural elements of a production is "music," which had a different meaning in that era. The aural elements, whether the actors' voices, the background music, or the clashing of swords, are an important part of the theatrical production. How a production sounds represents a series of conscious choices on the part of all the artists involved: playwright, director, actors, and designers. Just as a composer of a musical piece creates harmonies, dynamics, rhythms, and melodies, the director, working with the actors and sound designer, makes the production develop in an aural sense so that the audience is put into the right mood, drawn in the appropriate emotional direction, and captured by the attention points.

DYNAMICS

Every production has its own dynamic patterns, which we can chart (as in Fig. 4.1). They make the structural pattern of a play clear, and help to hold the interest of the audience. Scientific studies indicate that attention or interest is not a constant factor; human beings are able to concentrate on specific items only for very brief periods. Therefore, to hold audience attention over the two-hour span of a production, it is essential to employ devices whereby from time to time interest or attention is allowed to peak and then relax. The peaks must be carefully controlled. A production should build to a high point of dramatic interest—the climax. However, each scene or act has its own peak of development—again, to maintain interest. Thus the path from the beginning of the play to the high point of dramatic interest is not a steady rise, but a series of peaks and valleys. Each

4.11 Proscenium setting for Jean Kerr, *Mary, Mary*, University of Arizona Theatre.
Director: H. Wynn Pearce.
Scene and lighting designer: Dennis J. Sporre.

successive peak is closer to the ultimate one. The director controls where and how high these peaks are by controlling the dynamics of the actors—volume and intensity, both bodily and vocal.

THE ACTOR

Although it is not always easy to tell which functions in a production are the playwright's, which the director's, and which the actor's, the main channel of communication between the playwright and the audience is the actors. It is through their movements and speech that the audience perceives the play.

Our purpose is not to study acting; however, we can look for two elements in an actor's portrayal of a role that will enhance our response. The first is *speech*. Language should be understood as the playwright's words, and speech is the manner in which the actor delivers those words. Speech, like language, can range from high verisimilitude to high theatricality. If speech adheres to normal conversational rhythms, durations, and inflections, we respond in one way. If it utilizes extended vowel emphasis, long, sliding inflections, and dramatic pauses, we respond quite differently—even though the playwright's words are identical in both cases.

The second element of an actor's portrayal that aids our understanding is the physical reinforcement he or she gives to the character's basic motivation. Most actors try to identify a single basic motivation for their character. That motivation is called a *spine*, or *superobjective*. Everything that pertains to the decisions the person makes is kept con-

sistent because it all stems from this basic drive. Actors will translate the drive into something physical they can do throughout the play. For example Blanche, in Tennessee Williams' *A Streetcar Named Desire*, is driven by an immense desire to clean everything she encounters, because of the way she regards herself and the world around her. Ideally, the actress playing Blanche will discover that element of Blanche's personality as she reads the play and develops the role. But to make that spine clear to us in the audience, she will need to translate it into physical action. Therefore, we will see Blanche constantly smoothing her hair, rearranging and straightening her dress, cleaning the furniture, brushing imaginary dust from others' shoulders, and so forth. Nearly every physical move she makes will relate somehow to the act of cleaning. Of course, these movements will be subtle; if we are attentive, we will notice them, but even if we do not pick them up we are likely to perceive them subconsciously and so understand the nature of the character portrayed.

VERISIMILITUDE

In describing the relationship of the visual elements to the play, we have noted the designers' use of compositional elements. The use of these elements relative to life can be placed on a continuum, one end of which is theatricality and the other verisimilitude. Items high in verisimilitude are those with which we deal in everyday life: language, movements, furniture, trees. As we progress toward theatricality, the elements of the production express less and less relationship to everyday life. They become

4.12 Arena setting for Tennessee Williams, *The Glass Menagerie*, State University of New York at Plattsburgh. Director: H. Charles Kline. Scene and lighting designer: Dennis J. Sporre.

distorted, exaggerated, and perhaps even nonobjective. Poetry, as we noted, is high in theatricality; everyday speech is high in verisimilitude. The position of the various elements of a production on this continuum suggests the style of the play, in the same sense that brushstroke, line, and palette indicate style in painting.

Figures 4.11–4.16 illustrate the range between verisimilitude and theatricality. Figure 4.11 is a proscenium setting high in verisimilitude—including a full ceiling over the setting. Figure 4.12 is an arena setting high in verisimilitude; it reflects the basically lifelike style of the presentation. However, the requirement of the arena configuration that there be no walls can cause problems in some productions. Note that some theatricality—specifically, the empty picture frame —is present in the decoration of this set. This is not an inconsistency since the play develops as a flashback in the mind of its main character. In Figure 4.13, although the set props are high in verisimilitude and the setting is representational, the designer has attempted to heighten the theatrical nature of the production by using open space where one might expect solid walls in this proscenium production.

The setting in Figure 4.14 moves further toward theatricality, and indicates clearly through exaggerated detail and two-dimensionality the whimsical nature of the production. The design in Figure 4.15 creates a purely formal and theatrical environment. No locale is specifically depicted, but various areas of the set serve as locations and have realistic furniture, and this use of representational detail keeps the setting tied to the overall approach of the actors. Finally, in Figure 4.16, neither time nor place is indicated nor remotely suggested. Here the emphasis is on reinforcement of the high action of the production. The steep ramps throughout the set make it impossible for the actors to walk from one level to the next; the setting forces them to run.

In most arts the artist's style is unique—a recognizable mark on his or her artwork. Some artists change their style, but they do so by their own choice. Interpretive artists such as costume, scene, and lighting designers, and to a degree conductors as well, must submerge their personal style in favor of that of the work with which they are involved. Playwrights or directors set the style, and scene designers adapt to it and make their design reflect it.

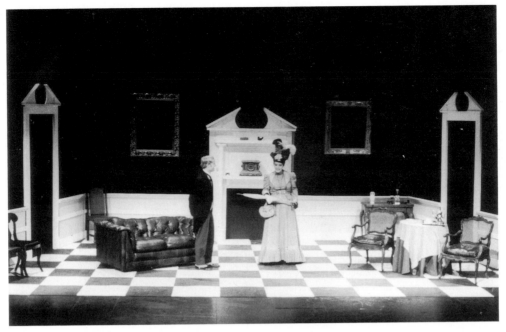

4.13 Proscenium setting for Oscar Wilde, *The Importance of Being Earnest*,
University of Arizona Theatre. Director: William Lang. Costume designer: Helen Workman Currie.
Scene and lighting designer: Dennis J. Sporre.

4.14 Scene design for Jerry Devine and Bruce Montgomery, *The Amorous Flea*, University of Iowa Theatre.
Director: David Knauf. Scene and lighting designer: Dennis J. Sporre.

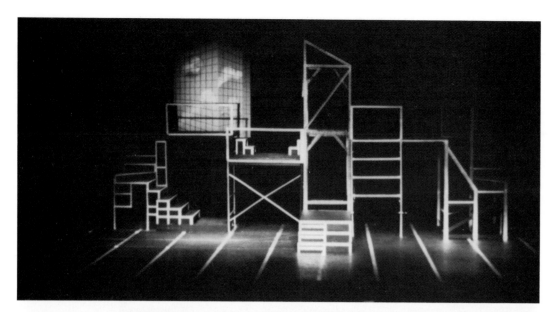

4.15 Proscenium setting for Stephen Sondheim musical, *Company*, University of Arizona Theatre. Director; Peter R. Marroney. Scene and lighting designer: Dennis J. Sporre.

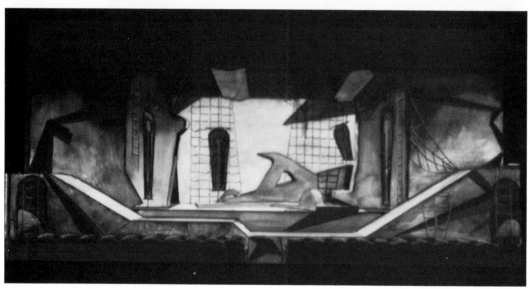

4.16 Scene design for Euripides, *The Bacchae*, University of Illinois at Chicago Circle. Director: William Raffeld. Scene and lighting designer: Dennis J. Sporre.

How does it
Stimulate the Senses?

In each of the elements just discussed, our senses are stimulated in a particular manner. We respond to the play's structure and how it works; we respond to dynamics. We are stimulated by the theatricality or verisimilitude of the language of the playwright and the movements and speech of the actors. We find our response shaped by the relationship of the stage space to the audience, and by the sets, lights, properties, and costumes. All of these elements bombard us simultaneously with complex visual and aural stimuli. How we respond, and how much we are able to respond, determines our ultimate reaction to a production.

The theatre is unique in its ability to stimulate our senses, because only in the theatre is there a direct appeal to our emotions through the live portrayal of other individuals involved directly in the human condition. Being in the presence of live actors gives us more of life in two hours than we could experience outside the theatre in that same time span. The term we use to describe our reaction to and involvement with what we experience in a theatrical production is *empathy*. Empathy causes us to cry when individuals whom we know are only actors become involved in tragic or emotional situations. Empathy makes us wince when an actor slaps the face of another one, or when two football players collide at full speed. Empathy is our mental and physical involvement in situations in which we are not direct participants.

THEATRE AND HUMAN REALITY

David Rabe, *Hurly-Burly*

David Rabe (b. 1940; **Fig. 4.17**) is one of America's foremost contemporary playwrights. A Vietnam veteran, Rabe has treated themes of physical and emotional violence—sometimes controversially—in plays that use war as a backdrop. *Hurly-Burly* (1984) is about drug- and people-abuse in Hollywood. As in many of his plays, the male hero, Eddie, has a hoodlum, demented quality. Such treatment suggests that Rabe likes to create a world in which people are defined by a particular "lingo." He has a very "masculine" vision of his heroes. The way they speak makes them who they are. That is Rabe's dramatic strategy, as he puts it: a choice.

In *Hurly-Burly* the characters speak the language of high tech and Hollywood. Rabe uses the language as a kind of stage poetry, metaphorically and stylistically, rather than trying to reflect reality. Eddie rants against television, and Rabe wants the audience to see Eddie's distress—the brilliance of his mind, and the waste of it. Rabe wants the audience to be drawn to Eddie, to recognize Eddie's ideas, and to develop a sympathetic chord in Eddie's sensibility. Eddie has a kind of innocence and gullibility. He is very open.

From Eddie's character and from the play, David Rabe tries to point out to the audience that, although somewhat off-centered, the people of *Hurly-Burly* can be found anywhere—not just in Hollywood. They could be from Wall Street, Washington, D.C., or professional athletics. From Rabe's point of view, everybody is addicted: "Cocaine and TV are both drugs."

For Rabe, human reality lies not in where a play is set or whether the language appears contemporary. Rather, it is defined by the cause-and-effect at work in human events. "Realism is sane—everybody is sane in realism, no matter how crazy they are."[3]

4.17 David Rabe in 1972.

Now let us examine a few of the more obvious ways a production can appeal to our senses. In plays that deal in conventions, *language* may act as virtually the entire stimulant of our senses. Through language the playwright sets the time, place, atmosphere, and even small details of decoration. We become our own scene, lighting, and even costume designer, imagining what the playwright tells us ought to be there. In the opening scene of *Hamlet* we find Bernardo and Francisco, two guards. The hour is midnight; it is bitter cold; a ghost appears, in "warlike form." How do we know all of this? In a modern production we might see it all through the work of the costume and set designers. But such need not be the case, because the playwright gives us all of this information in the dialogue. Shakespeare wrote for a theatre that had no lighting save for the sun. His theatre (such as we know of it) probably used no scenery. The costumes were the street clothes of the day. The theatrical environment was the same whether the company was playing *Hamlet, Richard III,* or *The Tempest.* So what needed to be seen needed to be imagined. The language provided the stimuli for the audience.

We also respond to what we *see.* A sword fight performed with flashing action, swift movements, and great intensity sets us on the edge of our chair. Although we know the action is staged and the incident fictitious, we are caught in the excitement of the moment.

We can also be gripped and manipulated by events of a quite different dynamic quality. In many plays we witness character assassination, as one life after another is laid bare before us. The intense but subtle *movements* of the actors— both bodily and vocal—can pull us here and push us there emotionally, and perhaps cause us to leave the theatre feeling emotionally drained. Part of our response is caused by subject matter, part by language—but much of it is the result of careful manipulation of *dynamics.*

Mood is an important factor in theatrical communication. Before the curtain is up, our senses are tickled by stimuli designed to put us in the mood for what follows. The houselights in the theatre may be very low, or we may see a cool or warm light on the front curtain. Music fills the theatre. We may recognize the raucous tones of a 1930s jazz piece, or a melancholy ballad. Whatever the stimuli, they are all carefully designed to prepare us for the way the director wishes us to react. Once the curtain is up, the assault on our senses continues. The palette utilized by the scene, lighting, and costume designers helps communicate the mood of the play and other messages about it. The rhythm and variation in the visual elements capture our interest and reinforce the rhythmic structure of the play. For example, in Figure 4.8, the use of line and form as well as color provides a formal atmosphere reflecting the epic grandeur of Ibsen's *Peer Gynt.*

The degree of plasticity or three-dimensionality created by the lighting designer's illumination of the actors and the set causes us to respond in many ways. If the primary lighting instruments are directly in front of the stage, plasticity will be diminished and the actors will appear washed out or two-dimensional. We respond quite differently to that visual stimulant than to the maximum plasticity and shadow resulting from lighting coming nearly from the side.

We also react to the mass of a setting. Scenery that towers over the actors and appears heavy is different in effect from scenery that seems minuscule relative to the human form. The settings in Figures 4.5, 4.6, 4.7, and 4.13 are different from one another in scale, and each places the actors in a different relationship with their surroundings. In Figure 4.13, the personages are at the center of their environment; in Figure 4.7 they are clearly subservient to it.

Finally, focus and line act on our senses. Careful composition can create movement, outlines, and shadows that are sharp. Or it can create images that are soft, or blurred. Each of these devices is a stimulant; each has the potential to elicit a relatively predictable response. Perhaps in no other art are such devices so available and full of potential for the artist. We, as audience, benefit through nearly total involvement in the life situation that comes to us over the footlights.

CHAPTER FIVE

FILM

WHAT IS IT?

NARRATIVE FILM
DOCUMENTARY FILM
ABSOLUTE FILM

HOW IS IT PUT TOGETHER?

EDITING
CAMERA VIEWPOINT
 The Shot
 Objectivity
CUTTING WITHIN THE FRAME
Profile: D. W. Griffith
DISSOLVES
FOCUS
MOVEMENT
LIGHTING

HOW DOES IT STIMULATE THE SENSES?

CROSSCUTTING
TENSION BUILD-UP AND RELEASE
Film and Human Reality: Sergei Eisenstein,
 Battleship Potemkin
DIRECT ADDRESS
MAGNITUDE AND CONVENTION
STRUCTURAL RHYTHM

IMPORTANT TERMS

Narrative Film Film that tells a story.

Documentary Film Film that records actual events.

Absolute Film Film that exists for its own aesthetic sake.

Editing The process of assembling the various pieces or shots of a film.

Master Shot A single shot of an entire piece of action, taken to facilitate the assembly of the film in the editing process.

Cutting Within the Frame A method of shooting the film that avoids the necessity of editing.

Dissolve A means of ending a scene.

Crosscutting An alternation between two separate actions that are related by theme, mood, or plot but occur at the same time.

Direct Address A technique whereby the actors appear to address the audience directly.

Structural Rhythm The manner in which various shots in a film are joined together and juxtaposed with other cinematic images, visual and aural.

Like theatre, but without the spontaneity of "live" performers, film can confront us with life very nearly as we find it on our streets. On the other hand, through the magic of sophisticated special effects, films can take us to new worlds open to no other form of art.

Film, the most familiar and most easily accessible art form, is usually accepted almost without conscious thought, at least in terms of the story line or the star image presented or the basic entertainment value of the product. Yet all these elements are carefully crafted out of editing techniques, camera usage, juxtaposition of image, and structural rhythms. These details of cinematic construction can enhance our viewing and raise film from mere entertainment into the realm of serious art. Bernard Shaw once observed, "Details are important; they make comments." It is not as easy as it might seem to perceive the details of a film because, while we search them out, the entertainment elements of the film are drawing our attention away from the search.

WHAT IS IT?

Film is aesthetic communication through the design of time and three-dimensional space compressed into a two-dimensional image. Of all the arts discussed in this volume, film is the only one that is also an invention. Once the principles of photography had evolved and the mechanics of recording and projecting cinematic images were understood, society was ready for the production of pictures that could move, be presented in color, and eventually talk.

If we examine a strip of film, we notice that it is only a series of still pictures running the length of the strip. Each of these pictures, or *frames*, is about ⁴⁄₅ inch (22 mm) wide and ³⁄₅ inch (16 mm) high. If we study the frames in relation to one another, we see that even though each may seem to show exactly the same scene, the position of the objects is slightly different. This film contains sixteen frames per foot (30 cm). When it is running on a projecting device and passed before a light source at the rate of twenty-four frames per second (sixteen to eighteen frames per second for silent films), a magnifying lens is used to enlarge the frames printed on it. Projected onto a screen, the images appear to move. However, the motion picture, as film is popularly called, does not really move but only seems to. This is due to an optical phenomenon called *persistence of vision*, which according to legend was discovered by the astronomer Ptolemy in the second century A.D. The theory is that the eyes take a fraction of a second to record an impression of an image and send it to the brain. Once

the impression is received, the eye retains it on the retina for about one-tenth of a second after the actual image has disappeared.

The film projector pulls the film between the light source and a lens in a stop-and-go fashion, the film pausing long enough at each frame to let the eye take in the picture. Then a shutter on the projector closes, the retina retains the image, and the projection mechanism pulls the film ahead to the next frame. Perforations along the right-hand side of the filmstrip enable the teeth on the gear of the driving mechanism to grasp the film and not only move it along frame by frame but also hold it steady in the gate (the slot between the light source and the magnifying lens). This stop-and-go motion gives the impression of continuous movement. If the film did not pause at each frame, the eye would receive a blurred image.

The motion picture was originally invented as a device for recording and depicting motion. But once this goal was realized, it was quickly discovered that the projector could record and present stories—in particular, stories that made use of the unique qualities of the medium of film.

Our formal response to film recognizes three basic techniques of presentation. These are narrative film, documentary film, and absolute film.

NARRATIVE FILM

Narrative film tells a story; in many ways it uses the technique of theatre. It follows the rules of literary construction in that it begins with expository material, adds levels of complications, builds to a climax, and ends with a resolution of all the plot elements. As in theatre, the personages in the story are portrayed by professional actors under the guidance of a director. The action of the plot takes place within a setting designed and constructed primarily for the action of the story but allowing the camera to move freely in photographing the action. Many narrative films are genre films, constructed out of familiar literary styles—the western, the detective story, and the horror story, among others. In these films the story elements are so familiar to the audience that they usually know the outcome of the plot before it begins. The final showdown between the "good guy" and the "bad guy," the destruction of a city by an unstoppable monster, and the identification of the murderer by the detective are all familiar plot elements that have become clichés or stereotypes within the genre; their use fulfills audience expectations. Film versions of popular novels and stories written especially for the screen are also part of the narrative-film form, but since film is a major part of the mass entertainment industry the narrative presented is usually material that will attract a large audience

and thus assure a profit. Narrative films may also include elements from documentary and absolute film (see below).

DOCUMENTARY FILM

Documentary film is an attempt to record actuality using primarily either a sociological or a journalistic approach. It is normally not reenacted by professional actors and is often shot as the event is occurring—at the time and place of its occurrence. The film may use a narrative structure, and some of the events may be ordered or compressed for dramatic reasons, but its presentation gives the illusion of reality. The footage shown on the evening television news, programming concerned with current events or problems, and full coverage either by television or film companies of a worldwide event, such as the Olympics, are all kinds of documentary film. All convey a sense of reality as well as a recording of time and place.

ABSOLUTE FILM

Absolute film is simply film that exists for its own sake, for its record of movement or form. It does not use narrative techniques, although documentary techniques can be used in some instances. Created neither in the camera nor on location, absolute film is built carefully, piece by piece, on the editing table or through special effects and multiple-printing techniques. It tells no story but exists solely as movement or form. Absolute film is rarely longer than twelve minutes (one reel) in length, and it is not usually created for commercial intent but is meant only as an artistic experience. Narrative or documentary films may contain sections that can be labeled absolute, and these can be studied either in or out of the context of the whole film.

HOW IS IT PUT TOGETHER?

EDITING

Film is rarely recorded in the order of its final presentation. It is filmed in bits and pieces and put together, after all the photography is finished, as one puts together a jigsaw puzzle or builds a house. The force or strength of the final product depends upon the editing process, the manner in which the camera and the lighting are handled, and the movement of the actors before the camera. Naturally, the success of a film depends equally on the strength of the story presented and the ability of the writers, actors, directors, and technicians who have worked on the film. However, this level of success is based on the personal taste of the audience and the depth of perception of the individual, and therefore does not lie within the boundaries of this discussion.

Perhaps the greatest difference between film and the other arts discussed within this volume is *plasticity*—the quality of film that enables it to be cut, spliced, and ordered according to the needs of the film and the desires of the filmmaker. If twenty people were presented with all the footage shot of a presidential inauguration and asked to make a film commemorating the event, you would probably end up with twenty completely different films. Each filmmaker would order the event according to his or her own views and artistic ideas. This concept of plasticity is, then, one of the major advantages of the use of the machine in consort with an art form.

The filmmaker must be able to synthesize a product out of many diverse elements. The editing process creates or builds the film, and within that process are many ways of joining shots and scenes to make a whole. Let's examine some of these basic techniques. *Cutting* is simply joining together shots during the editing process. A *jump cut* is a cut that breaks the continuity of time by moving forward from one part of the action to another that is obviously separated from the first by an interval of time, location, or camera position. It is often used for shock effect or to call attention to a detail, as in commercial advertising on television. The *form cut* cuts from one image to another—a different object that has a similar shape or contour; it is used primarily to make a smoother transition from one shot to another. For example, in D. W. Griffith's silent film *Intolerance*, attackers are using a battering ram to smash in the gates of Babylon. The camera shows the circular frontal area of the ram as it is advanced toward the gate. The scene cuts to a view of a circular shield, which in the framing of the shot is placed in exactly the same position as the front view of the ram.

Montage can be considered the most aesthetic use of the cut in film. It is handled in two basic ways: first, as an indication of compression or elongation of time and, second, as a rapid succession of images to illustrate an association of ideas. A series of stills from Léger's *Ballet mécanique* (Fig. 5.1) illustrates how images are juxtaposed to create comparisons. For example, a couple goes out to spend an evening on the town, dining and dancing. The film then presents a series of cuts of the pair—in a restaurant, then

113

dancing, then driving to another spot, then drinking, and then more dancing. In this way the audience sees the couple's activities in an abridged manner. Elongation of time can be achieved in the same way.

Montage also allows the filmmaker to depict complex ideas or draw a metaphor visually. Sergei Eisenstein, the Russian film director (see p. 119), presents a shot in one of his early films of a Russian army officer walking out of the room, his back to the camera and his hands crossed behind him. Eisenstein cuts immediately to a peacock strutting away from the camera and spreading its tail. These two images are juxtaposed, and the audience is allowed to make the association that the officer is as proud as a peacock.

CAMERA VIEWPOINT

Camera position and viewpoint are as important to the structure of the film as is the editing process. In the earliest days of the silent film the camera was merely set up in one basic position; the actors moved before it as if they were performing before an audience on a stage in a theatre. However, watching all the action from one position became dull, and the early filmmakers were forced to move the camera in order to add variety.

The Shot

The shot is what the camera records over a particular period of time and is the basic unit of filmmaking. Several varieties are used. The *master shot* is a single shot of an entire piece of action, taken to facilitate the assembly of the component shots of which the scene will finally be composed. The *establishing shot* is a long shot (see below) introduced at the beginning of a scene to establish the interrelationship of details, a time, or a place.

The *long shot* is taken with the camera a considerable distance from the subject, the *medium shot* is taken nearer to the subject, and the *close-up* even nearer. A close-up of two people within the frame is known as a *two-shot*, and a *bridging shot* is one inserted in the editing of a scene to cover a brief break in continuity.

Objectivity

An equally important variable of camera viewpoint is whether the scene is shot from an objective or subjective viewpoint. The *objective viewpoint* is that of an omnipotent viewer, roughly analogous to the technique of third-person narrative in literature. In this way film-makers

5.1 *Ballet mécanique*, 1924.
Director: Fernand Léger.

114

D. W. Griffith

David Lewelyn Wark Griffith (1875–1948) was the first giant of the motion-picture industry and a genius of film credited with making film an art form. As a director, D. W. Griffith never needed a script. He improvised new ways to use the camera and to cut the celluloid, which redefined the craft for the next generation of directors.

D. W. Griffith was born on January 22, 1875, in Floydsfork, Kentucky, near Louisville. His aristocratic Southern family had been impoverished by the American Civil War, and much of his early education came in a one-room schoolhouse or at home. His father, a former Confederate colonel, told him battle stories that may have affected the tone of Griffith's early films.

When Griffith was seven, his father died and the family moved to Louisville. He quit school at sixteen to go to work as a bookstore clerk. In the bookstore he met some actors from a Louisville theatre. This acquaintanceship led to work with amateur theatre groups and to tours with stock companies. He tried playwrighting, but his first play failed on opening night in Washington, D.C. He also attempted writing screenplays, but his first scenario for a motion picture also met with rejection. While acting for New York studios, however, he did sell some scripts for one-reel films, and when the Biograph Company had an opening for a director in 1908, Griffith was hired.

During the five years with Biograph, Griffith introduced or refined all the basic techniques of filmmaking. His innovations in cinematography included the close-up, the fade-in and fade-out, soft focus, high- and low-angle shots, and panning (moving the camera in panoramic long shots). In film editing, he invented the techniques of flashback and crosscutting—interweaving bits of scenes to give an impression of simultaneous action.

Griffith also expanded the horizon of film with social commentary. Of the nearly 500 films he directed or produced, his first full-length work was his most sensational. *The Birth of a Nation* (first shown as *The Clansman* in 1915; see Fig. **5.3**) was hailed for its radical technique but condemned for its racism. As a response to censorship of *The Birth of a Nation*, he produced *Intolerance* (1916), an epic integrating four separate themes.

After *Intolerance* Griffith may have turned away from the epic film because of the financial obstacles, but his gifted performers more than made up for this loss, for they were giants in their own right. Among the talented stars he introduced to the industry were Dorothy and Lillian Gish, Mack Sennett, and Lionel Barrymore.

In 1919 Griffith formed a motion picture distribution company called United Artists with Mary Pickford, Charlie Chaplin, and Douglas Fairbanks.

Griffith's stature within the Hollywood hierarchy was one of respect and integrity. He became one of the three linchpins of the ambitious Triangle Studios, along with Thomas Ince and Mack Sennett.

He died in Hollywood, California, on July 23, 1948.

allow their audience to watch the action through the eyes of a universal spectator. However, those who wish to involve their audience more deeply in a scene may use the *subjective viewpoint*: The scene is presented as if the audience were actually participating in it, and the action is viewed from the filmmaker's perspective. This is analogous to the first-person narrative technique, and is usually found in the films of more talented directors.

CUTTING WITHIN THE FRAME

Cutting within the frame is a method used to avoid the editing process. It can be created by actor movement, camera movement, or a combination of the two. It allows the scene to progress smoothly and is used most often on television. In a scene in John Ford's classic *Stagecoach*, the coach and its passengers have just passed through hostile territory without being attacked; the driver and his passengers all express relief. Ford cuts to a long shot of the coach moving across the desert and *pans*, or follows, it as it moves from right to left on the screen. This movement of the camera suddenly reveals in the foreground, and in close-up, the face of a hostile warrior watching the passage of the coach. In other words, the filmmaker has moved smoothly from a long shot to a close-up without needing the editing process. He has also established a spatial relationship. In a

5.2 *Jaws*, 1975. Universal Pictures.
Director: Steven Spielberg.

scene from *Jaws* (Fig. **5.2**) the camera also moves from distant objects to the face in the foreground, finally including them both in the frame; the pan across the scene is thus accomplished without editing of the film.

DISSOLVES

During the printing of the film negative, transitional devices can be worked into a scene. They are generally used to indicated the end of one scene and the beginning of another. The camera can cut or jump to the next scene, but the transition is smoother if the scene fades out into black and the next scene fades in. This is called a *dissolve*. A *lap dissolve* occurs when the fade-out and the fade-in are done simultaneously and the scene momentarily overlaps. A *wipe* is a form of optical transition in which an invisible line moves across the screen, eliminating one shot and revealing the next, much in the way a windshield wiper moves across the windshield of a car. In silent film the transition could also be created by closing or opening the aperture of the lens; this process is called an *iris-out* or an *iris-in*.

FOCUS

Even the manner in which the lens is focused can add to the meaning of the scene. If both near and distant objects are shown clearly at the same time, the camera is using *depth of focus*. In Figure **5.2** foreground and background are equally in focus. In this situation actors can move without necessitating a change of camera position. Many television shows photographed before an audience use this kind of focus.

If the main object of interest is photographed clearly while the remainder of the scene is blurred or out of focus, the camera is using *rack* or *differential focus*. With this technique the filmmaker can draw the audience's attention to one element within a shot.

MOVEMENT

The movement of the camera as well as its position can add variety or impact to a shot or scene. There are many kinds of physical (as opposed to apparent) camera movement. The *track* is a shot taken as the camera is moving in the same direction, at the same speed, and in the same place as the object being photographed. A *pan* is taken by rotating the camera horizontally while keeping it fixed vertically. It is usually employed in enclosed areas, particularly television studios. The *tilt* is taken by moving the camera vertically or diagonally, and is used to add variety to a sequence. Moving the camera toward or away from the subject is known as a *dolly shot*. Modern sophisticated lenses can achieve the same effect by changing the focal length—this negates the need for camera movement and is known as a *zoom shot*.

LIGHTING

The camera cannot photograph a scene without light, either natural or artificial. Most television productions shot before a live audience require a flat, general illumination pattern. For close-ups, stronger and more definitely focused lights are required to highlight features, eliminate

shadows, and add a feeling of depth. Cast shadows or atmospheric lighting (in art, chiaroscuro) are often used to create a mood, particularly in black-and-white films (Fig. 5.3). Lighting at a particular angle can heighten the feeling of texture, just as an extremely close shot can. These techniques add visual variety to a sequence.

If natural or outdoor lighting is used and the camera is hand-held, the film appears unsteady; this technique and effect is called *cinéma vérité*. Such camera work and natural lighting are found most often in documentary films or sequences photographed for newsreels or television news programming. It is one of the conventions of current-events reporting and adds to the sense of reality and immediacy suitable for this kind of film recording.

These techniques and many others are used to ease technical problems, to make films smoother or more static, depending upon the needs of the story line, or to add an element of commentary. One school of cinematic thought believes that camera technique is best when it is not noticeable; another, more recent way of thinking asserts that the obviousness of all the technical aspects of film adds meaning to the concept of cinema. In any case, camera technique is present in every kind of film and is used to add variety and commentary, meaning and method, to the shot, the scene, and the film.

HOW DOES IT STIMULATE THE SENSES?

The basic aim of film, as with any art, is to involve the audience in its product, either emotionally or intellectually. There is nothing like a good plot with well-written dialogue delivered by trained actors to create audience interest. But there are other ways in which filmmakers can enhance their final product—techniques that manipulate

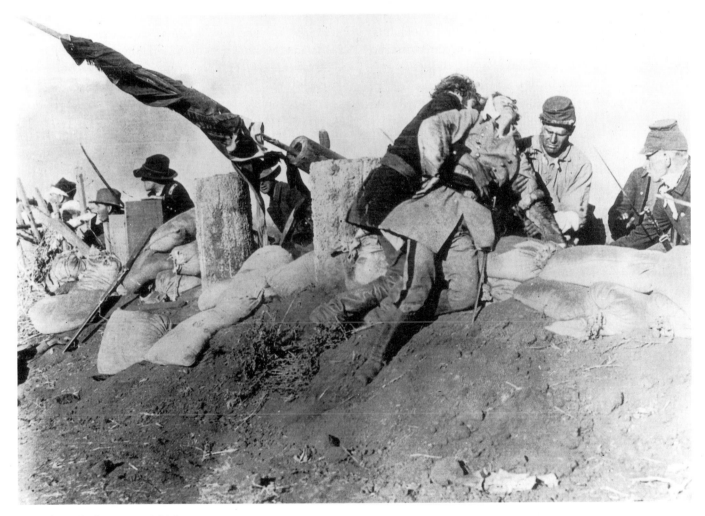

5.3 *The Birth of a Nation*, 1915.
Director: D. W. Griffith.

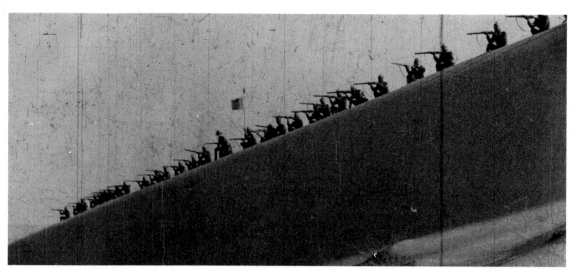

5.4 Still from an unidentified silent film.

the audience toward a deeper involvement or a heightened intellectual response. Figure 5.4 illustrates how angles and shadows within a frame help create a feeling of excitement and variety. An in-depth study of the films of Fellini, Hitchcock, or Bergman may indicate how directors use some of the technical aspects of film to underline emotions or strengthen a mood or an idea.

Perception is most important in the area of technical detail. We should begin to cultivate the habit of noticing even the tiniest details in a scene, for often these add a commentary that the average member of an audience misses. For example, in Hitchcock's *Psycho*, when the care-taker of the motel (Tony Perkins) wishes to spy upon the guests in cabin 1, he pushes aside a picture that hides a peephole. The picture is a reproduction of *The Rape of the Sabine Women*—Hitchcock's irony is obvious. Thus, per-ception becomes the method through which viewers of film find its deeper meanings as well as its basic styles.

CROSSCUTTING

The most familiar and most easily identified filmmaking technique used to heighten feeling is *crosscutting*. This is an alternation between two separate actions that are related by theme, mood, or plot but are usually occurring at the same time. Its most common function is to create suspense. Consider this familiar cliché. Pioneers going west in a wagon train are besieged by hostile Native Americans. The settlers are holding them off, but ammunition is running low. The hero has been able to find a cavalry troop, and they are riding to the rescue. The film alternates between pio-neers fighting for their lives and soldiers galloping across the countryside toward them. The film continues to cut

back and forth, the pace of cutting increasing until the sequence builds to a climax—then the cavalry arrives in time to save the wagon train. The famous chase scene in *The French Connection*, the final sequences in *Wait Until Dark*, and the sequences of the girl entering the fruit cellar in *Psycho* are each built for suspense through techniques of crosscutting.

A more subtle case of crosscutting—*parallel develop-ment*—occurs in *The Godfather, Part I*. At the close of that film Michael Corleone is acting as godfather for his sister's son; at the same time his men are destroying all his ene-mies. The film alternates between views of Michael at the religious service and sequences showing violent death. This parallel construction is used to draw an ironic com-parison; the juxtaposition allows the audience to draw their own inferences and added meaning.

TENSION BUILD-UP AND RELEASE

If the plot of a film is believable, the actors competent, and the director and film editor talented and knowledgeable, a feeling of tension will be built up. If this tension becomes too great, the audience will seek some sort of release, and an odd-sounding laugh, a sudden noise, or a loud com-ment from a member of the audience may cause the rest of the viewers to laugh, thus breaking the tension and in a sense destroying the atmosphere so carefully created. Wise filmmakers therefore build into their film a *tension release* that deliberately draws laughter from the audience, but at a place in the film where they wish them to laugh. This can be engineered by a comical way of moving, a gurgle as a car sinks into a swamp, or merely a comic line. It does not have to be too obvious, but it should be present in some manner.

118

Sergei Eisenstein, *Battleship Potemkin*

Sergei M. Eisenstein's *Battleship Potemkin* (1925) remains one of the most influential films ever made. It is a great classic of film art. When it was released, it brought instant fame both to Eisenstein and to a newly emerging film industry in the former Soviet Union. Among other things, it added a new dimension to film language—montage editing.

After the Bolshevik Revolution in 1917, the Soviet government took control of the country's film industry and decreed that film would serve the purpose of education and propaganda to indoctrinate the Russian masses and promote class consciousness throughout the world. Originally designed to celebrate the twentieth anniversary of the unsuccessful 1905 Revolution against the Czar, *Battleship Potemkin* was limited by Eisenstein to narrating a single episode in the struggle—the mutiny of the *Potemkin* and the subsequent massacre of civilians on the steps leading down to the harbor in Odessa (Fig. **5.5**).

The film has a number of qualities that give it the appearance of a documentary. Eisenstein engaged non-professionals who looked like the type of character he wished to portray. The film was shot on location. Its collective hero is the Russian people—represented by the people of Odessa, the mutineers, and the sailors on other ships who rebelled against Czarist oppression.

Eisenstein's use of montage, featuring juxtaposing shots and lighting, camera angle, and subject movement, creates meaning by incorporating shots within shots. His cuts between shots were intentionally jarring and designed to create shock and agitation in the audience. He identified five types of montage and used each in the film: (1) *metric montage*—conflict caused by the length of shots; (2) *rhythmic montage*—conflict generated by the rhythm of movement within the shots; (3) *tonal montage*—arrangement of shots by their "tone" or "emotional sound"; (4) *overtonal montage*—a synthesis of the previous three types; and (5) *intellectual montage*—the juxtaposition of images to create visual metaphor.

In the Soviet Union, the film did not immediately gain favor. Eisenstein was accused of being overly formal—that is, being concerned with aesthetic form rather than ideological content. Once they noted that it received universal acclaim outside the Soviet Union, the Soviet authorities changed their tune and supported the film enthusiastically.

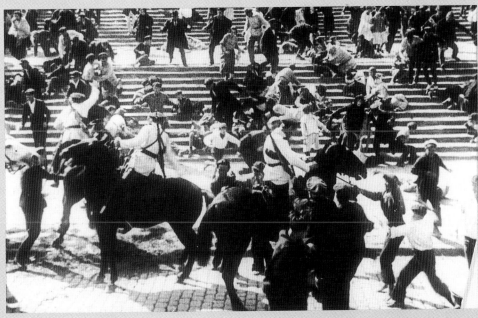

5.5 *Battleship Potemkin*, from the "Odessa steps" sequence, 1925. Director: Sergei M. Eisenstein.

After a suspenseful sequence the audience needs to be relaxed; once the tension release does its job, they can be drawn into another exciting situation.

Sometimes, to shock the audience or maintain their attention, a filmmaker may break a deliberately created pattern or convention of film. In *Jaws*, for example, each time the shark is about to appear, a four-note musical motif is played. The audience thereby grows to believe that they will hear this warning before each appearance, and so they relax. However, toward the end of the film the shark suddenly appears without benefit of the motif, shocking the audience. From that point until the end of the film they can no longer relax, and their full attention is directed to it.

DIRECT ADDRESS

Another method used to draw attention is that of *direct address*. In most films, the actors rarely look at or talk directly to the audience. However, in *Tom Jones*, while Tom and his landlady are arguing over money, Tom suddenly turns to the audience and says, "You saw her take the money." The audience's attention is focused on the screen more strongly than ever after that. This technique has been effectively adapted by television for use in commercial messages. For example, a congenial man looks at the camera (and you) with evident interest and asks if you are feeling tired, rundown, and sluggish. He assumes you are and proceeds to suggest a remedy. In a sense, the aside of nineteenth-century melodrama and the soliloquy of Shakespeare were also ways of directly addressing an audience and drawing them into the performance.

In silent films, where this type of direct address to the audience could not be used, the device of titles was substituted. However, some of the silent comedians felt that they should have direct contact with their audience, and so they developed a *camera look* as a form of direct address. After an especially destructive moment in his films, Buster Keaton would look directly at the camera, his face immobile, and stare at the audience. When Charlie Chaplin achieved an adroit escape from catastrophe he might turn toward the camera and wink. Stan Laurel would look at the camera and gesture helplessly (Fig. **5.6**), as if to say, "How did all this happen?" Oliver Hardy, after falling into an open manhole, would register disgust directly to the camera and the audience. These were all ways of letting the audience know that the comedians knew they were there. Some sound comedies adapted this technique too. In the "road" pictures of Bob Hope and Bing Crosby both stars, as well as camels, bears, fish, and anyone else who happened to be around, would comment on the film or the action

directly to the audience. However, this style may have been equally based on familiarity with radio programs in which the performer usually spoke directly to the home audience.

MAGNITUDE AND CONVENTION

In considering the magnitude of a film we must be aware of the means by which the film is to be communicated. In other words, was the film made for a television showing or for projection in a large theatre? Due to the size of the television screen, large panoramas or full-scale action sequences are not entirely effective on television—they become too condensed. To be truly effective, television films should be built around the close-up and around concentrated action and movement, because the television audience is closer to the screen than are the viewers in a large theatre. Scenes of multiple images with complex patterns of movement, or scenes of great violence, will become confusing because of the intimacy of television, and will seem more explicit than they really are. On the other hand, when close shots of intimate details are enlarged through projection in a theatre they may appear ridiculous. The nuance of a slightly raised eyebrow that is so effective in the living room will appear either silly or overly dramatic when magnified on a 60-foot (18-m) screen.

Film, as theatre, has certain conventions or customs that the viewer accepts without hesitation. When an exciting chase scene takes place, no one asks where the orchestra is that is playing the music that enhances the sequence. They merely accept the background music as part of the totality of the film. A film photographed in black-and-white is accepted as a recording of reality, even though the viewers know that the real world has color. When a performer sings and dances in the rain in the middle of a city street, none of the audience wonders whether the performer will be arrested for creating a public spectacle. The conventions of the musical film are equally acceptable to an audience conditioned to accept them.

This consideration of convention is especially important to the acceptance of the silent film as a form of art. The silent film should not be thought of as a sound film without sound, but as a separate entity with its own special conventions. These revolve around the methods used to indicate sound and dialogue without actually using them. The exaggerated pantomime and acting styles, the use of titles, character stereotyping, and visual metaphors are all conventions that were accepted during the silent era but can appear ludicrous today, because of changes in style and taste and improvements in the devices used for recording and projecting film. The action in the silent film was

recorded and presented at a speed of sixteen to eighteen frames per second; when it is presented today on a projector that operates at twenty-four frames per second, the movement becomes too fast and appears jerky and disconnected. However, once we learn to accept these antiquated conventions, we may find that the silent film is an equally effective form of cinematic art.

STRUCTURAL RHYTHM

Much of the effectiveness of a film relies on its success as a form as well as a style. Filmmakers create rhythms and patterns that are based on the way they choose to tell their stories or that indicate deeper meanings and relationships. The manner in which the various shots are joined together and juxtaposed with other cinematic images, both visual and aural, is known as *structural rhythm*.

Symbolic images in film range from the very obvious to the extremely subtle, but they are all useful in directing the attention of the audience to the ideas inherent in the philosophical approach underlying the film. This use of symbolic elements can be found in such clichés as the hero dressed in white and the villain dressed in black, in the more subtle use of water images in Fellini's *La Dolce Vita*, or even in the presence of an X whenever someone is about to be killed in *Scarface*.

Sometimes, symbolic references can be enhanced by form cutting—for example, cutting directly from the hero's gun to the villain's gun. Or the filmmaker may choose to repeat a familiar image in varying forms, using it as a composer would a motif in music. In *Fort Apache*, John Ford uses clouds of dust as a curtain to cover major events; the dust is also used to indicate the ultimate fate of the cavalry troop. Grass, cloud shapes, windblown trees, and patches of color have all been used symbolically and as motifs. Once such elements are perceived, serious students of film will find the deeper meanings of a film more evident and their appreciation heightened.

Another part of structural rhythm is the repetition of certain visual patterns throughout a film. A circular image positioned against a rectangular one, a movement from right to left, an action repeated regularly throughout a sequence—all can become observable patterns or even thematic statements. The silent film made extreme use of thematic repetition. In *Intolerance*, D. W. Griffith develops four similar stories simultaneously and continually cross-

5.6 *Your Darn Tootin'*, 1928. A Hal Roach Production for Pathé Films. Director: Edgar Kennedy.

121

cuts among them. This particular use of form enabled him to develop the ideas of the similarity of intolerance throughout the ages. In their silent films Laurel and Hardy often built up a pattern of "You do this to me and I'll do that to you"; they called it "tit for tat." Their audience would be lulled into expecting this pattern, but at that point the film would present a variation on the familiar theme (a process quite similar to the use of theme and variation in musical composition). The unexpected breaking of the pattern would surprise the audience into laughter.

Parallel development, discussed earlier, can also be used to create form and pattern throughout a film. For example, Edwin S. Porter's *The Kleptomaniac* alternates between two stories: a wealthy woman caught shoplifting a piece of jewelry, and a poor woman who steals a loaf of bread. Each sequence alternately shows crime, arrest, and punishment; the wealthy woman's husband bribes the judge to let her off, while the poor woman is sent to jail. Porter's final shot shows the statue of justice holding her scales, one weighted down with a bag of gold. Her blindfold is raised over one eye, which is looking at the money. In this case, as in others, the form is the film.

Audio Techniques

When sound films became practicable, filmmakers found many ways of using the audio track creatively in addition to just recording dialogue. It could be used for symbolism, for motifs that reinforced the emotional quality of a scene, or for stronger emphasis or structural rhythm.

Some filmmakers believe that a more realistic feeling can be created if film is cut rather than dissolved. Abrupt cuts from scene to scene give the film a staccato rhythm that approaches the reality they hope to achieve. Dissolves, on the other hand, create a slower pace and tend to make the film's transitions smooth and thus more romantic. If the abrupt cutting is done to the beat of the sound track, a pulsating rhythm is created for the film sequence; this in turn adds a sense of urgency.

In Fred Zinnemann's *High Noon*, the sheriff is waiting for the midday train to arrive. The sequence is presented in montage, showing the townspeople, as well as the sheriff, waiting. Every eight beats of the musical track the shot is changed. Then as noon approaches, the shot is changed every four beats. Tension mounts. The feeling of rhythm is enhanced by images of a clock's pendulum swinging to the beat of the sound track. Tension continues to build. The train's whistle sounds. A series of rapid cuts of faces turning and looking follows, but there is only silence on the sound track, which serves as a tension release. This last

moment of the sequence is also used as transition between the music and silence. In other films the track may shift from music to natural sounds and back to the music again. Or a pattern may be created of natural sound, silence, and a musical track. All depends on the mood the filmmaker is trying to create. In Hitchcock's films, music is often used as a tension release or an afterthought, as he usually relies on the force of his visual elements to create structural rhythm.

Earlier in this chapter we mentioned the use of motif in *Jaws*. Many films opt for an audio motif to introduce visual elements or to convey meaning symbolically. Walt Disney, particularly in his pre-1940 cartoons, often uses his sound track in this manner. For example, Donald Duck is trying to catch a pesky fly, but the fly always manages to elude him. In desperation Donald sprays the fly with insecticide. The fly coughs and falls to the ground. But on the sound track we hear an airplane motor coughing and sputtering, and finally diving to the ground and crashing. In juxtaposing these different visual and audio elements, Disney is using his track symbolically.

John Ford often underlines sentimental moments in his films by accompanying the dialogue of a sequence with traditional melodies. As the sequence comes to a close the music swells and then fades away to match the fading out of the scene. In *The Grapes of Wrath*, when Tom Joad says goodbye to his mother, "Red River Valley" is played on a concertina; as Tom walks over the hill the music becomes louder, and when he disappears from view it fades out. Throughout the film, this familiar folk song serves as a thematic reference to the Joads' home in Oklahoma and also boosts the audience's feelings of nostalgia.

In *She Wore a Yellow Ribbon*, the title of the film is underlined by the song of the same name, but through the use of different tempos and timbres its mood is changed each time it is heard. In the graveyard sequences the tune is played by strings and woodwinds in $\frac{2}{4}$ time in slow tempo, which makes the song melancholy and sentimental. As the cavalry troop rides out of the fort the song is played in a strong $\frac{4}{4}$ meter with a heavy emphasis on the brass; the sequence is cut to the beat of the track. Again, in the climactic fight sequence in *The Quiet Man*, John Ford cuts to the beat of a sprightly Irish jig, which enriches the comic elements of the scene and plays down the violence.

Our discussion in these last few paragraphs touches only the surface of the techniques and uses of sound in film; there are many other ways of using sound and the other elements discussed thus far. But part of the challenge of the film as an art form is the discovery by the viewer of the varying uses to which film technique can be put, and this in turn enhances further perceptions.

CHAPTER SIX

DANCE

WHAT IS IT?

BALLET
MODERN DANCE
FOLK DANCE

HOW IS IT PUT TOGETHER?

FORMALIZED MOVEMENT
LINE, FORM, AND REPETITION
RHYTHM
MIME AND PANTOMIME
IDEA CONTENT
MUSIC
Dance and Human Reality: Martha Graham,
 Appalachian Spring
Profile: Martha Graham
MISE-EN-SCÈNE
LIGHTING

HOW DOES IT STIMULATE THE SENSES?

MOVING IMAGES
FORCE
SIGN LANGUAGE
COLOR

IMPORTANT TERMS

Ballet "Classical" or formal dance.
Modern Dance Highly individualized twentieth-century dance works essentially antiballetic in philosophy.
Folk Dance A body of group dances performed to traditional music.
First Position The basic position for all movements in ballet. The heels are together and the toes "open" and out to the side.
Plié A bending of the knees with the feet in first position.
Choreographer The artist who creates a dance work.
Mime Bodily movement that suggests the actions of people or animals.
Pantomime The acting out of dramatic action without words.
Mise-en-scène The visual elements supporting a dance work, including settings, lighting, and costumes.

Every December, Tchaikovsky's *Nutcracker* ballet rivals Handel's *Messiah* and television reruns of the Jimmy Stewart movie *It's a Wonderful Life* as a holiday tradition. Nevertheless, ballet and dance in general seem remote from most people. Ballet, in particular, evokes strong personal opinions of like or dislike. Why this is so and what those opinions are create spirited classroom discussion.

Dance is one of the most natural and universal of human activities. In virtually every culture, regardless of location or level of sophistication, we find some form of dance. Dance appears to have sprung from humans' religious needs. For example, scholars are relatively sure that the theatre of ancient Greece developed out of that society's religious tribal dance rituals. So without doubt dance is part of human communication at its most fundamental level. We can see this expression even in little children who, before they begin to paint, sing, or imitate, begin to dance.

Carved and painted scenes from antiquity to the beginning of the era of film give us only the scantiest means by which to study the history of dance, an ephemeral art of movement—something we will notice as we move through Chapters 9–13 of this book. Dance is also a social activity and, although we take a fairly relativistic view of what comprises art, discussion of dance in this text is limited to what may be called "theatre dance"—dance that involves a performer, a performance, and an audience.

WHAT IS IT?

Dance focuses on the human form in time and space. In general it follows one of three traditions: ballet, modern dance, and folk dance. Other forms or traditions of dance exist, including jazz dance, tap, and musical comedy. Their properties as concert dance are often debated. We note jazz dance in passing later in the chapter and focus our brief discussion on ballet, modern dance, and folk dance.

BALLET

Ballet comprises what can be called "classical" or formal dance. Its rich tradition rests heavily upon a set of prescribed movements and actions. In general, ballet is a highly theatrical dance presentation consisting of solo dancers, duets, and choruses, or the *corps de ballet*. According to Anatole Chujoy in the *Dance Encyclopedia*, the basic principle in ballet is "the reduction of human gesture to bare essentials, heightened and developed into meaningful patterns." George Balanchine saw the single steps of a ballet as analogous to single frames in a motion picture. Ballet, then, became a fluid succession of images, existing within specialized codes of movement. As with all dance and indeed all the arts, ballet expresses basic human experiences and desires.

MODERN DANCE

Modern dance is a label given to a broad variety of highly individualized dance works limited to the twentieth century, American in derivation, and antiballetic in philosophy. It began as a revolt against the stylized and tradition-bound elements of ballet. The basic principle of modern dance could be stated as an exploration of natural and spontaneous or uninhibited movement, in strong contrast with the conventionalized and specified movement of ballet. The earliest modern dancers found stylized ballet incompatible with their need to communicate in twentieth-century terms. As Martha Graham characterized it, "There are no general rules. Each work of art creates its own code." None the less, in its attempts to be nonballetic, it has accrued certain conventions and characteristics. While there are narrative elements in many modern dances, there may be less emphasis on them than in traditional ballet. There also are differences in the use of the body, use of the dance floor, and interaction with the visual elements.

FOLK DANCE

Folk dance, somewhat like folk music, is a body of group dances performed to traditional music. It is similar to folk music in that we do not know the artists who developed it; no choreographer is recorded for folk dances. They began as a necessary or informative part of certain societies, and their characteristics are always stylistically identifiable with a given culture. They developed over a period of years, passing from one generation to another. They have prescribed movements, prescribed rhythms, and prescribed music and costume. At one time or another they may have become formalized—that is, committed to some form of record. But they are part of a heritage, and usually not the creative result of an artist or a group of interpretative artists, as is the case with the other forms of dance. Likewise, they exist more to involve participants than to entertain an audience.

Folk dancing establishes an individual sense of participation in society, the tribe, or a mass movement. "The group becomes one in conscious strength and purpose, and each individual experiences a heightened power as part of it . . . [a] feeling of oneness with one's fellows which is established by collective dancing."[1]

HOW IS IT PUT TOGETHER?

Dance is an art of time and space which utilizes many of the elements of the other arts. In the setting and in the line and form of the human body it involves many of the compositional elements of pictures, sculpture, and theatre. Dance also relies heavily on the elements of music—whether or not music accompanies the dance presentation. However, the essential ingredient of dance is the human body and its varieties of expression.

FORMALIZED MOVEMENT

The most obvious repository of formalized movement in dance is ballet. All movement in ballet is based upon five basic leg, foot, and arm positions. In the *first position* (Fig. **6.1**) the dancer stands with weight equally distributed between the feet, heels together, and toes open and out to the side. In ballet all movements evolved from this basic "open" position; the feet are never parallel to each other

6.2 Second position.

with both pointing straight forward. The *second position* (Fig. **6.2**) is achieved by opening the first position the length of one's foot, again with the weight placed evenly on both feet. In the *third position* (Fig. **6.3**) the heel of the front foot touches the instep of the back foot; the legs and feet must be well turned out. The heel of the front foot is opposite the toe of the back foot in the *fourth position* (Fig. **6.4**). The feet are parallel and separated by the length of the dancer's foot; again, the weight is placed evenly on both feet. The *fifth position* (Fig. **6.5**) is the most frequently used of the basic ballet positions. The feet are close together with the front heel touching the toe of the back foot. The legs and the feet must be well turned out to achieve this position correctly, and the weight is placed evenly on both feet. As is clear from Figures **6.1–6.5**, each position changes the attitude of the arms as well as that of the legs and feet. From these five basic positions a series of fundamental movements and poses is developed, and they are the core of every movement of the human body in formal ballet.

Some of the fundamental ballet poses and movements can be recognized throughout dance works, including modern dance; a few lend themselves to photographic illustration. Figure **6.6** shows a *demi-plié* (half-bend of the knees) in first position—it can be executed in any position. The *grand plié* shown in Figure **6.7**, also in first position,

6.1 First position.

carries the bend to its maximum degree. The *arabesque* is a pose executed on one foot with arms and foot extended. It can appear in a variety of positions, and is shown in Figure 6.8 in the *penchée*, or leaning position. *Port de bras* (Fig. 6.9) is simply the technique of moving the arms correctly.

Many variations can be made upon the five basic positions. For example, the *grande seconde* (Fig. **6.10**) is a variation upon second position in which one leg is elevated to full height. One leg also is elevated in the *demi-hauteur*, or "half-height" (Fig. **6.11**). Full height requires extension of the leg at a 90-degree angle to the ground; half height requires a 45-degree extension.

Movements carry the same potential for variety. For example, in the *ronds de jambe à terre* (Fig. **6.12**) the leg from the knee to and including the foot is rotated in a semi-circle. Other basic movements include the *assemblé, changement de pied, jeté, pirouette,* and *relevé.* As we develop expertise in perceiving dance, it will become obvious in watching formal ballet (and, to a lesser degree, modern dance) that we see a limited number of movements and poses, turns and leaps, done over and over again. Thus

these bodily compositions form a kind of theme with variations, and in that respect they are interesting in themselves.

In addition, it is possible to find a great deal of excitement in the bodily movements of formal ballet if for no other reason than the physical skills required for their execution. Just as in gymnastics or figure skating, the strength and grace of individuals in large part determine their qualitative achievement. Yet ballet is far more than just a series of gymnastic exercises.

Perhaps the most familiar element of ballet is the female dancer's toe work or dancing *on point* (Fig. **6.13**). A special kind of footgear is required (Fig. **6.14**). Dancing on point is a fundamental part of the female dancer's development, but it usually takes a minimum of two years of thorough training and development before a dancer can begin. Certain kinds of turns are not possible without toeshoes— for example, spinning on point or being spun by a partner.

We have focused on ballet in this discussion of formalized movement because it is the most familiar of the traditional, formalized dance forms. Ballet, however, is not alone in adhering to formalized patterns of movement. It

6.3 Third position.

6.4 Fourth position.

is, in part, formalized movement that allows us to distinguish folk and other dances, such as the *pavane*, the *galliard*, the *waltz*, and the *mambo*. All have formal or conventional patterns of movement. Perhaps only modern dance resists formal movement, and even then not completely.

LINE, FORM, AND REPETITION

The compositional elements of line, form, and repetition apply to the use of the human body in exactly the same sense that they apply to those elements in painting and sculpture—the latter especially. The body of the dancer can be analyzed as a sculptural, three-dimensional form which reflects the use of line, even though the dancer is continually in motion. The body as a sculptural form moves from one pose to another, and if we were to take a stop-action

6.5 (*below*) Fifth position.

6.6 (*right*) *Demi-plié* in first position.

6.7 (*bottom right*) *Grand plié* in first position.

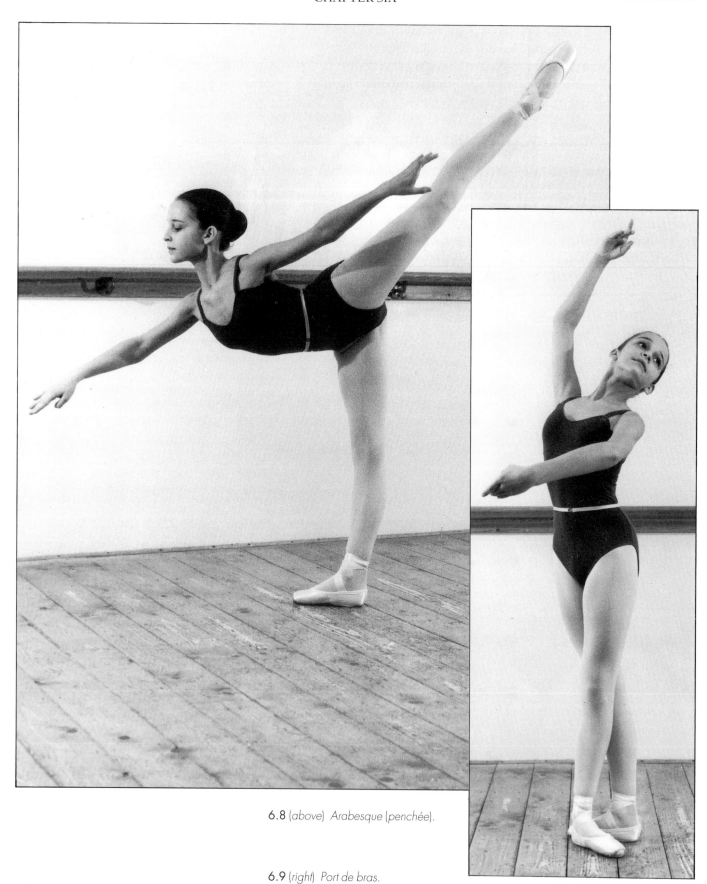

6.8 (above) *Arabesque (penchée).*

6.9 (right) *Port de bras.*

movie of a dance, we could analyze, frame by frame or second by second, the compositional qualities of the human body. The human form in every illustration in this chapter, including those that show groupings of dancers, can be analyzed as a composition of line and shape. Dance, therefore, can be seen at two levels: first, as a type of pictorial communication employing symbols that occur only for a moment and, second, as the design of transition with movement between those moments.

Because dancers move through time, the concept of repetition becomes an important consideration in analyzing how a dance work is put together. The relationship of the movements to each other as the dance progresses shows us a repetitional pattern that is very similar to theme and variation in music. *Choreographers* plan these patterns using individual dancers' bodies as well as combinations of dancers in duets, trios, or the entire *corps de ballet* (Figs. **6.15** and **6.16**).

RHYTHM

As we watch a dance we can see that the steps are related and coherent. Dance phrases are held together by their rhythm, in the same sense as in musical rhythm. Sequences

6.10 *Grande seconde.*

6.11 *Demi-hauteur.*

6.12 *Ronds de jambe à terre.*

129

of long and short motions occur which are highlighted by accents. In a visual sense dance rhythms occur in spatial arrangements, up and down, back and forth, curved and linear, large and small. We can also perceive rhythmic relationships in the ebb and flow of dancers' energy levels. Energy, of course, calls to mind dynamics in the sense the term is used in music and theatre.

MIME AND PANTOMIME

Within any dance form there may be elements of bodily movement that we call *mime* and *pantomime*. Bodily movement is mimetic whenever it suggests the kinds of movements we associate with people or animals. It is also mimetic if it employs any of the forms of conventional sign language, such as the Delsarte system. And if there are narrative elements in the dance and the dancer actually portrays a character in the theatrical sense, there also may be pantomimetic action. Pantomime is the "acting out" of dramatic action without words. In the romantic style of ballet, for example, pantomime helps to carry forward the story line. We sense the emotions and character relationship in the dancers' steps, gestures, movements, and facial expressions. Only when the movement of the dance is purely an emotional expression of the dancer can we say that it is free of mime or pantomime.

IDEA CONTENT

Our consideration of the presence or absence of mime leads us to a consideration of how dance communicates its idea content. There are three general possibilities. First, the dance may contain *narrative* elements—that is, it may tell a

6.13 On point.

6.14 On point, detail.

story. Romantic ballet usually has strong narrative elements. Second, the dance may communicate through *abstract* ideas. There is a specific theme to be communicated but no story line—the ideas relate to some aspect of human emotion or the human condition. Modern ballet—that is, twentieth-century ballet—has dealt increasingly with abstract ideas. Modern dance, especially, tends to explore human psychology and behavior. Social themes occur frequently, as do impressions or expressions from plays, poems, and novels. Religious and folk themes can be found too. The third possibility is the absence of any narrative or abstract communication. The work may be a *divertissement* (French for "diversion")—some ballets are *divertissements*.

A variation of abstract idea content in dance is *ethnic influence*. It is interesting to note how elements of dance reflect sociocultural background. Jazz dance, for example, may stimulate us to consider the African American heritage in the United States. Jazz dance has emerged strongly in the twentieth century, and many would include it as a form equal to ballet, modern, and folk. It has its own history, linked closely with the African American experience in the United States, show business, and jazz as a musical idiom.

MUSIC

Dance is associated with music as a matter of course. Most of the time music serves as a basis for the bodily movement of the work we are perceiving, although it is not absolutely necessary for dance to be accompanied by music. However, it is impossible to have dance without one element of music—rhythm. Every action of a dancer's body has some

6.15 *Nameless Hour*, Jazz Dance Theatre at Penn State, Pennsylvania State University. Choreographer: Jean Sabatine.

6.16 *Family Tree*, Jazz Dance Theatre at Penn State, Pennsylvania State University. Choreographer: Jean Sabatine.

DANCE AND HUMAN REALITY

Martha Graham, *Appalachian Spring*

Social criticism as an artistic message came into vogue in the United States during the Great Depression of the 1930s. During the same period, modern dance pioneer Martha Graham began to pursue topical themes in her dances. Her interest in the shaping of America led to a now renowned dance piece set to the music of Aaron Copland, *Appalachian Spring* (1944). It deals, among other things, with the triumph of love and common sense over the fire-and-brimstone of American puritanism at that time.

Appalachian Spring came about as a result of a commission funded by Elizabeth Sprague Coolidge and had its première on October 30 at the Library of Congress as part of its concert series. Its story deals with a pioneer frontier marriage. The characters are a young bride, a young groom, an older woman who is their advisor and protector, and a preacher—a fire-and-brimstone frontier evangelist who prophesies hellfire and damnation for all who do not agree with him. Around the preacher flock a group of young spinsters who worship him and whom Martha Graham used as a source of comedy in the dance. She treated the young couple and their taking over of a new house and a new farm with moving and sensitive simplicity. Overall, the work read like a "love letter, a dance of hope, budding, fresh, and beautiful."[2] *Appalachian Spring* has become perhaps the most admired work in the Graham company repertoire. Its music has become an American classic, and the stunning set by sculptor Isamu Noguchi (see p. 377) a benchmark in theatrical design.

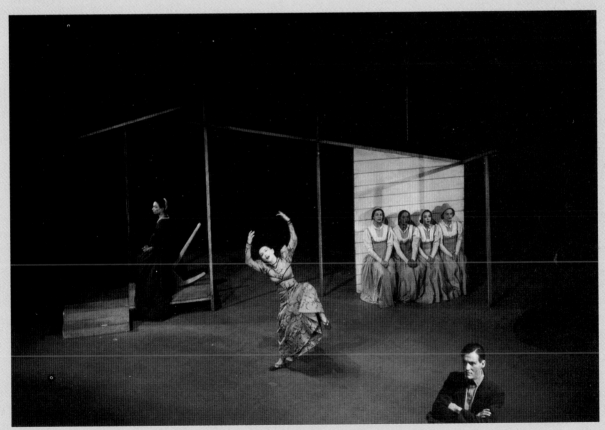

6.17 Martha Graham in *Appalachian Spring*, 1954. Choreographer: Martha Graham.

Martha Graham

Martha Graham (1893–1991), arguably, contributed more to the art of modern dance as an innovative choreographer and teacher than any other individual. Her techniques were rooted in the muscular and nerve-muscle responses of the body to inner and outer stimuli. She created the most demanding body-training method in the field of modern dancing.

Born in Pittsburgh on May 11, 1893, Graham spent her early years there and in Santa Barbara, California. As a teenager she began studying dance at Denishawn, a dance company founded by Ruth St. Denis and Ted Shawn. Her dance debut came in *Xochitl*, a ballet choreographed by St. Denis and based on an Aztec theme. It proved a great success both in vaudeville and concert performances.

Graham left Denishawn in 1923 to become a featured dancer in the Greenwich Village Follies. She also taught for a time at the Eastman School of Music in Rochester, N.Y. She debuted in New York City as an independent artist in 1926. One year later, her program included the dance piece *Revolt*, probably the first dance of protest and social comment in the United States.

Graham became interested in social comment as a legitimate theme in the arena of the arts, and combined it with her attraction to the early history of America. The result was her most famous ballet, *Appalachian Spring*, in which Graham herself danced the principal role of The Bride. Other roles included The Revivalist, The Husbandman, The Pioneering Woman, and The Followers. Perhaps the best loved of Graham's works, and the one with the finest score, *Appalachian Spring* takes as its pretext a wedding on the American frontier. The dance is like no actual ceremony or party, however. The movement not only expresses individual character and emotion, but it has a clarity, spaciousness, and definition that relate to the open frontier, which must be fenced and tamed. During the dance, the characters emerge to make solo statements; the action of the dance is suspended while they reveal what is in their hearts. The Bride's two solos suggest not only joy but trepidation for the future. (See box on previous page.)

In a career spanning seventy years, Martha Graham created 180 dance works. Some of these were based on Greek legends: *Night Journey*, first performed in 1947, about Jocasta, the mother of Oedipus; *Clytemnestra* (1958); and *Cave of the Heart* (1946), about the tragedy of Medea. *Letter to the World* (1940) was based on the life of poet Emily Dickinson. *Seraphic Dialogue* (1955) dealt with Joan of Arc, and *Embattled Garden* (1962) took up the Garden of Eden legend. Among her other works were *Alcestis* (1960); *Acrobats of God* (1960); and *Maple Leaf Rag* (1990). Graham announced her retirement in 1970, but she continued to create new dances until her death from cardiac arrest in New York City on April 1, 1991.

relationship in time to every other movement, and those relationships establish rhythmic patterns that are musical regardless of the presence or absence of sound.

When we hear music accompanying a dance we can respond to the relationship of the dance to the musical score. The most obvious link we see and hear is that between the gestures and footfalls of the dancer and the beat of the music. In some cases the two are in strict accord—the beat-for-beat relationship is one to one—in other cases not.

Another relationship is that of the *dynamics* of the dance to those of the music. Of prime importance in this relationship is the intensity, or force, of the dance. Moments of great intensity can manifest themselves in rapid movement and forceful leaps. Or they may be reflected in other qualities. The same kind of analysis can be used in dance as in theatre to plot dynamic levels and overall structure. For maximum interest there must be variety of intensity. If we chart the relationship of the peaks and valleys of dynamics, we are likely to conclude that the dynamic structure of a dance is similar to the dynamic structure of a play: it tends to be pyramidal, building to a high point and then relaxing to a conclusion. This applies whether or not narrative elements are present.

MISE-EN-SCÈNE

Because dance is essentially a visual and theatrical experience, part of our response must be to those theatrical elements of dance that are manifested in the environment of the presentation. In other words, we can respond to the *mise-en-scène* of the dance (Fig. **6.16**). We can note

elements of verisimilitude and how they reflect or otherwise relate to the aural and visual elements of the dance. A principal consideration here is the interrelationship of the dance with properties, settings, and the floor of the theatrical environment. Some dances employ massive stage designs. Others have no setting at all; they are performed in a neutral environment. A principal difference between formal ballet and modern dance lies in the use of the *dance floor*. In formal ballet the floor acts principally as an agent from which dancers spring and to which they return. But in modern dance the floor assumes an integral role in the performance, and we are likely to see the dancers sitting on the floor, rolling on it—in short, *interacting* with the floor. Consideration of the floor in dance also concerns how its use relates to the idea content of the dance.

In discussing the relationship of *costume* to dance, we would do well to return to the section on costume design in Chapter 4 to note the purposes of costume, because they apply equally to dance as to theatrical productions. In some dances costume will be traditional, conventional, and neutral. There would be little representation of story line or character in the tights and *tutu* of the female dancer shown in Figure 6.18. However, in many dances we are likely to see costumes high in verisimilitude. They may help portray character, locality, and other aspects of the dance (Figs. 6.15 and 6.16).

It is especially important that costumes should allow dancers to do whatever it is that the choreographer expects of them. In fact, costume may become an integral part of the dance itself. An example of this is Martha Graham's *Lamentation*, in which a single dancer is costumed in what could best be described as a tube of fabric—no arms, no legs, just a large envelope of cloth. Every movement of the dancer stretches the cloth so that the line and form is not that of a human body but rather of a human body enveloped in a moving fabric.

The final element of the dance costume to be considered, and one of great significance, is footgear. Dancers' footgear ranges from the simple, soft, and supple ballet slipper to the specialized toeshoe of formal ballet, with street shoes, character Oxfords, and a variety of representational or symbolic footwear in between. Modern dance is often done barefoot. The fundamental requirements of footgear are comfort and enough flexibility to allow the dancer to dance. It is essential that it is appropriate to the surface of the stage floor, whether toeshoe, ballet slipper, or character Oxford. Great care must be taken to ensure that

6.18 Traditional tights and tutu.

the dance floor is not too hard, too soft, too rough, too slippery, or too sticky. The floor is so important that many touring companies take their own floor with them to ensure that they will be able to execute their movements properly. There have been cases in which professional dance companies have refused to perform in local auditoriums because the floor was dangerous for the dancers.

LIGHTING

Inasmuch as the entire perception of a dance relies on viewing the human body as a three-dimensional form, the work of the lighting designer is of critical importance. How we perceive the human form in space depends on how that body is lit. Certainly our emotional and sense response is highly shaped by the nature of the lighting that plays on the dancer and the dance floor.

HOW DOES IT STIMULATE THE SENSES?

The complex properties of dance make possible diverse and intense communicative stimuli. We noted earlier that opera is a synthesis of all of the arts. The dance, as well, integrates elements of all of the arts, and does so in such a way as to communicate in a highly effective symbolic and nonverbal manner.

We noted previously that it is possible to respond at different levels to an artwork. To some extent we can respond even at a level of total ignorance. In many ways artworks are like onions. If they lack quality we can call them rotten. But more important, and more seriously, an artwork, like an onion, has a series of skins. As we peel away one that is obvious to us, we reveal another and another and another, until we have gotten to the core of the thing. There will be levels of understanding, levels of meaning, levels of potential response for the uninitiated as well as the thoroughly sophisticated viewer. The more sophisticated a *balletomane* one becomes, the fuller one's understand and response will be.

MOVING IMAGES

Like every other artwork that exists in space, dance appeals to our senses through the compositional qualities of line and form. These exist not only in the human body but in the visual elements of the *mise-en-scène*. Essentially, horizontal lines stimulate a sense of calm and repose.

Vertical lines suggest grandeur and elegance. Diagonal lines stimulate a feeling of action and movement (Fig. **6.16**), and curved lines, grace. As we react to a dance work we respond to how the human body expresses line and form—when it is standing still and when it moves through space. If we are alert and perceptive we will recognize not only how lines and forms are created but also how they are repeated from dancer to dancer and from dancer to *mise-en-scène*.

Often, the kind of line created by the body of a dancer is the key to understanding the work of the choreographer. George Balanchine, for example, insisted that his dancers be almost skin and bone; you would not see a corpulent or overly developed physique in his company. Thus bodies, too, affect our perception, and choreographers capitalize on that in their dance conceptions.

FORCE

We noted in Chapter 3 that the beat of music makes a fundamental appeal to our senses. Beat is the aspect of music that sets our toes tapping and our fingers drumming. Probably our most basic responses to a dance are to the dynamics expressed by the dancers and in the music. A dancer's use of vigorous and forceful action, high leaps, graceful turns, or extended pirouettes appeals directly to us, as does the tempo of the dance. Variety in dynamics—the louds and softs and the highs and lows of bodily intensity as well as musical sound—is the dancer's and choreographer's means of providing interest, just as it is the actor's, the director's, and the painter's.

SIGN LANGUAGE

Dancers, like actors, can stimulate us directly because they are human beings and can employ many symbols of communication. Most human communication requires us to learn a set of symbols—we can respond to dance at this level only when we have mastered its language. There are systems of sign language, such as the Delsarte, in which the positions of the arms, the hands, and the head have meanings. Likewise, each of the hand movements of the hula dance communicates an idea, and it is these on which we should concentrate, not the vigorous hip movements.

However, there is a set of universal body symbols to which all of us respond (so psychologists tell us), regardless of our level of familiarity or understanding. For example, the gesture of acceptance in which the arms are held outward with the palms up has the same meaning universally. Rejection is shown by holding the hands in front of the body with the palms out as if to push away. When

dancers employ universal symbols we respond to their appeal to our senses just as we would to the nonverbals or body language in everyday conversation.

COLOR

Although dancers use facial and bodily expressions to communicate some aspects of the human condition, we do not receive as direct a message from them as we do from the words of actors. So, to enhance the dancer's communication the costume, lighting, and set designers must strongly reinforce the mood of the dance through the *mise-en-scène* they create. The principal means of expression of mood is color. Because verisimilitude is not as important in dance as in the theatre, lighting designers are free to work in much more obvious ways with color. They may not have to worry if the face of a dancer is red or blue or green—which would be disastrous in a play. So we often see much stronger, more colorful, and more suggestive lighting in dance than in theatre. Colors are more saturated, intensity

much higher, and the qualities of the human body, as form, are explored much more strongly by light from various directions. The same is true of costumes and settings. Because dancers do not portray roles with high verisimilitude, their costumes can communicate in an abstract way.

On the other hand, scene designers must be careful to utilize color so as to focus on the dancer in the stage environment—that is, unless a synthesis of the dancer with the environment is intended, as in the case, for example, of some works by choreographer Merce Cunningham. In any but the smallest of stage spaces it is very easy for the human body to be overpowered by the elements of the setting, since the latter occupies so much more space. Nevertheless, scene designers use color as forcefully as they can to help reinforce the overall mood of the dance.

These examples of how dance affects our senses are rudimentary ones. Perhaps more than any other art, dance causes us to ascend beyond our three cognitive questions—What is it? How is it put together? How does it affect the senses?—and dwell on a fourth level of response—What does it mean?

CHAPTER SEVEN

ARCHITECTURE

WHAT IS IT?

HOW IS IT PUT TOGETHER?

STRUCTURE
 Post-and-lintel
 Arch
 Cantilever
 Bearing-wall
 Skeleton Frame
BUILDING MATERIALS
 Stone
 Concrete
 Wood
 Steel
LINE, REPETITION, AND BALANCE
SCALE AND PROPORTION
CONTEXT
SPACE
CLIMATE

HOW DOES IT STIMULATE THE SENSES?

CONTROLLED VISION AND SYMBOLISM
Profile: Frank Lloyd Wright
Architecture and Human Reality:
 Le Corbusier, Villa Savoye
STYLE
APPARENT FUNCTION
DYNAMICS
SCALE

IMPORTANT TERMS

Post-and-lintel An architectural structure consisting of horizontal beams laid across open spaces between vertical supports.

Tunnel vault Arches placed back to back to enclose space.

Arcade Several arches placed side by side.

Groin vault Tunnel vaults meeting at right angles.

Cantilever An overhanging beam or floor supported at only one end.

Bearing-wall A system of architectural structure in which the walls support themselves.

Skeleton frame A system of architectural structure in which a framework supports the building and the walls are attached to the frame.

Scale The relationship of the size of a building to the human form.

Context The environment surrounding a work of architecture.

Function The basic purpose of a building.

Prestressed concrete Concrete using metal rods and wires under stress or tension to cause structural forces to flow in predetermined directions.

Ferroconcrete Concrete cast in place with metal reinforcement embedded in the concrete.

Every street in our towns represents a museum of ideas and engineering. The houses, churches, and commercial buildings we pass every day reflect appearances and techniques that are almost as old as the human race itself. We go in and out of these buildings, often without noticing them, and yet they frequently dictate actions we can or cannot take.

In approaching architecture as an art, it is virtually impossible for us to separate aesthetic properties from practical or functional properties. In other words, architects first have a particular function to achieve in their building. That function is their principal concern. The aesthetics of the building are important, but they must be tailored to overall practical considerations. For example, when architects set about designing a 110-story skyscraper, they are locked into an aesthetic form that will be vertical rather than horizontal in emphasis. They may attempt to counter verticality with strong horizontal elements, but the physical fact that the building will be taller than it is wide is the basis from which the architects must work. Their structural design must take into account all the practical needs implicit in the building's use. None the less, considerable room for aesthetics remains. Treatment of space, texture, line, and proportion can give us buildings of unique style and character—or of unimaginative sameness.

7.1 Stonehenge, Salisbury Plain, England, c. 1800–1400 B.C.

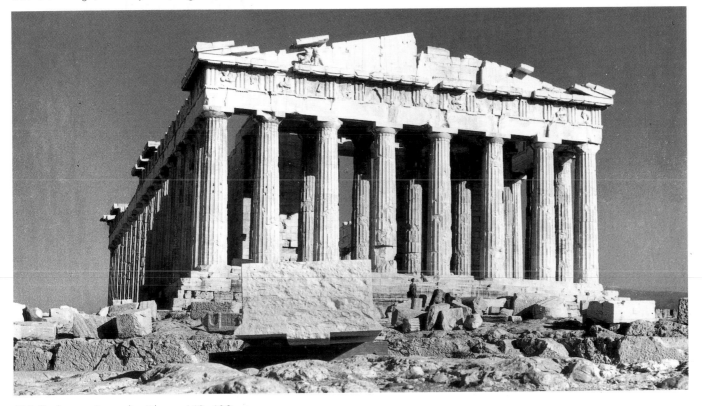

7.2 Parthenon, Acropolis, Athens, 448–432 B.C.

Architecture is often described as the art of sheltering. To consider it as such we must use the term "sheltering" very broadly. Obviously there are types of architecture within which people do not dwell and under which they cannot escape the rain. Architecture encompasses more than buildings. So, we can consider architecture as the art of sheltering people both physically and spiritually from the raw elements of the unaltered world.

WHAT IS IT?

As well as the art of sheltering, architecture is the design of three-dimensional space to create practical enclosure. Its basic forms are residences, places of worship, and commercial buildings. Each can take innumerable shapes, from single-family residences to the ornate palaces of kings to

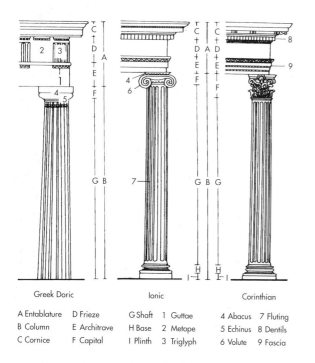

Greek Doric		Ionic		Corinthian	
A Entablature	D Frieze	G Shaft	1 Guttae	4 Abacus	7 Fluting
B Column	E Architrave	H Base	2 Metope	5 Echinus	8 Dentils
C Cornice	F Capital	I Plinth	3 Triglyph	6 Volute	9 Fascia

7.3 Greek columns and capitals: (*left*) Doric, (*center*) Ionic, (*right*) Corinthian.

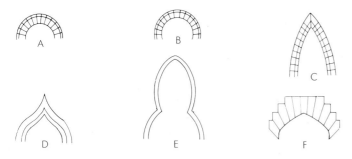

7.4 The arch: (A) round (Roman), (B) horseshoe (Moorish), (C) lancet (pointed, Gothic), (D) ogee, (E) trefoil, (F) Tudor.

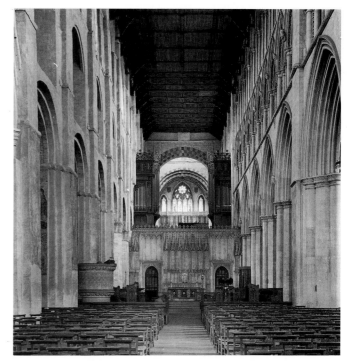

7.5 St. Alban's Cathedral, England, nave, facing east.

high-rise condominiums and apartments. The categorization of architectural forms can also be expanded to include bridges, walls, monuments, and so forth.

HOW IS IT PUT TOGETHER?

In examining how a work of architecture is put together we will limit ourselves to ten fundamental elements: structure, building materials, line, repetition, balance, scale, proportion, context, space, and climate.

STRUCTURE

There are many systems of construction or structural support. We will deal with only a few of the most prominent. *Post-and-lintel, arch,* and *cantilever* systems can be viewed, essentially, in historical terms. Contemporary architecture uses two additional systems, which to some extent overlap the others: *bearing-wall* and *skeleton frame.*

Post-and-lintel

Post-and-lintel structures consist of horizontal beams (lintels) laid across the open spaces between vertical supports (posts). The traditional material is stone. They are similar to *post-and-beam* structures, in which series of vertical posts

are joined by horizontal members, traditionally of wood. The wooden members of post-and-beam structures are held together by nails, pegs, or lap joints.

Because of the lack of *tensile strength* in its fundamental material, stone, post-and-lintel structures are limited in their ability to define space. Tensile strength is the ability of a material to withstand bending. If a slab of stone is laid across an open space and supported at each end, it can span only a narrow space before it cracks in the middle and falls to the ground. On the other hand, stone has great *compressive strength*—the ability to withstand compression or crushing.

A very early example of a post-and-lintel structure is Stonehenge, that ancient and mysterious religious configuration of giant stones in Great Britain (Fig. 7.1). The ancient Greeks refined this system to high elegance; the most familiar of their post-and-lintel creations is the Parthenon in Athens (Fig. 7.2).

The Greek post-and-lintel structure has served as a *prototype* for buildings throughout the world and down the centuries. One of its most interesting aspects is the treatment of *columns* and *capitals*. Figure 7.3 shows the three basic Greek orders—*Ionic, Doric*, and *Corinthian*. These are

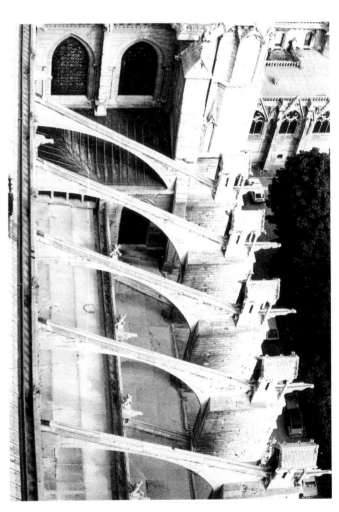

7.7 Notre Dame, Paris, flying buttresses.

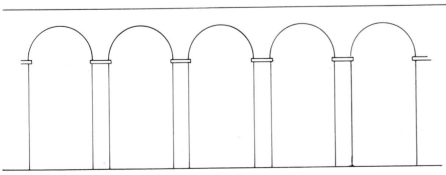

7.6 (A) The buttress: any projecting structure, generally of stone, built against a wall to support it. (B) Flying buttresses.

7.8 Arcade.

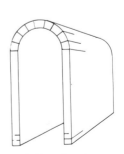

7.9 Tunnel vault.

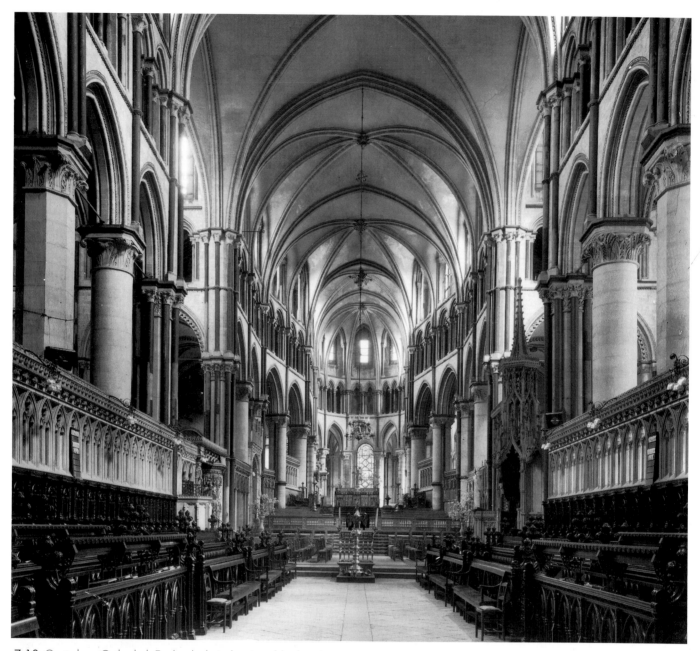

7.10 Canterbury Cathedral, England, choir showing ribbed vaulting.

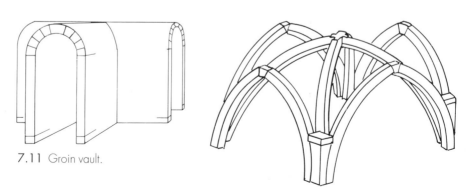

7.11 Groin vault.

7.12 Ribbed vault.

not the only styles possible—column capitals can be as varied as the imagination of the architect who has designed them. Their primary purpose is to act as a transition for the eye as it moves from post to lintel. The columns themselves also vary in shape and detail. A final element, present in some columns, is *fluting*—vertical ridges cut into the column.

Arch

A second type of architectural structure is the arch. Unlike post-and-lintel structure, which is limited in the amount of unencumbered space it can cross, the arch can define large spaces. This is because its stresses are transferred outward from the center (the *keystone*) to its legs, so it does not depend on the tensile strength of its material.

There are many different styles of arch, some of which are illustrated in Figure 7.4. The characteristics of different arches may have structural as well as decorative functions. As an example, examine St. Alban's Cathedral (Fig. 7.5), built in the English Norman style. This style of building, with its accent on rounded arches, was loosely based on the Classical architecture of Roman times.

The transfer of stress from the center of an arch outward to its legs dictates the need for a strong support to keep the legs from caving outward. Such a reinforcement is called a *buttress* (Fig. 7.6A). The designers of Gothic cathedrals sought to achieve a sense of lightness. Since stone was their basic building material, they recognized that some system had to be developed that would overcome the bulk of a stone buttress. Therefore they developed a system of buttresses that accomplished structural ends but were light in appearance. These are called *flying buttresses* (Figs. 7.6B and 7.7).

Several arches placed side by side form an *arcade* (Fig. 7.8). Arches placed back to back to enclose space form a *tunnel vault* (Fig. 7.9). When two tunnel vaults intersect at right angles, they form a *groin vault* (Fig. 7.11). The protruding masonry indicating diagonal juncture of arches in a groin vault is *rib vaulting* (Figs. 7.10 and 7.12).

When arches are joined at the top with their legs forming a circle, the result is a *dome* (Figs. 7.13 and 7.14). Through intersecting arches, this allows for more expansive, freer space within the structure. If the structures that support the dome form a circle, the result is a circular building such as the Pantheon in Rome. To permit squared space beneath a dome, the architect needs to transfer weight and stress through the use of *pendentives* (Fig. 7.15).

The problems architects face in utilizing one form or another for structural support are illustrated by the story of St. Paul's Cathedral, London. Its dome measures 112 feet (34 m) in diameter and stands 365 feet (110 m) tall at the top of the cross. The lantern and cross alone weigh 700 tons (711 tonnes), while the dome and its superstructure weigh in at 64,000 tons (65,000 tonnes). In designing this cathedral Wren was faced with seemingly insurmountable problems of supporting such a tremendous load. His solution was ingenious—the dome comprises nothing more than a timber shell covered in lead, and so the actual weight of the dome is only a fraction of what it would have been in stone. This allowed Wren to create a wonderful silhouette on the outside and to have a high ceiling in the interior (Fig. 7.16).

Cantilever

A cantilever is an overhanging beam or floor supported at only one end (Fig. 7.18). Although it is not a twentieth-century innovation—many nineteenth-century barns in the central and eastern parts of the United States employed it—the most dramatic uses of cantilevers have emerged with the introduction of modern materials such as steel beams and *prestressed concrete* (Fig. 7.17).

Bearing-Wall

In this system, the wall supports itself, the floors, and the roof. Log cabins are examples of bearing-wall construction; so are solid masonry buildings, in which the walls are the structure. In variations of bearing-wall construction, such as Figure 7.38, the wall material is continuous—that is, not jointed or pieced together. This is called *monolithic construction*.

Skeleton Frame

Here a framework supports the building. The walls are attached to the frame, thus forming an exterior skin. When skeleton framing utilizes wood, as in house construction, the technique is called *balloon construction*. When metal forms the frame, as in skyscrapers, it is known as *steel-cage construction*.

BUILDING MATERIALS

Historic and contemporary architectural practices and traditions often center on specific materials, and to understand architecture further, we need to note a few.

Stone

The use of stone as a material turns us back to post-and-lintel systems and Figures 7.1 and 7.2. When stone is used

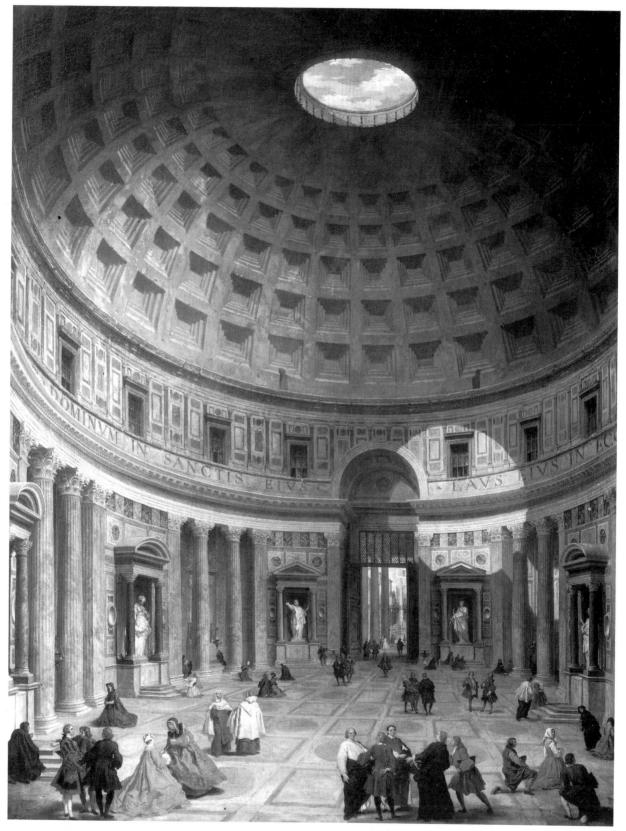

7.13 Giovanni Paolo Panini, *The Interior of the Pantheon, Rome*, c. 1734/5. Oil on canvas, 50½ x 39 ins (128 x 99 cm). National Gallery of Art, Washington, D.C. (Samuel H. Kress Collection).

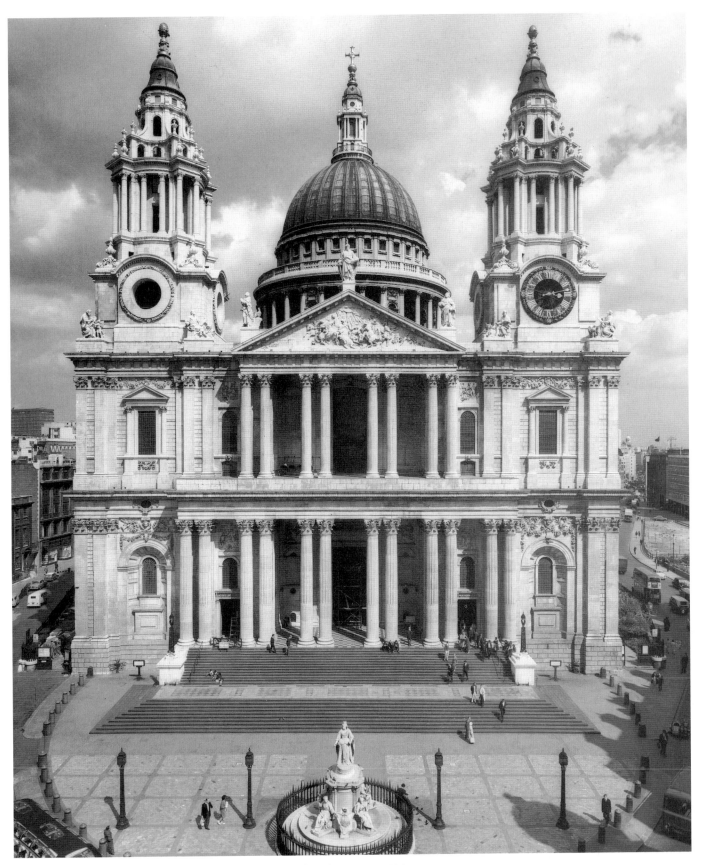

7.14 Christopher Wren, St. Paul's Cathedral, London, west façade, 1675–1710.

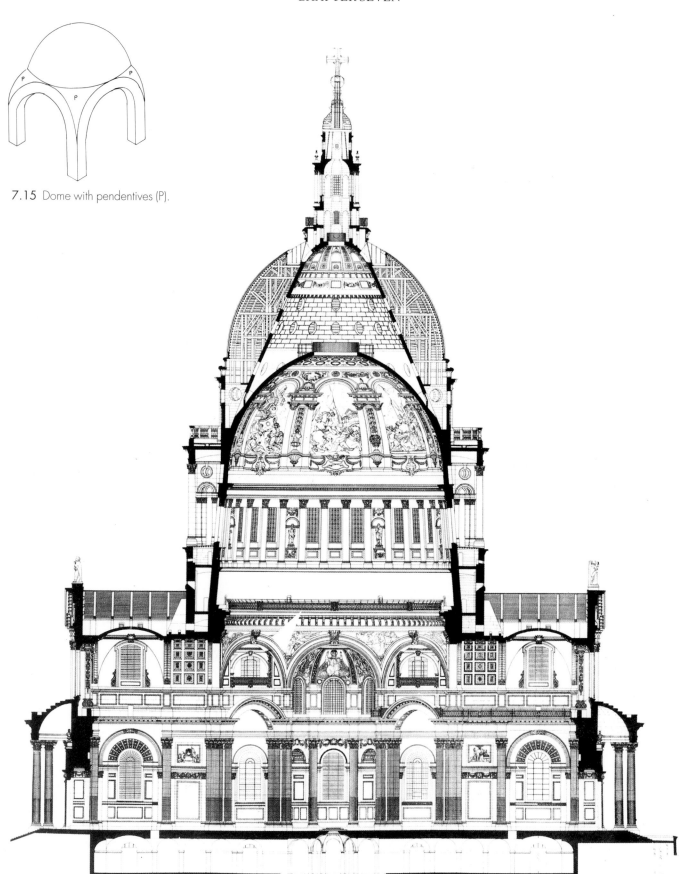

7.15 Dome with pendentives (P).

7.16 Christopher Wren, St. Paul's Cathedral, London, cross-section.

7.17 Eduardo Torroja, Zarzuela Race Track Grandstand, Madrid, 1935.

7.18 Cantilever.

with mortar—for example, in arch construction—that combination is called *masonry construction*. The most obvious example of masonry, however, is the brick wall. Masonry construction is based on the principle of joining stones, bricks, or blocks together with mortar, one on top of the other, to provide standard, structural, weight-bearing walls (Fig. **7.19**). There is a limit to what can be accomplished with masonry because of the pressures that play on the joints between blocks and mortar and the foundation on which they rest. However, when one considers that office buildings such as Chicago's Monadnock Building (Fig. **7.20**) are skyscrapers and that their walls are built solely of masonry—that is, there are no hidden steel reinforcements in the walls—it becomes obvious that much is possible with this elemental combination of stone and mortar.

7.19 Pont du Gard, near Nîmes, France, 1st century B.C.

Concrete

The use of concrete is central to much contemporary architectural practice, but it was also significant as far back in the past as ancient Rome. The Pantheon (Fig. **7.13**) comprises a masterful structure of concrete with a massive concrete dome, 142 feet (43 m) in diameter, resting on concrete walls 20 feet (6 m) thick. In contemporary architecture, we find *precast concrete*, which is cast in place using wooden forms around a steel framework. Also used is *ferroconcrete (reinforced concrete)*, which has metal reinforcement embedded in the concrete. Such a technique combines the tensile strength of the metal with the compressive strength of the concrete. *Prestressed* and *post-tensioned* *concrete* use metal rods and wires under stress or tension to cause structural forces to flow in predetermined directions. Both are extremely versatile building materials.

Wood

Whether in balloon framing or in laminated beaming, wood has played a pivotal role in architecture, especially in the United States. As new technologies emerge to make engineered beams from what was once scrapwood, it seems that it will remain a viable building product—with less negative impact on the environment.

7.20 Burnham & Root, Monadnock Building, Chicago, 1889–91.

7.21 Richard Buckminster Fuller, Geodesic dome, Climatron, St. Louis, Missouri, 1959.

Steel

Steel gives almost limitless possibilities for construction. Its introduction into the nineteenth-century industrial age forever changed style and scale in architecture. Steel-cage and cantilever construction were noted earlier. *Suspension construction* in structures such as bridges, superdomes, and aerial walkways has carried architects to the safe limits of space spansion—and sometimes beyond. The *geodesic dome* (Fig. 7.21), invented by an American architect, R. Buckminster Fuller, is a unique use of materials. Consisting of a network of metal rods and hexagonal plates, the dome is a light, inexpensive, yet strong and easily assembled building. Although it has no apparent size limit (Fuller claimed that he could roof New York City, given the funds), its potential for variation and aesthetic expressiveness seems somewhat limited.

LINE, REPETITION, AND BALANCE

Line and repetition perform the same compositional functions in architecture as in painting and sculpture. In his Marin County Courthouse in California (Fig. 7.22), Frank Lloyd Wright takes a single motif—the arc—and varies only its size, repeating it almost endlessly. The result, rather than being monotonous, is dynamic and fascinating.

Let's look at three other buildings. The main gate of Hampton Court Palace (Fig. 7.23), built in the English Tudor style around 1515 by Thomas Wolsey, at first appears haphazard because there seems to be virtually no repetition. Actually, this section of the palace is quite symmetrical, working its way left and right of the central gatehouse in mirror images. However, the myriad chimneys, the imposition of the main palace, which is not centered on the main gate, and the vantage point of the illustration cause an apparent clutter of line and form that prompts this initial reaction. Line and its resultant form give Hampton Court Palace the appearance of a substantial castle.

Although it seems incredible, Figure 7.24 shows part of the same Hampton Court Palace. Figure 7.23 reflects the style and taste of England during the reign of Henry VIII (who appropriated the palace from its original owner). Later monarchs disliked the cumbersome and medieval appearance, and Christopher Wren was commissioned to plan a "new" palace. So, in 1689, in the reign of William and Mary, renovation of the palace proper began. The result was a new and Classically oriented façade in the style of the English Baroque.

7.22 Frank Lloyd Wright, Marin County Courthouse, California, 1957–63.

As we can see in Figure **7.24**, Wren has designed a sophisticated and overlapping system of repetition and balance. Note first that the façade is symmetrical. The outward wing at the far left of the photograph is duplicated at the right. In the center of the building are four attached columns surrounding three windows. The middle window forms the exact center of the design, with mirror-image repetition on each side. Note that above the main windows is a series of relief sculptures, *pediments* (triangular casings), and circular windows. Now return to the main row of windows at the left border of the picture and count toward the center. The outer wing contains four windows; then seven windows, then the central three; then seven; and finally four. Patterns of threes and sevens are very popular in architecture and carry religious and mythological symbolism. Wren has established a pattern of four in the outer wing, three in the center, and then repeated it within each of the seven-window groups to create yet three addi-

tional patterns of three! How is it possible to create patterns of three with only seven windows? First, locate the center window of the seven. It has a pediment and a relief sculpture above it. On each side of this window are three windows (a total of six) without pediments. So, we have two groupings of three windows each. Above each of the outside four windows is a circular one. The window on each side of the center window does not have a circular one above it. Rather, it has a relief sculpture, the presence of which joins these two windows with the center window to give us our third grouping of three. Line, repetition, and balance in this façade form a marvelous perceptual exercise and experience.

Buckingham Palace, London (Fig. **7.25**), and the Palace of Versailles (Fig. **7.26**) illustrate different treatments of line and repetition. Buckingham Palace uses straight line exclusively, with repetition of rectilinear and triangular form. Like Hampton Court Palace, it exhibits *fenestration*

7.23 Hampton Court Palace, England, Tudor entry, c. 1515.

groupings of threes and sevens, and the building itself is symmetrically balanced and divided by three pedimented, porticolike protrusions. Notice how the predominantly horizontal line of the building is broken by the three major pediments and given interest and contrast across its full length by the window pediments and the verticality of the attached columns.

Compare Buckingham Palace with the Palace of Versailles, in which repetition occurs in groupings of threes and fives. Contrast is provided by juxtaposition and repetition of curved lines in the arched windows and Baroque statuary. Notice how the horizontal shape of the building, despite three porticoes, remains virtually undisturbed, in contrast with that of Buckingham Palace.

SCALE AND PROPORTION

The mass, or scale, and proportion of a building and its component elements are very important compositional qualities. Scale refers to the building's size and the relationship of the building and its decorative elements to the human form.

Proportion, or the relationship of individual elements in a composition to each other, also plays a role in the overall analysis and appearance of a design. Let's step outside architecture for a familiar example. The Concorde supersonic airliner appears to be a rather large plane when viewed on the movie screen or on television. Yet if we were to see the plane in actuality, we would be surprised to find that it is not particularly large in comparison with a DC10, a Boeing 747, or even a Boeing 757. It is the proportion of the Concorde's window area to its overall size that is misleading when we see the plane out of context. Its windows are very small—much smaller than those in other airliners. So when we see the Concorde in a newsreel we immediately equate the window size with which we are familiar with the windows in the Concorde. We assume that the relationships or proportion of window size to overall fuselage is conventional, and that assumption gives us a larger-than-actual image of the size of the plane.

In terms of architecture, proportion and scale are tools by which the architect can create relationships, either straightforward or deceptive. In many buildings, proportion is mathematical: The relationship of one part to

7.24 Hampton Court Palace, England, Wren façade, 1689.

another is often based on ratios such as three to two, one to two, or one to three, as were the parts of the highboy (Fig. **0.9**) discussed in the Introduction. Discovering such relationships in buildings is one of the fascinating ways in which we can respond to architecture.

CONTEXT

An architectural design should take into account its context, or environment. In many cases context is essential to the statement made by the design. For example, Chartres Cathedral (Fig. **7.27**) sits at the center of and on the highest point in the town of Chartres. Its placement at that particu-lar location had a purpose for the medieval artisans and clerics responsible for its design. The centrality of the cathedral to the community was an essential statement of the centrality of the church in the life of the medieval community. Context also has a psychological bearing on scale. A skyscraper in the midst of skyscrapers has great mass but does not appear as massive as it would in isolation. A cathedral, alongside a skyscraper, looks relatively small in scale. However, one standing at the center of a community of small houses appears quite the opposite.

Context is also important in terms of the design of line, form, and texture relative to the physical environment. Sometimes the environment can be shaped according to

7.25 Buckingham Palace, London, c. 1825.

7.26 Louis Le Vau and Jules Hardouin-Mansart, Palace of Versailles, France, 1669–85.

the compositional qualities of the building, as or after it is constructed. Perhaps the best illustration of that principle is Louis XIV's palace at Versailles, whose formal symmetry is reflected in the design of thousands of acres around it. On a more modest scale, the formal gardens of Hampton Court (Fig. **7.28**) were planned to reflect the line and form of the palace.

On the other hand, a building may be designed so as to reflect the natural characteristics of its environment. Frank Lloyd Wright's Fallingwater, in Pennsylvania (Fig. **7.29**), illustrates this principle. Such an idea has been advanced by many architects and can be seen especially in residences where large expanses of glass allow us to feel a part of the outside while we are inside. The interior decoration of such houses often takes as its theme the colors, textures, lines, and forms of the environment surrounding the home. Natural fibers, earth tones, delicate wooden furniture, pictures that reflect the surroundings, large open spaces—together they form the core of the design, selection, and placement of nearly every item in the home, from walls to furniture to silverware.

SPACE

It seems almost absurdly logical to state that architecture must concern space—for what else, by definition, is architecture? However, the world is overwhelmed with examples of architectural design that have not met that need. Design of space essentially means the design and flow of contiguous spaces relative to function. Take, for example, a sports arena. Of primary concern is the space necessary for the sports intended to occupy the building. Will it play host to basketball, hockey, track, football, or baseball? Each of these sports places a design restriction on the architect, and there may be curious results when functions not intended

by the design are forced into its parameters. When the Brooklyn Dodgers moved to Los Angeles, they played for a time in the Los Angeles Coliseum, a facility designed for the Olympic Games and track and field, and reasonably suited to the addition of football. However, the imposition of baseball created ridiculous effects; the left-field fence was only slightly over 200 feet (61 m) from home plate!

In addition to the requirements of the game, a sports arena must accommodate the requirements of the spectators. Pillars that obstruct the spectator's view do not create goodwill and discourage the purchase of tickets. Likewise, attempting to put too many seats in a confined space can create severe discomfort. It is not easy to determine where to drawn the line between more seats and fan comfort. The old Montreal Forum, in which anyone over the height of 5 feet 2 inches (1.58 m) was forced to sit with their knees under their chin, was not deleterious to ticket sales for the Montreal Canadiens hockey team. However, such space design might be disastrous for a franchise in a less hockey-oriented city.

7.27 Chartres Cathedral, France, exterior, 1145–1220.

7.28 Hampton Court Palace, England, view of formal landscaping

Finally, the design of space should take into account various needs peripheral to the primary functions of the building, such as rest rooms and concession stands.

Once functional concerns have been met, the architect can start to consider aesthetic aspects of space design. Eero Saarinen's Trans-World Airline Terminal in New York City takes the dramatic shape of flight in curved lines and carefully designed spaces, which accommodate large masses of people and channel them to and from waiting aircraft. (Such shapes can be executed only using modern con-

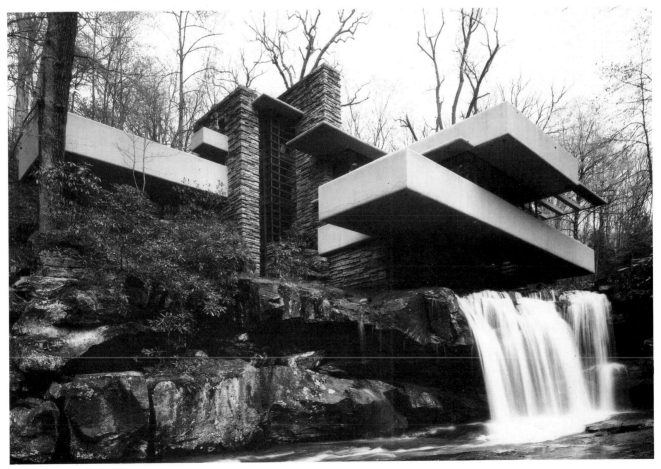

7.29 Frank Lloyd Wright, Fallingwater, Bear Run, Pennsylvania, 1936–7.

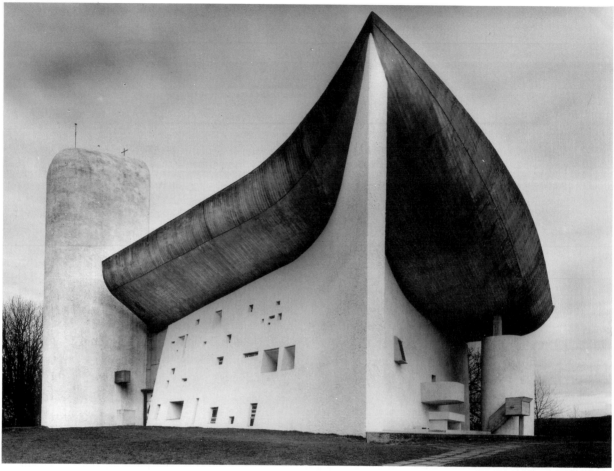

7.30 Le Corbusier, Notre-Dame-du-Haut, France, from the southeast, 1950–4.

struction techniques and materials such as reinforced concrete.) Flight has also been suggested by Le Corbusier's dynamic church Notre-Dame-du-Haut (Fig. 7.30). However, this pilgrimage church appears more like a work of sculpture than a building. Here function cannot be surmised from form. Rather, the juxtaposed *rectilinear* windows and *curvilinear* walls and the overwhelming roof nestled lightly on thin pillars above the walls all appear as a "pure creation of the spirit."

CLIMATE

Climate has always been a factor in architectural design in zones of severe temperature, either hot or cold. As the world's energy supplies diminish, this factor will grow in importance. In the temperate climate of much of the United States, solar systems and designs that make use of the moderating influence of the earth are common. These are *passive* systems—that is, their design accommodates

natural phenomena rather than adding technological devices such as solar collectors.

For example, in the colder areas of the United States an energy-efficient building can be made by creating a design with no glass, or minimal glass, on its north-facing side. Windows looking south can be covered in the summer and then uncovered to catch sunlight in midwinter, when it still provides considerable warmth.

Since temperatures at the shallow depth of 3 feet (1 m) below the earth's surface rarely go above or below 50°F (10°C), regardless of season, the earth presents a gold mine of potential for design. Houses built into the sides of hills or recessed below the earth's surface require much less heating or cooling than those standing fully exposed—whatever the extremes of climate. Even in zones of uniform and moderate temperature, climate is a design factor. The "California lifestyle," as it is often known, is responsible for design that accommodates easy access to the out-of-doors and large, open spaces with free-flowing traffic patterns.

Frank Lloyd Wright

Frank Lloyd Wright (1867–1959) pioneered ideas in architecture far ahead of his time and became probably the most influential architect of the twentieth century. Born in Richland Center, Wisconsin, Wright grew up under strong influences of his clergyman father's love of Bach and Beethoven. He entered the University of Wisconsin at fifteen, forced to study engineering because the school had no architecture program.

In 1887 Wright took a job as a draughtsman in Chicago and, the next year, joined the firm of Adler and Sullivan. In short order Wright became Louis Sullivan's chief assistant. As Sullivan's assistant Wright handled most of the firm's designing of houses. Deep in debt, Wright moonlighted by designing for private clients on his own. When Sullivan objected, Wright left the firm to set up his own private practice.

As an independent architect, Wright led the way in a style of architecture called the Prairie school. Houses designed in this style have low-pitched roofs and strong horizontal lines reflecting the flat landscape of the American prairie. These houses also reflect Wright's philosophy that interior and exterior spaces blend together.

In 1904 Wright designed the strong, functional Larkin Building in Buffalo, New York, and in 1906 the Unity Temple in Oak Park, Illinois. After traveling to Japan and Europe, he returned to America in 1911 to build a house on his grandfather's farm, Taliesin, which is Welsh for "shining brow." In 1916 Wright designed the Imperial Hotel in Tokyo, floating the structure on an underlying sea of mud. As a consequence, when the catastrophic earthquake of 1923 occurred, the hotel suffered very little damage.

The Great Depression of the 1930s greatly curtailed new building projects, and Wright spent his time writing and lecturing. In 1932 he established the Taliesin Fellowship, a school in which students learned by working with building materials and problems of design and construction. In winter the school moved from Wisconsin to Taliesin West, a desert camp near Phoenix, Arizona.

The mid-1930s represented a period of intense creative output for Wright, and some of his most famous designs occurred during those years. Perhaps his most dramatic project, the Kaufmann House—Fallingwater—in Bear Run, Pennsylvania (**Fig. 7.29**) emerged in 1936–7 during this period. Another famous project was the S. C. Johnson and Son Administration Building in Racine, Wisconsin.

Two other significant buildings, among many, came later. The Solomon R. Guggenheim Museum (**Fig. 7.40**) began in 1942 with completion in 1957, and the Marin County Courthouse, California, followed over the period 1957–63.

Wright's work was always controversial, and he lived a flamboyant life full of personal tragedy and financial difficulty. Married three times, he had seven children and died in Phoenix, Arizona on April 9, 1959.

HOW DOES IT STIMULATE THE SENSES?

As should be clear by this point, our sensual response to a form of aesthetic design is a composite experience. The individual characteristics we have discussed previously are the stimuli for our response. Lately, color has become an especially important tool for the Postmodern architect in stimulating our sense responses. The effects of color in the Piazza d'Italia (Fig. 7.33) turn architecture into an exotic sensual experience.

CONTROLLED VISION AND SYMBOLISM

The Gothic cathedral has been described as the perfect synthesis of intellect, spirituality, and engineering. The upward, striving line of the Gothic arch makes a simple yet powerful statement of medieval people's striving to understand their earthly relation to the spiritual unknown. Even today the simplicity and grace of that design have an effect on most who view a Gothic cathedral such as Notre Dame, Paris (Fig. 7.34).

The cathedral at Amiens (Fig. 7.35) is similar in basic composition to Notre Dame, but rather than creating a

ARCHITECTURE AND HUMAN REALITY

Le Corbusier, *Villa Savoye*

Art and architecture of the early twentieth century began to exhibit a no-nonsense approach that was simple and straightforward. That quality found an exponent in the Swiss painter–architect Charles-Edouard Jeanneret (1887–1965), known by his pseudonym Le Corbusier. Le Corbusier defined a house as "a machine for living." By that he did not mean that a house ought to be an artless, empty mechanical environment fit only for robots to inhabit. Rather, as was fairly typical of his time, he saw machines as beneficial to human needs. Le Corbusier believed that a house should be conceived, designed, and produced in the same rational manner as are tools, cars, and airplanes. He thought that traditional houses were irrational in design and frustrated the promise of the new age and the good life that machines would bring.

As a result, Le Corbusier attempted to design simple buildings whose structure and inner logic were clear and void of any surface decoration. The function of a building was to be clearly recognizable in the relation of its forms. Le Corbusier's realization of his philosophy came in the Villa Savoye, just outside Paris (Fig. **7.31**). Villa Savoye uses ferroconcrete, which exploits the possibilities offered by skeleton framing to create free and open spaces in the interior. It is a cube on pillars of reinforced concrete called pilotis (**Fig. 7.32**). This was a favorite device of Le Corbusier's because it allowed space to flow under and through the building and enhanced its sense of volume. Hollowed out on three sides, Villa Savoye allows sunlight to flood the center of the building. Without load-bearing walls in the interior, free space abounds. The building has no "front" or "back" because it is open on every side. Thus it achieves Le Corbusier's objective of total interpenetration of outer and interior space.

7.32 Section of the Villa Savoye.

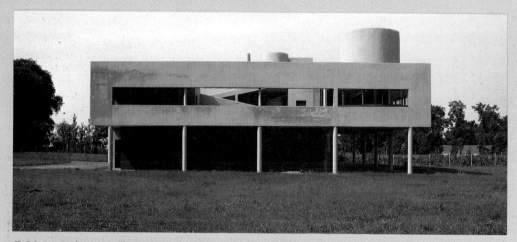

7.31 Le Corbusier, Villa Savoye, Poissy, France, 1928–30.

sense of foursquare power, it gives an impression of delicacy. Amiens Cathedral illustrates a late development of Gothic style. The differences between Amiens and Notre Dame provide an important lesson in the ways design can be used to elicit a response. At Amiens, greater detail, as opposed to flat stone, focuses our attention. Both cathedrals are divided into three obvious horizontal and vertical sections of roughly the same proportion. Notre Dame appears to rest heavily on its lowest section, whose proportions are diminished by the horizontal band of sculptures above the portals. Amiens, on the other hand, carries its portals upward to the full height of the lower section. In fact, the central portal, much larger than the central portal of Notre Dame, reinforces the line of the side portals to form a pyramid whose apex penetrates into the section above. The roughly equal size of the three portals of Notre Dame reinforces its horizontal sense, thereby giving it stability. Similarly, each use of line, form, and proportion in Amiens reinforces lightness and action, as compared with stability and strength in Notre Dame. This is not to imply that one design is better than the other. Each is valid on its own terms, and simply displays a different approach.

Together with the grandeur of simple vertical line in Gothic cathedrals is an ethereal lightness which defies the material from which they were constructed. The medieval architect created in stone not the heavy yet elegant composition of the early Greeks, which focused upon treatment of stone, but rather a construction that focuses on space—the ultimate mystery. Inside the cathedrals, the stained glass high above the worshipers' heads so controls the light entering that the overwhelming effect is, again, one of mystery. Line, form, scale, color, structure, balance, proportion, context, and space all combine to form unified compositions that have stood for hundreds of years as symbols of the Christian experience.

A totally different appeal to the emotions emerges from the ornate German Baroque Kaisersaal Residenz in Würzburg (Fig. 7.36), wherein opulence is the message conveyed by line and form, materials and color.

STYLE

The Christian experience is once again the determining factor in the design of the Holy Family Church in Parma, Ohio (Fig. 7.38). However, despite the upward-striving power of its composition that links it with its medieval predecessors, this church has a modern clarity of line and sophistication, which perhaps speaks more of our own conception of space as less unknowable and more conquerable. The juxtaposing of straight and curved lines

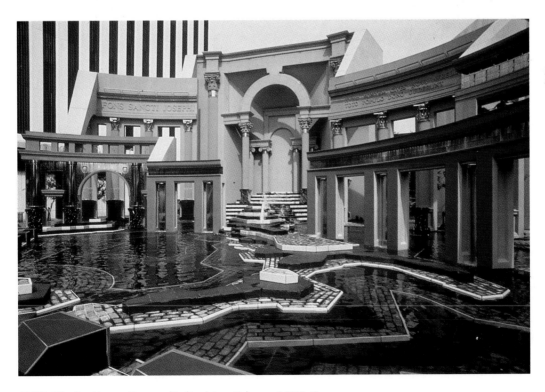

7.33 Charles Moore, Piazza d'Italia, New Orleans, 1978–9.

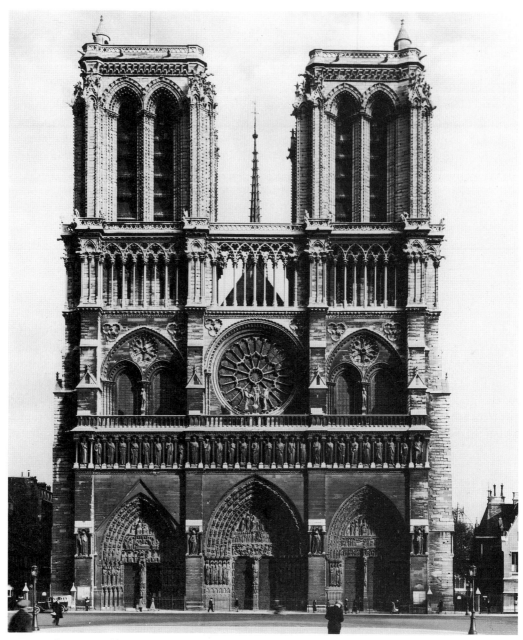

7.34 Notre Dame, Paris, west front, 1163–1250.

creates an active and dynamic response—one that prompts in us abruptness rather than mystery. The composition is cool, and its material calls attention to itself by its starkness and lack of decoration.

Each part of the church is distinct and is not quite subordinate to the totality of the design. This building perhaps represents a philosophy intermediate between that underlying Chartres Cathedral, whose entire design can be reduced to a single motif—the Gothic arch—and that of the Baroque, as seen in the Hall of Mirrors of the Palace of Versailles (Fig. 7.37). No single part of the design of this hall epitomizes the whole, yet each part is subordinate to

the whole. Our response to the hall is shaped by its ornate complexity, which calls for detachment and investigation and intends to overwhelm us with its opulence. Here, as in most art, the expression and stimuli reflect the patron. Chartres Cathedral reflects the medieval church; the Church of the Holy Family, the contemporary church; and Versailles, King Louis XIV. Versailles is complex, highly active, and yet warm. The richness of its textures, the warmth of its colors, and its curvilinear softness create a certain kind of comfort despite its scale and formality.

In the United States Capitol, a Neoclassical house of government (Fig. 7.39), formality creates a foursquare,

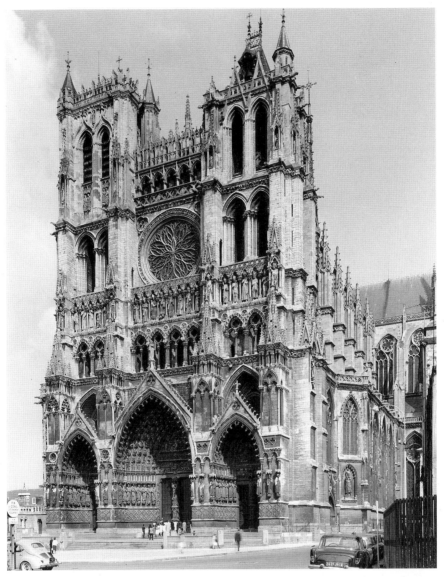

7.35 Amiens Cathedral, France, west front, c. 1220–59.

solid response. The symmetry of its design and the weight of its material give us a sense of impersonal power, which is heightened by the crushing weight of the dome. No longer do we see the upward-striving spiritual release of the Gothic arch, or even the powerful elegance of the Greek post-and-lintel. The Capitol Building, based on a Roman prototype, elicits a sense of struggle. This effect is achieved through upward columnar thrust (heightened by the context provided by Capitol Hill) and downward thrust (of the dome), focused toward the interior.

APPARENT FUNCTION

The architect Louis Sullivan (of whom Frank Lloyd Wright was a pupil) is credited with the concept that form follows function. To a degree we have seen that concept in the previous examples, even though, with the exception of the Church of the Holy Family, they all precede Sullivan in time. A worthy question concerning the Guggenheim Museum in New York City (Fig. 7.40) might be how well Wright followed his teacher's philosophy. There is a story that Wright hated New York City because of unpleasant experiences he had had with the city fathers during previous projects. As a result, the Guggenheim, designed late in his life, became his final gesture of derision to the city. This center of contemporary culture and art, with its single, circular ramp from street level to roof, was built (so the story goes) from the plans for a parking garage! Be that as it may, its line and form create a simple, smoothly flowing, leisurely, upward movement juxtaposed against another

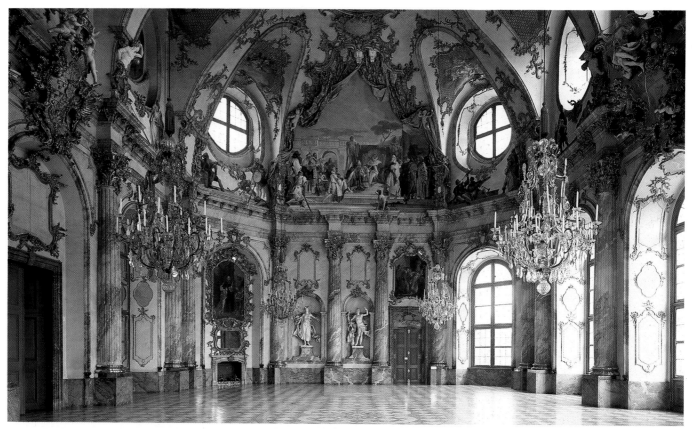

7.36 Balthasar Neumann, Kaisersaal Residenz, Würzburg, Germany, 1719–44.

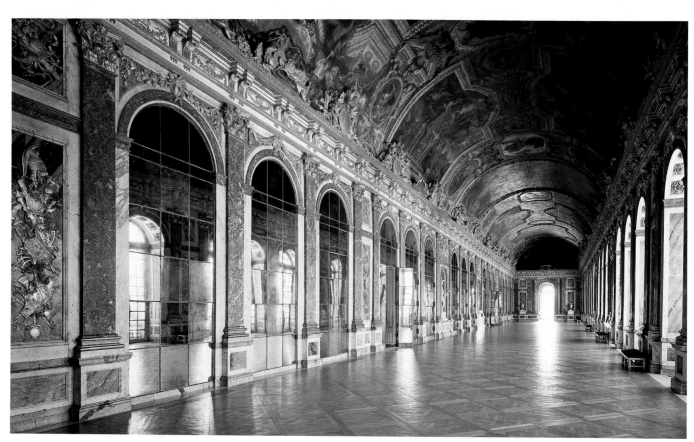

7.37 Jules Hardouin-Mansart and Charles Le Brun, Palace of Versailles, France, Hall of Mirrors, 1680.

7.38 Conrad & Fleishman, Holy Family Church, Parma, Ohio, 1965.

7.39 United States Capitol Building, Washington, D.C., 1792–1856.

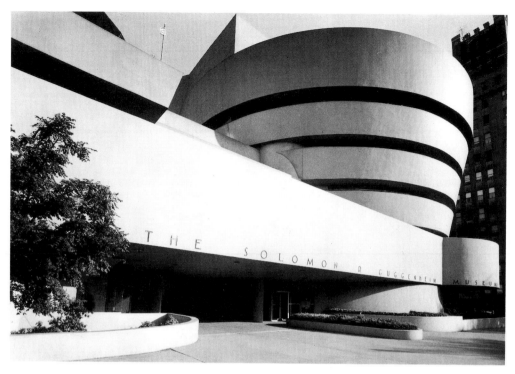

7.40 Frank Lloyd Wright, Guggenheim Museum, New York, 1942–59.

stark and dynamic rectilinear form. The building's line and color and the feeling they produce are contemporary statements appropriate to the contemporary art the museum houses. Its modernity is quite in contrast with the Classical proportions of the Metropolitan Museum of Art, just down the street, which houses great works of ancient and modern art. The Guggenheim's interior design is outwardly expressed in the ramp, and one can argue whether its slowly curving, unbroken line is highly appropriate to the manner and pace that one should pursue when going through a museum.

DYNAMICS

Leisurely progress is hardly what one would think of when confronted by the cantilevered roof of the grandstand at Zarzuela Race Track in Spain (Fig. 7.17). Speed, power, and flight are its preeminent concerns. The sense of dynamic instability inherent in the structural form—cantilever—and this particular application of it mirror the dynamic instability and forward power of the race horse at full speed. However, despite the form and the strong diagonals of this design, it is not out of control. The architect has created unity by repeating the track-level arcade in the arched line of the cantilevered roof. The design is dynamic and yet humanized in the softness of its curves and the control of its scale.

SCALE

Nothing symbolizes the technological achievement of modern humans more than the skyscraper. Also, nothing symbolizes the subordination of humans to their technology more than the scale of this monumental type of building (Fig. 7.41). Designed with rectangular components placed side by side, Chicago's Sears Tower is a glass and steel monolith overwhelming in its scale and proportions and cold in its materials. As a point of departure, its appeal to our senses raises the question of what comes next—the conquest of space, or a return to respect for its natural mysteries?

7.41 Skidmore, Owings, & Merrill, Sears Tower, Chicago, 1971.

CHAPTER EIGHT

LITERATURE

WHAT IS IT?

HOW IS IT PUT TOGETHER?

HOW DOES IT STIMULATE THE SENSES?

IMPORTANT TERMS

Fiction A work of literature created from the author's imagination rather than from fact.

Narrative poetry Poetry that tells a story.

Lyric poetry A brief, subjective work employing strong imagination, melody, and feeling.

Point of view The perspective of a work of fiction: first person, epistolary, third person, stream of consciousness.

Plot The structure of a work of literature.

Imagery A verbal representation of a sensory experience.

Figures The use of language to take words beyond their literal meaning.

Metaphors Figures of speech that give new implications to words; they are implied comparisons.

Meter The type and number of rhythmic units in a line of poetry.

Anecdotes Stories or observations about moments in a biography.

Read any good books lately? Ever tried to write poetry? From the earliest of times, cultures have been defined by their literature. Even before the invention of writing, myths and legends and prose and poetry told people who they were and where they came from. Today, before there can be a movie or a soap opera, there must be a story and, usually, a script. Such things comprise literature, our last subject for discussion in Part One.

WHAT IS IT?

In the same sense that all artworks communicate someone's perception of reality or truth, so literature communicates using the forms discussed below. There is a difference of approach between the two basic categories —literature that some call utilitarian and literature that may be creative. The approach determines the category in the same sense that a picture composed of line, form, and color is termed "art," whereas another picture, composed of those same characteristics but whose purpose is to provide a visual copy, is merely "illustration."

FICTION

Fiction is a work created from the author's imagination rather than from fact. Normally it takes one or two approaches to its subject matter: *realistic*—that is, the appearance of observable, true-to-life details; or *nonrealistic*—that is, fantasy. Other literary forms such as narrative poetry and drama can also be fiction, and fictional elements can be introduced into forms such as biography and epic poetry. Fiction is traditionally divided into *novels* and *short stories*.

PROFILE

Toni Morrison

Toni Morrison (b. 1931) was born in Lorain, Ohio as Chloe Anthony Wofford. She was the second of four children of George Wofford, a shipyard welder, and Ramah Willis Wofford. Her parents moved to Ohio from the South to escape racism and to find better opportunities in the North. At home, Chloe heard many songs and tales of Southern black folklore. The Woffords were proud of their heritage. Lorain was a small industrial town populated with immigrant Europeans, Mexicans, and Southern blacks who lived next to each other. Chloe attended an integrated school. In her first grade, she was the only black student in her class and the only child who could read. She was friends with many of her white schoolmates and did not encounter discrimination until she started dating. In college at Howard University in Washington, D.C., she majored in English, and because many people couldn't pronounce her first name correctly, she changed it to Toni, a shortened version of her middle name.

Later she taught at Howard, where she joined a small writers' group as refuge from an unhappy marriage to a Jamaican architect, Harold Morrison. Today Ms Morrison is one of America's most celebrated authors. Her six major novels, *The Bluest Eye* (1969). *Sula* (1973), *Song of Solomon* (1977), *Tar Baby* (1981), *Beloved* (1987), and *Jazz* (1992), have received extensive national acclaim. She received the National Book Critics Circle Award in 1977 for *Song of Solomon* and the 1988 Pulitzer Prize for *Beloved*. In 1993 Ms Morrison was awarded the Nobel Prize for literature. She is an editor at Random House and a visiting lecturer at Yale University.

She is noted for her spare but poetic language, emotional intensity, and sensitive observation of African American life. Her novel *Jazz* is meant to follow *Beloved* as the second volume of a projected trilogy, although *Jazz* doesn't extend the story told in *Beloved* in a conventional way. The characters are new, and so is the location. Even the narrative approach is different. In terms of chronology, however, *Jazz* begins roughly where *Beloved* ended and continues the greater story. Morrison wishes to tell of her people passing through their American experience, from the days of slavery in the 1900s to the present. The individuals struggle to establish and sustain a personal identity without abandoning their own history, while individual and community interests clash. *Jazz* reads like a blues ballad from the musical age it suggests.

Alice Walker, "Roselilly"

Wit and irony are tools used by the black American author Alice Walker (Fig. 8.1) in her novels, poetry, and critical writings. The battles she fights are for rights for blacks and women. However, she is prone to satirize political activists just as much as their opponents. Her life and writing reflect the tensions and ideals of a "womanist"—a word she has coined for a black feminist. The "twin afflictions" of the civil rights and black power movements and the women's movement are the focus of her work.

Walker came from a family of Georgia sharecroppers and was one of eight children. Because a childhood accident left her blind in one eye, she was able to attend Spelman College, a prestigious black women's college in Atlanta, on a state rehabilitation scholarship. She continued her education at Sarah Lawrence in New York and graduated in 1965. Her identity as a black and a woman was challenged by an unwanted pregnancy, an abortion, and a trip to South Africa. She returned to the South and married a Jewish civil rights leader, from whom she was divorced in 1976.

Her short stories indicate a preoccupation with "the oppressions, the insanities, the loyalties, and the triumphs of black women." Her technique is subtle and experimental, and we can see some of that in the way that she weaves together the ritual of the marriage ceremony and the thoughts of her female character in "Roselilly" as a counterpoint to her theme of the distance between promise and fulfillment.

8.1 Alice Walker reading six poems and excerpts from her Pulitzer Prizewinning novel *The Color Purple* in 1985.

Roselilly
Alice Walker
(b. 1944)

Dearly Beloved.
She dreams; dragging herself across the world. A small girl in her mother's white robe and veil, knee raised waist high through a bowl of quicksand soup. The man who stands beside her is against this standing on the front porch of her house, being married to the sound of cars whizzing by on highway 61.

We are gathered here
Like cotton to be weighed. Her fingers at the last minute busily removing dry leaves and twigs. Aware it is a superficial sweep. She knows he blames Mississippi for the respectful way the men turn their heads up in the yard, the women stand waiting and knowledgeable, their children held from mischief by teachings from the wrong God. He glares beyond them to the occupants of the cars, white faces glued to promises beyond a country wedding, noses thrust forward like dogs on a track. For him they usurp the wedding.

in the sight of God
Yes, open house. That is what country black folks like. She dreams she does not already have three children. A squeeze around the flowers in her hands chokes off three and four and five years of breath. Instantly she is ashamed and frightened in her superstition. She looks for the first time at the preacher, forces humility into her eyes, as if she believes he is, in fact, a man of God. She can imagine God, a small black boy, timidly pulling the preacher's coattail.

to join this man and this woman
She thinks of ropes, chains, handcuffs, his religion. His place of worship. Where she will be required to sit apart with covered head. In Chicago, a word she hears when thinking of smoke, from his description of what a cinder was, which they never had in Panther Burn. She sees hovering over the heads of the clean neighbors in her front yard black specks falling, clinging from the sky. But in Chicago. Respect, a chance to build. Her children at last from underneath the detrimental wheel. A chance to be on top. What a relief, she thinks. What a vision, a view, from up so high.

in holy matrimony
Her fourth child she gave away to the child's father who had some money. Certainly a good job. Had gone to Harvard. Was a good man but weak because good language meant so much to him he could not live with Roselilly. Could not abide TV in the living room, five beds in three rooms, no Bach except from four to six on Sunday afternoons. No chess at all. She does not forget to worry about her son among his father's people. She wonders if the New England climate will agree with him. If he

170

will ever come down to Mississippi, as his father did, to try to right the country's wrongs. She wonders if he will be stronger than his father. His father cried off and on throughout her pregnancy. Went to skin and bones. Suffered nightmares, retching and falling out of bed. Tried to kill himself. Later told his wife he found the right baby through friends. Vouched for, the sterling qualities that would make up his character.

It is not her nature to blame. Still, she is not entirely thankful. She supposes New England, the North, to be quite different from what she knows. It seems right somehow to her that people who move there to live return home completely changed. She thinks of the air, the smoke, the cinders. Imagines cinders big as hailstones; heavy, weighing on the people. Wonders how this pressure finds its way into the veins, roping the springs of laughter.

If there's anybody here that knows a reason why

But of course they know no reason why beyond what they daily have to know. She thinks of the man who will be her husband, feels shut away from him because of the stiff severity of his plain black suit. His religion. A lifetime of black and white. Of veils. Covered head. It is as if her children are already gone from her. Not dead, but exalted on a pedestal, a stalk that has no roots. She wonders how to make new roots. It is beyond her. She wonders what one does with memories in a brand-new life. This had seemed easy, until she thought of it. "The reasons why . . . the people who" . . . she thinks, and does not wonder where the thought is from.

these two should not be joined

She thinks of her mother, who is dead. Dead, but still her mother. Joined. This is confusing. Of her father. A gray old man who sold wild mink, rabbit, fox skins to Sears, Roebuck. He stands in the yard, like a man waiting for a train. Her young sisters stand behind her in smooth green dresses, with flowers in their hands and hair. They giggle, she feels, at the absurdity of the wedding. They are ready for something new. She thinks the man beside her should marry one of them. She feels old. Yoked. An arm seems to reach out from behind her and snatch her backward. She thinks of cemeteries and the long sleep of grandparents mingling in the dirt. She believes that she believes in ghosts. In the soil giving back what it takes.

together

In the city. He sees her in a new way. This she knows, and is grateful. But is it enough? She cannot always be a bride and virgin, wearing robes and veil. Even now her body itches to be free of satin and voile, organdy and lily of the valley. Memories crash against her. Memories of being bare to the sun. She wonders what it will be like. Not to have to go to a job. Not to work in a sewing plant. Not to worry about learning to sew straight seams in workingmen's overalls, jeans, and dress pants. Her place will be in the home, he has said, repeatedly, promising her rest she had prayed for. But now she wonders. When she is rested, what will she do? They will make babies—she thinks practically about her fine brown body, his strong black one. They will be inevitable. Her hands will be full. Full of what? Babies. She is not comforted.

let him speak

She wishes she had asked him to explain more of what he meant. But she was impatient. Impatient to be done with sewing. With doing everything for three children, alone. Impatient to leave the girls she had known since childhood, their children growing up, their husbands hanging around her, already old, seedy. Nothing about them that she wanted, or needed. The fathers of her children driving by, waiving, not waving; reminders of times she would just as soon forget. Impatient to see the South Side, where they would live and build and be respectable and respected and free. Her husband would free her. A romantic hush. Proposal. Promises. A new life! Respectable, reclaimed, renewed. Free! In robe and veil.

or forever hold

She does not even know if she loves him. She loves his sobriety. His refusal to sing just because he knows the tune. She loves his pride. His blackness and his gray car. She loves his understanding of her *condition*. She thinks she loves the effort he will make to redo her into what he truly wants. His love of her makes her completely conscious of how unloved she was before. This is something; though it makes her unbearably sad. Melancholy. She blinks her eyes. Remembers she is finally being married, like other girls. Like other girls, women? Something strains upward behind her eyes. She thinks of the something as a rat trapped, cornered, scurrying to and fro in her head, peering through the windows of her eyes. She wants to live for once. But doesn't know quite what that means. Wonders if she has ever done it. If she ever will. The preacher is odious to her. She wants to strike him out of the way, out of her light, with the back of her hand. It seems to her he has always been standing in front of her, barring her way.

his peace

The rest she does not hear. She feels a kiss, passionate, rousing, within the general pandemonium. Cars drive up blowing their horns. Firecrackers go off. Dogs come from under the house and begin to yelp and bark. Her husband's hand is like the clasp of an iron gate. People congratulate. Her children press against her. They look with awe and distaste mixed with hope at their new father. He stands curiously apart, in spite of the people crowding about to grasp his free hand. He smiles at them all but his eyes are as if turned inward. He knows they cannot understand that he is not a Christian. He will not explain himself. He feels different, he looks it. The old women thought he was like one of their sons except that he had somehow got away from them. Still a son, not a son. Changed.

She thinks how it will be later in the night in the silvery gray car. How they will spin through the darkness of Mississippi and in the morning be in Chicago, Illinois. She thinks of Lincoln, the president. That is all she knows about the place. She feels ignorant, *wrong*, backward. She presses her worried fingers into his palm. He is standing in front of her. In the crush of well-wishing people, he does not look back.[1]

171

Novels

The novel is a prose narrative of considerable length which has a plot that unfolds from the actions, speech, and thoughts of the characters. Normally the novel treats events within the range of ordinary experience and draws upon original subject matter rather than traditional or mythic subjects. Novels typically have numerous characters and employ normal, daily speech. Their subject matter can be divided into two general categories: *sociological-panoramic*, covering a wide-ranging story of many years and various settings; and *dramatic-intimate*, which is restricted in time and setting.

Often, novels are formally classified by their subject matter. A few of these categories are:

picaresque the adventures of a rogue

manners problems of personal relations

sentimental the development of emotionality, especially a sentimental appreciation of simplicity

Gothic the trials of a pure, sensitive, and noble heroine who undergoes terrifying experiences, emerging undamaged—usually this type of novel is stilted and melodramatic and exploits the dark side of emotional psychology

historical intertwines historical events and fictional characters

realistic focuses on familiar situations and ordinary people

lyrical a short work with a metaphoric structure and a limited number of characters.

Short Stories

As the name implies, short stories are short prose fictional works focusing on unity of characterization, theme, and effect.

POETRY

Poetry is designed to convey a vivid and imaginative sense of experience. It uses condensed language selected for its sound, suggestive power, and meaning, and employs specific technical devices such as meter, rhyme, and metaphor. Poetry can be divided into three major types: *narrative*, *dramatic*, and *lyric*.

Narrative

Narrative poetry tells a story. *Epic* poetry is narrative poetry of substantial length and elevated style. It uses strong symbolism, and has a central figure of heroic proportions. A *ballad* is a sung or recited narrative, and a *metrical romance* is a long narrative, romantic tale in verse.

Dramatic

Dramatic poetry utilizes dramatic form or dramatic technique. Its major form is the dramatic monologue.

Lyric

Lyric poetry was originally intended to be sung and accompanied by a lyre. It is a brief, subjective work employing strong imagination, melody, and feeling to create a single, unified, and intense impression of the personal emotion of the poet.

BIOGRAPHY

Biography is a written account of a person's life. Over the centuries it has taken many forms and witnessed many techniques and intentions, including literary narratives, catalogues of achievement, and psychological portraits. Accounts of the lives of saints and other religious figures are called *hagiographies*.

ESSAYS

The essay is a non-fictional literary composition on a single subject, usually presenting the personal views of the author. The word comes from the French, meaning "to try" and the vulgar Latin, meaning "to weigh." Essays include many subforms and a variety of styles, but they are characteristically marked by clarity, grace, good humor, wit, urbanity, and tolerance. For the most part, essays are brief, but occasionally much longer works, such as John Locke's treatise, *Essay Concerning Human Understanding* (1690), have appeared. Traditionally, essays fall into two categories: *informal* or *formal*.

Informal

Informal essays tend to be brief, conversational in tone, and loose in structure. They can be categorized as *familiar* (or *personal*) and *character*. The personal essay presents an aspect of the author's personality as he or she reacts to an event. Character essays describe individuals, isolating their dominant traits, for example.

Formal

Formal essays are longer and more tightly structured than informal ones. They tend to focus on impersonal subjects and place less emphasis on the personality of the author.

DRAMA

Drama is the written script, or play, upon which a theatre performance may be based (see Chapter 4).

How is it Put Together?

FICTION

Point of View

Fiction is a story told by someone at a particular time and place to a particular audience. So it has a definite perspective, and, therefore, certain limitations of objectivity. It raises questions about the right way of seeing things. The "point of view" is a device to objectify the circumstances. Four types of narrative point of view are (1) *first person*; (2) *epistolary*—that is, told through the use of letters written by the characters; (3) *omniscient narration* or "third person"; and (4) *stream of consciousness* or "interior monologue"—a flow of thoughts, feelings, and memories coming from a specific character's psyche. These arbitrary definitions may vary, or be combined by authors to suit their own purposes. Point of view, as we have discussed it here, means merely that one of the means by which fiction is put together is usable by an author in several ways, at several levels, to communicate meaning.

Appearance and Reality

Fiction claims to be true to actuality, but it is built on invented sequences of events. It refers back on itself, layering the fictional and the factual.

Tone

Tone may also be known as the atmosphere of the story. In essence, it is the author's attitude toward the story's literal facts. Reading is much like listening to conversation. That is, the words carry meaning, but the way in which they are said—their tone—shapes meaning much more than we realize. In addition, the atmosphere of the story sometimes includes the setting or the physical environment. In many stories, atmosphere is psychological as well as physical, and when all of these characteristics of tone are taken together, they provide subtle and powerful suggestions leading to fuller understanding of the work.

Character

Literature appeals through its people, but not just people alone. It draws our interest because we see a human character struggling with some important problem. Authors write to that potential interest and usually strive to focus our attention, and to achieve unity, by drawing a central character with whose actions, decisions, growth, and development we can identify, and in whom we can find an indication of some broader aspect of the human condition. As we noted in Chapter 4, the term character goes beyond the mere identification of a "person." Character means the psychological spine of individuals, the driving force that makes them respond the way they do when faced with a given set of circumstances. Character is what we are interested in: Given a set of troubling or challenging circumstances, what does the character of the individual lead him or her to do?

In developing character, an author has numerous choices, depending, again, on purpose. Character may be fully three-dimensional and highly individual—that is, as complex as the restrictions of the medium allow. Novels, because of their length and the fact that the reader can go back to double-check a fact or description, allow much more complex character development or individuality than do plays, whose important points must be found by the audience the moment they are presented. Also, a change of narrative viewpoint, appropriate to a novel but not to a play (unless a narrator is used, as in *Our Town*), can give the reader aspects of character in a more efficient manner than can revelation through action or dialogue.

On the other hand, the author's purpose may be served by presenting character not as a fully developed individual but as a type. Whatever the author's choice, the nature of character development tells much about the meaning of the work.

Plot

Plot is the structure of the work. It is more than the story line or the facts of the piece. In literature, as in the theatre, we find our interest dependent upon action. The action of a literary work is designed to dramatize a fully realized theme, situation, or character. Plot is the structure of that action. It creates unity in the work and thereby helps us to find meaning. Plot is the skeleton that determines the ultimate shape of the piece, once the elements of flesh have been added to it.

Plot may be the major or a subordinate focus in a work, and it can be open or closed. Closed plots rely on the Aristotelian model of pyramidal action with an exposition, a complication, and a resolution or dénouement. An open plot has little or no resolution. We merely leave the characters at a convenient point and imagine them continuing as their personalities will dictate.

Theme

Most good stories have an overriding idea or theme by which the other elements are shaped. Quality in works of art rests at least partly on artists' ability to utilize the tools of their medium, as well as on whether they have something worthwhile to say. Some critics argue that the quality of a theme is less important than what the author does with it. Yet the conclusion is inescapable: The best artworks are those in which the author has taken a meaningful theme and developed it exceptionally. The theme or idea of a work is thus what the author has to say. Theme may mean a definite intellectual concept, or it may indicate a highly complex situation such as occurs in "A Rose for Emily," reprinted on page 176. Clues to understanding the idea can come as early as our exposure to the title. Beyond that, the theme is usually revealed in small pieces as we move from beginning to conclusion.

Symbolism

Every work of literature is symbolic to one degree or another. It stands for something greater than its literal reality. Each word is a symbol, as is language. And any story is symbolic inasmuch as it symbolizes human experience.

Often the symbols in a story are cultural in derivation. That is why we can have difficulty in understanding the levels of meaning in works from other cultures. We also find it hard to grasp the symbols in works from our own tradition. The more we know about our culture and its various points of view through history, the more we are able to grasp the symbolism—and thereby the meaning—of the great thinkers, writers, and artists whose insights into the human condition can help us cope with the significant questions of our time and our personal condition.

Sometimes symbols are treated as if they are private or esoteric. In other words, writers may purposely try to hide some levels of meaning from all but the thoroughly initiated or truly sophisticated. Or they may try to create new symbol systems. Whatever the case, symbolism gives the story its richness and much of its appeal. When we realize that a character, for example, is a symbol, regardless of how much of an individual he or she may be, the story takes on

new meaning for us. In another way, every character in the story symbolizes us—that is, some aspect of our complex and often contradictory characters. Symbols can be hidden, profound, or simple. When we discover them and unlock their revelations, we have made a significant stride toward understanding meaning.

POETRY

Language

Rhythm in poetry consists of the flow of sound through accents and syllables. For example, in Robert Frost's "Stopping by Woods on a Snowy Evening" (see p. 180) each line contains eight syllables with an accent on every other syllable. Rhythms, like Frost's, that depend on a fixed number of syllables per line, are called *accentual-syllabic*. Contrast that with the freely flowing rhythm of Shakespeare's "The Seven Ages of Man," in which rhythmic flow uses naturally occurring stresses in the words. This use of stress to create rhythm is called *accentual*.

Imagery is a verbal representation of a sensory experience. It can be *literal* or *figurative*. In the former there is no change or extension in meaning; for example, "green eyes" are simply eyes that are a green color. In the latter, there is a change in literal meaning; for example, green eyes might become "green orbs."

Figures, like images, take words beyond their literal meaning. Much of poetic meaning comes in comparing objects in ways that go beyond the literal. For example, in Robert Frost's "Stopping by Woods on a Snowy Evening," snowflakes are described as "downy," which endows them with the figurative quality of soft, fluffy feathers on a young bird. In the same sense, Frost uses "sweep" and "easy" to describe the wind.

Metaphors are figures of speech by which new implications are given to words. Thus the expression "the twilight of life" applies the word "twilight" to the concept of life to create an entirely new image and meaning. Metaphors are implied but not explicitly stated comparisons.

Symbols are also often associated with figures of speech, but not all figures are symbols, and not all symbols are figures. Symbolism is critical to poetry, which uses compressed language to express, and carry us into, its meanings. In poetry "the whole poem helps to determine the meaning of its parts, and in turn, each part helps to determine the meaning of the whole poem."[2]

Structure

Form or structure in poetry derives from fitting together lines of similar structure and length tied to other lines by

end rhyme. For example, the sonnet has fourteen lines of iambic pentameters rhymed 1–3, 2–4, 5–7, 6–8, 9–11, 10–12, 13–14 (see "Meter" below).

Stanzas, which are any recurring groupings of two or more lines in terms of length, meter, and rhyme, are part of structure. A stanza usually presents a unit of poetic experience, and if the poem has more than one stanza, the pattern is usually repeated.

Sound Structures

Rhyme—the coupling of words that sound alike—is the most common sound structure in poetry. Its function is to tie the sense together with the sound. Rhyme can be *masculine, feminine,* or *triple.* Masculine rhyme is based on single-syllable vowels such as "hate" and "mate." Feminine rhyme is based on sounds between accented and unaccented syllables, for example, "hating" and "mating." Triple rhyme has a correspondence over three syllables, such as "despondent" and "respondent."

Alliteration is a second type of sound structure in which an initial sound is repeated for effect: for example, *fancy free.*

Assonance is a similarity among vowels but not consonants.

Consonance is the repetition or recurrence of identical or similar consonants, as in Shakespeare's song "The ousel cock so black of hue." It is often combined with assonance and alliteration.

Meter

Meter refers to the type and number of rhythmic units in a line. Rhythmic units are called *feet.* Four common kinds of feet are *iambic, trochaic, anapestic,* and *dactylic.* Iambic meter alternates one unstressed and one stressed syllable; trochaic alternates one stressed and one unstressed syllable; anapestic alternates two unstressed and one stressed syllable; and dactylic alternates one stressed and two unstressed syllables.

Line, also called *verse,* determines the basic rhythmic pattern of the poem. Lines are named by the number of feet they contain. One foot is monometer; two, dimeter; three, trimeter; four, tetrameter; five, pentameter; six, hexameter; seven, heptameter; and eight, octameter.

BIOGRAPHY

Facts

Facts are the verifiable details around which a biography is shaped. However, facts, other than matters such as birth, death, marriage, and other date-related occurrences, often have a way of becoming elusive. They can turn out to be observations filtered through the personality of the observer. Incontrovertible facts may comprise a chronological or skeletal framework for a biography, but they may well not create much interest. Frequently they do not provide much of a skeleton either. Few facts are recorded about many individuals who arouse our curiosity.

On the other hand, the lives of other important individuals have been chronicled in such great detail that almost too many facts exist. Artistry entails selection and composition, and many facts may have to be omitted from the narrative to maintain the reader's interest. Another issue is the question of what the author should actually do with the facts. If they are injurious, should they be used? In what context? Whatever the situation, facts alone are not sufficient for an artistic or interesting biography.

Anecdotes

Anecdotes are stories or observations about moments in a biography. They take the basic facts and expand them for illustrative purposes, thereby creating interest. Anecdotes may be true or untrue. Their purpose is often to create a memorable generalization. They may also generate debate or controversy.

Quotations form part of anecdotal experience. They are used to create interest by changing the presentational format to that of dialogue. In the sense that dialogue creates the impression that we are part of the scene, as opposed to being third parties listening to someone else describe a situation, it brings us closer to the subjects of the biography.

HOW DOES IT STIMULATE THE SENSES?

The following seven selections serve as illustrations of literature. Literature appeals to our senses by the way in which the writer uses the tools of the medium. We have applied the formal and technical elements of the arts enough times now that to do so again would be to restate the obvious. Read the following examples and decide for yourself how your response is manipulated by the author's use of the devices we have mentioned. Discuss each example with a friend to see if your reactions are similar or different. Where differences arise, try to determine why.

FICTION

A Rose for Emily
William Faulkner
1897–1962

1

When Miss Emily Grierson died, our whole town went to her funeral; the men through a sort of respectful affection for a fallen monument, the women mostly out of curiosity to see the inside of her house, which no one save an old manservant—a combined gardener and cook—had seen in at least ten years.

It was a big, squarish frame house that had once been white, decorated with cupolas and spires and scrolled balconies in the heavily lightsome style of the seventies, set on what had once been our most select street. But garages and cotton gins had encroached and obliterated even the august names of that neighborhood; only Miss Emily's house was left, lifting its stubborn and coquettish decay above the cotton wagons and the gasoline pumps—an eyesore among eyesores. And now Miss Emily had gone to join the representatives of those august names where they lay in the cedar-bemused cemetery among the ranked and anonymous graves of Union and Confederate soldiers who fell at the battle of Jefferson.

Alive, Miss Emily had been a tradition, a duty, and a care; a sort of hereditary obligation upon the town, dating from that day in 1894 when Colonel Sartoris, the mayor—he who fathered the edict that no Negro woman should appear on the streets without an apron—remitted her taxes, the dispensation dating from the death of her father on into perpetuity. Not that Miss Emily would have accepted charity. Colonel Sartoris invented an involved tale to the effect that Miss Emily's father had loaned money to the town, which the town, as a matter of business, preferred this way of repaying. Only a man of Colonel Sartoris' generation and thought could have invented it, and only a woman could have believed it.

When the next generation, with its more modern ideas, became mayors and aldermen, this arrangement created some little dissatisfaction. On the first of the year they mailed her a tax notice. February came, and there was no reply. They wrote her a formal letter, asking her to call at the sheriff's office at her convenience. A week later the mayor wrote her himself, offering to call or send his car for her and received in reply a note on paper of an archaic shape, in a thin flowing calligraphy in faded ink, to the effect that she no longer went out at all. The tax notice was also enclosed, without comment.

They called a special meeting of the Board of Aldermen. A deputation waited upon her, knocked at the door through which no visitor had passed since she ceased giving china-painting lessons eight or ten years earlier. They were admitted by the old Negro into a dim hall from which a stairway mounted into still more shadow. It smelled of dust and disuse—a close, dank smell. The Negro led them into the parlor. It was furnished in heavy, leather-covered furniture. When the Negro opened the blinds of one window, they could see that the leather was cracked; and when they sat down, a faint dust rose sluggishly about their thighs, spinning with slow motes in the single sun-ray. On a tarnished gilt easel before the fireplace stood a crayon portrait of Miss Emily's father.

They rose when she entered—a small, fat woman in black, with a thin gold chain descending to her waist and vanishing into her belt, leaning on an ebony cane with a tarnished gold head. Her skeleton was small and spare; perhaps that was why what would have been merely plumpness in another was obesity in her. She looked bloated, like a body long submerged in motionless water, and of that pallid hue. Her eyes, lost in the fatty ridges of her face, looked like two small pieces of coal pressed into a lump of dough as they moved from one face to another while the visitors stated their errand.

She did not ask them to sit. She just stood in the door and listened quietly until the spokesman came to a stumbling halt. Then they could hear the invisible watch ticking at the end of the gold chain.

Her voice was dry and cold. "I have no taxes in Jefferson. Colonel Sartoris explained it to me. Perhaps one of you can gain access to the city records and satisfy yourselves."

"But we have. We are the city authorities, Miss Emily. Didn't you get a notice from the sheriff, signed by him?"

"I received a paper, yes," Miss Emily said. "Perhaps he considers himself the sheriff . . . I have no taxes in Jefferson."

"But there is nothing on the books to show that, you see. We must go by the—"

"See Colonel Sartoris. I have no taxes in Jefferson."

"But, Miss Emily—"

"See Colonel Sartoris." (Colonel Sartoris had been dead almost ten years.) "I have no taxes in Jefferson. Tobe!" The Negro appeared. "Show these gentlemen out."

2

So she vanquished them, horse and foot, just as she had vanquished their fathers thirty years before about the smell. That was two years after her father's death and a short time after her sweetheart—the one we believed would marry her—had deserted her. After her father's death she went out very little; after her sweetheart went away, people hardly saw her at all. A few of the ladies had the temerity to call, but were not received, and the only sign of life about the place was the Negro man—a young man then—going in and out with a market basket.

"Just as if a man—any man—could keep a kitchen properly," the ladies said; so they were not surprised when the smell developed. It was another link between the gross, teeming world and the high and mighty Griersons.

A neighbor, a woman, complained to the mayor, Judge Stevens, eighty years old.

"But what will you have me do about it, madam?" he said.

"Why, send her word to stop it," the woman said. "Isn't there a law?"

"I'm sure that won't be necessary," Judge Stevens said. "It's probably just a snake or a rat that nigger of hers killed in the yard. I'll speak to him about it."

The next day he received two more complaints, one from a man who came in diffident deprecation. "We really must do something about it, Judge. I'd be the last one in the world to bother Miss Emily, but we've got to do something." That night the Board of Aldermen met—three graybeards and one younger man, a member of the rising generation.

"It's simple enough," he said. "Send her word to have her place cleaned up. Giver her a certain time to do it in, and if she don't . . ."

"Dammit, sir," Judge Stevens said, "will you accuse a lady to her face of smelling bad?"

So the next night, after midnight, four men crossed Miss Emily's lawn and slunk about the house like burglars, sniffing along the base of the brickwork and at the cellar openings while one of them performed a regular sowing motion with his hand out of a sack slung from his shoulder. They broke open the cellar door and sprinkled lime there, and in all the outbuildings. As they recrossed the lawn, a window that had been dark was lighted and Miss Emily sat in it, the light behind her, and her upright torso motionless as that of an idol. They crept quietly across the lawn and into the shadow of the locusts that lined the street. After a week or two the smell went away.

That was when people had begun to feel really sorry for her. People in our town, remembering how old lady Wyatt, her great aunt, had gone completely crazy at last, believed that the Griersons held themselves a little too high for what they really were. None of the young men were quite good enough for Miss Emily and such. We had long thought of them as a tableau. Miss Emily a slender figure in white in the background, her father a spraddled silhouette in the foreground, his back to her and clutching a horsewhip, the two of them framed by the backflung front door. So when she got to be thirty and was still single, we were not pleased exactly, but vindicated; even with insanity in the family she wouldn't have turned down all of her chances if they had really materialized.

When her father died, it got about that the house was all that was left to her; and in a way, people were glad. At last they could pity Miss Emily. Being left alone, and a pauper, she had become humanized. Now she too would know the old thrill and the old despair of a penny more or less.

The day after his death all the ladies prepared to call at the house and offer condolence and aid, as is our custom. Miss Emily met them at the door, dressed as usual and with no trace of grief on her face. She told them that her father was not dead. She did that for three days, with the ministers calling on her, and the doctors, trying to persuade her to let them dispose of the body. Just as they were about to resort to law and force, she broke down, and they buried her father quickly.

We did not say she was crazy then. We believed she had to do that. We remembered all the young men her father had driven away, and we knew that with nothing left, she would have to cling to that which had robbed her, as people will.

3

She was sick for a long time. When we saw her again, her hair was cut short, making her look like a girl, with a vague resemblance to those angels in colored church windows—sort of tragic and serene.

The town had just let the contracts paving the sidewalks, and in the summer after her father's death they began the work. The construction company came with niggers and mules and machinery, and a foreman named Homer Barron, a Yankee—a big, dark, ready man, with a big voice and eyes lighter than his face. The little boys would follow in groups to hear him cuss the niggers, and the niggers singing in time to the rise and fall of picks. Pretty soon he knew everybody in town. Whenever you heard a lot of laughing anywhere about the square, Homer Barron would be in the center of the group. Presently we began to see him and Miss Emily on Sunday afternoons driving in the yellow-wheeled buggy and the matched team of bays from the livery stable.

At first we were glad that Miss Emily would have an interest, because the ladies all said, "Of course a Grierson would not think seriously of a Northerner, a day laborer." But there were still others, older people, who said that even grief could not cause a real lady to forget *noblesse oblige*—without calling it *noblesse oblige*. They just said, "Poor Emily. Her kinsfolk should come to her." She had some kin in Alabama; but years ago her father had fallen out with them over the estate of old lady Wyatt, the crazy woman, and there was no communication between the two families. They had not even been represented at the funeral.

And as soon as the old people said, "Poor Emily," the whispering began. "Do you suppose it's really so?" they said to one another. "Of course it is. What else could . . ." This behind their hands; rustling of craned silk and satin behind jalousies closed upon the sun of Sunday afternoon as the thin, swift clop-clop-clop of the matched team passed: "Poor Emily."

She carried her head high enough—even when we believed that she was fallen. It was if she demanded more than ever the recognition of her dignity as the last Grierson; as if it had wanted that touch of earthiness to reaffirm her imperviousness. Like when she bought the rat poison, the arsenic. That was over a year after they had begun to say, "Poor Emily," and while the two female cousins were visiting her.

"I want some poison," she said to the druggist. She was over thirty then, still a slight woman, though thinner than usual, with cold, haughty black eyes in a face the flesh of which was strained across the temples and about the eyesockets as you imagine a lighthouse-keeper's face ought to look. "I want some poison," she said.

"Yes, Miss Emily. What kind? For rats and such? I'd recom—"

"I want the best you have. I don't care what kind."

The druggist named several. "They'll kill anything up to an elephant. But what you want is—"

"Arsenic," Miss Emily said. "Is that a good one?"

"Is . . . arsenic? Yes, ma'am. But what you want—"

"I want arsenic."

The druggist looked down at her. She looked back at him,

erect, her face like a strained flag. "Why, of course," the druggist said. "If that's what you want. But the law requires you to tell what you are going to use it for."

Miss Emily just stared at him, her head tilted back in order to look him eye for eye, until he looked away and went and got the arsenic and wrapped it up. The Negro delivery boy brought her the package; the druggist didn't come back. When she opened the package at home there was written on the box, under the skull and bones: "For rats."

4

So the next day we all said, "She will kill herself"; and we said it would be the best thing. When she had first begun to be seen with Homer Barron, we had said, "She will marry him." Then we said, "She will persuade him yet," because Homer himself had remarked—he liked men, and it was known that he drank with the younger men in the Elks' Club—that he was not a marrying man. Later we said, "Poor Emily" behind the jalousies as they passed on Sunday afternoon in the glittering buggy, Miss Emily with her head high and Homer Barron with his hat cocked and a cigar in his teeth, reins and whip in a yellow glove.

Then some of the ladies began to say that it was a disgrace to the town, and a bad example to the young people. The men did not want to interfere, but at last the ladies forced the Baptist minister—Miss Emily's people were Episcopal—to call upon her. He would never divulge what happened during that interview, but he refused to go back again. The next Sunday they again drove about the streets, and the following day the minister's wife wrote to Miss Emily's relations in Alabama.

So she had blood-kin under her roof again and we sat back to watch developments. At first nothing happened. Then we were sure that they were to be married. We learned that Miss Emily had been to the jeweler's and ordered a man's toilet set in silver, with the letters H. B. on each piece. Two days later we learned that she had bought a complete outfit of men's clothing, including a nightshirt, and we said, "They are married." We were really glad. We were glad because the two female cousins were even more Grierson than Miss Emily had ever been.

So we were not surprised when Homer Barron—the streets had been finished some time since—was gone. We were a little disappointed that there was not a public blowing-off, but we believed that he had gone on to prepare for Miss Emily's coming, or to give her a chance to get rid of the cousins. (By that time it was a cabal, and we were all Miss Emily's allies to help circumvent the cousins.) Sure enough, after another week they departed. And, as we had expected all along, within three days Homer Barron was back in town. A neighbor saw the Negro man admit him at the kitchen door at dusk one evening.

And that was the last we saw of Homer Barron. And of Miss Emily for some time. The Negro man went in and out with the market basket, but the front door remained closed. Now and then we would see her at a window for a moment, as the men did that night when they sprinkled the lime, but for almost six months she did not appear on the streets. Then we knew that this was to be expected too; as if that quality of her father that

had thwarted her woman's life so many times had been too virulent and too furious to die.

When we next saw Miss Emily, she had grown fat and her hair was turning gray. During the next few years it grew grayer and grayer until it attained an even pepper-and-salt iron-gray, when it ceased turning. Up to the day of her death at seventy-four it was still that vigorous iron-gray, like the hair of an active man.

From that time on her front door remained closed, save for a period of six or seven years, when she was about forty, during which she gave lessons in china-painting. She fitted up a studio in one of the downstairs rooms, where the daughters and granddaughters of Colonel Sartoris' contemporaries were sent to her with the same regularity and in the same spirit that they were sent to church on Sundays with a twenty-five cent piece for the collection plate. Meanwhile her taxes had been remitted.

The newer generation became the backbone and the spirit of the town, and the painting pupils grew up and fell away and did not send their children to her with boxes of color and tedious brushes and pictures cut from the ladies' magazines. The front door closed upon the last one and remained closed for good. When the town got free postal delivery, Miss Emily alone refused to let them fasten the metal numbers above her door and attach a mailbox to it. She would not listen to them.

Daily, monthly, yearly we watched the Negro grow grayer and more stooped, going in and out with the market basket. Each December we sent her a tax notice, which would be returned by the post office a week later, unclaimed. Now and then we would see her in one of the downstairs windows—she had evidently shut up the top floor of the house—like the carven torso of an idol in a niche, looking or not looking at us, we could never tell which. Thus she passed from generation to generation—dear, inescapable, impervious, tranquil, and perverse.

And so she died. Fell ill in the house filled with dust and shadows, with only a doddering Negro man to wait on her. We did not even know she was sick; we had long since given up trying to get any information from the Negro. He talked to no one, probably not even to her, for his voice had grown harsh and rusty, as if from disuse.

She died in one of the downstairs rooms, in a heavy walnut bed with a curtain, her gray head propped on a pillow yellow and moldy with age and lack of sunlight.

5

The Negro met the first of the ladies at the front door and let them in, with their hushed, sibilant voices and their quick, curious glances, and then he disappeared. He walked right through the house and out the back and was not seen again.

The two female cousins came at once. They held the funeral on the second day, with the town coming to look at Miss Emily beneath a mass of bought flowers, with the crayon face of her father musing profoundly above the bier and the ladies sibilant and macabre; and the very old men—some in their brushed Confederate uniforms—on the porch and the lawn, talking of Miss Emily as if she had been a contemporary of theirs, believing that they had danced with her and courted her perhaps,

confusing time with its mathematical progression, as the old do, to whom all the past is not a diminishing road but, instead, a huge meadow which no winter ever quite touches, divided from them now by the narrow bottleneck of the most recent decade of years.

Already we knew that there was one room in that region above the stairs which no one had seen in forty years, and which would have to be forced. They waited until Miss Emily was decently in the ground before they opened it.

The violence of breaking down the door seemed to fill this room with pervading dust. A thin, acrid pall as of the tomb seemed to lie everywhere upon this room decked and furnished as for a bridal: upon the valance curtains of faded rose color, upon the rose-shaded lights, upon the dressing table, upon the delicate array of crystal and the man's toilet things backed with tarnished silver, silver so tarnished that the monogram was obscured. Among them lay a collar and tie, as if they had just been removed, which, lifted, left upon the surface a pale crescent in the dust. Upon a chair hung the suit, carefully folded; beneath it the two mute shoes and the discarded socks.

The man himself lay in the bed.

For a long while we just stood there, looking down at the profound and fleshless grin. The body had apparently once lain in the attitude of an embrace, but now the long sleep that outlasts love, that conquers even the grimace of love, had cuckolded him. What was left of him, rotted beneath what was left of the nightshirt, had become inextricable from the bed in which he lay; and upon him and upon the pillow beside him lay that even coating of the patient and biding dust.

Then we noticed that in the second pillow was the indentation of a head. One of us lifted something from it, and leaning forward, that faint and invisible dust dry and acrid in the nostrils, we saw a long strand of iron-gray hair.[3]

POETRY

The Seven Ages of Man
William Shakespeare
1564–1616

All the world's a stage,
And all the men and women merely players.
They have their exits and their entrances,
And one man in his time plays many parts,
His acts being seven ages. At first the infant
Mewling[1] and puking in the nurse's arms.
Then the whining schoolboy, with his satchel
And shining morning face, creeping like snail
Unwillingly to school. And then the lover,
Sighing like furnace, with a woeful ballad[2]
Made to his mistress' eyebrow. Then a soldier,
Full of strange oaths and bearded like the pard,[3]
Jealous in honor,[4] sudden and quick in quarrel,
Seeking the bubble reputation[5]

Even in the cannon's mouth. And then the justice,
In fair round belly with good capon lined,[6]
With eyes severe and beard of formal cut,
Full of wise saws[7] and modern instances,[8]
And so he plays his part. The sixth age shifts
Into the lean and slippered Pantaloon,[9]
With spectacles on nose and pouch on side;
His youthful hose, well saved, a world too wide
For his shrunk shank, and his big manly voice,
Turning again toward childish treble, pipes
And whistles in his sound. Last scene of all,
That ends this strange eventful history,
Is second childishness and mere oblivion,
Sans[10] teeth, sans eyes, sans taste, sans everything.
As You Like It, Act II, scene vii, 139–66.

[1]Whimpering.
[2]Poem.
[3]Leopard.
[4]Sensitive about honor.
[5]As quickly burst as a bubble.
[6]Magistrate bribed with a chicken.
[7]Sayings.
[8]Commonplace illustrations.
[9]The foolish old man of Italian comedy.
[10]Without.

The Canterbury Tales
Geoffrey Chaucer
c. 1340–1400

THE COOK'S PROLOGUE

The cook from London, while the reeve yet spoke,
Patted his back with pleasure at the joke.
"Ha, ha!" laughed he, "by Christ's great suffering,
This miller had a mighty sharp ending
Upon his argument of harbourage!
For well says Solomon, in his language,
'Bring thou not every man into thine house';
For harbouring by night is dangerous.
Well ought a man to know the man that he
Has brought into his own security.
I pray God give me sorrow and much care
If ever, since I have been Hodge of Ware,
Heard I of miller better brought to mark.
A wicked jest was played him in the dark.
But God forbid that we should leave off here;
And therefore, if you'll lend me now an ear,
From what I know, who am but a poor man,
I will relate, as well as ever I can,
A little trick was played in our city."
Our host replied: "I grant it readily.

Now tell on, Roger; see that it be good;
For many a pasty have you robbed of blood,
And many a Jack of Dover have you sold
That has been heated twice and twice grown cold.
From many a pilgrim have you had Christ's curse,
For of your parsley they yet fare the worse,
Which they have eaten with your stubble goose;
For in your shop full many a fly is loose.
Now tell on, gentle Roger, by your name.
But yet, I pray, don't mind if I make game,
A man may tell the truth when it's in play."

 "You say the truth," quoth Roger, "by my fay!
But 'true jest, bad jest' as the Fleming saith.

 And therefore, Harry Bailey, on your faith,
Be you not angry ere we finish here,
If my tale should concern an inn-keeper.
Nevertheless, I'll tell not that one yet.
But ere we part your jokes will I upset."

 And thereon did he laugh, in great good cheer,
And told his tale, as you shall straightway hear.

Thus ends the prologue of the cook's tale

THE COOK'S TALE

There lived a 'prentice, once, in our city,
And of the craft of victuallers was he;
Happy he was as goldfinch in the glade,
Brown as a berry, short, and thickly made,
With black hair that he combed right prettily.
He could dance well, and that so jollily,
That he was nicknamed Perkin Reveller.
He was as full of love, I may aver,
As is a beehive full of honey sweet;
Well for the wench that with him chanced to meet.
At every bridal would he sing and hop,
Loving the tavern better than the shop.

 When there was any festival in Cheap,
Out of the shop and thither would he leap,
And, till the whole procession he had seen,
And danced his fill, he'd not return again.
He gathered many fellows of his sort
To dance and sing and make all kinds of sport.
And they would have appointments for to meet
And play at dice in such, or such, a street.
For in the whole town was no apprentice
Who better knew the way to throw the dice
Than Perkin; and therefore he was right free
With money, when in chosen company.
His master found this out in business there;
For often-times he found the till was bare.
For certainly a revelling bond-boy
Who loves dice, wine, dancing, and girls of joy—
His master, in his shop, shall feel the effect,
Though no part have he in this said respect;
For theft and riot always comrades are,

And each alike he played on gay guitar.
Revels and truth, in one of low degree,
Do battle always, as all men may see.

 This 'prentice shared his master's fair abode
Till he was nigh out of his 'prenticehood,
Though he was checked and scolded early and late
And sometimes led, for drinking, to Newgate;
But at the last his master did take thought,
Upon a day, when he his ledger sought,
On an old proverb wherein is found this word:
"Better take rotten apple from the hoard
Than let it lie to spoil the good ones there."
So with a drunken servant should it fare;
It is less ill to let him go, apace,
Than ruin all the others in the place.
Therefore he freed and cast him loose to go
His own road unto future care and woe;
And thus this jolly 'prentice had his leave.
Now let him riot all night long, or thieve.

 But since there's never thief without a buck
To help him waste his money and to suck
All he can steal or borrow by the way,
Anon he sent his bed and his array
To one he knew, a fellow of his sort,
Who loved the dice and revels and all sport,
And had a wife that kept, for countenance,
A shop, and whored to gain her sustenance.

Of this cook's tale Chaucer made no more.[4]

Stopping by Woods on a Snowy Evening
Robert Frost
1874–1963

Whose woods these are I think I know.
His house is in the village though;
He will not see me stopping here
To watch his woods fill up with snow.

My little horse must think it queer
To stop without a farmhouse near
Between the woods and frozen lake
The darkest evening of the year.

He gives his harness bells a shake
To ask if there is some mistake.
The only other sound's the sweep
Of easy wind and downy flake.

The woods are lovely, dark and deep.
But I have promises to keep.
And miles to go before I sleep.
And miles to go before I sleep.[5]

Musée des Beaux Arts
W. H. Auden
1907–73

About suffering they were never wrong,
The Old Masters; how well they understood
Its human position; how it takes place
While someone is eating or opening a window or just walking
 dully along;
How, when the aged are reverently, passionately waiting
For the miraculous birth, there always must be
Children who did not specially want it to happen, skating
On a pond at the edge of the wood:
They never forgot
That even the dreadful martyrdom must run its course
Anyhow in a corner, some untidy spot
Where the dogs go on with their doggy life and the torturer's
 horse
Scratches its innocent behind on a tree.
In Brueghel's *Icarus*, for instance: how everything turns away
Quite leisurely from the disaster; the ploughman may
Have heard the splash, the forsaken cry,
But for him it was not an important failure; the sun shone
As it had to on the white legs disappearing into the green
Water; and the expensive delicate ship that must have seen
Something amazing, a boy falling out of the sky,
Had somewhere to get to and sailed calmly on.[6]

BIOGRAPHY

God Brought Me Safe
John Wesley
1703–91

[Oct. 1743]

Thur. 20.—After preaching to a small, attentive congregation, I rode to Wednesbury. At twelve I preached in a ground near the middle of the town to a far larger congregation than was expected, on "Jesus Christ, the same yesterday, and to-day, and for ever." I believe every one present felt the power of God; and no creature offered to molest us, either going or coming; but the Lord fought for us, and we held our peace.

I was writing at Francis Ward's in the afternoon when the cry arose that the mob had beset the house. We prayed that God would disperse them, and it was so. One went this way, and another that; so that, in half an hour, not a man was left. I told our brethren, "Now is the time for us to go"; but they pressed me exceedingly to stay; so, that I might not offend them, I sat down, though I foresaw what would follow. Before five the mob surrounded the house again in greater numbers than ever. The cry of one and all was, "Bring out the minister; we will have the

minister." I desired one to take their captain by the hand and bring him into the house. After a few sentences interchanged between us the lion became a lamb. I desired him to go and bring one or two more of the most angry of his companions. He brought in two, who were ready to swallow the ground with rage; but in two minutes they were as calm as he. I then bade them make way, that I might go out among the people. As soon as I was in the midst of them I called for a chair, and, standing up, asked, "What do any of you want with me?" Some said, "We want you to go with us to the Justice." I replied, "That I will with all my heart." I then spoke a few words, which God applied; so that they cried out with might and main, "The gentleman is an honest gentleman, and we will spill our blood in his defence." I asked, "Shall we go to the Justice to-night, or in the morning?" Most of them cried, "To-night, to-night"; on which I went before, and two or three hundred followed, the rest returning whence them came.

The night came on before we had walked a mile, together with heavy rain. However, on we went to Bentley Hall, two miles from Wednesbury. One or two ran before to tell Mr. Lane they had brought Mr. Wesley before his Worship. Mr Lane replied, "What have I to do with Mr. Wesley? Go and carry him back again." By this time the main body came up, and began knocking at the door. A servant told them Mr. Lane was in bed. His son followed, and asked what was the matter. One replied, "Why an't please you, they sing psalms all day; nay, and make folks rise at five in the morning. And what would your Worship advise us to do?" "To go home," said Mr Lane, "and be quiet."

Here they were at a full stop, till one advised to go to Justice Persehouse at Walsall. All agreed to do this; so we hastened on, and about seven came to his house. But Mr. P. likewise sent word that he was in bed. Now they were at a stand again; but at last they all thought it the wisest course to make the best of their way home. About fifty of them undertook to convoy me. But we had not gone a hundred yards when the mob of Walsall came, pouring in like a flood, and bore down all before them. The Darlaston mob made what defense they could; but they were weary, as well as outnumbered; so that in a short time, many being knocked down, the rest ran away, and left me in their hands.

To attempt speaking was vain, for the noise on every side was like the roaring of the sea. So they dragged me along till we came to the town, where, seeing the door of a large house open, I attempted to go in; but a man, catching me by the hair, pulled me back into the middle of the mob. They made no more stop till they had carried me through the main street, from one end of the town to the other. I continued speaking all the time to those within hearing, feeling no pain or weariness. At the west end of the town, seeing a door half open, I made toward it, and would have gone in, but a gentleman in the shop would not suffer me, saying they would pull the house down to the ground. However, I stood at the door and asked, "Are you willing to hear me speak?" Many cried out, "No, no, knock his brains out; down with him; kill him at once." Others said, "Nay, but we will hear him first." I began asking, "What evil have I done? Which of you

all have I wronged in word or deed?" and continued speaking for above a quarter of an hour, till my voice suddenly failed. Then the floods began to lift up their voice again, many crying out, "Bring him away! Bring him away!"

In the meantime my strength and my voice returned, and I broke out aloud into prayer. And now the man who had just before headed the mob turned and said, "Sir, I will spend my life for you: follow me, and not one soul here shall touch a hair of your head." Two or three of his fellows confirmed his words, and got close to me immediately. At the same time, the gentleman in the shop cried out, "For shame, for shame! Let him go." An honest butcher, who was a little farther off, said it was a shame they should do thus; and pulled back four or five, one after another, who were running on the most fiercely. The people then, as if it had been by common consent, fell to the right and left; while those three or four men took me between them, and carried me through them all. But on the bridge the mob rallied again: we therefore went on one side over the mill-dam, and thence through the meadows, till, a little before ten, God brought me safe to Wednesbury, having lost only one flap of my waistcoat and a little skin from one of my hands.[7]

ESSAY

The Benefits of Luxury, in Making a People More Wise and Happy
Oliver Goldsmith
1730?–74

From such a picture of nature in primeval simplicity, tell me, my much respected friend, are you in love with fatigue and solitude? Do you sigh for the severe frugality of the wandering Tartar, or regret being born amidst the luxury and dissimulation of the polite? Rather tell me, has not every kind of life vices peculiarly its own? Is it not a truth, that refined countries have more vices, but those not so terrible; barbarous nations few, and they of the most hideous complexion? Perfidy and fraud are the vices of civilized nations, credulity and violence those of the inhabitants of the desert. Does the luxury of the one produce half the evils of the inhumanity of the other? Certainly those philosophers who declaim against luxury have but little understood its benefits; they seem insensible, that to luxury we owe not only the greatest part of our knowledge, but even of our virtues.

It may sound fine in the mouth of a declaimer, when he talks of subduing our appetites, of teaching every sense to be content with a bare sufficiency, and of supplying only the wants of nature; but is there not more satisfaction in indulging those appetites, if with innocence and safety, than in restraining them? Am not I better pleased in enjoyment than in the sullen satisfaction of thinking that I can live without enjoyment? The more various our artificial necessities, the wider is our circle of pleasure; for all pleasure consists in obviating necessities as they rise; luxury, therefore, as it increases our wants, increases our capacity for happiness.

Examine the history of any country remarkable for opulence and wisdom, you will find they would never have been wise had they not been first luxurious; you will find poets, philosophers, and even patriots, marching in luxury's train. The reason is obvious: We then only are curious after knowledge, when we find it connected with sensual happiness. The senses ever point out the way, and reflection comments upon the discovery. Inform a native of the desert of Kobi, of the exact measure of the parallax of the moon, he finds no satisfaction at all in the information; he wonders how any could take such pains, and lay out such treasures, in order to solve so useless a difficulty: but connect it with his happiness, by showing that it improves navigation, that by such an investigation he may have a warmer coat, a better gun, or a finer knife, and he is instantly in raptures at so great an improvement. In short, we only desire to know what we desire to possess; and whatever we may talk against it, luxury adds the spur to curiosity, and gives us a desire to becoming more wise.

But not our knowledge only, but our virtues are improved by luxury. Observe the brown savage of Thibet, to whom the fruits of the spreading pomegranate supply food, and its branches are habitation. Such a character has few vices, I grant, but those he has are of the most hideous nature; rapine and cruelty are scarcely crimes in his eye; neither pity nor tenderness, which ennoble every virtue, have any place in his heart; he hates his enemies, and kills those he subdues. On the other hand, the polite Chinese and civilized European seem even to love their enemies. I have just now seen an instance where the English have succoured those enemies, whom their own countrymen actually refused to relieve.

The greater the luxuries of every country, the more closely, politically speaking, is that country united. Luxury is the child of society alone; the luxurious man stands in need of a thousand different artists to furnish out his happiness; it is more likely, therefore, that he should be a good citizen who is connected by motives of self-interest with so many, than the abstemious man who is united to none.

In whatsoever light, therefore, we consider luxury, whether as employing a number of hands naturally too feeble for more laborious employment; as finding a variety of occupation for others who might be totally idle; or as furnishing out new inlets to happiness, without encroaching on mutual property; in whatever light we regard it, we shall have reason to stand up in its defence, and the sentiment of Confucius still remains unshaken: *that we should enjoy as many of the luxuries of life as are consistent with our own safety, and the prosperity of others; and that he who finds out a new pleasure is one of the most useful members of society.*[8]

PART TWO

THE STYLES OF THE ARTS

How Artists Portray "Reality"

THE STYLES OF THE ARTS

How Artists Portray "Reality"

STYLE

The manner in which artists express themselves constitutes their *style*. Style is tantamount to the personality of an art-work. It is the body of characteristics that identifies an art-work with an individual, a historical period, a "school" of artists, or a nation. Applying the term means assimilating materials and drawing conclusions.

The style of any artwork can be determined by analyzing how the artist has arranged the characteristics of the medium. If the usage is similar to that of others, we might conclude that they exemplify the same style. For example, Bach and Handel typify the Baroque style in music; Haydn and Mozart, the Classical. Listening to works by these composers quickly leads to the conclusion that the ornate melodic shapes and rhythmic patterns of Bach are like those of Handel, and quite different from the flowing themes and precise concern for structure of Mozart and Haydn. The precision and symmetry of the Parthenon compared with the ornate opulence of the Palace of Versailles suggest that, in line and form, the architects of these buildings treated their medium differently. Yet the design of the Parthenon is very much a visual companion, stylistically, of Mozart and Haydn; Versailles reflects an approach to design similar to that of Bach and Handel.

HOW CAN WE ANALYZE STYLE?

Let us take our examination one step further and play a game of stylistic analysis with four paintings. The first three were done by three different artists; the fourth, by one of those three. By stylistic analysis, we will determine the painter of the fourth.

The first painting (Fig. **II**.1) is Corot's *View Near Volterra*. Corot has primarily used curved *line* to create the edges of the forms or shapes in the painting, and it is somewhat soft-ened. That is, many of the forms—the rocks, trees, clouds—do not have crisp, clear edges. Color areas tend to blend with each other, giving the painting a somewhat fuzzy or out-of-focus appearance. This comfortable effect is heightened by Corot's use of palette. Palette, as we noted, encompasses the total use of color and contrast; since these illustrations are black-and-white, we can deal with only one aspect of palette: *value contrast*. As with his use of line, Corot maintains subtlety in his value contrast—that is, in the relationship of blacks to whites. Movement from light to dark is gradual, and he avoids stark contrasts. He employs a full range of black, grays, and whites, but does so without calling attention to their positioning. Corot's *brushstroke* is somewhat apparent: If we look carefully, we can see brush marks—individual strokes where paint has been applied—

throughout the painting. We can tell that the foliage was executed by *stippling* (by dabbing the brush to the canvas as one would dot an "i" with a pencil). Thus, even though the objects portrayed are lifelike, the artist has not made any pretensions about the fact that the picture has been painted. The overall effect is one of realism, but we can see in every area the spontaneity with which it was executed.

The second painting (Fig. **II.2**) is Picasso's *Guernica*. We hardly need be an expert to tell that this painting is by a different painter—or at least in a different style from the previous one. Picasso has joined curved and straight lines, placing them in such relationships that they create movement and dissonance. The edges of color areas and forms are sharp and distinct; nothing here is soft or fuzzy. Likewise, the value contrasts are stark and extreme. Areas of the highest value—that is, white—are forced against areas of the lowest value—black. In fact, the range of tonalities is far narrower than in the previous work. Mid or medium (gray) tones are here, but they play a minor role in the effect of the palette. Tonal areas are flat, and the starkness of the work is reinforced by brushstroke, which is noteworthy for its near *absence* of effect.

The third painting (Fig. **II.3**) is van Gogh's *Starry Night*. Use of line is highly active although uniformly curved. Forms and color areas have both hard and soft edges, and van Gogh, like Picasso, uses outlining to strengthen his images and reduce their reality. The overall effect of line is a sweeping and undulating movement, highly dynamic and yet far removed from the starkness of the Picasso. In contrast, van Gogh's curvilinearity and softened edges are quite different in effect from the relaxed quality of the Corot. Van Gogh's value contrasts are broad, but moderate. He ranges from darks through medium grays to white, all virtually equal in importance. Even when movement from one area to another is across a hard edge to a highly contrasting value, the result is moderate: not soft, not stark. It is, however, brushstroke that gives the painting its unique personality. We can see thousands of individual brush marks where the artist applied paint to canvas. The nervous, almost frenetic use of brushstrokes makes the painting come alive.

Now that we have examined three paintings in different styles and by different artists, can you determine which of the three painted Figure **II.4**? First, examine the use of line.

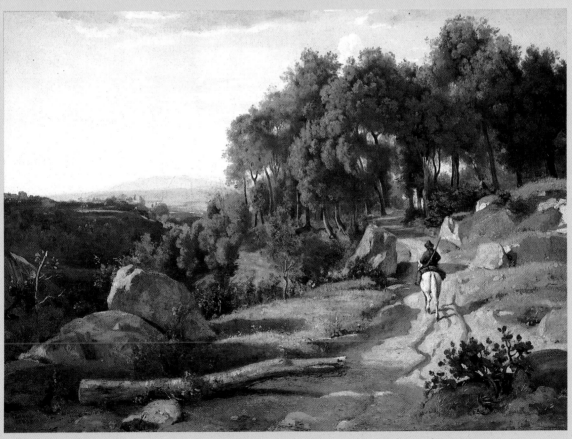

II.1 Jean-Baptiste-Camille Corot, *A View Near Volterra*, 1838. Oil on canvas, 27⅜ x 37½ ins (70 x 95 cm). National Gallery of Art, Washington, D.C. (Chester Dale Collection).

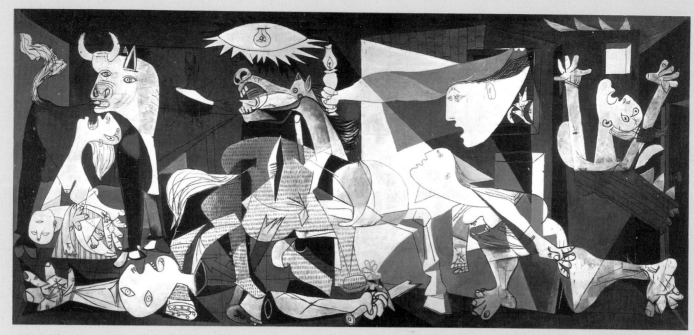

II.2 Pablo Picasso, *Guernica*, 1937. Oil on canvas, 11 ft 5 ins x 25 ft 5¾ ins (3.48 x 7.77 m). Museo Nacional Centro de Arte Reina Sofia, Madrid.

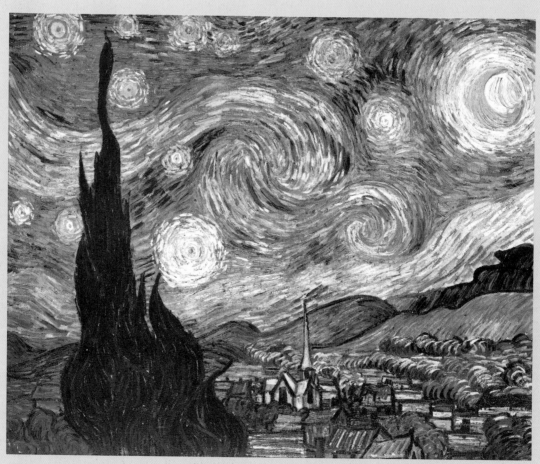

II.3 Vincent van Gogh, *The Starry Night*, 1889. Oil on canvas, 29 x 36¼ ins (73.7 x 92.1 cm). The Museum of Modern Art, New York (Acquired through the Lillie P. Bliss Bequest).

Form and color edges are hard. Outlining is used. Curved and straight lines are juxtaposed. The effect is active and stark: unlike Corot, a bit like van Gogh, and very much like Picasso. Next, examine palette. Darks, grays, and whites are used broadly. However, the principal impression is of strong contrast—the darkest darks against the whitest whites. This is not like Corot, a bit like van Gogh, and most like Picasso. Finally, brushstroke is generally unobtrusive. Tonal areas are mostly flat. This is definitely not a van Gogh and probably not a Corot. Three votes out of three go to Picasso—and the style is so distinctive that you probably had no difficulty deciding, even without the written analysis. However, would you have been so certain if asked whether Picasso painted Figure 1.11? A work by another Cubist painter might pose even greater difficulty. Some differences in style are obvious; others are subtler. It is quite a challenge to distinguish the work of one artist from another who designs in a similar fashion. However, the analytical process we just completed indicates how we can approach artworks to determine in what ways they exemplify a given style.

STYLE AND CULTURE

We sometimes recognize differences in style without thinking much about it. Our experience or formal training need not be extensive for us to recognize that the buildings in Figures II.5–II.8 reflect different cultural circumstances. The Russian Orthodox church in Figure II.6 is distinguishable by its characteristic domes and the icons that decorate its walls (Fig. II.5). The tomb in Figure II.7 is, similarly, typically Muslim, identifiable by its arch. The decorative embellishment (Fig. II.8), in contrast to the icons of the Orthodox Church, reflects the Islamic prohibition against depicting human form in an architectural decoration.

HOW DOES A STYLE GET ITS NAME?

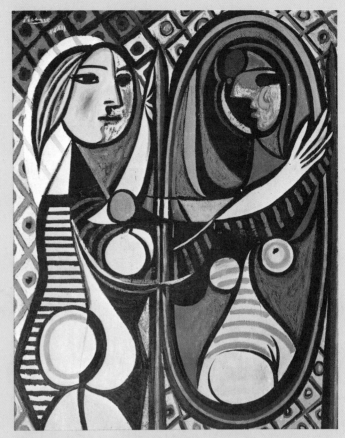

II.4 Exercise painting (see p. 42 for identification).

II.5 Church of Nikolai Khamovnik, Moscow, detail of front portal.

Why is some art called Classical, some Pop, some Baroque, and some Impressionist? Some styles were named hundreds of years after they occurred—the definition resulted from extended, common usage or a historical viewpoint. For example, the Athenian Greeks, whose works we know as Classical, were centuries removed from the naming of their style. Some labels, such as Surrealist, were coined by artists themselves. Many are attributed to individual critics who, having experienced the emerging works of several artists and noting a common or different approach, invented a term (sometimes a derogatory one) to describe it. Because of the influence of the critic or the catchiness of

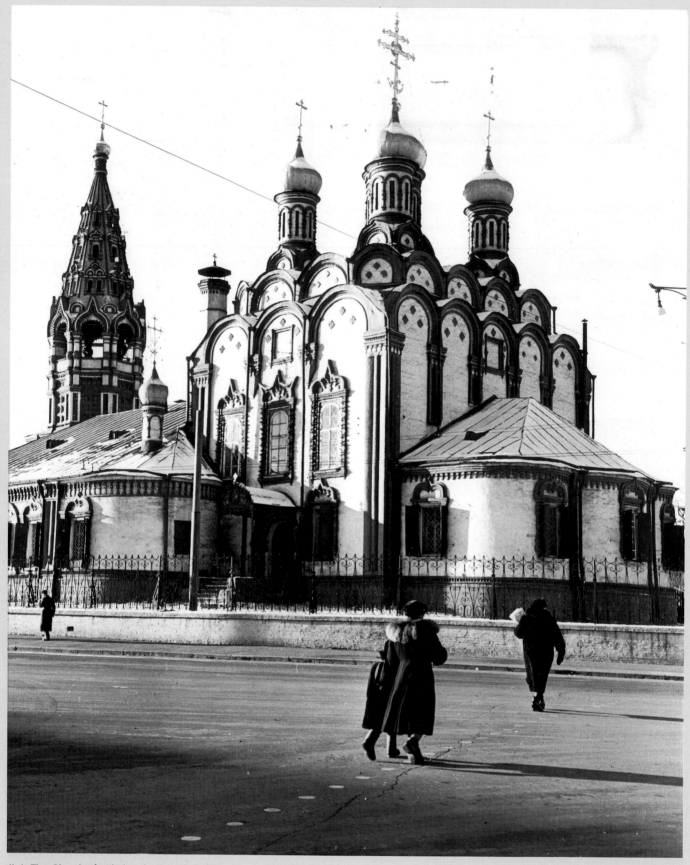

II.6 The Church of Nikolai Khamovnik, Moscow, Russia, 1679–82.

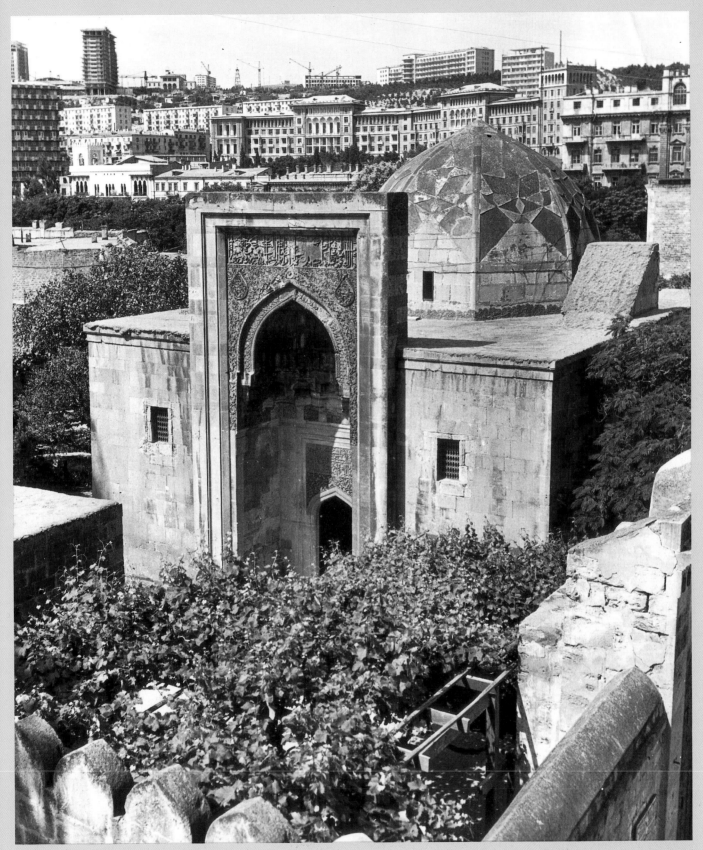

II.7 Tomb of the Shirvanshah, Baku, Azerbaijan, 15th century.

II.8 Tomb of the Shirvanshah, Baku, detail of front portal.

the term, the name was adopted by others. Thus, a style was born.

We must be careful, however, when we use labels for artworks. Occasionally they imply stylistic characteristics; sometimes they identify attitudes or tendencies that are not really stylistic. Often debate exists as to which is which. For example, Romanticism has stylistic characteristics in some art disciplines, but the term also describes a broad philosophy of life. A style label can be a composite of several elements with dissimilar characteristics but identical objectives—for example, Post-Impressionism (see p. 351). Terminology is convenient but not universally agreed upon in fine detail. Occasionally experts disagree as to whether certain artworks fall within the descriptive parameters of one style or another, even while agreeing on the definition of the style itself.

In addition, we can ask how the same label might identify stylistic characteristics of two or more unrelated art disciplines, such as painting and music. Is there an aural equivalent to visual characteristics, or vice versa? These are challenging questions, and the answers are debatable. More often than not, similarity of objectives results in the same stylistic label being used for works in quite different disciplines.

Styles do not start and stop on specific dates, nor do they recognize national boundaries. Some reflect deeply held

convictions or creative insights; some are imitations of previous styles. Many styles are profound; others are superficial. Some are intensely individual.

Merely dissecting artistic or stylistic characteristics is not an end in itself. What makes analysis come alive is the actual experience of artworks, as we describe our reactions and attempt to find the deepest level of meaning possible. Every artwork reflects the attempt of another human being to express some view of the human condition we all share. We can try to place that viewpoint in the context of the time or the specific biography that produced it and speculate upon why its style is as it is. We can attempt to compare those contexts with our own. We may never know the precise stimuli that caused a particular artistic reflection, but our attempts at understanding make our responses more informed and exciting, and our understanding of our own existence more profound.

APPROACHING PART II OF THE TEXT

"REALITY"

In the chapters that remain we examine the manner in which artists have portrayed and continue to portray "reality." We must remember that "reality" in terms of this textbook includes subject matter that we will never find in the world around us. Indeed, the products of our wildest fantasies can be forms of "reality" in its very broadest sense. But our purpose here is not to debate definitions but to experience works of art in a reasonably convenient way. The fact of the matter is that artists use certain tools that, in Part I, we have called "media" to create artistic visions of something—call it "reality" or call it something else. Whatever we believe it reflects or reveals, that creation is an artwork, and it has a specific signature that we call "style." In the remainder of the text, we will look at a variety of styles from around the world from the earliest times to the present.

ORGANIZATION

There probably is no perfect way to organize a study of the diverse styles we are about to discover. For the simple reason that chronology is familiar and convenient, we have chosen to proceed with an organization that focuses on style but does so in a roughly chronological fashion. However, rather than a true "history" of the arts, the material in these chapters constitutes a series of snapshots only—a sampling of the art humankind has produced over 35,000 years and the labels by which we have come to identify it. This gives us many styles to examine but precious few examples to describe them. Indeed, many artistic styles from around the world do not appear at all.

Thus, as we make our way through the remainder of the book, we will take some pretty dizzying jumps—geographically and time-wise. Think of it as an elaborate artistic buffet. The chronological arrangement is a way of keeping the meats together and the salads likewise. It is not the only way we could have organized the smorgasbord, but it is a helpful way of sorting out several hundred examples of humankind's artistic output. At a formal meal in a conventional restaurant, in contrast to a buffet, we would not find tables with fried potatoes sitting next to carrot salads or with seven different meats and ten different desserts. Think of a typical history book as a conventional restaurant where we can find specialization and concentrated details. At a buffet, on the other hand, we can sample many items and come away enlightened and satisfied even though we may have eaten only a tablespoonfull of any dish. If we are fortunate, we may discover, in the wide array, a dish or two that we might go to a traditional restaurant and order as a regular course in a more formal meal.

This book is a buffet, and a potpourri of presentation and discovery is what Part II intends, and what you should expect. If you concentrate on the names and characteristics of the styles, or approaches, presented, and compare one style's characteristics with those of another, regardless of when or where they occurred, you will succeed nicely. Such concentration and comparison not only will yield interesting results but also will polish your confidence and ability to respond to works of art that you will experience when this book has long been forgotten. Do not, however, try to find a continuum of artistic development as the material in Part II spins out. You won't find one; none is intended, even though the material has a chronological framework, and although it is extremely helpful to know, for example, that Greek Classicism occurred during the fifth century B.C., or that modern dance is a twentieth-century movement.

ART FROM MANY CULTURES

As if a sweep through 35,000 years of art in 200 pages weren't enough, we have the added factor of diverse cultures with which to contend. That need not be troublesome. As the text unfolds, very little in the way of back-

ground is presented. Nevertheless, as we noted in the Introduction, we can analyze art in both formal and contextual ways. Arguably, perhaps, we can never see a work of art outside our own culture in the way that someone nurtured in that culture can. We cannot hope to know the historic works of our own culture in the way they were known in their own times.

On the other hand, questions of style, organization, aesthetic flavor, and comparison can be addressed by purely formal means, and that is what this text emphasizes. At the bottom line, the unique and unforgettable quality of a work of art is the way it looks and sounds. And we can analyze, compare, and relate those qualities even if we do not know much about the context or culture that produced them. Fundamentally, formal skills of analysis and observation are what we are called upon to use most of the time when we experience art outside the world of the textbook and the classroom. When we meet a work of art for the first time, we can engage it formally and at great depth—luckily so, because most of the time we do not have contextual materials, as valuable as they might be, to call upon.

Finally, there is one general factor to note as we progress through Part II of this text. That is the changing emphasis on space and volume. We can see this within single cultures and among the diverse cultures examined here. The exercise in comparing the use of line, form, and color we just finished is an exercise to be performed repeatedly in comparing works of art within the European tradition and with works from Asia, Africa, and Native America. That exercise alone will yield critical insights of significant consequence.

CHAPTER NINE

ANCIENT APPROACHES

C. 30,000 TO C. 480 B.C.

IMPORTANT TERMS

Venus figure A feminine figurine from the Paleolithic period.

Stylized A type of depiction in which verisimilitude has been altered for artistic effect.

Bible From the Greek word for books, and referring to the town of Byblos. The name of the Hebrew scriptures.

Torah The Hebrew Bible's book of The Law, comprising the books of Genesis, Exodus, Leviticus, and Deuteronomy.

Psalm From the Psalter, the hymnal of ancient Israel.

Pao-chia system The ancient Chinese system of mutual responsibility.

Pre-Columbian Native American art that predates the arrival of Columbus in 1492.

Archaic style A style of Greek vase painting and sculpture dating to the sixth century B.C.

Doric style A style of Greek architecture marked by heavy, slanted columns with a flat slab for a capital.

Kouros Referring to Archaic sculpture of Greek youth.

Lyric poetry Poetry written to be accompanied by a lyre.

PALEOLITHIC EUROPEAN ART

SCULPTURE

Humankind's first known sculpture dates from the period from approximately 30,000 to 15,000 B.C. The head and body of a man carved from mammoth ivory were found in a burial site at Brno in the Czech Republic (Fig. **9.1**). Although many body parts are missing, the head reveals an apparent attention to anatomical details. The hair is closely cropped, the brow is low, and the eyes are deeply set.

Western European art probably began approximately 25,000 to 30,000 years before the Christian era and, at its earliest, consisted of simple lines scratched in damp clay. The people making these scratchings lived in caves and seem, eventually, to have elaborated them into the outlines of animals. This development—from what appears to be idle doodling into sophisticated art—seems to have come in three phases. Black outline drawings of animals with a single colored filler mark the first. Next came the addition of a second color within the outline, to create a sense of

9.1 Man from Brno, c. 27,000–20,000 B.C. Ivory, height 9 ins (20 cm). Moravian Museum, Brno, Czech Republic.

light and shade, or modeling. As we shall see, these depictions often incorporated projecting portions of the cave walls to add a sense of three-dimensionality. In many cases it appears as though the artist picked a specific rock protru-

9.2 Bison, from Altamira, Spain, c. 14,000–10,000 B.C. Paint, length 8 ft 3 ins (2.51 m).

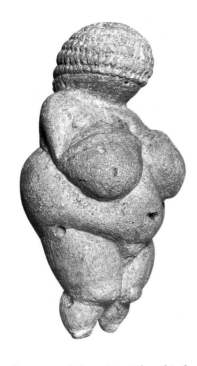

9.3 Woman from Willendorf, Lower Austria, c. 30,000–25,000 B.C. Limestone, height 4⅓ ins (11 cm). Naturhistorisches Museum, Vienna.

and a remarkable sense of movement, using only earth colors and charcoal.

The earliest artists seem to have shied away from the difficulties of drawing three-dimensionality, keeping their subjects in profile (as, much later, the Egyptians were to do). Only an occasional turning of head or antlers tests the artist's skill at portraying depth.

So-called Venus figures have been found on burial sites in a band stretching approximately 1,100 miles (1,833 km) from western France to the central Russian plain. Many scholars believe that these figures are the first works in a representational style. They share certain stylistic features and are remarkably similar in overall design. They may be symbolic fertility figures—hence modern scholars have named them after the Roman goddess of love and beauty—or they may be no more than objects for exchange or recognition. Whatever the case, each figure has the same tapering legs, wide hips, and tapering shoulders and head, forming a diamond-shaped silhouette.

The Woman from Willendorf (Fig. 9.3) is the best-known example of a Venus figure. Emphasis is on swollen thighs and breasts and prominent genitals, implying that the image is a fertility symbol. Some have gone so far as to suggest that these works reveal their makers' obsessions with sexual ideas. Carved from limestone, the Woman

sion or configuration for the animal drawing. The third phase in the development of early art consists of exciting multicolored paintings in impressive realistic style. In this category are the well-known paintings at Altamira in Spain (Fig. 9.2). Here the artists captured detail, essence, mass,

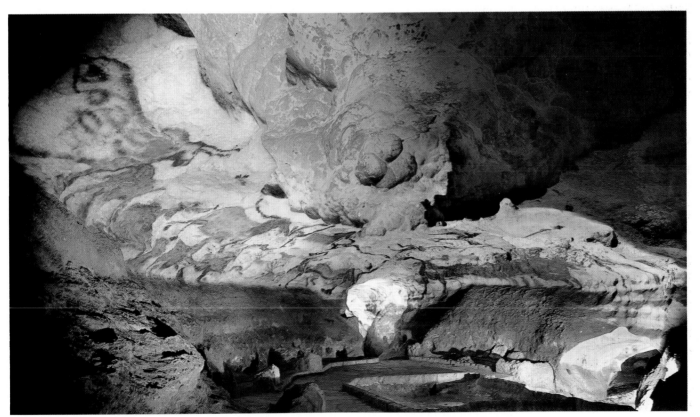

9.4 Main hall, or Hall of Bulls, Lascaux, France. Paint on limestone, 30 x 100 ft (9 x 30 m).

from Willendorf was originally colored red—the color of blood—perhaps symbolizing life itself. Corpses were painted red by many early peoples.

Although faceless, Venus figures usually have hair, often wear bracelets, beads, aprons, or a waist band, and sometimes show markings that may represent tattoos. Although the culture in which they were made was dominated by a male hunting ethos, only women are represented in the statuary that survives. Emphasis on their sexuality, the mystery and apparent miracle of birth, and the uniquely female role therein clearly influenced the carvers' perception of reality.

CAVE PAINTING

The caves of Lascaux lie slightly over a mile from the little French town of Montignac, in the valley of the Vézère River. A group of children, investigating a tree uprooted by a storm, scrambled down a fissure into a world undisturbed for thousands of years and discovered the caves. Hundreds of paintings were found there, as elsewhere in France, Spain, and other parts of Europe. The significance of the Lascaux works lies in the quantity and the quality of an intact group.

An overwhelming sense of the power and sweep of Lascaux emerges from the main hall or "Hall of Bulls" (Fig. 9.4). The thundering herd moves below a sky of rolling contours formed in the stone ceiling of the cave, sweeping our eyes forward. At the entrance of the hall an 8-foot (2.5-m) unicorn begins a monumental montage of bulls, horses, and deer, whose shapes intermingle and whose colors radiate warmth and power. With heights of up to 12 feet (3.5 m), these magnificent creatures captivate us. Although the paintings in the main hall were created over a long period and by a succession of artists, the cumu-

9.6 Vase with ritual scene, from E-anna, Uruk (modern Warka), Iraq, c. 3500–3100 B.C. Alabaster relief, height 36 ins (91 cm). Iraq Museum, Baghdad.

lative effect of this 30- by 100-foot (9- × 30-m) domed gallery is of a single work, carefully composed for maximum dramatic and communicative impact.

9.5 Cylinder seal and impression, showing snake-necked lions, from Mesopotamia, c. 3300 B.C. Green jasper, height 1¾ ins (4 cm). Louvre, Paris.

MASTERWORK

The Tell Asmar Statues

Undoubtedly the most striking features of these figures are their enormous, staring eyes, with their dramatic exaggeration. Arguably representing Abu, the god of vegetation (the large figure), a goddess assumed to be his spouse, and a crowd of worshipers, the statues occupied places around the inner walls of an early temple, as though they were at prayer, awaiting the divine presence. The figures have great dignity, despite the stylization and somewhat crude execution. In addition to the staring eyes, our attention is drawn to the distinctive carving of the arms, which are separate from the body. The lines of each statue focus the eye of the viewer on the heart, adding to the emotion suggested by the posture. The composition is closed and self-contained, reflecting the characteristics of prayer.

Certain geometric and expressive qualities characterize these statues. In typical Sumerian style, each form is based on a cone or cylinder, and the arms and legs are stylized and pipe-like, rather than being life-like depictions of the subtle curves of human limbs.

The god Abu and the mother goddess may be distinguished from the rest by their size and by the large diameter of their eyes. The meaning in these statues clearly bears out what we know of Mesopotamian religious thought. The gods were believed to be present in their images. The statues of the worshipers were substitutes for the real worshipers, even though no attempt appears to have been made to make the statues look like any particular individual: every detail is simplified, focusing attention on the remarkable eyes, which are constructed from shell, lapis lazuli, and black limestone.

Large and expressive eyes appear to be a basic convention of Sumerian art—although it is a convention found in other ancient art as well. Its basis is unknown, but the idea of the eye as a source of power permeates ancient folk-wisdom. The eye could act as a hypnotizing, controlling force, for good or for evil, hence the term "evil eye," which is still used today. Symbolic references to the eye range from "windows of the soul" to the "all-seeing" vigilance of the gods.

The Sumerians used art, like language, to communicate through conventions. Sumerian art took life-likeness, as it was perceived by the artist, and reduced it to a few conventional forms, which, to those who understood the conventions, communicated larger truths about the world.

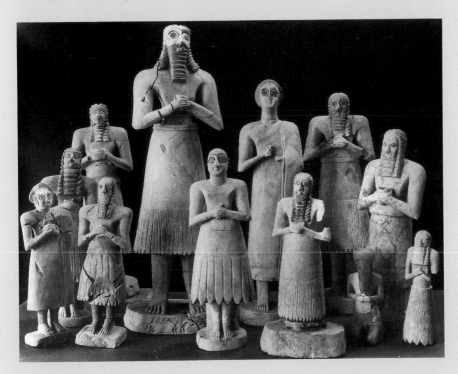

9.7 Statues of worshipers and deities from the Square Temple at Tell Asmar, Iraq, c.2750 B.C. Gypsum, tallest figure 30 ins (76 cm). Iraq Museum, Baghdad, and Oriental Institute, University of Chicago.

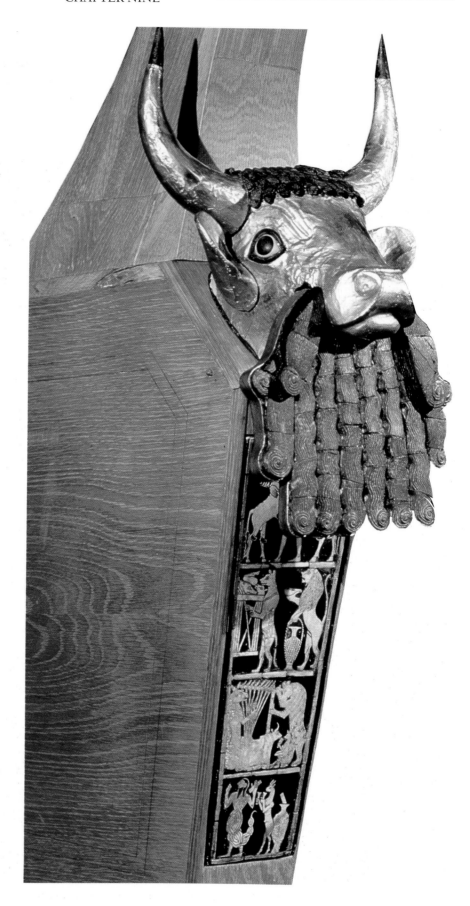

9.8 (*above*) Soundbox panel of the royal lyre, from the tomb of Queen Puabi, Ur, Iraq, 2650–2550 B.C. Shell inlay set in bitumen, height 13 ins (33 cm). Palmer Museum of Art, Pennsylvania State University.

9.9 (*right*) Royal lyre, from the tomb of Queen Puabi, Ur. Wood with gold, lapis lazuli, and shell inlay. Palmer Museum of Art, Pennsylvania State University.

SUMER

Some time around 6000 B.C. the first recognizable civilization appeared in that part of the Near East we call Mesopotamia—the region between the Tigris and Euphrates rivers (in what today is the country of Iraq)—and the earliest recognizable culture to emerge in this area was that of Sumer. Sumerians lived in villages and organized themselves around several important religious centers, which grew rapidly into cities. Sumerian mathematics employed a system of counting based on sixty and that system was used to measure time (we still have sixty minutes in one hour) and circles, divided into 360 degrees.

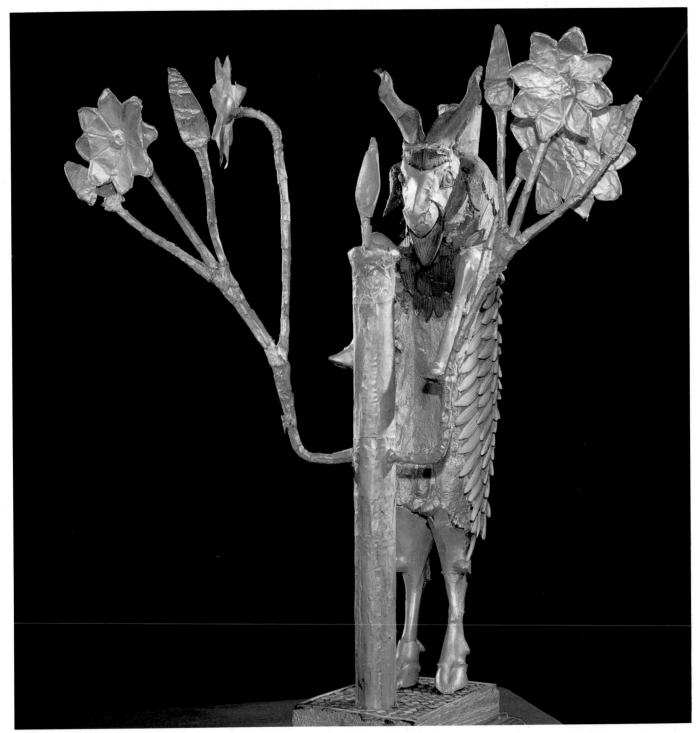

9.10 He-goat, from Ur, c. 2600 B.C. Wood with gold and lapis lazuli overlay, height 20 ins (51 cm). Palmer Museum of Art, Pennsylvania State University.

The wheel appeared in Sumer as early as 3000 B.C.

The majority of surviving artworks from Mesopotamia prior to 3000 B.C. are painted pots and stamp seals. Decoration of pottery served to satisfy the creative urge while providing functional objects. Decoration was abstract. Stamp seals, although clearly functional, went beyond tool status and were also regarded as surfaces ideally suited to exercise artists' creative ingenuity. Early seals were round or rectangular; later, for reasons unknown to us, cylindrical ones came into being. A carved wooden roller was applied to wet clay to produce a ribbonlike design of indefinite length. The creative possibilities inherent in cylinder seal design were far greater than in the other shapes. What seems to have fascinated the Sumerians is the way that intricate design can be repeated infinitely. Scenes of sacrifice, hunting, and battle all appear in the examples of cylinder seal art that have survived. Figure 9.5 combines two Sumerian fertility symbols: the lioness and the intertwined snake. This design appears repeatedly in Sumerian art.

In *low-relief* art of the early Sumerians such as Figure 9.6 we find a preoccupation with ritual and the gods. This large alabaster vase celebrates the cult of E-anna, goddess of fertility and love. Divided into four bands, it commemorates the marriage of the goddess, which was re-enacted to ensure fertility. The bottom band has alternate stalks of barley and date palms; above it are rams and ewes. In the second band, naked worshipers carry baskets of fruit and other offerings. At the top the goddess herself stands before her shrine—two coiled bundles of reeds—to receive a worshiper or priest, also nude, whose tribute basket brims with fruit.

The composition exhibits an alternating flow of movement: from left to right in the rams and ewes, and right to left in the worshipers. Conventions of figure portrayal are similar to but not as rigid as those in Egyptian art (see pp.204–5). Other works from this period such as Figures 9.8 and 9.9 illustrate the splendor of the Sumerian court. Inlaid in gold and laden with the symbolism of masculine fertility is the dazzling golden goat from the royal graves at Ur (Fig. 9.10). It manifests the basic Sumerian belief in a pantheon of gods personifying nature. The goat represents Tammuz, one of the gods of vegetation. His portrayal is crisp and elegant.

9.11 Sargon II's citadel, Dur Sharrukin (modern Khorsabad), Iraq, reconstruction.

9.12 Sargon II's citadel, Khorsabad (during excavation), gate with pair of winged and human-headed bulls. Limestone.

ASSYRIA

By the year 1000 B.C., a new power had arisen in Mesopotamia—the Assyrians. These were northern peoples from Ashur on the River Tigris. Their military power and skill enabled them to maintain supremacy over the region, including Syria, the Sinai peninsula, and as far as lower Egypt. For nearly 400 years they appear to have engaged in almost continuous warfare, ruthlessly destroying their enemies and leveling conquered cities. Finally, they, too, felt the conqueror's sword, and all their cities were utterly destroyed.

Under Sargon II, who came to power in 722 B.C., the high priests regained many of the privileges they had lost under previous kings, and the Assyrian Empire reached the peak of its power. Early in his reign he founded the city of Dur Sharrukin (on the site of modern Khorsabad), about 9 miles (15 km) northeast of Nineveh. His vast royal citadel, occupying an area of some quarter of a million square feet, was built as an image not only of his empire but of the cosmos itself. The reconstruction of the citadel in Figure **9.11** shows the style of architecture at the time and illustrates the priorities of Assyrian civilization. It is quite clear that in Sargon's new city secular architecture took precedence over temple architecture. The rulers seem to have been far more preoccupied with building fortifications and pretentious palaces than with erecting religious shrines. Dur Sharrukin was built, occupied, and abandoned within a single generation.

The citadel, representing the ordered world, rises like the hierarchy of Assyrian gods, from the lowest levels of the city, through a transitional level, to the king's palace, which stands on its own elevated terrace. Two gates connect the walled citadel to the outside world. The first was undecorated; the second was adorned with and guarded by winged bulls and genii (Fig. **9.12**).

Remarkably, excavations at the site have shown construction methods to have been fairly inadequate. In addition, buildings are arranged haphazardly, and within the inner walls five minor palaces were crowded with obvious difficulty into the available space.

The main palace comprises an arrangement of ceremonial apartments around a central courtyard. Entrances to the throne room were guarded by winged bulls and other figures. The walls of the room itself stood approximately 40 feet (12 m) high and were decorated with floor-to-ceiling murals. Three small temples adjoined the palace and beside these rose a *ziggurat* with successive stages painted in different colors, connected by a spiral staircase. Construction was of mud brick, laid without mortar while still damp and pliable, and of dressed and undressed stone. Some roof structures used brick barrel vaulting, although the majority appear to have had flat ceilings with painted beams.

Corresponding to the vast scale of the buildings are the great guardian figures of which Figure **9.12** is representa-

tive. Undoubtedly symbolizing the supernatural powers of the king, these colossal hybrids are majestically powerful in stature and scale. Carved partly in relief and partly in the round, they are rationalized to be seen from front or side: The sculptor has provided each figure with a fifth leg, with the result that the viewer can always see four. Each of these monoliths was carved from a single block of stone upward of 15 feet (4.5 m) square.

JUDEA

THE TEMPLE OF SOLOMON

Moving west from Mesopotamia and Assyria, we come to the ancient land of the Hebrews. The Temple in Jerusalem was the symbol of Hebrew faith as early as its third King, Solomon (c. 1000 B.C.). Described in the Bible in I Kings 5–9, the Temple of Solomon was primarily the house of the Lord God, rather than a place for the common people to come to worship.

The temple itself, as reconstructed in Figure 9.13, stood on a platform with a dominating entrance of huge wooden doors flanked by two bronze pillars about 18 feet (5.5 m) tall. The doors were decorated with carved palms, flowers, and cherubim (guardian winged beasts sometimes shown with human or animal faces). The entrance hall, or vestibule, measured approximately 15 by 30 feet (4.5 m × 9 m). Inside the temple proper was a Holy Place, or *Hekal*, about 45 feet (13.5 m) high, 60 feet (18 m) long, and 30 feet (9 m) wide. The paneled walls were made from cedars of

9.13 Reconstruction drawing of Solomon's Temple, Jerusalem. The significance of the two bronze pillars is uncertain, but some scholars suggest that they may have represented the twin pillars of fire and smoke that guided the Israelites during their wanderings in the desert after the Exodus from Egypt.

Lebanon and carved in rich floral designs, and were pierced at the top by small rectangular windows that allowed light to enter the temple. The room itself had various sacred furnishings: ten large lampstands, an inlaid table for priestly offerings, and a cedarwood altar covered with gold.

From a staircase behind the altar the High Priest entered the Holy of Holies, the most sacred part of the Temple. It was a windowless cubicle 30 feet (9 m) square and contained the Ark of the Covenant, the symbol of God's presence, which the Jews had carried with them from the wilderness. The Ark was flanked by two large cherubim.

THE HEBREW BIBLE

The word "bible" comes from the Greek word for book, and it refers to the town of Byblos, which exported the papyrus reed used in the ancient world for making books. The Jews compiled the history of their culture and religion into a collection of sacred writings called scriptures. The compilation grew from the oral traditions of the Hebrew people and took shape over a period of years as it was assembled, transcribed, and verified by state officials and scholars. The Bible has been handed down in a variety of forms. The Hebrew Bible, often called the Masoretic Text (MT), is a collection of twenty-four books written in Hebrew, with a few passages in Aramaic.

The earliest written Bible probably dates to the United Monarchy of King David in the tenth century B.C. It is composed of an assemblage of history, songs, stories, and prophecy. The current Hebrew Bible was canonized by the Council of Jamnia in A.D. 90. It contained three parts: The Law (Torah), The Prophets, and the Writings. Briefly, the Torah contains the books of Genesis, Exodus, Leviticus, Numbers, and Deuteronomy. The Prophets include Joshua, Judges, Samuel, Kings, Isaiah, Jeremiah, Ezekiel, and the twelve minor prophets. The Writings, which contain a variety of literary forms, including poetry and apocalyptic visions, are made up of the biblical books of Psalms, Proverbs, Job, Song of Songs, Ruth, Lamentations, Ecclesiastes, Esther, Daniel, Ezra, Nehemiah, and Chronicles.

The Psalter is the hymnal of ancient Israel. Most of the Psalms were probably composed to accompany worship in the temple. They can be divided into various categories such as hymns, enthronement hymns, songs of Zion, laments, songs of trust, thanksgiving, sacred history, royal psalms, wisdom psalms, and liturgies. Here we include Psalm 22 (a psalm of David), and Psalms 130 and 133 (Songs of Ascent).[1]

Psalm 22

My God, my God, why hast thou forsaken me?
Why art thou so far from helping me, from the words of my
groaning?

2 O my God, I cry by day, but thou dost not answer;
and by night, but find no rest.

3 Yet thou art holy,
enthroned on the praises of Israel.

4 In thee our fathers trusted;
they trusted, and thou didst deliver them.

5 To thee they cried, and were saved;
in thee they trusted, and were not disappointed.

6 But I am a worm, and no man;
scorned by men, and despised by the people.

7 All those who see me mock at me,
they make mouths at me, they wag their heads;

8 "He committed his cause to the LORD; let him deliver him,
let him rescue him, for he delights in him!"

9 Yet thou art he who took me from the womb;
thou didst keep me safe upon my mother's breasts.

10 Upon thee was I cast from my birth,
and since my mother bore me thou hast been my God.

11 Be not far from me,
for trouble is near
and there is none to help.

12 Many bulls encompass me,
strong bulls of Bashan surround me;

13 they open wide their mouths at me,
like a ravening and roaring lion.

14 I am poured out like water,
and all my bones are out of joint;
my heart is like wax,
it is melted within my breast;

15 my strength is dried up like a potsherd,
and my tongue cleaves to my jaws;
thou dost lay me in the dust of death.

16 Yea, dogs are round about me;
a company of evildoers encircle me;
they have pierced my hands and feet—

17 I can count all my bones—
they stare and gloat over me;

18 They divide my garments among them,
and for my raiment they cast lots.

19 But thou, O LORD, be not far off!
O thou my help, hasten to my aid!

20 Deliver my soul from the sword,
my life from the power of the dog!

21 Save me from the mouth of the lion,
my afflicted soul from the horns of the wild oxen!

22 I will tell of thy name to my brethren;
in the midst of the congregation I will praise thee:

23 You who fear the LORD, praise him!
all you sons of Jacob, glorify him,
and stand in awe of him, all you sons of Israel!

24 For he has not despised or abhorred
the affliction of the afflicted;
and he has not hid his face from him,
but has heard, when he cried to him.

25 From thee comes my praise in the great congregation;
my vows I will pay before those who fear him.

26 The afflicted shall eat and be satisfied;
those who seek him shall praise the LORD!
May your hearts live for ever!

27 All the ends of the earth shall remember
and turn to the LORD;
and all the families of the nations
shall worship before him.

28 For dominion belongs to the LORD,
and he rules over the nations.

29 Yea, to him shall all the proud of the earth bow down;
before him shall bow all who go down to the dust,
and he who cannot keep himself alive.

30 Posterity shall serve him;
men shall tell of the LORD to the coming generation,

31 And proclaim his deliverance to a people yet unborn,
that he has wrought it.

Psalm 130

Out of the depths I cry to thee, O LORD!
Lord, hear my voice!

2 Let thy ears be attentive
to the voice of my supplications!

3 If thou, O LORD, shouldst mark iniquities,
Lord, who could stand?

4 But there is forgiveness with thee,
that thou mayest be feared.

4 I wait for the LORD, my soul waits,
and in his word I hope;

6 My soul waits for the LORD
more than watchmen for the morning,
more than watchmen for the morning.

7 O Israel, hope in the LORD!
For with the LORD there is steadfast love,
and with him is plenteous redemption.

8 And he will redeem Israel from all his iniquities.

Psalm 133

Behold, how good and pleasant it is
when brothers dwell in unity!
2 It is like the precious oil upon the head,
running down upon the beard,
upon the beard of Aaron,
running down on the collar of his robes!
3 It is like the dew of Hermon,
which falls on the mountains of Zion!
For there the LORD has commanded the blessing,
life for evermore.

What we find in these poetic examples is the section of the Bible where humans express their feelings to God. Psalm 22, which many believe Jesus quoted as he hung on the cross, develops from despair to trust and praise, as the psalmist pours out his troubles and then recognizes his own frailty and the greatness and unfailing love of God. The imagery is powerful: "I am poured out like water, and all my bones are out of joint; my heart is like wax, it is melted within my breast." Psalm 130, likewise, develops from trouble to hope. As is typical of Hebrew tradition, things are stated twice, in different words: 1) "Out of the depths I cry to thee, O Lord! Lord, hear my voice." 2) "Let thy ears be attentive to the voice of my supplications!" Finally, Psalm 133 speaks of the benefits of peace, again with vivid imagery. When brothers dwell in unity, it is better than an excess of the most expensive commodities: "It is like precious oil upon the head, running down the beard."

ANCIENT EGYPT

A little further west, the other ancient culture in this part of the world was that of Egypt. Protected by deserts and confined to the narrow Nile valley, ancient Egypt was relatively isolated for thousands of years. It had a unified civilization, under the control of an absolute monarch. As a rural society, it was uniquely dependent upon the regular annual flooding of its single river. Ancient Egyptian history is divided into three periods, or kingdoms: Old, Middle, and New, beginning in about 2800 B.C. The other basic organizational unit is the dynasty, conforming to the period of a particular family of rulers.

Death—or, rather, everlasting life in the hereafter—was the focus of much of the art of the Egyptians. Appearing mostly in the service of the cult of a god or to glorify the power and wealth of a pharaoh, art and architecture centered on the provision of an eternal dwelling-place for the dead.

OLD KINGDOM

Sculpture was the major art form of the Egyptians. It not only furnished the "other self" for the tomb of the deceased, to provide immortality, but also stood in temples. By the time of the Old Kingdom (c. 2800–c. 2400 B.C.), sculptors had overcome many of the technical difficulties that plagued their predecessors. Possibly, religious tenets had also confounded sculptors during earlier times. (Many so-called primitive peoples throughout history have regarded lifelike portrayal of the human figure as inviting danger—making a likeness of an individual was thought to capture the soul.)

Old Kingdom sculpture shows technical mastery and is well crafted. Life-size pieces capture the human form in exquisite detail. At the same time, certain conventions are used to idealize royalty. The presumed divinity of the pharaoh dictated a dignified and majestic portrayal. Although rigidity of treatment lessened as time went on, softening and human-centered qualities never completely divested the pharaonic statue of its divine repose.

Rahotep and Nofret

The dual sculpture of Prince Rahotep and his wife Nofret (Fig. 9.14) comes from the tomb of the prince. The stylized posture is a trademark of Egyptian art, with its intellectual or conceptual, as opposed to lifelike or visual, nature. The statues' striking colors exemplify the Egyptian tendency to use paint to provide a decorative surface for sculpture. The eyelids of both figures are painted black, and their eyes are dull and light-colored quartz. In line with convention, the skin tones of the woman are several shades lighter than those of the man. A woman's skin was traditionally creamy yellow, whereas a man's ranged from light to dark brown.

In Dynasty IV the kings rose from peasant stock, an ancestry which is apparent in the sturdy, broad-shouldered, well-muscled physique of the prince. At the same time his facial characteristics—particularly the eyes and expression—exhibit alertness, wisdom, strength, and capacity. The portrayal of Nofret expresses similar individuality. Probably for the first time in Egyptian art, here is full development of the three-dimensional female body. Nofret is wearing the typical gown of the period, cut to reveal voluptuous breasts. The artist has meticulously observed and depicted detail here, as in all the details of the upper portion of both statues.

Egyptian admiration for the human body reveals itself

9.14 Prince Rahotep (*left*) and his wife Nofret (*opposite*), from Medum, Egypt, c. 2580 B.C. Painted limestone, height 3 ft 11½ ins (1.2 m). Egyptian Museum, Cairo.

clearly in both statues. Precise modeling and attention to detail are seen in the smallest items. In the statue of Nofret the gown at once covers and reveals the graceful contours of the body beneath. She has a sensual and pampered face. Her hair is a wig shaped in the style of the day, and beneath the constricting headband we can see Nofret's own hair, of much finer texture, parted in the middle and swept back beneath the wig. A precise and delicate treatment of the hand held open against the body reveals the artist's perception. Small dimples decorate the fingers and the unpainted nails are correctly portrayed as lighter than normal skin tone.

The Pyramids

The years around 2700 B.C. brought forth the most remarkable edifices of Egyptian civilization—the pyramid area of Giza. In addition to the three most obvious pyramids, the area comprises burial places for almost all of the important individuals of Dynasties IV and V. Each pyramid complex has four buildings. The largest pyramid, that of Cheops (Fig. 9.15), measures approximately 750 feet (228 m) square (440 cubits) and rises at an angle of approximately 51 degrees to a height of 481 feet (146 m). The burial chamber of the pharaoh lay hidden in the middle (Fig. 9.16). Construction consisted of irregularly placed, rough-hewn stone blocks covered by a carefully dressed limestone facing approximately 17 feet (5 m) thick. The famous Sphinx (Fig. 9.17) is a colossal figure carved from natural rock, lying at the head of the causeway leading

9.16 Longitudinal south–north section of the Great Pyramid of Cheops.

from the funerary temple adjoining the pyramid of Cheops' son Chephren, whose pyramid originally measured 707 feet (215 m) square, and rose at an angle of 52 degrees to a height of 471 feet (143 m).

Egypt's pyramids are the oldest existing buildings in the world. These ancient tombs are also among the world's largest structures. The largest stands taller than a forty-story building and covers an area greater than that of ten football fields. More than eighty pyramids still exist, and their once smooth limestone surfaces hide secret passageways and rooms. The pyramids of ancient Egypt served a vital purpose: to protect the pharaohs' bodies after death. Each pyramid held not only a pharaoh's preserved body but also all the goods he would need in his life after death.

9.15 Great Pyramid of Cheops (Khufu), Giza, Egypt, 2680–2565 B.C.

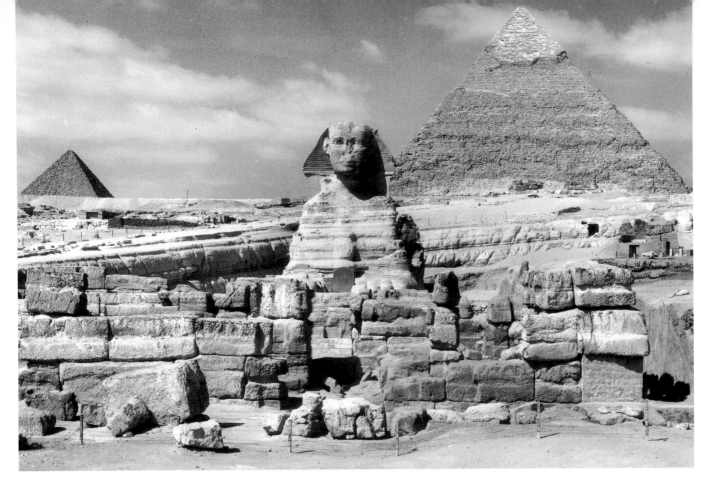

9.17 (*above*) The Sphinx, Giza, c. 2650 B.C.

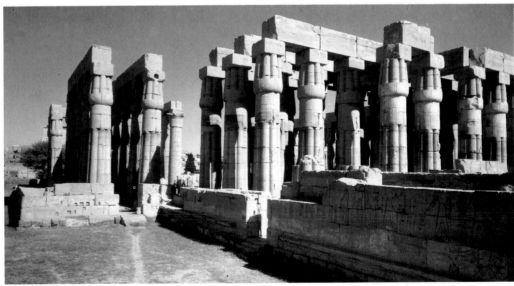

9.18 Temple at Luxor, Egypt, 1417–1397 B.C.

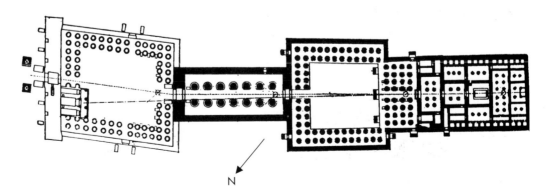

9.19 Temple at Luxor, plan.

9.20 *Queen Nefertari Guided by Isis*, from the First Room of the tomb of Queen Nefertari, Thebes.

PROFILE

Nefertiti

Nefertiti (c. 1372–1350 B.C.; Fig. **9.21**) was Akhenaton's Great Royal Wife. Scholars debate whether she was a princess from another land or an Egyptian. Those believing her to be of Egyptian origin are also divided. One group claims she was the daughter of Aye and Tiy, and the other claims her as the oldest daughter of Amenhotep III and another wife, possibly Sitamun. Whatever her parentage, Nefertiti was married to Akhenaton and while living in Memphis gave birth to six daughters. It is possible that she also had sons, although no record has been found of this. It was a practice in Egyptian art not to portray the male heirs as children. Possibly she was Tutankhamun's mother. Nefertiti achieved a prominence unknown to other Egyptian queens. Her name is enclosed in a royal cartouche, and there are, in fact, more statues and drawings of her than of Akhenaton. Some have even claimed that it was Nefertiti, not Akhenaton, who instigated the monotheistic religion of Aton. Around Year 15 of Akhenaton's reign, Nefertiti mysteriously disappeared from view. Perhaps she died, but no indication of this can be found. Some scholars think that she was banished for some reason, and lived the rest of her years in the northern palace, raising Tutankhamun. Whatever may have happened, she was replaced by her oldest daughter, Meritaten, and disappeared from history.

Akhenaton's own words describe Nefertiti: "The Hereditary Princess, Great of Favor, Mistress of Happiness, Gay with the two feathers, at hearing whose voice one rejoices, Soothing the heart of the king at home, pleased at all that is said, the Great and Beloved Wife of the King, Lady of the Two Lands, Neferu-aton Nefertiti, living forever."

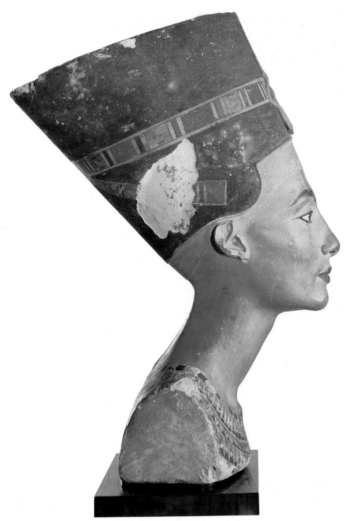

9.21 *Nofretete* (*Nefertiti*), c. 1360 B.C. Painted limestone, height 19 ins (48 cm). Egyptian Museum, Berlin.

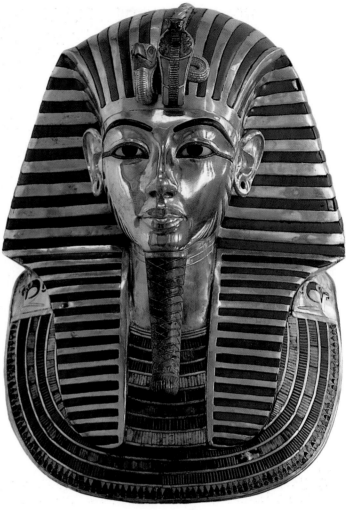

9.23 Funerary mask of King Tutankhamun, c. 1340 B.C. Gold inlaid with enamel and semiprecious stones, height 21¼ ins (54 cm). Egyptian Museum, Cairo.

9.22 Tomb of Queen Nefertari-mi-en-Mat, Thebes, Egypt, ground plan, 1290–1224 B.C.

NEW KINGDOM

The Temple at Luxor

Leaving the pyramids behind, we move to the New Kingdom (c. 1575–c. 1100 B.C.) and a building of great luxury and splendor: the temple at Luxor (Fig. **9.18**). It approaches more nearly the modern conception of architecture—as a useful place for humankind to spend the present, rather than eternity. Built by Amenhotep III, the temple is dedicated to the Theban Triad of Amun, Mut, and Chons. It served two purposes. First, it was the place of worship for Amun, Mut, and Chons. Second, during the great feast of the middle of the flood, the barques of these gods were anchored there for several days.

Amenhotep III was a great builder and his taste for splendid buildings drew sustenance from a number of

excellent architects. Notable among these was Athribis, whose likeness at age eighty is preserved in a magnificent statue showing he retained his intellectual and physical abilities and that he expected to reach the age of 110, which the Egyptians considered to be the natural human life span.

People entered the temple through a vestibule full of giant pillars with palm-shaped capitals (Fig. **9.19**). From the vestibule they progressed to a huge courtyard surrounded by bunched columns, then to the *hypostyle* room, and, finally, the Holy of Holies. We cannot escape the loveliness of the columns. The balance between the open spaces and the mass of the columns creates a beautiful play of light and shade. The proportions were massive: The seven pairs of central pillars in the Hall of Pillars are nearly 52 feet (15.8 m) high. Surviving the centuries, the temple grew when Rameses II added a forecourt. The inner enclosure served as a sanctuary for Alexander the Great, and in early Christian times it was used as a Christian church.

Theban Rock Tombs

The function of tomb paintings and low-relief carvings was to furnish the dead with an "eternal castle" and thus to establish the status they had attained on earth, which they would continue to have in the hereafter. Most of what is now known about Egyptian painting of this period comes from the Theban rock tombs. Ceiling decorations are common and elaborate. The paintings portray the vivacity and humor of daily life.

Queen Nefertari-mi-en-Mat, of Dynasty XIX, was one of the four principal wives of King Rameses II and his favorite. Her tomb lies in the Valley of Queens in western Thebes (now the west bank at Luxor), by precipitous cliffs at the end of the gloomy valley of Biban el Harin.

The paintings adorning the walls of Nefertari's tomb exemplify a style of painting done in low relief, and show great elegance, charm, and vivacious color. The tomb (Fig. 9.22) is entered through the First Room; off it and to the south lies the Main Room or offering chamber. Connected to these chambers is the major part of the tomb, in which the Hall of Pillars or Sarcophagus Chamber provides the central focus. Off and surrounding the Hall of Pillars lie three side rooms.

The northeast wall of the First Room houses a vibrant painting showing the goddess Selkis on the extreme left, with a scorpion on her head (Fig. **9.20**). On the extreme right appears the goddess Maat. Her hieroglyph, the feather, rests on her head. Over the door to the Main Room is the vulture goddess Nekhbet of El-Kab (partly visible in the top right corner of the illustration). Her claws hold the shen-sign, which symbolizes eternity and sovereignty. The rear wall of the recess depicts Queen Nefertari led by the goddess Isis toward the beetle-headed Khepri—a form assumed by the sun god implying his everlasting resurrection. On her crown Isis wears the horns of a cow, surrounded by the sun-disc from which hangs a cobra. In her left hand she carries the divine scepter. Queen Nefertari is dressed according to the fashion of the time, and over the vulture hood she wears the tall, feathered crown of the Divine Consort.

The painting is rich and warm, elegant, and highly stylized. The limited palette uses four hues, which never change in value throughout the work. Yet the overall effect of this wall decoration is one of great variety. The human form is treated in flat profile—the conventionalized style established in Dynasty I. Eyes, hands, head, and feet show no attempt at verisimilitude. Quite the contrary: The fingers become extenuated designs, elongating the arms to balance the elegant and sweeping lines of legs and feet. The matching figures of Selkis and Maat (extreme left and right) even have arms of unequal length and proportion.

Akhenaton and Monotheism: The Tell el Amarna Period

The reign of Akhenaton marks a break in the continuity of artistic style in Egypt. Stiff poses disappear in favor of a more natural form of representation. Moreover, the pharaoh is depicted in intimate scenes of domestic life as well as in the formal ritual or military acts that were expected. He is no longer seen with the traditional human and animal gods of Egypt. Rather, he and his queen are depicted worshiping the disc of the sun, Aton, whose rays end in hands that either bless the royal pair or hold to their nostrils the *ankh*, the symbol of life. What accounts for this revolution is not certain.

In the fifth or sixth year of his reign, the king moved his court to a sandy desert ground on the east side of the Nile: the newly constructed city of Tell el Amarna. It was a new city for a new king intent on establishing a new order based on a new religion. Because the movement failed and the city was abandoned, we are left with an encapsulated artistic synthesis, including the city itself. Tell el Amarna lay away from cultivated land, and, once abandoned, was never built over.

The town itself is dominated by the large estates of the wealthy, who chose the best sites and laid them out in the style of Egyptian country houses, with large gardens and

numerous outbuildings, enclosed within a wall. Between these large estates lay the smaller dwellings of the less wealthy. There was even a slum area outside the northern suburb. Nearby was the grand North Palace.

In many ways Amarna reflects the standard features of New Kingdom domestic architecture, but it seems much less sumptuous. Its lines and style are relatively simple. Structures are open, in contrast to the dark and secret character of the temple of Luxor, for example. At Amarna, numerous unroofed areas lead to Aton's altar, left open to provide access to the rays of his sun.

Sculpture at Amarna departed from tradition. It moved away from the strong emphasis on tombs and temples and became more a form of secular art. Amarna sculptors sought to represent the uniqueness and individuality of humankind through the human face. In one sense their sculptures are highly lifelike, and yet, in another, they depart into the realm of spirituality. The bust of Queen Nefertiti (Fig. 9.21) illustrates these characteristics. Of course, we have no way of knowing how Queen Nefertiti actually looked, but the figure is so anatomically correct that it could be a lifelike representation. None the less, the line and proportions of the neck and head appear elongated, probably to increase her spiritual appearance.

Depictions of Akhenaton show that he apparently suffered from physical deformity. The artistic trends of the period and Akhenaton's desire for truth seem to have resulted in his graphic representation as a man with a misshapen body, an elongated head, and drooping jaw. Yet the eyes are deep and penetrative. The effect is one of a brooding genius.

Although his religious reforms failed, Akhenaton's experiment in monotheism has left us with a clear portrait of an integrated scheme of life and culture.

Tutankhamun

One of the most popular artifacts from the succeeding period is an exquisite funerary mask from the tomb of Akhenaton's son Tutankhamun (Fig. 9.23), discovered in the Valley of Kings near Thebes. The mask is of solid beaten gold inlaid with semiprecious stones and colored glass. It was designed to cover the face of the king's mummy, and in it he wears the royal *nemes* headdress with two flaps hanging down at the sides. A ribbon holds his braid at the back. The hood formed by the headdress reveals two symbolic creatures: the uraeus serpent and the vulture goddess Nekhbet of El-Kab, divinities who protected Lower and Upper Egypt.

ANCIENT CHINA

From the earliest times, China witnessed the crowding of populations into tight-walled villages. That packing-in of people governed social and family relationships. The family—as opposed to the individual, state, or religious group—formed the most significant social unit. This was reinforced by the practice of ancestor worship. The family also formed the basic political unit. A scheme of mutual responsibility, called the *Pao-chia system*, made people in the same household answerable for each other's actions.

Within the family, a hierarchy existed. The position of each person was dictated by birth and marriage. (Marriages were arranged more as a union of families than of individuals.) Everyone was subordinate to the family and, in general, women were subordinate to men. Norms for social conduct, such as loyalty, sincerity, and benevolence, were inculcated in the family system. The greatest virtue was filial piety. Later, the ethical system of Confucianism fulfilled the role played by law and religion

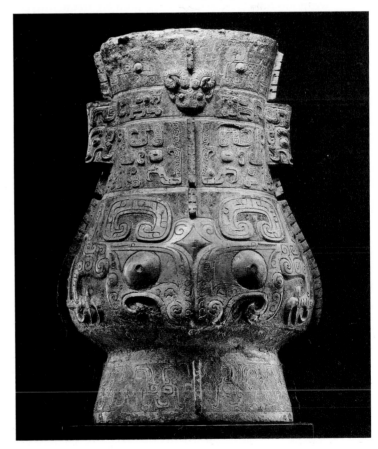

9.24 Ritual wine vessel or *hu*, c. 1300–1100 B.C. Bronze, height 16 ins (40.6 cm), width 11 ins (27.9 cm). Nelson Atkins Museum of Art, Kansas City.

9.25 Elephant feline head, from China, c. 1200 B.C. (Shang Dynasty). Jade, length 1⅝ ins (4 cm). Cleveland Museum of Art (Anonymous gift).

in the West. The Chinese social model was authoritarian and class-conscious.

At a time slightly prior to the Israelites' enslavement in Egypt, verifiable Chinese history was beginning: From approximately 1400 to 1100 B.C., the Shang Dynasty emerged. As in Egypt, the dynasty was the basic organizational unit of history.

The Shang Dynasty produced two types of bronzes: weapons and ceremonial vessels. Both are frequently covered with elaborate designs, either incised or in high-relief. Their exquisite craftsmanship surpasses that of virtually every culture and era, including the Renaissance in Europe. Each line has perfectly perpendicular sides and a flat bottom, meeting at a precise 90-degree angle; this contrasts, for example, with incised decoration, which forms a groove. The bronze ritual vessel in a shape called *hu* (Fig. **9.24**) has subtle symmetrical patterns and delicate craftsmanship. Deftly placed ridges and gaps break the graceful curves and although the designs are delicate, the overall impression is one of solidity and stability.

Another innovation of the Shang culture was stone sculpture in high-relief or in the round. The most numerous objects to survive are small-scale images in jade. There is a broad range: from fish, owls, and tigers as single units to metamorphoses such as the elephant head of Figure **9.25**. This design combines simplicity with subtle detail. Its feline head has large, sharp teeth, an elephant's trunk, and bovine horns.

NATIVE AMERICA

No less than ten general Native American cultural areas exist in North America alone. Mexico, Central America, and South America add many more. Native American art is labeled as either *pre-Columbian*—before Columbus, which we shall examine here,—or *post-Columbian* and encompasses weaving, metalsmithing, and pottery.

Native American artists, like all others, developed their own set of conventions or ground rules. Some of these are quite different from the artistic conventions of Western culture. Those who do not come from the culture themselves may never—probably cannot ever—fully engage a work of art from this tradition, with all its subtleties, comprehending what it comprises in the understanding of its creators.

In many respects, Native American art is the same as Western, Chinese, or any other art: It is an expression of a human perception of reality revealed in a particular medium and shared with others. All art is human, with visual, emotional, and psychological qualities.

Among many Native American groups there is no specific term equivalent to the word "art." In Native American culture in general, however, art is anything "that was well done in the technical sense, or in the end result. This effect might be magical, or it might be power . . . the concept of an artist was simply a person who was better at the job than another." Only a few Indian tribes—for example the Northwest Coast, Mayan, and Inca—had a group of professionals who earned a living by producing art.

Within Native American culture exists a wide variety of expressions, approaches to materials, and general styles. The earliest identifiable art in Mexico comes from the Olmecs—the word means "dwellers in the land of rubber"—and can be dated to approximately 1000 B.C. They carved a number of human and animal subjects, for example, the tiny figure shown in Figure **9.26**. The turned-down mouth of this figurine is a common characteristic of Olmec sculpture of the period. Even though much of the body is missing, we can see the care with which details were carved on this green-gray stone effigy.

9.26 Olmec-style head with trace of red paint inlay, from Xochipala, Guerrero, Mexico, 1250–750 B.C. Fragment of carved stone figurine, 3 x 1 ins (7.6 x 2.5 cm). National Museum of the American Indian, Smithsonian Institution, Washington, D.C.

ARCHAIC GREECE

The time from approximately 800 to 480 B.C. is called the "Archaic period" in order to contrast this phase of development in Greek civilization from a more vigorous cultural advancement called the "Classical period" which occurred in the middle third of the fifth century B.C. and which we will discuss in the next chapter. Archaic Greece was preceded by two nearby civilizations, the Minoan (c. 3000 B.C. to c. 1500 B.C.) and the Mycenaean (c. 1400 B.C. to c. 1200 B.C.), whose styles we, unfortunately, do not have space to discuss.

Archaic Greek culture consisted of a collection of city-states or poleis (singular—polis) of self-governing people. Each had its own sense of self. Some, like Athens, had high esteem for the arts and philosophy; others, like Sparta, were militaristic and seemingly indifferent to high culture.

9.27 Attic bowl showing Perseus and the gorgons—early sixth century B.C. 36½ ins (93 cm) high. Louvre, Paris.

9.28 (*right*) Kouros, c. 615 B.C. Marble, 6 ft 4 ins (1.93 m) high. Metropolitan Museum of Art (Fletcher Fund, 1932)

213

There was, however, a unifying spirit among these independent poleis of Greek derivation—they saw themselves as "Hellenes" and shared a common language and calendar, which dated to the first Olympic games in 776 B.C.

ARCHAIC STYLE

By the middle of the sixth century B.C. Greek artists were attempting to portray the human body in a three-quarter position, between profile and full frontal. A new feeling for three-dimensional space emerged, and artists began to depict eyes more accurately. Fabric began to assume the drape and folds of real cloth. All these characteristics mark vase painting in a style called Archaic (Fig. **9.27**).

Most of the freestanding statues in the Archaic style are of nude youths, and are known as kouroi. The term means, simply, "male youth," and the singular form is kouros (Fig. **9.28**). More than a hundred examples have survived. All exhibit a stiff, fully frontal pose. The head is raised, eyes are fixed to the front, and arms hang straight down at the sides, with the fists clenched. The emphasis of these statues is on physicality and athleticism. Most of the kouroi were sculpted as funerary and temple art. Many of them were signed by the artist: "So-and-so made me." The sculpture lacks refinement, and this is a characteristic that helps to differentiate the Archaic from the Classical style. In addition, the sculpture attempts to indicate movement. The left foot extends forward, giving a greater sense of motion than if both feet were side by side in the same plane.

ARCHITECTURE— THE DORIC STYLE

In the Archaic period, temples were built in a new adaptation of post-and-lintel structure. The style of these temples was called Doric after one of the Hellenic people, the Dorians. We can sense the qualities and details of the order by examining a reconstruction drawing of the west front of the Temple of Artemis at Corfu (Fig. **9.29**) and by referring to the drawing of the parts of the order in Figure **9.30**. We note especially the tapering columns that sit directly on the stylobate. The column shafts are fluted (vertically grooved), and the capital consists of a simple slab.

MUSIC

Surviving records tell us that Greek music consisted of a series of modes, the equivalent of our scales. Each mode—for example, the Dorian and Phrygian—had a name and a particular characteristic sound, not unlike the difference between our major and minor scales, and the Greeks attrib-

uted certain behavioral outcomes to each mode. Just as we say that minor scales sound sad or exotic, the Greeks held that the Dorian mode exhibited strong, even warlike, feelings, while the Phrygian elicited more sensual emotions.

We have a fairly good picture of what Greek musical instruments looked like from vase paintings. Figure **9.31** illustrates the aulos, a double-reed instrument, and the lyre, a stringed instrument. The Greeks were particularly fond of vocal music, and instruments were used principally to accompany vocal music. The lyrics of songs have survived, and these include songs to celebrate acts by the various gods, from whom some mortal had gained special favor.

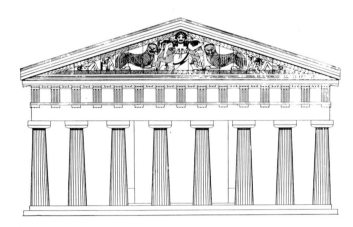

9.29 Reconstruction drawing of the west front of the Temple of Artemis, Corfu [after Rodenwaldt]

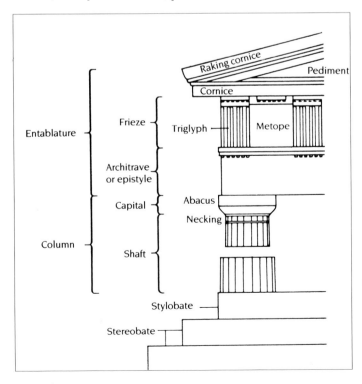

9.30 The Doric order

LITERATURE

Homer is probably the best-known of the ancient Greek poets, but he was by no means the only one. By the end of the seventh century B.C. poets appeared who tell us their names, and sing of themselves, their travels, military adventures, political contests, homesickness, drinking parties, poverty, hates, and loves. The poet Sappho, who was born around 615 B.C., lived all her life on the island of Lesbos. She gathered around her a coterie of young women interested in poetry. Many of Sappho's poems are written in honor of one or other of these young women. Sappho was called a lyrist or lyric poet because, as was the custom of the time, she wrote her poems to be performed with the accompaniment of a lyre. She was one of the first poets to write from the first person, describing love and loss as they affected her personally. Her style was sensual and melodic. As we can sense from the following poem, "God's Wildering Daughter," her tone is emotional and frank, her language simple and serious. In this example, she entreats Aphrodite, the immortal child of the god Zeus:

God's Wildering Daughter
Sappho

God's wildering daughter deathless Aphrodite,
A whittled perplexity your bright abstruse chair,
With heartbreak, lady, and breathlessness
Tame not my heart

But come down to me, as you came before,
For if ever I cried, and you heard and came,
Come now, of all times, leaving
Your father's golden house.

In that chariot pulled by sparrows reined and bitted,
Swift in their flying, a quick blur aquiver,
Beautiful, high. They drew you across steep air
Down to the black earth:

Fast they came, and you behind them. O
Hilarious heart, your face all laughter.
Asking, What troubles you this time, why again
Do you call me down?

Asking, In your wild heart, who now
Must you have? Who is she that persuasion
Fetch her, enlist her, and put her into bounden love?
Sappho, who does you wrong?

If she balks, I promise, soon she'll chase,
If she's turned from gifts, now she'll give them.
And if she does not love you, she will love,
Helpless, she will love.

9.31 Attributed to the Eucharides painter, amphora showing Apollo playing a lyre and Artemis holding an aulos before an altar, c. 490 B.C. 18½ ins (47 cm) high. Metropolitan Museum of Art, New York (Rogers Fund, 1907).

Come, then, loose me from cruelties.
Give my tethered heart its full desire.
Fulfill, and, come, lock your shield with mine
Throughout the siege.

Homer's *Iliad* and *Odyssey* created the mythical history that later Greeks accepted as their historic heritage. They took the dark and unknown past and created in a literary, originally oral, form a cultural foundation for an entire people. They told of heroes and described the gods. They depicted places and events, and they did so in a form that represented a significant artistic achievement: epic poetry. Both poems deal with minor episodes in the story of the battle of Troy, which ended, with the destruction of the city, in about 1230 B.C. Divided into twenty-four books, the *Odyssey* tells the story of Odysseus, king of Ithaca, as he travels home from the Trojan War to recover his house and kingdom. Also set in twenty-four books, the *Iliad* explores the heroic ideal with all its contradictions. Homer develops events on the battlefield and behind the lines of both adversaries. From his descriptions, an elaborate evocation emerges of the splendor and tragedy of war and the inconsistencies of mortals and gods.

215

CHAPTER TEN

ARTISTIC REFLECTIONS IN THE PRE-MODERN WORLD

C. 600 B.C. TO C. A.D. 1400

IMPORTANT TERMS

Classicism An artistic style dating to fifth-century B.C. Greece and exhibiting simplicity, clarity of structure, and appeal to the intellect.

Contrapposto stance In sculpture, the arrangement of body parts so that the weight-bearing leg is apart from the free leg, thereby shifting the hip/shoulder axis.

Diptych Two panels hinged together.

Hieratic style A style in Byzantine art presenting formalized, almost rigid, depictions to inspire reverence and meditation.

Aryballus A shape in Inca pottery containing a wide base and tall, flanged neck.

Plainchant Also called chant and plainsong (and sometimes, Gregorian chant). A body of sacred Christian monophonic music.

Organum Polyphony developed through the addition of melodic lines to plainchant.

Romanesque style A broad style of visual art and architecture referring to vaulted medieval architecture preceding the Gothic style.

Gothic style A style of visual arts and architecture most closely associated with the pointed arch and a sense of light and space.

GREEK CLASSICISM

Under the ruler Pericles, Classical Greek culture reached its miraculous zenith in the fifth century B.C. In the brief span of time between approximately 600 and 200 B.C., Greek influence and civilization spread throughout the Mediterranean world. At its widest, under Alexander the Great (356–323 B.C.), it stretched—for the span of a single lifetime—from Spain to the River Indus. All this was achieved by a people whose culture, at its height, took as its measure the human intellect. In society, as in the arts, rationality, clarity, and beauty of form were the aim. However, as the style we call Hellenistic developed in the fourth century B.C., artists increasingly sought to imbue their works with the expression of feeling.

Appeal to the intellect was the cornerstone of Classical style in all the arts. Four characteristics reflect that appeal. First and foremost is an emphasis on form: on the formal organization of the whole into logical and structured parts. A second characteristic is idealization—an underlying purpose to portray things as better than they are, or to raise them above the level of common humanity. For example, the human figure is treated as a type rather than as an individual. A third characteristic is the use of convention, and a fourth is simplicity. Simplicity does not mean lack of sophistication. Rather, it implies freedom from unnecessary ornamentation and complexity.

Style is generally related to treatment of form rather than content or subject matter, but often form and content cannot be separated. When Classicism was modified by a more individualized and lifelike treatment of form, its subject matter broadened to include the mundane, as opposed to the heroic.

Such expression, particularly in painting, reflects a technical advance as well as a change in attitude. Many of the problems of foreshortening—the perceivable diminution of size as the object recedes in space—had been solved and, as a result, figures have a new sense of depth. By the end of the fifth century the convention typified in Egyptian and Mesopotamian art—of putting all the figures along the baseline on the front plane of the design—gives way to suggestions of depth. Some figures are occasionally placed higher than others. By the end of the fourth century the problems of depth and foreshortening were fully overcome. Impressions of lifelikeness are also heightened in some cases by the use of light and shadow.

CLASSICAL PAINTING

Some records imply that mural painters of the Classical period were highly skillful in representation, but no examples have survived. What has come down to us is a wealth of vase painting. The restrictions inherent in the medium preclude assessment of the true level of skill and development of the two-dimensional art of this period.

Fifth-century Athenian painting of the Classical style demonstrates the artists' concern for formal design—that is, logical, evident, and perfectly balanced organization of space. What separates Classical painting from earlier styles is a new sense of idealized reality in figure depiction.

The idealism and dignity of the Classical style are portrayed by such artists as the Achilles Painter, whose work is seen in Figure **10.1**. The portrayal of feet in the frontal position is a significant development, reflecting the new skill in depicting space.

CLASSICAL SCULPTURE

The fifth century saw many of the most talented artists turn to sculpture and architecture. The age of Greek Classical style in sculpture probably begins with the sculptors Myron and Polyclitus in the middle of the fifth century B.C. Both contributed to the development of *cast* sculpture. Polyclitus reportedly achieved the ideal proportions of the male athlete (Fig. **10.2**). Note that the *Lance Bearer* represents *the* male athlete, and not *a* male athlete. In this work the body's weight rests on one leg in the *contrapposto* stance (see Glossary). This simple but important new posture, characteristic of Greek Classical style, results in a sense of relaxation and controlled dynamics and a subtle play of curves.

Polyclitus developed a set of rules for constructing the ideal human figure that he laid out in his treatise *The Canon* (*kanon* is the Greek word for "rule" or "law"). The *Lance Bearer* supposedly illustrates his theory, but because neither the treatise nor the original statue has survived, we do not know what set of proportions Polyclitus thought to be ideal. Probably, it was based on the ratios between some basic unit and the length of some body part or parts. Myron's best-known work is the *Discus Thrower* (see the Masterwork box, p. 220).

Classical Greek statuary may be portraiture, but the features are always idealized. Man may be the measure of all things, as the Greek philosopher Protagoras argued, but in art he is raised above human reality to the state of perfection found only in the gods.

CLASSICAL THEATRE

The theatre of Periclean Athens was a theatre of convention, and the term convention, as it applies here, takes on a new meaning. Every era and every style have their conventions—those underlying, accepted expectations and/or rules that influence artists subtly or otherwise. "Theatre of convention" implies a style of production lacking in illusion or stage realism. Theatre of convention is to a large

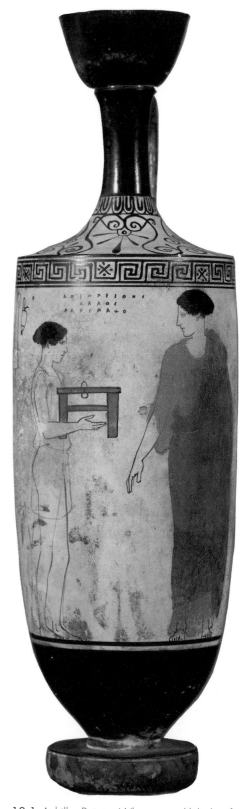

10.1 Achilles Painter, White ground lekythos from Gela (?), showing woman and her maid, 440 B.C. Height 15 ins (38 cm). Museum of Fine Arts, Boston (Francis Bartlett Fund).

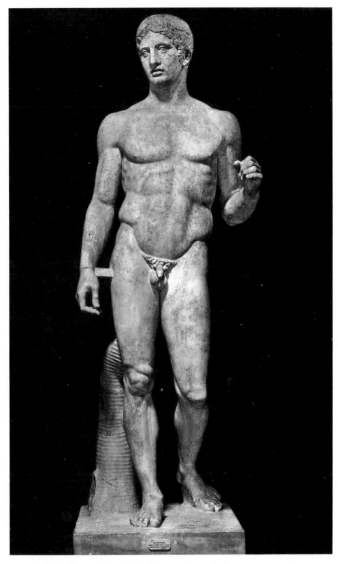

10.2 Polyclitus, *Doryphorus* (*Lance Bearer*), Roman copy after an original of c. 450–440 B.C. Marble, height 6 ft 6 ins (1.98 m). Museo Archeologico Nazionale, Naples.

extent freer to explore the ideal than theatre of illusion (in which scenic details are portrayed representationally) because dependence upon stage mechanics and historically accurate costume does not hamper the playwright. An audience will simply accept a poetic description in theatre of convention and will not demand to see it. Thus imagination is the key to theatre of convention. Greek dramatists found that with freedom from the restraints imposed by dependence on illusion or depiction, they were much better able to pursue the lofty moral themes fundamental to their perception of the universe.

Although some plays from the era have survived, and indicate what and how the playwright wrote, we are at a loss to know specifically how that work became theatre—that is, a production. Nevertheless, it is possible to build a picture of production from descriptions in the plays themselves, from other literary evidence, and from a few archeological examples.

Theatre productions in ancient Greece were part of religious festivals held three times a year: the City Dionysia, Rustic Dionysia, and Lenaea. The first of these was a festival of tragic plays and the last, of comic ones. The City Dionysia was held in the theatre of Dionysus in Athens. Our knowledge of Greek theatre is enhanced somewhat by the fact that, although we do not have most of the plays, we do know the titles and the names of the authors who won these contests from the earliest, in 534 B.C., to the final one. The records, inscribed in stone, show that three playwrights figured prominently and repeatedly as winners in the contests of the era:[1] Aeschylus, Sophocles, and Euripides. All the complete

MASTERWORK

Myron—*Discus Thrower*

Myron's *Discus Thrower* (or *Discobolus*) (Fig. 10.3) exemplifies the Classical concern for restraint in its subdued vitality and subtle suggestion of movement coupled with balance. But it also expresses the sculptor's interest in the flesh of the idealized human form. This example of the *Discus Thrower* is, unfortunately, a much later marble copy. Myron's original was in bronze, a medium that allowed more flexibility of pose than marble. A statue, as opposed to a relief sculpture, must stand on its own, and supporting the weight of the marble on a small area, such as one ankle, poses a significant structural problem. Metal has greater tensile strength (the ability to withstand bending and twisting), and thus this problem does not arise.

In *Discovery of the Mind: The Greek Origins of European Thought* Bruno Snell writes: "If we want to describe the statues of the fifth century in the words of their age, we should say that they represent beautiful or perfect men, or, to use a phrase employed in the early lyrics for the purposes of eulogy: 'god-like' men. Even for Plato the norm of judgment still rests with the gods, and not with men." Even though Greek statuary may take the form of portraiture, the features are idealized.

Myron's representation of this young athlete contributes a sense of dynamism to Greek sculpture. Here Myron tackles a vexing problem for the sculptor: how to condense a series of movements into a single pose without making the sculpture appear static or frozen. His solution dramatically intersects two opposing arcs: one created by the downward sweep of the arms and shoulders, the other by the forward thrust of the thighs, torso, and head.

As is typical of Greek freestanding statues, the *Discus Thrower* is designed to be seen from one direction only. It is thus a sort of freestanding, three-dimensional "super-relief." The beginnings of Classical style are represented by celebration of the powerful nude male figure. The suggestions of moral idealism, dignity, and self-control in the statue are all qualities inherent in Classicism. However, the *Discus Thrower* marks a step forward, in the increasing vitality of figure movement. Warm, full, and dynamic, Myron's human form achieves a new level of expressiveness and power. It is fully controlled and free of the unbridled emotion of later sculpture. For Myron, balanced composition remains the focus of the work, and form takes precedence over feeling.

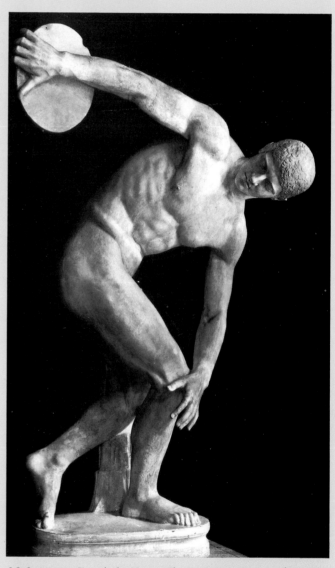

10.3 Myron, *Discobolus* (*Discus Thrower*), Roman copy after a bronze original of c. 450 B.C. Marble, life-size. Museo Nazionale Romano, Rome.

tragedies to survive are by these three playwrights: seven by Aeschylus, seven by Sophocles, and eighteen by Euripides.

A playwright entering the contests for tragedy or comedy was required to submit the work to a panel of presiding officers, who selected just three authors for actual production. Early plays in the Classical style had only one actor plus a chorus, and at selection time the playwright was assigned the chief actor plus a *choregus*—a patron who paid all production expenses. The playwright was author, director, choreographer, and musical composer. He often also played the leading role.

Aeschylus (525–456 B.C.)

Aeschylus was the most famous poet of ancient Greece. Clearly fitting the Classical mold, he wrote magnificent tragedies of high poetic language and lofty moral themes. In *Agamemnon*, the first play in the *Oresteia* trilogy, Aeschylus's chorus warns us that success and wealth are insufficient without goodness.

> Justice shines in sooty dwellings
> Loving the righteous way of life,
> But passes by with averted eyes
> The house whose lord has hands unclean.
> Be it built throughout of gold,
> Caring naught for the weight of praise
> Heaped upon wealth by the vain, but turning
> All alike to its proper end.[2]

Aeschylus probed questions that we still ask: How responsible are we for our own actions? How much are we controlled by the will of heaven? His characters are larger than life; they are types rather than individuals, in accordance with the idealism of the time. Yet they are also human. Aeschylus's early plays consist of the traditional single actor, plus a chorus of fifty. Later, he is credited with the addition of a second actor, and by the end of his career a third actor had been added and the chorus reduced to twelve.

Aeschylus's plays make a strong appeal to the intellect. He lived through the Persian invasions, witnessed the great Athenian victories, and fought at the battle of Marathon (490 B.C.). His plays reflect this experience and spirit.

Sophocles (496?–406 B.C.)

Overlapping with Aeschylus was Sophocles, who reached the peak of his career at the zenith of the Greek Classical style with works like *Oedipus the King*. But he lived well beyond the death of Pericles in 429 B.C., experiencing the shame of Athenian defeat.

Sophocles's plots and characterizations illustrate a trend toward increasing realism. Yet the trend was not a progression toward theatre of illusion. Sophocles was a less formal poet than Aeschylus. His themes are more humane and his characters more subtle, although his exploration of the themes of human responsibility, dignity, and fate matches the intensity and seriousness of Aeschylus. His plots show increasing complexity, but within the formal restraints of the Classical spirit. Classical Greek theatre was mostly discussion and narration. Themes often dealt with bloodshed, but, though the play led up to violence, blood was never shed on stage.

Euripides (480?–406 B.C.)

Euripides was younger than Sophocles, although both men died in 406 B.C. They competed with each other but did not share the same style. Euripides's plays carry realism to the furthest extent we see in Greek tragedy. They deal with individual emotions rather than great events, and his language, though still basically poetic, is closer to normal speech and much less formal than that of his predecessors.

Euripides experimented with, and ignored, many of the conventions of Greek theatre. He explored the mechanics of scene painting and was less dependent than his rivals on the chorus.[3] Sometimes he questioned the religion of his day. His plays are, strictly speaking, tragicomedies rather than pure tragedies. Some critics have described many of them as melodramas.

Plays such as *The Bacchae* reflect the changing Athenian spirit and dissatisfaction with contemporary events. Euripides was not particularly popular in his time, perhaps because his audience expected a more idealistic, formal, and conventional treatment of dramatic themes and characters. Was he perhaps too close to the reality of his age? His plays were received with enthusiasm in later years.

Aristophanes (448?–380? B.C.)

Tragedies and satyr plays were not the only works produced in the theatre of the Classical era in Athens. The Athenians were extremely fond of comedy; unfortunately no examples survive from the Periclean period. Aristophanes was the most gifted of the comic poets, and his comedies of the post-Classical period, such as *Lysistrata*, are highly satirical, topical, sophisticated, and often obscene. Eleven of his plays have survived, and translated productions of them are still staged. As the personal and political targets of his invective are unknown to us, these modern productions are mere shadows of what took the stage at the turn of the fourth century B.C. As we noted

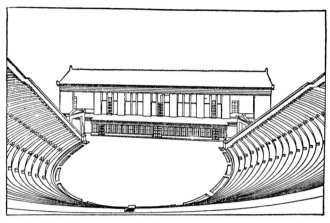

10.4 Reconstruction of the Hellenistic theatre at Ephesus, Turkey, c. 280 B.C., rebuilt c. 150 B.C.

in the Introduction, in *Lysistrata* Aristophanes creates a plot in which the women of Athens go on a sex strike to rid the city of war and war-mongers.

Theatre Design

The form of the Greek theatre owes much to the choral dances associated with the worship of Dionysus from which it originated. In 534 B.C. Thespis is reported to have introduced a single actor to these dances, or dithyrambs. In 472, Aeschylus added a second actor, and in 458, Sophocles added a third.

Throughout its history the Greek theatre comprised a large circular *orchestra*—an acting and dancing area—with an altar at its center, and a semicircular *theatron*—an auditorium or viewing place—usually cut into or occupying the slope of a hill. Since the actors played more than one role, they needed somewhere to change costume, and so a *skene*—a scene building or retiring place—was added. The gradual development of the *skene* to include a raised stage is somewhat obscure, but it is clear that later, by Hellenistic times, it had come about, and the building had become a rather elaborate affair with projecting wings at each end (Fig. **10.4**).

The earliest surviving theatre, dating from the fifth century B.C., is the Theatre of Dionysus on the south slope of the Acropolis in Athens. There the plays of Aeschylus, Sophocles, Euripides, and Aristophanes were staged. Its current form dates back to a period of reconstruction work around 338–326 B.C.

The theatre at Epidaurus (Figs. **10.5** and **10.6**) is the best preserved ancient theatre. It was built by Polyclitus the Younger about 350 B.C., 100 years after the end of the Classical period. Its sheer size demonstrates the monumental character the theatre had assumed by that time. The

orchestra has a diameter of 80 feet (24 m) and an altar to Dionysus in the center. The auditorium—slightly more than a semicircle—is divided by an *ambulatory*, or covered walkway, about two-thirds of the way-up, and by radiating stairways. All the seats were of stone. The first or lowest row was reserved for the dignitaries of Athens, and here the seats had backs and arms. Some were decorated with relief sculptures.

There was undoubtedly variation in the design of theatres in different locations but, again, time has removed most examples from our grasp. The many theories of how Greek theatre productions worked, how scenery was or was not used, and when there was a raised stage make fascinating reading.

CLASSICAL ARCHITECTURE

The arts of the Western world have returned over the past 2,400 years to the style of Classical Greek architecture. Nothing brings it so clearly to mind as the Greek temple. Most people have an amazingly accurate concept of its structure and proportions. The art historian H. W. Janson suggests that the crystallization of the characteristics of a Greek temple is so complete that when we think of one Greek temple, we basically think of all Greek temples. Even the Gothic cathedral does not have this capacity, for despite the characteristic Gothic arch, its usage is so diverse that no one work typifies the many.

The Classical Greek temple, as seen in Figure **10.7**, has a structure of horizontal blocks of stone laid across vertical columns. This *post-and-lintel construction* is not unique to Greece, but certainly the Greeks refined it to its highest aesthetic level. As we saw in Chapter 7, this type of structure creates some very basic problems. Stone is not high in tensile strength—the ability to withstand bending and

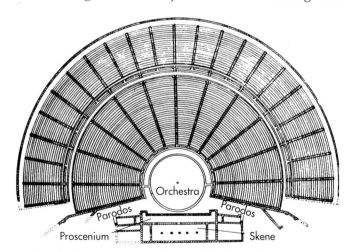

10.5 Polyclitus the Younger, Theatre at Epidaurus, Greece, c. 350 B.C., plan.

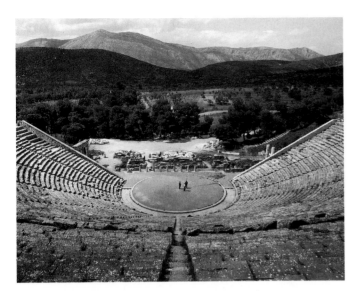

10.6 Theatre at Epidaurus. Diameter 373 ft (114 m), orchestra 80 ft (24 m) across.

twisting—although it is high in compressive strength—the ability to withstand crushing. Downward thrust works against tensile qualities in horizontal slabs (lintels) and works for compressive qualities in vertical columns (posts). As a result, columns can be relatively delicate, whereas lintels must be massive.

Only limited open space can be created using this structural system. Such restriction was not of great concern to the Greeks because their temples were seen and used from the outside. Exterior structure and aesthetics were the primary concerns.

Greek temples were of three *orders*: Ionic, Doric, and Corinthian (Fig. 7.3). These are not just decorative and elevational conventions, but systems of proportion. The first two are Classical; the third, though of Classical derivation, is of the later, Hellenistic style. The contrasts between these types make an important, if subtle, stylistic point. Simplicity was an important characteristic of the Greek Classical style, and the Ionic and Doric orders maintain clean and simple lines in their capitals. The Corinthian order has more ornateness and complexity. There are differences in column bases and the configuration of the lintels, as well as in the columns and capitals.

The earlier of the two Classical types—the Doric—has a massive appearance compared to the Ionic. The Ionic, with a round base, has a curved profile which raises the column above the baseline of the building. The fluting (ridging) of the Ionic order, usually twenty-two per column, is deeper and separated by wider edges than is that of the Doric, giving the former a more delicate appearance. The Ionic capital is surrounded by a crown of hanging leaves, or *kymation*. The *architrave*—the section resting directly on the capitals—is divided into three parts, and each diminishes downward. This creates a much lighter impression than the more massive architrave of the Doric.

The Parthenon

Perched on the top of the Acropolis at Athens, the Parthenon (Fig. 10.7) stands as the greatest temple built by the Greeks and the prototype for all Classical buildings thereafter. When the Persians sacked Athens in 480 B.C., they destroyed the then existing temple and its sculpture. Pericles rebuilt the Acropolis in the late fifth century. Athens was at its zenith, and the Parthenon was its crowning glory.

In plan the Parthenon is a peripteral temple—that is, columns surround the interior room, or *cella*, and the number of columns on the sides is twice the number across the front, plus one. Inside it is divided into two parts, and it would have housed the 40-foot (12-m)-high ivory and gold statue of the goddess Athena Parthenos.

The Parthenon typifies every aspect of Greek Classical style in architecture. It is Doric in character and geometric in configuration. Balance is achieved through symmetry, and the clean, simple line and plan hold the composition together perfectly.

The internal harmony of the design lies in the regular repetition of virtually unvaried form. Each column is alike and equidistant from its neighbor, except at the corners, where the spacing is clearly lessened in subtle, aesthetic adjustment. A great deal has been written about the so-called "refinements" of the Parthenon—the elements that intentionally depart from strict geometric regularity. According to some scholars, the slight outward curvature of horizontal elements compensates for the tendency of the eye to perceive downward sagging if all elements are actually parallel. Each column swells about 7 inches (17 cm), supposedly to compensate for the tendency of vertical parallel lines to appear to curve inward. The columns also tilt inward at the top so as to appear upright. The *stylobate* (the foundation immediately below the row of columns) is raised toward the center so as not to appear to sag under the immense weight of the stone columns and roof.

The white color of the marble, which in other circumstances might appear stark, may have been chosen to harmonize with and reflect the intense Athenian sunlight. However, some parts of the temple and its statuary would originally have been brightly painted.

Here we have the perfect embodiment of Classical characteristics: *convention, order, balance, idealization, simplicity, grace,* and *restrained vitality*—of this earth but mingled with the divine.

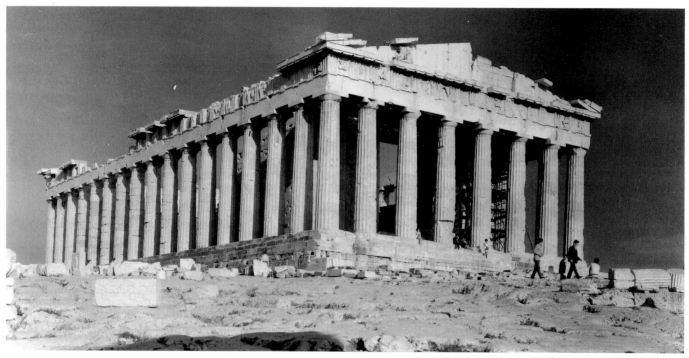

10.7 Ictinus and Callicrates, Parthenon, Acropolis, Athens, from the northwest, 447–438 B.C.

LATE CLASSICAL STYLE IN SCULPTURE

Sculpture of the fourth century B.C. illustrates the change in emphasis reflected in late Classical styles. Praxiteles is famous for *individualism* and delicacy in choice of themes. In the *Cnidian Aphrodite* (Fig. **10.8**) there is a looking inward which is different from the formal detachment of earlier sculpture. (Note that this is a copy; the original has never been found.) Aphrodite's body bends to the left in the famous Praxitelean S-curve. Originally, she rested her weight on one foot. Strain on the ankle was minimized by attaching the arm to drapery and a vase.

The late fourth century found in the sculpture of Lysippus (a favourite of Alexander the Great) a dignified naturalness and a new concept of space. In the *Scraper* (Fig. **10.9**) he attempts to put the figure into motion, in contrast to the posed figures at rest of earlier periods. The theme of the sculpture is mundane—an athlete scraping dirt and oil from his body. The proportions of the figure are even more naturalistic than those of Polyclitus, but the naturalism is still far from accurate. Style had moved a long way from earliest Classicism, but Classical influence remained.

HELLENISTIC STYLE

As the age of Pericles gave way to the Hellenistic period, the dominant characteristics of Classicism were gradually modified to a less formal, more realistic, and more emotional style reflecting a diversity of approaches.

Like other media and art forms, vase painting around the year 400 B.C. had a highly ornate style. Thick lines, dark patterns on garments, and a generous use of white and yellow characterized compositions of crowded figures represented mainly in three-quarter views. Illustrative of this change in style is the combat scene from an *amphora*, or storage jar, painted by the Suessula Painter (Fig. **10.13**). Here there is also an illusion of spatial depth, as the figures step away from the baseline.

In the Hellenistic era, everyday scenes—sometimes comic and vulgar—occurred in wall painting. These scenes are remarkable for the use of aerial and linear perspective to indicate three-dimensional space. Unfortunately, the few surviving examples of Classical and Hellenistic two-dimensional art furnish us with only a glimpse of the two important painting styles, so closely linked, yet reflecting such different attitudes.

Hellenistic style in sculpture dominated the Mediterranean world for several centuries until the first century B.C. As time progressed, style changed to reflect an increasing interest in individual human differences. Hellenistic sculptors often turned to pathos, banality, trivia, and flights of individual virtuosity. *The Dying Gaul* (Fig. **10.10**) is a powerful expression of emotion and pathos, depicting a noble warrior on the verge of death. Representing a Gallic casualty in the wars between Pergamon and barbarian

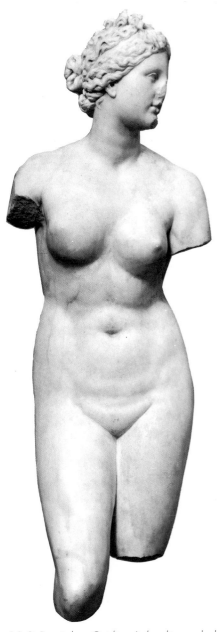

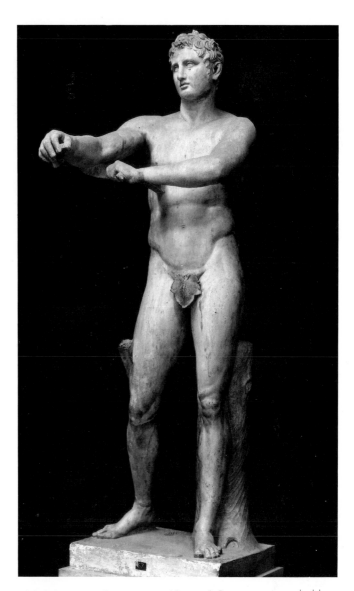

10.9 Lysippus, *Apoxyomenus* (*Scraper*), Roman copy, probably after a bronze original of c. 330 B.C. Marble, Height 6 ft 9 ins (2.05 m). Musei Vaticani, Rome.

10.8 Praxiteles, *Cnidian Aphrodite*, probably Hellenistic copy of 4th-century B.C. bronze original. Marble, height 5 ft ½ in (1.54 m). Metropolitan Museum of Art, New York (Fletcher Fund).

invaders, the man is slowly bleeding to death from a chest wound. The figure sits on a stage, as if to act out a drama. The *Nike of Samothrace* (Fig. **10.11**), or *Winged Victory*, displays a dramatic, dynamic technical virtuosity. Symbolizing a triumph of one of Alexander's successors, the victory figure "brings strength, weight, and airy grace into an equipoise one would not expect to be achieved in the hard mass of sculptured marble." The sculptor has treated stone almost as if the work were a painting. As a result, the full, awesome reality of wind and sea comes across.

The common Hellenistic theme of suffering is taken up explosively in the Laocoön group (Fig. **10.12**). The Trojan priest Laocoön and his sons are depicted being strangled by

10.10 *Dying Gaul*, Roman copy of a bronze original from Pergamon, Turkey, of c. 230–220 B.C. Marble, life-size. Museo Capitolino, Rome.

225

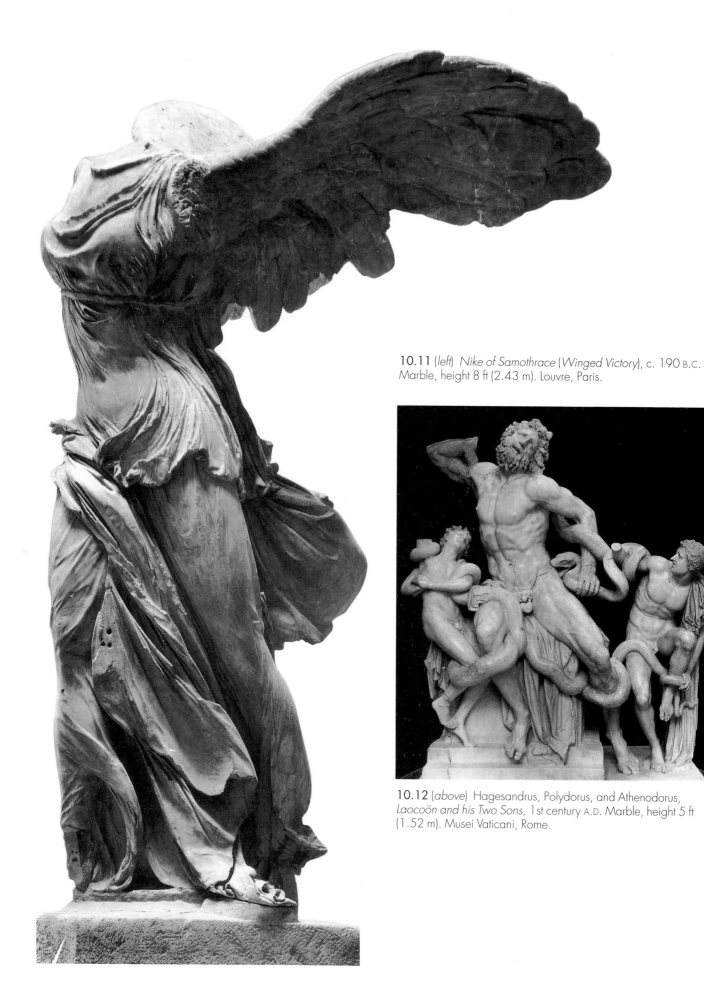

10.11 (*left*) *Nike of Samothrace* (*Winged Victory*), c. 190 B.C. Marble, height 8 ft (2.43 m). Louvre, Paris.

10.12 (*above*) Hagesandrus, Polydorus, and Athenodorus, *Laocoön and his Two Sons*, 1st century A.D. Marble, height 5 ft (1.52 m). Musei Vaticani, Rome.

10.13 Attributed to the Suessula Painter, Amphora showing combat of Greeks and Amazons, 5th–6th century B.C. Height 14ins (36 cm). Metropolitan Museum of Art, New York (Fletcher Fund).

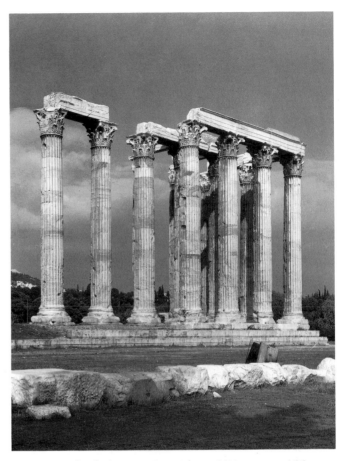

10.14 Temple of Olympian Zeus, Athens, 174 B.C.–A.D. 130.

sea serpents. Based on Greek myth, the subject is Laocoön's punishment for defying Poseidon, god of the sea, and warning the Trojans of the Greek strategy of the Trojan horse. Emotion and movement are freed from all restraint, and straining muscles and bulging veins are portrayed with stark realism.

The temple of the Olympian Zeus (Fig. **10.14**) illustrates Hellenistic modification of Classical style in architecture—similar to that in painting, sculpture, and theatre. Temple architecture in this style was designed to produce an overpowering emotional experience. Scale and complexity have increased, but order, balance, moderation, and consonant harmony are still present. In these huge ruins we can see a change in proportions from the Parthenon, and slender and ornate Corinthian columns replace the Doric ones. This is the first major Corinthian temple. Begun by the architect Cossutius for King Antiochus IV of Syria, it was not completed until the second century A.D., under the Roman emperor Hadrian. The cause was its elaborate detail. The remaining ruins only vaguely suggest the scale and richness of the original building, which was surrounded by an immense, walled precinct.

AFRICA

For thousands of years, African artists and craftsmen have created objects of sophisticated vision and masterful technique. The modern banalities of so-called primitive "airport art" sold to tourists belie the rich cultural history of the African continent. It traded with the Middle East and Asia as early as A.D. 600; this is borne out by Chinese Tang Dynasty coins found along the coast of East Africa. Climate, materials, and the nature of tribal culture doomed much of African art to extinction; only a small fraction remains. None the less, what has survived traces a rich vision which varies from culture to culture and, stylistically, runs from abstract to realistic. Its purposes range from magical to utilitarian, sometimes portraying human reality in ways that individuals from other cultural traditions may be ill-equipped to understand. Works from African traditions—as from any others—can nevertheless reward the viewer with great satisfaction.

10.15 Head from Jemaa, Nigeria, c. 400 B.C. Terracotta, height 10 ins (25 cm). National Museum, Lagos.

IGBO-UKWU STYLE

The level of skill achieved by the ninth and tenth centuries A.D. can be seen in a ritual war pot from the village of Igbo-Ukwu in eastern Nigeria (Fig. **10.17**). Cast using the *cire-perdue* or lost-wax process, this leaded bronze artifact is amazing in its virtuosity. The graceful design of its curved lines and flaring base in itself is exquisite, but the addition of a delicate and detailed rope overlay reflects sophistication of both technique and vision.

IFE STYLE

A link between the Nok culture and that of Ife, also in Nigeria, may have existed to draw these two cultures together in their art across the centuries. Ife was an important cultural and religious center in the southwest. The accomplishments of its artists—their mastery of the terracotta medium, their rendering skills, and the depth of their vision—suggest to some scholars a long developmental period, culminating in twelfth- to thirteenth-century works such as Figure **10.16**. There can be little question that this represents a mature artistic style. The anatomical detail is remarkable, and even today the textures are so exquisite that the figures seem ready to come to life. The full mouth and expressive eyes suggest extreme sensitivity. The high brow and minutely detailed headdress complete this portrait and bring to its surface the innermost qualities of the individual.

NOK STYLE

During the first millennium B.C., on the Jos plateau of northern Nigeria, a nonliterate culture of farmers entered the Iron Age and developed an accomplished artistic style. Named the "Nok style" after the village of Nok where the first sculptures were discovered, it was used for terracotta figures comparable to the Qin Dynasty warriors of China (Fig. **10.20**). The sculptures were boldly designed; some represent animals realistically and others portray life-sized human heads (Fig. **10.15**). Although stylized, for example, with segmented lower eyelids, each work reveals individualized character. Facial expressions and hair styles differ and "it is this unusual combination of human individuality and artistic stylization which gives them their peculiar power."[4] These heads are probably portraits of ancestors of the ruling class. The technique and medium of execution seem to have been chosen to ensure permanence, for magical rather than artistic reasons. The Nok style appears to have influenced several West African styles.

10.16 Head of a queen, from Ife, Nigeria, 12th–13th century. Terracotta, height 10 ins (25 cm). Museum of Ife Antiquities, Ife.

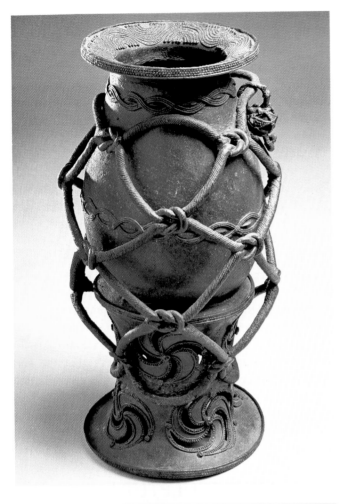

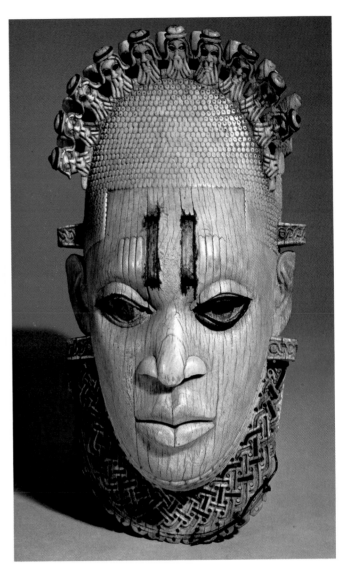

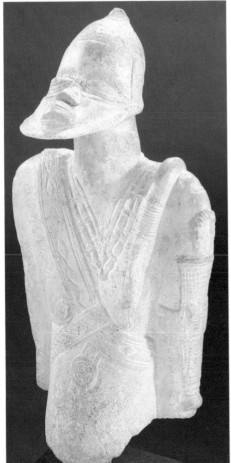

10.19 (*above*) Pectoral or waist mask, early 16th century. Ivory, height 9¼ ins (25 cm). British Museum, London.

10.17 (*above left*) Roped pot on a stand, from Igbo-Ukwu, Nigeria, 9th–10th century. Leaded bronze, height 12½ ins (32 cm). National Museum, Lagos.

10.18 Bearded male figure from Djenne, Mali, 14th century. Terracotta, height 15 ins (38 cm). Detroit Institute of Arts (Eleanor Clay Ford Fund for African Art).

DJENNE STYLE

The styles of African art range from realistic to highly expressive and abstract. Some way up the Niger River at Djenne, in Mali, the latter is found in a small, fourteenth-century terracotta figure of a bearded male (Fig. **10.18**). The most striking aspect is its thrusting chin, which flies in the face of anatomical lifelikeness. The lower and upper jaws protrude grotesquely from a platelike appendage—probably a stylized beard—where the jaw would normally be. Lightly incised into the conical surface of the head are the man's eyes. The torso's proportions pinch inward, as if compressed by the undetached arms, and details of what could be armor show exquisite workmanship. The sophisticated rendering of the entire form suggests that the artist intended to reflect internal psychological or spiritual qualities.

BENIN STYLE

Superb craftsmanship is also the hallmark of an early sixteenth-century ivory mask of the Benin school. The origins of this style are suggested by local tradition to belong to either a master from Ife or the Portuguese. Whatever the root, the result is an exquisite portrayal made for the Oba, or King of Benin (Fig. **10.19**), reigning when the Portuguese arrived in Africa. Again, the elongated head and stylized features create expressiveness. The carver has obvious mastery of the medium. The details of the mask are precise and delicate, and the heads of Portuguese men with beards, woven skilfully into the headdress, hold some symbolic, yet unclear, meaning.

CHINA

Confucius (551–479 B.C.), probably the first professional teacher and philosopher in China, is also recognized as the greatest. His teaching is contained in five classical works (not all of which were actually written by him). One, the *Analects*, is probably an authentic collection of his sayings and conversations, in the format of questions and answers.

His thought rests more on a pragmatic level than an intellectual one. His primary interest lay in politics. He proposed a return to the ancient way, in which persons must play their proper, assigned roles subject to authority. But he saw government primarily as an ethical challenge. It was a ruler's virtue, rather than power, that yielded contentment in the people. His aim was to convince rulers to pursue ethical principles. Thus he became China's first moralist, and founder of a great ethical tradition.

In contrast to Confucianism, Daoism, or "The Way," teaches independence for the individual. It, too, emerged in the sixth century B.C. Confucianism is pragmatic; Daoism is mystical. The Daoist goal is profound, joyful, and practical harmony with the universe, and to this end meditation and simplicity are encouraged. Followers believe that *yin* (the feminine) balances *yang* (the masculine), and that all extreme positions revert to their opposites.

Buddhism is a system of philosophy and ethics founded by Gautama Siddhartha, the Buddha (563–483 B.C.), in northeast India. The Four Noble Truths of Buddha are: (1) existence is suffering; (2) the origin of suffering is desire; (3) suffering ceases when desire ceases; and (4) the way to reach the end of desire is to follow the Eightfold Path. This comprises right belief, right resolve (to renounce carnal pleasure, harm no living creature, and so on), right speech, right conduct, right occupation or living, right effort, right contemplation or right-mindedness, and right ecstasy. The final goal of the religious person is to gain enlightenment and so escape from existence into blissful nonexistence—*nirvana*. Buddhists believe that the substance of all objects is illusion, and that it is greed, hatred, and delusion that separate people from reality and keep them tied to the cycle of earthly existence. It is from this cycle that they can escape by religious living.

CHINESE SCULPTURAL STYLE

By the third century B.C., the Chinese had reached a high level of technical accomplishment in sculpture. They had developed scientific manufacturing processes for pottery and knew how to control firing temperatures.

We know this because Emperor Qin Shihuangdi, who reigned for almost the whole of the Qin Dynasty (221–206 B.C.), spent most of his time preparing his palace and mausoleum. In March 1974, during the digging of a well at Lintong, some life-size and lifelike pottery figures were unearthed. Pits were found containing terra-cotta warriors, horses, and bronze chariots. In one vault alone (measuring 760 × 238 feet [231 × 72 m]), 6,000 terra-cotta warriors and horses were found. A total of three vaults contain over 8,000 figures (Fig. **10.20**).

The warriors have various expressions. Some are dignified; others, vigorous; some are cheerful; others, debonair. Some appear lost in brooding, while still others look witty and handsome. Each figure displays an almost knowable character, as if some living form had been miraculously frozen in time. The lifelikeness and the consummate skill of the artists who created these figures are breathtaking.

Detailing is so precise that in addition to temperament, we can determine the rank and home province of these warriors. Common soldiers, for example, appear in short battle tunics or laceless armored suits. Their heads are covered by small round caps, and they wear square-toed sandals on their feet.

The horses appear well bred, and all look muscular and vigorous. Their proportions are perfect (Fig. **10.21**) and even their expressions indicate the artists' strong insight, understanding, and skill. The eyes stare ahead intensely and the necks stretch in graceful curvature, reflecting energy and power. The hardness of the figures and their almost flaw-free condition testify to the superior clay-making technology of the Qin Dynasty.

The demand for Buddhist images in the sixth century A.D. made the period one of significant sculptural output. It was probably the one great age of Chinese sculpture, showing deep spirituality. It reflected a stiff, austere abstraction (Fig. **10.22**). In this stone carving of Guanyin, the Goddess of Mercy, we see a female Bodhisattva, or person who is going to attain enlightenment. The gentle curving flow of line from all points in the image directs the eye upward to the serene face. Repetition of deep curves unifies the composition, giving it grace, harmony, and softness. In this later feminine form, the Bodhisattva stays in this world to help others achieve salvation before passing onto *nirvana* herself; she becomes a gentle and compassionate protectress.

When in the following centuries Chinese interests turned in a more humanistic direction, sculpture reflected more intimacy and humanity. Images became rounder and more lifelike, in line with Chinese concepts of human beauty.

CHINESE ARCHITECTURAL STYLE

Very little has survived of early Chinese architecture, partly because most of it was constructed of wood, and partly because there was a mass destruction of Buddhist monasteries, temples, and shrines in 845. We can capture a sense of its style, however, by examining a reconstruction drawing of the main hall of the ninth-century Fo-kuang-ssu (Monastery of the Buddha's Halo) on Mount Wu-t'ai (Fig. 10.23). Dating to the Tang Dynasty (618–906), this is China's oldest wooden building and is located in northern Shansi. We can see in the curved roof lines, deep overhangs, and ornate decoration the indicators that have come to represent Asian style.

Temples

Also typical is the Liurong Temple or Six Banyan Pagoda of Guangzhou (Fig. 10.25). Built in its final form in approximately 989, in the early years of the Song Dynasty (960–1279), the pagoda rises 188 feet (57 m) in nine exterior stories. On the inside it contains seventeen stories. The pagoda is richly painted in red, green, gold, and white, so colorfully that it was at one time called the Flowery Pagoda. The current name comes from the famous writer and calligrapher Su Dong-po, who visited it in 1100 and admired the six banyan trees surrounding it. The upward curving lines of the eaves and the colorful glazed roof tiles became characteristic of Chinese architecture from this time onward.

10.20 Warriors, Tomb of Emperor Qin Shihuangdi, Lintong, near Xi'an (Shaanxi), China, c. 221–209 B.C. (Qin Dynasty). Terra-cotta, life-size figures.

CHINESE PAINTING STYLE

Our quick survey gives us two examples of Chinese painting style separated by more than one thousand years. In the first, from the Han Dynasty (206 B.C.–A.D. 220), we find movement and lively depictions of, for example, mythical beings, dragons, and rabbits: On the painted tile in Figure **10.24** are skillfully rendered figures whose brushstroke suggests liveliness and movement. They appear in three-quarter poses, which gives the painting a sense of depth and action, and the diagonal sweep of the line adds to the sense of motion. The poses of the personages suggest character—that is, the psychology of the figure portrayed. Although the use of pose and direction reflects a sophisticated approach and technique, the figures stand on the same baseline, with no sense of placement in deeper space.

Since the Song Dynasty of the thirteenth century, the Chinese have regarded painting as their greatest art. The basic conventions were established then and painting reached a height that has probably never been surpassed. Buddhist influence remained strong, although secular art grew in prominence too. In secular painting emphasis was on landscapes, as opposed to human events and images. Figure **10.26**, in a soft and atmospheric style, is part of a larger scroll entitled *Twelve Views from a Thatched Cottage* by Xia Gui (c. 1180–1230). It depicts a mountain range and a lake with boats. Each of the sections of the scroll carries an inscription—for example, "Distant Mountains and Wild Geese." Taken as a whole, the scroll reveals time as well as space as it moves from daylight to dusk.

10.22 *Guanyin, The Bodhisattva of Compassion*, from the Ku Shihto Ssu monastery, Sion, Shensi Province, China (Northern Chou-sui Dynasty). Limestone, height 6⅜ ins (16.2 cm).

10.21 Rider with saddled horse, from Tomb of Emperor Qin Shihuangdi, Lintong. Clay, life-size.

10.23 Fo-kuang-ssu (Monastery of the Buddha's Halo), Mount Wu-t'ai, northern Shansi, China, front elevation and cross section of main hall, 9th century (Tang Dynasty).

Subtle technique merges soft washes with firm brush-strokes, and images move from sharp focus to indistinct suggestion. The detailing gives the subject a degree of life-likeness, but it goes beyond that to give a "sense" of nature. The images are impressions rather than depictions. The artist selects details carefully and concentrates on essences.

In the eleventh century, color mattered little. Most Chinese painting was monochromatic. For the Chinese, landscapes represent nature as a whole: Each small detail symbolizes the larger universe. In this painting an overriding mysticism emerges, probably reflecting the Daoist belief system.

CHINESE THEATRICAL STYLE

History

Confucianism played a large part in shaping early Chinese drama. Tradition holds that Confucius put to death an entire troupe of actors who took part in a play that violated his teaching. Daoism also provided important building blocks for Chinese theatre. As a result, some Chinese drama takes the mysticism of Daoism and portrays the relationship between individuals and society with an intuitive and emotional drift, with great imagination and flights into fantasy.

10.25 Liurong Temple (Six Banyan Pagoda), Guangzhou, China, c. 989 (Song Dynasty).

10.24 Lintel and pediment of tomb, from China, 1st century B.C. (Han Dynasty). Gray earthenware; hollow tiles painted in ink and colors on a whitewashed ground, 29 x 80½ ins (73.8 x 204.7 cm). Museum of Fine Arts, Boston (Denman Waldo Ross Collection, and Gift of C. T. Loo).

10.26 Xia Gui, *Twelve Views from a Thatched Cottage* (detail), c. 1200–30. Handscroll, ink on silk, height 11 ins (28 cm). Nelson Atkins Museum of Art, Kansas City (Purchase: Nelson Trust).

One significant characteristic of Chinese drama, emerging from its socioreligious roots, concerned women on the stage. Women in China were subject to severe restrictions and were certainly forbidden to act in the theatre. Therefore, women's roles were portrayed by men. These portrayals mimicked the teetering style of walking that resulted from the practice of footbinding among the upper classes, and utilized a device called *tsai jiao* to keep the actor "on point," as in ballet, throughout the performance.

Legend suggests the presence of actors and clowns and a dramatic form known as the Peking (now Beijing) play as early as the nineteenth century B.C.

The period roughly equivalent to the Gothic era (see p. 262) in Western history witnessed the Chinese golden age of literature, when popular theatre and literature flourished. During the thirteenth and fourteenth centuries writers often dealt with various aspects of injustice and despotism. Written in everyday language, the drama sought to reach a broader and less highly educated audience than had literature in the past. The use of the vernacular reflected a general trend in Chinese society: All written materials sought to reach out to those who had not been classically educated.

As the Western world entered its Renaissance, China moved into the Ming Dynasty (1368–1644). In pursuit of social stability, the new rulers severely limited popular entertainment. Nothing could be produced which in any way criticized or offended the emperor, the establishment, or Confucius. The theatre that developed during this period was aristocratic, or court, theatre, and had little to do with the common people.

Beijing Opera

The major form of Chinese drama is the Beijing Opera. There are two major types, civil and military. The civil type explores domestic and social issues, while the military type deals with the exploits of warriors and/or robbers. In both the action always ends happily. Beijing Opera plays are often based on history, legend, or popular novels. They concentrate on high points, and relegate the development of the story to the narrative passages. Thus interest is focused on climactic moments rather than spread over a fully dramatized story.

"On stage" in Chinese theatre means "center stage." When actors exit, they merely move to an area away from the center. Although they remain in full view of the audience, by convention they are not there, and so they can do whatever tasks need to be done, from drinking tea to adjusting a costume. All entrances occur from stage left, and all exits from stage right.

Costume and Symbolism

Costume and makeup play a significant and symbolic part in Chinese theatre. Color, especially, portrays emotion and social standing. Red connotes loyalty, and also indicates high social standing. Dark crimson is reserved for military personages and barbarians. Yellow means royalty. Black symbolizes the poor and the fierce. Green stands for virtue; white represents the old, the very young, and the bereaved. Color also distinguishes character types.

10.27 Chinese theatrical performance.

We get an impression of the subtlety, complexity, and depth of Chinese drama and its audience relationships when we realize that costume is used to make very specific and detailed statements about character, with perhaps as many as 300 combinations of headdresses, shoes, and other costume items per actor (Fig. **10.27**).

In China, neither theatrical costume nor scenery attempts to depict history accurately. Styles and periods mix freely so as to create dramatic effect. Nuance and subtle inflection form important parts of Chinese philosophy and language, and the same is true for the theatre. Design motifs, as well as color, indicate meaning for an audience. For example, animal and insect designs carry specific information: The emperor is symbolized by a dragon; butterflies mean long life and happiness; tigers symbolize power; and the phoenix, good fortune. Flowers also have meaning: Spring and beauty are represented by the peony while wisdom and charm are indicated by the plum blossom.

Often flags appear appended to the shoulders of a character. Such characters represent generals and, the higher the general's rank, the more flags stick out of his shoulders. The melodramatic American movie form, the western, is not unlike Chinese drama in its use of costume. In the former, the "good guys" wear white hats, and the "bad guys," black ones. In Chinese theatre, the good guys wear square hats, and the bad guys, round ones.

IMPERIAL ROMAN CLASSICISM

By A.D. 70 the Romans had destroyed the Temple of Solomon in Jerusalem and colonized Britain, spreading their pragmatic and pluralistic version of Hellenistic Mediterranean civilization to peoples of the Iron Age in northern and western Europe. Under Augustus, the first Roman emperor (63 B.C.–A.D. 14), Roman culture turned again to Greek Classicism and in that spirit glorified Rome, the emperor, and the Empire. Inventive and utilitarian, Roman culture left us roads, fortifications, viaducts, planned administration, and a sophisticated yet robust legal system.

ROMAN SCULPTURAL STYLE

Some Roman art appears to imitate Greek prototypes, but much displays vigorous creativity that is uniquely Roman. Scholars are divided not only on what various works of Roman sculpture reveal but also on what motivated them. The *Portrait of an Unknown Roman* (Fig. **10.28**) dates from a time when Hellenistic influence was becoming well established in Rome. It is tempting to attribute the highly lifelike representation of this work to the same artistic

viewpoint that governed Hellenistic style, and conclude that it is a copy of Hellenistic work. Such a conclusion, however, neglects an important Etruscan–Roman religious practice, undoubtedly of stronger influence. Portraits were an integral part of household and ancestor worship, and the image of a departed ancestor was maintained in a wax death mask. Wax is not a substance ideally suited for immortality, and there is a possibility that the naturalism of this bust stems from the fact that it was made from a death mask. However, there may be more than mere portrait accuracy in this work, and some scholars point to an apparent selectivity of features and a reinforcement of an idea or ideal of ruggedness and character.

Hellenistic influence grew in the late first century B.C. Greek Classical influence dominated, but always with a Roman—that is, a more practical and individual—character. By the first century A.D., Classical influence had returned sculpture to the idealized style of Periclean Athens. Greek Classical form was duplicated, recast, and translated into vital forms of the present. It was also a common practice to copy the idealized body of a well-known Greek statue and add to it a portrait head of a contemporary Roman (Fig. **10.29**). The aesthetics of sculptural depiction thus remained Greek, with Roman clothing added: The pose, rhythm, and movement of the body originated in the past. Much sculpture at this time portrayed

10.28 *Portrait of an Unknown Roman*, 1st century B.C. Marble, height 14⅜ ins (36 cm). Metropolitan Museum of Art, New York (Rogers Fund).

10.29 *Augustus of Primaporta*, early 1st century A.D. Marble, height 6 ft 8 ins (2.03 m). Musei Vaticani, Rome.

the emperor. Emperors were raised to the status of gods, perhaps because a far-flung empire required assurances of stability and suprahuman characteristics in its leaders.

The reality that men are men and not gods was not long in returning to Roman consciousness, however, and third-century sculpture exhibits an expressive starkness. In the fourth century a new and powerful emperor took the throne, and his likeness (Fig. **10.30**)—part of a gigantic sculpture (the head is over 8 feet [2.5 m] tall)—shows an exaggerated, ill-proportioned intensity comparable with Expressionist works of the early twentieth century (see p. 371). This work is not an actual likeness of Constantine.

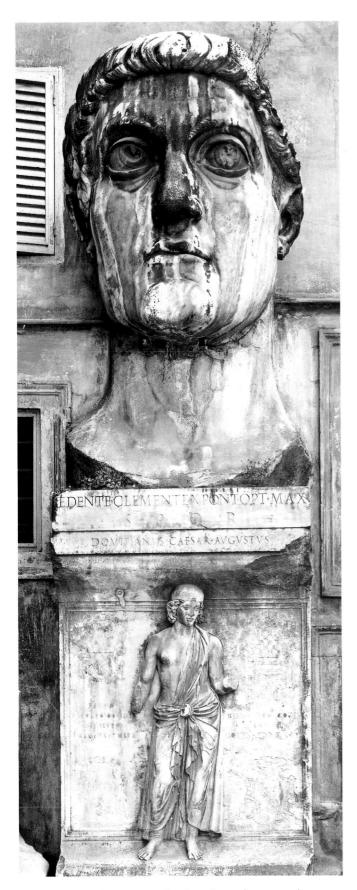

10.30 Head of Constantine the Great (part of an original colossal seated statue), A.D. 313. Marble, height 8 ft 6⅜ ins (2.61 m). Palazzo dei Conservatori, Rome.

Instead, it is the artist's view of Constantine's perception of himself as emperor, and of the office of emperor itself.

ROMAN LITERARY STYLE

At the time when literature became reasonably acceptable to the practical Romans, it was nurtured chiefly through the contributions of Greek slaves. At first, it imitated Greek literature and was written in Greek. Latin was initially seen as a peasant language with few words capable of expressing abstract notions. Credit for developing a Latin prose style and vocabulary for the expression of philosophical ideas is probably due to Cicero (106–43 B.C.). His contemporaries Lucretius and Catullus inaugurated the Golden Age of Latin literature with their poetry.

During the reign of Augustus, the poets Horace (65–8 B.C.) and Virgil (70–19 B.C.) wrote verses glorifying the emperor, on the origins of Rome, the simple honesty of rural life, patriotism, and the glory of dying for one's country. Livy (59 B.C.–A.D. 17) set about retelling Roman history in sweeping style. Virgil's *Aeneid* tells the story of the founding of Rome, in an epic account of the journey of Aeneas from the ruins of Troy to the shores of Italy. The main section of Book 1 follows.

The Aeneid
Book 1
Virgil
70–19 B.C.

ARMS and the man I sing, who first made way
Predestined exile, from the Trojan shore
To Italy, the blest Lavinian strand.
Smitten of storms he was on land and sea
By violence of Heaven, to satisfy
Stern Juno's sleepless wrath; and much in war.
He suffered, seeking at the last to found
The city, and bring o'er his fathers' gods
To safe abode in Latium; whence arose
The Latin race, old Alba's reverend lords,
And from her hills wide-walled, imperial Rome.

O Muse, the causes tell! What sacrilege,
Or vengeful sorrow, moved the heavenly Queen
To thrust on dangers dark and endless toil
A man whose largest honor in men's eyes
Was serving Heaven? Can gods such anger feel?

In ages gone an ancient city stood—
Carthage, a Tyrian seat, which from afar
Made front on Italy and on the mouths
Of Tiber's stream; its wealth and revenues
Were vast, and ruthless was its quest of war.

237

'T is said that Juno, of all lands she loved,
Most cherished this—not Samos' self so dear.
Here were her arms, her chariot; even then
A throne of power o'er nations near and far,
If Fate opposed not, 't was her darling hope
To 'stablish here; but anxiously she heard
That of the Trojan blood there was a breed
Then rising, which upon the destined day
Should utterly o'erwhelm her Tyrian towers;
A people of wide sway and conquest proud
Should compass Libya's doom;—such was the web
The Fatal Sisters spun.
 Such was the fear
Of Saturn's daughter, who remembered well
What long and unavailing strife she waged
For her loved Greeks at Troy. Nor did she fail
To meditate th' occasions of her rage,
And cherish deep within her bosom proud
Its griefs and wrongs: the choice by Paris made;
Her scorned and slighted beauty; a whole race
Rebellious to her godhead; and Jove's smile
That beamed on eagle-ravished Ganymede.
With all these thoughts infuriate, her power
Pursued with tempests o'er the boundless main
The Trojans, though by Grecian victor spared
And fierce Achilles; so she thrust them far
From Latium; and they drifted, Heaven-impelled
Year after year, o'er many an unknown sea—
O labor vast, to found the Roman line!

Below th' horizon the Sicilian isle
Just sank from view, as for the open sea
With heart of hope they sailed, and every ship
Clove with its brazen beak the salt, white waves.
But Juno of her everlasting wound
Knew no surcease, but from her heart of pain
Thus darkly mused: "Must I, defeated, fail
Of what I will, not turn the Teucrian King
From Italy away? Can Fate oppose?
Had Pallas power to lay waste in flame
The Argive fleet and sink its mariners,
Revenging but the sacrilege obscene
By Ajax wrought, Oileus' desperate son?
She, from the clouds, herself Jove's lightning threw,
Scattered the ships, and ploughed the sea with storms.
Her foe, from his pierced breast out-breathing fire,
In whirlwind on a deadly rock she flung.
But I, who move among the gods a queen,
Jove's sister and his spouse, with one weak tribe
Make war so long! Who now on Juno calls?
What suppliant gifts henceforth her altars crown?"

So, in her fevered heart complaining still,
Unto the storm-cloud land the goddess came,
A region with wild whirlwinds in its womb,
Æolia named, where royal Æolus

In a high-vaulted cavern keeps control
O'er warring winds and loud concourse of storms.
There closely pent in chains and bastions strong,
They, scornful, make the vacant mountain roar,
Chafing against their bonds. But from a throne
Of lofty crag, their king with sceptred hand
Allays their fury and their rage confines.
Did he not so, our ocean, earth, and sky
Were whirled before them through the vast inane
But over-ruling Jove, of this in fear,
Hid them in dungeon dark: then o'er them piled
Huge mountains, and ordained a lawful king
To hold them in firm sway, or know what time,
With Jove's consent, to loose them o'er the world.

To him proud Juno thus made lowly plea:
"Thou in whose hands the Father of all gods
And Sovereign of mankind confides the power
To calm the waters or with winds upturn,
Great Æolus! a race with me at war
Now sails the Tuscan main towards Italy,
Bringing their Ilium and its vanquished powers.
Uprouse thy gales! Strike that proud navy down!
Hurl far and wide, and strew the waves with dead!
Twice seven nymphs are mine, of rarest mould,
Of whom Deiopea, the most fair,
I give thee in true wedlock for thine own,
To mate thy noble worth; she at thy side
Shall pass long, happy years, and fruitful bring
Her beauteous offspring unto thee their sire."
Then Æolus: "'T is my sole task, O Queen,
To weigh thy wish and will. My fealty
Thy high behest obeys. This humble throne
Is of thy gift. Thy smiles for me obtain
Authority from Jove. Thy grace concedes
My station at your bright Olympian board,
And gives me lordship of the darkening storm."
Replying thus, he smote with spear reversed
The hollow mountain's wall; then rush the winds
Through that wide breach in long embattled line,
And sweep tumultuous from land to land:
With brooding pinions o'er the waters spread,
East wind and south, and boisterous Afric gale
Upturn the sea; vast billows shoreward roll;
The shout of mariners, the creak of cordage,
Follow the shock; low-hanging clouds conceal
From Trojan eyes all sight of heaven and day;
Night o'er the ocean broods; from sky to sky
The thunders roll, the ceaseless lightnings glare;
And all things mean swift death for mortal man.

Straightway Æneas, shuddering with amaze,
Groaned loud, upraised both holy hands to Heaven,
And thus did plead: "O thrice and four times blest,
Ye whom your sires and whom the walls of Troy
Looked on in your last hour! O bravest son

Greece ever bore, Tydides! O that I
Had fallen on Ilian fields, and given this life
Struck down by thy strong hand! where by the spear
Of great Achilles, fiery Hector fell,
And huge Sarpedon; where the Simois
In furious flood engulfed and whirled away
So many helms and shields and heroes slain!"
While thus he cried to Heaven, a shrieking blast
Smote full upon the sail. Up surged the waves
To strike the very stars; in fragments flew
The shattered oars; the helpless vessel veered
And gave her broadside to the roaring flood,
Where watery mountains rose and burst and fell.
Now high in air she hangs, then yawning gulfs
Lay bare the shoals and sands o'er which she drives.
Three ships a whirling south wind snatched and flung
On hidden rocks,—altars of sacrifice
Italians call them, which lie far from shore
A vast ridge in the sea; three ships beside
An east wind, blowing landward from the deep,
Drove on the shallows,—pitiable sight,—
And girdled them in walls of drifting sand.

That ship, which, with his friend Orontes, bore
The Lycian mariners, a great, plunging wave
Struck straight astern, before Æneas' eyes.
Forward the steersman rolled and o'er the side
Fell headlong, while three times the circling flood
Spun the light bark through swift engulfing seas.
Look, how the lonely swimmers breast the wave!
And on the waste of waters wide are seen
Weapons of war, spars, planks, and treasures rare,
Once Ilium's boast, all mingled with the storm.
Now o'er Achates and Ilioneus,
Now o'er the ship of Abas or Aletes,
Burst the tempestuous shock; their loosened seams
Yawn wide and yield the angry wave its will.

Meanwhile, how all his smitten ocean moaned,
And how the tempest's turbulent assault
Had vexed the stillness of his deepest cave,
Great Neptune knew; and with indignant mien
Uplifted o'er the sea his sovereign brow.
He saw the Teucrian navy scattered far
Along the waters; and Æneas' men
O'erwhelmed in mingling shock of wave and sky.
Saturnian Juno's vengeful stratagem
Her brother's royal glance failed not to see;
And loud to eastward and to westward calling,
He voiced this word: "What pride of birth or power
Is yours, ye winds, that, reckless of my will,
Audacious thus, ye ride through earth and heaven,
And stir these mountainous waves? Such rebels!—
Nay, first I calm this tumult! But yourselves
By heavier chastisement shall expiate

Hereafter your bold trespass. Haste away
And bear your king this word! Not unto him
Dominion o'er the seas and trident dread,
But unto me, Fate gives. Let him possess
Wild mountain crags, thy favored haunt and home,
O Eurus! In his barbarous mansion there,
Let Æolus look proud, and play the king
In yon close-bounded prison house of storms!"

He spoke, and swiftlier than his word subdued
The swelling of the floods, dispersed afar
Th' assembled clouds, and brought back light to heaven.
Cymothoë then and Triton, with huge toil,
Thrust down the vessels from the sharp-edged reef
While, with the trident, the great god's own hand
Assists the task; then, from the sand-strewn shore
Out-ebbing far, he calms the whole wide sea,
And glides light-wheeled along the crested foam.
As when, with not unwonted tumult, roars
In some vast city a rebellious mob,
And base-born passions in its bosom burn,
Till rocks and blazing torches fill the air
(Rage never lacks for arms)—if haply then
Some wise man comes, whose reverend looks attest
A life to duty given, swift silence falls:
All ears are turned attentive; and he sways
With clear and soothing speech the people's will.
So ceased the sea's uproar, when its grave Sire
Looked o'er th' expanse, and, riding on in light,
Flung free rein to his winged obedient car.

Æneas' wave-worn crew now landward made,
And took the nearest passage, whither lay
The coast of Libya. A haven there
Walled in by bold sides of a rocky isle,
Offers a spacious and secure retreat,
Where every billow from the distant main
Breaks, and in many a rippling curve retires.
Huge crags and two confronted promontories
Frown heaven-high, beneath whose brows outspread
The silent, sheltered waters; on the heights
The bright and glimmering foliage seems to show
A woodland amphitheatre; and yet higher
Rises a straight-stemmed grove of dense, dark shade.
Fronting on these a grotto may be seen,
O'erhung by steep cliffs; from its inmost wall
Clear springs gush out, and shelving seats it has
Of unhewn stone, a place the wood-nymphs love.
In such a port, a weary ship rides free
Of weight of firm-fluked anchor or strong chain.
Hither Æneas, of his scattered fleet
Saving but seven, into harbor sailed;
With passionate longing for the touch of land,
Forth leap the Trojans to the welcome shore,
And fling their dripping limbs along the ground.[5]

239

The influence of Horace, Virgil, and Livy on Western culture is difficult to overestimate; "they are so much a part of us that we take their values for granted and their epigrams for truisms."[6] As far as Augustus was concerned, they fully expressed the Roman tradition and Roman language. Horace, Virgil, and Livy created a literature that distracted the upper classes from Greek "free thought" and which the emperor could exploit to rally them to the ancient Roman order as represented in his person.

Throughout the literature of the Augustan period runs a moralizing Stoicism. This Greek philosophy held that God was the basis of the universe, that human souls were sparks of the divine fire, and that virtue was all-important. The most remarkable product of Stoicism in poetry was satire, which allowed writers to advocate morality with great popular appeal. Martial (c. A.D. 40–104) and Juvenal (c. A.D. 60–130) utilized poetry to attack vice—which gave them license to describe it in graphic detail. Petronius (fl. 1st century A.D.) produced satirical verse and prose novels describing the adventures of roguish heroes. Their details were as readable as Martial's and Juvenal's but void of their morality. Lucan (A.D. 39–65) and Apuleius (fl. 2nd century A.D.) followed in the same literary tradition. Apuleius's *Golden Ass* creates a fictional biography describing how he was tried and condemned for the murder of three wineskins. He was brought back to life by a sorceress, and in the process of trying to follow her in the form of a bird, he was changed instead into an ass. The only cure for his affliction appeared to be the procurement of rose leaves, and in his search for these, he fell into some bizarre and fantastic adventures.

Latin was later to become the language of learning and of the Christian Church throughout Europe.

ROMAN ARCHITECTURAL STYLE

Given the practicality of the Roman viewpoint, it is not surprising that there is an immediately distinctive Roman style in architecture. The clear crystallization of form we found in the post-and-lintel structure of the Classical Greek temple is also apparent in the Roman arch.

Very little early Roman architecture remains, but what there is has Corinthian orders and fairly graceful lines, suggesting a strong Hellenistic influence. There are notable differences, however. Hellenistic temples were built on an impressive scale, but Roman temples were even smaller than the Classical Greek ones. This was principally because Roman worship was mostly a private rather than a public matter. Roman temple architecture also employed engaged columns—columns partly embedded in the wall.

As a result, on three sides Roman temples lacked the open colonnade of the Greek temple.

The Temple of Fortuna Virilis (Fig. **10.31**) is the oldest and best preserved example of its kind, dating from the second century B.C. The influence of Greek style can be seen in the delicate Ionic columns and entablature. The cella (main enclosed space), containing only one room, is a departure from an earlier convention of three rooms. Roman temples were used to display trophies from military campaigns as well as to house the image of the deity.

In the Augustan age Roman architecture was refashioned in the light of Classical Greek style, as we also saw in the case of sculpture. This accounts for the dearth of surviving buildings from previous eras. Temples were built on Greek plans, but the proportions were significantly different. The first through fourth centuries brought what is typically identified as the Roman style. Its most significant characteristic is the use of the arch as a structural system in arcades and tunnel and groin vaults.

The Colosseum

The Colosseum (Figs. **10.32** and **10.33**), the best known of Roman buildings and one of the most stylistically typical, combines an arcaded exterior with vaulted corridors. It seated 50,000 spectators and was a marvel of engineering. Its aesthetics are reminiscent of Greek Classicism, but fully Roman in style. The circular sweep of the building is carefully countered by the vertical line of engaged columns flanking every arch. Doric, Ionic, and Corinthian columns each mark one level, progressing upward from heavy to lighter orders. The Colosseum was a new type of building called an "amphitheatre," in which two "theatres," facing each other, were combined to form an arena surrounding an oval space.

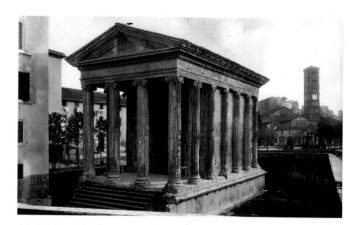

10.31 Temple of Fortuna Virilis, Rome, late 2nd century B.C.

Placed in the center of the city of Rome, the Colosseum housed gladiatorial games, including the martyrdom of Christians by turning lions loose on them as a gruesome "spectator sport." Emperors competed with their predecessors to produce the most lavish spectacles here. Originally a series of poles and ropes supported awnings to provide shade for the spectators. The space below the arena contained animal enclosures, barracks for gladiators, and machines for raising and lowering scenery.

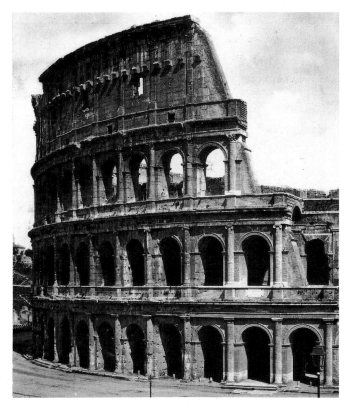

10.32 Colosseum, Rome, c. A.D. 70–82.

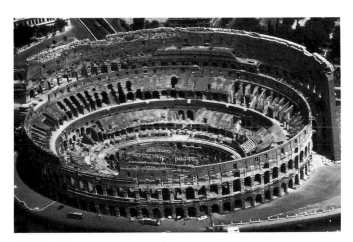

10.33 Colosseum, interior.

The Arch of Titus

Roman triumphal arches were another sort of impressive architectural monument. In the Arch of Titus (Fig. **10.34**), the Roman Classical style survives in a memorial to the emperor Titus (reigned A.D. 79–81) raised by his younger brother, Domitian (reigned A.D. 81–96). It records accomplishments that Titus shared with his father, Vespasian (reigned A.D. 69–79), in the conquest of Jerusalem. The sculptural reliefs on the arch show Titus riding in his chariot in triumph. The reliefs are allegories of political reverence rather than illustrations of historical events. Accompanying Titus in them are figures such as the *Genius Senatus* and the *Genius Populi Romani*—embodiments of the spirit of the Senate, or governing body, and the general populace. This work illustrates the contrast of external appearance—the richly and delicately ornamented façade—with the massive internal structure of the arch, a characteristic which reappeared in Renaissance architecture.

The Pantheon

The Pantheon (Figs. **7.13**, **10.35**, and **10.36**) fuses Roman engineering, practicality, and style in a domed temple of unprecedented scale, dedicated, as its name indicates, to all the gods.

In both plan and section the Pantheon is round. From the exterior we glimpse a cella comprising a simple, unadorned cylinder capped by a gently curving dome. The entrance is a Hellenistic porch with huge Corinthian

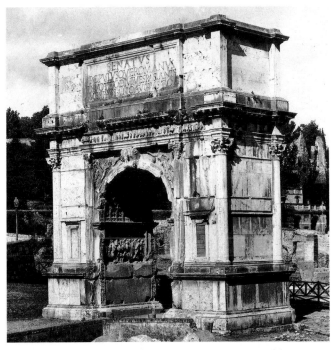

10.34 Arch of Titus, Roman Forum, Rome, A.D. 81. Marble.

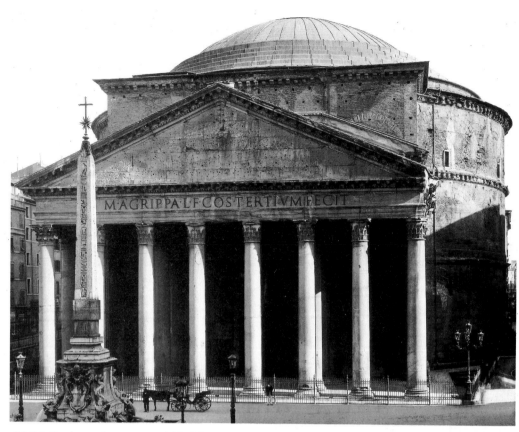

10.35 Pantheon, Rome, c. A.D. 118–28.

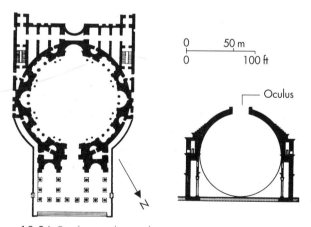

10.36 Pantheon, plan and section.

columns. Originally it was approached by a series of steps and attached to a rectangular forecourt, so we see only part of a more complex design.

Inside, the scale and detail are overwhelming. The drum and dome consist of solid monolithic concrete reinforced with bands of vitrified tile. The vertical gravity loads are collected and distributed to the drum by arches incorporated in the concrete. The wall of the 20-foot-thick drum has alternating rectangular and curved niches cut into it, thus forming a series of massive radial buttresses.

Originally, statues of the gods occupied these niches, which are carved out of the massive walls. Corinthian columns add grace and lightness to the lower level, and heavy horizontal moldings accentuate a feeling of open space made possible by the huge dome. It is 143 feet (43 m) in both diameter and height (from the floor to the *oculus* [Latin for "eye"], the round opening at the top of the dome). The circular walls supporting the dome are 20 feet (6 m) thick and 70 feet (21 m) high. Recessed square *coffers* on the underside of the dome give an added sense of lightness and reflect the framework into which concrete was poured. Originally the ceiling was gilded to suggest the golden dome of heaven.

How could the Romans have built such a colossal structure? Historians have argued that the key lies in a novel form of concrete containing a specific kind of cement developed near Naples. The secret, however, may rest with the mysterious rings around the dome, as suggested by a Princeton University study: "Probably they perform a function similar to the buttresses of a Gothic cathedral . . . The extra weight of the rings . . . helps stabilize the lower portion of the dome: Rather than functioning like a conventional dome, the Pantheon behaves like a circular array of arches, with the weight of the rings holding the end of each arch in place."[7]

JAPAN

Chinese chronicles mention Japan for the first time in the first century A.D. By that time Japan had entered the Metals Age and had developed a major rice-growing economy. The first development of any major political center, however, appears to have occurred in the fourth century. The country was controlled by a strongly entrenched aristocracy, the Yamato, whose dominance continued throughout the fifth and sixth centuries. At this time Japan experienced strong Korean cultural influence.

Between the sixth and eighth centuries Japan passed from what historians call "protohistory" into civilization. The Yamato created a state centered on the Chinese model. Buddhism was introduced and adopted by the court sometime in the sixth century, although Shinto, Japan's ancient polytheistic nature cult, appears to have been maintained. Over the next 200 years the constitution was modeled on Confucian ethics, land reform transformed the aristocracy into a bureaucracy paid by the state, legal and penal codes were introduced, and historical chronicles were developed. An official break with China in 894 testified to the divergence of Japanese culture.

Japanese aesthetics matured as well. By the fifteenth century, Japanese culture and society reached one of their highest points. Level local economies, technological advances, and a burgeoning sea trade each contributed their part. As in the Western world, a new middle class, or bourgeoisie, made a significant impact on Japanese culture. Zen gardens proliferated and the tea ceremony was invented. Architectural masterpieces were built and Noh theatre was founded. However, on the political front, Japan could not maintain a steady course. Centralized authority

all but disappeared, and civil strife reigned. The shogunate—the hereditary officials who governed Japan at this period—became incapable of controlling the vassals, and became so weak that the opposite occurred. Despite prosperity and cultural accomplishment, Japan was a sorely divided state when the Portuguese arrived in 1543 bringing Christianity and firearms.

JAPANESE STYLE IN ARCHITECTURE

Buddhism made a significant impact on Japan during the Jogan or Early Heian period (794–897). Esoteric Buddhism, or the Mikkyo, emphasized secrecy and mystery, and its precepts can be found in a monastery (Fig. 10.37) in a remote part of Nara prefecture. The secluded location of Muroji (-ji means "temple") removes the temple from "distractions and corruptions." The design of the *kondo*, or main hall, is asymmetrical, with a close relationship to the natural site. Its shingled roof sets it apart from the tiled-roof structures of Chinese influence and argues for a native Japanese style in temple architecture.

JAPANESE STYLE IN PAINTING AND SCULPTURE

In the thirteenth century, Japanese sculpture turned to a simple style which stressed strength and virility. A series of civil wars had led to the military dictatorship of the shoguns and their samurai (warriors) and to a broadly based feudal regime. This was reflected in the works of sculptors such as Unkei, whose demonic and colossal wooden Buddhist deities (Fig. 10.40) guard the entrance to the Todaiji at Nara, one-time capital of Japan. We are drawn both by the statue's power, expressed in the fierce facial expression and forbidding hand, and by its simplicity, through the clean lines of the swirling fabrics.

In the late thirteenth century, Japanese painting expanded its subject matter from individual portraiture to include landscape (Fig. 10.39). The Kumano Mandala draws into close proximity three Shinto shrines which are geographically many miles apart. Above them are *mandalas* containing Buddhist deities. A *mandala* is a circular diagram of the cosmos used for meditation, ceremonial incantation, or magic. The presence of Buddhist deities in portrayals of Shinto shrines attests to the dominance of Buddhism at the time. Around and between the depiction of the shrines appears a delicately rendered landscape. The presentational style creates a shorthand of ideas and a beautiful design of

10.37 Kondo of Muroji, Nara prefecture, Japan, 9th century (Early Heian period).

delicate and active line, holding the entire work together and leading the eye from section to section.

In contrast to the Kumano Mandala, with its mysticism, the Heiji Monogatari scroll (Fig. 10.38) depicts a dramatic fire scene replete with crowds and emotion. As the Sanjo Palace burns, figures and flames explode from the right border to the left. The artist creates a masterful stylized scene which is so tightly controlled compositionally that it could be a study for any painter of any age. The forceful diagonals and the powerful, horizontal, dark thrust of the palace roof meet to form an arrow shooting across the paper. In a design as intricate and powerful as any Baroque painting (see p. 292), this work builds detailed individual pieces, stimulating in their own right, into a large and complicated unity of contrasting colors, values, and textures. Straight and curved lines combine to create further conflict and dramatic tension.

JAPANESE STYLE IN THEATRE

Japan's two great dramatic forms, Noh and the later Kabuki (see p. 292), both originated from religious rituals dating to the late eighth and early ninth centuries, when drama was used as a teaching tool by Buddhist monks. The dramatizing of religious ritual in Buddhism slowly became more and more secularized, found its way out of the sanctuary, and gained in popularity, much as did miracle, mystery, and morality plays in medieval Europe (see p. 265). The results emerged as dramatic forms performed in markets as well as places of worship.

10.39 Kumano Mandala, c. 1300 (Kamakura period). Color on silk. Cleveland Museum of Art (John L. Severance Fund).

10.38 *Night Attack on the Sanjo Palace*, from the Heiji Monogatari scroll, detail, second half of 13th century (Kamakura period). Handscroll; ink and colors on paper, 16¼ ins x 23 ft (41.3 cm x 7 m). Museum of Fine Arts, Boston (Fenollosa-Weld Collection).

Noh Drama

Noh drama matured during the fourteenth century into an original literary and performing art. Highly conventionalized, it emerged from two sources: simple dramas based on symbolic dances performed to music at the imperial court, and mimes popular with the common people. Its final form is credited to a Shinto priest named Kan'ami (1333–84) and his son Seami (1363–1443). They also founded one of the hereditary lines of Noh performers, the Kanze, who still perform today.

Noh drama is performed on a simple, almost bare stage and, like early Classical Greek tragedy, uses only two actors. Also, as in Classical Greek drama, actors wear elaborate masks and costumes, and a chorus functions as a narrator. Actors chant highly poetic dialogue to orchestral accompaniment. All actions suggest rather than depict, which gives the drama its stylization and conventionality; symbolism and restraint characterize both acting and staging.

Subjects range from stories of Shinto gods to Buddhist secular history, and usually center on the more popular Buddhist sects. The tone of Noh plays tends to be serious—appealing to the intellect—with a focus on the spirit of some historical person who wishes for salvation but is tied to this earth by worldly desires. The plays tend to be short, and an evening's performance encompasses several, interspersed with comic burlesques called Kyogen ("Crazy Words"). Although Noh drama is performed today and is extremely popular, it remains primarily a fourteenth-century form. Almost all of its canon of scripts (approximately 240) come from that period, with more than 100 written by Seami.

In general, Noh plays can be classified into five types, according to subject: (1) gods; (2) warriors; (3) women; (4) spirits or mad persons; and (5) demons. Traditionally, an evening's performance included all five types, performed in the order noted. Contemporary practice, however, has shortened the program to two or three.

BYZANTIUM

Astride the main land route from Europe to Asia and its riches, Byzantium possessed tremendous potential as a major metropolis. In addition, the city was a defensible deep-water port and controlled the passage between the Mediterranean and the Black Sea. Blessed with fertile agricultural surroundings, it formed the ideal "New Rome." For this was the objective of the emperor Constantine when he dedicated his new capital in A.D. 330 and changed its name to Constantinople (literally, "city of Constantine"). It prospered, and became the center of

10.40 Unkei, *Nio*, Todaiji, Nara, 1203. Wood, height 26 ft 6 ins (8 m).

Orthodox Christianity and mother to a unique and intense style in the visual arts and architecture. When Rome fell to the Goths in 476 it had long since handed the torch of civilization to Constantinople. Here the arts and learning of the Classical world were preserved and nurtured, along with an Eastern orientation, while western Europe underwent the turmoil and destruction of barbarian invasion.

BYZANTINE STYLE

A fundamental characteristic of Byzantine visual art is the concept that art has the potential to interpret as well as to represent. Byzantine art and literature were both conservative and mainly anonymous and impersonal. Much Byzantine art remains undated, and questions concerning derivation of styles lie unresolved. Yet the development of narrative Christian art, with its relatively new approach, can be dated to the mid-fifth century, and early attempts at *iconography* (the pictorialization of sacred personages) can be traced to the third and fourth centuries.

The content and purpose of Byzantine art was always religious, although the style of representation underwent numerous changes. The period of Justinian (reigned 527–65) marks an apparent deliberate break with the past. What is now described as the Byzantine style, with its anti-naturalistic character, began to take shape in the fifth and sixth centuries, although the Classical Hellenistic tradition seems to have survived as an undercurrent. Throughout the seventh century Classicism and decorative abstraction intermingled in Byzantine art.

By the eleventh century Byzantine style had adopted a *hierarchical* formula in wall painting and mosaics. The Church represented the kingdom of God: Moving up the hierarchy, figures changed in form from human to divine. Thus placement in the composition depended upon religious, not spatial, relationships. A strictly two-dimensional, flat style appeared—elegant and decorative, without any perspective or illusionism.

Stylization and dramatic intensity characterize twelfth-century Byzantine art; approaches further intensified in the thirteenth century with turbulent movement, architectural backdrops, and elongated figures. The fourteenth century produced small-scale, crowded works with narrative content. Their use of space is confused and perspective is irrational. Figures are distorted, with small heads and feet. A more intense spirituality comes across.

We can draw a few general conclusions with regard to Byzantine art (which, we must remember, encompasses nearly 1000 years of history, and, thereby, several shifts in style). First, the *content* of Byzantine art focuses on human figures. Those figures reveal three main elements: (1) *holy*

figures—Christ, the Virgin Mary, the saints, and the apostles with bishops and angels portrayed in their company; (2) *the emperor*—believed divinely sanctioned by God; (3) *the Classical heritage*—images of cherubs, mythological heroes, gods and goddesses, and personifications of virtues. In addition, the *form* of Byzantine two-dimensional art increasingly reflected a consciously-derived spirituality.

BYZANTINE ARCHITECTURE

Western Byzantium: San Vitale

The church of San Vitale in Ravenna, Italy (Figs. **10.41–10.43**), is the major Justinian monument in the West, and was probably built as a testament to Orthodox Christianity. The structure consists of two concentric octagons (Fig. **10.42**). The hemispherical dome rises 100 feet (30.5 m) above the inner octagon, and floods the interior with light. Eight large piers alternate with columned niches to define the central space. An extraordinary feature is the placement of the *narthex* (porch) at an odd angle. Two possible explanations—one practical and one spiritual—are: (1) the narthex paralleled a street that existed when the building was under construction, and (2) it was designed in order to make worshipers reorient themselves on entering the complex arrangement of spaces, so that they would experience a transition from the outside world to the spiritual one.

On the second level of the *ambulatory* was a special gallery reserved for women—a standard feature of Byzantine churches. The design is intricate and complex; the visitor experiences an ever-changing scene of arches within arches, and flat and curved spaces. The aisles and galleries contrast strikingly with the calm area under the dome. Clerestory light reflects off the mosaic tiles with great richness. In fact, new construction techniques in the vaulting allow for windows on every level and open the sanctuary to much more light than was previously possible, or than was found in the West until the end of the Romanesque style and the advent of the Gothic.

The sanctuary itself is alive with mosaics of the imperial court and sacred events. Figure **10.44** provides a vivid picture of the emperor. Particularly fascinating here is the stylistic contrast of two mosaics in the same church. *Abraham's Hospitality and the Sacrifice of Isaac* (Fig. **10.45**) demonstrates a relaxed realism whereas the mosaic depicting Justinian and his court demonstrates an orientalized style, more typically Byzantine, with the figures posed rigidly and frontally rather than realistically. The emperor has a golden halo with a red border, is robed in regal purple,

10.41 San Vitale, Ravenna, Italy, A.D. 526–47.

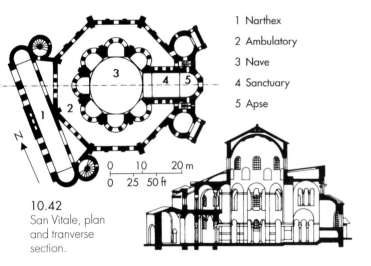

1 Narthex
2 Ambulatory
3 Nave
4 Sanctuary
5 Apse

0 10 20 m
0 25 50 ft

10.42
San Vitale, plan
and tranverse
section.

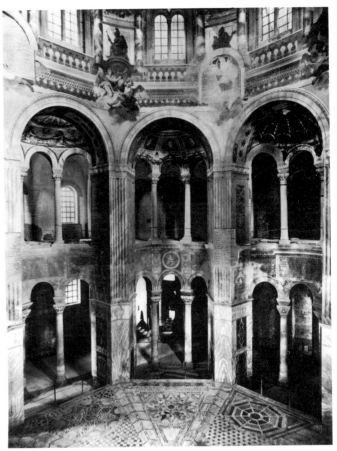

10.43 San Vitale, interior.

and presents a golden bowl to Christ, pictured in the semi-dome above. The mosaics link the church to the Byzantine court, reflecting the connection of emperor to the faith, of Christianity to the state, and, indeed, the concept of the "Divine Emperor." Justinian and the empress, Theodora, are portrayed as analogous to Christ and the Virgin.

Eastern Byzantium: Hagia Sophia

If San Vitale praises the emperor and Orthodox Christianity in the West, the church of Hagia Sophia (Holy Wisdom) in Constantinople (modern Istanbul) represents a crowning memorial in the East (Figs. **10.46–10.49**). Characteristic of Justinian Byzantine style, Hagia Sophia uses Roman vault-

ing techniques with Hellenistic design and geometry. The result is a richly colored building in an Eastern antique style. Basic to the conception is the elevated central area with its domed image of heaven and large, open, and functional spaces. Hagia Sophia provides us with a rare experience of Byzantine artistry.

Its architect, Anthemius, was a natural scientist and geometer from Tralles in Asia Minor, who built the church to replace an earlier basilica. For a long time this was the largest church in the world, yet it was completed in only five years and ten months. Byzantine masonry techniques were used, in which courses of brick alternate with courses of mortar equally thick as or thicker than the bricks. Given the speed of construction, this caused great weight to be placed on insufficiently dry mortar. As a result, arches buckled and buttresses had to be erected almost at once. The eastern arch and part of the dome fell in 557, after two earthquakes. No one has since constructed such a large dome that is so flat. Also remarkable is the delicate proportioning of the vaults which support such great weight. The building suggests an intense spirituality and yet is capable of holding large numbers of worshipers; it creates a transcendental environment, where thoughts and

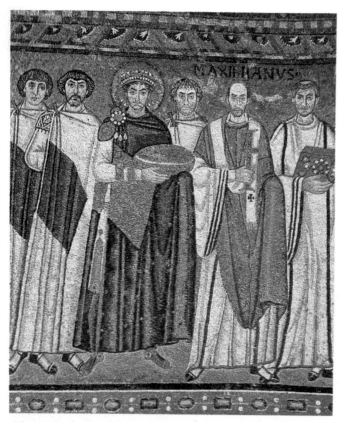

emotions are wafted to a spiritual sphere. "It seemed as if the vault of heaven were suspended above one," wrote the sixth-century Byzantine historian Procopius.

Justinian's reign thus inaugurated the style called Byzantine, blending together previous styles—Eastern and Western—to create something new. Forms and relationships were given a spiritual essence built on Classical models but shaped uniquely. The wide range of works from the reign of Justinian synthesizes the relationships between God, the State, philosophy, and art. The emperor was the absolute monarch and also defender of the faith, seen to govern by and for the will of God. Reality was therefore spiritualized and was reflected in works of art that depicted earthly habitation in a *hieratic* ("holy" or "sacred") style.

BYZANTINE STYLE IN MOSAICS AND IVORIES

By about the year 500 the style known as hieratic was used in Byzantine art to present formalized, almost rigid depictions intended not so much to represent people as to inspire reverence and meditation (Fig. **10.44**). (Do not

10.44 *Emperor Justinian and His Court,* San Vitale, Ravenna, C. A.D. 547. Wall mosaic.

10.45 *Abraham's Hospitality and the Sacrifice of Isaac,* San Vitale, Ravenna. Wall mosaic.

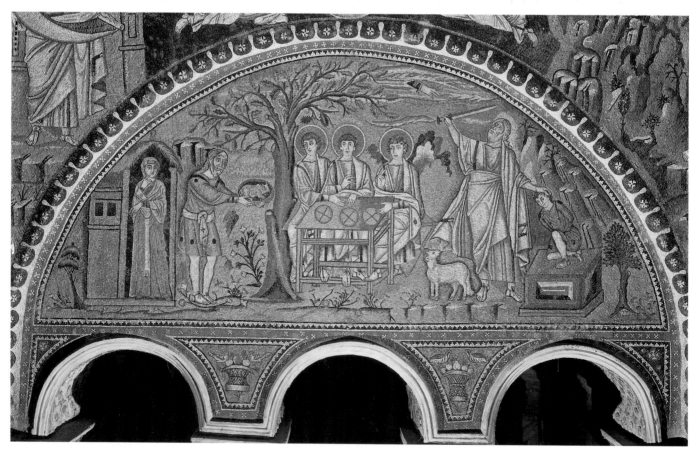

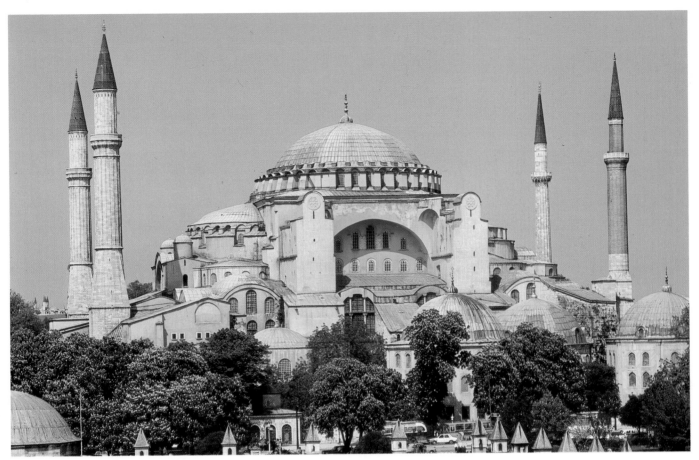

10.46 Anthemius of Tralles and Isidorus of Miletus, Hagia Sophia, A.D. 532–7.

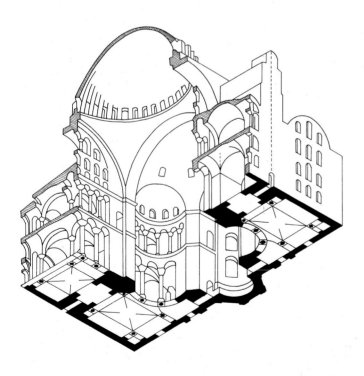

10.47 Hagia Sophia, axonometric section (bird's eye view).

confuse this style with the hierarchical formula discussed earlier.) One formula of the hieratic style ordained that an individual should measure nine heads (seven heads would be our modern measurement). The hairline had to be a nose's length above the forehead. "If the man is naked, four nose's lengths are needed for half his width." By the thirteenth century, mosaics returned to more realistic depictions, but still with a clear sense of spirituality.

Ivory, traditionally a luxury material, was always popular in Byzantium. A number of carved works of different styles provide evidence of the varying influences and degrees of technical ability in the Eastern Byzantine Empire. Many, but not all, Byzantine ivories are *diptychs*—on two hinged panels. Ivories from the tenth century show delicate elegance and a highly finished style. The Harbaville Triptych (Fig. **10.50**) has been described as the most beautiful of all Byzantine ivories. Called a *triptych* because of its three sections (*tri-*), it was probably intended as a portable altar or shrine. Each of the two wings folded shut across the center panel. In the top center Christ is enthroned and flanked by John the Baptist and the Virgin Mary. They plead for mercy on behalf of all humanity. Five

10.48 Hagia Sophia, interior.

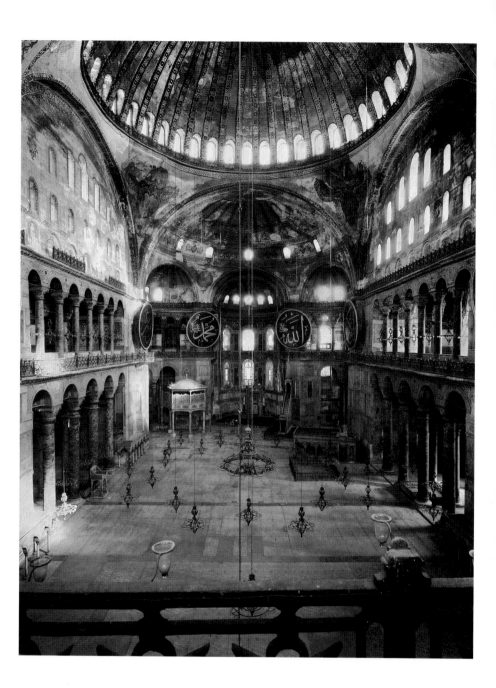

10.49 Hagia Sophia, plan.

of the apostles appear below. An ornament, repeated with the addition of rosettes at the bottom border and three heads in the top border, divides the two *registers* of the central panel. On either side of Christ's head appear medallions depicting angels holding the symbols of the sun and the moon. The Harbaville Triptych exhibits the frontal pose, formality, solemnity, and slight elongation of form that typify the Byzantine hieratic style. Here it produces a sense of detachment from the world and evokes a deep spirituality.

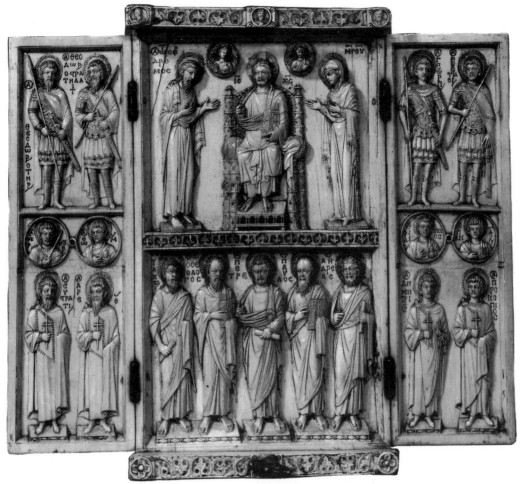

10.50 *The Harbaville Triptych,* interior, late 10th century. Ivory, height 9½ ins (24 cm); width of central panel 5⅜ ins (14 cm). Louvre, Paris.

ISLAM

The Islamic tradition in art springs from the religion of Islam (meaning submission), of which Muhammad was the prophet. Adherents are called Muslims or Moslems. Muslims are those who submit to the will of God ("Allah" in Arabic). The latest of the three great monotheistic religions, it drew upon the other two—Judaism and Christianity. Abraham and Jesus are in the list of prophets preceding Muhammad. Muslims generally believe that Jesus will return as the Mahdi—Messiah—at the end of the world. Islam is based on the sacred book the Koran, which Muslims believe was revealed by God to Muhammad. Five duties are prescribed for every Muslim; the last is a once-in-a-lifetime pilgrimage (Hajj) to Mecca. This has made the pilgrimage the greatest in the world and a great unifying force in Islam. In addition to the Koran, Islam accepts the Sunna—collections of moral sayings and anecdotes of

10.51 Al-Qasim ibn 'Ali al-Hariri, *Maqamat al-Hariri* (a book of stories), 1323.
Mesopotamian manuscript. British Library, London (Oriental Collection).

251

10.52 Dome of the Rock, Jerusalem, late 7th century A.D.

10.53 Great Mosque, Damascus, Syria, courtyard looking west, c. A.D. 715.

10.54 (*above*) and **10.55** (*top right*) Great Mosque, Damascus, details of mosaic decoration, c. A.D. 715.

Muhammad, collected as early as the ninth century. There appear to be contradictions in the Sunna, but they are resolved by the doctrine of Ijma: Every Muslim holds a belief that the greater part of Islam is infallibly true—a principle that has made the religion flexible.

Early in its history, a great split occurred in Islam between Sunnites and Shiites, and it has persisted.

10.56 Dome of the Rock, Jerusalem, details of mosaic decoration, A.D. 691–2.

Originally it was over the caliphate, which was the crowning institution of the structure of Islam—the placement of both religious and political leadership in the hands of a single ruler. The caliphs were the successors—so-called deputies—of Muhammad, and their claim to authority rested on their descent from the families of the Prophet or his early associates. In Muslim countries the civil law is not in theory separate from religious law, though in some places secularism has modified the unity somewhat. Religion governs all aspects of life.

Islam spread rapidly in the seventh and eighth centuries and was soon dominant from Spain to India. Today, it spreads across Asia to the South Pacific, prevails in North Africa, and is still gaining converts in the rest of Africa. Originally spread "by the sword," Islam appealed through its openness to everyone: It stresses the brotherhood of the faithful before God, regardless of race or culture. Interestingly, the Arab warriors who started out to conquer the world for Allah did not expect to make converts of conquered peoples—they merely expected the unbelievers to be obedient to them. Converts were expected to become Arabs: The Koran was not translated because it was believed to have been dictated by God to Muhammad in Arabic. Converts also had to submit to the social and legal systems of the Muslim community. As a result, the conquering Arabs resisted the usual fate of conquerors—to be absorbed into the culture of the conquered.

ISLAMIC STYLE IN VISUAL ART

Theoretically, all human and animal figures are prohibited from Islamic art because of the Scriptural command against making images. In reality, images are widespread: The only prohibition seems to have been on objects intended for public display. In the courts of the caliphs, images of living things were commonplace. They were considered harmless if they did not cast a shadow, were small in scale, or appeared on everyday objects.

In the early years of Islam, there seems to have been some continuity in the visual arts. The Arabs obtained manuscripts from Byzantium and were tremendously interested in Greek science. The result was a plethora of texts translated into Arabic and then illustrated, and sometimes the original Greek pictures were copied. Typical of this type of Arab illustration is a pen-and-ink sketch thought maybe to be from a Mesopotamian manuscript of the fourteenth century (Fig. 10.51). The drawing has a clear presentation, with many of the strokes seeming to act as accents. The lines flow freely in subtle curving movements to establish a comfortable rhythm across the page. In very simple line, the artist is able to capture human charac-

ter, thus showing strong observational ability. The witty flavor of the drawing goes far beyond mere illustration.

ISLAMIC STYLE IN LITERATURE

Probably the most familiar Islamic literature, besides the Koran, is a collection of tales called *The Arabian Nights* or *The Thousand and One Nights*. These accumulated during the Middle Ages, and as early as the tenth century they were part of the oral traditions of Islam in the Near East. Over the years more tales were added, including a unifying device called a *frame-tale*, which places all of the separate stories within a large framework. By around 1450 the work had assumed its final form.

The frame-tale recounts the story of a jealous Sultan who, convinced that all women were unfaithful, married a new wife each evening and put her to death the following morning. A new bride, Shaharazad, gained a reprieve by beginning a story on her wedding night and artfully maintaining the Sultan's curiosity. She was able to gain a reprieve for 1,001 nights—during which time she produced three male heirs. After this the Sultan abandoned his original practice. The tales capture the spirit of Islamic life, its exotic setting, and its sensuality. Although no particular moral purpose underlies the stories, there is a moral code within them. They cover a variety of subjects and range from fact to fiction. They include stories of camel trains, desert riders, and insistent calls to prayer. They are supernatural, aristocratic, romantic, bawdy, and satiric.

ISLAMIC STYLE IN ARCHITECTURE

Work on the first major example of Islamic architecture—the Dome of the Rock in Jerusalem (Fig. 10.52)—began in A.D. 685. It was started by Islamic emperors who were direct descendants of the Prophet's companions. Built near the site of the Temple of Solomon (see p. 202), it was designed as a special holy place—not an ordinary mosque. Its location is revered by Jews as the tomb of Adam and the place where Abraham prepared to sacrifice Isaac. According to Muslim tradition, it also is the place from which Muhammad ascended into heaven. Written accounts suggest that it was built to overshadow a sacred temple of similar construction on the other side of Jerusalem—the Holy Sepulchre. Caliph Abd al-Malik wanted a monument that would outshine the Christian churches of the area, and, perhaps, the Ka'ba in Mecca.

The Dome of the Rock is shaped as an octagon, and inside it contains two concentric ambulatories (walkways)

surrounding a central space capped by the dome. The exterior was later decorated with the glazed blue tiles that give the façade its dazzling appearance; the interior glitters with gold, glass, and mother-of-pearl multi-colored mosaics. A detail of its richly intricate mosaics can be seen in Figure 10.56. This symmetrical pattern in deep red and gold, highlighted with accents of white and purple, illustrates the skill and delicacy of Muslim artists.

Undoubtedly, the Dome of the Rock was intended to speak to Christians as well as Muslims, distracting the latter from the splendor of Christian churches. Inside the mosque is an inscription: "The Messiah Jesus Son of Mary is only an apostle of God, and His Word which he conveyed into Mary, and a Spirit proceeding from Him. Believe, therefore in God and his apostles and say not 'Three.' It will be better for you. God is only one God. Far be it from his glory that He should have a son."

Another excellent example of Islamic architecture is the Great Mosque in Damascus, Syria (Fig. 10.53). When the Muslims captured Damascus in 635, they adapted the precinct of a pagan temple, which had meanwhile been converted into a Christian church, into an open-air mosque. Seventy years later, Caliph al-Walid demolished the church and set about building Islam's largest mosque. The only feature of the original buildings left standing was the Roman wall, though the four original towers were metamorphosed into the first minarets, from which the faithful were called to prayer. Unfortunately, the centuries have not been kind to the Great Mosque. Sacked a number of times, it has lost much of the splendor of its lavish decorations. However, some of its grandeur can be seen in the arcaded courtyard, with fine, gold-inlaid detailing visible in the returns of the arches (Fig. 10.53). Inside, colorful mosaics (Figs. 10.54 and 10.55) express great subtlety of detail and texture. These works rank among the most accomplished of mosaics and were probably produced by Byzantine craftsmen.

NATIVE AMERICA

Native American art tends to be portable and functional because the people were primarily nomadic, and practicality demanded that possessions be kept to a minimum and provide maximum utilization. If works of art—objects of beauty—were necessary, then they should fulfill their aesthetic functions *and* some domestic function as well. There were, however, some works of art designed for their own sake—for example, Figure 10.57, an openwork vessel with a design representing a bird. This ceramic object, with cutout areas precluding its use as a container, appears to be

only aesthetic in function. In cultures such as the Plains Indians, Aztecs, and Incas, which were strongly militaristic, artistic expression found its way into ceremonial objects, as well as costumes and weaponry.

The Inca culture came late to South America, beginning around A.D. 1200 and reaching empire status around 1438. When the Spaniards arrived in 1532, the Inca Empire was at its peak, and extended from Argentina and Chile to Ecuador. Characteristic of Inca art is a pottery shape called the *aryballus*, shown in Figure 10.58. Delicate in design, this multicolored ceramic urn features carefully painted small geometric patterns arranged symmetrically. The insect appended to the bowl creates an intriguing focal point and provides a visual counterpoint to the smooth and lustrous surface. The neck of the urn rises in a graceful

10.57 Openwork bird jar, from Ocklockonee Bay, Florida. Redware, with pre-fired "kill" hole in base, height 10½ ins (26.7 cm). National Museum of the American Indian, Smithsonian Institution, Washington, D.C.

10.58 Arybal-shaped Inca vessel, from Bolivar, Ecuador, 10½ x 8¾ ins (26.7 x 22.2 cm). National Museum of the American Indian, Smithsonian Institution, Washington, D.C.

curve and then splays outward into a disclike lip, divided symmetrically by underhung droplets. Aesthetic sensitivity and sophistication can be seen in the treatment of the lip. The asymmetrical handles placed below the centerline of the bowl give it a dynamic force and create additional interest for the viewer.

MEDIEVAL EUROPE

At its broadest, the Middle Ages is the name we have come to use for the 1,000 years from the fall of Rome to the Renaissance in Italy. In monasteries and convents throughout Europe, literacy, learning, and artistic creativity were nurtured. It was widely believed that the year 1000 would see the end of the world.

The later Middle Ages saw a spiritual and intellectual revival. In Christianity, emphasis shifted from the wrath of God to the mercy and sweetness of the loving Savior and the Virgin Mary. The growth of towns and cities accelerated the pace of life, turning the focus of wealth and power away from the feudal countryside, and universities replaced monasteries as centers of learning.

MEDIEVAL MUSICAL STYLE

Chant

By around the year 500, a body of sacred—that is, religious—music called chant, *plainchant*, or *plainsong* had been developed for use in Christian worship services. (The terms, along with Gregorian chant, are commonly used as synonyms,

PROFILE

Hildegard of Bingen

One of the significant musical and literary figures of the time, the German nun Hildegard of Bingen (1098-1179) was educated at the Benedictine cloister of Disibodenberg and became prioress there in 1136. Having experienced visions since she was a child, at age forty-three she consulted her confessor, who reported the matter to the archbishop of Mainz. A theological committee confirmed the authenticity of her visions, and a monk was appointed to help her record them in writing. The finished work, *Scivias* (1141–52), consisted of twenty-six visions, prophetic, symbolic, and apocalyptic in form. About 1147 she left Disibodenberg to found a convent at Rupertsberg, where she continued to prophesy and to record her visions in writing.

She is the first composer whose biography is known. She founded a convent, where her musical plays were performed. She wrote music and texts to her songs, mostly liturgical plainchant honoring saints and the Virgin Mary. She believed that music was the means of recapturing the original joy and beauty of paradise and that music was invented and musical instruments made in order to worship God appropriately. She wrote in the plainchant tradition of a single vocal melodic line that we have just discussed. She wrote seventy-seven chants and the first musical drama in history, which she entitled "The Ritual of the Virtues."

Hildegard of Bingen's music was written for performance by the nuns of the convent she headed. She combined all her music into a cycle called *The Symphony of the Harmony of the Heavenly Revelations*, from which the "Lauds of Saint Ursula" ("O Ecclesia" excerpt, CD track 5) is one example. This music is sung by three sopranos accompanied by an instrumental drone, which serves as a sustained bass above which the voices soar in the chant-like melody. It celebrates St. Ursula, who, according to legend, was martyred with eleven thousand virgins in Cologne.

Hildegard believed that many times a day, humans fall out of sorts and lose their way. Music was the sacred technology that could best redirect human hearts toward heaven. It could integrate mind, heart, and body and heal discord.

Hildegard's numerous other writings include a morality play, a book of saints' lives, two treatises on medicine and natural history, and extensive correspondence, in which are to be found further prophecies and allegorical treatises. Her lyrical poetry, gathered in *The Symphony of the Harmony of the Heavenly Revelations* (*Symphonia armonie celestium revelationum*), consists of seventy-seven poems (all with music), and together they form a liturgical cycle.

although detailed study reveals differences.) Chant was vocal and took the form of a single melodic line (*monophony*) using notes relatively near each other on the musical scale. The haunting, undulating character of early chant possibly points to Near Eastern origins. Chants were sung in a flexible tempo with unmeasured rhythms following the natural accents of normal Latin speech. In one type of chant setting, called *syllabic*, each syllable of the chant was given one note. In another, called *melismatic* (mehl-iz-MAT-ik), each syllable was spread over several notes. The selection "Kyrie: Hodie Christus Resurrexit" (CD track 4) lets us sense the flavor of the undulating and ethereal melody of the melismatic type. Kyrie is one of the five parts of the *mass ordinary*. These sections, sung by the choir, are alternated with the affirmation, "*Hodie Christus Resurrexit*" ("Today Christ is Risen"), sung by a soloist, which gives the piece an ABABA structure.

Plainchant is often called Gregorian chant because Pope Gregory I (540–604) supposedly supervised the selection of melodies and texts he thought most appropriate and compiled them for church services. Although Pope Gregory did not invent plainchant, his contributions of selection and codification were apparently such that the form acquired his name.

Polyphony: Organum

At some time between the eighth and tenth centuries, monks in monastery choirs began to add a second melodic line to the chant. At first the additional line paralleled the original at the interval of a fourth or a fifth. Medieval music that consists of Gregorian chant and an additional melodic line (or lines) is called *organum* (OHR-guh-nuhm). Between the tenth and thirteenth centuries organum became truly *polyphonic*. As time progressed, the independent melodies became more and more independent of each other and differed rhythmically as well as melodically.

ROMANESQUE STYLE IN ARCHITECTURE

At the beginning of the new millennium a new and radical style in architecture emerged. The Romanesque style took hold throughout Europe in a relatively short period. Originally meaning "debased Roman," it takes its name from the Roman-style round arches and columns of its doorways and windows. The term was invented in the early nineteenth century to describe medieval vaulted architecture that preceded the Gothic pointed arch. In addition to arched doorways and windows, characteristic

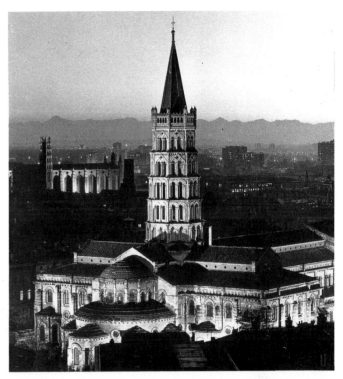

10.59 St.-Sernin, Toulouse, France, c. 1080–1120. (The top part of the tower was added in the 13th century.)

of this style was a massive, static quality—a further reflection of the barricaded mentality and lifestyle generally associated with the Middle Ages.

The Romanesque style none the less exemplified the power and wealth of the Church Militant and Triumphant. If the style mirrored the social and intellectual system that produced it, it also reflected a new religious fervor and a turning of the Church toward its growing flock. Romanesque churches were larger than their predecessors—Figures **10.59** and **10.60** give some impression of their scale. St.-Sernin is an example of southern French Romanesque, and it reflects a heavy elegance and complexity. The plan of the church is a *Roman cross*, and the side aisles extend beyond the crossing to create an ambulatory. Here pilgrims, who were mostly on their way to Spain, could walk around the altar without disturbing the service.

Significantly, the roof of this church is stone, whereas earlier buildings had wooden roofs. As we view the magnificent vaulted interior we wonder how the architect reconciled the conflicting forces of engineering, material, and aesthetics. Given the properties of stone and the increased force of added height, did he try to push his skills to the brink of practicality in order to create an interior of breathtaking scale? Did his efforts reflect the glory of God or the abilities of humankind?

Returning to the exterior view, we can see how some of the stress of the high tunnel vaulting was diffused. In a

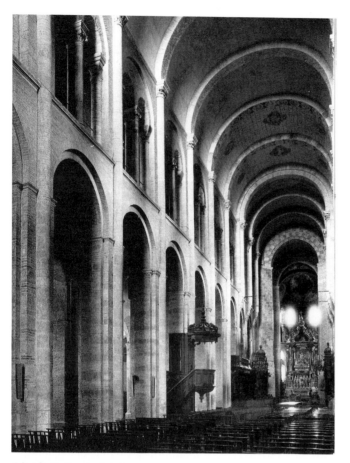

10.60 St.-Sernin, interior.

complex series of vaults, the tremendous weight and outward thrust of the central vault were transferred to the ground, leaving a high and unencumbered central space. If we compare this structural system with that of post-and-lintel and consider the compressive and tensile properties of stone, we can easily see the superiority of the arch as a structural device for creating open space.

ROMANESQUE STYLE IN SCULPTURE

In the case of sculpture, Romanesque refers more to an era than to a style. Examples are so diverse that if most sculptural works were not decorations attached to Romanesque architecture, they probably could not be grouped under a stylistic label. However, some general conclusions about Romanesque sculpture can be drawn. First, it is associated with Romanesque architecture. Second, it is heavy and solid. Third, its medium is usually stone. Fourth, it is monumental. These last two characteristics represent a distinct departure from previous sculptural style. Monumental stone sculpture had all but disappeared in the fifth century. Its reemergence across Europe in such a short time was remarkable, indicating at least a beginning of an outward dissemination of knowledge from the cloistered world of

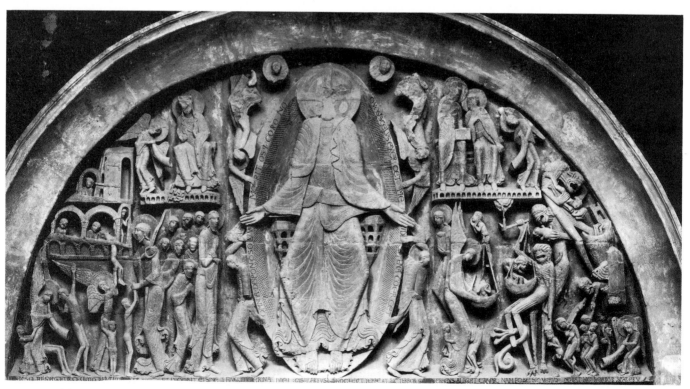

10.61 Gislebertus, Last Judgment tympanum, Autun Cathedral, France, c. 1130–5.

the monastery to the general populace—for it was applied to the exterior of the building, where it could appeal to the lay worshiper. This artistic development almost certainly led to an increase in religious zeal among the laity.

In the Last Judgment tympanum at Autun in France (Fig. **10.61**), the message is quite clear. In the center of the composition, framed by a Roman-style arch, is an awe-inspiring figure of Christ. Beside him are a series of disproportional figures. The inscription of the artist, Gislebertus, tells us that their purpose was "to let this horror appal those bound by earthly sin." Death was still central to medieval thought, and devils share the stage, gleefully pushing the damned into the flaming pit.

MEDIEVAL LITERATURE

St. Benedict (c. 480–c. 550) was one of the few great scholars of the early medieval period. In the early Middle Ages, with the notable exception of the Carolingian court of the late eighth and early ninth centuries, the politically powerful cared little for culture, and for the most part could neither read nor write. Thanks to the efforts of the monastic community, and particularly Benedictine monks, important books and manuscripts were carefully preserved and copied.

Literature flourished in Spain, where Muslim contact with Greek scholarship led to the setting up of schools in Córdoba. Aristotle, Plato, and Euclid were on the curriculum alongside the Koran. Toledo and Seville were also centers of learning. Biblical literature, however, was the central focus of the Middle Ages in Christian Europe.

In addition, there were the poems of the *troubadours, Minnesänger,* and *trouvères* or court poets, who were popular throughout Europe. These professional storytellers produced fantastic legends and romances, such as the *Song of Roland* from France. In the *Song of Roland,* an unknown poet with fine but simple dramatic skills tells the story of a great battle between the emperor Charlemagne (742–814) and the Saracens of Saragossa in Spain, which took place in the year 778. Charlemagne is deceived by the Saracens, draws his main army back into France, and leaves Roland with a rearguard to hold the mountain pass. The Saracens are aided by recreant Christian knights, and after a furious struggle, Roland and his entire army are killed. Our extract describes the battle between Roland's army and the Saracens.

The Song of Roland

King Marsilion comes along a valley
with all his men, the great host he assembled;
twenty divisions, formed and numbered by the King,
helmets ablaze with gems beset in gold,
and those bright shields, those hauberks sewn with brass.
Seven thousand clarions sound the pursuit,
and the great noise resounds across that country.
Said Roland then: "Oliver, Companion, Brother,
that traitor Ganelon has sworn our deaths:
it is treason, it cannot stay hidden,
the Emperor will take his terrible revenge.
We have this battle now, it will be bitter,
no man has ever seen the like of it.
I will fight here with Durendal, this sword,
and you, my companion, with Halteclere—
we've fought with them before, in many lands!
how many battles have we won with these two!
Let no one sing a bad song of our swords." AOI.[8]

When the French see the pagans so numerous,
the fields swarming with them on every side,
they call the names of Oliver, and Roland,
and the Twelve Peers: protect them, be their warranter.
The Archbishop told them how he saw things:
"Barons, my lords, do not think shameful thoughts,
do not, I beg you all in God's name, run.
Let no brave man sing shameful songs of us:
let us all die here fighting: that is far better.
We are promised: we shall soon find our deaths,
after today we won't be living here.
But here's one thing, and I am your witness:
Holy Paradise lies open to you,
you will take seats among the Innocents."
And with these words the Franks are filled with joy,
there is no man who does not shout Munjoie! AOI.

A Saracen was there of Saragossa,
half that city was in this pagan's keeping,
this Climborin, who fled before no man,
who took the word of Ganelon the Count,
kissed in friendship the mouth that spoke that word,
gave him a gift: his helmet and its carbuncle.
Now he will shame, says he, the Land of Fathers,
he will tear off the crown of the Emperor;
sits on the horse that he calls Barbamusche,
swifter than the sparrowhawk, than the swallow;
digs in his spurs, gives that war horse its head,
comes on to strike Engeler of Gascony,
whose shield and fine hauberk cannot save him;
gets the head of his spear into his body,
drives it in deep, gets all the iron through,
throws him back, dead, lance straight out, on the field.

And then he cries: "It's good to kill these swine!
At them, Pagans! At them and break their ranks!"
"God!" say the French, "the loss of that good man!" AOI.

Roland the Count calls out to Oliver:
"Lord, Companion, there is Engeler dead,
we never had a braver man on horse."
The Count replies: "God let me avenge him";
and digs with golden spurs into his horse,
grips—the steel running with blood—Halteclere,
comes on to strike with all his mighty power:
the blow comes flashing down; the pagan falls.
Devils take away the soul of Climborin.
And then he killed Alphaïen the duke,
cut off the head of Escababi,
struck from their horses seven great Arrabites:
they'll be no use for fighting any more!
And Roland said: "My companion is enraged!
Why, he compares with me! he earns his praise!
Fighting like that makes us dearer to Charles";
lifts up his voice and shouts: "Strike! you are warriors!" AOI.

And now again: a pagan, Valdabrun,
the man who raised Marsilion from the font,
lord of four hundred dromonds that sail the sea:
there is no sailor who does not call him lord;
the man who took Jerusalem by treason:
he violated the temple of Solomon,
he killed the Patriarch before the fonts;
took the sworn word of Ganelon the Count,
gave him his sword and a thousand gold coins.
He rides the horse that he calls Gramimund,
swifter by far than the falcon that flies;
digs hard into its flanks with his sharp spurs,
comes on to strike Sansun, our mighty duke:
smashes his shield, bursts the rings of his hauberk,
drives in the streamers of his bright gonfanon,
knocks him down, dead, lance straight out, from the saddle:
"Saracens, strike! Strike and we will beat them."
"God!" say the French, "the loss of that great man!" AOI.

Roland the Count, when he sees Sansun dead—
now, lords, you know the rage, the pain he felt;
digs in his spurs, runs at that man in fury,
grips Durendal, more precious than fine gold,
comes on, brave man, to strike with all his power,
on his helmet, beset with gems in gold,
cuts through the head, the hauberk, the strong body,
the good saddle beset with gems in gold,
into the back, profoundly, of the horse,
and kills them both, praise him or damn him who will.
Say the pagans: "A terrible blow for us!"
Rolan replies: "I cannot love your men,
all the wrong and presumption are on your side." AOI.

An African, come there from Africa,
is Malquidant, the son of King Malcud,
his battle gear studded with beaten gold:
he shines to heaven, aflame among the others
rides the war horse that he calls Salt Perdut—
no beast on earth could ever run with him;
comes on to strike Anseïs, strikes on his shield
straight down, and cut away the red and blue,
burst into shreds the panels of his hauberk,
thrust into him the iron and the shaft.
The Count is dead, his days are at an end.
And the French say: "Lord, you fought well and died!"

Across the field rides Archbishop Turpin.
Tonsured singer of masses! Where is the priest
who drove his body to do such mighty deeds?
said to the pagan: "God send you every plague,
you killed a man it pains my heart to remember";
and sent his good war horse charging ahead,
struck on that pagan shield of Toledo;
and he casts him down, dead, on the green grass.

And now again; a pagan, Grandonie,
son of Capuel, the king of Cappadocia,
he is mounted on the horse he calls Marmorie,
swifter by far than the bird on the wing;
loosens the reins, digs in sharp with his spurs,
comes on to strike with his great strength Gerin,
shatters the dark red shield, drags it from his neck,
and driving bursts the meshes of his hauberk,
thrusts into him the blue length of his banner
and casts him down, dead, upon a high rock;
and goes on, kills Gerer, his dear companion,
and Berenger, and Guion of Saint Antonie;
goes on still, strikes Austorie, a mighty duke
who held Valence and Envers on the Rhône,
knocks him down, dead, puts joy into the pagans.
The French cry out: "Our men are losing strength!"

Count Roland holds his sword running with blood;
he has heard them: men of France losing heart;
filled with such pain, he feels he will break apart;
said to the pagan: "God send you every plague,
the man you killed, I swear, will cost you dear";
his war horse, spurred, runs straining every nerve.
One must pay, they have come face to face.

Grandonie was a great and valiant man,
and very strong, a fighter; and in his path
he came on Roland, had never seen him before;
but knew him now, knew him now, knew him now,
that fury on his face, that lordly body,
that look, and that look, the tremendous sight of him;
does not know how to keep down his panic,
and wants to run, but that will not save him;

the blow comes down, Roland's strength is in it,
splits his helmet through the nosepiece in two,
cuts through the nose, through the mouth, through the teeth,
down through the trunk, the Algerian mail,
the silver bows of that golden saddle,
into the back, profoundly, of the horse;
and killed them both, they never rode again.
The men of Spain cry out their rage and grief.
And the French say: "Our defender has struck!"

The battle is fearful, there is no rest,
and the French strike with all their rage and strength,
cut through their fists and their sides and their spines,
cut through their garments into the living flesh,
the bright blood flows in streams on the green grass.
The pagans cry: "We can't stand up to this!
Land of Fathers, Mahummet's curse on you!
Your men are hard, we never saw such men!"
There is not one who does not cry: "Marsilion!
Come to us, King! Ride! We are in need! Help!"

The battle is fearful, and vast,
the men of France strike hard with burnished lances.
There you would have seen the great pain of warriors,
so many men dead and wounded and bleeding,
one lies face up, face down, on another.
The Saracens cannot endure it longer.
Willing and unwilling they quit the field.
The French pursue, with all their heart and strength. AOI.

Marsilion sees his people's martyrdom.
He commands them: sound his horns and trumpets;
and he rides now with the great host he has gathered.
At their head rides the Saracen Abisme:
no worse criminal rides in that company,
stained with the marks of his crimes and great treasons,
lacking the faith in God, Saint Mary's son.
And he is black, as black as melted pitch,
a man who loves murder and treason more
than all the gold of rich Galicia,
no living man ever saw him play or laugh;
a great fighter, a wild man, mad with pride,
and therefore dear to that criminal king;
holds high his dragon, where all his people gather.
The Archbishop will never love that man,
no sooner saw than wanted to strike him;
considered quietly, said to himself:
"That Saracen—a heretic, I'll wager.
Now let me die if I do not kill him—
I never loved cowards or cowards' ways." AOI.

Turpin the Archbishop begins the battle.
He rides the horse that he took from Grossaille,
who was a king this priest once killed in Denmark.
Now this war horse is quick and spirited,

his hooves high-arched, the quick legs long and flat,
short in the thigh, wide in the rump, long in the flanks,
and the backbone so high, a battle horse!
and that white tail, the yellow mane on him,
the little ears on him, the tawny head!
No beast on earth could ever run with him.
The Archbishop—that valiant man—spurs hard,
he will attack Abisme, he will not falter,
strikes on his shield, a miraculous blow:
a shield of stones, of amethysts, topazes,
esterminals, carbuncles all on fire—
a gift from a devil, in Val Metas,
sent on to him by the Admiral Galafre.
There Turpin strikes, he does not treat it gently—
after that blow, I'd not give one cent for it;
cut through his body, from one side to the other,
and casts him down dead in a barren place.
And the French say: "A fighter, that Archbishop!
Look at him there, saving souls with that crozier!"

Roland the Count calls out to Oliver:
"Lord, Companion, now you have to agree
the Archbishop is a good man on horse,
there's none better on earth or under heaven,
he knows his way with a lance and a spear."
The Count replies: "Right! Let us help him then."
And with these words the Franks began anew,
the blows strike hard, and the fighting is bitter;
there is a painful loss of Christian men.
To have seen them, Roland and Oliver,
these fighting men, striking down with their swords,
the Archbishop with them, striking with his lance!
One can recount the number these three killed:
it is written—in charters, in documents;
the Geste tells it: it was more than four thousand.
Through four assaults all went well with our men;
then comes the fifth, and that one crushes them.
They are all killed, all these warriors of France,
all but sixty, whom the Lord God has spared:
they will die too, but first sell themselves dear. AOI.

Count Roland sees the great loss of his men,
calls on his companion, on Oliver:
"Lord, companion, in God's name, what would you do?
All these good men you see stretched on the ground.
We can mourn for sweet France, fair land of France!
a desert now, stripped of such great vassals.
Oh King, and friend, if only you were here!
Oliver, Brother, how shall we manage it?
What shall we do to get word to the King?"
Said Oliver: "I don't see any way.
I would rather die now than hear us shamed." AOI.[9]

Another major literary accomplishment of the early Middle Ages, one with a completely different subject matter, was the German *Nibelungenlied* ("Song of the People of the Mists," meaning the dead). These early hero-stories of northern peoples, which took their final shape in southeast Germany c. 1200, are a rich mixture of history, magic, and myth.

The favorite Old English epic *Beowulf* (c. 725) is the earliest extant poem in a modern European language. Composed by an unknown author, it falls into separate episodes that incorporate old legends. Its three folk stories center on the hero Beowulf, and his exploits against the monster Grendel, Grendel's mother—a hideous water hag—and a fire-breathing dragon.

From the period of the Middle Ages corresponding to the Gothic style, came the Italian poet Dante (1265–1321), perhaps the greatest poet of the age. The major work of his life was *The Divine Comedy*. Its description of heaven, hell, and purgatory is a vision of the state of souls after death told in an allegory—that is, a dramatic device in which the superficial sense is accompanied by a deeper or more profound meaning. It works on several levels to demonstrate the human need for spiritual illumination and guidance. On a literal level, it describes the author's fears as a sinner and his hopes for eternal life. On deeper levels, it represents the quandaries and character of medieval society faced with, for example, balancing Classicism and Christianity. Here is a sample:

(Circle Two) Canto V

The Carnal

So we went down to the second ledge alone;
 a smaller circle of so much greater pain
 the voice of the damned rose in a bestial moan.

There Minos sits, grinning, grotesque, and hale.
 He examines each lost soul as it arrives
 and delivers his verdict with his coiling tail.

That is to say, when the ill-fated soul
 appears before him it confesses all,
 and that grim sorter of the dark and foul

decides which place in Hell shall be its end,
 then wraps his twitching tail about himself
 one coil for each degree it must descend.[10]

The late Middle Ages was the time of Geoffrey Chaucer, a sample of whose work we read in Chapter 8, and Christine de Pisan (c. 1365–c. 1463), who was a prolific and versatile French poet and author whose diverse writings include numerous poems of courtly love and several works championing women. Her works include *The Book of the City of Ladies* (1405), in which she described women known for their heroism and virtue.

Decameron, by Giovanni Boccaccio (1313–75), uses a frame-tale (see Glossary) in which ten young people flee the plague in Florence in 1348 to sit out the danger in the countryside. To amuse themselves, they tell one hundred stories. The *Decameron* extols the virtue of humankind, proposing that to be noble, one must accept life as one finds it, without bitterness. Above all, one must accept the responsibility for, and consequences of, one's actions.

GOTHIC PAINTING

In the twelfth to the fifteenth centuries, traditional paintings in the form of frescoes and altar panels returned to prominence while manuscript illumination continued. The characteristics of Gothic style in painting include the beginning of three-dimensionality in figure representation and a striving to give figures mobility and life within three-dimensional space. Space is the essence of Gothic style. Gothic painters and illuminators had not mastered perspective, and their compositions do not have the spatial rationality of later works, but if we compare them with their predecessors of the earlier medieval eras, we discover that they have more or less broken free from the static, frozen two-dimensionality of earlier styles. Gothic painting also shows spirituality, lyricism, and a new humanism (mercy, as opposed to the irrevocable judgment of the past). It is less crowded and frantic.

The Gothic style of two-dimensional art found magnificent expression in manuscript illumination. The courts of France and England produced some truly exquisite works. In *David Harping* (Fig. **10.62**) the curious proportions of the face and hands of David, and the awkward linear draping of fabric juxtaposed against the curves of the harp and chair, create a sense of unease and nervous tension. There is almost a carelessness about the layout of the background screen. The upward curving arcs at the top are intended to be symmetrical, but their hand-drawn quality is reinforced by the imprecision of the repetition of diamond shapes. A touch of realism appears in the curved harp string that David is plucking, and rudimentary use of highlight and shadow gives basic three-dimensionality to cloth and skin. While unbalanced in the interior space, the figure, none the less, does not appear to crowd the borders.

GOTHIC ARCHITECTURE: THE CATHEDRAL

Gothic style in architecture took many forms, but is best exemplified in the Gothic cathedral. The cathedral, in its synthesis of intellect, spirituality, and engineering, perfectly expresses the medieval mind. Gothic architectural style developed initially in a very localized way on the Île de France in the late twelfth century and spread outward to the rest of Europe. It had died as a style in some places before it was adopted in others. The "slipping, sliding, and overlapping" circumstances of artistic development were fully applicable to Gothic architecture.

Cathedrals were church buildings whose purpose was the service of God. However, civic pride as well as spirituality inspired their construction. Various local guilds contributed their services in financing or in the actual building work, and guilds were often memorialized in special chapels and stained-glass windows. Gothic cathedrals occupied the central, often elevated, area of the town or city. Their physical centrality and context symbolized the dominance of the universal Church over human affairs, both spiritual and secular. Probably no other style has exercised such an influence across the centuries or played such a central role, even in twentieth-century Christian architecture.

The beginnings of Gothic architecture can be pinpointed between 1137 and 1144 in the rebuilding of the royal Abbey Church of St.-Denis near Paris. There is ample evidence that Gothic was a physical extension of philosophy, rather than a practical response to the structural limitations of the Romanesque style—that is, Gothic theory preceded its application. Abbot Suger, who was advisor to Louis VI and a driving force in the alteration of St.-Denis, held that harmony—the perfect relationship of parts—is the source of beauty, that Light Divine is a mystic revelation of God, and that space is symbolic of God's mystery. The composition of St.-Denis and subsequent Gothic churches expressed that philosophy and, as a result, Gothic architecture is more unified than Romanesque. Both in exterior spires and the pointed arch, Gothic cathedrals use refined, upward-striving line to symbolize humanity's striving to escape from earth into the mystery of space.

The pointed arch is the most easily identifiable characteristic of this style, and it represents not only a symbol of Gothic spirituality but also an engineering practicality. Compared with the round arch, it redistributes the thrust of downward force into more equal and controllable directions. The round arch places tremendous pressure on its *keystone*, which then transfers thrust outward to the sides and requires massive external buttressing, whereas the pointed arch controls thrust into a downward path through its legs. The pointed arch also makes design more flexible. Space encompassed by a round arch is limited to the radius of specific semicircles, whereas dimensions around a pointed arch can be adjusted to whatever practical and aesthetic parameters are desired.

Engineering advances implicit in the new form made possible larger *clerestory* (see Glossary) windows (hence more light) and more slender ribbing (hence a greater emphasis on space as opposed to mass). Outside, practical and aesthetic flying buttresses carry the outward thrust of the vaults through a delicate balance of ribs, vaults, and buttresses gracefully and comfortably to the ground. The importance of stained-glass windows in Gothic cathedrals cannot be overemphasized. Now that the bulky Romanesque walls have been replaced by an emphasis on space and light, the windows take the place of frescoes in telling the story of the gospels and the saints. They carefully control light entering the sanctuary, reinforcing a marvelous sense of mystery.

With the exception of St. Paul's Cathedral in London, Salisbury (Fig. **10.63**) is the only English cathedral whose entire interior structure was built to the design of a single architect and completed without a break, in 1265. However, the cathedral took another fifty-five years to complete, and the famous spire, built between 1285 and 1310, added an additional 404 feet (123 m) to a squat tower which rose only a few feet above the nave. The spire thus became the highest in England and the second highest in Europe. Unfortunately, the piers and foundations were not designed to carry the additional 6,400 tons, and the masons were forced to add a strong stone vault at the crossing of the nave below the tower.

Compared to the soaring vertical cathedrals of France, Salisbury seems long, low, and sprawling. The west front, wider than the nave, functions almost as a screen wall. Its horizontal bands of decoration emphasize the horizontal thrust of the building. The plan of the cathedral (Fig. **10.64**), with its double *transept*, retains features of the Romanesque style. The same emphasis on the horizontal appears in the interior, where the nave wall is made up of a succession of arches and supports (Fig. **10.65**). Typical of Early English Gothic, the nave vaults curve steeply with the ribs extending down to the *triforium* level and thereby tucking the clerestory windows into the vaults. Also characteristic of the Early English style is the use of dark Purbeck marble for the colonnettes and capitals, establishing an almost Romanesque color contrast. The building is free of tracery and the lancet windows are grouped in threes and fives.

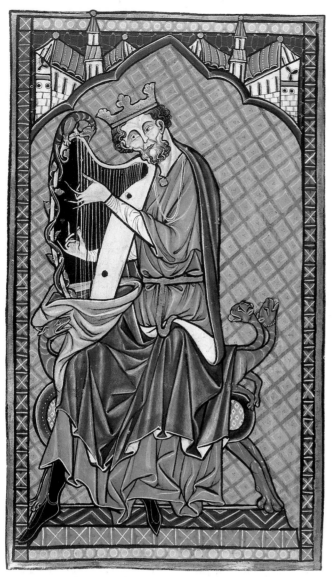

10.62 *David Harping*, from the Oscott Psalter, c. 1270.
7½ x 4¾ ins (20 x 11.1 cm).
British Library, London.

GOTHIC SCULPTURE

Gothic sculpture again reveals the changes in attitude of the period. It portrays serenity and idealization. Like Gothic painting, it has a human quality. The vale of tears, death, and damnation typical of earlier in the Middle Ages are replaced with conceptions of Christ as a benevolent teacher and of God as beautiful. This style has a new order, symmetry, and clarity. Its visual images carry with distinctiveness over a distance. The figures of Gothic sculpture stand away from their backgrounds (Fig. 10.66).

Schools of sculpture developed throughout France, and although individual stone carvers worked alone, their common training gave their works a unified character. Reims, for example, had an almost Classical reputation, while Paris was dogmatic and intellectual (perhaps a reflection of its role as a university city). Spirituality was sacrificed to everyday appeal, and sculpture reflected the increasing influence of secular interests, both middle-class and aristocratic.

Compositional unity changed from Early to Late Gothic. Early architectural sculpture was subordinate to the overall design of the building, but later work lost much of that integration as it gained in emotionalism (Fig. **10.67**).

The sculptures of Chartres Cathedral, which bracket nearly a century, illustrate clearly the transition from Early to Late Gothic. The attenuated figures of Figure **10.66** display a relaxed tranquillity, idealization, and simple realism. Although an integral part of the portal columns, they emerge from them, each statue in its own space. Detail is somewhat formalized and shallow, but we now see the human figure beneath the fabric—in contrast to previous uses of fabrics as mere compositional decoration.

Lifelikeness is even more pronounced in the figures of 100 years later (Fig. **10.67**). Here we can see the characteristics of the High Gothic style. Proportion is more lifelike, and the figures have only the most tenuous connection to the building. Figures are carved in subtle S-curves rather than as rigid perpendicular columns. Fabric drapes are much more naturally depicted, with deeper and softer folds. In contrast to the idealized older saints, these figures have the features of specific individuals expressing qualities of spirituality and determination.

The content of Gothic sculpture is also noteworthy. Like most church art, it was didactic, or designed to teach. Many of its lessons are fairly straightforward and can be appreciated by anyone with a basic knowledge of the Bible. Christ appears as a ruler and judge of the universe above the main doorway of Chartres Cathedral (Fig. **10.68**), with a host of symbols of the apostles and others. Also decorating the portals are sculptures of the prophets and kings of the Old Testament, whose purpose is to proclaim the harmony of secular and spiritual rule by implying that the kings of France are the spiritual descendants of biblical rulers—in much the same sense as we noted in the art of Justinian at Ravenna (see p. 246).

Other lessons of Gothic cathedral sculpture are more hidden. According to some scholars, specific conventions, codes, and sacred mathematics are involved. These factors relate to positioning, grouping, numbers, symmetry, and recognition of subjects. For example, the numbers three, four, and seven (often found in compositions of later periods) symbolize the Trinity, the Gospels, the sacraments, and the deadly sins. The positioning of the figures around Christ shows their relative importance—the place on his right is the most important. These codes and

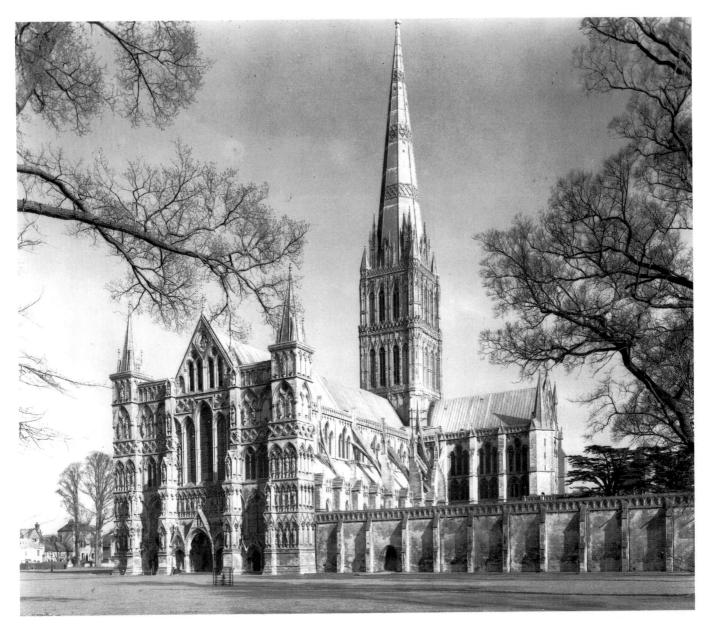

10.63 Salisbury Cathedral, England, from the southwest, begun 1220.

symbols are used on highly complex levels. All of this is consistent with the mysticism of the period, which held to strong beliefs in allegorical and hidden meanings in holy sources.

MEDIEVAL THEATRE

As the Middle Ages progressed, drama was associated with the Church. Earliest church drama was a simple elaboration and illustration of the mass. Later drama included bible stories (mystery plays), lives of the saints (miracle plays), and didactic allegories (morality plays).

Mystery plays take their name from the Latin word meaning "service" or "occupation" rather than from the word for "mystery." The designation probably refers to the

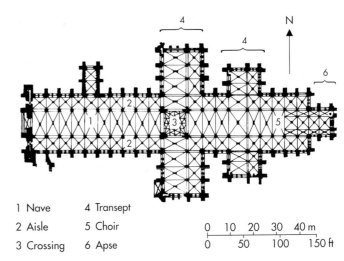

1 Nave 4 Transept
2 Aisle 5 Choir
3 Crossing 6 Apse

10.64 Salisbury Cathedral, plan.

265

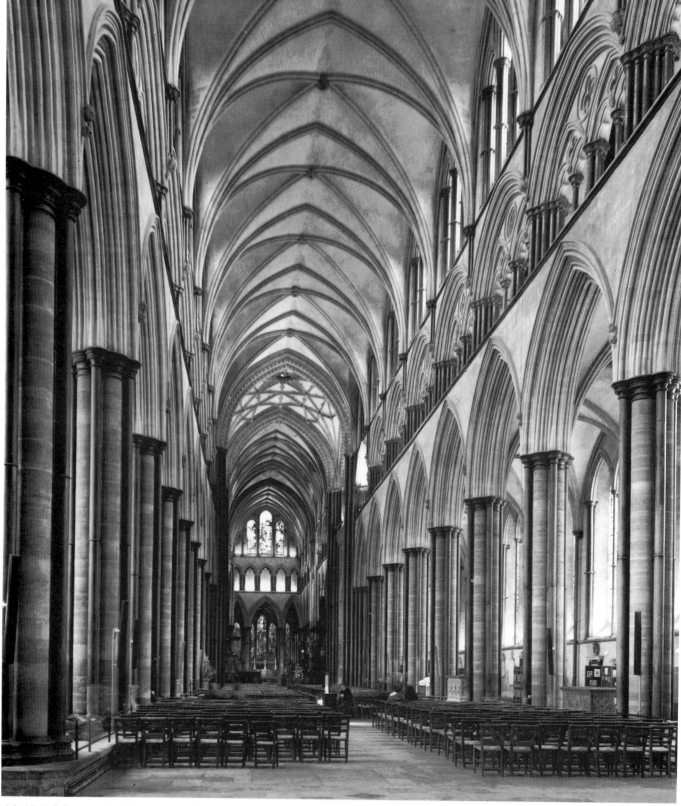

10.65 Salisbury Cathedral, nave and choir.

production of religious plays by the occupational guilds of the Middle Ages rather than the "mysteries" of revelation. Dating from the twelfth century, *The Representation of Adam* is the oldest known French mystery play. There were three parts, each with written dialogue: The Fall of Adam and Eve, the Murder of Abel, and the Prophecies of Christ.

Latin instructions, which indicated scenery, costumes, and even actors' gestures, were written into the play: "Paradise shall be situated in a rather prominent place, and is to be hung all around with draperies and silk curtains."

Miracle plays presented a real or fictitious account of the life, miracles, or martyrdom of a saint. Almost all the

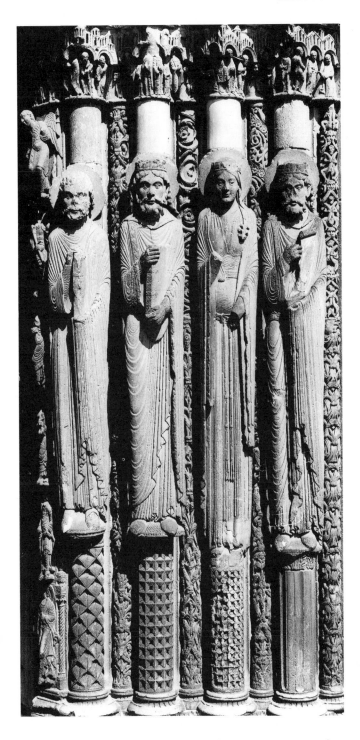

10.66 Chartres Cathedral, France, jamb statues on west portal, c. 1145–70.

10.67 Chartres Cathedral, jamb statues on south portal, c. 1215–20.

surviving miracle plays concern either the Virgin Mary or St. Nicholas, the fourth-century bishop of Myra in Asia Minor, both of whom had active cults during the Middle Ages. The Mary plays consistently involve her coming to the aid of all who invoke her, be they worthy or wanton. The Nicholas plays are similar, usually chronicling the deliverance of a crusader or the conversion of a Saracen king.

Morality plays used allegorical characters such as Sloth, Gluttony, Lust, Pride, and Hatred to communicate their message. The most famous morality play (one which is still performed) is *Everyman*. In its story, Death summons Everyman

267

10.68 Chartres Cathedral, central tympanum of west portal, c. 1145–70.

to his final judgment. Everyman then seeks, as companions on his journey to judgment, the qualities (characters) of Fellowship, Kindred, Cousin, and Goods. Each refuses to join him. He finally asks Good Deeds, but Good Deeds is too weak from neglect to make the journey. Seeking advice from Knowledge, Everyman is told to do penance—an act that revives Good Deeds, who then takes up the journey with Everyman. Along the way, Five Wits also deserts him as he nears the grave. Good Deeds, however, stays with him until the end. So he is welcomed to Heaven.

CHAPTER ELEVEN

ARTISTIC STYLES IN THE EMERGING MODERN WORLD

c. 1400 TO c. 1800

IMPORTANT TERMS

Renaissance The period from approximately 1400 to 1527 that was seen as a rebirth of understanding after the Middle Ages.

High Renaissance The period between 1495 and 1527 encapsulated by the genius of Leonardo da Vinci, Michelangelo, and Raphael.

Word painting A musical technique in which the music attempts to enhance the meaning and emotion of a written text.

Mass The most important rite of the Roman Catholic liturgy. A musical form reflecting the parts of the mass.

Madrigal A musical setting of lyric poetry for four or five voices.

Baroque style A diverse seventeenth-century style in the visual and performing arts generally typified by largeness, ornateness, and emotional appeal.

Program music Music written to illustrate an external idea.

Absolute music Music that presents purely musical ideas.

Rococo style An eighteenth-century style typified by intricacy, grace, charm, and delicacy.

THE RENAISSANCE

The Renaissance was seen by its leading exponents as a rebirth of our understanding of ourselves as social and creative beings. "Out of the sick Gothic night our eyes are opened to the glorious touch of the sun," was how the French humanist and satirist François Rabelais (1483–1553) expressed what most of his educated contemporaries felt. At the center of Renaissance concerns were the visual arts, whose new ways of looking at the world soon had their counterparts in the performing arts as well. For the first time, it seemed possible not merely to emulate the works of the Classical world but to surpass them.

The Reformation challenged institutional Christian faith and its authority. The proposal of a sun-centered universe knocked humankind from its previously assured place at the center of all things. Harmony seemed once more to be an unattainable ideal as Europe was riven by wars and as philosophers cast doubt on the certainties of the Renaissance. The modern age was in the making.

RENAISSANCE PAINTING IN FLORENCE

It was in Italy, and more precisely in Florence, that the Renaissance found its early spark and heart in about 1400. Florence was a wealthy commercial center and, like Athens, leapt into a golden age on a soaring spirit of victory as the city successfully resisted the attempts of the Duke of Milan to subjugate it. The consequent outpouring of art made Florence the focal point of the Early Italian Renaissance.

During the first two decades of the fifteenth century, sculpture reigned as the premier visual art of the time. Painters, for the most part, were kept busy painting altarpieces for Florentine churches—generally in a variation of Gothic style. Unlike sculpture, painting showed little concern for the human spirit or for the stylistic problems that occupied sculptors. But ideas were developing, and came to fruition in the work of Masaccio (Tommaso di Giovanni, 1401–29). The hallmark of Masaccio's invention and development of a "new" style is the way he employs deep space and rational foreshortening or perspective in his figures. In collaboration with the artist Masolino, Masaccio was summoned in 1425 to create a series of frescoes for the Brancacci Chapel of the Church of Santa Maria del Carmine in Florence.

Masaccio, The Tribute Money

The most famous of Masaccio's frescoes in the Brancacci family chapel is *The Tribute Money* (Fig. **11.2**). Its setting makes full use of the new discovery of linear perspective, as the rounded figures move freely in unencumbered deep space. It employs a technique called "continuous narration," unfolding a series of events across a single canvas—here the New Testament story from Matthew (17:24–7).

The figures in this fresco are remarkably accomplished. In the first place, they are dressed in fabric that falls like real cloth. Next, weight and volume are depicted entirely differently from how they were in Gothic painting: Each figure is in Classical *contrapposto* stance. The sense of motion is not particularly remarkable, but the accurate rendering of the feet makes these figures seem to stand on real ground. Masaccio uses light to reveal form and volume. The key is establishing a source for the light that strikes the figures and then rendering the objects in the painting so that all highlights and shadows occur as if caused by that single light source.

Masaccio's figures form a circular and three-dimensional grouping rather than a flat line across the surface of the work as in Botticelli's *La Primavera* (Fig. **11.3**). Even the haloes of the apostles appear in the new perspective and

surfaces with delicate detail. He also conveys a tremendous sense of space in each of the ten panels. In *The Story of Jacob and Esau* (Fig. **11.4**), for example, he uses receding arcades to create depth and perspective. The bold relief of these scenes took Ghiberti twenty-one years to complete.

The greatest masterpieces of fifteenth-century Italian Renaissance sculpture came from the unsurpassed master of the age, Donatello. He had a passion for antiquity, and began his career as an assistant on the Florentine Baptistery doors. His early statues were similar to medieval works in that they were architectural and designed to occupy niches. His magnificent *David* (Fig. **11.1**) was the first freestanding nude since Classical times. Unlike Classical nudes, David is partially clothed. His armor and helmet, along with bony elbows and adolescent character, invest him with a highly individualized nature. Donatello has returned to Classical *contrapposto* stance, but the carefully executed form expresses a new humanity suggesting that the statue is almost capable of movement. The work symbolizes Christ's triumph over Satan. The laurel crown on the helmet and laurel wreath on which the work stands allude to the Medici family, in whose palace the statue was displayed in 1469.

RENAISSANCE LITERATURE

The sixteenth century witnessed the climax and close of what amounted to an Italian monopoly in Renaissance literature. The influence of the Italian Renaissance spread to the rest of Europe, reaching France in the middle third of the century and England in the last third of the century. The common factor everywhere was imitation of the classics. In Italy the writers of the High Renaissance were apparently indifferent to the tragic social and political events to which they bore witness. Most, like Castiglione, chose to ignore what was going on. However, it is reasonably clear that after the Spanish Sack of Rome in 1527, literature, with perhaps the exception of Torquato Tasso, slipped into mediocrity.

Baldassare Castiglione

In essence, the Renaissance state was monarchical. In fact, the whole movement of the Renaissance was toward monarchical government. In Italy, it may have seemed less so than in France and Spain, but it was none the less the case in the petty duchies and principalities, and the gentlemen and ladies of the Renaissance were courtiers. The Conte Baldassare Castiglione (1478–1529) was himself the perfect courtier (Fig. **11.5**), and his book *Il Cortegiano* or *The Courtier* became a universal guide to "goodly

11.4 Lorenzo Ghiberti, *The Story of Jacob and Esau*, panel of the *Gates of Paradise*, Baptistery, Florence, c. 1435. Gilt bronze, 31¼ ins (79 cm) square.

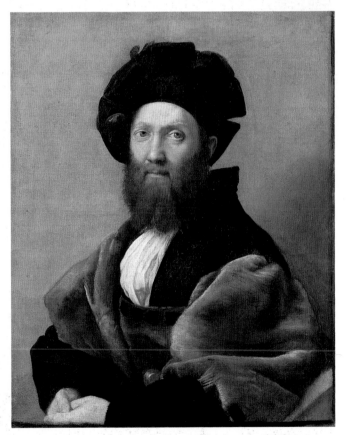

11.5 Raphael, *Count Baldassare Castiglione*, 1514. Oil transferred from wood to canvas, 2 ft 9¾ ins x 2 ft 3½ ins (82 x 66 cm). Louvre, Paris.

manners" and "civil conversation" of the court of the duchy of Urbino. In effect, he was the arbiter of courtly behavior for all of Europe. In this influential work, Castiglione suggests, through an imagined dialogue, a picture of an artistically ordered society, in which cultivated Italians regard social living as a fine art.

Castiglione was raised at the court of Duke Sforza of Milan. He studied Greek, Latin, and Italian poetry, music, painting, and horsemanship. As his portrait reveals, he was a handsome, intelligent man, who entered the service of the duke of Urbino in 1504, thereby entering an environment with a fabulous library that was the rendezvous of European scholars and artists. As a diplomat, he visited England, became an advisor of Pope Leo X, and papal nuncio of Pope Clement VII to the court of the Holy Roman Emperor Charles V. When the Emperor's troops sacked Rome, Castiglione became the subject of numerous rumors of treason.

The particular character of *The Courtier* lies in the realistic manner in which the conversations are handled and the way in which the various opinions of the participants are introduced. Above all, *The Courtier* propounds the humanist's ultimate ideals—of men and women of intellectual refinement, cultural grace, moral stability, spiritual insight, and social consciousness. It provided a model of the ideal Renaissance society, but its values are timeless: true worth is determined "by character and intellect rather than by birth." The excerpt that follows, although brief, illustrates both the context of the time and the content of Castiglione's work.

The Courtier
Baldassare Castiglione
On Women

Leaving aside, therefore, those virtues of the mind which she must have in common with the courtier, such as prudence, magnanimity, continence and many others besides, and also the qualities that are common to all kinds of women, such as goodness and discretion, the ability to take good care, if she is married, of her husband's belongings and house and children, and the virtues belonging to a good mother, I say that the lady who is at Court should properly have, before all else, a certain pleasing affability whereby she will know how to entertain graciously every kind of man with charming and honest conversation, suited to the time and the place and the rank of the person with whom she is talking. And her sense and modest behavior, and the candor that ought to inform all her actions, should be accompanied by a quick and vivacious spirit by which she shows her freedom from boorishness; but with such a virtuous manner that she makes herself thought no less chaste, prudent and benign than she is pleasing, witty and discreet. Thus she must observe a certain difficult mean, composed as it

were of contrasting qualities, and take care not to stray beyond certain fixed limits. Nor in her desire to be thought chaste and virtuous, should she appear withdrawn or run off if she dislikes the company she finds herself in or thinks the conversation improper. For it might easily be thought that she was pretending to be straitlaced simply to hide something she feared others could find out about her; and in any case, unsociable manners are always deplorable.[1]

Ludovico Ariosto

A second major literary figure of the time was Ludovico Ariosto (1474–1533). Ariosto was a courtier of the house of Este at Ferrara, and was in the civil and diplomatic service, as well as court poet. Classically trained, he wrote most of his work in Latin until he was twenty-five years old. His father died when he was twenty-six, and he assumed responsibility for providing for his four brothers and five sisters. He spent fourteen years as confidential secretary to Cardinal d'Este, and during this time he traveled throughout Italy on political missions. In 1518, he entered the service of the cardinal's brother, the duke of Ferrara, eventually becoming the duke's director of entertainment. Under Ariosto's supervision, the court enjoyed pageants and dramatic productions, Ariosto himself designing the theatre and scenery and writing a number of the plays. As early as 1505 he began his masterpiece, *Orlando Furioso*, forty cantos (sections) of which were published in 1516. For nearly thirty years he continued to revise the work, which became one of the most influential poems of the Renaissance. *Orlando Furioso* ("Roland in a Mad Fury") is a romantic epic—its forty-six cantos total over 1200 pages—of "Loves and Ladies, Knights and Arms … Of Curtesies, and many a Daring Feat." Ariosto depended heavily on the Greco-Roman tradition of Homer and Virgil, and borrowed incidents, character types, and rhetorical devices, such as the catalogue of troops and extended simile. Designed for a sophisticated audience, it employs an ottava rima (a stanza of eight lines rhyming abababcc), and it has a polished, graceful style. It became a bestseller throughout Europe.

Orlando Furioso captivated its sixteenth-century readers with its elements of supernatural trips to the moon, allegorical incidents that taught modesty and chastity, and romantic adventure. However, the characters are shallow and two-dimensional, for Ariosto made no attempt to probe the depths of human behavior or to tackle important issues. None the less, individual incidents are worked out with care and carried through to a climax, after which the next is taken up, and all the loose threads are tied together

11.6 (*opposite*) Filippo Brunelleschi, Florence Cathedral, dome, 1420–36.

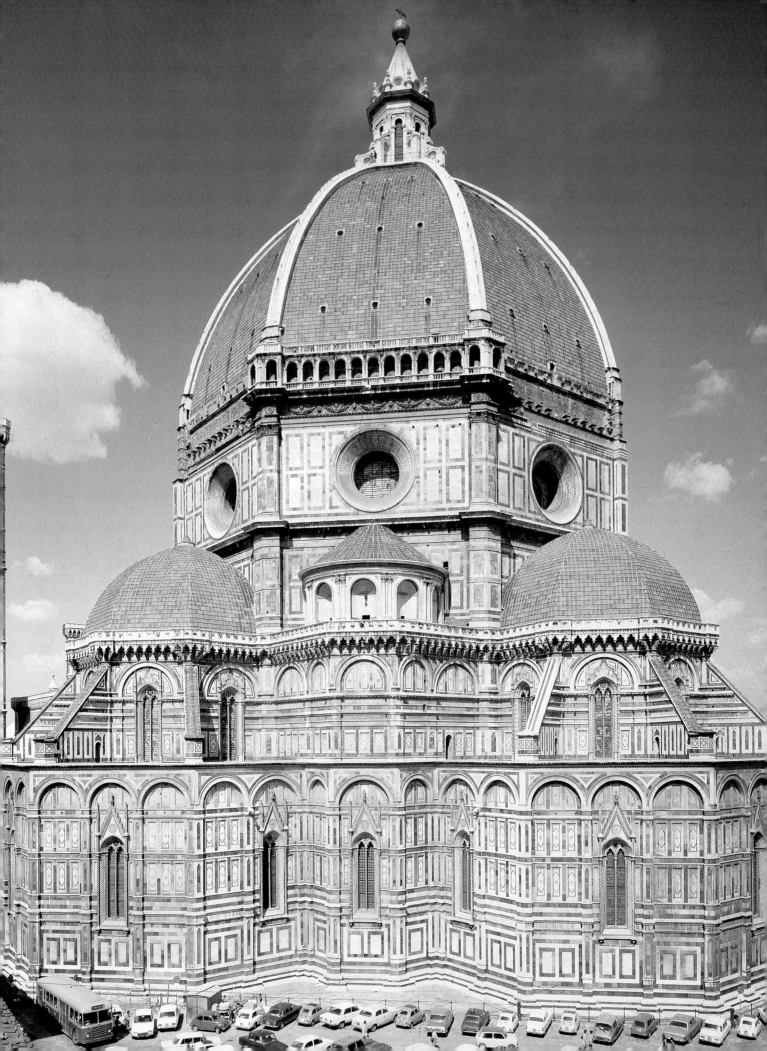

at the end. *Orlando Furioso* served the Renaissance as a model of the large-scale narrative poem that was written with technical skill, smoothness, and the gracefulness typical of the classics. Ariosto spent most of his adult life writing and revising this masterpiece.

RENAISSANCE ARCHITECTURE

Early Renaissance architecture was centered in Florence and departed from medieval architecture in three significant ways. First was its concern with the revival of Classical models along technical lines. Ruins of Roman buildings were measured carefully and their proportions became those of Renaissance buildings. Rather than seeing Roman arches as limiting factors, Renaissance architects saw them as geometric devices by which a formally derived design could be composed. The second departure from the medieval was the application of decorative detail—non-structural ornamentation—to the façade of the building. Third, and a manifestation of the second difference, was a radical change in the outer expression of structure. The outward form of a building was previously closely related to the structural support of the building—for example, post-and-lintel, masonry, and the arch. In the Renaissance, these supporting elements were hidden from view and the external appearance was no longer sacrificed to structural concerns.

Early architecture of the period, such as the dome of Florence Cathedral (Fig. **11.6**), was an imitation of Classical form appended to medieval structures. This curious design by Filippo Brunelleschi (1377–1446) was added to a fourteenth-century building in the fifteenth century. The soaring dome rises 180 feet (55 m) into the air, and its height is apparent from both outside and within.

Compared with the Pantheon (Figs. **10.35** and **10.36**), Brunelleschi's departure from traditional practice becomes clear. The dome of the Pantheon is impressive only from the inside of the building, because its exterior supporting structure is so massive that it clutters the visual experience. On the exterior of Brunelleschi's dome, though, the supporting elements such as stone and timber girdles and lightweight ribbings are hidden. The result is an aesthetic statement where visual appearance rivals structural considerations.

Classical ornamentation can also be seen in Brunelleschi's Pazzi Chapel (Fig. **11.7**). Small in scale, it uses its walls to serve as a plain background for surface decoration. Concern for proportion and geometric design is clear, but the overall composition is not a slave to pure arithmetical considerations. Rather, the Pazzi Chapel reflects Brunelleschi's sense of Classical aesthetics. Brunelleschi's influence was profound in the first half of the fifteenth century, and he served as a model and inspiration for later Renaissance architects.

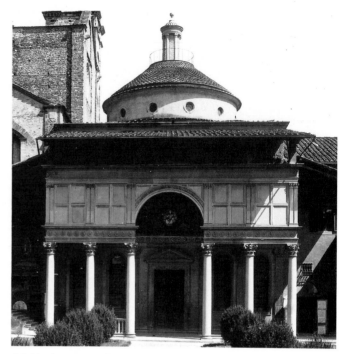

11.7 Filippo Brunelleschi, Pazzi Chapel, Santa Croce, Florence, c. 1440–61.

THE HIGH RENAISSANCE IN ROME

As important and revolutionary as the fifteenth century was in Italy, the high point of the Renaissance came in the early sixteenth century. Its importance as the apex of Renaissance art has led scholars to call this period in the visual arts the High Renaissance. Painters of the High Renaissance included giants of Western visual art: Leonardo da Vinci, Michelangelo, Raphael, Giorgione, and Titian. A concept of particular importance to our overview of visual art in the High Renaissance style is the concept of genius. It was implicit in humanistic exploration of the individual's earthly potential and fulfillment. In Italy between 1495 and 1520 everything in visual art was subordinate to the overwhelming genius of two men, Leonardo da Vinci and Michelangelo Buonarroti. Their impact has led many to debate whether the High Renaissance of visual art was a culmination of earlier Renaissance style or a new departure.

By 1500 the courts of the Italian princes had become important sources of patronage and cultural activity. In pursuit of their world of beauty, the Italian nobility needed artists, writers, and musicians. The arts of the Early Renaissance now seemed vulgar and naive. A more aristocratic, elegant, dignified, and exalted art was demanded. This new style was lofty.

The reestablishment of papal authority, the wealth of the popes, and their desire to rebuild and transform Rome on a grand scale also contributed significantly to the shift in style

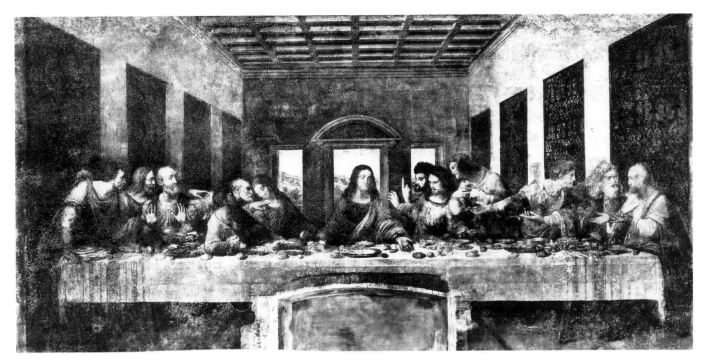

11.8 Leonardo da Vinci, *The Last Supper*, Santa Maria delle Grazie, Milan, c. 1495–8.

and the emergence of Rome as the center of High Renaissance patronage. Music came of age as a major art, finding a great patron in Pope Leo X. There was a revival of ancient Roman sculptural and architectural style. Important discoveries of ancient sculptures such as the *Apollo Belvedere* and the *Laocoön* (Fig. 10.12) were made. Because the artists of the High Renaissance had such a rich immediate inheritance of art and literature from the Early Renaissance and felt they had developed even further, they considered themselves on an equal footing with the artists of the antique period. Their approach to the antique in arts and letters was therefore different from that of their Early Renaissance predecessors.

High Renaissance painting sought a universal ideal achieved through impressive art, as opposed to overemphasis on anatomy or tricks of perspective. Figures became types again, rather than individuals—godlike human beings in the Greek Classical tradition. Artists and writers of the High Renaissance sought to capture the essence of Classical art and literature without resorting to copying, which would have captured only the externals. They tried to emulate, and not to imitate. As a result, High Renaissance art idealizes all forms and delights in composition. It is stable without being static, varied without confusion, and clearly defined without dullness.

High Renaissance artists carefully observed how the ancients borrowed motifs from nature, and they then set out to develop a system of mathematically defined proportion and compositional beauty. Such faith in harmonious proportions reflected a belief among artists, writers, and composers that a harmonious universe and nature possessed perfect order. High Renaissance style departed from previous styles in its meticulously arranged composition, based almost exclusively on geometric devices, such as a central triangle or an oval. Composition was closed—line, color, and form kept the viewer's eye continually redirected into the work, as opposed to leading off the canvas.

Leonardo da Vinci

The work of Leonardo da Vinci (1452–1519) contains an ethereal quality which he achieved by blending light and shadow (called *sfumato*—literally, "smoked," from the Italian). His figures hover between reality and illusion as one form disappears into another, and only highlighted portions emerge. It is difficult to say which of Leonardo's paintings is the most popular or admired, but certainly *The Last Supper* (Fig. 11.8) ranks among the greatest. It captures the drama of Christ's prophecy, "One of you shall betray me," at the moment when the apostles are responding with disbelief. Leonardo's choice of medium proved most unfortunate because his mixture of oil, varnish, and pigments (as opposed to fresco) was not suited to the damp wall. The painting began to flake and was reported to be perishing as early as 1517. Since then it has been clouded by retouching, defaced by a door cut through the wall at Christ's feet, and bombed during World War II. Miraculously, it survives.

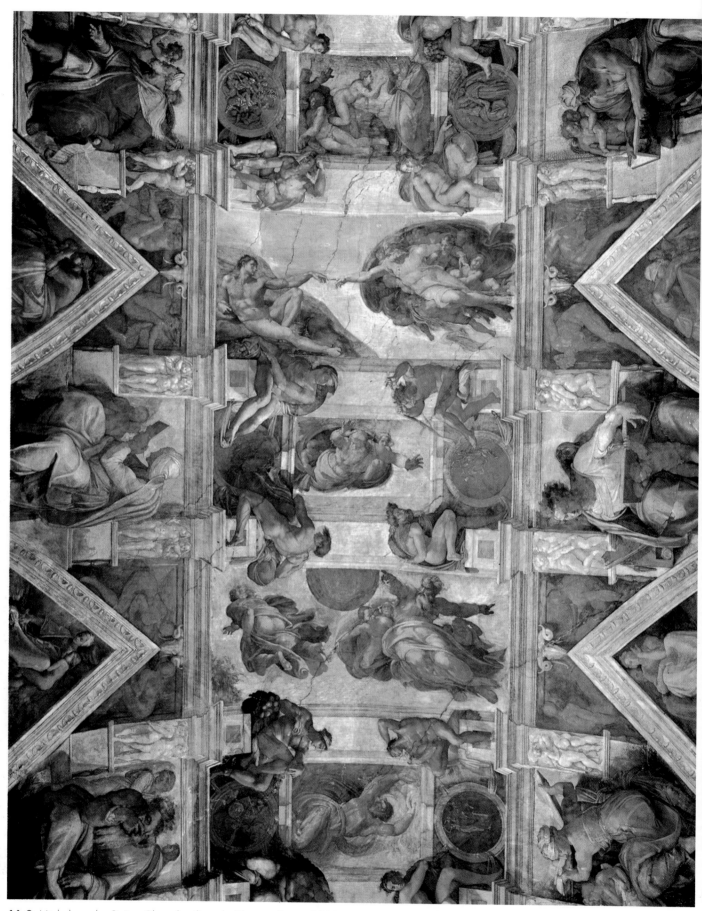

11.9 Michelangelo, Sistine Chapel ceiling, the Vatican, Rome, 1508–12.

In *The Last Supper*, human figures and not architecture are the focus. The figure of Christ dominates the center of the painting, forming a stable yet active central triangle. All line, actual and implied, leads outward from his face, pauses at various subordinate focal areas, is directed back into the work, and returns to the central figure. Various postures, hand positions, and groupings of the disciples direct the eye from point to point. Figures emerge from the gloomy architectural background in strongly accented relief; nothing anchors them to the floor of the room where they sit. This typically geometric composition is amazing in that so much drama can be expressed within such a mathematical format. Yet, despite the drama, the mood in this work and others is calm, belying the conflict of Leonardo's own life and times.

Michelangelo

Perhaps the most dominant figure of the High Renaissance was Michelangelo Buonarroti (1475–1564). While Leonardo was a skeptic, Michelangelo was a man of great faith. Leonardo was fascinated by science and natural objects; Michelangelo showed little interest in anything other than the human form.

Michelangelo's Sistine Chapel ceiling (Fig. **11.9**) is a shining example of the ambition and genius of this era and its philosophies. Some scholars see in this monumental work a blending of Christian tradition and a *Neoplatonist* view of the soul's progressive ascent through contemplation and desire. In each of the triangles along the sides of

the chapel the ancestors of Christ await the Redeemer. Between them, amidst painted pillars, are the sages of antiquity. In the corners Michelangelo depicts various biblical stories, and across the center of the ceiling he unfolds the episodes of the first book of the Bible, Genesis. The center of the ceiling captures the Creation of Adam (Fig. **11.10**) at the moment of fulfillment, and does so in sculpturesque human form and beautifully modeled anatomical detail. God, in human form, stretches outward from his matrix of angels to a reclining but dynamic Adam, awaiting the divine infusion, the spark of the soul. The figures do not touch, and we are left with a supreme feeling of anticipation of what we imagine will be the power and electricity of God's physical contact with mortal man.

The Sistine Chapel ceiling creates a visual display of awesome proportions. It is not possible to get a comprehensive view of the entire ceiling standing at any point in the Chapel. If we look upward and read the scenes back toward the altar, the prophets and sibyls appear on their sides. If we view one side as upright, then the other appears upside down. These opposing directions are held together by the structure of simulated architecture, whose transverse arches and diagonal bands separate vault compartments. Twenty nudes appear at intersections and harmonize the composition because they can be read either with the prophets and sibyls below them or with the Genesis scenes, at whose corners they appear. We thus see the basic High Renaissance principle of composition created by the interaction of the component elements.

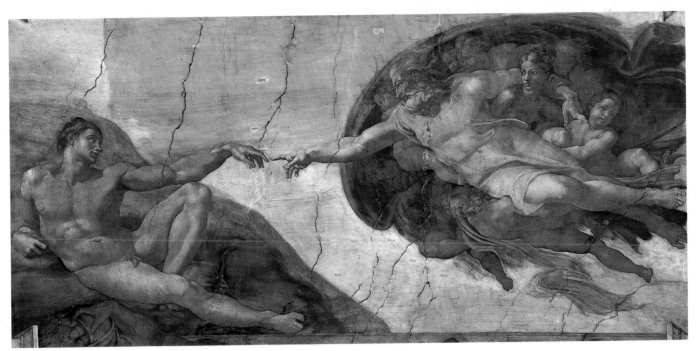

11.10 Michelangelo, *The Creation of Adam*, Sistine Chapel ceiling (detail).

Michelangelo believed that the image from the artist's hand must spring from the idea in his or her mind. The idea is the reality, and it is revealed by the genius of the artist. The artist does not create the ideas, but finds them in the natural world, which reflects the absolute idea: beauty. So, to the Neoplatonist, imitation of nature in art reveals hidden truths within nature.

Michelangelo broke with earlier Renaissance artists in his insistence that measurement was subordinate to judgment. He believed that measurement and proportion should be kept "in the eyes," and so established a rationale for the release of genius to do what it would, free from any preestablished "rules." This enabled him to produce works such as *David* (Fig. **2.19**), a colossal figure and the earliest monumental sculpture of the High Renaissance.

Papal Splendor: The Vatican

Here for almost 2,000 years has been the center of a spiritual communion; in countries all over the world, Christians aspire to achieve a community of spirit with the successor to St. Peter. By comprehending this significance of the Vatican, one can also understand what it was that led Roman Catholicism to embellish the center of its spiritual power with the diversity of human knowledge, including the arts.[2]

Rome was the city of the arts in the fifteenth and sixteenth centuries. The Renaissance—and particularly the High Renaissance, when the papacy called all great artists to Rome—contributed most of the splendor of Vatican art and architecture. The papacy as a force and the Vatican as the symbol of that force represent a synthesis of Renaissance ideas and reflections. St. Peter's and the Vatican have earthly and heavenly qualities which reflect the reality of the Church on earth and the mystery of the spiritual church of Christ (Fig. **11.11**).

Plans for replacement of the original basilica of Old St. Peter's were made by Nicholas V (reigned 1447–55) in the fifteenth century, but it was Pope Julius II (reigned 1503–13) who decided to put them into effect. Julius commissioned Donato Bramante (1444–1514) to construct the new basilica. Bramante's design called for a building in the form of a Greek cross (Fig. **11.12**). The work was planned as "an harmonious arrangement of architectural forms" in an "image of bright amplitude and picturesque liveliness." But Bramante died before his plans were carried out, and was succeeded by two of his assistants and Raphael (1483–1520). Changes were made, partly because the designs were then severely criticized by Michelangelo.

Eventually Pope Paul III (reigned 1534–49) convinced Michelangelo to become chief architect. Michelangelo set aside liturgical considerations and returned to Bramante's original conception, which he described as "clear and pure, full of light . . . whoever distances himself from Bramante, also distances himself from the truth" (Fig. **11.13**). Michelangelo's project was completed in May of 1590 as the last stone was added to the dome and a High Mass was celebrated. Work on thirty-six columns continued, however, and was completed by Giacomo della Porta (c. 1522/3–1602) and Domenico Fontana (1543–1607) after Michelangelo's death. Full completion of the basilica as it stands today was under the direction of yet more architects, including Carlo Maderno (1556–1629). He was forced to yield to the wishes of the cardinals and change the original form of the Greek cross to a Latin cross (Fig. **11.14**). As a result, the Renaissance design of Michelangelo and Bramante, with its central altar, was rejected. It was replaced by Maderno's design, including a *travertine* façade of gigantic proportions and sober elegance. His extension of the basilica was influential in the development of Baroque architecture. The project was completed in 1614, over 150 years after the first plans were laid.

FLANDERS

In the north of Europe lies a small area known as the Low Countries where, in the fifteenth century, Flemish painters and musicians forged new approaches amid a dominant culture of Late Gothic architecture and sculpture. Here in Flanders they formed a link with their contemporaries in northern Italy—the heart of the Early Renaissance in art; they were to influence European painters and musicians for the next century. Many scholars believe that early-fifteenth-century Flemish arts remained part of the Late Gothic style, despite the contact with Italy, and despite Italian admiration of Flemish painting.

Flemish painting of this period was revolutionary. Whereas painters of the Gothic style essentially retained a certain childish or fairy-tale quality, a two-dimensional feeling, and little continuity in their perspective, Flemish painters achieved pictorial reality and rational perspective. The sense of completeness and continuity marks a new and clearly different style. Line, form, and color are painstakingly controlled to compose subtle, varied, three-dimensional, clear, and logically unified statements.

Part of the drastic change in Flemish painting stemmed from a new development in painting media—oil paint.

11.11 Michelangelo, St. Peter's, Rome, from the west, 1546–64 (dome completed by Giacomo della Porta, 1590).

→ N

0 100 ft
0 30 m

11.12 Bramante's design for St. Peter's, 1506.

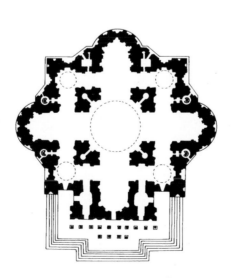

11.13 Michelangelo's design for St. Peter's, 1547.

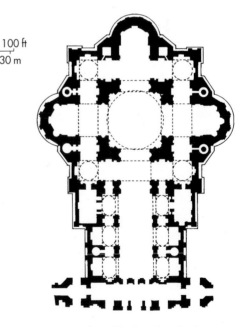

11.14 Plan of St. Peter's as built to Michelangelo's design, with alterations by Carlo Maderno, 1606–15.

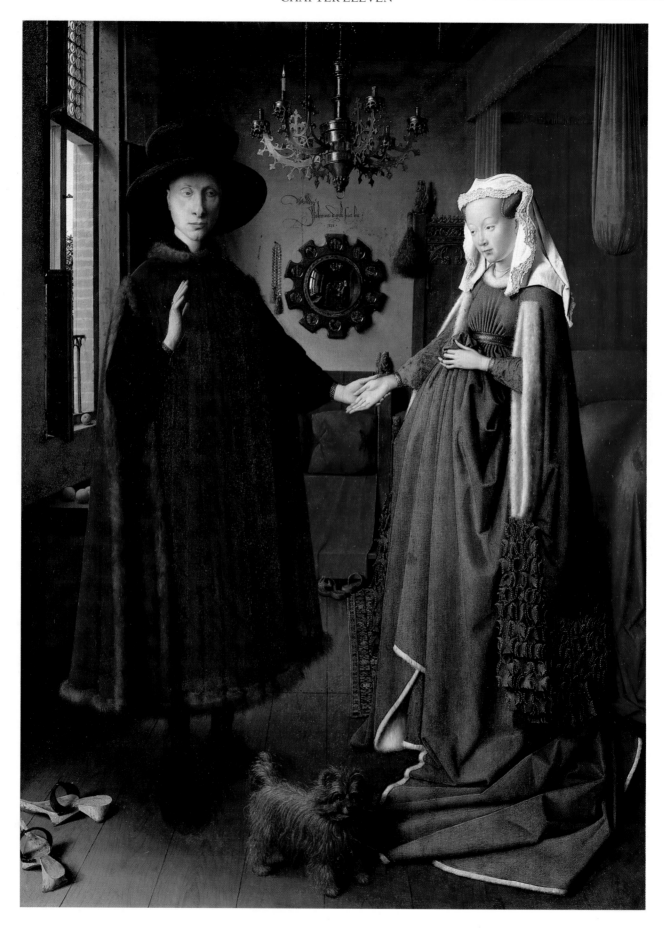

Oil's versatile characteristics gave Flemish painters new opportunities to vary surface texture and brilliance, and to create far greater subtlety of form. Oil paint allowed blending of color areas, because it could be worked wet on the canvas, whereas egg tempera, the previous painting medium, dried almost immediately upon application. Gradual transitions between color areas made possible by oils allowed fifteenth-century Flemish painters to use *atmospheric perspective*—the increasingly hazy appearance of objects furthest from the viewer—and control this most effective indicator of deep space better than had previously been possible. Blending between color areas also enhanced chiaroscuro, by which all objects assume three-dimensionality, for without highlight and shadow the illusion of depth is lost. Early-fifteenth-century Flemish painters explored light and shade not only to heighten three-dimensionality of form but also to achieve rational unity in their compositions, for example, by having consistent light sources and natural shadows on surrounding objects. This new unity and realistic three-dimensionality separated the fifteenth-century Flemish style from Gothic art and tied it to the Renaissance.

The Arnolfini Marriage, or *Giovanni Arnolfini and His Bride* (Fig. **11.15**), by Jan van Eyck (c. 1390–1441) illustrates the qualities of Flemish painting and also stimulates a marvelous range of aesthetic responses. Van Eyck used the full range of values from darkest darks to lightest lights and blended them with extreme subtlety to achieve a soft and realistic appearance. His colors are rich, varied, and predominantly warm in feeling. All forms achieve three-dimensionality through subtle color blending and softened shadow edges. Natural highlights and shadows emanate from obvious sources, such as the windows, and tie the figures and objects together.

The painting depicts a young couple taking a marriage vow in the sanctity of the bridal chamber, and the painting is thus both a portrait and a marriage certificate. The artist has signed the painting in legal script above the mirror

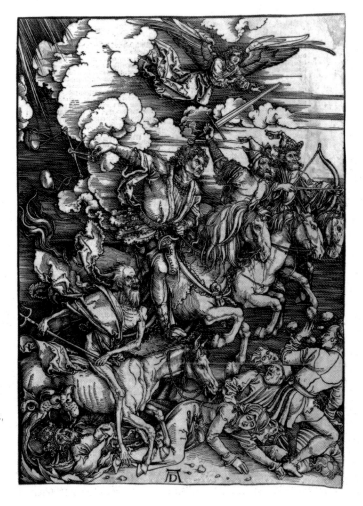

11.15 (*opposite*) Jan van Eyck, *The Arnolfini Marriage* (*Giovanni Arnolfini and His Bride*), 1434. Oil on panel, 33 x 22½ ins (84 x 57 cm). National Gallery, London.

11.16 Albrecht Dürer, *The Four Horsemen of the Apocalypse*, c. 1497–8. Woodcut, 15⅖ x 11 ins (39.2 x 27.9 cm). Museum of Fine Arts, Boston (Bequest of Francis Bullard).

"Johannes de Eyck fuit hic. 1434" (Jan van Eyck was here. 1434). In fact, we can see the artist and another witness reflected in the mirror.

GERMANY

As early as the late Middle Ages, southern Germany was positioned at the center of a thriving trade axis that connected the Netherlands with Italy. Throughout Europe, much of the wealth created in centers such as the Netherlands and Germany was used for the encouragement of arts and letters. By the late fifteenth century important artists such as Albrecht Dürer were following the trade routes back and forth to Italy, and helping to bring the Renaissance to northern Europe.

Albrecht Dürer (1471–1528), was, like Leonardo da Vinci, a transitional figure and, at the same time, innovator. Dürer shared Leonardo's deep curiosity about the natural world, a curiosity that is expressed especially in his drawings, which explore human figure and physiognomy, animals, plants, and landscapes. Unlike Leonardo, Dürer worked principally as an engraver and was tortured by religious problems during this time of the Protestant Reformation. We can see Dürer's skill as a printmaker and his remarkable artistic and religious insight in the woodcut *The Four Horsemen of the Apocalypse* (Fig. 11.16) (see also Fig. 1.4). Here are present the tensions evident in northern Europe at the end of the fifteenth century. The emotions of *The Four Horsemen of the Apocalypse* exhibit a medieval preoccupation with superstition, famine, fear, and death that typify German art of this period and place Dürer at a pivot point between medieval and Renaissance styles. This woodcut is the fourth work in a series, and this print presents a frightening vision of doomsday and the omens leading up to it, as described in the Revelation of St. John, the last book of the Bible. In the foreground, Death tramples a bishop, and working toward the background, Famine swings a scales, War brandishes a sword, and Pestilence draws a bow. Underneath, trampled by the horses' hoofs, lies the human race. The crowding and angularity of shapes are reminiscent of late Gothic style, and yet the perspective foreshortening and three-dimensionality of figures reflect the influence of the Italian Renaissance. We can read human character and emotion in the faces of the figures, which humanize them and give them a sense of reality and a proximity to life that adds depth to the meaning of the work. The technique of the woodcut gives the work its particular quality, and Dürer creates lines of tremendous delicacy, which combine into a poignantly complex picture.

LATE RENAISSANCE THEATRE IN ENGLAND

While Late Renaissance Italy prepared the way for our modern theatre building and certain acting techniques, sixteenth-century England produced a new theatre of convention, and history's foremost playwright.

We must always be careful when we try to draw conclusions about why the arts developed as they did within a particular historical context. While Italy and France saw the arts prosper under varying forms of extravagant patronage, England saw a theatre of great literary consequence prosper under a monarch who loved the theatre only as long as it did not impose upon her financially. Elizabeth I encouraged the arts not by patronage of the kind provided by the Medici or the Church but, rather, by benign neglect.

England's drama in the mid- to late sixteenth century was national in character, influenced by the severance of Church and state under Henry VIII. Nevertheless, there were also strong Italian literary influences and the theatre reflected them.

The Elizabethans loved drama, and the theatres of London saw prince and commoner together among their audiences. They sought and found—usually in the same play—action, spectacle, comedy, character, and intellectual stimulation so deeply reflective of the human condition that Elizabethan plays have found universal appeal through the centuries since their first production.

Shakespeare

Shakespeare (1564–1616) was the preeminent Elizabethan playwright. His sensitivity to and appreciation of the Italian Renaissance can be seen in the settings of many of his plays. In true Renaissance expansiveness, Shakespeare took his audiences back into history, both British and Classical, and far beyond, to the fantasy world of Caliban in *The Tempest*. We gain perspective on the Renaissance world's self-perception when we compare the placid, composed reflections of Italian painting with Shakespeare's tragic portraits of intrigue in Renaissance Italy.

Like most playwrights of his age, Shakespeare wrote for a specific professional company (of which he became partial owner). The need for new plays to keep the company alive from season to season provided much of the impetus for his prolific writing. There is a robust, peculiarly Elizabethan quality in Shakespeare's plays. His ideas have

11.17 The second Globe Theatre, as reconstructed, c. 1614.

universal appeal because of his understanding of human motivation and character and his ability to probe deeply into emotion. He provided insights that are the equivalent of Rembrandt's visual probings. Shakespeare's plays reflect life and love, action and nationalism; and they present those qualities robustly, in magnificent poetry that explores the English language in unrivaled fashion. Shakespeare's use of tone, color, and complex or new word meanings gives his plays a musical as well as dramatic quality which appeals to every generation.

More is known about the theatres that Shakespeare played in than about his life, but that information is far from complete. They may have looked like the reconstruction in Figure **11.17**.

Shakespeare's plays fall into three distinct genres: comedies, tragedies, and histories. His history plays are large-scale dramatizations and glorifications of events that took place between 1200 and 1550. His greatest tragedy is *Hamlet* (first performed in 1601 and published in 1603). The Hamlet story was a widespread legend in northern Europe.

Marlowe

Shakespeare was not the only significant playwright of the English Renaissance stage. The plays of Christopher Marlowe (1564–93) and Ben Jonson (1573–1637) still captivate theatre audiences. Marlowe's love of sound permeates his works, and if his character development is weak, his heroic grandeur has the Classical qualities of Aeschylus and Sophocles (see p. 221). His most famous play is *Doctor Faustus* (*The Tragical History of the Life and Death of Doctor Faustus*), first published in 1604. The story resembles the plot of a medieval morality play, using richly poetic language to narrate a man's temptation, fall, and damnation. His language was a breakthrough in drama of the time. His flexible use of blank verse and the brilliance of his imagery combine to stimulate emotion and rivet his audience's attention. The imagery of terror in the final scene is among the most powerful in all drama. In addition, Marlowe's language and imagery unify the play: The patterns in Faust's references to heaven subtly imply the force he cannot escape and yet which he must, at the beginning, deny. "He cannot escape from a world order and from responsibility, nor can he escape from a dream of unfettered domination. That is his tragedy."[3]

MASTERWORK

Shakespeare — *Hamlet*

Hamlet, Shakespeare's most famous play, was first performed in 1601 and published in 1603. Shakespeare's source for the play may have been Belleforest's *Histoires Tragiques* (1559). Shakespeare's play may also have used as a source a lost play supposedly by Thomas Kyd, usually referred to as the *Ur-Hamlet*. *Hamlet*, however, has its own unique central element in Hamlet's tragic flaw, his hesitation to avenge his father's murder.

At the beginning of the play, Hamlet mourns the death of his father, who has been murdered, and also laments his mother's marriage to his uncle Claudius within a month of his father's death. Hamlet's father's ghost appears to Hamlet, telling him that he was poisoned by Claudius and asking him to avenge his death. Hamlet hesitates, requiring further evidence of foul play. His uncertainty and hesitancy make him increasingly moody, and everyone believes that Hamlet is going mad. The pompous old courtier Polonius believes Hamlet is lovesick over his daughter Ophelia.

Despite Claudius' apparent guilt, Hamlet still cannot act. Nevertheless, he terrorizes his mother and kills the eavesdropping Polonius. Fearing for his life, Claudius sends Hamlet to England with his friends Rosencrantz and Guildenstern, who have orders to have Hamlet killed. Discovering the orders, Hamlet arranges to have his friends killed instead. Returning to Denmark, Hamlet learns that Ophelia has killed herself, and her brother Laertes has vowed vengeance on Hamlet for Polonius' death. Claudius happily arranges the duel. Both Hamlet and Laertes are struck by the sword that Claudius has had dipped in poison. Gertrude mistakenly drinks from the cup of poison intended for Hamlet. Before Hamlet dies, he fatally stabs Claudius.

In the play, Shakespeare appears to suggest that traditional beliefs about revenge are over-simplified, arguing that revenge does not solve evil if evil lies in a complex situation: "The time is out of joint; O cursed spite/That ever I was born to set it right" (V.i.189–90). He also seems to maintain that revenge itself is morally wrong. In *Hamlet*, as well as the other tragedies (*Othello, King Lear,* and *Macbeth*), Shakespeare explores with great psychological subtlety how the personality flaws in the protagonist lead almost inevitably to his own destruction and the destruction of those around him.

<div align="center">

Hamlet
William Shakespeare
Act 3, Sc. 1
</div>

Hamlet:
> To be, or not to be: that is the question:
> Whether 'tis nobler in the mind to suffer
> The slings and arrows of outrageous fortune,
> Or to take arms against a sea of troubles,
> And by opposing end them? To die: to sleep:
> No more; and by a sleep to say we end
> The heartache and the thousand natural shocks
> That flesh is heir to,—'tis a consummation
> Devoutly to be wish'd. To die, to sleep;
> To sleep: perchance to dream: ay, there's the rub:
> For in that sleep of death what dreams may
> come,
> When we have shuffled off this mortal coil,
> Must give us pause: there's the respect
> That makes calamity of so long life;
> For who would bear the whips and scorns of
> time,
> The oppressor's wrong, the proud man's
> contumely,
> The pangs of despised love, the law's delay,
> The insolence of office and the spurns
> That patient merit of the unworthy takes,
> When he himself might his quietus make
> With a bare bodkin? Who would fardels bear,
> To grunt and sweat under a weary life,
> But that the dread of something after death,
> The undiscover'd country from whose bourn
> No traveller returns, puzzles the will
> And makes us rather bear those ills we have
> Than fly to others that we know not of?
> Thus conscience does make cowards of us all;
> And thus the native hue of resolution
> Is sicklied o'er with the pale cast of thought,
> And enterprises of great pith and moment
> With this regard their currents turn awry,
> And lose the name of action.

RENAISSANCE MUSIC

Renaissance music differed from medieval style particularly in features such as greater melodic and rhythmic integration, a more extended range, broader texture, and subjection to harmonic principles of order. In the sixteenth century this integrated style produced distinct vocal and instrumental idioms, and vocal music, under the influence of humanism, became increasingly intent on expressing a text. In fact, vocal music, because of the humanistic interest in language, was a more important musical idiom than instrumental music. Renaissance composers tried to enhance the meaning and emotion of the written text. In doing so, they often used what is called *word painting*—for example, if a text described a descent, then the music might utilize a descending melodic line. In sum, however, and despite the increased sense of emotion, Renaissance music remained restrained and balanced, avoiding extreme contrasts in dynamics, tone color, or rhythm.

The texture of Renaissance music was mostly polyphonic, with imitation among the voices being fairly common. There was also homophony, especially in light music such as dance. In addition, the musical texture of a piece might vary, with the contrast used to highlight the particular emotion of the composition.

Sacred Music

In Rome, the papal chapel was one of the central musical forces in Europe. There, the career of Giovanni Pierluigi da Palestrina (1526?–94) flourished. Palestrina enjoyed the grace and favor of popes and cardinals. Director of the Julian Chapel Choir from 1551 to 1555, he became a singer in the pontifical choir in the latter year and began to compose for the papal chapel. Because he was married, however, he was forced to leave his post when Pope Paul IV imposed a stricter discipline in choral appointments.

Palestrina's works are exclusively vocal and almost totally liturgical; the only exception is a single book of madrigals and a collection of spiritual madrigals. He wrote 105 masses. Palestrina became the most celebrated composer of his time. Palestrina's *Pope Marcellus Mass* is his most famous. It was dedicated to Pope Marcellus II, who reigned briefly in 1555, when Palestrina sang in the papal choir. The mass is written for six voice parts (*a cappella*—that is, without accompaniment): soprano, alto, two tenors, and two basses. Earlier we examined a

Kyrie from Gregorian chant (CD track 4). Let's now examine the Kyrie from Palestrina's *Pope Marcellus Mass* (CD track 7).

The Kyrie has a rich, polyphonic texture in which the six voices imitate each other. The melodic contours are rounded, evoking images of the Gregorian chant. The melody is in the top voice, the cantus or soprano line. The Kyrie is in three sections:

1. *Kyrie eleison* (Lord, have mercy upon us).

2. *Christe eleison* (Christ, have mercy upon us).

3. *Kyrie eleison* (Lord, have mercy upon us).

The words of this brief text are repeated with different melodic treatments and express calm supplication. Each section ends with all voices coming together on sustained chords.

Another important form of Renaissance sacred music is the *motet*, which is like the mass in style, but shorter than the mass. The Renaissance motet is a polyphonic choral work set to a Latin text other than the ordinary of the mass.

Secular Music

The sixteenth century witnessed development of previous forms into the *madrigal*, a setting of lyric poetry for four or five voices. Madrigal is the name given to two important types of secular vocal music. One type was cultivated exclusively in fourteenth-century Italy; the other developed anew and flourished in Italy during the sixteenth century amid an explosion of Italian poetry. Poetically, the sixteenth-century madrigal normally comprises a text of from three to fourteen lines (of seven and eleven syllables in no particular order) arranged in a rhyme scheme of the poet's choosing. The musical setting emphasizes the mood and meaning of individual words and phrases of the text rather than formal structure.

Madrigals were composed for as few as three and as many as eight parts, although, in general, before 1650 a four-part texture was preferred. After that, a five-part texture predominated. Madrigals were often sung by solo voices, one per part, but also were performed with instruments substituting for some of the voices or doubling the various parts. By the second half of the sixteenth century, the madrigal had become established as the dominant form of secular music in Italy and the rest of Europe.

ASIAN STYLES

CHINA

Ming Sculpture and Ceramics

The lengthy Ming Dynasty (1368–1644) brought about a centralization of power and money in the court of the emperor. As a result, the demand for decorative arts caused a tremendous increase in the number and quality of ceramic works. The celebrated Ming vases have become a symbol for the wide variety of ceramic ware produced during this period. Strong traditions in ceramic style and technique had been established much earlier (see p. 230). The Ming Dynasty capitalized on them and took ceramic art to even higher levels, especially in porcelains. By the fifteenth century an underglaze decoration of cobalt blue had been developed, and artisans achieved remarkable skill in color control. Familiar blue-and-white porcelains had their classic period between 1426 and 1435. They were marked by clarity of detail and variety of shapes. Over the next 100 years the palette was enriched by adding multicolored enamels to the basic blue. The result can be seen in a five-color covered jar from the reign of Wan Li (1573–1620; Fig. **11.18**). The complex process of adding layers of color called for refined designs and repeated firings. First, blue designs were applied to the white ground and were glazed and fired. Over this glaze, the decoration was completed in red, green, yellow, and brown; the work was then refired. The process resulted in a rich and delicate ceramic with freely painted narrative scenes and floral compositions of charm, grace, and appeal. Their shapes tend to be slightly irregular, which gives them a uniqueness and human quality that adds warmth to their otherwise perfect execution.

INDIA

Rajput Style

One style of Indian painting is called the Rajput style, after a group of clans in northern and central India, who fought vigorously against the Muslim invaders. Their art has a folk quality and takes much of its subject matter from Hindu literature. Its treatment ranges widely, from abstract to intel-

11.18 Mark of Wan Li, covered jar, c. 1600. Porcelain, height 4 ins (10.2 cm). Cleveland Museum of Art (John L. Severance Fund).

11.19 *Madhu Madhavi Ragini*, from Malwa, India, c. 1630–40. Color on paper, 7⁹⁄₁₆ x 5¹³⁄₁₆ ins (19.2 x 14.8 cm). Cleveland Museum of Art (Gift of J. H. Wade).

lectual to concrete and emotional. Figure **11.19**, *Madhu Madhavi Ragini*, is a typical example. Its primary characteristic is its distinctive dark blue background. The title of the painting refers both to a musical mode and to a representation of a heroine who goes into the night to meet her lover with peacocks flying around her and lightning flashing. However, there seems little here that is ominous. Space is limited to the surface plane. Crossing diagonals give the work a sense of movement, and strong colors and contrasts make the painting forceful and appealing. The conventions of figure portrayal are similar to those of Egypt (see p. 204).

Punjab Style

Another major school of Indian painting, the Punjab hills style, comes from the northwest of the Indian subcontinent. Its drawings are linear, in a gentle, lyrical mode. For example *Gajahamurti*, which means "after the death of the elephant-demon" (Fig. **11.20**), presents deities posed formally in a perfectly balanced composition of gently curved forms and careful coloring. The gods Siva and Devi are presented in rigid formality, with Siva, the slayer of the demon, as the

main focus. The two figures float in the sky on the elephant's hide. Swirling clouds seem to suggest a storm, especially in their strong contrast to the dark blue background. The sky takes predominance over a rather conventionally and sparsely illustrated earth. None the less, the flowers show fine detailing and individuality. The ducks are also delicate and graceful, both in the water and in flight. Overall, the tone is subdued rather than violent.

MUSLIM AND HINDU ARCHITECTURE

The Mughal emperors of the seventeenth century were great patrons of architecture, and the most famous of all Indian architectural accomplishments—the Taj Mahal at Agra, near Delhi (Fig. **11.22**)—is Islamic. It does, however, blend Persian and indigenous Indian styles. It was built by Shah Jahan (1592–1666) as a mausoleum for his favorite wife Mumtaz Mahal (1593–1631). Such a tomb for a wife was entirely without precedent in Islam, and it is possible that the building was also intended as an allegory of the day of resurrection: The building is a symbolic replica of the

11.20 *Gajahamurti* (*Shiva and Devi on Gajasura Hide*), from Basohli, India, c. 1657–80. Color on paper, 9¼ x 6¼ ins (23.5 x 15.8 cm). Cleveland Museum of Art (Edward L. Whittemore Fund).

11.21 Pampapati Temple, Vijayanagar, India, *gopura* (gateway tower), 16th century (renovated in 17th century).

11.22 Ustad Ahmad Lahori (architect), Taj Mahal, Agra, India, 1632–48.

throne of God. Four intersecting waterways in the garden symbolize the four flowing rivers of Paradise, as described in the Koran. The scale of the building is immense, and yet the details—entirely geometric and nonfigurative—are exquisitely refined. Proportions are well-balanced and symmetrical. The effect of this huge, white, octagonal structure, with its impressive dome and flanking minarets, is nothing short of breathtaking.

By contrast, the Hindu architectural tradition is almost defiantly anti-Islamic, with an abundance of figurative sculpture celebrating a plurality of deities. Examples can be seen throughout India, but especially in the south, in the ten-square-mile city of Vijayanagar, formerly the center of a Hindu empire established in the fourteenth century. Here, huge and exquisite temples come alive with brilliantly colored sculpture depicting the Hindu pantheon (Fig. **11.21**). Upward-striving terraces with ornate detail reach toward a vaulted pinnacle. In Vijayanagar the concept of the temple went beyond a single shrine and encompassed an entire complex of buildings within concentric enclosures. These were entered through tall gate towers called *gopuras*, which were packed with *friezes* of the Hindu gods, and which increased in size as one moved from inner to outer walls.

JAPAN

The seventeenth century witnessed impressive economic growth and a tripling of the population to more than 30 million. Samurai (warriors) were forced to live in towns near their masters. Sharply divided from other classes by their superior status, they became an administrative class responsible for managing the revenue of the shogun. They attended special schools where they were taught Neo-Confucianism, among other subjects. Japanese society became increasingly urban through the eighteenth century, and a strong middle class of merchants and artisans developed. The arts flourished; the puppet theatre and Kabuki theatre emerged. The reign of the Tokugawa shoguns (1603–1867) was at its peak.

PAINTING STYLE

Tawayara Sotatsu (d. 1643) was a highly creative painter of the late sixteenth and early seventeenth centuries. In contrast with other Japanese painters, who tended to use Chinese motifs and patterns, Sotatsu painted in a style that emphasized boldness, severity, and asymmetry, with simplified silhouettes. He deftly broadened the use of colors

and ink, developing a notable skill in fading the edges of color areas and in creating blurred and pooled effects in wet colors by allowing ink and color to run together. He looked to sources in Japanese traditions for his subject matter. His hanging paper scroll *The Zen Priest Choka* (Fig.

11.23) shows the priest sitting in a tree. The remarkable aspect of this painting is its use of space—the subject occupies only a small portion of the work. Choka sits in a tree, but it is only faintly suggested at the left border: Its trunk and limbs ebb and flow up the boundary and give us a glimpse here and there of their presence, but mostly leave a full configuration to our imagination. The priest himself is curiously de-emphasized. Sotatsu portrays him with pale color and soft lines of medium tonality. Although most of the painting is void of images, it is fully in balance. Sotatsu has cleverly split the universe of this work into halves divided on the lower left/upper right diagonals. This is a fascinating example of how, both philosophically and visually, something can be balanced by nothing.

IMARI PORCELAIN

The discovery of *porcelain* clay in Japan in the early seventeenth century, and the importation of Chinese techniques, led to some remarkable accomplishments in ceramic art. Typical of Japanese mastery of this medium is an Imari porcelain from the late seventeenth century (Fig. 11.24). The exquisite recurved silhouette of this piece has a relaxing flow. The proportions call attention to themselves as the design divides in half at the top of the lower bowl, is balanced by a gracefully slim neck that enlarges into an asymmetrical bulb, and ends in a delicate lip at the top. The ornate flowers have elegance and fine detail that give the

11.23 (*left*) Tawayara Sotatsu, *The Zen Priest Choka*, pre-1643. Ink on paper, 37¾ x 15¼ ins (95.9 x 38.7 cm). Cleveland Museum of Art (Norman O. Stone and Ella A. Stone Memorial Fund).

11.24 (*right*) Imari ware Japanese vase, late 17th century. Porcelain, height 22 ins (55.9 cm). Cleveland Museum of Art (Gift of Ralph King).

vase delicacy and refinement. European figures often appear in this style of ceramics: Dutch and Portuguese men, and also Western ships.

KABUKI THEATRE

Kabuki drama began as "middle-class theatre" in the seventeenth century and, as such, was the object of contempt by the samurai and the court. The earliest Kabuki plays were simple sketches; two-act plays did not appear until the middle of the century. The most important Kabuki playwright was the legendary seventeenth-century writer Chikamatsu (1653–1724). By the mid-eighteenth century, the plays of the popular writer Takeda Izumo (1691–1756) had reached a length of eleven acts, and required a whole day to perform.

The focus of a Kabuki play tends to be a climactic moment, as opposed to the plot. Connections between scenes tend to be vague, in contrast with much of Western theatre, whose plot development runs according to cause and effect. A narrator and chorus play predominant roles in Kabuki productions, because although there is a musical accompaniment, the actors themselves do not sing. The narrator describes the scene, comments on the action, and even speaks portions of the dialogue. The overall style of Kabuki drama tends to fall somewhere between convention and depiction. Every location is portrayed scenically, and scenery is changed in full view of the audience.

Kabuki theatre has changed significantly since the mid-sixteenth century because of its ability to shift with the times and incorporate aspects of other theatre traditions. It has borrowed freely from Noh drama (see p. 245) and from the popular Japanese puppet theatre whose plays and stage machinery it incorporated. Productions continue to be lengthy, although the day-long practice of the eighteenth century has now been pared back to two five-hour performances per day.

BAROQUE STYLE IN EUROPE

The seventeenth century in Europe brought an age of intellectual, spiritual, and physical action. Along with the new age came a tremendously diverse new style, the Baroque. In many cases, it meant opulence, intricacy, ornateness, and appeal to the emotions, and outdid previous styles in reflecting the grandiose expectations of its patrons. In other cases, it was intellectual and more subdued. The idea of proving one's position to one's peers using overwhelming art infected the aristocracy, the bourgeoisie (middle classes), and even the Roman Catholic Church. Its strategy for coping with the Reformation and the spread of Protestantism included attracting worshipers back into the Church with magnificent art, architecture, and music.

Systematic rationalism sprang forth as a means of explaining the universe in secular and scientific terms, and as an organizational concept for works of art. Thus in all Baroque art a sophisticated organizational scheme subordinates a multitude of single parts to the whole and carefully merges one part into the next to create an exceedingly complex but highly unified design. The world became more and more secularized as power shifted from the Church to more worldly institutions. Over all of them reigned the absolute or all-powerful monarch.

> The idea of absolutism dominated individual as well as collective psychology in the baroque age, each man governing his life like an absolute monarch. Balthasar Gracian advises the courtier: "Let all your actions be those of a king, or at least worthy of a king in due proportion to your estate." Every man was inwardly a king. The ego, or the superego, became an entity which recognized no limits beyond itself. . . . The baroque artist exercises this sovereignty "in due proportion to his estate" as Balthasar Gracian would have any man do; that is, his art. The seventeenth century produced artists who, if not solitaries, were at least independent men . . . who considered their art, even if it depended upon commissions, as a personal activity, allowing no limits to be placed on their creative power.[4]

In the Baroque, color and grandeur are emphasized, as is dramatic use of lights and darks that carry the viewer's eye off the canvas. Baroque art takes Renaissance clarity of form and recasts it into intricate patterns of geometry and fluid movement. Open composition is used to symbolize the notion of an expansive universe and a wider reality. The human figure, as an object or focus in painting, can be monumental in full Renaissance fashion, but can also now be a minuscule figure in a landscape—part of, but subordinate to, an overwhelming universe. Above all, Baroque style is characterized by intensely active compositions which emphasize feeling rather than form, emotion rather than intellect. Paintings exhibit clear individuality, and virtuosity emerged as artists sought to establish a style that was distinctly their own.

Baroque painting is fairly easily identifiable as a general style, although its uses were diverse and pluralistic, not conforming to a simple mold. It spread throughout Europe, with examples in every area, between 1600 and 1725.

11.25 Caravaggio, *The Calling of St. Matthew*, c. 1596–8.
Oil on canvas, 11 ft 1 in x 11 ft 5 ins (3.38 x 3.48 m). Contarelli Chapel, Santo Luigi dei Francesi, Rome.

CATHOLIC REFORMATION BAROQUE

The Catholic Reformation was the Roman Catholic Church's response to the Protestant Reformation, which took place at the same time as the Renaissance and perhaps represented the most shattering blow the Christian Church has ever experienced. It did not just appear out of the blue, but was, rather, the climax of centuries of sectarian agitation. The Reformation also was perhaps as much an economic and political circumstance as it was religious. Catholic Reformation Baroque art was art in the Baroque style which pursued the objects and visions of the Roman Catholic Church.

Caravaggio

In Rome—the center of early Baroque—papal patronage and the Catholic Reformation spirit brought artists together to make Rome the "most beautiful city of the entire Christian world." Caravaggio (Michelangelo Merisi, 1569–1609) was probably the most significant of the Roman Baroque painters. His extraordinary style carries verisimilitude to new heights. In *The Calling of St. Matthew* (Fig. **11.25**) highlight and shadow create a dynamic portrayal of the moment when the future apostle is touched by divine grace. Here a religious subject is depicted in contemporary terms. Turning away from idealized Renaissance form, Caravaggio uses realistic imagery and an everyday setting. The call from Christ streams, in dramatic

chiaroscuro, across the two groups of figures. This painting expresses central themes of Catholic Reformation belief: Faith and grace are open to all who have the courage and simplicity to transcend intellectual pride, and spiritual understanding is a personal, mysterious, and overpowering emotional experience.

Bernini

The Baroque style was particularly suited to sculpture. Form and space were charged with energy, carrying beyond the limits of actual physical confines. As with painting,

11.27 Peter Paul Rubens, *Henry IV Receiving the Portrait of Maria de' Medici*, 1622–5. Oil on canvas, 13 ft x 9 ft 8 ins (3.96 x 2.95 m). Louvre, Paris.

11.26 Bernini, *David*, 1623. Marble, height 5 ft 7 ins (1.7 m). Galleria Borghese, Rome.

sculpture appealed to the emotions by inviting participation rather than neutral observation. Feeling was the focus. Baroque sculpture also treated space pictorially, almost like a painting, to describe action scenes rather than single sculptural forms. The best examples we can draw upon are those of the sculptor Gianlorenzo Bernini (1598–1680).

David (Fig. **11.26**) exudes dynamic power, action, and emotion as he curls to unleash his stone at an imagined Goliath standing some distance away. Our eyes sweep upward along a diagonally curved line and are propelled outward by the concentrated emotion of David's expression. Throughout the work the curving theme is repeated in deep, rich, and fully contoured form. A wealth of elegant and ornamental detail occupies the composition. Again the viewer participates emotionally, feels the drama, and responds to the sensuous contours of dramatically articulated muscles. Bernini's *David* flexes and contracts in action, rather than repressing pent-up energy as does Michelangelo's giant-slayer (Fig. **2.19**).

ARISTOCRATIC BAROQUE

Aristocratic Baroque is art in the general Baroque style that reflects the visions and purposes of the aristocracy. Their power was increasingly coming under threat from the growing bourgeoisie.

Rubens

Peter Paul Rubens (1577–1640) is noted for his vast, overwhelming paintings and fleshy female nudes. In 1621–5, he painted a series of works as a commission from Maria de' Medici, a Florentine princess, the widow of the French king Henri IV, and regent during the minority of her son Louis XIII. *Henry IV Receiving the Portrait of Maria de' Medici* (Fig. **11.27**) is one of twenty-one canvases that give an allegorical version of the queen's life. In this painting, we see Rubens' ornate curvilinear composition, lively action, and complex color. Typical are the corpulent cupids (*putti*) and female flesh—it has a sense of softness and warmth found in the work of few other artists. Rubens' colors are warm, with deep rich blues throughout the picture. There is strong contrast, making for enhanced dynamics between lights and darks and between lively and more subdued tones. The composition sweeps from upper left to lower right and circles around the rectangular frame of Maria's portrait at the juncture of the vertical, horizontal, and diagonal axes. The painting seems to swirl before the viewer's eyes. It is rich in detail, but each finely rendered part is subordinate to the whole. Rubens leads the eye around the painting, upward, downward, inward, and outward, occasionally escaping the frame altogether. Nevertheless, the sophisticated composition beneath all this complexity holds the base of the painting solidly in place and leads the eye to the smiling face of Maria. The overall effect is of richness, glamor, and optimism. Its appeal is directly to the emotions rather than the intellect.

The Classical allegory of the painting shows Minerva, the Roman goddess of wisdom, advising the aging King Henry IV (whose helmet and shield are being stolen by the cupids) to accept the Florentine princess as his second bride. Maria's portrait is presented by Mercury, god of commerce, and Juno and Jupiter, the principal Roman gods, look on approvingly. The painting depicts happy promises of divine intervention, radiant health, and grandeur.

Rubens produced works at a prolific rate, primarily because he ran what was virtually a painting factory where he employed numerous artists and apprentices to assist in his work. He priced his paintings on the basis of their size and depending on how much actual work he, personally, had done on them. We should not be overly disturbed by this, especially when we consider the individual qualities and concepts expressed in his work. His unique Baroque style emerges from every painting, and many untrained observers can recognize a Rubens with relative ease. Clearly artistic value here lies in the conception, not merely in the handiwork.

Versailles

Probably no monarch better represents the *absolutism* of the Baroque era than the French King Louis XIV, known as the Sun King (reigned 1643–1715). No artwork better represents the magnificence and grandeur of the Baroque style than does the Palace of Versailles, near Paris, and its sculpture and grounds—a grand design of buildings and nature to reflect systematic rationalism. The great Versailles complex grew from the modest hunting lodge of Louis XIII into the grand palace of the Sun King over a number of years, involving several architects, and amid curious political and religious circumstances.

The Versailles *château* (French for "castle") was rebuilt in 1631 by Philibert Le Roy. The façade was decorated by Louis Le Vau with bricks and stone, sculpture, wrought iron, and gilt lead. In 1668 Louis XIV ordered Le Vau to enlarge the *château* by enclosing it in a stone envelope containing the king's and queen's apartments (Fig. **11.29**). The city side of the building retains the spirit of Louis XIII, but the park side (Fig. **11.28**) reflects Classical French influence. François d'Orbay and, later, Jules Hardouin-Mansart expanded the *château* into a palace whose west façade extends over 2,000 feet (609 m). It became Louis XIV's permanent residence in 1682. French royalty was at the height of its power and Versailles was the symbol of the Divine Right of Kings—the absolute authority of the monarch.

As much care, elegance, and precision was employed on the interior as on the exterior. With the aim of developing French commerce, Louis XIV had his court live in unparalleled luxury. He also decided to furnish his palace permanently, something which was unheard of. The result was a fantastically rich and beautiful set of furnishings. Royal manufacturers produced mirrors, tapestries, and brocades. The highest quality was required, and these furnishings became highly sought after in Europe. Le Brun kept a meticulous eye on anything for the State Apartments, such as the creation of statues and the design of ceilings.

The grounds are adorned throughout with fountains and statues. Sitting astride the east–west axis of the grounds is the Fountain of Apollo (Fig. **11.30**). This magnificent composition by Tuby was originally covered with gold. The sculpture was executed from a drawing by Le Brun and inspired by a painting by Albani. It glorifies the

11.28 Louis Le Vau and Jules Hardouin-Mansart, Palace of Versailles, garden façade, 1669–85.

11.29 Palace of Versailles, Queen's Staircase.

Sun King using allegory: The sun god rises in his chariot from the waters at daybreak. Apollo was the perfect symbol for Louis XIV, whose absolutism shone in Baroque splendor.

As a symbol and in practical fact, Versailles played a fundamental role in keeping France stable. Its symbolism as a magnificent testament to royal centrality and to France's sense of nationalism is fairly obvious. As a practical device, Versailles served the purpose of pulling the aristocracy out of Paris where they could foment discontent, and isolated them where Louis XIV could keep his eye on them and keep them busy. Versailles further served as a giant economic engine to develop and export French taste and the French luxury trades.

11.30 Palace of Versailles, Fountain of Apollo.

11.31 Rembrandt van Rijn, *The Night Watch* (*The Company of Captain Frans Banning Cocq*), 1642. Oil on canvas, 12 ft 2 ins x 14 ft 6 ins (3.7 x 4.44 m). Rijksmuseum, Amsterdam.

BOURGEOIS BAROQUE

Bourgeois Baroque is the category of Baroque art that reflects the visions and objectives of the new and wealthy middle classes. In some cases their riches were greater than those of the aristocracy and, as a result, a power struggle was at hand.

Rembrandt

Rembrandt van Rijn (1606–69), in contrast to Rubens, could be called a middle-class artist. Born in Leiden in the Netherlands, he trained under local artists and then moved to Amsterdam. His early and rapid success gained him many commissions and students. Rembrandt became what can only be called a capitalist artist. He believed that art had value not only in itself but also in its market worth. He reportedly spent huge sums of money buying his own works so as to increase their value.

Rembrandt's genius lay in depicting human emotions and characters. He suggests rather than depicts great detail, as seen in *The Night Watch*, one of his greatest works (Fig. 11.31). He concentrates here on atmosphere and shadow, implication and emotion. As in most Baroque art, the viewer is invited to share in an emotion, to enter into an experience rather than to observe as an impartial witness.

The huge canvas now in the Rijksmuseum in Amsterdam is only a portion of the original, which was cut down in the eighteenth century to fit into a space in Amsterdam Town Hall. It no longer shows the bridge members of the watch were about to cross. Group portraits, especially of military units, were popular at the time. They usually showed the company in a social setting such as a gathering around a banquet table. Rembrandt chose to break with the norm and portrayed it as if on duty. The result was a scene of greater vigor and dramatic intensity, true to the Baroque spirit—but it displeased his patrons.

A recent cleaning has revealed the vivid color of the original, making it a good deal brighter than it was in its previous state. However, it has not explained its dramatic highlights and shadows—no analysis of light can solve the problem of how these figures are illuminated, for there is no natural light whatsoever in the scene. Another problem lies in the title of the work. It has been suggested that this is, in fact, a "Day Watch," so that the intense light at the center of the work can be explained as morning sunlight. But it seems that Rembrandt has made his choice of highlights for dramatic purposes only. While the figures are rendered with a fair degree of verisimilitude, no such claim can be made for the light sources.

BAROQUE MUSIC

The adjectives generally used to describe Baroque painting and sculpture—ornate, complex, and emotionally appealing—are applicable in a nonvisual sense to music. Reflective of the systematic rationalism of the era, Baroque music established norms of harmonic progression and major and minor keys that remained basic to Western music for the next 300 years.

Baroque composers also began to write for specific instruments, in contrast to previous practices of writing music that might be either sung or played. They built into their music implicit forces of action and tension—for example, strong and immediate contrasts in tonal color or volume. The Baroque era produced great geniuses in music and many new ideas, new instruments, and new forms such as the concerto and opera (see Chapter 3).

Vivaldi

One of the masters of the concerto (see p. 76 for definition) was Antonio Vivaldi (1669–1741), who composed for specific occasions and usually for a specific company of performers. About two-thirds of his approximately four hundred fifty concertos are for solo instruments and orchestra and one-third are concerto grossi.

Probably his most familiar solo concerto is "Spring," one of four works in opus 8 (1725), *The Four Seasons*. *The Four Seasons* is an early example of *program music*, written to illustrate an external idea, in contrast with *absolute music*, which presents purely musical ideas. In "Spring" (CD track 11) a series of individual pieces interlock to form an ornate whole. In the first movement (allegro) Vivaldi alternates an opening theme (A) with sections that depict bird song, a flowing brook, a storm, and the birds' return (ABACADAEA).

Handel

Another major development in the same vein was the oratorio. Broad in scale like an opera, it combined a sacred subject with a poetic text. Like a cantata, it was designed for concert performance, without scenery or costume. Many oratorios could be staged and have highly developed dramatic content with soloists portraying specific characters.

Oratorio began in Italy in the early seventeenth century, but all other oratorio accomplishments pale in comparison with the works of its greatest master, George Frederick Handel (1685–1759). Although Handel was German by birth he lived in England and wrote oratorios in English.

PROFILE

Johann Sebastian Bach

Although currently considered one of the giants of music, Johann Sebastian Bach (1685–1750) was considered old-fashioned during his lifetime, and his works lay virtually dormant after his death. Not until the nineteenth century did he gain recognition as one of the greatest composers of the Western world. He was born in Thuringia, in what is now Germany, and when he was ten years old both his parents died. His oldest brother, Johann Christoph, took responsibility for raising and teaching him, and Johann Sebastian became a choirboy at the Michaelskirche in Luneburg when he was fifteen. He studied the organ and was appointed organist at Neukirche in Arnstadt, where he remained for four years. Then he took a similar post at Muhlhausen at about the same time as he married his cousin Maria Barbara Bach. One year later, he took the position of court organist at Weimar, remaining there until 1717, when Prince Leopold of Kothen hired him as his musical director. While he was serving as musical director to Prince Leopold, Bach completed the Brandenberg Concertos in 1721.

In 1720 Bach's wife died, and one year later he married Anna Magdalena Wilcken. In 1723 he moved to Leipzig as the city's musical director at the school attached to St Thomas' Church, and among his responsibilities to the city, was the supply of performers for four churches. In 1747 he played at Potsdam for Frederick II the Great of Prussia but shortly thereafter his eyesight began to fail, and he went blind just before his death in 1750.

Bach's output as a composer was prodigious but also required as part of his responsibilities, especially at Leipzig. Over his career, he wrote more than two hundred cantatas, the *Mass in B Minor*, and three settings of the Passion story, works that illustrate Bach's deep religious faith. His sacred music allowed him to explore and communicate the profound mysteries of the Christian faith and to glorify God. His cantatas typify the Baroque exploration of wide-ranging emotional development. They range from ecstatic expressions of joy to profound meditations on death. The Passions, of which the *St Matthew Passion* is typical, tell the story of the trial and crucifixion of Jesus. Written in German rather than the traditional Latin, the Passions express Bach's devotion to Lutheranism.

In addition to his sacred works, Bach wrote a tremendous amount of important music for harpsichord and organ, including the forty-eight Preludes and Fugues, called *The Well-Tempered Clavier*, and the *Goldberg Variations*. In the fugues, he develops a single theme, which is then imitated among the polyphonically developed voices of the composition. Among his many instrumental works are twenty concertos and twelve unaccompanied sonatas for violin and cello.

Most of them are highly dramatic in structure and contain exposition, conflict or complication, and dénouement or resolution sections. Many could be staged in full operatic tradition (except for two outstanding examples, *Israel in Egypt* and *Messiah*). Handel's oratorios rely strongly on the chorus. The choral numbers are most frequently polyphonic, with soprano, alto, tenor, and bass parts each taking a turn with the same melody, although there are homophonic sections too. Most of the solo arias can stand on their own as performance pieces. They also fit magnificently together in a systematic development, usually following a portion of recitative, where the storyline is progressed.

Handel's works continue to enjoy wide popularity, and each year *Messiah* has thousands of performances around the world. Written in 1741 in twenty-four days, it is divided into three parts: the birth of Jesus; Jesus's death and resurrection; and the redemption of humanity. The music comprises an overture, choruses, recitatives, and arias, and is written for small orchestra, chorus, and soloists. The choruses provide some of the world's best-loved music, including the famous "Hallelujah Chorus."

The "Hallelujah Chorus" (CD track 10) comprises the climax of the second part. The text proclaims a victorious Lord whose host is an army with banners. Handel creates infinite variety by sudden changes of texture among

monophony, polyphony, and homophony. Words and phrases are repeated over and over again. In unison the voices and instruments proclaim, "for the Lord God omnipotent reigneth." Polyphony marks the repeated exclamations of "Hallelujah" and yields to homophony in the hymn-like "The kingdom of this world":

Hal-le-lu-jah, Hal-le-lu-jah, Hal-le-lu-jah, Hal-le-lu-jah, Hal-
-le-lu-jah, Hal-le-lu-jah, Hal-le-lu-jah, etc.

11.32 G. F. Handel, *Hallelujah Chorus.*

Bach

Bach's organ compositions are famous for their drama, virtuoso technique, and bold pedal solos (played by the feet while the hands are busy on the keyboards). The Fugue in G Minor, or "Little Fugue," is a characteristic example (see p. 76 for a definition). This fugue is in duple meter and has four voices—the separate lines are known as voices even when they are played on an instrument. The subject is first stated in the top voice and then answered by the alto.

Bach was a master of the cantata (see p. 75 for a definition). An excellent example, whose theme is well known, is *Cantata No. 80*: "Ein feste Burg ist unser Gott" ("A Mighty Fortress is Our God," Fig. **11.33**). The chorale on which the cantata is based was written by Martin Luther (Luther probably wrote both words and music), and the chorale is a centerpiece of Protestant hymnology. Luther's words and melody are used in the first, second, fifth, and

last movements. Salomo Franck, Bach's favorite librettist, wrote the remainder of the text. The first movement, a choral fugue, states the familiar theme and text:

> A mighty fortress is our God,
> A good defense and weapon;
> He helps free us from all the troubles
> That have now befallen us.
> Our ever evil foe,
> In earnest plots against us,
> With great strength and cunning
> He prepares his dreadful plans.
> Earth holds none like him.

The final movement (CD track 9) rounds off the cantata. Luther's chorale is now sung in Bach's own four-part harmonization. Instruments double each voice, and the simple, powerful melody stands out against the lower parts:

> Das Wort, sie sollen lassen stahn
> und kein Dank dazu haben.
> Er ist bei uns wohl auf dem Plan
> mit seinem Geist und Gaben.
> Nehmen sie uns den Leib,
> Gut, Her, Kind und Weib,
> lass fahren dahin
> sie habens kein Gevinn
> das Reich muss uns doch bleiben.

> Now let the Word of God abide
> without further thought.
> He is firmly on our side
> with His spirit and strength.
> Though they deprive us of life,
> Wealth, honor, child and wife,
> we will not complain,
> It will avail them nothing
> For God's kingdom must prevail.

Ein fe-ste Burg ist un-ser Gott, ein gu-te Wehr und
Er hilft uns frei aus al-ler Not, die uns jetzt hat be-

Waf - fen; Der al-te bö-se Feind, mit Ernst
-trof - -fen.

er's jetzt meint, gross macht und viel List sein grau-sam

Rü - stung ist; auf Erd' ist nicht seins gleich - -en.

11.33 J. S. Bach, "Ein feste Burg ist unser Gott" from Cantata No. 80.

THE ENLIGHTENMENT IN EUROPE

In Europe, the eighteenth century was an age of change and revolution in some areas and prosperous stability in others. The idea of the absolute monarch was challenged—though with varying success. The middle classes rose to demand their place in society, and social philosophy attempted to make a place for all classes in the scheme of things. *Philosophes*—a group of writers and scholars—undertook the challenge of making the great ideas and texts of human intellect accessible to the general public. In short, they were popularizers. Knowledge, for them, was a transcendent and universal goal. The aristocracy found itself in decline, and the *Rococo* style reflected their increasingly superficial and delicate condition. The pendulum then swung back from exquisite refinement and artifice to intellectual seriousness, at least for a while. The structural clarity of Classicism returned in painting, sculpture, and architecture, and above all in music, in which a remarkable century culminated in works of emotional depth and formal inventiveness. The century closed in anticipation of the upheavals of *Sturm und Drang* (German for "storm and stress") and the Romantics.

ROCOCO STYLE IN PAINTING

The change from grand Baroque courtly life to that of the small salon and intimate townhouse was reflected in a new style of painting called Rococo. Among other characteristics, it satirized the customs of the age, but criticized with humor. Its intimate grace, charm, and delicate superficiality reflect the social ideals and manners of the period. Informality replaced formality in both life and painting. The logic and academic character of the Baroque style were found lacking in feeling and sensitivity. Its overwhelming scale and grandeur were too ponderous. In Rococo art, deeply dramatic action gives way to lively effervescence and

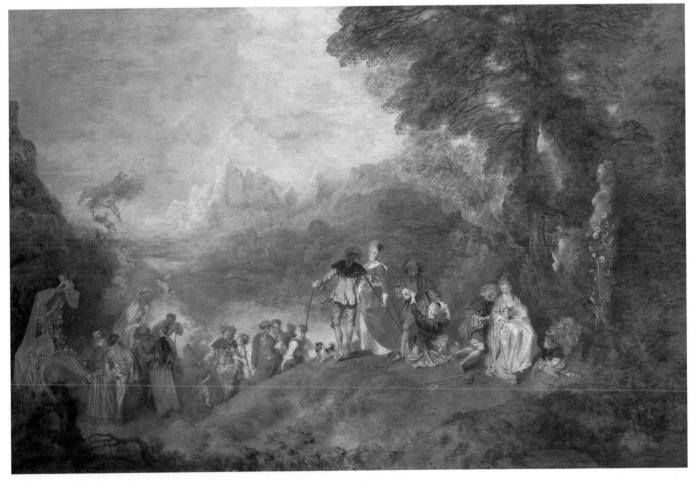

11.34 Antoine Watteau, *Embarkation for Cythera*, 1717. Oil on canvas, 4 ft 3 ins x 6 ft 4½ ins (1.3 x 1.94 m). Louvre, Paris.

melodrama. Love, sentiment, pleasure, and sincerity become predominant themes. None of these characteristics conflicts significantly with the overall tone of the Enlightenment, whose major goal was the refinement of humankind. The arts of the period dignified the human spirit through social consciousness and bourgeois social morality, as well as through the graceful gamesmanship of love. Delicacy, informality, lack of grandeur, and lack of action did not always imply superficiality or limp sentimentality.

The quandary of the declining aristocracy can be seen in the Rococo paintings of Antoine Watteau (1683–1721). Although largely sentimental, Watteau's work avoids frivolity. *Embarkation for Cythera* (Fig. **11.34**) gives an idealized picture of aristocratic social graces. Cythera is a mythological land of enchantment—the island of Venus, Roman goddess of love. Watteau portrays aristocrats waiting to depart, idling away their time in amorous pursuits. The fantasy quality of the landscape is created by fuzzy color areas and hazy atmosphere. A soft, undulating line underscores the human figures, all posed in slightly affected attitudes. Watteau's fussy details and decorative treatment of clothing stand in contrast to the diffused quality of the background. Each grouping of couples engages in graceful conversation and love games typical of the age. Delicacy pervades the scene, over which an armless bust of Venus presides. The doll-like figurines, which are only symbols, engage in sophisticated and elegant pleasure, but their usefulness is past, and the softness and affectation of the work counterbalance gaiety with languid sorrow.

ROCOCO STYLE IN SCULPTURE

Sculpture struggled in the eighteenth century. The Academy of Sculpture and the French Academy in Rome encouraged the copying of Classical sculptures, and resisted change. Sculptors continued to work in the Baroque style, and lacked originality. Rococo style did find expression in the work of Etienne-Maurice Falconet (1716–91) and Clodion (Claude Michel, 1738–1814), with their myriad decorative cupids and nymphs. It is not on the monumental scale of its predecessors. Rather, in the spirit of decoration that marks the era, it often takes the form of delicate and graceful porcelain and metal figurines. Venus

11.35 (*top right*) Etienne-Maurice Falconet, *Madame de Pompadour as the Venus of the Doves*, 1782. Marble, height 29½ ins (75 cm). National Gallery of Art, Washington, D.C. (Samuel H. Kress Collection).

11.36 (*right*) Clodion (Claude Michel), *Satyr and Bacchante*, c. 1775. Terra-cotta, height 23¼ ins (59 cm). Metropolitan Museum of Art, New York (Bequest of Benjamin Altman).

appears frequently, often depicted in the thinly disguised form of a prominent lady of the day. Madame de Pompadour (1721–64), mistress of Louis XV, who epitomized love, charm, grace, and delicacy for the French, often appears as a subject in sculpture as well as in painting.

Falconet

Falconet's *Madame de Pompadour as the Venus of the Doves* (Fig. **11.35**) captures the erotic sensuality, delicacy, lively intelligence, and charm of the Rococo. The unpretentious nudity indicates the complete comfort and naturalness the eighteenth century found in love and affairs of the flesh. Typical of Rococo sculpture, it exhibits masterful technique. Surface textures, detail, and line all display superb delicacy and control of the medium. If this style—and the society it exemplifies—is found wanting in profundity, it must be admired for its technical achievement.

Clodion

Clodion presents the delicate themes of the time in dynamic miniatures such as the *Satyr and Bacchante* (Fig. **11.36**). "His groups of accurately modeled figures in erotic abandon are made all the fresher and more alluring by his knowing use of pinkish terracotta as if it were actually pulsating flesh, rendering each incipient embrace 'forever warm and still to be enjoyed'."[5]

ROCOCO STYLE IN INTERIORS

Rococo also exhibited itself in interior design. Its refinement and decorativeness applied nicely to furniture and

11.37 François de Cuvilliés, Pagodenburg, Schloss Nymphenburg, Munich, Germany, c. 1722.

11.38 G. H. Krohne, Music Room, 1742–51. Thuringer Museum, Eisenach, Germany.

décor. Baroque opulence gives way to Rococo delicacy. Figure **11.38** shows a polygonal music room characteristic of German Rococo. Wall surfaces are broken up with *stucco* decoration of floral branches in a pseudo-realistic effect.

In Venice, curved leg furniture, cornices, and gilded carvings were in fashion. French designer François de Cuvilliés (1695–1768) combined refinement, lightness, and reduced scale to produce a pleasant atmosphere of grace and propriety (Fig. **11.37**).

SATIRE

In strong contrast to the aristocratic frivolity of Rococo style was the biting satire and social comment of enlightened individuals such as William Hogarth (1697–1764) in England in the 1730s. Hogarth portrayed dramatic scenes on moral subjects, attacking the foppery of the aristocracy, drunkenness, and social cruelty. His *Rake's Progress* and *Harlot's Progress* series are attempts to instil solid middle-class values. In the *Harlot's Progress* series the woman is a victim of circumstance. She arrives in London, is seduced by her employer, and ends up in Bridewell Prison. Hogarth portrays her final fate less as a punishment for her sins than as a comment on humankind's general cruelty. The same may be said of the *Rake's Progress*, which portrays the downfall of a foolish young man from

comfortable circumstances. It moves through several unusual and exciting incidents (Fig. **11.41**) to a final fate in Bedlam insane asylum. Hogarth's concern for and criticism of social conditions are clearly expressed in his paintings. Their incitement to action is characteristic of eighteenth-century humanitarianism. The fact that they were made into engravings and widely sold as prints to the public illustrates the popularity of attacks on social institutions of the day.

LANDSCAPE AND PORTRAITURE

Portraiture and landscape painting also increased in popularity in the eighteenth century. One of the most influential English artists of the time was Thomas Gainsborough (1727–88), whose landscapes bridge the gap between Baroque and Romantic style and whose portraits range from Rococo lightheartedness to sensitive elegance.

The Market Cart (Fig. **11.40**) is reminiscent of Watteau and other Rococo painters from mainland Europe in its delicate use of color. Gainsborough's exploration of tonalities

and shapes expresses a deep and almost mystical response to nature. Although pastoral, the composition derives energy from its diagonal character. The tree forms on the right border are twisted and gnarled. The foremost tree leads the viewer's eye up and to the left, to be caught by the downward circling line of the trees and clouds in the background and returned on the diagonal. Gainsborough does not wish us to become too interested in the humans in the picture—they are warmly rendered, but not as specific individuals. Their forms remain indistinct, suggesting that they are subordinate to the forces of nature which ebb and flow around and through them.

STILL LIFE AND *GENRE*

A new bourgeois flavor is found in the mundane (*genre*) subjects of France's Jean-Baptiste Siméon Chardin (1699–1779). He was the finest still-life and genre painter of his time, on a par with Dutch masters of the previous century such as Jan Vermeer, whose technique we looked at in Chapter 1 (Fig. **1.27**). His early works are almost exclusively still lifes. *Menu de Gras* (Fig. **11.39**)

11.39 Jean-Baptiste Siméon Chardin, *Menu de Gras*, 1731. Oil on canvas, 13 x 16⅛ ins (33 x 41 cm). Louvre, Paris.

11.40 Thomas Gainsborough, *The Market Cart*, 1786–7. Oil on canvas, 6 ft ½ in × 5 ft ¼ in (1.84 × 1.53 m). Tate Gallery, London.

illustrates how the everyday can be imbued with interest. With gentle insight, the artist invests cooking pot, ladle, pitcher, bottles, cork, a slab of meat, and other small items with significance. Richness of texture and color combined with sensitive composition and the use of chiaroscuro make these humble items somehow noble. The eye moves slowly from point to point, carefully directed by shapes and angles, color and highlight. The work controls the speed of our viewing: Each new focus demands that we pause and savor its richness. There is pure poetry in Chardin's brush. We are subtly urged to go beyond the surface impression of the objects themselves into a deeper reality.

NEOCLASSICAL STYLE

Painting

The late eighteenth century went whirling back to antiquity, and in particular to nature, in the light of the discovery of the ruins of Pompeii, the art historian Winckelmann's interpretation of Greek Classicism, the philosopher Rousseau's concept of the Noble Savage, and the philosopher Baumgarten's invention of the term "aesthetics." Theoreticians of the eighteenth century saw history as a series of compartments—Antiquity, Middle Ages, Renaissance, and so on—rather than as a single, continuous cultural stream broken by a medieval collapse of Classical values.

One of the principal Neoclassical painters was Jacques-Louis David (1748–1825). His works illustrate the newly perceived grandeur of antiquity and its reflection in subject matter, composition, depiction, and historical accuracy. They show a Roman two-dimensionality and have a strong, classically simple compositional unity. But Classical detail and principles are treated selectively and adapted—the Neoclassicism of David and others is not confined to copying ancient works. David sought to inspire patriotism and democracy, and so some of his works are propagandist in tone (see Masterwork box, p. 308).

Architecture

In the mid-eighteenth century architecture changed entirely, embracing the complex philosophical concerns of the Enlightenment. Three important concepts emerged as a result. First was the archeological concept, which viewed the present as continually enriched by persistent inquiry

11.41 William Hogarth, *The Rake's Progress: The Orgy,* 1733–4. Oil on canvas, 24½ x 29½ ins (62 x 75 cm). Soane Museum, London.

into the past—the idea of *progress*. Second was *eclecticism*, which allowed artists to choose among styles or, more importantly, to combine elements of various styles. The third was *modernism*, which viewed the present as unique and, therefore, possible of expression in its own terms. These concepts fundamentally changed the basic premises of art from that time forward.

Basic to Neoclassicism in architecture are the identifiable forms of Greece and Rome. They found enthusiastic advocates in the Frenchman Abbé Laugier and the Italian Giovanni Battista Piranesi (1720–78). Laugier's *Essai sur l'architecture* (Paris, 1753) was strictly rationalistic and expressed Neoclassicism in a nutshell. He discarded the architectural language developed since the Renaissance. Rather, he urged architects to seek truth in principles demonstrated in the architecture of the ancient world. They should use those principles to design modern buildings along the same logical lines as the Classical temple. Laugier's Classicism descended directly from the ancient Greeks, with only passing reference to the Romans.

Piranesi was incensed that Laugier's arguments placed Greece above Rome. He retaliated with an overwhelmingly detailed work, *Della Magnificenza ed Architettura dei Romani*, which professed to prove the superiority of Rome over Greece—perhaps by sheer weight of evidence. The revival of Classicism in architecture was seen in many quarters as a revolt against the frivolity of the Rococo with an art that was serious and moral.

The designs of colonial architects like Thomas Jefferson (1743–1826) reflect the complex interrelationships of this period. Jefferson's philosophy of architecture was founded on a belief that the architecture of antiquity embodied indisputable natural principles. He was highly influenced, too, by the Italian architect Andrea Palladio (1508–80), who enjoyed popularity in a significant revival in English villa architecture between 1710 and 1750. Jefferson felt that a theory of architecture could be built on a Palladian-style reconstruction of the Roman temple. Monticello (Fig. **11.42**) has at its center superimposed Doric and Ionic *porticos* (porches). Short, low wings are attached by continuing Doric *entablatures*. The simplicity and refinement of Jefferson's building go beyond reconstruction of Classical prototypes and appeal directly to the intellect.

MUSICAL CLASSICISM

In 1785 Michel Paul de Chabanon wrote, "Today there is but one music in all of Europe." The basis of this statement was music composed to appeal not only to the aristocracy but to the broad middle classes as well. The move toward equality and the popularizing of ideals typical of the *philosophes* had influenced artists, and they now aimed at a

11.42 Thomas Jefferson, Monticello, Charlottesville, Virginia, 1770–84 (rebuilt 1796–1800).

David – *The Oath of the Horatii*

David's famous painting *The Oath of the Horatii* concerns the conflict between love and patriotism. In legend, the leaders of the Roman and Alban armies, on the verge of battle, decided to resolve their conflicts by means of an organized combat between three representatives from each side. The three Horatius brothers represented Rome; the Curatius sons represented the Albans. A sister of the Horatii was the fiancée of one of the Curatius brothers. David's painting depicts the Horatii as they swear on their swords to win or die for Rome, disregarding the anguish of their sister.

The work captures a directness and intensity of expression that were to play an important role in Romanticism. But the starkness of outline, the strong geometric composition (which juxtaposes straight line in the men and curved line in the women), and the smooth color areas and gradations hold it to the more formal, Classical tradition. The style of *The Oath of the Horatii* is academic Neoclassicism. The scene takes place in a shallow picture box, defined by a severely simple architectural framework. The costumes are historically correct. The musculature, even the arms and legs of the women, has a surface devoid of warmth or softness, like the drapery.

It is ironic that David's work was admired and purchased by King Louis XIV, against whom David's revolutionary cries were later directed and whom David, as a member of the French Revolutionary Convention, would sentence to death. Neo-classicism increased in popularity and continued through the Napoleonic era and into the nineteenth century.

11.43 Jacques-Louis David, *The Oath of the Horatii*, 1784–5. Oil on canvas, c. 14 x 11 ft (4.27 x 3.35 m). Louvre, Paris.

wider audience. Eighteenth-century rationalism regarded excessive ornamentation and excessive complexity (both Baroque characteristics) as unsuitable when trying to meet a broader social mix on its own terms. Against the background of Neoclassicism, this prompted a move to order, simplicity, and careful attention to form. In music the style is known as Classical (the term was not applied until the nineteenth century) rather than Neoclassical or Classical revival. This is because music had no known Classical antecedents to revive, whereas other arts returned (more or less) to Greek and Roman prototypes. Music thus turned to Classical ideals, though not to Classical models.

The Classical style in music had, among others, five basic characteristics. The first of these is variety and contrast in *mood*. In contrast to Baroque style, which typically dealt with a single emotion, Classical pieces typically explore contrasts between moods. There may be contrasting moods within movements and also within themes. Changes in mood may be gradual or sudden; they are, however, as one might expect of a style called "Classical," well controlled, unified, and logical.

A second characteristic of Classical style is flexibility of *rhythm*. Classical music explores a wide variety of rhythms, utilizing unexpected pauses, syncopations, and frequent changes from long to shorter notes. As in mood, changes in rhythm may be sudden or gradual. A third characteristic of Classical style is a predominantly homophonic *texture*. Nonetheless, texture also is flexible, with sudden and gradual shifts from one texture to another.

A fourth characteristic is memorable *melody*. The themes of Classical music tend to be very tuneful, and often have a folk or popular flavor. Classical melodies tend toward balance and symmetry, again what one would expect of "Classical" works as we have seen them since the Athenian Greeks. Frequently Classical themes have two phrases of equal length. The second phrase often begins like the first but ends more decisively.

A fifth characteristic of Classical style is gradual changes in *dynamics*, in contrast to Baroque music, which employs sudden changes in dynamics (*step dynamics*). One of the consequences of this direction in composition was the replacement of the harpsichord with the piano, which was more capable of handling the subtlety of Classical dynamic patterns.

The Classical Sonata and Sonata Form

As we noted in Chapter 3, "sonata" has been used to denote many different musical forms, from a short piece for a single instrument to complex works in many sections or movements, for a large ensemble. By the middle of the eighteenth century, however, the sonata for one or two keyboard instruments, or for another instrument accompanied by keyboard, was utilized as an instrumental genre comparable to the symphony, which we discuss momentarily. These genres share a flexible multi-movement design that music analysts call the *sonata cycle*. The term *sonata form* refers to the form of a *single movement* and should not be confused with the term *sonata*, which describes a composition made of several movements. The sonata form, the most important musical structure of the Classical period, was used in symphonies, sonatas, and other genres mostly in the first movement, although sometimes in other movements as well. Sonata form has three main sections: *exposition* (where themes are presented), *development* (where themes are treated in new ways), and *recapitulation* (where the themes return). These three sections often are followed by a concluding section, the *coda* (Italian for tail). The three main sections comprise an ABA design.

The Classical Symphony

The word "symphony" comes from the Latin *symphonia* (in turn, based on a Greek word), meaning "a sounding together." In practical terms, a symphony is an extended, ambitious composition typically lasting between twenty and forty-five minutes and exploring the broad range of tone colors and dynamics of the Classical orchestra. Franz Josef Haydn (see below) began composing symphonies in the Classical sense about 1757. In his long life he solidified and enriched symphonic style, culminating in a set of twelve works composed for London in 1791–5 (called the "Salomon Symphonies," after the German impresario J. P. Salomon, who, in 1790, persuaded Haydn to go to England). Haydn wrote 104 symphonies (some scholars put the number higher), which were widely performed and imitated during his lifetime. Wolfgang Amadeus Mozart wrote forty-one symphonies, and his last six—No. 35 in D (*Haffner*), No. 36 in C (*Linz*), No. 38 in D (*Prague*), No. 39 in E-flat, No. 40 in G Minor, and No. 41 in C (*Jupiter*)—are complex in design and rich in orchestration, wedding formal perfection and expressive depth. Ludwig van Beethoven wrote only nine symphonies (1800–24), but in them he greatly increased the form's weight and size.

The Classical orchestra, which performed the Classical symphony, was typified by the supreme orchestra of the time, the court orchestra at Mannheim, Germany, which flourished in the third quarter of the century. It had approximately thirty string players and helped to standardize the remaining instrumental complement, specifically, two flutes, two oboes, two bassoons, two horns, two trumpets, two kettledrums, and a new instrument, the clarinet.

Beethoven increased the technical demands on every Classical orchestra by writing parts for piccolo, trombones, and contrabassoon. The finale of his *Symphony No. 9* also requires triangle, cymbals, and bass drum (in addition to choral voices).

Other Classical Forms

Although the sonata and symphony were the most important musical forms of this period, there were others. One form called *theme and variations* was widely used as an independent piece or as one movement of a symphony, sonata, or string quartet. In a theme and variations the theme (a basic musical idea) is repeated over and over, each time with some change—for example, mood, rhythm, dynamics and so on.

A form known as *minuet and trio*, or *minuet*, often occurs as the third movement of a symphony, string quartet, or other works. The form originated as a stately dance, but in Classical music it is designed for listening, not dancing. It has triple meter and, usually, a moderate tempo. Its ABA form consists of a minuet (A), trio (B), and minuet (A). The trio (B) section utilizes fewer instruments than the minuet (A) sections. Another form popular in the Classical time was the *rondo*. It features a melodic main theme (A) that returns several times, alternating with other themes. Other forms such as the concerto witnessed their own transformation into Classical characteristics.

Haydn

Austrian-born Franz Joseph Haydn (1732–1809) pioneered the development of the symphony from a short, simple work into a longer, more sophisticated one. Haydn's symphonies are diverse and numerous. Many of the early ones use the pre-Classical three-movement form. His middle symphonies, from the early 1770s, have more emotion and are on a larger scale than the earlier works. In particular, the development sections of the first movements are dramatic and employ sudden and unexpected changes of dynamics. The slow movements contain great warmth, and in the third movements Haydn frequently drew on Austrian folk songs and Baroque dance music. His changes of tonality contain great dramatic power.

11.44 Haydn, *Symphony No. 94 in G major*, first theme.

Among his late works the most famous is *Symphony No. 94 in G major* (1792), commonly known as the "Surprise Symphony" (Fig. **11.44**). The surprise is a very loud chord played by the full orchestra when it is least expected.

Mozart

Wolfgang Amadeus Mozart (1756–91), also an Austrian, was a child prodigy—he performed at the court of Empress Maria Theresa at the age of six. As was the case throughout the Classical period, aristocratic patronage was essential for musicians to earn a living, although the middle classes provided a progressively larger portion of commissions, pupil fees, and concert attendance. Mozart's short career (he died at the age of thirty-five) was dogged by financial insecurity.

His early symphonies are simple and relatively short, like those of Haydn, while his later works are longer and more complex. The last three are generally regarded as his greatest symphonic masterpieces, and *Symphony No. 40 in G minor* (Fig. **11.45**) is often referred to as the typical Classical symphony. This work and Nos. 39 and 41 have clear order and yet exhibit tremendous emotional urgency, which many scholars cite as the beginning of the Romantic style.

11.45 Mozart, *Symphony No. 40 in G minor*, first movement.

Mozart is also well known for his operas, and was especially skilled in *opera buffa*. *The Marriage of Figaro* is fast and humorous, with slapstick action in the manner of farce, but has great melodic beauty. In this quotation from the beginning of the opera (Fig. **11.46**) the main character, Figaro, is measuring the new bedroom his employer has allocated to him for his married life.

11.46 Mozart, *The Marriage of Figaro*, first theme of "Cinque . . . dieci" duet.

In a totally different vein, the final movement of Mozart's *Sonata No. 11 for Piano in A* (CD track 12) has always been a public favorite. Called the *Rondo alla Turca* or "Turkish Rondo," it has an exotic or "Turkish" character

underlined by the main theme in A minor (Fig. **11.47**) that reappears throughout the rondo, softly:

11.47 W. A. Mozart. *Sonata No. 11 for Piano in A* (K. 331) "Turkish Rondo."

Beethoven

Ludwig van Beethoven (1770–1827) is often considered apart from the Classical period and treated as a singular transitional figure between Classicism and Romanticism. Beethoven wanted to expand the Classical symphonic form to accommodate greater emotional character. The typical Classical symphony moves through contrasting movements; Beethoven continued that but began to work toward using a single theme throughout, thereby unifying the work.

Beethoven's symphonies are significantly different from those of Haydn and Mozart. They are more dramatic and use changing dynamics more often for emotional effects. Silence, too, is used as a device in pursuit of dramatic and structural ends. His works are also longer. He lengthened both the development section of sonata form and the coda.

He also changed traditional numbers and relationships among movements. In the Symphony No. 5 no break occurs between the third and fourth movements. Beethoven's symphonies draw heavily on imagery, for example heroism in Symphony No. 3 and pastoral settings in Symphony No. 6. The famous *Symphony No. 5 in C minor*, for example, begins with a motif that Beethoven described as "fate knocking at the door." The first movement (allegro con brio) develops according to typical sonata form (see definition, p. 77; CD track 13).

LITERATURE

SATIRE

Jonathan Swift represents the enlightened spirit in literature. An Anglo-Irish satirist and churchman, he wrote *Gulliver's Travels*, which mocks pomposity and woolly-headed idealism equally. His other famous work in prose, *A*

Modest Proposal, took satire to the very edge of horror with its chillingly deadpan suggestion that the English should solve the "Irish Problem" by eating the babes of the poor.

A Modest Proposal
Jonathan Swift
1667–1745

For Preventing the Children of Poor People in Ireland from Being a Burden to Their Parents or Country, and for Making Them Beneficial to the Public

It is a melancholy object to those who walk through this great town or travel in the country, when they see the streets, the roads and cabin doors, crowded with beggars of the female sex, followed by three, four, or six children, all in rags and importuning every passenger for an alms. These mothers, instead of being able to work for their honest livelihood, are forced to employ all their time in strolling to beg sustenance for their helpless infants, who, as they grow up, either turn thieves for want of work, or leave their dear native country to fight for the Pretender in Spain, or sell themselves to the Barbadoes.

I think it is agreed by all parties that this prodigious number of children in the arms, or on the backs, or at the heels of their mothers, and frequently of their fathers, is in the present deplorable state of the kingdom a very great additional grievance; and therefore whoever could find out a fair, cheap, and easy method of making these children sound, useful members of the commonwealth would deserve so well of the public as to have his statue set up for a preserver of the nation.

But my intention is very far from being confined to provide only for the children of professed beggars; it is of a much greater extent, and shall take in the whole number of infants at a certain age who are born of parents in effect as little able to support them as those who demand our charity in the streets.

As to my own part, having turned my thoughts for many years upon this important subject, and maturely weighed the several schemes of other projectors, I have always found them grossly mistaken in their computation. It is true, a child just dropped from its dam may be supported by her milk for a solar year, with little other nourishment; at most not above the value of two shillings which the mother may certainly get, or the value in scraps, by her lawful occupation of begging; and it is exactly at one year old that I propose to provide for them in such a manner as instead of being a charge upon their parents or the parish, or wanting food and raiment for the rest of their lives, they shall on the contrary contribute to the feeding, and partly to the clothing, of many thousands.

There is likewise another great advantage in my scheme, that it will prevent those voluntary abortions and that horrid practice of women murdering their bastard children, alas, too frequent among us, sacrificing the poor innocent babes, I doubt, more to avoid the expense than the shame, which would move tears and pity in the most savage and inhuman breast.

The number of souls in this kingdom being usually reckoned one million and a half, of these I calculate there may be about two hundred thousand couples whose wives are breeders; from which number I subtract thirty thousand couples who are able to maintain their own children, although I apprehend there cannot be so many under the present distresses of the kingdom; but this being granted, there will remain an hundred and seventy thousand breeders. I again subtract fifty thousand for those women who miscarry, or whose children die by accident or disease within the year. There only remain an hundred and twenty thousand children of poor parents annually born. The question therefore, is, how this number shall be reared and provided for, which, as I have already said, under the present situation of affairs, is utterly impossible by all the methods hitherto proposed. For we can neither employ them in handicraft or agriculture; we neither build houses (I mean in the country) nor cultivate land. They can very seldom pick up a livelihood by stealing till they arrive at six years old, except where they are of towardly parts; although I confess they learn the rudiments much earlier, during which time they can however be looked upon only as probationers, as I have been informed by a principal gentleman in the county of Cavan, who protested to me that he never knew above one or two instances under the age of six, even in a part of the kingdom so renowned for the quickest proficiency in that art.

I am assured by our merchants that a boy or a girl before twelve years old is no salable commodity; and even when they come to this age they will not yield above three pounds, or three pounds and half a crown at most on the Exchange; which cannot turn to account either to the parents or the kingdom, the charge of nutriment and rags having been at least four times that value.

I shall now therefore humbly propose my own thoughts, which I hope will not be liable to the least objection.

I have been assured by a very knowing American of my acquaintance in London, that a young healthy child well nursed is at a year old a most delicious, nourishing, and wholesome food, whether stewed, roasted, baked, or boiled; and I make no doubt that it will equally serve in a fricassee or a ragout.

I do therefore humbly offer it to public consideration that of the hundred and twenty thousand children, already computed, twenty thousand may be reserved for breed, whereof only one fourth part to be males, which is more than we allow to sheep, black cattle, or swine; and my reason is that those children are seldom the fruits of marriage, a circumstance not much regarded by our savages, therefore one male will be sufficient to serve four females. That the remaining hundred thousand may at a year old be offered in sale to the persons of quality and fortune through the kingdom, always advising the mother to let them suck plentifully in the last month, so as to render them plump and fat for a good table. A child will make two dishes at an entertainment for friends; and when the family dines alone, the fore or hind quarter will make a reasonable dish, and seasoned with a little pepper or salt will be very good boiled on the fourth day, especially in winter.

I have reckoned upon a medium that a child just born will weigh twelve pounds, and in a solar year if tolerably nursed increaseth to twenty-eight pounds.

I grant this food will be somewhat dear, and therefore very proper for landlords, who, as they have already devoured most of the parents, seem to have the best title to the children.

Infant's flesh will be in season throughout the year, but more plentiful in March, and a little before and after. For we are told by a grave author, an eminent French physician, that fish being a prolific diet, there are more children born in Roman Catholic countries about nine months after Lent than at any other season; therefore, reckoning a year after Lent, the markets will be more glutted than usual, because the number of popish infants is at least three to one in this kingdom; and therefore it will have one other collateral advantage, by lessening the number of Papists among us.

I have already computed the charge of nursing a beggar's child (in which list I reckon all cottagers, laborers, and four fifths of the farmers) to be about two shillings per annum, rags included; and I believe no gentleman would repine to give ten shillings for the carcass of a good fat child, which, as I have said, will make four dishes of excellent nutritive meat, when he hath only some particular friend or his own family to dine with him. Thus the squire will learn to be a good landlord, and grow popular among the tenants; the mother will have eight shillings net profit, and be fit for work till she produces another child.

Those who are more thrifty (as I must confess the times require) may flay the carcass; the skin of which artificially dressed will make admirable gloves for ladies, and summer boots for fine gentlemen.

As to our city of Dublin, shambles may be appointed for this purpose in the most convenient parts of it, and butchers we may be assured will not be wanting; although I rather recommend buying the children alive, and dressing them hot from the knife as we do roasting pigs.

A very worthy person, a true lover of his country, and whose virtues I highly esteem, was lately pleased in discoursing on this matter to offer a refinement upon my scheme. He said that many gentlemen of this kingdom, having of late destroyed their deer, be conceived that the want of venison might be well supplied by the bodies of young lads and maidens, not exceeding fourteen years of age nor under twelve, so great a number of both sexes in every county being now ready to starve for want of work and service; and these to be disposed of by their parents, if alive, or otherwise by their nearest relations. But with due deference to so excellent a friend and so deserving a patriot, I cannot be altogether in his sentiments, for as to the males, my American acquaintance assured me from frequent experience that their flesh was generally tough and lean, like that of our schoolboys, by continual exercise, and their taste disagreeable; and to fatten them would not answer the charge. Then as to the females, it would, I think with humble submission, be a loss to the public, because they soon would become breeders themselves; and besides, it is not improbable that some scrupulous people might be apt to censure such a practice (although indeed very unjustly) as a little bordering upon cruelty; which I confess, hath always been with me the strongest objection against any project, how well soever intended.

But in order to justify my friend, he confessed that this expedient was put into his head by the famous Psalmanazar, a native of the island Formosa, who came from thence to London

above twenty years ago, and in conversation told my friend that in his country when any young person happened to be put to death, the executioner sold the carcass to persons of quality as a prime dainty; and that in his time the body of a plump girl of fifteen, who was crucified for an attempt to poison the emperor, was sold to his Imperial Majesty's prime minister of state, and other great mandarins of the court, in joints from the gibbet, at four hundred crowns. Neither indeed can I deny that if the same uses were made of several plump young girls in this town, who without one single groat to the fortunes cannot stir abroad without a chair, and appear at the playhouse and assemblies in foreign fineries which they never will pay for, the kingdom would not be the worse.

Some persons of a desponding spirit are in great concern about that vast number of poor people who are aged, diseased, or maimed, and I have been desired to employ my thoughts what course may be taken to ease the nation of so grievous an encumbrance. But I am not in the least pain upon that matter, because it is very well known that they are every day dying and rotting by cold and famine, and filth and vermin, as fast as can be reasonably expected. And as to the younger laborers, they are now in almost as hopeful a condition. They cannot get work and consequently pine away for want of nourishment to a degree that if at any time they are accidentally hired to common labor, they have not strength to perform it; and thus the country and themselves are happily delivered from the evils to come.

I have too long digressed, and therefore shall return to my subject. I think the advantages by the proposal which I have made are obvious and many, as well as of the highest importance.

For first, as I have already observed, it would greatly lessen the number of Papists, with whom we are yearly overrun, being the principal breeders of the nation as well as our most dangerous enemies; and who stay at home on purpose to deliver the kingdom to the Pretender, hoping to take their advantage by the absence of so many good Protestants,who have chosen rather to leave their country than stay at home and pay tithes against their conscience to an Episcopal curate.

Secondly, the poorer tenants will have something valuable of their own, which by law be made liable to distress, and help to pay their landlord's rent, their corn and cattle being already seized and money a thing unknown.

Thirdly, whereas the maintenance of an hundred thousand children, from two years old and upwards, cannot be computed at less than ten shillings a piece per annum, the nation's stock will be thereby increased fifty thousand pounds per annum, besides the profit of a new dish introduced to the tables of all gentlemen of fortune in the kingdom who have any refinement in taste. And the money will circulate among ourselves, the goods being entirely of our own growth and manufacture.

Fourthly, the constant breeders, besides the gain of eight shillings sterling per annum by the sale of their children,will be rid of the charge of maintaining them after the first year.

Fifthly, this food would likewise bring great custom to taverns, where the vintners will certainly be so prudent as to procure the best receipts for dressing it to perfection, and consequently have their houses frequented by all the fine gentlemen, who justly value themselves upon their knowledge in good eating; and a skillful cook, who understands how to oblige his guests, will contrive to make it as expensive as they please.

Sixthly, this would be a great inducement to marriage, which all wise nations have either encouraged by rewards or enforced by laws and penalties. It would increase the care and tenderness of mothers toward their children, when they were sure of a settlement for life to the poor babes, provided in some sort by the public, to their annual profit instead of expense. We should see an honest emulation among the married women, which of them could bring the fattest child to the market. Men would become as fond of their wives during the time of their pregnancy as they are now of their mares in foal, their cows in calf, or sows when they are ready to farrow; nor offer to beat or kick them (as is too frequent a practice) for fear of miscarriage.

Many other advantages might be enumerated. For instance, the addition of some thousand carcasses in our exportation of barreled beef, the propagation of swine's flesh, and improvement in the art of making good bacon, so much wanted among us by the great destruction of pigs, too frequent at our tables, which are no way comparable in taste or magnificence to a well-grown, fat, yearling child, which roasted whole will make a considerable figure at a lord mayor's feast or any other public entertainment. But this and many others I omit, being studious of brevity.

Supposing that one thousand families in this city would be constant customers for infants' flesh, besides others who might have it at merry meetings, particularly weddings and christenings, I compute that Dublin would take off annually about twenty thousand carcasses, and the rest of the kingdom (where probably they will be sold somewhat cheaper) the remaining eighty thousand.

I can think of no one objection that will possible be raised against this proposal, unless it should be urged that the number of people will be thereby much lessened in the kingdom. This I freely own, and it was indeed one principal design in offering it to the world. I desire the reader will observe, that I calculate my remedy for this one individual kingdom of Ireland and for no other that ever was, is, or I think ever can be upon earth. Therefore let no man talk to me of other expedients: of taxing our absentees at five shillings a pound: of using neither clothes nor household furniture except what is of our own growth and manufacture: of utterly rejecting the materials and instruments that promote foreign luxury: of curing the expensiveness of pride, vanity, idleness, and gaming in our women: of introducing a vein of parsimony, prudence, and temperance: of learning to love our country, in the want of which we differ even from Laplanders and the inhabitants of Topinamboo: of quitting our animosities and factions, nor acting any longer like the Jews, who were murdering one another at the very moment their city was taken: of being a little cautious not to sell our country and conscience for nothing: of teaching landlords to have at least one degree of mercy toward their tenants: lastly, of putting a spirit of honesty, industry, and skill into our shopkeepers; who, if a resolution could now be taken to buy only our native goods, would immediately unite to cheat and exact upon us in the price, the measure, and the goodness, nor could ever yet be

brought to make one fair proposal of just dealing, though often and earnestly invited to it.

Therefore I repeat, let no man talk to me of these and the like expedients, till he hath at least some glimpse of hope that there will ever be some hearty and sincere attempt to put them in practice.

But as to myself, having been wearied out for many years with offering vain, idle, visionary thoughts, and at length utterly despairing of success, I fortunately fell upon this proposal, which, as it is wholly new, so it hath something solid and real, and no expense and little trouble, full in our own power, and whereby we can incur no danger in disobliging England. For this kind of commodity will not bear exportation, the flesh being of too tender a consistence to admit a long continuance, in salt, although perhaps I could name a country which would be glad to eat up our whole nation without it.

After all, I am not so violently bent upon my own opinion as to reject any offer proposed by wise men, which shall be found equally innocent, cheap, easy, and effectual. But before something of that kind shall be advanced in contradiction to my scheme, and offering a better, I desire the author or authors will be pleased maturely to consider two points. First, as things now stand, how they will be able to find food and raiment for an hundred thousand useless mouths and backs. And secondly, there being a round million of creatures in human figure throughout this kingdom, whose sole subsistence put into a common stock would leave them in debt two millions of pounds sterling, adding those who are beggars by profession to the bulk of farmers, cottagers, and laborers, and their wives and children who are beggars in effect; I desire those politicians who dislike my overture, and may perhaps be so bold to attempt an answer, that they will first ask the parents of these mortals whether they would not at this day think it a great happiness to have been sold for food at a year old in the manner I prescribe, and thereby have avoided such a perpetual scene of misfortunes as they have since gone through by the oppression of landlords, the impossibility of paying rent without money or trade, the want of common sustenance, with neither house nor clothes to cover them from the inclemencies of the weather, and the most inevitable prospect of entailing the like or greater miseries upon their breed forever.

I profess, in the sincerity of my heart, that I have not the least personal interest in endeavoring to promote this necessary work, having no other motive than the public good of my country, by advancing our trade, providing for infants, relieving the poor, and giving some pleasure to the rich. I have no children by which I can propose to get a single penny; the youngest being nine years old, and my wife past childbearing.[6]

SOCIAL OBSERVATION AND REFORM

Goldsmith

Eighteenth-century literature reflects the focus on the commonplace seen in Chardin's paintings. Day-to-day occur-rences are frequently used as symbols of a higher reality—for example, in the work of Oliver Goldsmith (1730–74), a prominent British poet and playwright. He grew up in the village of Lissoy, where his father was vicar. "The Deserted Village," written in 1770, describes the sights and personalities of his village.

> Sweet Auburn! Loveliest village of the plain
> Where health and plenty cheered the laboring swain;
> Where smiling spring its earliest visit paid,
> And parting summer's lingering blooms delayed,
> Dear lovely bowers of innocence and ease,
> Seats of my youth, where every sport could please;
> How often have I loitered o'er thy green,
> Where humble happiness endeared each scene!

His portrait of the old village parson includes a lovely simile:

> To them his heart, his love, his griefs were given,
> But all his serious thoughts had rest in heaven.
> As some tall cliff that lifts its awful form,
> Swells from the vale, and midway leaves the storm,
> Eternal sunshine settles on its head.

Finally, there is great tenderness in his description of an unfulfilled dream of ending his life amid the scenes in which it began.

> In all my wanderings round this world of care,
> In all my griefs—and God has given my share—
> I still had hopes, my latest hours to crown,
> Amid these humble bowers to lay me down,
> To husband out life's taper at the close,
> And keep the flame from wasting by repose.

> And as an hare whom hounds and horns pursue,
> Pants to the place from which at first she flew,
> I still had hopes my long vexations past,
> Here to return—and die at home at last.[7]

Johnson

The mid-eighteenth century is often called the Age of Johnson. Samuel Johnson began his literary career as a sort of miscellaneous journalist, writing for a newspaper in London. His principal achievement was as an essayist, and the 208 *Rambler* essays cover a huge variety of topics including "Folly of Anger: Misery of a Peevish Old Age" and "Advantages of Mediocrity: An Eastern Fable." His purpose was to promote the glory of God and the salvation of himself and others.

In 1758, Johnson began the *Idler Essays*, a weekly contribution to the *Universal Chronicle*. Here the moralist and social reformer is still present, together with an increasingly comic element.

The Idler

No. 22. Saturday, September 9, 1758
Samuel Johnson
1709–84

Many naturalists are of opinion, that the animals which we commonly consider as mute, have the power of imparting their thoughts to one another. That they can express general sensations is very certain; every being that can utter sounds, has a different voice for pleasure and for pain. The hound informs his fellow when he scents his game; the hen calls her chickens to their food by her cluck, and drives them from danger by her scream.

Birds have the greatest variety of notes; they have indeed a variety, which seems almost sufficient to make a speech adequate to the purposes of a life, which is regulated by instinct, and can admit little change or improvement. To the cries of birds, curiosity or superstition has been always attentive, many have studied the language of the feathered tribes, and some have boasted that they understood it.

The most skillful or most confident interpreters of the silvan dialogues have been commonly found among the philosophers of the East, in a country where the calmness of the air, and the mildness of the seasons, allow the student to pass a great part of the years in groves and bowers. But what may be done in one place by peculiar opportunities, may be performed in another by peculiar diligence. A shepherd of Bohemia has, by long abode in the forests, enabled himself to understand the voice of birds, at least he relates with great confidence a story of which the credibility may be considered by the learned.

"As I was sitting (said he) within a hollow rock, and watching my sheep that fed in the valley, I heard two vultures interchangeably crying on the summit of the cliff. Both voices were earnest and deliberate. My curiosity prevailed over my care of the flock; I climbed slowly and silently from crag to crag, concealed among the shrub, till I found a cavity where I might sit and listen without suffering, or giving disturbance.

"I soon perceived, that my labour would be well repaid; for an old vulture was sitting on a naked prominence, with her young about her, whom she was instructing in the arts of a vulture's life, and preparing, by the last lecture, for their final dismission to the mountains and the skies.

"'My children,' said the old vulture, 'you will the less want my instructions because you have had my practice before your eyes; you have seen me snatch from the farm the household fowl, you have seen me seize the leveret in the bush, and the kid in the pasture, you know how to fix your talons, and how to balance your flight when you are laden with your prey. But you remember the taste of more delicious food; I have often regaled you with the flesh of man.' 'Tell us,' said the young vultures, 'where man may be found, and how he may be known; his flesh is surely the natural food of a vulture. Why have you never brought a man in your talons to the nest?' 'He is too bulky,' said the mother; 'when we find a man, we can only tear away his flesh and leave his bones upon the ground.' 'Since man is so big,' said the young ones, 'how do you kill him? You are afraid of the wolf and of the bear, by what power are vultures superior to man, is man more defenseless than a sheep?' 'We have not the strength of man,' returned the mother, 'and I am sometimes in doubt whether we have the subtilty; and the vultures would seldom feast upon his flesh, had not nature, that devoted him to our uses, infused into him a strange ferocity, which I have never observed in any other being that feeds upon the earth. Two herds of men will often meet and shake the earth with noise, and fill the air with fire. When you hear noise and see fire which flashes along the ground, hasten to the place with your swiftest wing, for men are surely destroying one another; you will then find the ground smoking with blood and covered with carcasses, of which many are dismembered and mangled for the convenience of the vulture.' 'But when men have killed their prey,' said the pupils, 'why do they not eat it? When the wolf has killed a sheep he suffers not the vulture to touch it till he has satisfied himself. Is not man another kind of wolf?' 'Man,' said the mother, 'is the only beast who kills that which he does not devour, and this quality makes him so much a benefactor to our species.' 'If men kill our prey and lay it in our way,' said the young one, 'what need shall we have of labouring for ourselves?' 'Because man will, sometimes,' replied the mother, 'remain for a long time quiet in his den. The old vultures will tell you when you are to watch his motions. When you see men in great numbers moving close together, like a flight of storks, you may conclude that they are hunting, and that you will soon revel in human blood.' 'But still,' said the young one, 'I would gladly know the reason for this mutual slaughter. I could never kill what I could not eat.' 'My child,' said the mother, 'this is a question which I cannot answer, tho' I am reckoned the most subtle bird of the mountain. When I was young I used frequently to visit the ayry of an old vulture who dwelt upon the Carpathian rocks; he had made many observations; he knew the places that afforded prey round his habitation, as far in every direction as the strongest wing can fly between the rising and setting of the summer sun; he had fed year after year on the entrails of men. His opinion was, that men had only the appearance of animal life, being really vegetables with a power of motion; and that as the boughs of an oak are dashed together by the storm, that swine may fatten upon the falling acorns, so men are by some unaccountable power driven one against another, till they lose their motion, that vultures may be fed. Others think they have observed something of contrivance and policy among these mischievous beings, and those that hover more closely round them, pretend, that there is, in every herd, one that gives directions to the rest, and seems to be more eminently delighted with a wide carnage. What it is that intitles him to such pre-eminence we know not; he is seldom the biggest or the swiftest, but he shews by his eagerness and diligence that he is, more than any of the others, a friend to vultures.'"[8]

CHAPTER TWELVE

THE BEGINNINGS OF MODERNISM

c. 1800 TO c. 1900

IMPORTANT TERMS

Guardian figure An artistic manifestation believed to protect the remains of the dead.

Animism The belief that a spirit exists in every living thing.

Romanticism A wide-ranging style and philosophy that emphasizes emotional appeal, personalization, and imagination.

Art song A solo musical composition for voice, usually with piano accompaniment.

Program music Music composed around a nonmusical story, a picture, or some other idea.

Idée fixe A recurrent melodic motif representing a nonmusical idea.

Requiem A mass for the dead.

Gesamtkunstwerk A comprehensive work of art in which music, poetry, and scenery are all subservient to the central generating idea.

Leitmotif A musical theme that is tied to an idea, a person, or an object.

Melodrama A genre of theatre typically characterized by sensationalism and sentimentality, with stereotyped characters and exaggerated action.

Realism A style of painting and sculpture based on the theory that the method of presentation should be true to life.

Impressionism A style in painting emphasizing the presence of color and the interrelated mechanisms of the camera and the eye. A musical style exemplified by Debussy, using reduced melodic development and gliding chords.

Post-Impressionism A very diverse and personal style of visual art typically concerned with capturing sensory experience and insisting on "art for art's sake" and a return to form and structure.

Art Nouveau A style of architecture characterized by the lively, serpentine curve and a fascination with plant and animal life and organic growth.

12.2 (*right*) Katsushika Hokusai, Page from *Manga*, vol. 8, 1817. Woodcut, 9 x 5¾ ins (22.8 x 14.6 cm). British Museum, London.

12.1 (*below*) Katsushika Hokusai, *The Great Wave off Kanazawa*, 1823–9. Polychrome woodblock print, 10 x 14¾ ins (25.5 x 37.5 cm). Victoria & Albert Museum, London.

JAPANESE STYLE IN PRINTMAKING

In the nineteenth century, as Japan began to look westward, the style of the country's two-dimensional art began to evolve. Some of the changes can be seen in the works of two printmakers, Katsushika Hokusai (1760–1849) and Ando Hiroshige (1797–1858).

HOKUSAI

Hokusai broadened subject matter to include all aspects of Japanese life. In particular, his prints document in detail the streetlife in and around Edo. His works, entitled *Manga*, fill fifteen volumes, which he began to publish in 1814. Full of vibrancy, virility, and humor, his works show humankind in all its contrasting nobility and gracelessness. In a woodcut from *Manga* he portrays acrobats in

various attitudes (Fig. **12.2**). They seem oblivious of any observer, and their antics reveal an earthy forthrightness that seems totally at odds with the graceful power one would normally associate with them. They seem cartoonish caricatures, and yet there is vitality, energy, and suppleness within the unflattering representation.

In his landscapes, Hokusai forged new directions in Japanese art. *The Great Wave off Kanazawa*, for example (Fig. **12.1**), is a boldly colored rendering that is neither realistic nor idealized. While Mount Fuji reposes calmly in the background, the great wave breaks over the boats with raging fury, and the foam reaches out like grasping fingers to crash down on the fragile craft. There is a new sense of directness here, and yet Hokusai's response to natural forms and his decorative patterning lie firmly within the traditions of Japanese art.

HIROSHIGE

A similar freshness can be seen in the strongly colored landscape, *Maple Leaves at the Tekona Shrine, Mamma*, by Hiroshige (Fig. **12.5**). Unlike the perspective treatment of artists we have previously seen, it shows deep space in a novel fashion, using the foreground to "frame" the distance. Hiroshige uses neither linear nor atmospheric perspective to achieve the illusion of deep space and yet the portrayal appears rational. The distance seems logical even though the colors and details are the same in foreground and background. Only the trees exhibit any degree of foreshortening. Our vision is pulled back and forth in space as the red maple leaves—placed directly in our line of sight to the distance—constantly compete with middle ground and background for our attention. Thus, we are invited to focus on the series of huts staggered across a line, which divides the print into fourths. Downward deflecting leaves and a strong, dark border redirect us into the painting at the top, while the framing diagonals of the tree trunks carry us back into the lower fourth of the work. There is clever manipulation of hue, value, and contrast to keep interest and control. The red leaves and complementary gray-green limbs and mountains strike a harmonious visual chord, and the ocher grass, thatched roofs, and lightened sky stand in contrast—both in tone and value—to create a counterpoint and to hold our vision stable in the center of the work.

AFRICA AND EARLY BLACK AMERICA

ART AND ANCESTOR WORSHIP

One of the most widespread features of animistic societies such as those in tribal Africa is ancestor worship (the term "animism" is the belief that a spirit exists in every living thing). Ancestor worship takes a variety of forms, depending on the tribe, and its artistic manifestations also vary widely. One form is the *guardian figure*, used to protect the remains of the dead. In Gabon in Equatorial Africa, the Kota tribe of the last century produced polished metal figures which guarded large containers of skulls of ancestors—believed to be communal dwellings of ancestor spirits. The guardian figure in Figure **12.3** is in an abstract geometric style typical of the art of primitive societies. Despite its abstraction, the anatomical parts of the body are clearly defined. The entire design has been flattened into a single plane, and the work is perfectly symmetrical in balance. It has a calming effect: This guardian was clearly not intended to frighten the viewer.

The animism of the Kota people is all-embracing—for example, trees have spirits that must be appeased before the tree can be cut down; the individual tree spirit merges

12.3 Guardian figure of the Kota tribe, from Gabon, late 19th century. Wood, brass, ivory (?) eyes, height 16⅝ ins (42.2 cm). Metropolitan Museum of Art, New York (Michael C. Rockefeller Memorial Collection, Bequest of Nelson Rockefeller).

12.4 Mask, from the Bamenda area, Cameroon, late 19th century. Wood, height 26½ ins (67.3 cm). Rietberg Museum, Zürich (Heydt Collection).

with a general "tree spirit"; this in turn merges with a larger "life spirit." Spirits are believed to dwell in rivers, lakes, forests, the sun, the moon, wind, and rain. In dealing with the spirit world, tribal peoples act out relationships with the spirits in dances and other dramatic ceremonies. Sometimes they disguise themselves so as to assume the role of the spirit temporarily. In the Bamenda area of Cameroon, the traditional costume for these ceremonies features a prominent mask. The one shown in Figure **12.4** is typical. Like the guardian figure, it has a symmetrical composition and distinct detailing. Again the design is abstract while leaving anatomical details recognizable. The elevated eyebrows with their delicate arching lines give the mask a sophisticated and striking appearance. Its dignity and strength stem from its straightforwardness and the solidity of its detailing.

TRANSPORTATION TO AMERICA

The European colonization of Africa had a negative impact on African art. More important was the transportation of African culture to the Americas as a result of the slave trade that serviced the plantation lifestyle of the American South. The blending of Euro- and African-centered cultures created a significant African American artistic heritage in the colonies (that were to become the United States). It emerged publicly during and immediately after the Civil War (1861–5), and has been felt most strongly in music.

AFRICAN AMERICAN MUSIC

African American music consists of three basic types: folk music, art music, and popular music. Each has its own idiom, function, and place in the sociology of African American culture. Folk music—for example, the spiritual—is anonymous in origin, orally transmitted, and shows the "expressive melodic and racial feeling, character, and expression of the people."[1] This was a profoundly social musical form that defined a coherent experience for a dislocated people, supported people in distress, occasionally contained coded language of rebellion and escape, and provided a subtle language for exploring emotional extremities. Art music has a technical tradition in the hands of a group of highly trained specialists involved in both creation and performance. Popular music—for example, blues, ragtime, jazz, and soul—combines the art and folk traditions. It concerns itself with the contemporary world, seeks novelty, and tends to be faddish. We will briefly examine some of the folk music of the African American tradition that is appropriate to the time-frame of this chapter.

As Northern soldiers, journalists, and missionaries arrived in the South toward the end of the Civil War, their reports created a new interest in and documentation of the culture of African Americans—especially their music. Numerous chronicles of this music can be found in newspaper and journal articles, letters, and other documents from the mid-1860s. In these lies the record of a musical heritage that expresses the joys and sorrows, thoughts and reactions of a people immersed in a struggle for freedom.

African Americans played numerous roles in the war: They were, for example, body servants for Southern officers, soldiers, cooks, hospital attendants, and railroad workers. Out of one unsuccessful attempt to organize freed men for military service came a plaintive song of regret:

> Oh Lord, I want some valiant soldier,
> I want some valiant soldier,
> I want some valiant soldier,
> To help me bear de cross.
> For I weep, I weep,
> For I weep, I weep,
> I can't hold out;
> If any mercy, Lord,
> O pity poor me.[2]

On the eve of the expected Emancipation Proclamation, December 31, 1862, a prayer meeting and song service vigil

12.5
Ando Hiroshige,
*Maple Leaves at the
Tekona Shrine,
Mamma*, 1857.
Polychrome wood-
block print,
13¾ x 9 ¾ ins
(35 x 24 cm).
British Museum,
London.

held in the District of Columbia produced a spontaneous musical outpouring:

Go Down Moses was sung several times . . . in [the] contraband camp. Afterwards, a woman on her knees loudly sang:

If de Debble do not ketch
Jeff Davis, dat infernal retch,
An roast and frigazee dat rebble,
Wat is de use ob any Debble?

Then one contraband began the following strain:

The first of January next, eighteen sixty-three,—
So says the Proclamation,—the slaves will all be free!
To every kindly heart 'twill be the day of jubilee;
For the bond shall all go free!

Next a small black man, "with a cracking voice, appearing by his gestures to be inwardly on fire," began jumping and singing.

The whole company then proclaimed:

Oh! we all longed for freedom,
Ah, we prayed to be free;
Though the day was long in coming,
That we longed to see.
We'll strive to learn our duty,
That all our friends may see,
Though so long oppressed in bondage,
We were worthy to be free.[3]

By the end of the war, nearly 200,000 African Americans had served as soldiers in 166 regiments. Nearly 20,000 had served as sailors—almost one quarter of the entire United States Navy. Casualties numbered around 70,000, with approximately 30,000 killed. African Americans fought well and sang well. They linked their military struggle with their belief in a kind and liberating God. They wanted to be free, and one chronicle recorded this soldier's prayer:

I hab lef' my wife in de land o' bondage; my little ones dey say eb'ry night, War is my fader? But when I die, when de bressed mornin' rises, when I shall stan' in de glory, wid one foot on de water an' one foot on de land, den O Lord, I shall see my wife an' my little chil'en once more.[4]

Imprisoned slaves in Richmond echoed in song their hopes of imminent freedom:

Slavery's chain done broke at las'!
Broke at las'! Broke at las'!
Most done waiting for de mornin' star!
Gonna praise God till I die![5]

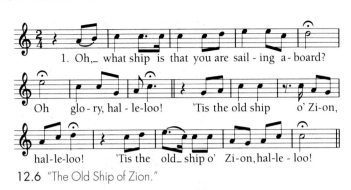

12.6 *"The Old Ship of Zion."*

The songs of slavery and the American South fill volumes. Clearly, music formed the core of the African American's life and culture during the two centuries of bondage. There were slave songs, religious folk songs, camp meeting songs, and spirituals. Most had strong religious themes—for example, the slave song "The Old Ship of Zion" (Fig. 12.6).

2. Oh, what are the timbers for buildin' of the ship?
 Oh glory, halleloo!
She is made o' gospel timbers, halleloo!
She is made o' gospel timbers, halleloo!

3. Oh what is the compass you've got aboard the ship?
 Oh glory, halleloo!
The Bible is our compass, halleloo!
Oh, the Bible is our compass, halleloo!

The spiritual remains the most popular of the African American genres. A common misconception is that most of this music is in the minor key—it is not. It *is* a commentary on the awful state of the African American's daily life, yet it is full of patience for that life coupled with triumph in the life to come. Some songs focus on the present and some on the future, but the two were inexorably tied together, at least by implication. For example, in the spiritual "This World Almost Done" we hear the patient reminder,

Brudder, keep your lamp trimmin' and a-burnin',
Keep your lamp trimmin' and a-burnin',
Keep your lamp trimmin' and a-burnin',
 For dis world most done.
So keep your lamp trimmin' [etc.]
 For dis world most done.[6]

In "I Want to Go Home" the patience remains, but the final reward is proclaimed:

Dere's no rain to wet you,
 O, yes, I want to go home.
Dere's no sun to burn you,
 O, yes, I want to go home.
O, push along, believers,

O, yes, I want to go home.
Dere's no hard trials,
 O, yes, I want to go home.
Dere's no whips a crackin',
 O, yes, I want to go home.
My brudder on de wayside,
 O, yes, I want to go home.
O, push along, my brudder,
 O, yes, I want to go home.
Where dere's no stormy weather,
 O, yes, I want to go home.
Dere's no tribulation,
 O, yes, I want to go home.[7]

The first 250 years of African American cultural history reflect a diversity of reactions: Sometimes the people howled in alarm; sometimes they fought back and learned the advantages of resistance. They certainly did not "accept" slavery and oppression. The music of the time reflected the mind of the people and their circumstances.

The influence of this outpouring of musical expression in the folk idiom has been pervasive, and it has become a significant part not only of African American culture, but of American culture as a whole. In 1914 Henry Edward Krehbiel asserted:

> Is it not the merest quibble to say that these songs are not American? They were created in America under American influences and by people who are Americans in the same sense that any other element of our population is American—every element except the aboriginal.[8]

NATIVE AMERICA

Native American artists pursue many of the same goals of artists from any culture—they try to evoke emotional responses in the viewer. But in the case of Native American artists, the viewer might be a supernatural being. Much of their art deals with religious matters, and its purpose is like that of prayer—to entreat a benign god or placate a hostile one. Tradition dictates the manner or form. In fact, in Native American culture a major criterion for "art" is how well the artist recognizes the force of tradition. Little room for artistic experimentation exists within the established tribal organization. However, there are exceptions, and artists such as Nampeyo, the Hopi potter, have been able to introduce new elements to the cultural tradition, perhaps solely by the force of their individual talent.

INFLUENCES

Naturally, many different factors have influenced Native American works of art. Function is one factor. Environment is another: The accessibility of materials has played an important role in determining the nature of Native American art. For example, availability of soapstone and lack of access to clay have meant that Inuit art is carved rather than ceramic. In addition, traditions have sometimes mixed as one people conquers another or as intertribal marriage occurs, thereby creating new traditions. Often, tribal groups such as the Hopi and Navajo share a common environment and lifestyle, and the function of their art is similar. Tradition and tribal integrity, however, keep their styles separate, and the works of both cultures remain distinguishable.

SYMBOLISM

The meaning of works of art from Native American cultures can prove baffling to someone raised in a Euro-centered culture. Native American artists do not draw merely to recreate a picture of something, for they understand that they could not draw a tree as perfectly as it could be made by the Creator. This spiritual consciousness finds its way into the works of art. "Therefore, it can be said that Indian art is not so much drawings, carvings or reproductions *of* an object, but more the representation of the spirit *within* it. In short, it embodies the essence of the subject as well as its appearance."[9] Native American art has a magical quality rather than a "meaning" in the sense that Western minds expect.

INUIT STYLE

In a wide band of the Arctic, stretching right across North America, hundreds of tribes comprise the Inuit culture. All of them are related culturally and/or linguistically. Out of the bleak and inhospitable environment of the North—where the quest for survival would seemingly leave little room for artistry—comes a tremendously imaginative artistic tradition. The long Arctic winter nights have given individuals ample time to carve ivory obtained from walrus and killer whales and, more recently, stone. Because of the difficulty of obtaining materials, Inuit art tends to be small in scale. In the case of tusk ivory, it is of necessity larger at one end than at the other. Characteristic of Inuit art is humor: Caricatures found in the form of driftwood masks are common (Fig. **12.7**). This mask was originally decorated with snow goose feathers. It is typical of the elaborate or grotesque dance masks that are widely crafted among the Inuit people. They depict a variety of subjects—sacred and secular, human and animal.

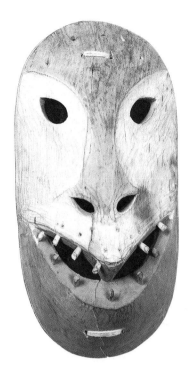

12.7 (*left*) Carved dance masks of the Inuit tribe, from Mamtrek, Alaska, late 19th century. Wood (originally decorated with snow goose feathers), 8½ x 4½ ins (21.6 x 11.4 cm). National Museum of the American Indian, Smithsonian Institution, Washington, D.C.

12.8 (*right*) Housepost, from Haida, Alaska, 19th century. Wood, height 11 ft 6½ ins (3.52 m). National Museum of the American Indian, Smithsonian Institution, Washington, D.C.

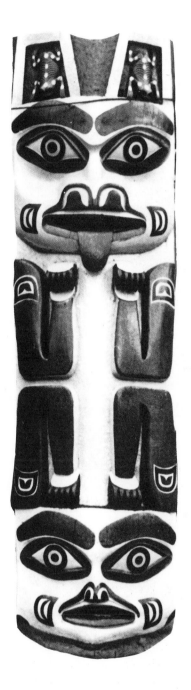

NORTHWEST COASTAL STYLE

The Pacific Northwest of North America produced stable Native American cultures. This is in great measure due to the abundance of resources and temperate climate, which figure prominently in the social and cultural fabric of the tribes. Fishing, hunting, and foraging produce ample means of sustenance, and therefore, the people of this region had no reason to cultivate crops or domesticate animals. Their cultures have tended to share certain features, probably because they traded and warred with one another. Artistic motifs are alike and they share a common religion, shamanism—an ancient form of magic, centered on wise, all-seeing men (shamans). (It is also shared with the hunting tribes of Siberia and various African cultures.) Although their pantheons and myths may differ, the Northwest tribes all acknowledge the power of shamans to contact the spirits of the forest and waters, to heal the sick, and to predict the future.

The rich forests of the area have provided Native American artists with a wealth of materials for sculpting. Huge spruce and cedar trees abounded for many centuries, and when steel knives were obtained from fur traders and used as tools, Northwest-coast artists excelled in producing magnificent totem poles, carved posts for wooden dwellings, masks, rattles, and other objects. Figure **12.8** shows a carved housepost that was used inside a wooden dwelling to support the roof and to give additional decoration to the interior. It depicts the sea bear and has a frog carved in each ear. It was presented as a token of respect to Chief Frog Ears of Sukkwan by the people of a neighboring village. Proximity to the sea also provided abalone shells that were used as inlays to give luster to sculpted works.

Although many art objects from the area, such as masks, concern themselves with shamanistic religious rituals, a fair amount of art is secular. Like some African art, it is used to maintain the social fabric and bolster a ruler's power. In the Tlingit tribe, for example, communities are made up of a number of families, each of which has its own chief who inherits his rank from his mother. Carefully devised social customs oblige both men and women to

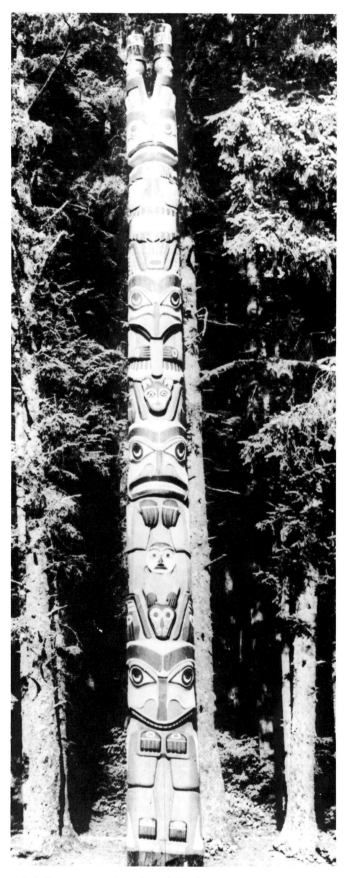

12.9 Tlingit totem pole, Sitka, Alaska, late 19th century. Carved and painted wood.

marry outside their own clan. In this way a balance is established in which no one family achieves dominance. None the less, chiefs compete fiercely with each other in displays of riches. Totem poles form a part of this ostentation, proclaiming prestige and family pride through genealogy—much like the coats of arms of the European aristocracy. Totem poles are carved from single tree trunks and often reach a height of 90 feet (27.4 m). Probably originating as funerary monuments, by the nineteenth century they had become fixtures adorning the exteriors of chiefs' houses.

Eagles, beavers, and whales appear on the totem poles (Fig. **12.9**), in essence as crests that a chief inherited from his ancestors. The Tlingit do not worship these figures or have any supernatural relationship with them. They are governed by traditional artistic principles. One of these is that of bilateral symmetry—the designs on either side of the central axis are identical. Another specifies the transition from one motif to another: Each design must appear to grow from the one below. Thus, not only the overall vertical form of the totem pole, but also the design of its interior parts, leads the eye upward along its central axis. In our example, the patchwork of contrasting colors and upward striving line carry us with rhythmic precision from one motif to another until, finally, we reach the top. At the top, a darkly colored, triangular form and a strong horizontal capping band redirect the eye downward.

As historical documents that record the wealth, social position, and relative importance of the person who paid for them, totem poles are quite similar to sculptural records from other cultures. The ultimate function of such art was probably to act as a gift: "The life goal of many of these tribes involved the belief that the greatest value was to give away all of one's possessions."[10] The actual working out of such a philosophy created some interesting scenarios. The more one gave away, the greater was one's prestige. In turn, one's rival was more or less obliged to give back the same or more material wealth in order to prove greater disdain for possessions. As a result, totems and other goods were often burned, thrown into the sea, or otherwise destroyed. It even went so far that slaves were occasionally killed and entire families sold into slavery.

LITERARY STYLE

Literacy among Native Americans began to take hold in the late eighteenth century as a result of missionary activity—particularly that of Methodists and Presbyterians—and a century later, increased interest in America's heritage gave rise to the publication of tribal histories written by Native Americans. Fiction writing among Native Americans appeared as early as 1823.

Between 1870 and 1920, Native American culture underwent tremendous change: Tribal autonomy decreased, and all tribes within the territory of the United States were confined to reservations. By the end of 1870, the federal government had become actively involved in Native American education, and a subsequent increase in literacy produced something of an intellectual elite. Numerous authors emerged, one of whom was "Bright Eyes" (Susette La Flesche). Her story "Nedawi" was first published in 1881 in a popular magazine for children. It arguably represents the first short story written by a Native American that is not a reworking of a legend. The author's gender testifies to the prominence of women in Native American (as well as American) literature. Describing a past way of life in nostalgic terms, "Nedawi" is representative of much of Native American fiction prior to 1920. The story emphasizes ethnocentric detail, has a strong moralistic tone, and appeals to young readers.

Nedawi

An Indian Story from Real Life
"Bright Eyes" (Susette La Flesche)

"Nedawi!" called her mother, "take your little brother while I go with your sister for some wood." Nedawi ran into the tent, bringing back her little red blanket, but the brown-faced, roly-poly baby, who had been having a comfortable nap in spite of being all the while tied straight to his board, woke with a merry crow just as the mother was about to attach him, board and all, to Nedawi's neck. So he was taken from the board instead, and, after he had kicked in happy freedom for a moment, Nedawi stood in front of her mother, who placed Habazhu on the little girl's back, and drew the blanket over him, leaving his arms free. She next put into his hand a little hollow gourd, filled with seeds, which served as a rattle; Nedawi held both ends of the blanket tightly in front of her, and was then ready to walk around with the little man.

Where should she go? Yonder was a group of young girls playing a game of *konci*, or dice. The dice were five plum-seeds, scorched black, and had little stars and quarter-moons instead of numbers. She went over and stood by the group, gently rocking herself from side to side, pretty much as white children do when reciting the multiplication table. The girls would toss up the wooden bowl, letting it drop with a gentle thud on the pillow beneath, the falling dice making a pleasant clatter which the baby liked to hear. The stakes were a little heap of beads, rings, and bracelets. The laughter and exclamations of the girls, as some successful toss brought down the dice three stars and two quarter-moons (the highest throw), made Nedawi wish that she, too, were a young girl, and could win and wear all those pretty things. How gay she would look! Just then, the little glittering heap caught baby's eye. He tried to wriggle out of the blanket to

get to it, but Nedawi held tight. Then he set up a yell. Nedawi walked away very reluctantly, because she wanted to stay and see who would win. She went to her mother's tent, but found it deserted. Her father and brothers had gone to the chase. A herd of buffalo had been seen that morning, and all the men in the tribe had gone, and would not be back till night. Her mother, her sister, and the women of the household had gone to the river for wood and water. The tent looked enticingly cool, with the sides turned up to let the breeze sweep through, and the straw mats and soft robes seemed to invite her to lie down on them and dream the afternoon away, as she was too apt to do. She did not yield to the temptation, however, for she knew Mother would not like it, but walked over to her cousin Metai's tent. She found her cousin "keeping house" with a number of little girls, and stood to watch them while they put up little tents, just large enough to hold one or two girls.

"Nedawi, come and play," said Metai. "You can make the fire and cook. I'll ask Mother for something to cook."

"But what shall I do with Habazhu?" said Nedawi.

"I'll tell you. Put him in my tent, and make believe he's our little old grandfather."

Forthwith he was transferred from Nedawi's back to the little tent. But Habazhu had a decided objection to staying in the dark little place, where he could not see anything, and crept out of the door on his hands and knees. Nedawi collected a little heap of sticks, all ready for the fire, and went off to get a fire-brand to light it with. While she was gone, Habazhu crawled up to a bowl of water which stood by the intended fire-place, and began dabbling in it with his chubby little hands, splashing the water all over the sticks prepared for the fire. Then he thought he would like a drink. He tried to lift the bowl in both hands, but only succeeded in spilling the water over himself and the fire-place.

When Nedawi returned, she stood aghast; then, throwing down the brand, she took her little brother by the shoulders and, I am sorry to say, shook him violently, jerked him up, and dumped him down by the door of the little tent from which he had crawled. "You bad little boy!" she said. "It's too bad that I have to take care of you when I want to play."

You see, she was no more perfect than any little white girl who gets into a temper now and then. The baby's lip quivered, and he began to cry. Metai said to Nedawi: "I think it's real mean for you to shake him, when he doesn't know any better."

Metai picked up Baby and tried to comfort him. She kissed him over and over, and talked to him in baby language. Nedawi's conscience, if the little savage could be said to have any, was troubling her. She loved her baby brother dearly, even though she did get out of patience with him now and then.

"I'll put a clean little shirt on him and pack him again," said she, suddenly. Then she took off his little wet shirt, wrung it out, and spread it on the tall grass to dry in the sun. Then she went home, and, going to a pretty painted skin in which her mother kept his clothes, she selected the red shirt, which she thought was the prettiest. She was in such a hurry, however, that she forgot to close and tie up the skin again, and she carelessly left his clean shirts lying around as she had laid them out. When Baby was on her back again, she walked around with him, giving

directions and overseeing the other girls at their play, determined to do that rather than nothing.

The other children were good-natured, and took her ordering as gracefully as they could. Metai made the fire in a new place, and then went to ask her mother to give her something to cook. Her mother gave her a piece of dried buffalo meat, as hard as a chip and as brittle as glass. Metai broke it up into small pieces, and put the pieces into a little tin pail of water, which she hung over the fire. "Now," she said, "when the meat is cooked and the soup is made, I will call you all to a feast, and Habazhu shall be the chief."

They all laughed. But alas for human calculations! During the last few minutes, a shy little girl, with soft, wistful black eyes, had been watching them from a little distance. She had on a faded, shabby blanket and a ragged dress.

"Metai," said Nedawi, "let's ask that girl to play with us; she looks so lonesome."

"Well," said Metai, doubtfully, "I don't care; but my mother said she didn't want me to play with ragged little girls."

"My father says we must be kind to poor little girls, and help them all we can; so I'm going to play with her if you don't," said Nedawi, loftily.

Although Metai was the hostess, Nedawi was the leading spirit, and had her own way, as usual. She walked up to the little creature and said, "Come and play with us, if you want to." The little girl's eyes brightened, and she laughed. Then she suddenly drew from under her blanket a pretty bark basket, filled with the most delicious red and yellow plums. "My brother picked them in the woods, and I give them to you," was all she said. Nedawi managed to free one hand, and took the offering with an exclamation of delight, which drew the other girls quickly around. Instead of saying "Oh! Oh!" as you would have said, they cried "Hin! Hin!" which expressed their feeling quite as well, perhaps.

"Let us have them for our feast," said Metai, taking them.

Little Indian children are taught to share everything with one another, so it did not seem strange to Nedawi to have her gift looked on as common property. But, while the attention of the little group had been concentrated on the matter in hand, a party of mischievous boys, passing by, caught sight of the little tents and the tin pail hanging over the fire. Simultaneously, they set up a war-whoop and, dashing into the deserted camp, they sent the tent-poles scattering right and left, and snatching up whatever they could lay hands on, including the tin pail and its contents, they retreated. The little girls, startled by the sudden raid on their property, looked up. Rage possessed their little souls. Giving shrieks of anger, they started in pursuit. What did Nedawi do? She forgot the plums, baby, and everything. The ends of the blanket slipped from her grasp, and she darted forward like an arrow after her companions.

Finding the chase hopeless, the little girls came to a standstill, and some of them began to cry. The boys had stopped, too; and seeing the tears flow, being good-hearted boys in spite of their mischief, they surrendered at discretion. They threw back the articles they had taken, not daring to come near. The did not consider it manly for big boys like themselves to strike or hurt

little girls, even though they delighted in teasing them, and they knew from experience that they would be at the mercy of the offended party if they went near enough to be touched. The boy who had the dinner brought the little pail which had contained it as near as he dared, and setting it down ran away.

"You have spilt all our soup. There's hardly any of it left. You bad boys!" said one of the girls.

They crowded around with lamentations over their lost dinner. The boys began to feel remorseful.

"Let's go into the woods and get them some plums to make up for it."

"Say, girls, hand us your pail, and we'll fill it up with plums for you."

So the affair was settled.

But, meanwhile, what became of the baby left so unceremoniously in the tall grass? First he opened his black eyes wide at this style of treatment. He was not used to it. Before he had time, however, to make up his mind whether to laugh or cry, his mother came to the rescue. She had just come home and thrown the wood off her back, when she caught sight of Nedawi dropping him. She ran to pick him up, and finding him unhurt, kissed him over and over. Some of the neighbors had run up to see what was the matter. She said to them:

"I never did see such a thoughtless, heedless child as my Nedawi. She really has 'no ears.' I don't know what in the world will ever become of her. When something new interests her, she forgets everything else. It was just like her to act in this way."

Then they all laughed, and one of them said:

"Never mind—she will grow wiser as she grows older," after which consoling remark they went away to their own tents.

It was of no use to call Nedawi back. She was too far off.

Habazhu was given over to the care of the nurse, who had just returned from her visit. An hour or two after, Nedawi came home.

"Mother!" she exclaimed, as she saw her mother frying bread for supper, "I am so hungry. Can I have some of that bread?"

"Where is your little brother?" was the unexpected reply.

Nedawi started. Where *had* she left him? She tried to think.

"Why, Mother, the last I remember I was packing him, and—and oh, Mother! you *know* where he is. Please tell me."

"When you find him and bring him back to me, perhaps I shall forgive you," was the cold reply.

This was dreadful. Her mother had never treated her in that way before. She burst into tears, and started out to find Habazhu, crying all the way. She knew that her mother knew where baby was, or she would not have taken it so coolly; and she knew also that her mother expected her to bring him home. As she went stumbling along through the grass, she felt herself seized and held in somebody's strong arms, and a great, round, hearty voice said:

"What's the matter with my little niece? Have all her friends deserted her that she is wailing like this? Or has her little dog died? I thought Nedawi was a brave little woman."

It was her uncle Two Crows. She managed to tell him, through her sobs, the whole story. She knew, if she told him herself, he would not laugh at her about it, for he would sympathize in her

troubles, though he was a great tease. When she ceased, he said to her: "Well, your mother wants you to be more careful next time, I suppose; and, by the way, I think I saw a little boy who looked very much like Habazhu, in my tent."

Sure enough, she found him there with his nurse. When she got home with them, she found her mother,—her own dear self,—and, after giving her a big hug, she sat quietly down by the fire, resolved to be very good in the future. She did not sit long, however, for soon a neighing of horses, and the running of girls and children through the camp to meet the hunters, proclaimed their return. All was bustle and gladness throughout the camp. There had been a successful chase, and the led horses were laden with buffalo meat. These horses were led by the young girls to the tents to be unpacked, while the boys took the hunting-horses to water and tether in the grass. Fathers, as they dismounted, took their little children in their arms, tired as they were. Nedawi was as happy as any in the camp, for her seventeen-year-old brother, White Hawk, had killed his first buffalo, and had declared that the skin should become Nedawi's robe, as soon as it was tanned and painted.

What a pleasant evening that was to Nedawi, when the whole family sat around a great fire, roasting the huge buffalo ribs, and she played with her little brother Habazhu, stopping now and then to listen to the adventures of the day, which her father and brothers were relating! The scene was truly a delightful one, the camp-fires lighting up the pleasant family groups here and there, as the flames rose and fell. The bit of prairie where the tribe had camped had a clear little stream running through it, with shadowy hills around, while over all hung the clear, star-lit sky. It seemed as if nature were trying to protect the poor waifs of humanity clustered in that spot. Nedawi felt the beauty of the scene, and was just thinking of nestling down by her father to enjoy it dreamily, when her brothers called for a dance. The little drum was brought forth, and Nedawi danced to its accompaniment and her brothers' singing. She danced gravely, as became a little maiden whose duty it was to entertain the family circle. While she was dancing, a little boy, about her own age, was seen hovering near. He would appear, and, when spoken to, would disappear in the tall, thick grass.

It was Mischief, a playmate of Nedawi's. Everybody called him "Mischief," because mischief appeared in every action of his. It shone from his eyes and played all over his face.

"You little plague," said White Hawk; "what do you want?"

For answer, the "little plague" turned a somersault just out of White Hawk's reach. When the singing was resumed, Mischief crept quietly up behind White Hawk, and, keeping just within the shadow, mimicked Nedawi's grave dancing, and he looked so funny that Nedawi suddenly laughed, which was precisely Mischief's object. But before he could get out of reach, as he intended, Thunder, Nedawi's other brother, who had been having an eye on him, clutched tight hold of him, and Mischief was landed in front of the fire-place, in full view of the whole family. "Now," said Thunder, "you are my prisoner. You stay there and dance with Nedawi." Mischief knew there was no escape, so he submitted with a good grace. He went through all sorts of antics, shaking his fists in the air, twirling suddenly

around and putting his head close to the ground, keeping time with the accompaniment through it all.

Nedawi danced staidly on, now and then frowning at him; but she knew of old that he was irrepressible. When Nedawi sat down, he threw into her lap a little dark something and was off like a shot, yelling at the top of his voice, either in triumph at his recent achievements or as a practice for future war-whoops.

"Nedawi, what is it?" said her mother.

Nedawi took it to the fire, when the something proved to be a poor little bird.

"I thought he had something in his hand when he was shaking his fist in the air," said Nedawi's sister, Nazainza, laughing.

"Poor little thing!" said Nedawi; "it is almost dead."

She put its bill into the water, and tenderly tried to make it drink. The water seemed to revive it somewhat.

"I'll wrap it up in something warm," said Nedawi, "and maybe it will sing in the morning."

"Let me see it," said Nedawi's father.

Nedawi carried it to him.

"Don't you feel sorry for it, daughter?"

"Yes, Father," she answered.

"Then take it to the tall grass, yonder, and put it down where no one will step on it, and, as you put it down, say: 'God, I give you back your little bird. As I pity it, pity me.'"

"And will God take care of it?" said Nedawi, reverently, and opening her black eyes wide at the thought.

"Yes," said her father.

"Well, I will do as you say," said Nedawi, and she walked slowly out of the tent.

Then she took it over to the tall, thick grass, and making a nice, cozy little nest for it, left it there, saying just what her father had told her to say. When she came back, she said:

"Father, I said it."

"That was right, little daughter," and Nedawi was happy at her father's commendation.

Nedawi always slept with her grandmother and sister, exactly in the middle of the circle formed by the wigwam, with her feet to the fire-place. That place in the tent was always her grandmother's place, just as the right-hand side of the tent was her father's and mother's and the left-hand her brothers'. There never was any confusion. The tribe was divided into bands, and every band was composed of several families. Each band had its chief, and the whole tribe was ruled by the head-chief, who was Nedawi's father. He had his own particular band besides. Every tent had its own place in the band, and every band had its own particular place in the great circle forming the camp. Each chief was a representative, in council, of the men composing his band, while over all was the head-chief. The executive power was vested in the "soldiers' lodge," and when decisions were arrived at in council, it was the duty of its soldiers to execute all its orders, and punish all violations of the tribal laws. The office of "town-crier" was held by several old men, whose duty it was "to cry out" through the camp the announcements of councils, invitations to feasts, and to give notice of anything in which the whole tribe were called on to take part.

Well, before Nedawi went to sleep this evening, she hugged her grandmother, and said to her:

"Please tell me a story."

Her grandmother said:

"I cannot, because it is summer. In the winter I will tell you stories."

"Why not in summer?" said Nedawi.

"Because, when people tell stories and legends in summer, the snakes come around to listen. You don't want any snakes to come near us to-night, do you?"

"But," said Nedawi, "I have not seen any snakes for the longest time, and if you tell it right softly they won't hear you."

"Nedawi," said her mother, "don't bother your grandmother. She is tired and wants to sleep."

Thereupon Grandmother's heart felt sorry for her pet, and she said to Nedawi:

"Well, if you will keep still and go right to sleep when I am through, I will tell you how the turkeys came to have red eyelids.

"Once upon a time, there was an old woman living all alone with her grandson, Rabbit. He was noted for his cunning and for his tricks, which he played on everyone. One day, the old woman said to him, 'Grandson, I am hungry for some meat.' Then the boy took his bow and arrows, and in the evening he came home with a deer on his shoulders, which he threw at her feet, and said, 'Will that satisfy you?' She said, 'Yes, grandson.' They lived on that meat several days, and, when it was gone, she said to him again, 'Grandson, I am hungry for some meat.' This time he went without his bow and arrows, but he took a bag with him. When he got into the woods, he called all the turkeys together. They gathered around him, and he said to them: 'I am going to sing to you, while you shut your eyes and dance. If one of you opens his eyes while I am singing, his eyelids shall turn red.' Then they all stood in a row, shut their eyes, as he had told them, and began to dance, and this is the song he sang to them while they danced:

> Ha! wadamba thike
> Inshta zhida, inshta zhida,
> Imba theonda,
> Imba theonda.

[The literal translation is:

> Ho! he who peeps
> Red eyes, red eyes,
> Flap your wings,
> Flap your wings.]

"Now, while they were dancing away, with their eyes shut, the boy took them, one by one, and put them into his bag. But the last one in the row began to think it very strange that his companions made no noise, so he gave one peep, screamed in his fright, 'They are making 'way with us!' and flew away. The boy took his bag of turkeys home to his grandmother, but ever after that the turkeys had red eyelids."

Nedawi gave a sigh of satisfaction when the story was finished, and would have asked for more, but just then her brothers came in from a dance which they had been attending in some

neighbor's tent. She knew her lullaby time had come. Her brothers always sang before they slept either love or dancing songs, beating time on their breasts, the regular beats making a sort of accompaniment for the singing. Nedawi loved best of all to hear her father's war-songs, for he had a musical voice, and few were the evenings when she had gone to sleep without hearing a lullaby from her father or brothers. Among the Indians, it is the fathers who sing, instead of the mothers. Women sing only on state occasions, when the tribe have a great dance, or at something of the sort. Mothers "croon" their babies to sleep, instead of singing.

Gradually the singing ceased, and the brothers slept as well as Nedawi, and quiet reigned over the whole camp.[11]

THE INDUSTRIAL WEST

With its roots in the eighteenth century, the Romantic movement entered the nineteenth with a force that matched the new engines of industrial progress. Again, in the arts, the pendulum had swung. Classical formality and restraint gave way to a relentless questioning and self-questioning, and in some cases an escapism. Artists, now moral heroes liberated from patronage, were on their own, to rise or fall, to experiment, and to protest. Caught between the expectations of the artistic establishment, the tastes of the public, and the artist's own vision of individual expression, each generation reacted more strongly against the style of its predecessors. The pace of change—social, technological, artistic—was quickening.

NEOCLASSICAL STYLE

Painting: Ingres

The Neoclassical traditions of the eighteenth century continued into the nineteenth, particularly in France. David's pursuit of physical and intellectual perfection was taken up by Jean-Auguste-Dominique Ingres (1780–1867). The work of Ingres, and perhaps David as well, illustrates the confusing relationships and conflicts surrounding the Neoclassical and Romantic traditions in painting. Ingres' *Grande Odalisque*, or *Harem Girl* (Fig. 12.10), has been called both Neoclassical and Romantic, and in many ways it represents both. Ingres professed to despise Romanticism, and yet his subject exudes Romantic individualism, exoticism, and escape. His sensuous textures appear emotional, not intellectual. At the same time, his line is Neoclassically simple, his palette is cool, and his spatial effects are geometric. The linear rhythms of his painting are precise and intellectual in appeal.

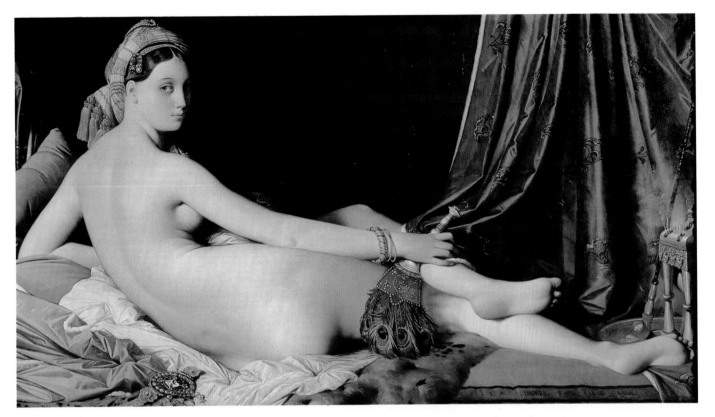

12.10 Jean-Auguste-Dominique Ingres, *Grande Odalisque* (*Harem Girl*), 1814. Oil on canvas, 35¼ x 63¾ ins (89.5 x 161.9 cm). Louvre, Paris.

Sculpture: Canova

Neoclassical sculpture prevailed during the early years of the nineteenth century and consisted predominantly of reproductions of Classical works rather than revisions of them, as was the case with architecture. No style is free from outside influences, and nineteenth-century Neo-classical sculpture often reveals aspects of Rococo, Baroque, and Romantic styles. In France, Neoclassicism served commemorative and idealizing ends as the political tool of Napoleon. He was glorified in various Greek and Roman settings, sometimes garbed in a toga and sometimes in the nude—as if a Greek god.

The Italian Antonio Canova (1757–1822) is recognized as the greatest of the Neoclassical sculptors. The title of *Venus Victrix*, or *Victorious Venus* (Fig. **12.11**), points to its Roman inspiration. Pauline Borghese, Napoleon's sister, was the model. The sculpture's Classical pose and proportions are similar in many ways to Ingres' *Grand Odalisque*. Line, costume, and hair style reflect the ancients, but sensuous texture, individualized expression, and realistic and fussy detail point to Romantic and Rococo influences. Interestingly, this work is almost two-dimensional—Canova has created it to be seen only from the front.

Architecture in the United States

The nineteenth century was an age of increased individualism and subjective viewpoints. However, what is possible by way of experimentation for the painter, sculptor, musician, choreographer, and, to some degree, the playwright, is not always possible for the architect. An architect's work involves a client who must be satisfied, and the results are public and permanent.

The revival of Greek and Roman architectural forms after 1750 can be broken into two general periods: Roman prior to 1815, and Greek from then on. The plethora of terms describing this period—Classical revival, Neoclassicism, Federal style—can be confusing. Classical revival and Neoclassicism are essentially the same, while Federal style is a specific substyle of the resurrection of ancient prototypes in the Romantic era.

In the Catholic cathedral in Baltimore (Fig. **12.12**), Benjamin H. Latrobe (1764–1820) mixes Greek and Roman elements. The Ionic orders of Athens are used in the alcove behind the altar, while a Roman dome, like that of the Pantheon, dominates the nave. These basically Classical forms are significantly modified and embellished with numerous individualized details. Traditional Roman semicircular arches flank the central opening above the

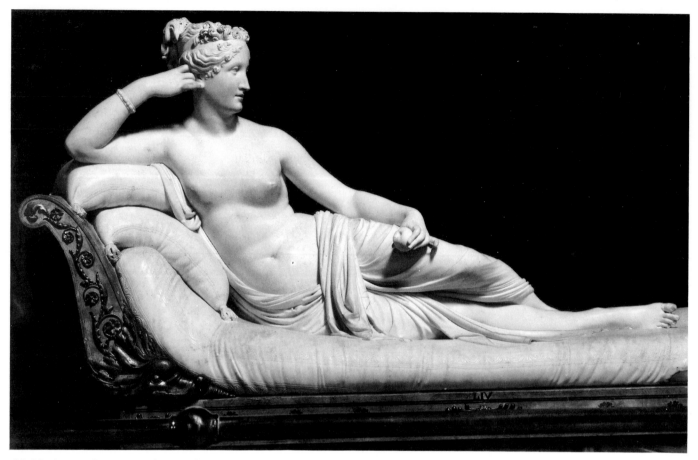

12.11 Antonio Canova, *Pauline Borghese as Venus Victrix*, 1808. Marble, life-size. Galleria Borghese, Rome.

altar, yet that arch and its complements are flattened and also broken by cantilevered balconies. Whimsical, starlike decoration marks the dome, and a misty panorama of painted scenes winds over and through the modified pendentives.

There are numerous examples of Classical revival in domestic architecture in the United States. The Belamy Mansion in Wilmington, North Carolina, is one of the most exquisite and stately examples (Fig. **12.13**). Designed by Connecticut architect Rufus H. Bunnell, the house was built by skilled, free African Americans and completed in 1859. It is situated on a major thoroughfare a few blocks from the downtown business district, central to the city now as it was a century ago. The beautifully proportioned main body of the house is offset by a massive portico whose Corinthian columns uphold a monumental cornice and pediment. Above this, the building is crowned by a rectangular cupola. The entire structure is raised some 5 feet (1.5 m) off the ground on brick pillars, hiding a basement.

ROMANTIC STYLE

The Romantic style has emotional appeal and tends toward the picturesque, nature, the Gothic, and, often, the macabre.

Romanticism sought to break the geometric compositional principles of Classicism, instead fragmenting images. The intent was to dramatize, to personalize, and to escape into imagination.

Painting

Romantic painting reflected a striving for freedom from social and artistic rules and an intense introversion. Formal content was subordinated to expressive intent. As French novelist Emile Zola (1840–1902) said of Romantic naturalism, "A work of art is part of the universe as seen through a temperament." Closely associated with French critic and poet Charles Baudelaire (1821–67), Romanticism explored the capacity of color and line to affect the viewer independently of subject matter.

Many Romantic painters are worthy of note, but a detailed look at Goya and Bonheur will suffice for our overview (see also Fig. **1.30**).

The Spanish painter and printmaker Francisco de Goya (1746–1828) used his paintings to attack the abuses perpetrated by governments—both the Spanish and the French. His highly imaginative and nightmarish works capture the emotional character of humanity and nature, and often their malevolence.

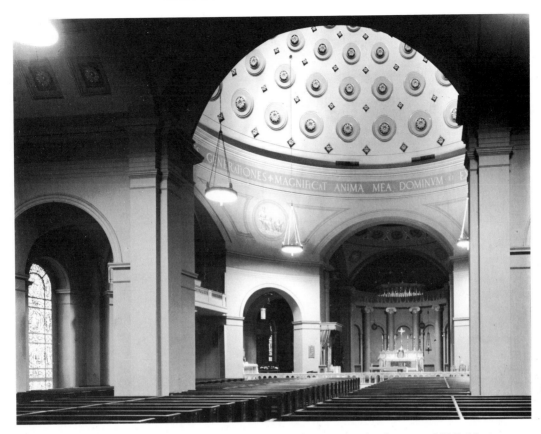

12.12 Benjamin H. Latrobe, *Basilica of the Assumption*, Baltimore, Maryland, interior, 1805–18.

The Third of May 1808 (Fig. **12.14**) tells a true story. On that date, the citizens of Madrid rebelled against the invading army of Napoleon. People were summarily executed. Using compositional devices to fragment the painting, Goya captures the climactic moment. It is impossible to escape the focal point of the painting, the man in white who is about to die.

Goya leads us beyond the death of individuals here. These figures are not realistically depicted people. Napoleon's soldiers are not even human types. Their faces are hidden, and their rigid, repeated forms become a line of subhuman automatons. Goya is making a powerful social and emotional statement. The murky quality of the background strengthens the value contrasts in the painting, and this charges the emotional drama of the scene. Color areas have hard edges, and a stark line of light running diagonally from the oversized lantern to the lower border irrevocably separates executioners and victims. Goya has no sympathy for French soldiers as human beings here. His subjectivity fills the painting, which is as emotional as the irrational behavior he condemns.

Rosa Bonheur (1822–99), the most popular woman painter of her time, has been labeled both a Realist and a Romantic in style. Her subjects are mostly animals, and she draws out their raw energy. "Wading in pools of blood," as

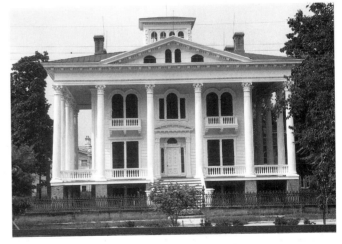

12.13 Rufus H. Bunnell, *Belamy Mansion*, Wilmington, North Carolina, 1859.

she puts it, she studied animal anatomy, even in slaughter houses. She was particularly interested in animal psychology. *Plowing in the Nivernais* (Fig. **12.15**) expresses the tremendous power of the oxen on which European agriculture depended before the Industrial Revolution. The beasts appear almost monumental, and each detail is precisely executed. This painting reveals Bonheur's reverence for the dignity of labor and humankind's harmony with nature.

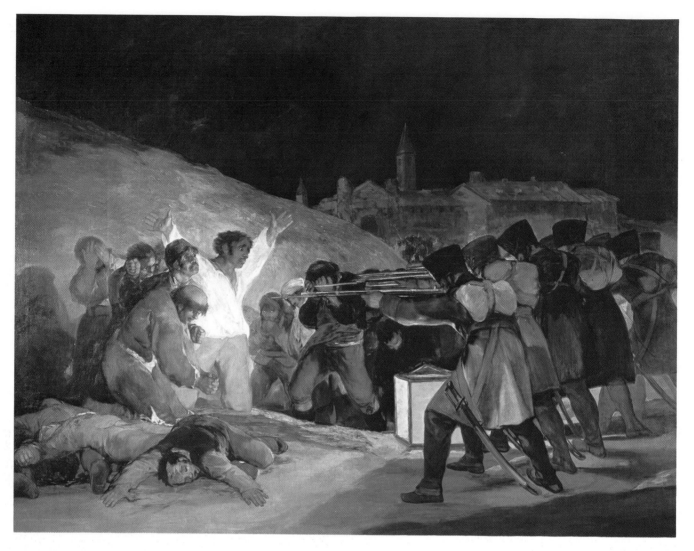

12.14 Francisco de Goya, *The Third of May 1808*, 1814. Oil on canvas, 8 ft 6 ins x 11 ft 4 ins (2.6 x 3.45 m). Prado, Madrid.

Sculpture

Romantic sculpture never developed into a uniform style. Those works not clearly of the Neoclassical and Rococo traditions show a generally eclectic spirit and a uniformly undistinguished character. There may be a reasonable explanation for such a phenomenon in Romantic idealism, whose strivings after nature and the far away and long ago cannot easily be translated into sculptural expression.

The term Romantic is often applied loosely to almost anything of the nineteenth century, and this is the case with the most remarkable sculptor of the era, Auguste Rodin (1840–1917). Rodin's textures, more than anything else, reflect Impressionism (see p. 349)—his surfaces appear to shimmer as light plays on their irregular features. They are more than reflective surfaces—they give his works dynamic and dramatic qualities. *The Thinker* (Fig. **12.16**) shows the difficulty inherent in attempting to put into sculptural form what painters like Monet were trying to do with color and texture (Fig. **12.31**). Although Rodin used a fair degree of verisimilitude, he nevertheless presented a reality beneath the surface.

Literature

The beginning of the main phase of Romantic literature can be dated to around 1790. One characteristic was the tendency of writers, such as the Germans Johann Wolfgang von Goethe (1749–1832) and Friedrich Schiller (1759–1805), to form groups or partnerships. Britain produced major literary figures, especially poets: Wordsworth, Coleridge, Scott, Byron, Shelley, and Keats, of whom we will examine only Wordsworth.

William Wordsworth charged the commonplace and everyday with transcendental and often indefinable signif-

PROFILE

Rosa Bonheur

One of the most significant and prominent women artists of the time, Rosa Bonheur (1822–99) focused her artistic attention almost solely on animals. Born in Bordeaux, France, she was the eldest of four children of an amateur painter. After early instruction from her father, she studied with Léon Cogniet at the École des Beaux-Arts in Paris, and soon began to specialize in animal subjects, studying them wherever she could. Her early paintings won awards in Paris, and in 1848 she won a first-class medal for *Plowing in the Nivernais*. By 1853 her work had reached full maturity, and she received high acclaim in Europe and the United States. Her paintings were much admiredand she became widely known through engraved copies. She was also well known as a sculptor, and her animal subjects led to her success among her contemporary French sculptors.

Rosa Bonheur had an independent spirit and fought to gain acceptance on a level equal to that of male artists of the time. Her ability and popularity earned her the title of Chevalier of the Legion of Honor in 1865, and she was the first woman to receive the Grand Cross of the Legion. Befriended by Queen Victoria of Britain, who became her patron, Bonheur was also a favorite among the British aristocracy, although her last years were spent in France, and she died near Fontainebleau in 1899.

12.15 Rosa Bonheur, *Plowing in the Nivernais*, 1849. Oil on canvas, 5 ft 9 ins x 8 ft 8 ins (1.75 x 2.64 m). Musée Nationale du Château de Fontainebleau, France.

icance. He created a new world of beauty through his closeness to nature and in the harmony he felt existed between humanity and nature. In 1795, he met the English poet Samuel Taylor Coleridge (1772–1834), and this friendship opened up his life and writing. Out of it came the *Lyrical Ballads*, which Wordsworth published anonymously along with four poems by Coleridge. Among these ballads, "Tintern Abbey" reveals Wordsworth's love of nature. That love is first seen as a sensuous animal passion, then as a moral influence, and finally as a mystical communion.

12.16
Auguste Rodin, *The Thinker*, first modeled c. 1880, executed c. 1910. Bronze, height 27½ ins (70 cm). Metropolitan Museum of Art, New York (Gift of Thomas F. Ryan).

Lines Composed a Few Miles above Tintern Abbey, on Revisiting the Banks of the Wye during a Tour, July 13, 1798
William Wordsworth
1770–1850

Five years have past; five summers, with the length
Of five long winters! and again I hear
These waters, rolling from their mountain-springs
With a soft inland murmur.—Once again
Do I behold these steep and lofty cliffs,
That on a wild secluded scene impress
Thoughts of more deep seclusion; and connect
The landscape with the quiet of the sky.
The day is come when I again repose
Here, under this dark sycamore, and view
These plots of cottage-ground, these orchard-tufts,
Which at this season, with their unripe fruits,
Are clad in one green hue, and lose themselves
'Mid groves and copses. Once again I see
These hedge-rows, hardly hedge-rows, little lines

Of sportive wood run wild: these pastoral farms,
Green to the very door; and wreaths of smoke
Sent up, in silence, from among the trees!
With some uncertain notice, as might seem
Of vagrant dwellers in the houseless woods,
Or of some Hermit's cave, where by his fire
The Hermit sits alone.

These beauteous forms,
Through a long absence, have not been to me
As is a landscape to a blind man's eye:
But oft, in lonely rooms, and 'mid the din
Of towns and cities, I have owed to them
In hours of weariness, sensations sweet,
Felt in the blood, and felt along the heart;
And passing even into my purer mind,
With tranquil restoration:—feelings too
Of unremembered pleasure: such, perhaps,
As have no slight or trivial influence
On that best portion of a good man's life,
Into a sober pleasure; when thy mind
Shall be a mansion for all lovely forms,
Thy memory be as a dwelling-place
For all sweet sounds and harmonies; oh! then,
If solitude, or fear, or pain, or grief,
Should be thy portion, with what healing thoughts
Of tender joy wilt thou remember me,
And these my exhortations! Nor, perchance—
If I should be where I no more can hear
Thy voice, nor catch from thy wild eyes these gleams
Of past existence—wilt thou then forget
That on the banks of this delightful stream
We stood together; and that I, so long
A worshipper of Nature, hither came
Unwearied in that service: rather say
With warmer love—oh! with far deeper zeal
Of holier love. Nor wilt thou then forget,
That after many wanderings, many years
Of absence, these steep woods and lofty cliffs,
And this green pastoral landscape, were to me
More dear, both for themselves and for thy sake![12]

Jane Austen (1775–1817) lived and worked in the high years of the major English Romantics, but she shunned the Romantic cult of personality and remained largely indifferent to Romantic literature. She looked back to Neoclassicism and the comedy of manners as her sources, and her work portrays middle-class people living in provincial towns and going about the daily routine of family life—a life of good breeding, wit, and a reasonable hope that difficulties can be resolved in a satisfactory

manner. She occasionally portrayed disappointments in love and threatened or actual seduction, but, somehow, these seem less important than the ongoing and routine conversations and rituals of daily life. Merely because she portrayed a quiet form of life does not mean, however, that her characters lack depth or interest. She explored human experience deeply and with humor. She proved that one does not require spectacular events in order to provide engaging art.

Her early years produced a variety of works that parody the sentimental and romantic clichés of popular fiction. In her second period of writing, from 1810 on, she crowned her career with works such as *Emma* (1815), *Persuasion* (1818), and *Mansfield Park* (1813). *Emma* shows Austen's ability to remain detached from her heroine, Emma Woodhouse, who represents self-deception, as she misreads evidence, misleads others, and discovers her own feelings only by accident. In her other works, Austen portrayed many gentle and self-effacing characters in the mode of her earlier masterpiece *Pride and Prejudice* (1813).

Music

In an era of Romantic subjectivity, music provided the medium in which many found an unrivaled opportunity to express emotion. In trying to express human emotion, Romantic music made stylistic changes to Classical music, and although Romanticism amounted to rebellion in many of the arts, in music it involved a more gradual and natural extension of Classical principles.

As in painting, spontaneity replaced control, but the primary emphasis of music in this era was on beautiful, lyrical, and expressive melody. Phrases became longer, more irregular, and more complex than they had been in Classical music. Much Romantic rhythm was traditional, but experiments produced new meters and patterns. Emotional conflict was often suggested by juxtaposing different meters, and rhythmic irregularity became increasingly common as the century progressed.

Romantic composers emphasized colorful harmonies and instrumentation. Harmony was seen as a means of expression, and any previous "laws" regarding key relationships could be broken to achieve striking emotional effects. Harmonies became increasingly complex, and traditional distinctions between major and minor keys were blurred in chromatic harmonies, complicated chords, and modulations to distant keys. In fact, some composers used key changes so frequently that their compositions are virtually nothing but whirls of continuous modulation.

As composers sought to disrupt the listener's expectations, more and more dissonance occurred, until it became a principal focus. Dissonance was explored for its own

sake, as a strong stimulant of emotional response rather than merely as a decorative way to get to the traditional tonic chord. By the end of the Romantic period, the exhaustion of chromatic usage and dissonance had led to a search for a completely different type of tonal system.

Exploring musical color to elicit feeling was as important to the Romantic musician as it was to the painter. Interest in tonal color, or timbre, led to great diversity in vocal and instrumental performance, and the music of this period abounds with solo works and exhibits a tremendous increase in the size and diversity of the orchestra. We have many options in how we might go about exploring Romantic music, none of which we could pursue exhaustively. We will proceed by isolating some major genres and, within them, noting major composers as we pass.

LIEDER In many ways, the "art song," or *Lied*, characterized Romantic music. A composition for solo voice with piano accompaniment and poetic text allowed for a variety of lyrical and dramatic expressions and linked music directly with literature.

The burst of German lyric poetry in this period encouraged the growth of *Lieder*. Literary nuances affected music, and music added deeper emotional implications to the poem. This partnership had various results: some *Lieder* were complex, others were simple; some were structured, others were freely composed. The pieces themselves depended on a close relationship between the piano and the voice. In many ways, the piano was an inseparable part of the experience, and certainly it served as more than accompaniment, for the piano explored mood and established rhythmic and thematic material, and sometimes had solo passages of its own. The interdependency of the song and its accompaniment is basic to the art song.

The earliest, and perhaps the most important, composer of *Lieder* was Franz Schubert (1797–1828). Schubert's troubled life epitomized the Romantic view of the artist's desperate and isolated condition. Known only among a close circle of friends and musicians, Schubert composed almost one thousand works, from symphonies to sonatas and operas, to masses, choral compositions, and *Lieder*. None of his work was publicly performed, however, until the year of his death. He took his *Lieder* texts from a wide variety of poems, and in each case the melodic contours, harmonies, rhythms, and structures of the music were determined by the poem.

Schubert's song *Der Erlkönig* (The Erlking, 1815; CD track 14; Fig. **12.17**) provides an excellent example both of Schubert's work and of Romantic music in general. The song consists of a musical setting of a poem about the supernatural by Goethe. Schubert uses a through-composed setting—that is, he writes new music for each

MASTERWORK

Austen—*Pride and Prejudice*

Pride and Prejudice (1813) contains little of the satire of works of the same period, but an ironic and sympathetic view of human nature and its propensity for comic incongruity. The narrative, which Austen originally titled "First Impressions," describes the clash between Elizabeth Bennet, the daughter of a country gentleman, and Fitzwilliam Darcy, a rich and aristocratic landowner. Austen reverses the convention of first impressions: "pride" of rank and fortune, and "prejudice" against Elizabeth's inferiority of family, hold Darcy aloof; while Elizabeth is equally fired both by the pride of self-respect and by prejudice against Darcy's snobbery. Ultimately they come together in love and self-understanding.

The central comedy of *Pride and Prejudice* lies in the fully developed character that reveals a sense of human realities and values. For example, in the character of Mr. Bennet, Austen makes a symbolic comment on intelligence that exists without will or drive. In her two opposing protagonists, Darcy and Elizabeth, who reflect the title of the book, Austen depicts character overlaid with class superciliousness and character abounding in independence and sharpness of mind that acts with prejudgment, wrong-headedness, and self-satisfaction. In all situations, Jane Austen remains detached, witty, and good-humored. Her disturbances are minor intrusions in an unshakable moral universe in which one can point out an entire range of human frailties and yet not despair.

In the story, as summarized in *The Bloomsbury Guide to English Literature* (Prentice Hall, 1990), Mr and Mrs Bennet belong to the minor gentry and live at Longbourn, near London. Mr Bennet is witty and intelligent, and bored with his foolish wife. They have five daughters, whose marriage prospects are Mrs Bennet's chief interest in life, since the estate is 'entailed'—i.e. by the law of the period it will go on Mr Bennet's death to his nearest male relation, a sycophantic clergyman called Mr Collins. The main part of the story is concerned with the relationship between the witty and attractive Elizabeth Bennet and the haughty and fastidious Fitzwilliam Darcy, who at first considers her beneath his notice and later, on coming to the point of asking her to marry him, finds that she is resolutely prejudiced against him.

Elizabeth is subjected to an insolent offer of marriage by Mr Collins and the arrogant condescension of his patroness, Lady Catherine de Bourgh, Darcy's aunt. In the end, chastened by finding in one another a fastidiousness and pride that equal their own and despite a family scandal, they are united.

stanza—in order to capture the poem's mounting excitement. The piano plays the role of an important partner in transmitting the mood of the piece, creating tension with rapid octaves and menacing bass motif. Imaginative variety in the music allows Schubert's soloist to sound like several characters in the dramatic development.

Wer rei - tet so spät durch Nacht und Wind?

12.17 Franz Schubert, from *The Erlking.*

Who rides so late through the night and the wind?
It is the father with his child;
He folds the boy close in his arms,
He clasps him securely, he holds him warmly.

"My son, why do you hide your face so anxiously?"
"Father, don't you see the Erlking?
The Erlking with his crown and his train?"
"My son, it's a streak of mist."

"Dear child, come, go with me!
I'll play the prettiest games with you.
Many-colored flowers grow along the shore;
My mother has many golden garments."

"My father, my father, and don't you hear
The Erlking whispering promises to me?"
"Be quiet, stay quiet, my child;
The wind is rustling in the dead leaves."

"My handsome boy, will you come with me?
My daughters shall wait upon you;
My daughters lead off in the dance every night,
And cradle and dance and sing you to sleep."

"My father, my father, and don't you see there
The Erlking's daughters in the shadows?"
"My son, my son, I see it clearly;
The old willows look so gray."

"I love you, your beautiful figure delights me!
And if you are not willing, then I shall use force!"
"My father, my father, now he is taking hold of me!
The Erlking has hurt me!"

The father shudders, he rides swiftly on;
He holds in his arms the groaning child,
He reaches the courtyard weary and anxious:
In his arms the child was dead.

Translated by Philip L. Miller

PIANO WORKS The development of the art song depended in no small way on nineteenth-century improvements in piano design. The instrument for which Schubert wrote had a much warmer, richer tone than earlier pianos, and improvements in pedal technique made sustained tones possible and gave the instrument greater lyrical potential.

Such flexibility made the piano an excellent instrument for accompaniment, and, more importantly, made it an almost ideal solo instrument. As a result, new works were composed solely for the piano, ranging from short, intimate pieces, similar to *Lieder*, to larger works designed to exhibit great virtuosity in performance. Franz Schubert wrote such pieces, as did Franz Liszt (1811–86). Liszt was one of the most celebrated pianists of the nineteenth century and one of its most innovative composers. He enthralled audiences with his expressive, dramatic playing, and taught most of the major pianists of the next generation. He also influenced Richard Wagner and Richard Strauss. His piano works include six *Paganini Études* (1851), concertos, and twenty *Hungarian Rhapsodies* based on Hungarian urban popular music rather than folk music. The technical demands of Liszt's compositions, and the rather florid way he performed them, gave rise to a theatricality, the primary purpose of which was to impress audiences with flashy presentation. This fitted well with the Romantic concept of the artist as hero.

The compositions of Frédéric Chopin (1810–49) were somewhat more restrained. Chopin wrote almost exclusively for the piano. Each of his *Études*, or studies, explored a single technical problem, usually set around a single motif. More than simple exercises, these works explored the possibilities of the instrument and became short tone poems in their own right. A second group of compositions included short intimate works such as preludes, nocturnes, and impromptus, and dances such as waltzes, polonaises, and mazurkas. (Chopin was Polish but lived in France, and Polish folk music had a particularly strong influence on him.) A final class of larger works included scherzos, ballades, and fantasies. Chopin's compositions are highly individual, many without precedent. His style is almost totally without standard form. His melodies are lyrical, and his moods vary.

Chopin's nocturnes, or night pieces, are among his most celebrated works. His *Nocturne in E flat major* Op. 9, No. 2 (CD track 15; 1833) illustrates the structure and style of this sort of mood piece well. It has a number of sections, with a main theme alternating with a second until both give way to a third. The piece has a complex AA'BA"B'A'"CC' structure. The nocturne is in andante tempo, a moderate, walking speed, and begins with the most important theme (Fig. **12.18**).

12.18 Frédéric Chopin, *Nocturne in E flat major*, Op. 9, No. 2, first theme.

The melody is very graceful and lyrical over its supporting chords. The contours of the melody alternately use pitches that are close together and widely spaced. The theme is stated, then immediately repeated with ornamentation. The second theme begins in the dominant key of B flat major and returns to E flat for a more elaborate repeat of the first theme. The second theme is restated, and followed by an even more elaborate restatement of the first theme, leading to a dramatic climax in the home key. A third theme is presented and then repeated more elaborately in the tonic key. The work ends with a short cadenza, which builds through a crescendo and finishes pianissimo, very softly.

PROGRAM MUSIC One of the new ways in which Romantic composers structured their longer works was to build them around a non-musical story, a picture, or some other idea. Music of this sort is called "descriptive." When the idea is quite specific and closely followed throughout the piece, the music is called "programmatic" or "program music."

These techniques were not entirely new—we have already noted the descriptive elements in Beethoven's "Pastoral" Symphony—but the Romantics found them particularly attractive and employed them with great gusto. A nonmusical idea allowed composers to rid themselves of formal structure altogether. Of course, actual

practice varied tremendously—some used programmatic material as their only structural device, while others subordinated a program idea to formal structure. Nevertheless, the Romantic period has become known as the "age of program music." Among the best-known composers of program music were Hector Berlioz (1803–69) and Richard Strauss (1864–1949).

Berlioz's *Symphonie Fantastique* (1830) employed a single motif, called an *idée fixe* (ee-DAY feex), to tie the five movements of the work together. The story on which the musical piece is based involves a hero who has poisoned himself because of unrequited love. However, the drug only sends him into semi-consciousness, in which he has visions. Throughout these visions the recurrent musical theme (the *idée fixe*) symbolizes his beloved. Movement 1 consists of "Reveries" and "Passions." Movement 2 represents "A Ball." "In the Country" is movement 3, in which he imagines a pastoral scene. In movement 4, "March to the Scaffold," (Fig. **12.19**; CD Track 16) he dreams he has killed his beloved and is about to be executed. The *idée fixe* returns at the end of the movement and is abruptly shattered by the fall of the axe. The final movement describes a "Dream of a Witches' Sabbath" in grotesque and orgiastic musical imagery.

12.19 Hector Berlioz, from the *Symphonie Fantastique*, fourth movement: A. "March to the Scaffold;" B. *idée fixe*.

Not all program music depends for its interest upon an understanding of its text. Many people believe, however, that the tone poems, or symphonic poems, of Richard Strauss require an understanding of the story. His *Don Juan*, *Till Eulenspiegel*, and *Don Quixote* draw such detailed material from specific legends that program explanations and comments are integral to the works and help to give them coherence. In *Till Eulenspiegels lustige Streiche (Till Eulenspiegel's Merry Pranks)*, Strauss tells the legendary German story of Till Eulenspiegel and his practical jokes. Till is traced through three escapades, all musically identifi-

able. He is then confronted by his critics and finally executed. Throughout, the musical references are quite specific.

SYMPHONIES Beethoven's powerful symphonies strongly influenced nineteenth-century composers. Schubert, whom we just discussed as a composer of *Lieder*, wrote eight symphonies, one of which, the so-called "Unfinished" (B Minor) has a darkly romantic style. Hector Berlioz's *Symphonie Fantastique* (see above) illustrated that a symphony could be written in an entirely different manner from Beethoven's. Felix Mendelssohn (1809–47) followed Classical tradition in most of his symphonies, but we should note that although Classical form was followed in many Romantic symphonies, the form was employed more as a means to a Romantically expressive end and not for its own sake.

An outstanding example of the Romantic symphony is Brahms' *Symphony No. 3 in F major* (1883). Composed in four movements, the work calls for pairs of flutes, oboes, clarinets, a bassoon, a contrabassoon, four horns, two trumpets, three trombones, two timpani, and strings—not an adventurous grouping of instruments for the period. Composed in sonata form, the first movement is allegro con brio (fast with spirit), and begins in F major (Fig. **12.20**).

12.20 Johannes Brahms, *Symphony No. 3 in F major*, opening motif of first movement.

The exposition section closes with a return to the opening motif and meter, employing rising scales and arpeggios. Then, following Classical tradition, the exposition is repeated.

The development section uses both the principal themes, with changes in tonal colors, dynamics, and modulation.

The recapitulation opens with a forceful restatement of the opening motif, followed by a restatement and further development of materials from the exposition. Then comes a lengthy coda, again announced by the opening motif, and based on the first theme. A final, quiet, restatement of the opening motif and first phrase of the theme brings the first movement to an end.

TRENDS The Romantic period also gave birth to new trends in music. The roots of such movements went deep into the past, but composers also wrote with the political circumstances of the century in mind. Folk tunes appear in

Johannes Brahms

Although he was born into an impoverished family, Johannes Brahms (1833-97) appears to have had a relatively happy childhood. His father was an itinerant musician, who eked out a meager living playing the horn and double bass in taverns and nightclubs. The family lived in the slums of Hamburg, Germany, but, despite their economic hardships, they retained close and loving family relationships. Early in life, Johannes showed evidence of considerable musical talent, and the eminent piano teacher Eduard Marxsen agreed to teach him without pay.

By the time he was twenty Brahms had gained acclaim as a pianist and accepted an invitation to participate in a concert tour with the Hungarian violinist Eduard Remenyi. The event was invaluable to the young Brahms, because it introduced him to Franz Liszt and Robert Schumann, and through Schumann's efforts Brahms was able to publish several of his compositions, which opened the door to the wider artistic world and launched his prolific career. Brahms gained experience as musical director at the little court of Detmold and as founder and director of a women's chorus in Hamburg, for which he wrote several choral works. His musical creativity showed a deep love of folk music and a sensitivity of expression. He mastered German *Lieder* and remained devoted to the Romantic style throughout his career, notwithstanding his fondness for clarity of structure and form based in the Classical style of the previous century.

Although Brahms wanted to stay in Hamburg, he was passed over for a position, and, feeling betrayed and neglected by his native town, he moved to Vienna. That city's rich musical ambience enriched his talent and experience, and he gained tremendous success, serving as director of the Vienna Singakademie and as conductor of the Society of Friends of Music. In 1875, he resigned his positions and spent the rest of his days in creative endeavors. For the next twenty-two years, he sacrificed his personal life in pursuit of his career, and the results gained him—in his own lifetime—recognition as one of the world's greatest artists.

His work spanned several idioms, from solo piano compositions and chamber music to full orchestral works. He was never interested in music for the stage nor in program music, but he reveled in symphonic compositions ruled by purely musical ideas, favoring absolute music.

these works as themes, as do local rhythms and harmonies. The exaltation of national identity was consistent with Romantic requirements, and it occurs in the music of nineteenth-century Russia, Bohemia, Spain, Britain, Scandinavia, Germany, and Austria.

Of all the composers of the Romantic period, the Russian Peter Ilyich Tchaikovsky (1840–93) has enjoyed the greatest popularity with his *1812 Overture* perhaps topping the list, followed closely by his *Nutcracker* ballet. In his First Symphony, he imitates the lyricism of Russian folk song, and the traits of the nineteenth-century Russian salon song can be found in his Fifth and Sixth Symphonies.

The *symphonic poem*, an offshoot of the symphony proper, was a term invented by Franz Liszt to describe a series of orchestral works he wrote which take their musical form and rhetoric from nonabstract ideas, some of them poetic and others visual. Other composers followed Liszt's lead, and the model proved especially popular in topics stemming from nationalistic sources, among them Smetana (*My Country*), Dvořák (*The Noonday Witch*), Borodin (*In the Steppes of Central Asia*), Sibelius (*Tapiola*), and Elgar (*Falstaff*).

CHORAL MUSIC Vocal music ranged from solo to massive ensemble works. The emotional requirements of Romanticism were well served by the diverse timbres and lyricism of the human voice. Almost every major composer of the era wrote some form of vocal music. Franz Schubert is remembered for his masses, the most notable of which is the *Mass in A flat major*. Felix Mendelssohn's *Elijah* stands beside Handel's *Messiah* and Haydn's *Creation* as a masterpiece of oratorio. Hector Berlioz marshaled full Romantic power for his *Requiem*, which called for 210 voices, a large orchestra, and four brass bands.

One of the most enduringly popular choral works of the Romantic period is Brahms' *Ein Deutsches Requiem* (*A German Requiem*). Based on selected texts from the Bible,

in contrast with the Latin liturgy of traditional requiems, Brahms' work is not so much a mass for the dead as a consolation for the living. It is principally a choral work—the solos are minimal: two for baritone and one for soprano—but both vocal and instrumental writing are very expressive. Soaring melodic lines and rich harmonies weave thick textures. After the chorus sings "All mortal flesh is as the grass," the orchestra suggests fields of grass moving in the wind. The lyrical movement, "How lovely is thy dwelling place," soars with emotion. Brahms' *Requiem* begins and ends with moving passages aimed directly at the living: "Blest are they that mourn." Hope and consolation underlie the entire work.

An important factor in Brahms' music is its lyricism and its vocal beauty. Brahms explored the voice as a human voice, and not as another instrument or some other mechanism unaffected by any restrictions, as other composers have done. His parts are written and his words chosen so that no voice is ever required to sing outside its natural range or technical capacity.

OPERA The spirit and style of Romanticism are summed up in that perfect synthesis of all the arts, opera. Three countries, France (especially Paris), Italy, and Germany, dominated the development of opera.

Paris occupied an important position in Romantic opera during the first half of the nineteenth century. The spectacular quality of opera and the size of its auditoriums had made it an effective vehicle for propaganda during the Revolution, and as an art form, opera enjoyed great popular appeal among the rising and influential middle classes.

A new type of opera, called "grand opera," emerged early in the nineteenth century, principally through the efforts of Louis Veron, a businessman, the playwright Eugène Scribe, and Giacomo Meyerbeer, a composer. These three broke away from Classical themes and subject matter and staged spectacular productions with crowd scenes, ballets, choruses, and fantastic scenery, written around medieval and contemporary themes. Meyerbeer (1791–1864), a German, studied Italian opera in Venice and produced French opera in Paris. *Robert the Devil* and *The Huguenots* typify Meyerbeer's extravagant style; they achieved great popular success, although the composer Schumann called *The Huguenots* "a conglomeration of monstrosities." Berlioz's *The Trojans*, written in the late 1850s, was more Classically based and more musically controlled. At the same time, Jacques Offenbach (1819–80) brought to the stage a lighter style, in which spoken dialogue was mixed with the music. This type of opera, called *opéra comique*, is serious in intent despite what the French word *comique* might suggest. It is a satirical and light form of opera, using vaudeville humor to satirize other operas, popular events,

and so forth. In between the styles of Meyerbeer and Offenbach there was a third form of Romantic opera, lyric opera. Ambroise Thomas (1811–96) and Charles Gounod (1818–93) turned to Romantic drama and fantasy for their plots. Thomas's *Mignon* contains highly lyrical passages, and Gounod's *Faust*, based on Goethe's play, stresses melodic beauty.

Early Romantic opera in Italy featured the *bel canto* style, which emphasizes beauty of sound, and the works of Gioacchino Rossini (1792–1868) epitomize this feature. Rossini's *The Barber of Seville* takes melodic singing to new heights with light, ornamented, and highly appealing work, particularly for his soprano voices.

Great artists often stand apart from or astride general stylistic trends while they explore their own themes. Such is the case with the Italian composer Giuseppe Verdi (1813–1901). With Verdi, opera is truly a human drama, expressed through simple, beautiful melody.

In what might be described as typical of Romanticism, Verdi dared to make an operatic hero out of a hunchbacked court jester—Rigoletto—whose only redeeming quality seems to be his great love for his daughter, Gilda. Rigoletto's master is the licentious duke of Mantua, who, while posing as a poor student, wins Gilda's love. When the duke seduces the innocent girl, Rigoletto plots his death. Despite the seduction, Gilda loves the dissolute duke and ultimately gives her life to save his. Virtue does not triumph in this opera.

Act Three contains one of the most popular of all operatic arias, "La donna è mobile" ("Woman is fickle"; Fig. **12.21**; CD track 17):

Woman is fickle
Like a feather in the wind,
She changes her words
And her thoughts.
Always a lovable
And lovely face,
Weeping or laughing,
Is lying.
Woman is fickle, etc.
The man's always wretched
Who believes in her,
Who recklessly entrusts
His heart to her!
And yet no one who never
Drinks love on that breast
Ever feels
Entirely happy!
Woman is fickle, etc.

Late in his career, Verdi wrote works such as *Aïda* (1871), grand operas of spectacular proportions built upon tightly woven dramatic structures. Finally, in a third phase, he pro-

12.21 Giuseppe Verdi, "La donna è mobile", from *Rigoletto* (1851).

duced operas based on Shakespearean plays. *Otello* (1887) contrasts tragedy and *opera buffa*—comic opera, not *opéra comique*—and explores subtle balances among voices and orchestra, together with strong melodic development.

Richard Wagner (1813–83) was one of the masters of Romantic opera. At the heart of Wagner's artistry lay a philosophy that has affected the stage from the mid-nineteenth century to the present day. His ideas were laid out principally in two books, *Art and Revolution* (1849) and *Opera and Drama* (1851). Wagner's philosophy centered on the *Gesamtkunstwerk* (geh-ZAMT-koonst-VAIRK), a comprehensive work of art in which music, poetry, and scenery are all subservient to the central generating idea. For Wagner, the total unity of all elements was supremely important. In line with German Romantic philosophy, which gives music supremacy over the other arts, music has the predominant role in Wagner's operas. Dramatic meaning unfolds through the *Leitmotif* (LYT-moh-TEEF), for which Wagner is famous, although he did not invent it. A *Leitmotif* is a musical theme that is tied to an idea, a person, or an object. Whenever that idea, person, or object appears on stage or comes to mind in the action, that theme is heard. Juxtaposing *Leitmotifs* gives the audience an idea of relationships between their subjects. *Leitmotifs* also give the composer building blocks to use for development, recapitulation, and unification. The sweeping strains of an excerpt ("Liebestod") from the opera *Tristan und Isolde* (CD track 18) can only suggest to us the power of Wagner's music.

Each of Wagner's magnificent operas deserves detailed attention. Anything we might say here by way of description or analysis would be insignificant compared to the dramatic power these works exhibit in full production. Even recordings cannot approach the tremendous effect of these works on stage in an opera house.

Theatre

"The play-going world of the West End is at this moment occupied in rubbing its eyes, that it may recover completely from the dazzle of Thursday last, when, amid the acclamations of Queen Victoria's subjects, King Richard the Second was enthroned at the Princess's Theatre." Thus began the reviewer's comments in *The Spectator*, 14 March 1857. The dazzle of scenery, revivals, and a pot-pourri of

uncertain accomplishments helped a stumbling theatre to keep up with the other arts that flourished through the early years of the nineteenth century.

POPULARISM AND HISTORICAL ACCURACY Romanticism as a philosophy of art was its own worst enemy in the theatre. Artists sought new forms to express great truths, and they strove to free themselves from Neoclassical rules and restraints. They did, however, admire Shakespeare as an example of new ideals and as a symbol of freedom from structural confinement. Intuition reigned, and the artistic genius was set apart from everyday people and above normal constraints. As a result, Romantic writers had no use for any guide but their own imagination.

Unfortunately, the theatre operates within some rather specific limits. Many nineteenth-century playwrights penned scripts that were unstageable and/or unplayable, and great writers could not or would not abide by constraints of the stage, while the hacks, yielding to popular taste, could not resist overindulgence in phony emotionalism, melodrama, and stage gimmickry. As a result, the best Romantic theatre performances came from the pen of William Shakespeare, whose work was revived in a great rush of nineteenth-century antiquarianism.

Poor as it may have been in original drama, however, the Romantic period did succeed in loosening the arbitrary rules of Neoclassical convention. Thus, it paved the way for a new theatrical era in the later years of the century.

The audiences of the nineteenth century played a significant part in determining what took the stage. Royal patronage was gone, and box office receipts were needed to pay the bills. A rising middle class had swelled the eighteenth-century audience and changed its character. Then, in the nineteenth century, the lower classes began attending the theatre. The Industrial Revolution had created larger urban populations and expanded public education to a degree. As feelings of egalitarianism spread throughout Europe and America, theatre audiences grew, and theatre building flourished. To appeal to this diverse audience, theatre managers had to put on plays for the popular as well as the sophisticated taste if they wanted to make money, so to offer something for everyone, an evening's theatre program might contain several types of fare and last over five hours. The consequence was predictable. Fewer and fewer sophisticated patrons chose to attend, and the quality of the productions declined.

By 1850, theatres began to specialize, and sophisticated playgoers came back to certain theatres, although the multipart production remained typical until nearly the turn of the twentieth century. Audience demand was high, and theatre continued to expand.

The early nineteenth-century theatre had some very particular characteristics. First of all, there was the repertory company, with a set group of actors, including stars, which stayed in one place and staged several productions during a given season. (That is quite unlike contemporary Broadway professional theatre, in which each play is produced and cast independently and runs for as long as it shows a profit.) Gradually, better-known actors capitalized on their reputations and began to go on tour, starring in local productions and featuring their most famous roles. A craze for visiting stars developed, and the most famous actors began to make world tours. This increase in touring stars led to an increase in touring companies, and, in the United States especially, these companies, with their star attractions and complete sets of costumes and scenery, became a regular feature of the landscape. By 1886 America could boast 282 touring companies. At the same time, local resident companies became less popular, except in Germany, where a series of local, state-run theatres was established.

After the Civil War a number of African American theatre companies emerged, featuring artists such as Anna and Emma Hyers, classically trained actors from California. In 1884, J. A. Arneaux founded the Astor Place Company of Colored Tragedians, who performed a repertory of Shakespearean plays. By the turn of the twentieth century, African Americans had made notable contributions to straight drama in the works of such playwrights as William Edgar Easton, who wrote historical plays.

Although theatre design was by now very diverse, some general similarities existed. Principally, the changes in nineteenth-century stages and staging were prompted by increased interest in historical accuracy and popular demand for depiction rather than convention. Before the eighteenth century, history had been considered irrelevant to art. Knowledge of antiquity that began with archeological excavations in Pompeii, however, aroused curiosity, and the Romantic dream of escape to the long ago and far away suggested that the stage picture of exotic places should be somehow believable. At first, such detail was used inconsistently, but, by 1823, some productions claimed that they were entirely historical in every respect. Attempts at historical accuracy had begun as early as 1801, and in France, Victor Hugo and Alexandre Dumas *père* insisted on historically accurate settings and costumes during the early years of the century. However, it was Charles Kean (1811–68) who brought the spectacle of antiquarianism in the London theatre to fruition in the 1850s (Fig. **12.22**).

The onset of accuracy as a standard for production led to three-dimensionality in settings and away from drop and wing scenery to the box set. The stage floor was leveled—

12.22 Charles Kean's production of Shakespeare's *Richard II*, London, 1857. Between Acts III and IV, the Entry of Bolingbroke into London. Contemporary watercolour by Thomas Grieve. Victoria & Albert Museum, London.

12.23 Illustrations from *The Art of Dancing*, 1820, by Carlo Blasis. The New York Public Library.

342

12.24 Marie Taglioni
(1804–84). Engraving, 1834.
The New York Public Library

since the Renaissance it had been raked—and new methods of shifting and rigging were devised to meet specific staging problems. Over a period of years, all elements of the production became integrated, much in the spirit of Wagner's totally unified artwork, the *Gesamtkunstwerk*. The distraction of numerous scene changes was eliminated by closing the curtain.

MELODRAMA On the popular side, nineteenth-century theatre developed a Romantically exaggerated form called "melodrama." Typically this kind of theatre is characterized by sensationalism and sentimentality. Characters are stereotyped, and everything and everyone tends to be all good or all evil. Plots are sentimental and the action is exaggerated. Regardless of circumstances, good must be rewarded and evil punished. There was often also some form of comic relief, usually through a minor character. The action of melodrama progresses at the whim of the villain, and the hero is forced to endure episode after episode of trial and suffering. Suspense is imperative, and a reversal at the end is obligatory.

The term "melodrama" implies music and drama, and, in the nineteenth century, these plays were accompanied by a musical score tailored to the emotional or dynamic character of the scene. In practice, this was very similar to the way music is used in films and television programs today, with the added attractions of incidental songs and dances that were used as curtain raisers and *entr'acte* entertainment.

Melodrama was popular throughout Europe and the United States. *Uncle Tom's Cabin*, based on the novel by Harriet Beecher Stowe (1852), took the stage by storm. The stage version was opposed by Stowe, but copyright laws did not exist to protect her. The play does retain her complex themes of slavery, religion, and love. The action involves a number of episodes, some of which are rather loosely connected. Characteristic of melodrama, *Uncle Tom's Cabin* places considerable emphasis on spectacle, the most popular of which at the time was Eliza's crossing of the ice with mules, horses, and bloodhounds in pursuit.

Ballet

In a totally unrehearsed move, a ballerina leaped from the tomb on which she posed and narrowly escaped a piece of falling scenery. This and other disasters plagued the opening night performance of Meyerbeer's *Robert the Devil* in 1831. The novelty of tenors falling into trapdoors, and falling stagelights and scenery, however, was eclipsed by the startling novelty of the choreography for this opera. Romantic ballet was at hand. To varying degrees, all the arts turned against the often cold formality of Classicism and

343

12.25 John Nash, Royal Pavilion, Brighton, England, remodeled 1815–23.

Neoclassicism. The subjective (not the objective) viewpoint and feeling (rather than reason) sought release.

Two sources are helpful in understanding the Romantic ballet, the writings of Théophile Gautier and Carlo Blasis. Gautier (1811–72) was a poet and critic, and his aesthetic principles held first of all that beauty was truth, a central Romantic conception. Gautier believed that dance was visual stimulation to show "beautiful forms in graceful attitudes." Dancing for Gautier was like a living painting or sculpture—"physical pleasure and feminine beauty." This exclusive focus on ballerinas placed sensual enjoyment and eroticism squarely at the center of his aesthetics. Gautier's influence was significant, and it accounted for the central role of the ballerina in Romantic ballet. Male dancers were relegated to the background, strength being the only grace permissible to them.

The second general premise for Romantic ballet came from *Code of Terpsichore* by Carlo Blasis (1803–78). Blasis was much more systematic and specific than Gautier—he was a former dancer—and his principles covered training, structure, and positioning. Everything in the ballet required a beginning, a middle, and an ending. The basic "attitude" in dance, which was modeled on Bologna's statue of *Mercury*, was to stand on one leg with the other brought up behind at a 90-degree angle with the knee bent. The dancer needed to display the human figure with taste and elegance. If the dancer trained each part of the body, the result would be grace without affectation. From Blasis comes the turned-

out position, which is still fundamental to ballet today (Fig. **12.23**). These broad principles provided the framework, and, to a great extent, a summary, of objectives for Romantic ballet: delicate ballerinas, lightly poised, costumed in soft tulle, and moving *en pointe*, with elegant grace.

The first truly Romantic ballet, *Robert the Devil* told the story of Duke Robert of Normandy, his love for a princess, and an encounter with the devil. The ballet contains ghosts, bacchanalian dancing, and a spectral figure who was danced by Marie Taglioni (Fig. **12.24**).

Taglioni went on to star in perhaps the most famous of all Romantic ballets, *La Sylphide* (1832). Here the plot centered on the tragic impossibility of love between a mortal and a supernatural being. A spirit of the air, a sylph, falls in love with a young Scot on his wedding day. Torn between his real fiancée and his ideal, the sylph, he deserts his fiancée to run off with the spirit. A witch gives him a scarf, and, unaware that it is enchanted, he ties it around the spirit's waist. Immediately her wings fall off and she dies. She drifts away to sylphs' heaven. The young man, disconsolate and alone, sees his fiancée passing in the distance with a new lover on the way to her wedding. The Scottish setting was exotic, at least to Parisians. Gaslight provided a ghostly, moonlit mood in the darkened auditorium. Taglioni danced the role of La Sylphide like "a creature of mist drifting over the stage" (assisted by flying machinery). Her lightness, delicacy, and modest grace established the standard for Romantic style in dancing. The story, exotic

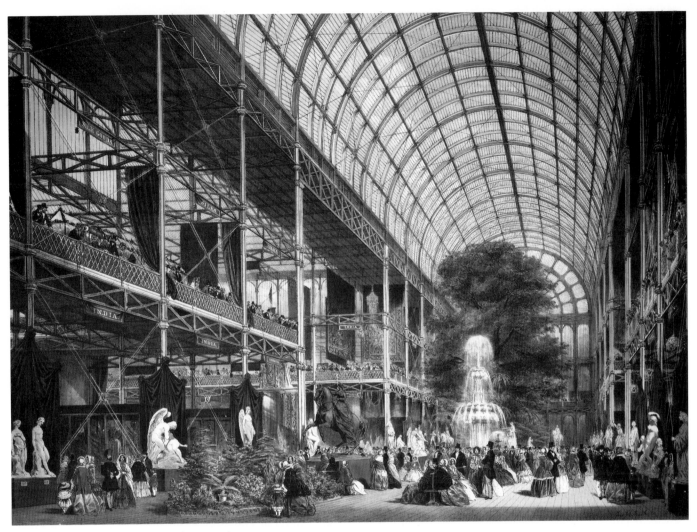

12.26 Sir Joseph Paxton, Crystal Palace, London, 1851.

12.27 Sir Charles Barry and Augustus Welby Northmore Pugin, Houses of Parliament, London, 1839–52.

12.28 Gustave Courbet, *The Stone Breakers*, 1849. Oil on canvas, 5 ft 3 ins x 8 ft 6 ins (1.6 x 2.59 m). Formerly in the Gemäldegalerie, Dresden (destroyed 1945).

design, and mood-evoking lighting completed the production style, a style that prevailed for the next forty years—"moonbeams and gossamer," as some have described it.

Choreographers of Romantic ballet sought magic and escape in fantasies and legends. Ballets about elves and nymphs enjoyed great popularity, as did ballets about madness, sleepwalking, and opium dreams. Unusual subject matter came to the fore. For example, harem wives revolt against their oppressors with the help of the "Spirit of Womankind" in Filippo Taglioni's *The Revolt in the Harem*, possibly the first ballet about the emancipation of women. Women appeared not only as performers and as subjects of the dance, however. They also began to come to prominence as choreographers.

The ballet *Giselle* (1841) marks the height of Romantic achievement. With its many fine dancing roles, both for women and for men, it has been a favorite of ballet companies since its first production.

The ballet has two acts; Act I is in sunlight, and Act II in moonlight. During a vine festival in a Rhineland village, Giselle, a frail peasant girl in love with a mysterious young man, discovers that the object of her affection is Albrecht, Count of Silesia. Albrecht is already engaged to a noblewoman. Giselle is shattered. She goes mad, turns from her deceitful lover, tries to commit suicide, swoons, and falls dead. In Act II, Giselle is summoned from her grave,

deep in the forest, by Myrthe, Queen of the Wilis, spirits of women who, having died unhappy in love, are condemned to lead men to destruction. (The word *wili* comes from a Slavic word for "vampire.") When a repentant Albrecht comes to bring flowers to Giselle's grave, Myrthe orders her to dance him to his death. Instead, Giselle protects Albrecht until the first rays of dawn break Myrthe's power.

In St Petersburg, Russia, in 1862, an English ballet called *The Daughter of Pharaoh*, choreographed by Marius Petipa, sent Russian audiences into rapture. Petipa had come to Russia from France in 1842, and he remained a central figure in Russian ballet for almost sixty years. By the middle of the nineteenth century, ballet companies were flourishing in Moscow and St Petersburg. Dancers enjoyed positions of high esteem in Russia, as they did not in the rest of Europe.

In Russia, the influence of Petipa carried Russian ballet forward in a quasi-Romantic style. He shared the sentimental taste of his time, but his works often contained very strange elements and numerous anachronisms. Minor characters might wear costumes suggesting period or locale, but the stars wore conventional garb, often of Classical derivation. Prima ballerinas often appeared in stylish contemporary coiffures and jewels, even when playing the role of a slave. *Divertissements* (dee-vair-TEES-mawn)—light enter-

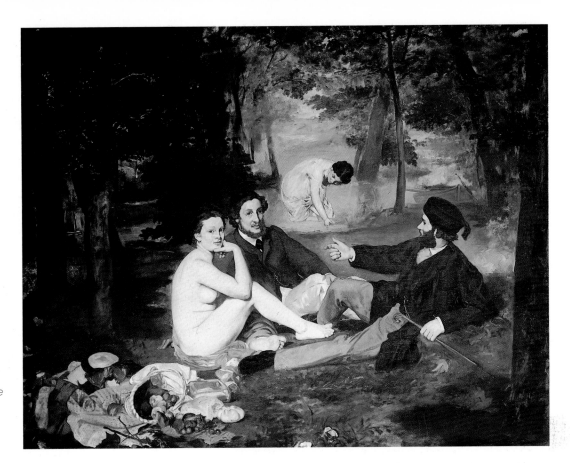

12.29 (*right*) Edouard Manet, *Déjeuner sur l'herbe* (*The Picnic*), 1863. Oil on canvas, 7 ft x 8 ft 10 ins (2.13 x 2.69 m). Musée d'Orsay, Paris.

12.30 (*bottom right*) Henry O. Tanner, *The Banjo Lesson*, c.1893. Oil on canvas, 48 x 35 ins (122 x 89 cm). Hampton University Museum, Hampton, Virginia.

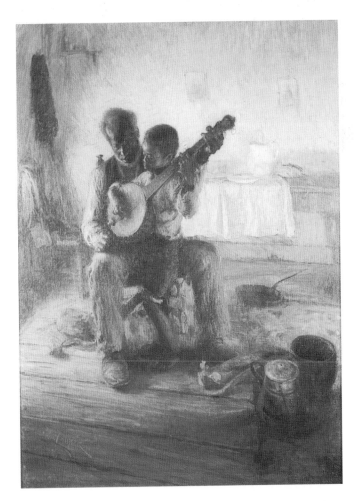

tainments—were often inserted into a ballet. Petipa included many different kinds of dance in his ballets—Classical, character, and folk dance. His creative approach more than compensated for his anachronisms. As some have said in his defense, "No one criticized Shakespeare for having Antony and Cleopatra speak in blank verse."

From this Russian school came the ever-popular *Nutcracker* and *Swan Lake*. The scores for both were composed by Tchaikovsky. *Swan Lake* was first produced in 1877 by the Moscow Bolshoi and *Nutcracker* in 1892. *Swan Lake* popularized the *fouetté*, or whipping turn, introduced by the ballerina Pierina Legnani in Petipa's *Cinderella* and incorporated for her in *Swan Lake*. In one scene, Legnani danced thirty-two consecutive *fouettés*, and to this day that number is mandatory.

Architecture

One of the characteristics of Romantic architecture is the way it borrowed styles from other eras. A vast array of buildings revived Gothic motifs, adding a major element of fantasy to create the Picturesque style. Eastern influence and whimsy abound in the Royal Pavilion

at Brighton, England (Fig. **12.25**), designed by John Nash (1752–1835). Picturesque also describes the most famous example of Romantic architecture, the Houses of Parliament in London (Fig. **12.27**). Significantly, its exterior walls function as a screen, and suggest nothing of structure, interior design, or usage—a modern tendency in architectural design. Conversely, the inside has absolutely no spatial relationship to the outside. Note, too, the strong contrast of forms and asymmetrical balance.

The nineteenth century was an age of industry, of experimentation and new materials. In architecture, iron, steel and glass came to the fore. At first it took courage for an architect actually to display structural honesty by allowing support materials to be seen as part of the design. England's Crystal Palace (Fig. **12.26**) exemplifies the nineteenth-century fascination with new materials and concepts. Built for the Great Exhibition of 1851, this mammoth structure was completed in the space of just nine months. Space was defined by a three-dimensional grid of iron bars and girders, designed specifically for mass production and rapid assembly (in this case, disassembly as well—the entire structure was dismantled and rebuilt in 1852–4 at Sydenham). Like the Houses of Parliament, the Crystal Palace highlights the growing divergence of function (as reflected in the arrangement of interior spaces), surface decoration, and structure.

REALISM

A new painting style called *Realism* arose in the mid-nineteenth century. The term "reality" came to have special significance in the nineteenth century because the camera—a machine to record events, people, and locations—thrust itself into what had previously been considered the painter's realm.

Courbet

The central figure of Realism was Gustave Courbet (1819–77). His aim was to make an objective and unprejudiced record of the customs, ideas, and appearances of contemporary French society. He depicted everyday life in terms of the play of light on surfaces, as seen in *The Stone Breakers* (Fig. **12.28**). This painting was the first to display his philosophy to the full. Courbet painted two men as he has seen them, working beside a road. The painting is life-size, and the treatment seems objective, and yet it makes a sharp comment on the tedium and laborious nature of the task. As a Social Realist, Courbet was more intent on political message than on meditative reaction.

Manet

Edouard Manet (1832–83) strove to paint "only what the eye can see." Yet his works go beyond a mere reflection of reality to encompass an artistic reality: Painting has an internal logic different from that of familiar reality. Manet thus liberated the canvas from competition with the camera. As indicated in the catalogue for an exhibition he produced when he was excluded from the International Exhibition in Paris in 1867, Manet believed that he presented in his art sincere—rather than faultless—perception.

His sincerity carried a form of protest—his impressions. To a certain extent Manet was both a conformist and a protester. He came from a comfortable bourgeois background and yet maintained a conviction about socialism. His work leans heavily on the masters of the past—for example, Raphael and Watteau—and at the same time explores completely new ground. He sought acceptance in salon circles while aiming to shock those same individuals. Striving to be a man of his own time, he rejected the superficiality he found in Romantic themes. He gave the reality of the world around him a different and more straightforward interpretation. As a result, he is often hailed as the first modern painter.

Déjeuner sur l'herbe (Fig. **12.29**) shocked the public when it first appeared in 1863. Manet sought specifically to "speak in a new voice." The setting is pastoral, as in Watteau (Fig. **11.34**), for example, but the people are real and identifiable: Manet's model, his brother, and the sculptor Leenhof. The apparent immorality of a naked frolic in a Paris park outraged the public and the critics. Had his figures been nymphs and satyrs, all would have been well; but Manet wanted both to be accepted by the official Salon, and to shock its organizers and visitors. The painting is modern while commenting upon similar themes of the past. But the intrusion of reality into the sacred confines of the mythical proved more than the public could handle.

Manet's search for harmonious colors, subjects from everyday life, and faithfulness to observed lighting and atmospheric effects led to the development of a style described in 1874 by a hostile critic as Impressionist.

Tanner

The first important African American painter, Henry O. Tanner (1859–1937), studied with the American Realist Thomas Eakins (1844–1916). *The Banjo Lesson* (Fig. **12.30**) presents its images in a strictly realistic manner, without sentimentality. The painting's focus is achieved through contrast, with clarity in the central objects and less detail in surrounding areas. This technique reflects contemporary experiments investigating the

nature of perceptual experience. A natural phenomenon had been discovered: Only objects immediately in the center of our vision are in sharp focus, and the rest remain slightly out of focus. Tanner's skill can be seen in the way he has captured the atmosphere of concentration and the warm relationship of teacher and pupil.

IMPRESSIONISM

Painting

In France, the Impressionists created a new way of seeing reality, seeking to capture "the psychological perception of reality in color and motion." Manet is credited with the original concepts of the style. It emerged in competition with the newly invented technology of the camera, for the Impressionists tried to beat photography at its own game by portraying the essentials of perception which the camera cannot capture. The style lasted only fifteen years in its purest form, but it profoundly influenced all art that followed.

Working out of doors, the Impressionists concentrated on the effects of natural light on objects and atmosphere. They emphasized the presence of color within shadows and based their style on an understanding of the interrelated mechanisms of the camera and the eye: vision consists of the result of light and color making an "impression" on the retina. Their experiments resulted in a profoundly different vision of the world around them and a new way of rendering that vision. For them, the painted canvas was first of all a material surface covered with pigments and filled with small patches of color, which together create lively and vibrant images.

Despite the individualistic nature of the nineteenth century, Impressionism is as collective a style as any we have seen thus far. It reflects the common concerns of a relatively small group of artists who met frequently and held joint exhibitions. As a result, the style has marked characteristics which apply to all its exponents. The paintings are relatively small and use clear, bright colors. Composition appears casual and natural. Typical subjects are everyday scenes such as landscapes, rivers, streets, and cafés.

Au Bord de l'eau, Bennecourt (*On the Seine at Bennecourt*) (Fig. 12.31) by Claude Monet (1840–1926) illustrates several of the concerns of the Impressionists. It portrays a pleasant, objective picture of the times, in contrast with the often subjective viewpoint of the Romantics. It suggests a fleeting moment—a new tone in an era when the pace of life has increased. Monet, along with Renoir and Berthe Morisot, among others, was a central figure in the development of Impressionism.

Pierre Auguste Renoir (1841–1919) specialized in portraying the human figure, seeking out what was beautiful in the body. His paintings sparkle with the joy of life. In *Moulin de la Galette* (Fig. 12.32) he depicts the bright gaiety of a Sunday crowd in a popular Parisian dance hall. He celebrates the liveliness and charm of these everyday folk as they talk, crowd the tables, flirt, and dance. Sunlight and shade dapple the scene and create a floating sensation in light. There is a casualness here, a sense of life captured in a fleeting and spontaneous moment. A much wider scene seems to extend beyond the canvas—the composition is an open one, not formally composed like David's *Oath of the Horatii* (Fig. 11.43). Rather, we are invited to become part of the action. People are going about their everyday routine with no reaction to the painter's presence. As opposed to the Classicist, who focuses on the universal and the typical, the Impressionist seeks realism in "the incidental, the momentary and the passing."

The original group of Impressionists included a woman, Berthe Morisot (1841–95), on equal terms. Gently introspective, her works often focus on family members. Her view of contemporary life is edged with pathos and sentimentality. In *In The Dining Room* (Fig. 12.33) she uses Impressionist techniques to give a penetrating glimpse of psychological reality. The servant girl has a personality, and she stares back at the viewer with complete self-assurance. The painting captures a moment of disorder: The cabinet door stands ajar with what appears to be a used tablecloth merely flung over it. The little dog playfully demands attention. Morisot's brushstroke is delicate, and her scenes are full of insight.

Music

In music, the anti-Romantic spirit produced a style analogous to that of the Impressionist painters. There was some direct influence from the Impressionist painters, but mostly Impressionism in music turned to the *Symbolist* poets for inspiration.

Ironically, Impressionist music's primary champion, Claude Debussy (1862–1918), did not like to be called an Impressionist. In fact, this is not surprising, for the label had been coined by a severe critic of the painters and was intended to be derogatory. Debussy maintained that he was "an old romantic who has thrown the worries of success out of the window," and he sought no association with the painters. However, similar motifs can be seen. His use of tone color has been described as "wedges of color" applied in a similar way to painters' individual brushstrokes. He delighted in natural scenes and sought to capture the effects of shimmering light. Debussy wished above all to

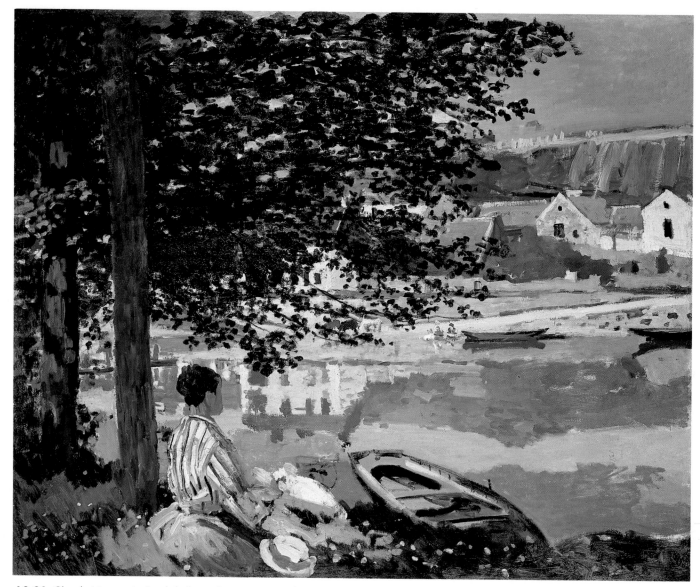

12.31 Claude Monet, *Au Bord de l'eau, Bennecourt* (*On the Seine at Bennecourt*), 1868. Oil on canvas, 31⅞ x 39½ ins (81.5 x 100.7 cm). Art Institute of Chicago (Potter Palmer Collection).

return French music to fundamental sources in nature and move it away from the heaviness of the German tradition.

In contrast to his predecessors, Debussy abandoned chordal harmony's traditional progressions—perhaps his greatest break with tradition. Oriental influence is apparent in his use of the Asian five-tone scale and dissonance is common. Each chord is considered strictly on the merits of its expressive capabilities and apart from any context of tonal progression. As a result, gliding chords (repetition of a chord up and down the scale) became a hallmark of musical Impressionism.

Debussy reduced melodic development to short motifs—an analogy can again be drawn with the individual brushstrokes of the painters. Irregular rhythm and meter further

distinguish his works. So, once more, form and content are subordinate to expressive intent. His music tends to suggest, rather than to state, and to leave the listener with ambiguity—with an impression. Key elements of his style are freedom, flexibility, and non-traditional timbres. His most famous composition is the *Prélude à l'après-midi d'un faune* (*Prelude to the Afternoon of a Faun*; see also p. 81), based on a sensual poem by the Symbolist Stéphane Mallarmé (1842–98). The piece uses a large orchestra, with emphasis on the harps and woodwinds, most notably in the haunting, chromatically sliding theme running throughout. Although freely ranging in an irregular 9/8 meter and virtually without tonal centers, the *Prélude* has a basically traditional ABA structure (CD track 19).

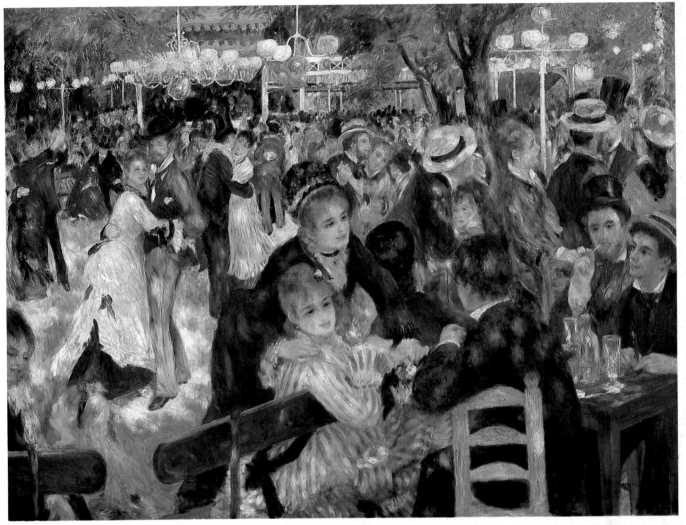

12.32 Pierre-Auguste Renoir, *Moulin de la Galette*, 1876. Oil on canvas, 51½ x 69 ins (131 x 175 cm). Musée d'Orsay, Paris.

POST-IMPRESSIONISM

In the last two decades of the nineteenth century Impressionism evolved gently into a collection of rather disparate styles called, simply, Post-Impressionism. In subject matter Post-Impressionist paintings are similar to Impressionist ones—landscapes, familiar portraits, groups, and café and nightclub scenes. The Post-Impressionists, however, gave their subject matter a profoundly personal significance.

The Post-Impressionists were deeply concerned about the formal language of art and its ability to capture sensory experience. They maintained the contemporary philosophy of art for art's sake and rarely attempted to sell their works. They did wish to share their subjective impressions of the real world, but moved beyond the Romantic and Impressionist world of pure sensation. They were more interested in the painting as a flat surface carefully composed of shapes, lines, and colors, an idea that became the foundation for most of the art movements that followed.

The Post-Impressionists called for a return to form and structure in painting, characteristics they believed were lacking in the works of the Impressionists. Taking the evanescent light qualities of the Impressionists, they brought formal patterning to their canvases. They used clean color areas, and applied color in a systematic, almost scientific manner. The Post-Impressionists sought to return painting to traditional goals while retaining the clean palette of the Impressionists.

Seurat

Georges Seurat (1859–91) is often described as a Neo-Impressionist rather than a Post-Impressionist (he called his approach and technique *divisionism*). He took the Impressionist method of painting one step further. In his

patient and systematic technique specks of paint are applied with the point of the brush, one small dot at a time. He used paint in accordance with his theories of optics and of color perception: *Sunday Afternoon on the Island of La Grande Jatte* (Fig. **12.34**) illustrates his concern for the accurate depiction of light and color. Its composition and depiction of shadow show attention to perspective, and yet Seurat willfully avoids three-dimensionality. As in much Post-Impressionist art, Japanese influence is apparent: Color areas are fairly uniform, figures are flattened, and outlining is continuous. Throughout the work we find conscious systematizing. The painting is broken into proportions of three-eighths and halves, which Seurat believed represented true harmony. He also selected his colors by formula. Physical reality for Seurat was just a pretext for the artist's search for a superior harmony, for an abstract perfection.

Cézanne

Paul Cézanne (1839–1906) is considered by many as the father of modern art. *Mont Sainte-Victoire* (Fig. **12.35**) illustrates his concern for formal design with its nearly geometric configuration and balance. Foreground and background are tied together systematically so that both join in the foreground to create patterns. Shapes are simplified and outlining is used throughout. Cézanne employed geometric shapes—the cone, the sphere, and the cylinder—as metaphors of the permanent reality that lay beneath surface appearance.

Cézanne tried to invest his paintings with a strong sense of three-dimensionality. His use of colored planes is much like Seurat's use of dots. He took great liberty with color and changed traditional ways of rendering objects, utilizing the cones and other geometric shapes just mentioned.

Gauguin

A highly imaginative approach to Post-Impressionist goals came from Paul Gauguin (1848–1903). He and his followers were known as Symbolists or Nabis (the Hebrew word for prophet). An artist without training, and a nomad who believed that all European society and its works were sick, Gauguin devoted his life to art and wandering, spending many years in rural Brittany and the end of his life in Tahiti and the Marquesas Islands. His work shows an insistence on form and a resistance to realistic effects. *The Vision after the Sermon* (Fig. **12.39**) has Gauguin's typically flat, outlined figures, simple forms, and symbolism. In the background Jacob wrestles with the angel, as described in Genesis, the first book of the Bible. Meanwhile, in the foreground, a priest, nuns, and women in Breton costume pray. The intense reds of this work are typical of Gauguin's symbolic and unnatural use of color, used here to portray the powerful sensations of a Breton folk festival.

Van Gogh

We move now to look at the work of the Dutch Post-Impressionist Vincent van Gogh (1853–90). His emotionalism in the pursuit of form is unique. Van Gogh's turbulent life included numerous short-lived careers, impossible love affairs, a tempestuous friendship with Gauguin, and, finally, serious mental illness. Biography here is essential because van Gogh gives us one of the most personal and subjective artistic viewpoints in the history of Western art. Works such as *The Starry Night* (Fig. **1.1**) explode with frenetic energy manifested in the brushwork. Flattened forms and outlining reflect Japanese influence. Here there is tremendous power and controlled focus; dynamic, personal energy and mental turmoil. This work represents one of the earliest and most famous examples of Expressionism, a style we will examine in the next chapter.

Works such as *Harvest at La Crau* (*The Blue Cart*; Fig. **12.36**), which van Gogh produced in his Arles period, reflect an interest in *complementary colors* (colors on opposite sides of the color wheel—see the Introduction). Unlike Seurat, for example, who applied such colors in small dots, van Gogh, inspired by Japanese prints, placed large color areas side by side. Doing so, he believed, expressed the quiet, harmonious life of the rural community. Notice that the brushwork in the foreground is active while the fields in the background are smooth. Subtle diagonals break up the predominantly horizontal line of the work.

ART NOUVEAU

Art Nouveau (French for "new art") pervaded the visual arts in the United States and Europe in the 1890s and early 1900s. Characteristic is the lively, serpentine curve known as the "whiplash." The style reflects a fascination with plant and animal life and organic growth. The influence of Japanese art is evident in its undulating curves. Art Nouveau incorporates organic and often symbolic motifs, treating them in a linear, relief-like manner. One of its greatest exponents, Antoni Gaudí (1852–1926), designed townhouses such as the Casa Batlló (Fig. **12.37**) in Barcelona.

EXPERIMENTATION IN ARCHITECTURE

The new age of experimentation took nineteenth-century architects in a new direction—upward. Late in the

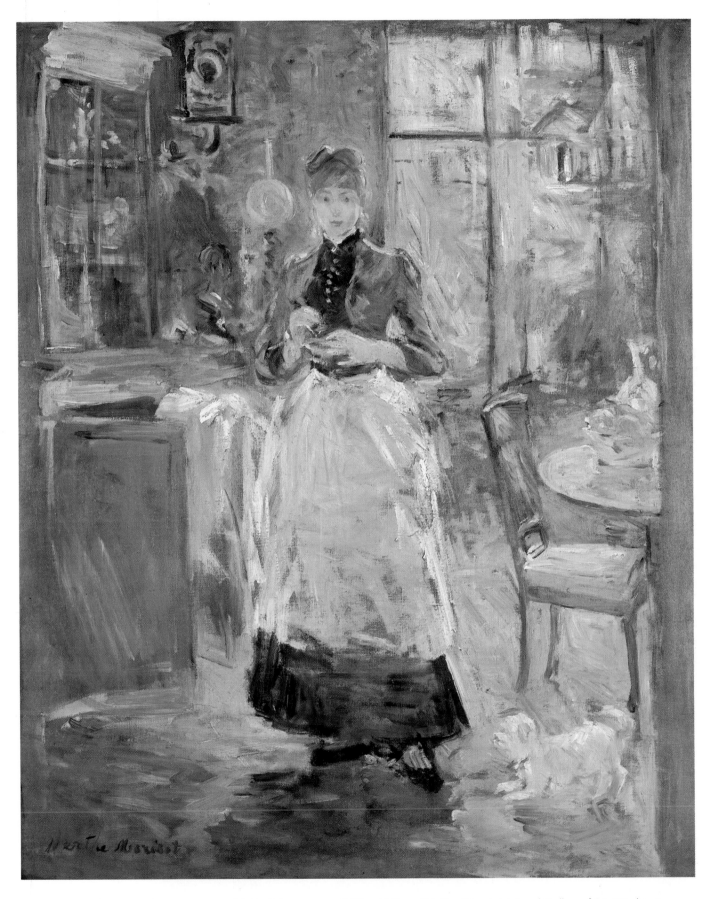

12.33 Berthe Morisot, *In the Dining Room*, 1886. Oil on canvas, 24⅛ x 19¾ ins (61.3 x 50 cm). National Gallery of Art, Washington, D.C. (Chester Dale Collection).

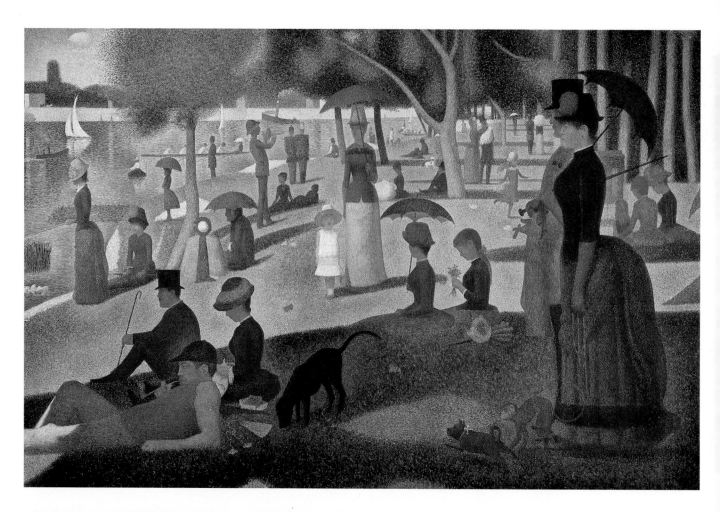

12.34 (*above*) Georges Seurat, *Sunday Afternoon on the Island of La Grande Jatte*, 1884–6. Oil on canvas, 6 ft 9½ ins x 10 ft ⅜ ins (2.07 x 3.06 m). Art Institute of Chicago (Helen Birch Bartlett Memorial Collection).

12.35 Paul Cézanne, *Mont Sainte-Victoire seen from Les Lauves*, 1902–4. Oil on canvas, 27½ x35¼ ins (70 x 90 cm). Philadelphia Museum of Art (George W. Elkins Collection).

12.36 Vincent van Gogh. *Harvest at La Crau* (The Blue Cart). 1888. Oil on canvas, 281/2 x 361/4 ins (72.5 x 92 cm). Rijksmuseum, Vincent van Gogh, Amsterdam.

12.37 (*below left*) Antoni Gaudí, Casa Batlló, Barcelona, 1905–7.

12.38 (*below*) Louis Henry Sullivan, Carson, Pirie, & Scott Department Store, Chicago, 1899–1904.

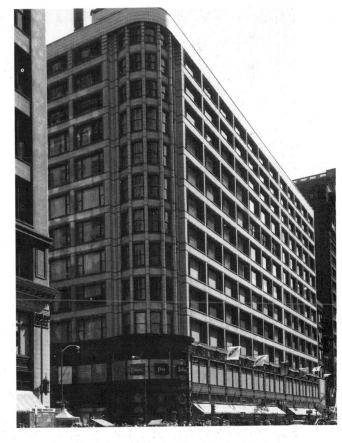

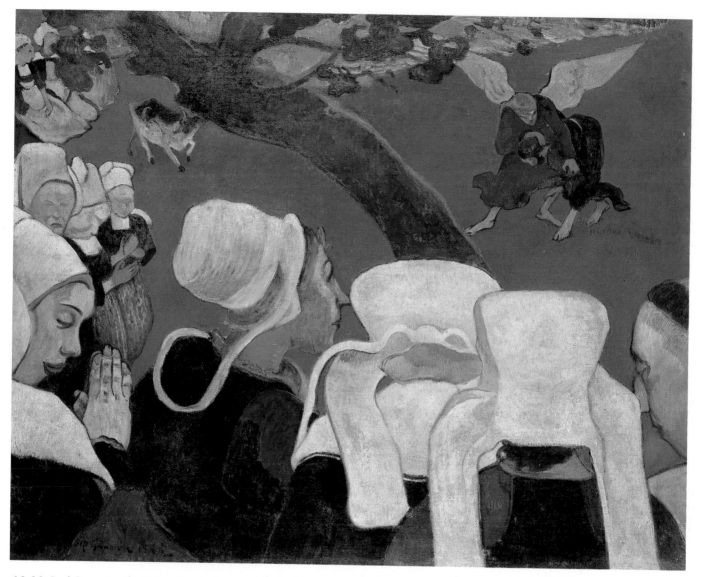

12.39 Paul Gauguin, *The Vision after the Sermon*, 1888. Oil on canvas, 28¾ x 36¼ ins (73 x 92 cm). National Gallery of Scotland, Edinburgh.

period—not until a man named Elisha Graves Otis (1811–61) had invented a safe elevator—the skyscraper was designed in response to the need to create commercial space on limited property in burgeoning urban areas. At that period it was almost exclusively limited to America. Burnham & Root's Monadnock Building in Chicago (Fig. 7.20) is an early example and illustrates the trend toward thinking in a unified way about design, materials, and new concepts of architectural space. This prototypical "skyscraper" is all masonry—built completely of brick and requiring increasingly thick walls toward its base— which limited its possible height. Soon architects were able to erect buildings of unprecedented height without increasing the thickness of the lower walls. This was done by erecting structural frameworks (first of iron, later of steel) and by treating walls as independent

partitions. Each story was supported on horizontal girders.

An influential figure in the development of the skyscraper and in the whole philosophy of modern architecture was Louis Sullivan (1856–1924). The first truly modern architect, he worked in the last decade of the nineteenth century in Chicago, then the most rapidly developing metropolis in the world. Sullivan designed buildings characterized by dignity, simplicity, and strength. Most importantly, he created a rubric for modern architecture by combining form and function: In his theory the former flows from the latter. As Sullivan said to an observer of the Carson, Pirie, & Scott building (Fig. **12.38**), "It is evident that we are looking at a department store. Its purpose is clearly set forth in its general aspect, and the form follows the function in a simple, straightforward way."[13]

CHAPTER THIRTEEN

PLURALISM IN A MODERN AND POSTMODERN AGE

1900–2000

IMPORTANT TERMS

Abstract Expressionism A painting style of the late 1940s and early 1950s, predominantly American, characterized by its rendering of expressive content by abstract or nonobjective means.

Cubism A style of art noted for the geometry of its forms, its fragmentation of the object, and its increasing abstraction.

Expressionism An art that stresses the psychological and emotional content of the work.

Fauvism An art movement characterized by its use of bold arbitrary color.

Futurism An art movement characterized by the desire to celebrate the movement and speed of modern industrial life.

Modernism Generally speaking, the various strategies and directions employed in twentieth-century arts to explore the particular formal properties of a given medium.

Pop Art A style arising in the 1960s characterized by its emphasis on the forms and imagery of mass culture.

Postmodernism A term used to describe the willfully plural, eclectic, and typically anti-modern forms of art of the late twentieth century.

Surrealism A style of art that emphasized dream imagery, chance operations, and rapid, thoughtless forms of notation that expressed the unconscious mind.

Serialism A system of musical composition emphasizing the tone row or twelve-tone technique.

Musique actuelle Cutting-edge music drawing on jazz and rock to create vibrant, lively, personalized expressions.

The one constant in the arts of the turbulent and phenomenal twentieth century was a seemingly inexhaustible quest for originality and freshness. Among the awesome contradictions of an age that witnessed the worst and the best that humanity is capable of, its vision of itself and where it was going is as troublesome as it was for our Paleolithic ancestors.

In contrast to the atmosphere of flurried change in the West, many cultures still make use of the traditional practices and techniques of their predecessors. The so-called "primitive" art of Africans and Native Americans in fact masks a web of complicated rituals, myths, and beliefs in which art plays a crucial role. Despite enormous differences between the function and style of tribal and Western art, the two-way flow of influence has been significant, particularly in the modern and postmodern era.

Increasingly, we recognize that even as our humanness unites us, there are manifold expressions of individuality in that togetherness. To paraphrase St. Paul the Apostle, the body that represents humanity is not all one part, whether ears or eyes or feet. It takes diverse members, each with a different purpose, to make a complete body. Thus, here at the beginning of the twenty-first century, the evidence, indeed, the celebration, of pluralism—of difference—remains an important theme.

NATIVE AMERICA

FICTION

As discussed in the last chapter, the period from 1870 to 1920 produced a profound change in Native American culture and circumstances. Confinement to reservations and an increase in formal education changed both the traditional way of life and, in particular, its oral transmission of culture. A frequent issue for both Native Americans and settlers was whether their cultures were incompatible. Cultural conflict was a common preoccupation and central theme for Native American writers, many of whom were "half-breeds" and the products of the white educational system. "Half-breeds" were themselves popular subjects in the nineteenth and early twentieth centuries, and writers who focused in this way on the meeting point between the two cultures give us a profound insight into the Native American mind.

Gertrude Bonnin, a South Dakota Yankton Sioux, who had a full-blooded mother and an Anglo-American father, wrote under the pen name of Zitkala-Sa (Red Bird). The mixed-culture protagonist of "The Soft-Hearted Sioux" (published in 1901) reflects the conflicts of a Native American caught between cultures. Unable to function in either world, he is given no alternative but to face a violent death.

The Soft-Hearted Sioux
Zitkala-Sa (Gertrude Bonnin)

1

Beside the open fire I sat within our tepee. With my red blanket wrapped tightly about my crossed legs, I was thinking of the coming season, my sixteenth winter. On either side of the

wigwam were my parents. My father was whistling a tune between his teeth while polishing with his bare hand a red stone pipe he had recently carved. Almost in front of me, beyond the center fire, my old grandmother sat near the entranceway.

She turned her face toward her right and addressed most of her words to my mother. Now and then she spoke to me, but never did she allow her eyes to rest upon her daughter's husband, my father. It was only upon rare occasions that my grandmother said anything to him. Thus his ears were open and ready to catch the smallest wish she might express. Sometimes when my grandmother had been saying things which pleased him, my father used to comment upon them. At other times, when he could not approve of what was spoken, he used to work or smoke silently.

On this night my old grandmother began her talk about me. Filling the bowl of her red stone pipe with dry willow bark, she looked across at me.

"My grandchild, you are tall and no longer a little boy." Narrowing her old eyes, she asked, "My grandchild, when are you going to bring here a handsome young woman?" I stared into the fire rather than meet her gaze. Waiting for my answer, she stooped forward and through the long stem drew a flame into the red stone pipe.

I smiled while my eyes were still fixed upon the bright fire, but I said nothing in reply. Turning to my mother, she offered her the pipe. I glanced at my grandmother. The loose buckskin sleeve fell off at her elbow and showed a wrist covered with silver bracelets. Holding up the fingers of her left hand, she named off the desirable young women of our village.

"Which one, my grandchild, which one?" she questioned.

"Hoh!" I said, pulling at my blanket in confusion. "Not yet!" Here my mother passed the pipe over the fire to my father. Then she too began speaking of what I should do.

"My son, be always active. Do not dislike a long hunt. Learn to provide much buffalo meat and many buckskins before you bring home a wife." Presently my father gave the pipe to my grandmother, and he took his turn in the exhortations.

"Ho, my son, I have been counting in my heart the bravest warriors of our people. There is not one of them who won his title in his sixteenth winter. My son, it is a great thing for some brave of sixteen winters to do."

Not a word had I to give in answer. I knew well the fame of my warrior father. He had earned the right of speaking such words, though even he himself was a brave only at my age. Refusing to smoke my grandmother's pipe because my heart was too much stirred by their words, and sorely troubled with a fear lest I should disappoint them, I arose to go. Drawing my blanket over my shoulders, I said, as I stepped toward the entranceway: "I go to hobble my pony. It is now late in the night."

2

Nine winters' snows had buried deep that night when my old grandmother, together with my father and mother, designed my future with the glow of a camp fire upon it.

Yet I did not grow up the warrior, huntsman, and husband I was to have been. At the mission school I learned it was wrong to kill. Nine winters I hunted for the soft heart of Christ, and prayed for the huntsmen who chased the buffalo on the plains.

In the autumn of the tenth year I was sent back to my tribe to preach Christianity to them. With the white man's Bible in my hand, and the white man's tender heart in my breast, I returned to my own people.

Wearing a foreigner's dress, I walked, a stranger, into my father's village.

Asking my way, for I had not forgotten my native tongue, an old man led me toward the tepee where my father lay. From my old companion I learned that my father had been sick many moons. As we drew near the tepee, I heard the chanting of a medicine-man within it. At once I wished to enter in and drive from my home the sorcerer of the plains, but the old warrior checked me. "Ho, wait outside until the medicine-man leaves your father," he said. While talking he scanned me from head to feet. Then he retraced his steps toward the heart of the camping-ground.

My father's dwelling was on the outer limits of the round-faced village. With every heart-throb I grew more impatient to enter the wigwam.

While I turned the leaves of my Bible with nervous fingers, the medicine-man came forth from the dwelling and walked hurriedly away. His head and face were loosely covered with the loose robe which draped his entire figure.

He was tall and large. His long strides I have never forgot. They seemed to me then as the uncanny gait of eternal death. Quickly pocketing my Bible, I went into the tepee.

Upon a mat lay my father, with furrowed face and gray hair. His eyes and cheeks were sunken far into his head. His sallow skin lay thin upon his pinched nose and high cheek-bones. Stooping over him, I took his fevered hand. "How, Ate?" I greeted him. A light flashed from his listless eyes and his dried lips parted. "My son!" he murmured, in a feeble voice. Then again the wave of joy and recognition receded. He closed his eyes, and his hand dropped from my open palm to the ground.

Looking about, I saw an old woman sitting with bowed head. Shaking hands with her, I recognized my mother. I sat down between my father and mother as I used to do, but I did not feel at home. The place where my grandmother used to sit was now unoccupied. With my mother I bowed my head. Alike our throats were choked and tears were streaming from our eyes; but far apart in spirit our ideas and faiths separated us. My grief was for the soul unsaved; and I thought my mother wept to see a brave man's body broken by sickness.

Useless was my attempt to change the faith in the medicine-man to that abstract power named God. Then one day I became righteously mad with anger that the medicine-man should thus ensnare my father's soul. And when he came to chant his sacred songs I pointed toward the door and bade him go! The man's eyes glared upon me for an instant. Slowly gathering his robe about him, he turned his back upon the sick man and stepped out of our wigwam. "Hā, hā, hā! my son, I cannot live without the medicine-man!" I heard my father cry when the sacred man was gone.

3

On a bright day, when the winged seeds of the prairie-grass were flying hither and thither, I walked solemnly toward the center of the camping-ground. My heart beat hard and irregularly at my side. Tighter I grasped the sacred book I carried under my arm. Now was the beginning of life's work.

Though I knew it would be hard, I did not once feel that failure was to be my reward. As I stepped unevenly on the rolling ground, I thought of the warriors soon to wash off their war-paints and follow me.

At length I reached the place where the people had assembled to hear me preach. In a large circle men and women sat upon the dry red grass. Within the ring I stood, with the white man's Bible in my hand. I tried to tell them of the soft heart of Christ.

In silence the vast circle of bareheaded warriors sat under an afternoon sun. At last, wiping the wet from my brow, I took my place in the ring. The hush of the assembly filled me with great hope.

I was turning my thoughts upward to the sky in gratitude, when a star called me to earth again.

A tall strong man arose. His loose robe hung in folds over his right shoulder. A pair of snapping black eyes fastened themselves like the poisonous fangs of a serpent upon me. He was the medicine-man. A tremor played about my heart and a chill cooled the fire in my veins.

Scornfully he pointed a long forefinger in my direction and asked, "What loyal son is he who, returning to his father's people, wears a foreigner's dress?" He paused a moment, and then continued: "The dress of that foreigner of whom a story says he bound a native of our land, and heaping dry sticks around him, kindled a fire at his feet!" Waving his hand toward me, he exclaimed, "Here is the traitor to his people!"

I was helpless. Before the eyes of the crowd the cunning magician turned my honest heart into a vile nest of treachery. Alas! the people frowned as they looked upon me.

"Listen!" he went on. "Which one of you who have eyed the young man can see through his bosom and warn the people of the nest of young snakes hatching there? Whose ear was so acute that he caught the hissing of snakes whenever the young man opened his mouth? This one has not only proven false to you, but even to the Great Spirit who made him. He is a fool! Why do you sit here giving ear to a foolish man who could not defend his people because he fears to kill, who could not bring venison to renew the life of his sick father? With his prayers, let him drive away the enemy! With his soft heart, let him keep off starvation! We shall go elsewhere to dwell upon an untainted ground."

With this he disbanded the people. When the sun lowered in the west and the winds were quiet, the village of cone-shaped tepees was gone. The medicine-man had won the hearts of the people.

Only my father's dwelling was left to mark the fighting-ground.

4

From a long night at my father's bedside I came out to look upon the morning. The yellow sun hung equally between the snow-covered land and the cloudless blue sky. The light of the new day was cold. The strong breath of winter crusted the snow and fitted crystal shells over the rivers and lakes. As I stood in front of the tepee, thinking of the vast prairies which separated us from our tribe, and wondering if the high sky likewise separated the soft-hearted Son of God from us, the icy blast from the north blew through my hair and skull. My neglected hair had grown long and fell upon my neck.

My father had not risen from his bed since the day the medicine-man led the people away. Though I read from the Bible and prayed beside him upon my knees, my father would not listen. Yet I believed my prayers were not unheeded in heaven.

"Hā, hā, hā! my son," my father groaned upon the first snow-fall. "My son, our food is gone. There is no one to bring me meat! My son, your soft heart has unfitted you for everything!" Then covering his face with the buffalo-robe, he said no more. Now while I stood out in that cold winter morning, I was starving. For two days I had not seen any food. But my own cold and hunger did not harass my soul as did the whining cry of the sick old man.

Stepping again into the tepee, I untied my snow shoes, which were fastened to the tent-poles.

My poor mother, watching by the sick one, and faithfully heaping wood upon the center fire, spoke to me:

"My son, do not fail again to bring your father meat, or he will starve to death."

"How, Ina," I answered, sorrowfully. From the tepee I started forth again to hunt food for my aged parents. All day I tracked the white level lands in vain. Nowhere, nowhere were there any other footprints but my own! In the evening of this third fast-day I came back without meat. Only a bundle of sticks for the fire I brought on my back. Dropping the wood outside, I lifted the door-flap and set one foot within the tepee.

There I grew dizzy and numb. My eyes swam in tears. Before me lay my old gray-haired father sobbing like a child. In his horny hands he clutched the buffalo-robe, and with his teeth he was gnawing off the edges. Chewing the dry stiff hair and buffalo-skin, my father's eyes sought my hands. Upon seeing them empty, he cried out:

"My son, your soft heart will let me starve before you bring me meat! Two hills eastward stand a herd of cattle. Yet you will see me die before you bring me food!"

Leaving my mother lying with covered head upon her mat, I rushed out into the night.

With a strange warmth in my heart and swiftness in my feet, I climbed over the first hill, and soon the second one. The moonlight upon the white country showed me a clear path to the white man's cattle. With my hand upon the knife in my belt, I leaned heavily against the fence while counting the herd.

Twenty in all I numbered. From among them I chose the best-fattened creature. Leaping over the fence, I plunged my knife into it.

My long knife was sharp, and my hands, no more fearful and slow, slashed off choice chunks of warm flesh. Bending under the meat I had taken for my starving father, I hurried across the prairie.

Toward home I fairly ran with the life-giving food I carried upon my back. Hardly had I climbed the second hill when I heard sounds coming after me. Faster and faster I ran with my load for my father, but the sounds were gaining upon me. |I heard the clicking of snow-shoes and the squeaking of the leather straps at my heels; yet I did not turn to see what pursued me, for I was intent upon reaching my father. Suddenly like thunder an angry voice shouted curses and threats into my ear! A rough hand wrenched my shoulder and took the meat from me! I stopped struggling to run. A deafening whir filled my head. The moon and stars began to move. Now the white prairie was sky, and the stars lay under my feet. Now again they were turning. At last the starry blue rose up into place. The noise in my ears was still. A great quiet filled the air. In my hand I found my long knife dripping with blood. At my feet a man's figure lay prone in blood-red snow. The horrible scene about me seemed a trick of my senses, for I could not understand it was real. Looking long upon the blood-stained snow, the load of meat for my starving father reached my recognition at last. Quickly I tossed it over my shoulder and started again homeward.

Tired and haunted I reached the door of the wigwam. Carrying the food before me, I entered with it into the tepee.

"Father, here is food!" I cried, as I dropped the meat near my mother. No answer came. Turning about, I beheld my gray-haired father dead! I saw by the unsteady firelight an old gray-haired skeleton lying rigid and stiff.

Out into the open I started, but the snow at my feet became bloody.

5

On the day after my father's death, having led my mother to the camp of the medicine-man, I gave myself up to those who were searching for the murderer of the paleface.

They bound me hand and foot. Here in this cell I was placed four days ago!

The shrieking winter winds have followed me hither. Rattling the bars, they howl unceasingly: "Your soft heart! your soft heart will see me die before you bring me food!" Hark! something is clanking the chain on the door. It is being opened. From the dark night without a black figure crosses the threshold It is the guard. He tells me that tomorrow I must die. In his stern face I laugh aloud. I do not fear death.

Yet I wonder who shall come to welcome me in the realm of strange sight. Will the loving Jesus grant me pardon and give my soul a soothing sleep? or will my warrior father greet me and receive me as his son? Will my spirit fly upward to a happy heaven? or shall I sink into the bottomless pit, an outcast from a God of infinite love?

Soon, soon I shall know, for now I see the east is growing red. My heart is strong. My face is calm. My eyes are dry and eager for new scenes. My hands hang quietly at my side. Serene and brave, my soul awaits the men to perch me on the gallows for another flight. I go.[1]

POETRY

During the last thirty-five years of the twentieth century, Native Americans struggled to avoid succumbing to a sense of despair about their culture's demise—a seeping assimilation into the general American "melting pot." Writers, in particular, made the assault on such feelings a major focus of their works. In 1969, Scott Momaday's novel *House Made of Dawn* won a Pulitzer Prize and made a new generation of Native American writers aware of a powerful message: People caught between cultures can, despite a variety of problems, find ways to survive.

Paula Gunn Allen, perhaps representative of many Native American writers, believes that Momaday's book created a new future for her: It "brought my land back to me." She believes that she and many Native Americans suffer from "land sickness"—a deep sense of exile caused by the loss of her land and birthright. In passages from *House Made of Dawn* she found that she shared a familiarity with the places Momaday described: "I knew every inch of what he was saying." It gave her the strength and inspiration—the will—to continue. In her poem "Recuerdo" she creates images of movement, loss, and of searching. She looks for a sense of "being securely planted."

Recuerdo
Paula Gunn Allen

I have climbed into silence trying for clear air
and seen the peaks rise above me like the gods.
That is where they live, the old people say.
I used to hear them speak when I was a child
and we went to the mountain on a picnic
or to get wood. Shivering in the cold air then
I listened and I heard.

Lately I write, trying to combine sound and memory,
searching for that significance once heard and nearly lost.
It was within the tall pines, speaking.
There was one voice under the wind—something in it
that brought me to terror and to tears. I wanted
to cling to my mother so she could comfort me,
explain the sound and my fear, but I simply sat,
frozen, trying to feel as warm as the campfire,
the family voices around me suggested I should.

Now I climb the mesas in my dreams.
The mountain gods are still, and still I seek.
I finger peyote buttons and count the stalks of sweetsage
given me by a friend—obsessed with a memory
that will not die.

I stir wild honey into my carefully prepared cedar tea
and wait for meaning to arise,
to greet and comfort me.

Maybe this time I will not away.
Maybe I will ask instead what that sounding means.
Maybe I will find that exact hollow
where terror and comfort meet.
Tomorrow I will go back and climb the endless mesas
of my home. I will seek thistles drying in the wind,
pocket bright bits of obsidian and fragments
old potters left behind.[2]

CERAMICS AND PAINTING

Pottery was the greatest of the prehistoric arts, and it continues almost completely as an aesthetic activity. Early pottery vessels, however, were designed for everyday use, and finishing techniques took second place to practical concerns—most important was to get the object into use. Clay bowls such as that pictured in Figure 13.1 reflect the time-honored traditions of the Southwest, but have risen in quality of finish and design to the status of high art. Thus, the culture has been sustained. Other of its artistic forms include silversmithing—the popular silver and turquoise jewelry is still made—and sand painting. Sand paintings incorporate important religious meanings, and many rituals cannot be performed without them.

The traditional materials of Native American art—indigenous and easily accessible—were supplemented in the twentieth century by standard Western media—for example, watercolor. In Figure 13.2 one of the foremost Navajo painters documents typical Native American life. One characteristic aspect of Native American watercolor painting from the middle of the last century is this use of space: The painting stays on the surface plane and no background or spatial environment appears. The women and the corn are the only concerns. They are rendered in two dimensions with only the diminutive size of the woman on the left to hint at three-dimensional space or perspective. The horizon line, or viewer's eye level, is at the bottom of the painting.

MUSIC

As in the case of African tribal music, Native American music continues as an important part of cultural reality. For example, Inuit music has developed into an art form with complex rhythms using contrasting accents and meters. Its melodies are fairly conjunct, creating a gentle and undulating quality, but the style can be declamatory—similar to recitative in Western operas.

13.1 Lucy Lewis, Ceramic bowl, from the Pueblo area, Acoma, New Mexico, 1969. National Museum of the American Indian, Smithsonian Institution, Washington, D.C.

13.2 Harrison Begay, *Women Picking Corn*, mid-20th century. Watercolor, 15 x 11½ ins (38.1 x 29.2 cm). National Museum of the American Indian, Smithsonian Institution, Washington, D.C.

In Northwest-coast Native American music, only the owner of a song is permitted to perform it. However, it is possible to buy a song, to inherit it, or even to obtain it by murdering the owner. Additionally, songs are owned by secret societies within the tribes. In musical terms, Northwest Native American music is similar to some African music, using parallel harmonies sung by separate voices and *drone* notes (single notes sustained while the remaining parts sing on). Rhythms tend toward strongly percussive and intricate patterns.

Songs among the southwestern Native Americans, especially the Pueblos, have a complex tonal system. They are based on six- or seven-note scales and stay at the low end of the register. This is in contrast to the music of the Plains Indians, who tend to use high pitches. Nearly every social occasion, holy day, and ceremony has its own special music.

AFRICA

African tribal art maintained its traditions into the twentieth century. As we examine some final examples, let us review a few of its characteristics.

First of all, and perhaps unlike much of Western art, African art is made to be used—for example, it is fre-

quently worn, as in the case of a mask or costume in a dance. The dance itself will have a ritual function: to ensure the continuity of the tribe. The rituals enact complex dramas of birth, succession of power, and initiation to adulthood.

Like art from all traditions—including much from Western culture—African art frequently serves a religious function, for religion permeates all facets of African life and death. Art is created to represent local deities and/or personal spirits, in the hope that they will grant favors to the worshiper in return for offerings and ceremonials. It can function as a device for divining the future and for worshiping ancestors—ancestor shrines often have figurative sculptures carved in honor of the dead. And it can symbolize concepts like family unity and character traits like aggression.

In addition, African art maintains a political function. Traditionally, tribal power was held both by a king and by a governing body of tribal elders who balanced the royal authority. In many regions, a queen mother (or another female relative of the king) also held a powerful position within the community. Frequently art objects were created to symbolize and sustain the ruling authority. Like Native American art—and Western art from such periods as the Baroque—African art often proclaims the wealth and power of the king. The works are often made from the richest of materials, and become proof positive of the king's majesty and his ability to commission works from the greatest artists.

Finally, although African artworks are primarily functional, this does not mean that beauty is not a consideration. Rarely does African art copy nature. Rather, we can think of it as conceptual—that is, artists emphasize the physical and symbolic characteristics of the essences, rather than the visible nature, of their subjects.

SCULPTURAL STYLE

Figures

Two carved figures of a dancing royal couple (Fig. **13.3**) from the Bangwa Kingdom of Cameroon exemplify typically dynamic combinations of line, form, and texture. These cult images have a ritualistic purpose encompassing the appeasement of the spirit of the tree from which they were carved. The sculptor has captured the movement of two figures caught at a moment in a dance, complete with flexing legs and tightening muscles. The neck and chin of the female strain upward, showing tension filled with dynamic energy. Open mouths indicate that the dance was accompanied by a song. Both sculptures—the female form,

363

especially—seem to be built up out of ovoid sections although each was carved from one piece of wood. Smooth, sweeping curves create a dynamic rhythm, while the slender points of articulation between body parts heighten the intensity of motion.

Although these depictions suggest reality, they modify and stylize it. Like the figures of the ancient and Classical Greeks, these statues represent types rather than individuals. However, they are very human, with facial expressions that communicate individual human emotion and expression—although some proportions have been exaggerated, for example, the eyes in the male figure. The wooden surface has been polished to a degree of smoothness that suggests the play of light on real skin. Clothing and accoutrements represent the costume of the tribe. Both of these figures suggest youth and health. They seem powerful, alive, and in the prime of life. Despite their less-than-life-

like proportions, they communicate grace and flexibility—characteristics particularly admired by Africans in dancers.

The lengthy European presence in Africa has, in some cases, had a subtle influence on the construction of traditional tribal artifacts. The early twentieth-century figure in Figure 13.4, an animal from Loango in Congo Brazzaville, displays African symbolic significance but is made of European materials. This animal is called a *power figure*—it is a magical effigy. Its spines are iron nails and blades driven into a wooden core. The act of driving the nails and blades into the figure was thought to activate magic, used either to cure or kill. Because nails are of European manufacture, more than one expert has suggested that the concept of giving them supernatural power stemmed from the story of Christ's crucifixion, told by missionaries who first came to Africa after the great age of discovery in the sixteenth century. In fact, from the early sixteenth to the late seventeenth century, Christianity was the state religion in the area where these figures were found, but clearly traditional beliefs coexisted with it. Although these nails are European, iron had older ritual significance in Africa. The metal had been smelted from early times in northern Nigeria and was used widely in agriculture and warfare long before Christianity reached Africa. It is therefore likely that iron as a magical symbol predates Christian influence.

Whatever the case, this feisty animal bristles with life. Like a worried porcupine, it seems set in an aggressive posture, with quills poised at the optimum angle for attacking an enemy. The open mouth, extended tongue, and bulging eyes convey a sense of imminent action. Because the front legs slant backward, we feel that the animal is poised to spring forward.

Power figures like this one apparently had only a short lifespan. Unlike some others, these effigies were discarded

13.3 Dancing royal couple from Bangwa, Cameroon, early 20th century. Wood, height 34½ and 34¼ ins (87.6 and 87 cm). Harry A. Franklin family, on loan to the Los Angeles County Museum of Art.

13.4 Magic animal, from Loango, Congo Brazzaville, early 20th century. Wood, with iron nails and blades, length 35 ins (88 cm). Musée de l'Homme, Paris.

once their original purpose had been achieved (or after they had proven ineffective). Whatever their original intention, these works transcend anthropological speculation and have interest purely as works of sculpture. Their texture, line, and form surely communicate far more than their makers intended.

Headdress Masks

Headdress masks are widely used in African rituals, and the following example from western Africa gives some insight into their importance.

This Yoruba headdress mask (Fig. 13.5) was made for a tribal festival—Gelede—found only among the southwestern Yoruba peoples along the border between Nigeria and the Republic of Benin. Gelede is in the spring, from March through May, when the rains arrive. Coinciding with a time of vegetative renewal, the festival aims to renew the social condition of the tribe by honoring "the mothers."

Gelede masks such as this one represent elder Yoruba women in their dual role as "the mothers" and as witches: They have the power to create, but also to destroy. The term "the mothers" signifies the collective power of women and refers specifically to elderly women, female ancestors, and female deities. The power ascribed to them affects the fertility of the fields, the family, and the peace and prosperity of the community.

In this particular example, the head of one of "the mothers" is carved as a headdress with a turtle held above it by the jaws of two snakes which wrap around the headpiece. The headdress is daubed with white and red paint which gives the image a mottled texture, strengthening the three-dimensionality of the carving.

The Yoruba peoples' art represents the Guinea Coast Style Zone, and this large and diverse zone consists of several stylistic approaches of peoples who are principally farmers. Centralized political institutions and hierarchical organization characterize the region. The arts are used in secret societies; in representations of ancestors, protective images, and nature spirits; in funerary, initiation, and public entertainment performances; and in the service of traditional political institutions.

13.5 Yoruba Gelede mask headdress with carved turtle superstructure, from Benin, 20th century. Height 15 ins (38.1 cm).

AFRICAN INFLUENCE ON WESTERN ART

The direct influence of African art can be seen in the early work of the Romanian sculptor Constantin Brancusi (1876–1957). While his work borrows freely from African tribal motifs, the smooth, precise surfaces of much of his work seem to have an abstract, mechanistic quality. His search for essential form led to very economical presentations, often ovoid and simple, yet animate. *Mlle. Pogany* (Fig. 13.6) has the enigmatic character of an African mask despite its superbly polished surface and the accomplished curves that lead the eye inward. The surface has a modern sleekness, and there is great psychological complexity here; and yet the "primitive" essence remains, reminding us of the work of African or Aboriginal tribes.

AFRICAN TRIBAL MUSIC

Although African tribal music could have been introduced at any point, it has been placed here so that we can understand its continuing presence in African life. Music in Africa is truly universal: Its importance crosses all societal levels, from royalty to the common person. Every aspect of

13.6 Constantine Brancusi, *Mlle. Pogany*, 1931. Marble on limestone base, height 19 ins (48 cm). Philadelphia Museum of Art (Louise and Walter Arensberg Collection).

tribal existence has special music—for example, there is music for communicating news, for entertainment, for legal dealings, for hunting, and for working in the fields. Special life events—like marriage, birth, and death—and times and seasons—such as the new year and the new moon—have their own songs and dances.

The heritage of the tribe is communicated from generation to generation by means of song and dance. Thus, music plays a vital role in keeping alive the spirit and cohesiveness of society. Nearly every one of Africa's hundreds of tribes has its own individual musical characteristics. Because African music tends to be sung, the language of the tribe contributes its unique sounds and textures. This is especially true of the tone languages—those in which pitch helps to denote meaning. A particular word, when sung, must stay in a specific pitch range because to move into another pitch range would change its meaning.

Typically, the music of tribal Africa consists of short melodic phrases that are repeated, alternated, and varied in order to create longer melodies. Often a phrase is sung by a leader and then repeated in response by a chorus. Voices move in parallel chords—always consistent in their separation—and this gives African music its characteristic harmonic quality. Another interesting aspect of some African music is a drone held by one voice while a second voice sings a phrase; the drone then passes to the second voice while the first sings a phrase, and so on. Also typical is the use of complicated and contrasting rhythmic patterns. Quite often one voice or drum will maintain a duple meter while another works in triple meter against it. Harmonically, melodically, and rhythmically, African music is very complex not only across the range of tribes but also within specific tribal groups (CD track 3).

AFRICAN AMERICA

HARLEM RENAISSANCE

From 1919 to 1925 Harlem, a small enclave in New York City, became the international capital of African culture. "Harlem was in vogue" wrote the poet Langston Hughes (see p. 369). African American painters, sculptors, musicians, poets, and novelists joined in a remarkable artistic outpouring. The period became intensely controversial, its artistic merits attacked by some critics of the time as isolationist and conventional; the qualities of the Harlem Renaissance still provoke debate. None the less, this period of intense creative activity by African Americans "gave the artists an identifiable artistic context for their work, propelled them to the forefront of the New Negro Movement, and inspired their art for the remainder of their careers."[3]

The artistic works of this period reached a national audience through exhibitions sponsored by the Harlem Foundation. The movement explored several themes: African American heritage; the traditions of African folklore; and the daily life of African American people. In every case Harlem Renaissance artists broke with previous African artistic traditions. They celebrated their history and culture and "defined a visual vocabulary for Black Americans."[4]

Intellectuals such as W. E. B. Du Bois, Alain Locke, and Charles Spurgeon spearheaded the movement. Among the notable artists were social documenter and photographer James van der Zee (1886–1983), painter Palmer Hayden (1890–1973), painter Aaron Douglas (1899–1979), painter William Henry Johnson (1901–70), painter Jacob Lawrence (b. 1917), sculptor Meta Vaux Warrick Fuller (1877–1968), and poet Langston Hughes (1902–67).

Painting

Palmer Hayden (Peyton Cole Hedgeman) trained at the Cooper Union in New York in 1919 and later at the Boothbay Art Colony. In 1927 he traveled to Europe and studied at the Ecole des Beaux Arts. His work was exhibited widely in New York and despite its symbols of ethnic heroism it drew heavy criticism from those who believed that his depictions mocked African American people and sustained negative stereotypes. Later in life he created the John Henry series, twelve oil paintings portraying the life and death of a folk hero. This was part of his focus on African American legends visually expressing the wealth of material from the African American oral culture of the rural South and from Africa itself. His main approach was to use folk themes to illustrate industrial America's dependence on the African American labor force.

Aaron Douglas, perhaps the foremost painter of the Harlem Renaissance, earned a bachelor of fine arts degree from the University of Nebraska and a master's degree from Columbia University. His training encouraged him to explore the rich vocabulary of African American myth and culture. His work is highly stylized, explores a palette of muted tones, and is well known through its appearance as illustrations and cover designs for many books by African American writers. His mural *Aspects of Negro Life*, at the New York Public Library's Cullen Branch, documents in four panels the emergence of an African American identity. The first panel portrays cultural background in images of music, dance, and sculpture. The next two bring to life slavery and emancipation in the American South and flight to the cities of the North. The fourth panel returns to the theme of music. Among Douglas's wide variety of stylistic approaches, his realistic portrait of Aalta (Fig. **13.7**) provides a warm and relaxed composition. Its palette and expression show dignity, elegance, and stability.

William Henry Johnson trained at the National Academy of Design in New York, followed by a three-year fellowship in 1926 to study in Europe. Under the influence of the European Impressionists and Realists, his style grew

13.7 Aaron Douglas, *Aalta*, 1936. Oil on canvas, 18 x 23 ins (45.7 x 58.4 cm). Carl Van Vechten Gallery of Fine Arts, Fisk University (Afro-American Collection of Art).

in personal expressiveness. His many works focus on African American experience. Harlem, where he spent his childhood, is the central theme. Just prior to World War II his style changed again, moving from fully rounded to flat figures.

In Jacob Lawrence's works, such Modernist effects—for example, the flattening of space and the use of undifferentiated planes of color—are secondary to the need to convey an intelligible narrative to the viewer (Fig. **13.8**). Having trained at the Harlem Art Workshop and the American Artists' School in New York, he is a fine example of an artist acutely aware of his privileged position and, at the same time, his membership of a dispossessed and disadvantaged section of society.

Sculpture

Meta Vaux Warrick Fuller "was the first Black American artist to draw heavily on African themes and folklore for her subjects."[5] Years before the Harlem Renaissance, she began to express the pan-African ideals that later permeated the movement. After finishing graduate work at the Pennsylvania Museum and School for Industrial Arts, she studied in Paris at the Ecole des Beaux Arts and the Académie Colarossi. One of her mentors was the sculptor Auguste Rodin (see p. 332), and his influence can be seen in her impressionistic surface treatment of Romantic Realist subjects. Fuller built her own studio in Framingham, Massachusetts, and focused on themes dealing with anti-slavery and protests against injustice to African Americans. In one of the earliest works by an American focusing on the African heritage, her sculpture *Ethiopia Awakening* shows an Egyptian woman emerging from her embalming wrappings. "The work symbolically represents the emergence of Black cultural awareness from the 'wrappings' of ignorance and oppression, and the beginnings of the end of colonial rule in Africa."[6] Works such as *The Talking Skull* are based on African models and illustrate the confrontation of humans with death, a prevalent theme in her career.

13.8 Jacob Lawrence, "One of the largest race riots occurred in East St. Louis," Panel 52 from *The Migration Series*, 1940–1; text and title revised by the artist, 1993. Tempera on gesso on composition board, 12 x 18 ins (30.5 x 45.7 cm). The Museum of Modern Art, New York (Gift of Mrs. David M. Levy).

Poetry

Langston Hughes is often referred to as the "poet laureate of Harlem." He portrays the life of the ordinary African American in the United States, catching with sharp immediacy and intensity the humor, pathos, irony, and humiliation of being black in America. His poetry particularly appeals to young people. He speaks of the basic qualities of life: love, hate, aspirations, and despair. Yet he writes with a faith in humanity in general. He interprets all life as it is experienced in the real world, as well as touching on the ideal. Hughes struggled within himself between what he wanted to express and what his audience expected him to write. Thus some of his work is militant, with broad sociopolitical implications.

Hughes received considerable attention as a poet as early as 1921 with his poem "The Negro Speaks of Rivers." In his novel *Not Without Laughter*, he creates a brilliant portrayal of an African American youth's passage into manhood. In the selections that follow, readers can sense something of the African American experience and perception of the universe.

Theme for English B
Langston Hughes
1902–67

The instructor said,
 Go home and write
 a page tonight.
 And let that page come out of you—
 Then, it will be true.
I wonder if it's that simple?

I am twenty-two, colored, born in Winston-Salem.
I went to school there, then Durham, then here
to this college on the hill above Harlem.
I am the only colored student in my class.
The steps from the hill lead down into Harlem
through a park, then I cross St. Nicholas.
Eighth Avenue. Seventh, and I come to the Y,
the Harlem Branch Y, where I take the elevator
up to my room, sit down, and write this page:
It's not easy to know what is true for you or me
at twenty-two, my age. But I guess I'm what
I feel and see and hear, Harlem, I hear you:
hear you, here me—we two—you, me, talk on this page.
(I hear New York, too) Me—who?
Well, I like to eat, sleep, drink, and be in love.
I like to work, read, learn, and understand life.
I like a pipe for a Christmas present,
or records—Bessie, bop, or Bach.
I guess being colored doesn't make me not like
the same things other folks like who are other races.

So will my page be colored that I write?
Being me, it will not be white.
But it will be
a part of you, instructor.
You are white—
yet a part of me, as I am a part of you,
that's American.
Sometimes perhaps you don't want to be a part of me.
Nor do I often want to be a part of you.
But we are, that's true!

As I learn from you
I guess you learn from me—
although you're older—and white—
and somewhat more free.

This is my page for English B.

Harlem
Langston Hughes

What happens to a dream deferred:

Does it dry up
like a raisin in the sun?
Or fester like a sore—
and then run?
Does it stink like rotten meat?
Or crust and sugar over—
like a syrupy sweet?

Maybe it just sags
like a heavy load.

Or does it explode?[7]

JAZZ

Probably the most significant African American contribution to music, *jazz* began near the turn of the last century. It is essentially made up of improvised variations on a theme. The earliest form—*blues*—went back to the music of the slaves. It consists of two rhythmic lines and a repeat of the first line (AAB). At the end of the nineteenth century, performers like Bessie Smith gave the blues an emotional quality, which the accompanying instruments tried to imitate.

At approximately the same time came *ragtime*, a form of piano jazz with a strict two-part form. Syncopation—the displacement of accent from the normally accented beat to the offbeat—played an important role in this style. Its most famous artist was Scott Joplin.

New Orleans, the cradle of jazz, also produced *traditional jazz*, featuring improvisation on a basic chord

sequence. This was followed in the 1930s and 1940s by *Swing* and *Be-bop*. The term "Be-bop" was coined as a result of the characteristic long-short triplet rhythm that ended many phrases. Its prime developers were alto saxophonist Charlie "Bird" Parker (Fig. **13.9**) and trumpeter Dizzie Gillespie. Styles stemming from traditional jazz proliferated after World War II. There was a gradual move away from big bands to smaller groups and and a desire for much more improvisation. The *Cool Jazz* style developed in the early 1950s with artists like Miles Davis. Although the technical virtuosity of Be-bop continued, it also emphasized a certain lyric quality, particularly in the slow ballads. More importantly, actual tone quality was a major distinction, particularly in the wind instruments.

Were our space unlimited, we could look further into this African American form and include such gifted performers as Thelonius Monk, John Coltrane, and Cecil Taylor. John Coltrane, for example, has had a tremendous influence on African American society in the United States. Coltrane's personality and charisma are clear in his albums *A Love Supreme, Ascension Meditations*, and those that followed. These works acted as a significant spiritual reservoir for African Americans and have cast a hugely influential shadow over jazz ever since.

DANCE

The American dance scene has benefited from a number of exceptional choreographers of African American heritage who draw upon their culture. Among them is Alvin Ailey (b. 1931), a versatile dancer whose company is known for its unusual repertoire and energetically free movements. Another form of dance that has its roots in Africa, but which draws upon the broad experiments of modern dance, is *jazz dance*. Like modern dance in general, its form and direction are still in flux. Nevertheless, stemming from sources as diverse and yet as allied as "primitive" Africa and the urban ghetto, it has seen significant activity and experimentation throughout the United States (Figs. **6.15–16**). Pioneered by choreographers such as Asadata Dafora Horton in the 1930s and Katherine Dunham and Pearl Primus in the 1940s, jazz dance flourished at the end of the century under choreographers such as Talley Beatty and Derglas MacKayle.

LIBERATION IN THE THEATRE

Theatrical liberation of the African American began in the 1960s. One manifestation of the civil rights movement of the 1950s and 1960s was the angry, militant African Americans who espoused "Black consciousness." Many converted to the African Muslim version of Islam, and many longed for a completely separate "Black nation." Radical groups talked about destroying Western society. A number of African Americans turned toward Africa and sought a new identity in the Third World. In the 1980s, there was a change in self-description from Black to African American.

Many of these ideas were expressed in the works of playwrights such as LeRoi Jones (who became Imamu Amiri Baraka). His plays dramatize the dangers of Blacks allowing Whites into their private lives and call for racial separation. Charles Gordonne's *No Place to Be Somebody* renews Baraka's cause, and espouses violence as legitimate action in the penetrating story of a fair-skinned Black searching for his own racial identity.

Many new African American theatre companies emerged in the 1960s. The Negro Ensemble Company, founded by Douglas Turner Ward, is one enduring example. It staged a moving production of *Home* by Samm-Art Williams. *Home* traces the ups and downs in the life of an African American Southerner named Cephus. Raised on a farm, he leaves for the big city. Convicted of draft evasion and sent to jail, he progresses to joblessness and welfare, disease and despair. Finally, he returns to the honest labor and creative values on the farm. The poetic language and the conventions of its production format give *Home* a unique and endearing quality. Cephus is played by a single actor, but all the other roles—old, young, male, female, Black, White—are played by two women who take on whatever role they wish by changing costumes. Sometimes they are characters in Cephus's journey and other times they act as a chorus, helping the audience to follow leaps in time and space. The chorus format helps the audience to see Cephus from the point of view of African American history and culture. Although Cephus is constantly on the move, the stage setting never changes, and although the actresses play several different roles, they never change. Through these devices, the playwright suggests that "home" is at hand all the time, waiting to be grasped. The force that stands in the way is unwillingness: to acknowledge one's inner yearnings, to accept help from others, and to extend oneself by choosing a path of peace instead of confrontation.

The son of a White father and a Black mother, August Wilson (b. 1945) writes with an ear tuned to the rhythms and patterns of the blues and the speech of African American neighborhoods. He founded the Playwrights Center in Minneapolis. His plays range from *Jitney* and *Ma Rainey's Black Bottom* in the 1980s to *Two Trains Running* and *Seven Guitars* in the 1990s. Wilson believes that the African American has the most dramatic story of all

humankind to tell. His concern lies with the stripping away of important African traditions and religious rituals from Blacks by Whites. In plays such as *The Piano Lesson*, he portrays the complexity of African American attitudes toward themselves and their past. Both the blatant and the more subtle conflicts between Black and White cultures and approaches form the central core of Wilson's work and can be seen in plays such as *Fences*.

Fences treats the lives of African American tenement-dwellers in Pittsburgh in the 1950s. Troy Maxson, a garbage collector, takes great pride in his ability to hold his family together and to take care of them. As the play opens, Troy discusses his challenge to the union concerning Blacks' access to doing the same "easy" work as Whites. He is frustrated and believes that he has been deprived of the opportunities to get what he deserves—and this becomes a central motif. He describes his wrestling match with death in 1941 when he had pneumonia. He also tells of his days in the African American baseball leagues, barred from playing in the majors because of his race.

AMERICA AND EUROPE

EXPRESSIONISM

Visual Arts

Expressionism traditionally refers to a movement in Germany between 1905 and 1930, but used more broadly it applies to a focus on the joint reaction of artist and viewer to composition elements. Any element (line, form, color, and so on) can be emphasized to elicit a specific response. The artist consciously tries to stimulate a reaction specifically relating to his or her feelings about, or commitment to, the subject matter. Subject matter itself mattered little; what counted was the artist's attempt to evoke in the viewer a similar response to his or her own. In Max Beckmann's *Christ and the Woman Taken in Adultery*

13.9 Saxophonist Charlie Parker in performance with Tommy Potter. Parker died prematurely in 1955, aged 35, but by that time he was already a legendary figure.

(Fig. **13.10**), the artist's revulsion against physical cruelty and suffering is transmitted through distorted figures crushed into shallow space. Linear distortion, changes of scale and perspective, and a nearly Gothic spirituality communicate Beckmann's reactions to the horrors of World War I. In this approach, meaning relies on specific nonverbal communication.

The 1970s saw a continuation of Expressionism in the lyrical work of artists such as William T. Williams (b. 1942). *Batman* (Fig. **13.11**) has a methodology that has been compared to jazz improvisation. In the carefully defined two-part structure, verticals subtly play across the dividing line to pull the work together. At the same time delicate traceries reinforce the basic structure and provide endless variations. The resulting texture is evocative, like cracking or peeling paint on a series of old boards. True to its Expressionist heritage, the work links the artist's memory with the experience of the viewer.

Theatre and Film

Expressionism found its way into the theatre in scenic design, as the painters' revolt against realism was adopted. But here we must tread carefully, because the theatre is both visual and oral. As regards concepts and plots, Expressionism was merely an extension of realism, and disillusionment often came to the fore. Yet it allowed playwrights a more adequate means to express their own reactions to specific items in the universe around them. The Swedish dramatist August Strindberg (1849–1912), for example, turns inward to the subconscious in Expressionistic plays such as the *Ghost Sonata*. In so doing, he creates a presentational rather than representational style.

Expressionism also found its way to America. Elmer Rice's play *Adding Machine* depicts Mr. Zero, a cog in the great industrial machinery of twentieth-century life, who stumbles through a pointless existence. Finding himself replaced by an adding machine he goes berserk, kills his employer, and is executed. Then, adrift in the hereafter, he is too narrow-minded to understand the happiness offered to him there. He becomes an adding machine operator in Heaven and finally returns to earth to begin his tortured existence all over again.

German Expressionism made its mark in film as well as in the visual and other performing arts, and in 1919 its best example, Robert Wiene's *Cabinet of Dr. Caligari*, shook the world. Macabre sets, surrealistic lighting effects, and distorted properties all combine to portray a menacing post-war German world.

CUBISM

Between 1901 and 1912 a new approach to pictorial space emerged: *Cubism*. Cubist space violates all concepts of two- or three-dimensional perspective. In the past the space within a composition had been thought of as separate from the main object of the work. That is, if the subject were removed, the space would remain, unaffected. Pablo Picasso (1881–1973) and Georges Braque (1882–1963) changed that relationship to one in which the artist tried to paint "not objects, but the space they engender." The area around an object became an extension of the object itself. If the object were removed, the space around it would collapse. Cubist space is typically quite shallow and gives the impression of reaching forward toward the viewer, thereby intruding into space outside of the frame. Essentially the style developed as the result of independent experiments by Braque and Picasso with ways of describing form. Newly

13.10 (*above*) Max Beckmann, *Christ and the Woman Taken in Adultery*, 1917. Oil on canvas, 4 ft 10¾ ins x 4 ft 1⅞ ins (1.49 x 1.27 m). St. Louis Art Museum (Bequest of Curt Valentin).

13.11 (*opposite*) William T. Williams, *Batman*, 1979. Acrylic on canvas, 6 ft 8 ins x 5 ft (2.03 x 1.52 m). Collection of the artist.

evolving notions of the time–space continuum were being proposed by the German physicist Albert Einstein (1879–1955) at this time. We cannot be sure whether the Theory of Relativity influenced Picasso and Braque, but it certainly helped to make their works more acceptable.

Picasso influenced the visual arts of the twentieth century more than any other individual. Born in Spain, he moved in 1900 to France, where he resided for most of his life. In Paris he was influenced by Toulouse-Lautrec and the late works of Cézanne (see p. 352), particularly in terms of their organization, analysis of forms, and assumption of different viewpoints. He focused on form kept within the frame. Mass was "built up within [the frame] like a box within a box."[8]

Very early on, Picasso began to identify deeply with society's misfits and cast-offs. He was able to express this strongly in his art. Depression characterized his works from 1901 until around 1904 or 1905. This is known as his Blue Period and was followed by his Rose Period (1904–6) "in which he was less concerned with the tragic aspects of poverty than with the nostalgic charm of itinerant circus performers and the school of make-believe."

Les Demoiselles d'Avignon (Fig. **13.12**) has become the single most discussed image in modern art. Its simplified forms and restricted color were adopted by many Cubists, as they reduced their palettes in order to concentrate on spatial exploration. A result of personal conflicts on the part of the artist, combined with his ambition to be recognized as the leader of the avant garde, the painting deliberately breaks with the traditions of Western illusionistic art. The painter denies both Classical proportions and the organic integrity and continuity of the human body.

Les Demoiselles d'Avignon (Avignon in the title refers to a street in Barcelona's red-light district) is aggressive and harsh like the world of the prostitutes who inhabit it. Forms are simplified and angular, and colors are restricted to blues, pinks, and terracottas. Picasso breaks his subjects into angular wedges which convey a sense of three-dimensionality. We do not know whether the forms protrude out or recess in. In rejecting a single viewpoint, Picasso pres-

13.12 Pablo Picasso, *Les Demoiselles d'Avignon*, Paris, June to July 1907. Oil on canvas, 8 ft x 7 ft 8 ins (2.44 x 2.34 m). The Museum of Modern Art, New York (Acquired through the Lillie P. Bliss Bequest).

ents "reality" not as a mirror image of what we see in the world, but as images that have been reinterpreted within the terms of new principles. Understanding thus depends on knowing rather than seeing in the literal sense. Cubism uniformly reduced its palette range, thereby emphasizing the exploration of space.

FAUVISM

The label "Fauves" (French for "wild beasts") was applied by a critic in response to a sculpture (exhibited in 1905) which seemed to him "a Donatello in a cage of wild beasts." Violent distortion and outrageous coloring mark the subjective expression of the Fauves. Their two-dimensional surfaces and flat color areas were new to European painting. The best-known artist of this short-lived movement was Henri Matisse (1869–1954). He tried to paint pictures that would "unravel the tensions of modern existence." In his old age he made a series of joyful designs for the Chapel of the Rosary in Venice, not as exercises in religious art but, rather, to express the almost religious feeling he had for life. *The Blue Nude* (Fig. **13.13**), painted after the Fauves disbanded, illustrates the wild coloring and distortion of Matisse and *Fauvism*. The painting takes its name from the energetically applied blues all over the figure as darkened accents. For Matisse color and line were indivisible. His bold strokes of color are both coloristic and linear stimulants, and also revelations of form. Matisse literally "drew with color." Underlying this work is Matisse's desire to express his feelings about the nude as an object of aesthetic interest, rather than to draw the woman as he saw her in life.

FUTURISM

New concerns for space turned, logically, to three-dimensional space and its potential. Technological developments and new materials also encouraged the search for novel forms characteristic of the age. Futurists in the visual arts searched for dynamic qualities; some sculptures even included moving parts. Others followed mechanistic lines, as people began to appreciate that many of the new machines of the era had sculptural form.

Boccioni's *Unique Forms of Continuity in Space* (Fig. **13.14**) takes the mythological subject of Mercury, messenger of the gods, and turns him into a futuristic machine. The overall form is recognizable and the connotations of the myth suggest subject matter. None the less, this is primarily an exercise in composition of forms. The intense sense of energy and movement is created by the variety of surfaces and curves that flow into one another in a seemingly random yet highly controlled pattern. The overall impression is of a figure in motion, rather than of the figure itself.

ABSTRACTION

Abstract art contains minimal reference to natural objects—that is, objects in the phenomenal or natural world. In many ways abstract art contrasts with

13.13 Henri Matisse, *Blue Nude* ("*Souvenir de Biskra*"), 1907. Oil on canvas, 36¼ x 55¼ ins (91 x 104 cm). Baltimore Museum of Art (Cone Collection, formed by Dr. Claribel Cone and Miss Etta Cone of Baltimore, Maryland).

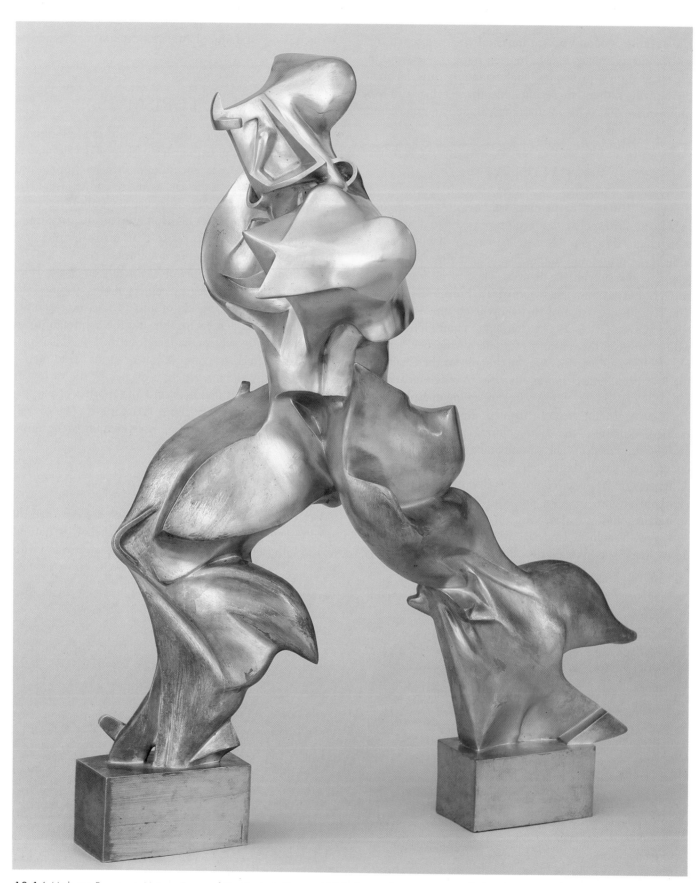

13.14 Umberto Boccioni, *Unique Forms of Continuity in Space*, 1913. Bronze (cast 1931), 43⅞ x 34⅞ x 15¾ ins (111.2 x 88.5 x 40 cm). The Museum of Modern Art, New York (Acquired through the Lillie P. Bliss Bequest).

Impressionism and Expressionism in that the observer can read little or nothing in the painting of the artist's feelings about the universe. Abstract art seeks to explore the expressive qualities of formal design elements in their own right. These elements are assumed to stand apart from subject matter. The aesthetic theory underlying abstract art maintains that beauty can exist in form alone, and no other quality is needed.

Visual Arts

Piet Mondrian (1872–1944) believed that the fundamental principles of life consisted of straight lines and right angles. A vertical line signified active vitality and life; a horizontal line signified tranquillity, rest, and death. The crossing of the two in a right angle expressed the highest possible tension between these forces, positive and negative. *Composition in White, Black, and Red* (Fig. **1.40**) explores Mondrian's philosophy in a manner characteristic of all his linear compositions. The painting's planes are close to the surface of the canvas, creating, in essence, no space, in con-

trast to the deep space of other styles. The palette is restricted to three hues. Even the edges of the canvas take on expressive possibilities as they provide additional points of interaction between lines. Mondrian believed that he could create "the equivalence of reality" and make the "absolute appear in the relativity of time and space" by keeping visual elements in a state of constant tension.

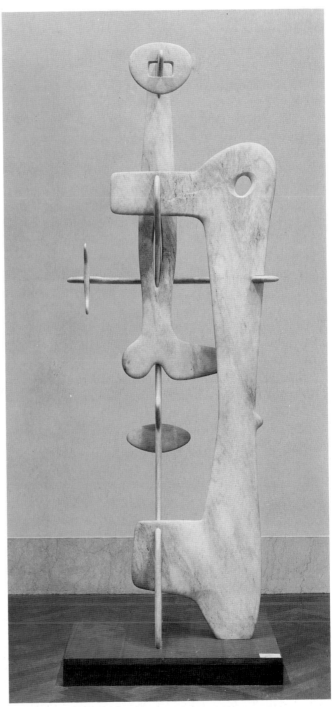

13.16 Isamu Noguchi, *Kouros* (in nine parts), 1944–5. Pink Georgia marble, slate base, height c. 9 ft 9 ins (2.97 m). Metropolitan Museum of Art, New York (Fletcher Fund).

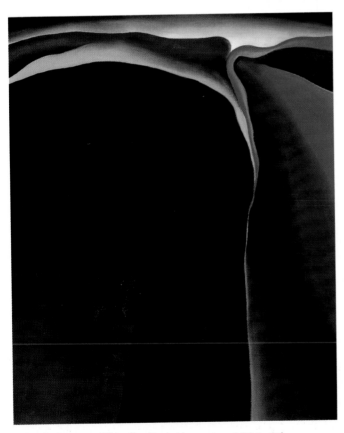

13.15 Georgia O'Keeffe, *Dark Abstraction*, 1924. Oil on canvas, 24⅞ x 20⅞ ins (63.3 x 53 cm). St. Louis Art Museum (Gift of Charles E. and Mary Merrill).

The American Georgia O'Keeffe (1887–1986) has proved to be one of the most original artists of our time. Her imagery draws on a diverse repertoire of objects abstracted in a uniquely personal way. She takes, for example, an animal skull and transforms it into a form of absolute simplicity and beauty. In *Dark Abstraction* (Fig. **13.15**) an organic form becomes an exquisite landscape which, despite its modest size, appears monumental. Her lines flow gracefully upward and outward with skillful blending of colors and rhythmic grace. Whatever the subject of the painting, it expresses a mystical reverence for nature. O'Keeffe creates a sense of reality that takes us beyond our surface perceptions.

Isamu Noguchi (1904–88), seemingly less concerned with expressive content than others, has continually experimented with abstract sculptural design since the 1930s. His creations have gone beyond sculpture to provide highly dynamic designs which have inspired the choreography of Martha Graham, with whom he was associated for a number of years. Noguchi's *Kouros* figures (Fig. **13.16**) are an abstract response to archaic Greek sculpture, with exquisitely finished surfaces and exemplary technique.

The original mobiles of Alexander Calder (1898–1976) (Fig. **2.18**) put abstract sculpture into motion. Deceptively simple, these colorful shapes turn at the whim of subtle breezes or are powered by motors. Here is the discovery that sculpture can be created by movement in undefined space.

Objectivity returns in the work of Alberto Giacometti (1901–66). He explores the reality of the human figure and surface depiction and meaning, as can be seen in Figure **2.15**. Here form is reduced to its essence in a tortured fragmentation that appears to comment on the nature of humankind in the contemporary world.

Poetry

The Englishman Wystan Hugh Auden (1907–73) took abstraction into poetry. His main concerns in the 1930s were for humanity, society, and personal problems. His writings show a strong desire for pattern and order. In this early period he tends toward discussion, logic, and reasoning. In later works, Auden appears to have become disenchanted with Marx and Freud. These poems are marked by skepticism, irony, and a semireligious tone. In 1936 Auden traveled to Spain to support the left-wing cause in the Spanish Civil War. From 1948 until the mid-1950s, he experimented with symbolic landscape poetry, characterized by a syllabically counted line. Auden's writing was influenced by numerous factors, including Greek literature, Old English poetry, and the Icelandic sagas. He remains one of the major influences in twentieth-century British and American poetry.

In War Time
(For Caroline Newton)
W. H. Auden
1907–73

Abruptly mounting her ramshackle wheel,
Fortune has pedalled furiously away:
The sobbing mess is on our hands today.

Those accidental terrors, Famine, Flood,
Were never trained to diagnose or heal
Nightmares that are intentional and real.

Nor lust nor gravity can preach an aim
To minds disordered by a lucid dread
Of seeking peace by going off one's head.

Nor will the living waters whistle; though
Diviners cut their throats to prove their claim,
The desert remains arid all the same.

If augurs take up flying to fulfill
The doom they prophesy, it must be so;
The herons have no modern sign for No.

If nothing can upset but total war
The massive fancy of the heathen will
That solitude is something you can kill,

If we are right to choose our suffering
And be tormented by an Either-Or,
The right to fail is worth dying for,

If so, the sweets of victory are rum;
A pride of earthly cities premising
The Inner life as socially the thing,

Where, even to the lawyers, Law is what,
For better or for worse, our vows become
When no one whom we need is looking, Home

A sort of honour, not a building site,
Wherever we are, when if we chose, we might
Be somewhere else, yet trust that we have chosen right.

Two's Company
W. H. Auden

Again in conversations
Speaking of fear
And throwing off reserve
The voice is nearer
But no clearer
Than first love
Than boys' imaginations.

For every news
Means pairing off in twos and twos
Another I, another You
Each knowing what to do
But of no use.

Never stronger
But younger and younger
Saying good-bye but coming back, for fear
Is over there
And the centre of anger
Is out of danger.

The Composer
W. H. Auden

All the others translate: the painter sketches
A visible world to love or reject;
Rummaging into his living, the poet fetches
The images out that hurt and connect.

From Life to Art by painstaking adaption,
Relying on us to cover the rift;
Only your notes are pure contraption.
Only your song is an absolute gift.

Pour out your presence, O delight, cascading
The falls of the knee and the weirs of the spine.
Our climate of silence and doubt invading;
You alone, alone, O imaginary song,
Are unable to say an existence is wrong,
And pour out your forgiveness like a wine.[9]

SURREALISM

Fascination with the subconscious mind, as popularized by the Austrian psychoanalyst Sigmund Freud (1856–1939), stimulated explorations in psychic experience. By 1924 a Surrealist manifesto had been put forward which tied the subconscious mind to painting. It could be done by "pure psychic automatism" rather than by using the conscious mind. *Surrealism* was seen by its advocates as a means for discovering the basic reality of psychic life through automatic association. A dream was supposedly capable of transference from the unconscious mind to canvas without the artist's control.

Surrealism is characterized by the paintings of Salvador Dali (1904–89). Dali called his works, such as *The Persistence of Memory* (Fig. **1.28**), "hand-colored photographs of the subconscious." The high verisimilitude of this work, coupled with its nightmarish relationships of objects, makes a forceful impact. The whole idea of time is destroyed in these "wet watches" (as they were called by those who first saw this work) hanging limply and crawling with ants. And yet there is a strange fascination here, akin to our fascination with the world of our dreams. The irrationality of Dali can be entrancing. The starkness and graphic clarity speak of the unpolluted light of another planet, yet nonetheless reflect a world we seem to know.

REALISM

Painting

In the twentieth century, pictorial objectivity continued in the Realist tradition in the works of Grant Wood (1892–1942)—for example, *American Gothic* (Fig. **0.5**), a celebration of America's heartland and its simple, hard-working people. There is a lyric spirituality behind the façade of this down-home illustration. The upward movement of the elongated forms is pulled together at the top into a pointed arch which encapsulates the Gothic window of the farmhouse and escapes the frame of the painting through the lightning rod, in the same sense that the Gothic spire released the spirituality of the earth into heaven at its tip. Rural American reverence for home and labor is fêted here with gentle humor. There is a capricious two-dimensionality. All objects, and the people, line up horizontally. There is no linear perspective in the middle ground, and so the buildings appear pressed against the backs of the farmer and his wife.

Film

World War II and its aftermath brought radical change to the form and content of the cinema. A film came out in 1940 that stunned even Hollywood. Darryl Zanuck and John Ford's version of John Steinbeck's *Grapes of Wrath* took the social criticism of Steinbeck's portrayal of the

Depression and presented it visually, creating art through superb cinematography and compelling performances. Social commentary burst forth again in 1941 with two outstanding works, *How Green was my Valley*, which dealt with exploited coal miners in Wales, and *Citizen Kane*, about wealth and power, and thought by some to be the best film ever produced. The cinematic techniques of *Citizen Kane* forged a new trail. Orson Welles, director and star, and Greg Toland, cinematographer, brilliantly combined deep-focus photography, new lighting effects, rapid cutting, and moving camera sequences.

But as the war ended and Italy overthrew the yoke of Fascism, a new concept set the stage for the years ahead. In 1945 Roberto Rossellini's *Rome, Open City* graphically depicted the misery of Rome during the German occupation. It was shot on the streets of the capital using hidden cameras and mostly nonprofessional actors and actresses. Technically, the quality of the work was deficient, but the effectiveness of its objective viewpoint and documentary realism changed the course of cinema and inaugurated a style called *Neorealism*.

Theatre

Realism continued its strong tradition in the theatre throughout the postwar era, owing much of its strength to the works of the American playwrights Tennessee Williams (1912–83) and Arthur Miller (b. 1915). It has now expanded since its nineteenth-century conception to include more theatrical approaches, such as fragmented settings. Including many nonrealistic devices, such as symbolism, it has become broader and more eclectic. Undoubtedly the theatre has concluded that stage realism and life's realism are two entirely different issues.

Tennessee Williams skillfully blends the qualities of Realism with whatever scenic, structural, or symbolic devices are necessary to meet his goals. His plays, such as *The Glass Menagerie*, deal sensitively and poignantly with the problems and psychology of everyday people. Character development is thorough and occupies the principal focus as he explores the mental and emotional ills of our society. Arthur Miller, too, probes the social and psychological forces that destroy contemporary men and women in plays such as *Death of a Salesman*.

ABSTRACT EXPRESSIONISM

The first fifteen years following the end of World War II were dominated by a style called Abstract Expressionism. Beginning essentially in New York, it spread rapidly throughout the world. Like most modern styles, it is used with some variation among individual artists. Two characteristics can be identified. One is freedom from traditional use of brushwork, and the other is the exclusion of representational subject matter. Individual expression used to reflect inner life gave artists rein to create works of high emotional and dynamic intensity. The freedom of this style appears to relate to the optimistic postwar sense of conquest over totalitarianism. By the early 1960s, when life was less certain and the implications of the nuclear age had sunk in, Abstract Expressionism had all but ceased to exist.

The most heralded artist of this style was Jackson Pollock (1912–56). A rebellious spirit, he evolved a method of dripping and spilling paint onto huge canvases placed on the floor (Fig. **13.17**). This was just ten years before his death. Often called *action painting*, the controlled dripping gives a sense of tremendous energy, and a revolutionary concept of space, line, and form. Pollock rejected much of the European tradition in favor of cruder, rougher formal values identified with the American frontier. The term "action painting" (coined by an art critic) refers to active paint handling by the artist. Pollock indicated that he was more at ease with painting on the floor, believing that in that way he could literally be in the painting, and when in the painting, not aware of what he was doing. The result was pure harmony. Thus, Pollock found deep pleasure in the technique, which provided him a sense of being fully absorbed in action and freed from any estrangement from the world.

The Abstract Expressionist tradition continues in the work of Helen Frankenthaler (b. 1928). Her staining technique, as seen in *Buddha* (Fig. **13.18**), consists of pouring color across an unprimed canvas, creating amorphous shapes which seem to float in space. The image has infinite potential meaning, apart from that suggested by the title. The very freedom of the form symbolizes our freedom to choose its associations. However, we are directed by the sensual quality of the work. Its fluidity and the nonlinear use of color give it softness and grace.

Abstract Expressionism proved ultimately to be an American movement. Nowhere else did anything even remotely comparable emerge during this time. However, by the early 1960s the style seems to have reached its zenith. An entirely new perception of reality—one of consumerism and affluence—began to sweep the world.

After and in some instances as a reaction against the emotionalism of Abstract Expressionism came an explosion of styles: Pop Art, Op Art, Hard Edge, Primary Structures, Minimal Art, Post-Minimal Art, Environmental Art, Body Art, Earth Art, Video Art, Kinetic Art, Photo Realism, and Conceptualism. We have space to note only some of these.

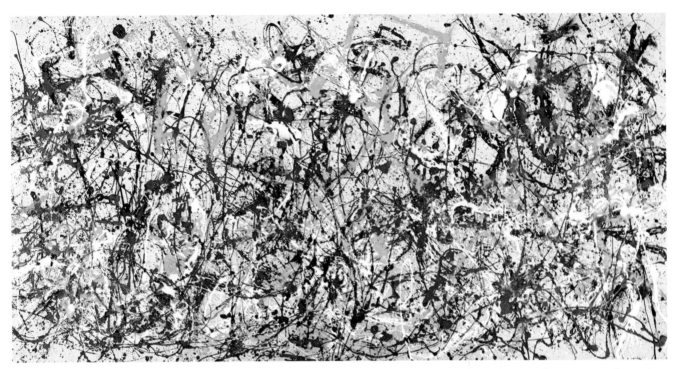

13.17 Jackson Pollock, *Autumn Rhythm*, 1950. Oil on canvas, 8 ft 9 ins x 17 ft 3 ins (2.67 x 5.26 m). Metropolitan Museum of Art, New York (George A. Hearn Fund).

13.18 Helen Frankenthaler, *Buddha*, 1988. Acrylic on canvas, 6 ft 2 ins x 6 ft 9 ins (1.88 x 2.06 m). Private collection.

POP ART

Pop Art evolved in the 1950s, and concerns itself above all with image in a representational sense. Subjects and treatments in this style come from mass culture and commercial design. These sources provide Pop artists with what they consider to be essential aspects of their visual environment. Pop Art is essentially an ironic reflection of the contemporary scene. The term "Pop" was coined by the English critic Lawrence Alloway.

Probably the compelling depictions of Roy Lichtenstein (b. 1923) are the most familiar (Fig. **13.19**). These magnified cartoon-strip details use the Ben Day screen of dots by which colored ink is applied to cheap newsprint. Using a stencil about the size of a coin, the artist builds the image up into a stark and dynamic, if sometimes violent, portrayal.

Pop objects serve as source materials for Claes Oldenburg (b. 1929). *Dual Hamburgers* (Fig. **13.20**) presents an enigma to the viewer. What are we to make of it? Is it a celebration of the mundane? Or is there a greater comment on the age implicit in these objects? Certainly Oldenburg calls our attention to the design of ordinary objects by taking them out of their context and changing their scale.

HARD EDGE

Hard Edge or Hard Edged Abstraction came to its height during the 1950s. The work of Ellsworth Kelly (b. 1923) and Frank Stella (b. 1936) best illustrates this style: Flat color areas have hard edges which carefully separate them from each other. Essentially, Hard Edge is an exploration of design for its own sake. Stella often abandons the rectangular format in favor of irregular compositions to be sure that his paintings bear no relationship to windows. The shape of the canvas is part of the design itself, as opposed to being a frame or a formal border within which the design is executed. Some of Stella's paintings have iridescent metal powder mixed into the paint, and the metallic shine further enhances the precision of the composition. *Tahkt-i-Sulayman I* (Fig. **13.21**) stretches 20 ft (6 m) across and intersperses wonderfully surging circles and half-circles of yellow and green, reds and blues. The intensity of the surface counters the grace of its form with jarring fluorescence. The simplicity of these forms deceptively counters the variety of their repetitions.

PRIMARY STRUCTURES

The Primary Structures movement pursues two main goals: extreme simplicity of shape and a kinship with architecture. It is the space–time relationship that distinguishes Primary Structures from other sculpture. The viewer is invited to share an experience in three-dimensional space by walking around and/or through the works. Form and content are abstracted to Minimalist qualities.

Louise Nevelson (1900–88), perhaps the twentieth century's first major woman sculptor, overcame the perception that sculpture was a man's profession because of the heavy manual labor involved. In the 1950s she began using found

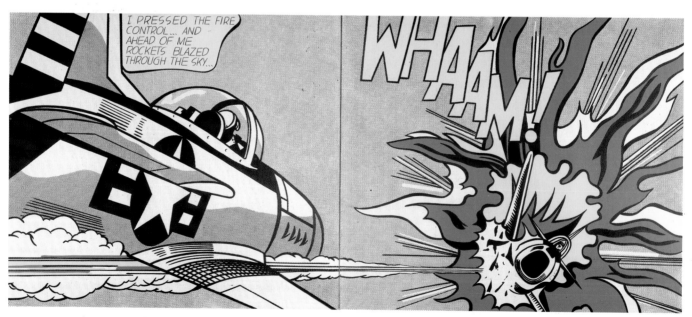

13.19 Roy Lichtenstein, *Whaam!*, 1963. Acrylic on canvas, 5 ft 8 ins x 13 ft 4 ins (1.73 x 4.05 m). Tate Gallery, London.

pieces of wood to construct her own vision of reality—at first miniature cityscapes. Her work grew to larger proportions—for example, *Black Wall* (Fig. **13.22**), a relieflike wall unit painted a monochromatic flat black. These pieces suggest the world of dreams, but their meaning and logic remain a puzzle with intense appeal to the imagination.

ENVIRONMENTAL ART

Environmental Art creates an inclusive experience. In *Jardin d'Email* (Fig. **13.23**) by Jean Dubuffet (1901–85), an area is made of concrete covered with white paint and black lines. It is capricious in form and surrounded by high walls.

13.20 Claes Oldenburg, *Two Cheeseburgers, with Everything* (*Dual Hamburgers*), 1962. Burlap soaked in plaster, painted with enamel, 7 x 14¾ x 8⅝ ins (17.8 x 37.5 x 21.8 cm). The Museum of Modern Art, New York (Philip Johnson Fund).

Inside the sculptural environment are a tree and two bushes made of polyurethane. We might conclude that Dubuffet has pushed the essence and boundaries of art to their limits. He has consistently opted for chaos, for *art brut*—the art of children, psychotics, and amateurs. The *Jardin d'Email* is one of a small series of projects in which he depicts the chaotic, disorienting, and inexplicable in three-dimensional form.

FEMINISM

During the 1970s feminist artists of the Women's Art Movement attempted to break down old barriers. Substantially as a result of this movement, women began to achieve increased recognition in the American art world. Marches, protests, the organization of women's cooperative galleries, active promotion of women artists, critical exploration by women art historians, and the development of a Feminist Art Program at the California Institute of the Arts, in 1971, brought about significant results. One of the founders of the CalArts program, Judy Chicago, can be seen as an example. At the end of the 1960s she began to use feminine sexual imagery to reveal the sexism of the male-dominated art world. *The Dinner Party* (Fig. **13.24**) records the names of 999 notable women, and pays homage to thirty-nine legendary women, including an Egyptian Queen and Georgia O'Keeffe (see p. 377). At each side of the triangular table are thirteen settings (the number of witches in a coven and the number of men at the

13.21 Frank Stella, *Tahkt-i-Sulayman I*, 1967.
Polymer and fluorescent paint on canvas, 10 ft ¼ x 20 ft 2¼ ins (3.04 x 6.15 m).
Pasadena Art Museum, California (Gift of Mr. and Mrs. Robert A. Rowan).

383

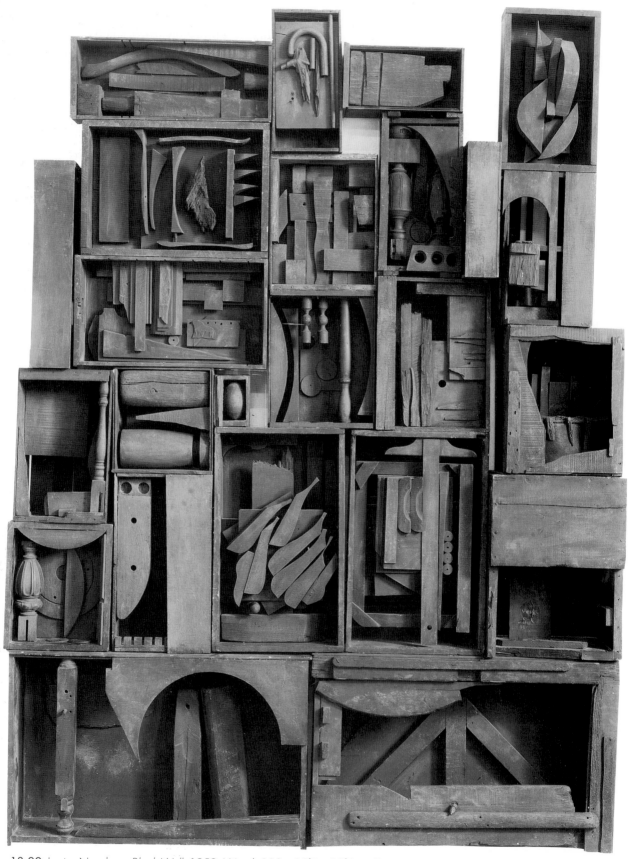

13.22 Louise Nevelson, *Black Wall*, 1959. Wood, 112 x 85¼ x 25½ ins (264 x 216 x 65 cm). Tate Gallery, London.

13.23 Jean Dubuffet, *Jardin d'Email*, 1973–4. Concrete, epoxy paint, and polyurethane, 66 ft 8 ins x 100 ft (20 x 30 m). State Museum Kröller-Müller, Otterlo, The Netherlands.

13.24 Judy Chicago. *The Dinner Party*. 1974–79. White tile floor inscribed in gold with 999 women's names; triangular table with painted porcelain, sculpted porcelain plates, and needlework, each side 48' (14.6 m). Courtesy the artist

Last Supper). The triangular shape is a symbol for woman. During the French Revolution it stood for equality. Each of the place settings at the table features a runner in a style appropriate to the woman it represents, in addition to a large ceramic plate. Included are traditional women's art forms such as stitchery, needlepoint, and china painting, which Chicago wished to raise to the status given to painting and sculpture. Suggestions of female genitalia throughout the painting are the artist's comment that that was all the women at the table had in common.

MODERNISM

Architecture

EXPERIMENTATION Structural expression and preoccupation with building materials dominated the early twentieth century, as it had the nineteenth. Of vital importance was reinforced concrete, or ferroconcrete. It had been in use since around 1850, but nearly fifty years elapsed before it emerged fully as an important architectural material. Auguste Perret (1874–1954) single-mindedly set about developing formulas for building with ferroconcrete, and his efforts were influential in the works of those who followed. Some of the implications are evident in Perret's Garage Ponthieu (Fig. **13.25**). The reinforced concrete structure protrudes from the façade, and glass or ceramic panels fill the open spaces. The result is a certain elegance and a logical expression of strength and lightness.

Perret's contemporary, Frank Lloyd Wright (1867–1959), was one of the most innovative and influential of twentieth-century architects. While Perret encapsulated and continued earlier traditions, Wright initiated new ones. One of Wright's creations was the Prairie Style, developed around 1900 and drawing upon the flat landscape of the Midwest for its tone. Prairie houses reflected Japanese influence in their simple horizontal and vertical accents.

As assistant to Louis Sullivan (see p. 356), Wright was influenced in his pursuit of form and functional relationships. Wright attempted to devise practical arrangements for his interiors and to reflect the interior spaces in the exterior appearance of the building (Fig. 7.40). He also tried to relate the exterior of the building to its context or natural environment. Wright designed some of the furniture for his houses; comfort, function, and design integration were his chief criteria. Textures and colors in the environment were duplicated in the materials, including large expanses of wood in both the house and its furniture. He made a point of producing multifunctional furniture—for example, tables also served as cabinets. All spaces and

13.25 Auguste Perret, Garage Ponthieu, Paris, 1905–6.

objects were precisely designed to present a complete environment. Wright was convinced that houses profoundly influence the people who live in them, and he saw the architect as a "molder of humanity." His works range from the simple to the complex, from the serene to the dramatic, and from interpenetration to enclosure of space. He always pursued experimentation: Exploration of the interrelationships of spaces and geometric forms marks his designs.

A new concept in design can also be seen in the works of Le Corbusier (see p. 160) in the 1920s and 1930s. He espoused a domino system of house construction, using a series of poured concrete slabs supported on slender columns. The resulting building was boxlike, with a flat roof which could be used as a terrace (Fig. 7.31). Much machine-related art in the first half of the century sought depersonalization, but not Le Corbusier's design. Rather, it implied efficient construction from standard, mass-produced parts, logically planned for use in an efficient "house-machine."

INTERNATIONAL AND CORPORATE ARCHITECTURE
It is hard to sample or overview the architecture of the late twentieth century. In a sense, the task is particularly difficult in this medium, because the human element of artistic creation has been blurred by architectural corporations, as opposed to individual architects. There is also a tendency for the contemporary observer to see a sameness in the glass and steel boxes of the International Style that dominate our cities and to miss the innovative design of, say, a housing project in an obscure locale.

World War II caused a ten-year break in architectural construction and, to a certain extent, separated what came after from what went before. However, the gap is bridged by the continuing careers of architects who achieved significant accomplishments before the war. Geographical focus shifted from Europe to the United States, Japan, and even South America. But the overall approach remained modern or international in flavor, which helps us to select a few examples to illustrate general tendencies.

As a type, the skyscraper saw a resurgence in the fifties, in a glass-and-steel box form. Illustrative of this approach is Lever House in New York City (Fig. **13.26**). An important consideration in this design is the open space surrounding it. Created by setting the tower back from the perimeter of the site, the space around the building creates its own envelope of environment or context. The glazed appearance of the Lever Building has been copied over the past fifty years, and sometimes even intensified, using metalized windows, rather than normal glass, for the exterior surface. This has been particularly popular in the Sun Belt, because metalized glass reflects the sun's rays and heat. Similarly, designers have gone the other way, reducing the glazing by creating surfaces such as aluminum pierced by small windows. In both cases, the functional plain rectangle of the International Style has continued as a general architectural form regardless of individual variation.

The rectangle, which has so uniformly—and, in many cases, thoughtlessly—become the mark of contemporary architecture leads us to one of its prewar advocates. The German architect Ludwig Mies van der Rohe (1886–1969) insisted that form should not be an end in itself. Rather, the architect should discover and state the function of the

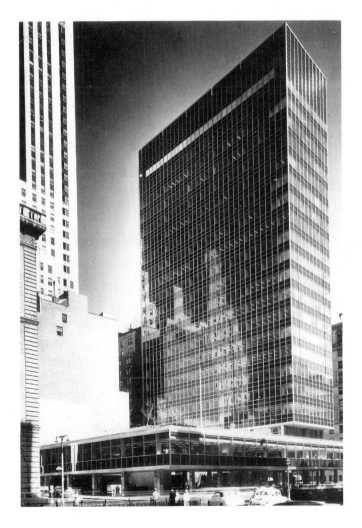

13.26 Gordon Bunshaft (Skidmore, Owings, & Merrill), Lever House, New York, 1950–2.

MASTERWORK

Wright–Kaufmann House

Frank Lloyd Wright is one of the greatest American artists in any medium. His primary message is the relationship of architecture to its setting, a lesson that some modern architects seem to have forgotten. Wright's buildings seem to grow out of, and never violate, their environment.

One of his most inventive designs is the Kaufmann House, Fallingwater, at Bear Run, Pennsylvania. Cantilevered over a waterfall, its dramatic imagery is exciting. The inspiration for this house was probably the French Renaissance château of Chenonceaux, built on a bridge across the River Cher. However, Fallingwater is no house built on a bridge. It seems to erupt out of its natural rock site, and its beige concrete terraces blend harmoniously with the colors of the surrounding stone. Wright has successfully married two seemingly dissimilar styles: the house is a part of its context, yet it has the rectilinear lines of the International Style, to which Wright was usually opposed. He has taken those spare, sterile boxes and made them harmonize with their natural surroundings.

Wright's great asset, and at the same time his greatest liability, was his myopic insistence on his own vision. He could work only with clients who could bend to his wishes. So, unlike many architects, whose designs are tempered by the vision of the client, what Wright built was Wright's, and Wright's only.

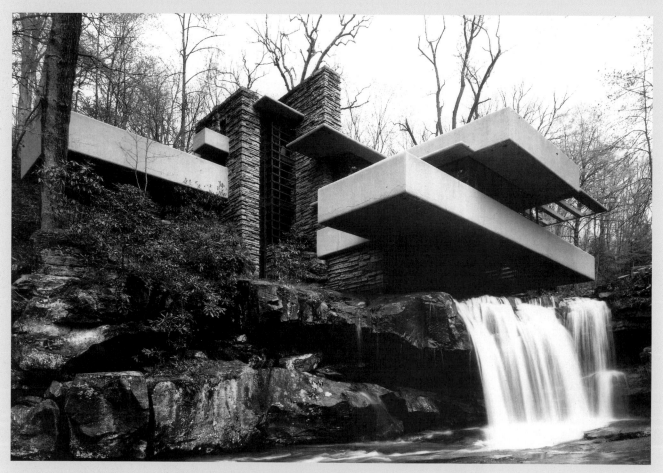

13.27 Frank Lloyd Wright, Fallingwater, Bear Run, Pennsylvania, 1936–7.

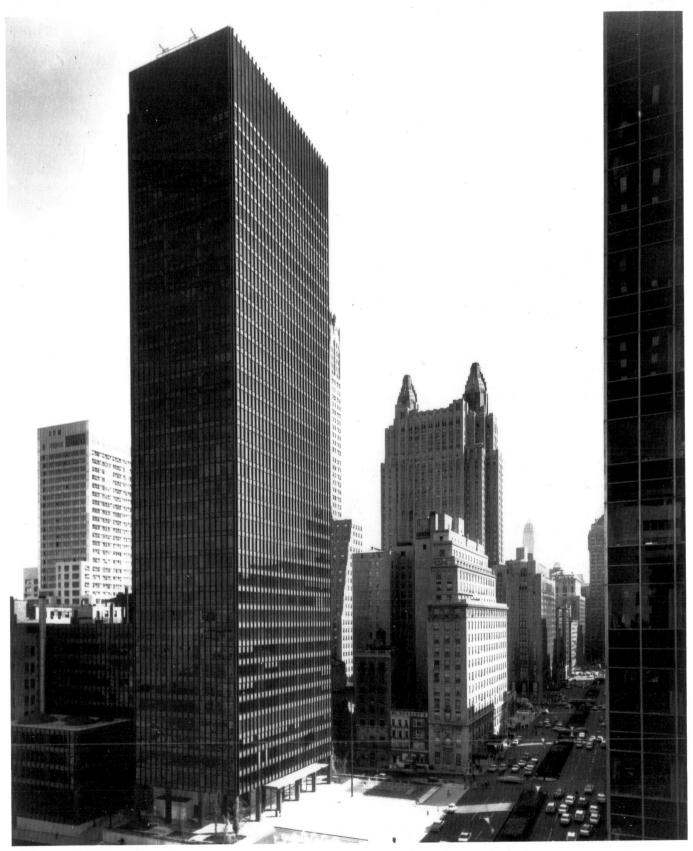

13.28 Ludwig Mies van der Rohe and Philip Johnson, Seagram Building, New York, 1958.

building. His pursuit of those goals and his honesty in outwardly expressing the shapes of mass-produced materials—bricks, glass, and manufactured metals—was the basis for the rectangularization that is the common ground of twentieth-century architecture. His search for proportional perfection can be traced, perhaps, to the German Pavilion of the Barcelona Exposition in 1929 and was expressed in projects such as New York's Seagram Building (Fig. **13.28**).

Contemporary design has ultimately pursued the question formulated by the American architect Louis I. Kahn (b. 1901), "What form does the space want to become?" In the case of Frank Lloyd Wright's Guggenheim Museum (Fig. **7.40**), space has become a relaxing spiral reflecting the leisurely progress one should make through an art museum.

The simple curves of the arch and dome characterize the work of two noteworthy architects. The unencumbered free space in their projects contrasts with the self-contained boxes of the International Style. Pier Luigi Nervi's Small Sports Palace (Fig. **13.29**) and Richard Buckminster Fuller's Climatron (Fig. **7.21**) illustrate the trend toward *spansion architecture*, which stretches engineering to the limits of its materials.

Music

Modernism in music took no less radical a path from its nineteenth-century heritage than it did in painting and sculpture. Nevertheless, contemporary concert programs illustrate that response to works of art is always in the present tense. Our own responses to the meanings in works of art are those of today, whether the artwork was created this morning or 20,000 years ago. So we have the luxury of sharing experiences directly with Michelangelo, Shakespeare, Leonardo da Vinci, J. S. Bach, and the architects of Athens, as well as with artists of our own era who

illuminate and comment upon the events and circumstances surrounding us. Our contemporaries may, and do, choose to follow the traditions of the past and invent new ones.

Twentieth-century music took both paths. The radical one diverges from the past essentially in three ways. The first is rhythmic complexity. Prevailing tradition since the Middle Ages has emphasized grouping beats together in measures. The accents of duple and triple meters have helped to characterize and unify compositions. But Modernist composers have done away with these regular accents, choosing instead to employ complex, changing rhythms in which it is virtually impossible to determine meter, or even the actual beat.

The second change concerns dissonant harmonies. Prior to the late nineteenth century, musical convention in the West centered upon consonance as the norm to which all harmonic progressions returned. Dissonance was used to disturb the norm. The late nineteenth century witnessed significant tampering with that concept. By the twentieth century composers were using more and more dissonance, focusing on it, and refraining from consonant resolution.

The third major change from the past was a rejection of traditional tonality and sense of key altogether. Traditional thinking held that one note, the *do* or tonic of a scale, was the most important. All music was composed with a specific key in mind. Modulations into distant or related keys occurred, but even then the tonic of the original key was the touchstone to which all progression related. In the twentieth century, many composers rejected that manner of systematizing musical sound and chose, instead, to reject any sense of tonal center. All twelve tones of the chromatic scale thus become equal, and the system is known as *twelve-tone composition*, which was later refined into *serialism*.

The more conservative path saw a transition from the nineteenth to the twentieth century in France that rode primarily on the works of one major composer, the

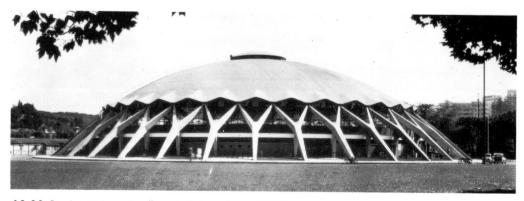

13.29 Pier Luigi Nervi, Small Sports Palace, Rome, 1957.

Impressionist Claude Debussy (see p. 349). Debussy's style linked him closely with the French composer Maurice Ravel (1875–1937), who began as an Impressionist but became more and more Classical in orientation as years went by. However, even in his earlier works, Ravel did not adopt Debussy's complex sonorities. Ravel's *Bolero* exhibits strong primitive influences and the unceasing rhythm of Spanish dance music. More typical works of Ravel—for example, his *Piano Concerto in G*—use Mozart and traditional Classicism as their models. As a result of Ravel's tendencies and the similar concerns of other composers—a Classically oriented style was adopted by Camille Saint-Säens (1835–1921), for example—music in the early twentieth century took a Neoclassical direction, maintaining the established conventions of Western music but rejecting both Impressionist and serialist developments.

The American composer William Schuman also took the more traditional path in the 1930s and 1940s. His symphonies have bright timbres and energetic rhythms and focus on eighteenth- and nineteenth-century American folklore. The eighteenth-century American composer William Billings figures prominently in the works of Schuman in the *William Billings Overture* and the *New England Triptych*, based on three pieces by Billings. *American Festival Overture* is perhaps his most famous composition.

Traditional tonality can also be found in the works of Russia's Prokofiev. Notwithstanding this, his *Steel Step* reflects the encroachment of mechanization during the 1920s. The machine as a symbol for tremendous energy and motion found its way into music; in the *Steel Step* Prokofiev intentionally dehumanizes the subject in order to reflect contemporary life.

HINDEMITH Experimentation and departure from traditional tonality mark the compositions of the German composer Paul Hindemith (1895–1963). Concerned with problems of musical organization, he formulated a systematic solution in the *Craft of Musical Composition*. His music is extremely chromatic—almost atonal. He used "tonal centers," but abandoned the concepts of major and minor keys. He hoped that his new system would become a universal music language, but it did not. He was, however, extremely influential in twentieth-century music composition, both as a composer and a teacher. His works are broad and varied, encompassing nearly every musical genre, including ten operas, art songs, cantatas, requiems, chamber music, sonatas, concertos, and symphonies.

BARTÓK The Hungarian composer Béla Bartók (1881–1945) took another nontraditional approach to tonality. He was interested in folk music. His research into eastern European folk music is significant, because much of it does not use Western major/minor modality. Bartók invented his own types of harmonic structure, which could accommodate folk melodies. He also used tonal centers, and his music is often harshly dissonant.

As nontraditional as some of his work is, however, Bartók also employed traditional devices and forms. His style was precise and tightly structured. He often developed whole movements from one or two very short motifs. His larger works are unified by repetition of thematic material throughout. Occasionally he even used the Classical sonata form. Textures in Bartók's works are largely contrapuntal, which gives them a melodic emphasis on the motifs that are being developed.

Rhythm is important in Bartók's music—it has great rhythmic energy, employing many different devices, such as repeated chords and irregular meters (always to generate impetus). His use of polyrhythms—that is, various juxtaposed rhythms—creates a nonmelodic counterpoint of unique quality. In part, this reflects the influence of folk song and dance. Bartók's compositions—many piano pieces (including three concertos), six string quartets, the *Concerto for Orchestra*, an opera entitled *Duke Bluebeard's Castle*, and others—have a wonderfully spontaneous freshness.

STRAVINSKY Nontraditionalism was followed in other quarters, and with *The Firebird* the Russian composer Igor Stravinsky (1882–1971) came to prominence in 1910. *The Rite of Spring* (CD track 20) created an even greater impact a couple of years later. Both works were scores for ballets. *The Firebird* was a commission for the Russian impresario Diaghilev, and premièred successfully at the Paris Opéra, while *The Rite of Spring* caused a near riot and a great scandal because of revolutionary orchestrations, dissonance, and driving primitive rhythms. It had a great impact on twentieth-century music.

In later works, Stravinsky adopted a Neoclassical style as he attempted to revive Baroque and Classical elements and forms, for example in the oratorio *Oedipus Rex* and the opera *The Rake's Progress*. Toward the end of his life Stravinsky also experimented with serialism.

SCHOENBERG The movement that drew the most attention in the first half of the twentieth century grew out of German Romanticism and took a radical turn into atonality, and the composer at its root was Arnold Schoenberg (1874–1951). Between 1905 and 1912 Schoenberg turned away from the gigantic Post-Romantic works he had been composing to a more contained style. He broke down the musical texture, alternating timbres swiftly and fragmenting rhythm and melody.

Although the word atonality (without tonality) is used to describe Schoenberg's works, he preferred the term pan-tonality—that is, inclusive of all tonalities. His compositions use any combination of tones without the necessity of having to resolve chordal progressions. He called that concept "the emancipation of dissonance."

By 1923 Schoenberg was composing in twelve-tone technique, in which a row or series of the twelve tones in an octave is used in order before any note can be repeated. The tone row can then be used upside down, backward, or upside down and backward. This serial arrangement can also be applied to rhythm and dynamics. The logical structure of the technique is mathematical and somewhat formalized, but it does maintain a complete absence of key sense, and a balance between emotion and mechanization. The important thing for a listener to understand about these works which stand outside conventional tonal organization is the fact that they contain their own internal logical order.

BERG Alban Berg (1885–1935) was a close friend and disciple of Schoenberg, and his compositions are based on the serial technique. However, Berg's sense of lyricism means his works do not have the disconnectedness of much serial music. Many of the characteristics of his work can be found in his *Lyric Suite* (1927), a string quartet in six movements with a binary (AA) form. It is based on several different tone rows. Berg is probably best known for his operas *Wozzeck* and *Lulu*.

IVES AND COPLAND Ives and Copland were both Americans with experimental styles. Charles Ives (1874–1954) was so experimental and ahead of his time that many of his compositions were considered unplayable and did not receive public performances until after World War II. Content to remain anonymous, and financially able to do so, as he worked in insurance, Ives went unrecognized for many years. His melodies spring from folk and popular songs, hymns, and other, often familiar, material, which he treated in most unfamiliar ways. He experimented with quarter tones, polytonality, and polyrhythms. His rhythms are often irregular and without measure delineation except for an occasional bar line to indicate an accent beat. Some of the tone clusters in his piano music are unplayable without using a block of wood to depress all the necessary keys at once. Ives's experimentations, such as the *Unanswered Question*, employ ensembles placed in various locations to create stereophonic effects. For Ives, all music related to life's experiences and ideas, some of which were consonant and some dissonant, and his music reflected that philosophy accordingly.

Aaron Copland (1900–90) integrated national American idioms into his compositions. Jazz, dissonance, Mexican folk songs, and Shaker hymns all appear. The latter figure prominently in Copland's most significant work, *Appalachian Spring* (CD track 21). First written as a ballet, it was later reworked as a suite for symphony orchestra. Some of Copland's music is reserved and harmonically complex, and some simple. He often used all the tones in the diatonic scale simultaneously, particularly in the opening chord of a work. Despite a diversity of influences, he achieved a distinctive personal style which is traditionally tonal. His manipulation of rhythms and chords was highly influential in twentieth-century American musical composition.

Dance

DUNCAN Romantic ballet had become conventional and static by the late nineteenth century. The remarkable Isadora Duncan (1878–1927) was to introduce a revolutionary new style. By 1905 she had gained notoriety for her barefoot and deeply emotional dancing. She was considered controversial among balletomanes and reformers alike.

Although an American, Isadora Duncan achieved her fame in Europe. Her dances interpreted moods suggested to her by music or nature. Her costume was loose and flowing, inspired by Greek tunics and draperies, and the fact that she did not wear dancing shoes was deeply significant—this unconventional approach stuck and continues to this day in the modern dance tradition she helped to form.

DENISHAWN Isadora Duncan's contemporary Ruth St. Denis and her husband, Ted Shawn, were to lay more substantial cornerstones for modern dance. St. Denis's dancing began as a strange combination of exotic, Oriental interpretations and Delsartian poses. (Delsarte is a nineteenth-century system originated by François Delsarte as a scientific examination of the manner in which emotions and ideas are transmitted. His overzealous disciples formed his findings into a series of graceful gestures and poses, which supposedly denoted specific things.) St. Denis's impact on dance was solidified by the formation with her husband of the Denishawn company and school to carry on her philosophies and choreography. Their headquarters were in Los Angeles. A totally eclectic approach to dance was followed—any and all traditions were included, from formal ballet to Oriental and American Indian dances.

GRAHAM First to leave Denishawn was Martha Graham (1894–1991), probably the most influential figure in modern dance. Although the term modern dance defies

accurate definition and satisfies few, it remains the most appropriate label for the nonballetic tradition Martha Graham has come to symbolize. She maintains that artistic individualism is fundamental. "There are no general rules. Each work of art creates its own code." Even modern dance has come to include its own conventions, however, principally because it tries so hard to be different from formal ballet. Ballet movements are largely rounded and symmetrical. Therefore, modern dancers emphasize angularity and asymmetry. Ballet stresses leaps and bases its line on toework, while modern dance hugs the floor and dancers go barefoot. As a result, the early works of Graham and others tended to be rather fierce and earthy, as opposed to graceful. But beneath it all was the desire to express emotion first and foremost. The execution of conventional positions and movements, on which ballet is based, was totally disregarded. Martha Graham has described her choreography as "a graph of the heart."

Her ballets, often concerned with the psychological exploration of mythological themes, include *Primitive Mysteries* and *Circe*. After the Depression, when social criticism formed a large part of artistic expression, Graham pursued topical themes concerning the shaping of America, including her renowned work to the music of Aaron Copland, *Appalachian Spring*. It dealt with the effects of Puritanism and depicted the overcoming of its fire and brimstone by love and common sense (see p. 133).

CUNNINGHAM Martha Graham's troupe produced a radical and controversial choreographer who broke with many of the traditions of modern dance (as flexible as those traditions have been). He incorporated chance elements into his choreography and has often been associated with the composer John Cage. Merce Cunningham (b. 1919) uses everyday activity as well as dance movements in his works. His concern is for the audience to see dance in a new light; his choreography is radically different from anyone else's. His works show elegance and coolness, as well as a severely abstract quality. Dances such as *Summerspace* and *Winterbranch* illustrate Cunningham's use of chance, or indeterminacy. He thoroughly prepares numerous options and orders for sets, which can then be varied and intermixed in different orders from performance to performance (sometimes the choices are made by flipping a coin). The same piece may thus appear different from one night to the next. Cunningham also treats space as an integral part of the performance and allows focus to be spread across various areas of the stage, unlike classical ballet which tends to concentrate its focus on center stage or downstage center alone. So Cunningham allows audience members to choose where to focus, as opposed to forcing that focus. Finally, he tends to allow each element of the dance to go its own way. As a result, the direct, beat-for-beat relationship that audiences have come to expect between music and footfalls in ballet and much modern dance simply does not exist.

LATER DEVELOPMENTS Since 1954, another graduate of Martha Graham's troupe (and also of Merce Cunningham's) has provided strong direction in modern dance. Paul Taylor's work has a vibrant, energetic, and abstract quality that often suggests primordial actions. Taylor, like Cunningham, often uses strange combinations of music and movement in highly ebullient and unrestrained dances such as *Book of Beasts*. Interestingly, Taylor's music often turns to Classical composers, such as Beethoven, and to specialized works like string quartets. The combination of such formal music with his wild movements creates challenge for the audience.

In a tradition which encourages individual exploration and independence, there have been many accomplished dancer/choreographers, among them Alvin Ailey (see p. 370) and Alwin Nikolais. Nikolais designs scenery, costumes, and lights and composes the music, as well as the choreography—his works tend to be mixed-media extravaganzas celebrating the electronic age. Often the display is so dazzling that the audience loses the dancers in the lighting effects and scenic environment. Twyla Tharp and Yvonne Ranier have both experimented with space and movement. James Waring has combined Bach and 1920s pop songs, florid pantomimes and abstractions, Romantic point work and modern dance.

ULTRARATIONALISM AND BEYOND

Avant-Garde Music

Music from the late 1950s until the early 1970s went to further extremes in "ultrarational" and "antirational" directions. At times the desire for novelty superseded most other considerations. The German composer Karlheinz Stockhausen (b. 1928), for example, became interested in the total manipulation of sound and the acoustic space in which the performance was to take place, as seen in works like *Gruppen*, for three orchestras. As he became more and more interested in timbre, he encompassed a greater variety of sound sources, both electronic and acoustic, in an interesting combination of control and noncontrol, as in *Microphonie I*.

The American Elliott Carter (b. 1908) has developed a highly organized approach toward rhythm, called metric modulation: The mathematical principles of meter, standard rhythmic notation, and other elements are developed in complex ways. The pitch content of Carter's music is highly chromatic, and his music requires virtuoso playing both from the individual and the ensemble. Like Stockhausen, he has written a work for three orchestras.

Virtuoso playing produced an important composer–performer relationship in the 1960s, and many composers, such as the Italian Luciano Berio (b. 1925), wrote specifically for individual performers, such as trombonist Stewart Dempster. In the same vein percussionist Max Neuhaus was associated with Stockhausen, and pianist David Tudor with John Cage (b. 1912).

Experimentation with *microtones* has been of interest to Western music theorists throughout history and many non-Western cultures employ them routinely. Microtones can be defined as intervals smaller than a half step. Our system divides the octave into twelve equal parts. There seems to be no reason why the octave cannot be divided into 24, 53, 95, or any number of parts. The possibilities are limited only by the listener's ability to hear such intervals and the performer's ability to produce them. Alois Haba experimented in the early part of the century with quarter tones (24 per octave) and sixth tones (36 per octave) and, as we have mentioned, so did Charles Ives. A number of instruments have been designed to produce microtones, and experimentation and composition have been carried out widely.

In an atmosphere of constant searching and experimentation, composers of the past few decades have often questioned the validity of traditional concepts of art in general and specifically the limitations of the traditional concert hall. The earlier work of John Cage and others led in a number of directions—including theatre pieces, multimedia or mixed media, so-called danger music, biomusic, soundscapes, happenings, and total environments (which might include stimulation of all the senses in some way). Thus the definition of a composer as opposed to playwright, filmmaker, visual artist, and so on was often obscured.

Since the early 1960s electronic instruments have been highly influential in music composition. Live performance mixed with prerecorded tape first occurred in the 1950s, and by the 1960s it became common to alter the sound of live performers by electronic means. Computer technology has been added to the composition and performance of music, and the options available through computer application are now limited only to the imagination and competence of programmers and performers.

Theatre music, sometimes referred to as experimental music, has a wide range. At one end are relatively subtle examples of performers playing or singing notated music and moving to various points on the stage, as in Berio's *Circles*. More extreme works, such as those of La Monte Young, might instruct the performer to "draw a straight line and follow it" or even to exchange places with the audience. A more active example is Nam June Paik's *Homage to John Cage*, in which the composer ran down into the audience, cut off Cage's tie, dumped liquid over his head, and ran from the theatre, later to phone and let the audience know the composition had ended. Such compositions contain a high degree of chance.

Some works are not intended to be performed, but only conceptualized. Nam June Paik's *Danger Music for Dick Higgins* instructs the performer to "Creep into the vagina of a living whale," and Robert Moran's *Composition for Piano with Pianist* instructs the pianist to climb into the grand piano. A return to minimal materials is exemplified by Stockhausen's *Stimmung* (*Tuning*), dating from 1968: Six vocalists sing only six notes. Minimal music can be defined as music that uses very little musical material, but often for an extended length of time. Examples are *One Sound* for string quartet by Harold Budd and the electronic piece *Come Out* by Steve Reich.

Many mainstream composers continued writing from the late 1950s to the early 1970s. However, a noticeable element of controlled chance has found its way into the music of many of them. This period brought greater tolerance and acceptance on the part of composers for each other's varying aesthetic viewpoints and musical styles, in a blending of avant-garde techniques with the mainstream.

Freedom from melodic, rhythmic, and formal restraints in jazz led to the free jazz art form of the 1960s. Saxophonist Ornette Colman was one of the earliest proponents of such freedom. Others, such as John Coltrane, developed a rhythmically and melodically free style based on modal materials, while Cecil Taylor moved more toward chromaticism. In the mid to late 1960s a mature blend of this freedom was reached, with control and sophistication, in Miles Davis's *Bitches Brew* album. A number of musicians who originally worked with Miles Davis became leading artists in the 1970s, developing a style called jazz-rock, or fusion.

Polish composer Krzysztof Penderecki (b. 1933) has striven to produce new sounds from traditional string instruments. He is widely known for both instrumental and choral works, including a major composition, the *Requiem Mass*, written in 1985. His *Polymorphia* uses twenty-four violins, eight violas, eight cellos, and eight double basses. Because of his experimentation with new techniques and sounds for strings, Penderecki has had to invent a whole new series of musical markings, listed at the

beginning of each score. In actual performance, timings are measured by a stop watch and there is no clear meter. *Polymorphia* uses a free form with structure defined only by textures, harmonies, and string techniques. The piece is dissonant and atonal until the very end. It begins with a low, sustained chord in the bass. The mass of sound grows purposefully, with the entry of the upper strings, and then the middle register. Then comes a section of *glissandos*, which can be played at any speed between two given pitches—what amounts to improvisation. A climax occurs, after which the sound tapers off. Then a number of plucked-string effects are explored. Fingertips are used to tap the instruments, and the strings are hit with the palms of the hands (this has to be done gently so as not to damage the instruments). A second climax occurs. After another section in which sustained and sliding sounds are explored, a third climax is reached. The work ends with a somewhat surprising C major chord.

Musique Actuelle

In the late 1990s, improvised music, viewed as the cutting edge of musical style, took the name *musique actuelle* (mue-ZEEK akt-yoo-EL). It freely draws on jazz and rock and elicits vibrancy, liveliness, and personal expression. Its literal translation means "current," and it represents a number of sub-factions from various localities such as New York, San Francisco, Vancouver, Chicago, and Montreal. Illustrative of this approach is Gianni Gebbia and his trio, whose music reflects one of the heroes of musique actuelle, Evan Parker. Gebbia's music integrates three strains, American jazz, free improvising, and traditional Sicilian music. Always in musique actuelle there seems to be a strain of humor—for instance, the vocalist in Gebbia's trio might alternate between phrases reminiscent of opera and phrases utilizing nasal whines and fearsome guttural groans in two simultaneous pitches.

POSTMODERNISM

For more than twenty years, debates about Postmodernism dominated the cultural and intellectual scene in many fields. In aesthetic and cultural theory, arguments emerged over whether "Modernism" in the arts was or was not dead and what sort of "Postmodern" art was succeeding it. In philosophy, discussion centered upon whether or not the tradition of modern philosophy had ended and been replaced by a new "Postmodern" philosophy. Eventually, the Postmodern discussion produced new social and political theories, as well as theoretical attempts to define the multifaceted aspects of the Postmodern phenomenon itself.

Basically, discourses about Postmodernism raise issues that resist easy conclusions. Advocates for Postmodernism harshly criticize traditional culture, theory, and politics, and defenders of Modernism respond either by ignoring the challenges, attacking Postmodernism in return, or attempting to come to terms with new discourses and positions. Critics of Postmodernism contend that it is a passing fad, a specious invention of self-seeking intellectuals, or an attempt to devalue the liberating theories and values of Modernism.

In fact, there is no unified Postmodern theory, or even a coherent set of positions. Rather, we find great diversity among theories often lumped together as "Postmodern" and a great plurality—often contradictory—among Postmodern positions. We certainly do not have the space to trace the issue in depth, but we must, at least, acknowledge them "up front," as it were.

The questions, What is Modernism? and What is Postmodernism? are highly relevant to the twentieth century and its arts. "Modernity" is often conceptualized as the "modern age" and "postmodernity" as a term for describing the period that allegedly follows modernity. Modernity is a term for an historical period encompassing the epoch that follows the Middle Ages or feudalism. Modernism, then, might be defined as an attempt to overturn the feudal world and to produce a just and egalitarian social order that embodies reason and social progress. Modernity enters everyday life through the dissemination of modern art, the products of consumer society, new technologies, and new modes of transportation and communication that have constituted the modern world. "Modernism" could be used to describe the art movements of the modern age (Impressionism, art for art's sake, Expressionism, Surrealism, and other avant-garde movements), which have strong formalist bases.

Postmodern theorists, however, claim that in the contemporary high-tech media society, emergent processes of change and transformation are producing a new, "Postmodern" society that constitutes a novel state of history and novel socio-cultural formation which requires new concepts and theories. "Postmodernism" would describe those diverse aesthetic forms and practices that come after and break with Modernism and formalism. These forms include the architecture of Philip Johnson (Fig. **13.28**), the musical experiments of John Cage, the art of Andy Warhol (Fig. 0.2), the novels of Thomas Pynchon, and films like *Blade Runner* or *Blue Velvet*. The debate centers on whether there is or is not a sharp conceptual distinction between Modernism and Postmodernism and the relative merits and limitations of these movements.

Therefore, Postmodernism begins with a loss of faith in the dreams of Modernism (the mindset that emerged

PROFILE

Richard Danielpour

Richard Danielpour (b. 1956) studied at the New England Conservatory and the Juilliard School and also trained as a pianist. Currently he is a member of the composition faculty at the Curtis Institute and the Manhattan School of Music. Speaking of his recent rise in the ranks of recognized composers, Danielpour reflected, "From the beginning, it was agonizing. It was like waiting for a Polaroid to develop, but the Polaroid took 10 years instead of 30 seconds." Indicative of his standing in the music world is his collaboration with Nobel Prize-winning writer Toni Morrison on a piece titled "Sweet Talk," premiered by Jessye Norman at Carnegie Hall.

In the early 1980s Mr. Danielpour moved away from the complexities of Modernism toward a more accessible style. As a result, his music's large and romantic gestures, brilliant orchestrations, and vibrant rhythms appeal to a wide cross-section of the public. In this regard, some critics have compared him to Leonard Bernstein, Aaron Copland, Igor Stravinsky, Dmitri Shostakovich, and other twentieth-century masters.

"As I got older, I was aware of a number of different strands coming together in my music, rather than seeing myself on a mission with one particular ax to grind," he said. He calls himself an assimilator rather than an innovator. By utilizing familiar and unthreatening styles as a basis for his compositions, he has been able to win over even conservative audiences.

In the process of finding the means to express his message, Danielpour draws from many resources. "For me style is not the issue," he said. "It's how well a piece is written on a purely technical level. If other composers see themselves as superior just because their music may be more 'original,' that's O.K. That's not what I'm about." His "American-sounding rhythmic swagger," easy lyricism, and keen understanding of instrumental color create an appealing formula.

Although reluctant to discuss his music's spiritual component, he tends to label supposedly abstract instrumental works with intriguing, metaphysical titles. The movements of his Piano Quintet, for example, are "Annunciation," "Atonement," and "Apotheosis." Such titles, he admits, can be distracting. "Maybe it would be better not to have any at all," he said. When he does discuss spirituality in music, he doesn't hesitate to place himself in good company. "Some of my favorite composers," he said, "are also philosopher-composers who find themselves addressing questions about life and death in the very music they write: Mahler, Shostakovich, Bernstein."

He speaks of the creative process in spiritual and perhaps eccentric terms. "Where is the music received from?" he asked. "Where do your dreams come from? Composing is like being in a waking dream. To me the where is not important. It's intuition that has to lead the way and thinking that has to follow it. To speak of the mind first is worthless."

Perhaps typical of all professionals in today's music world, he has a sense of the business side of music. He knows about contracts and commissions and how to be in the right place at the right time. Nonetheless, Mr. Danielpour insists that he is no more active in self-promotion than his colleagues.[10]

during the Enlightenment, an optimistic faith in the idea that the methodology of science could lead to meaningful understanding of people). Postmodernism, however, does not suggest anything to replace Modernism. Rather, it invents a new and evolving language with words such as "metaphorical structuring," "deconstruction," and "meta-narrative." As we work our way through this section, perhaps—just perhaps—this engaging and challenging dilemma will begin to coalesce for us.

Visual Arts

The period from the late 1960s through the 1980s witnessed a variety of reactions to the styles of the past—including the recent past of the twentieth century. Like the collective styles of the end of the nineteenth century, which were called Post-Impressionist, these "new" styles have been lumped together as Postmodernist although they seem to have no common thread. They are, generally speaking, highly individualistic, although some artists

prefer to return art to the anonymity of pre-Renaissance times. One aspect of Postmodernist style appears to be a desire for recognizable content or meaning in works of art. Artists following this path are reacting to what they feel is a clutter and lack of content in previous styles. They seek to "make it new" and take great pains to be "different." The question of difference, however, has become complicated by the fact that many, such as the Postmodernist architects, take great delight in eclectically borrowing from the past. They mix old styles to create something "new."

One artist who represents this mélange of styles is the sculptor Joel Shapiro (b. 1941). He was born, raised, and educated in New York, and his art gradually evolved into the production of miniature clay, glass, copper, and lead pieces shaped objectively. One particular aspect of his works illustrates the art of the 1980s—the use of a variety of media, some of which are new and require new techniques. The mixing of media in previously untried ways provides new avenues of experimentation and mastery as well as providing works of art that have a different appearance from those of the past. Shapiro's works graduated from clusters of small geometric pieces—spread out on the floors of galleries where the actual space in which they were assembled became an important element—to large-scale stick figures exhibiting precarious balance, such as *Untitled* (Fig. **13.30**).[11] It is cast in metal but retains the texture and apparent construction methods of the wood from which it was originally made.

Architecture

Contemporary architecture has, like the other visual arts, turned in pluralistic directions. Past styles are also given new manifestations in Postmodern or Revisionist architecture. The Spanish architect Ricardo Bofill (b. 1939) and the Italian Aldo Rossi (b. 1931) both derive much of their architectural language from the past. As Bofill remarked, his architecture takes "without copying, different themes from the past, but in an eclectic manner, seizing certain moments in history and juxtaposing them, thereby pre-figuring a new epoch." We see this in his public housing development called, with typical grandiosity, the Palace of Abraxas (Fig. **13.31**). Here columnar verticality is suggested by glass and by cornice/capitals, which dynamically present characteristics of Classicism. Postmodern architecture focuses on meaning and symbolism: The past and ornamentation are acceptable; functionalism no longer controls. The Postmodernist seeks to create buildings "in the fuller context of society and the

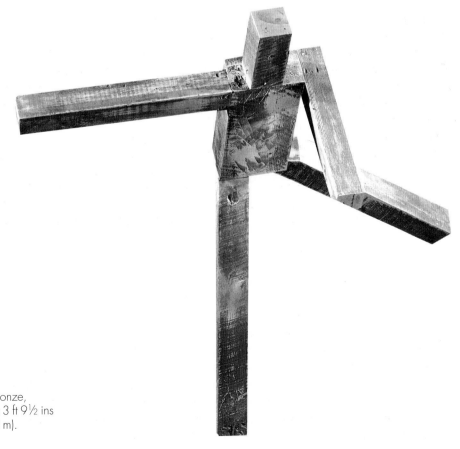

13.30 Joel Shapiro,
Untitled, 1980–1. Bronze,
4 ft ⅞ in x 5 ft 4 ins x 3 ft 9½ ins
(1.34 x 1.62 x 1.15 m).
Private collection.

13.31 Ricardo Bofill, *Palace of Abraxas*, Marne-la-Vallée, near Paris, 1978–93.

environment." Social identity, cultural continuity, and sense of place become foundations for art.

In a clear repudiation of the glass and steel box of the International Style and other popular forms in mainstream architecture, the design for the Pompidou Center in Paris (Fig. **13.32**) turns the building inside out, externalizing its network of ducts, pipes, and elevators while hiding the internal structure, which has no fixed walls—temporary dividers can be arranged in any desired configuration. The bright primary colors of the exterior combine with serpentine, plexiglass-covered escalators to give a whimsical, lively appearance to a functional building. The Pompidou Center has become a tourist attraction rivaling the Eiffel Tower and, although controversial, has wide popular acceptance.

Dance

Rising in the Judson Dance Theatre of the 1960s, Postmodern dance, like the style in the other arts, seeks the interrelationships between art and life. The Judson Dance Theatre comprised an informal collective of experimentalists who rejected traditional choreography and technique in favor of open-ended scores and ordinary movement. Again, Postmodernism does not lend itself to descriptions of "typical" adherents, but one example surely is Deborah Hay (b. 1942), one of the style's pioneers. Ms Hay defines dance broadly as "the place where I practice attention. . . .

It's a kind of alertness in my body that I have at no other time. So dance for me is about playing awake."[12]

Most of Ms Hay's work is playful, and "Voil," a forty-minute solo piece, requires the dancer to gallop and prance, engage in awkward gesticulations, and do storytelling, vocalizations (tongue clicks and guttural rumblings), as well as other sorts of emotional outburst. The dance is "fierce, tentative, sorrowful, amazed, earnest, exasperated . . . [with] ugly faces and . . . silly kid's Stuff."[13]

Literature

Exemplary of Postmodernism in literature is Thomas Pynchon (b. 1937), an American novelist and short story writer, who combines black humor and fantasy to portray human alienation in the chaos of modern society. His masterpiece, *Gravity's Rainbow* (1973), is based on the idea of conspiracy and filled with descriptions of paranoid fantasies, grotesque imagery, and esoteric mathematical language.

NEOABSTRACTION

By the mid-1980s young artists were seeking to make their mark by reacting against the Postmodernist trends. They returned to abstraction and near-abstraction, including Hard Edge (see p. 382). These Neoabstractionists, like the Postmodernists, make up a loose confederation of mostly individualistic approaches. An example is the work of Lynda Benglis (b. 1941), a painter who has turned to sculpture. Her work also represents Process Art—that is, taking molten materials, letting them flow freely on the floor, and then adding color and/or shape to them. *Passat* (Fig. **13.33**) illustrates her recent work, in which she shapes knots, bows, and pleats into insectlike sculptures in shiny metal. Like the Postmodernists, Neoabstractionists borrow freely from others by modifying or changing the scale, media, or color of older works to give them a new framework and, hence, new meaning. Occasionally, the new meanings include sarcasm and satire and often comment on the decadence of contemporary American society.

"NEW" REALISM

The realistic style of the nineteenth century (see p. 348) returns from time to time, and in the late 1990s we find its evidence in the work of a number of young painters. The first of these, Kerry James Marshall (b. 1955), employs conventional techniques and traditional approaches to figure depiction to illuminate personal and historical African American narratives. He looks into the particulars of African American daily living, from ordinary interpersonal exchanges to specif-

13.32 Renzo Piano and Richard Rogers, Pompidou Center, Paris, 1971–8.

ically political interaction. He tries to suggest that in his pictures there is something a little too right, too ordered. In *Den Mother* (Fig. **13.34**) such a sense of goodness pervades that we wonder if this could possibly be a portrait of a real individual, and in reality, Marshall has given us an archetype, an icon, and an oxymoron—an object more identifiable with white suburbs than black identity.

Mark Tansey (b. 1949) tries in his painting to find what he calls a new "technaphor"—that is, "a metaphorical technique for connecting subject matter and ideas." *Study for "Discarding the Frame"* (Figure **13.35**) features the intense monochromatic treatment typical of Tansey's works. The extreme contrast between the strong, deep blues and the pure whites draws attention first to the active composition in which the highlights reveal an indeterminate space—a void with undefined parameters. Two figures plunge from a well-lit world into a cave-like space with smooth walls and floor. The earth appears real, but the walls and floor of the "cave" seem almost painterly, as if their interesting texture were part of a stage setting—paint on a canvas floor cloth. The fundamental composition of the picture juxtaposes circular and rectilinear forms, both explicit and implied. The rectangle of the frame, and its shadow, stands in strong

13.33 Lynda Benglis, *Passat*, 1990. Aluminum, 78 × 52 × 27 ins (198 × 132 × 68.5 cm). Paula Cooper Gallery, New York.

399

13.35 Mark Tansey, *Study for "Discarding the Frame"* (1999). Oil on canvas, 36 x 30 ins (91 x 76 cm), Curt Marcus Gallery, New York.

13.34 Kerry James Marshall, *Den Mother*, 1996. Acrylic on paper mounted on wood, 41 x 40 ins (104.1 x 101.6 cm). Collection of General Mills Corporation, Minneapolis, Minnesota. The Jack Shainman Gallery, New York.

contrast to the hole in the earth and the illumined area of the floor. The reaching arms of the falling figure and the high-light areas create a basic compositional triangle suggesting, perhaps, the High Renaissance and the long traditions of painting. That conjecture leads, in addition, to the matter of the painting's title: "Discarding the Frame." With a sense of irony, Tansey seems to be portraying the nightmarishly unnerving sense of helpless falling by artists who turn away from the standard conventions of painting, as symbolized by the hard borders of the rectangular frame.

Julie Roberts (b. 1963), a Welsh painter from London, takes a restrained approach to both realism and the drama of human life. She leaves much to the viewer's imagination while creating an effective tension between the paint sur-face and the disturbing suggestions of the images. *Sacred and Profane Love* (Fig. **13.36**) was inspired by a painting (of the same title) by Titian in the Borghese Museum in Rome. Its references to sacrificial offerings, religious orthodoxy, and the papacy jar us with vibrant colors and dynamic diag-onals. The covered visage of the figure mystifies as it causes us to contemplate its symbolism and relevance.

13.36 Julie Roberts, *Catholic/Sacred and Profane Love*, 1996. Oil and acrylic on canvas, 5 ft x 5 ft (1.5 x 1.5 m). Sean Kelly Gallery, New York.

NOTES

INTRODUCTION

1 Edwin J. Delattre, "The Humanities Can Irrigate Deserts," *The Chronicle of Higher Education*, October 11, 1977, p. 32.

CHAPTER FOUR

1 August Wilson, *Fences*, in Lee A. Jacobus, *The Bedford Introduction to Drama* (New York: St. Martin's Press, 1989), p. 1055.

2 Pierre Corneille, *Le Cid*, trans. and ed. John C. Lapp (New York: Appleton Century Crofts, 1955), pp. 36–7.

3 *American Theatre Magazine*, January 1991.

CHAPTER SIX

1 John Martin, *The Dance* (New York: Tudor Publishing Company, 1946), p. 26.

2 Agnes DeMille, *Martha, the Life and Work of Martha Graham* (New York: Random House, 1991), p. 261.

CHAPTER EIGHT

1 Alice Walker, "Roselilly," from *In Love & Trouble: Stories of Black Women*, copyright © 1972 by Alice Walker, reprinted by permission of Harcourt Brace & Company.

2 K. L. Knickerbocker and W. Willard Reninger, *Interpreting Literature* (New York: Holt, Rinehart, & Winston, 1969), p. 218.

3 William Faulkner, "A Rose for Emily," in *American Poetry and Prose*, ed. Norman Foerster (New York: Houghton Mifflin, 1970), pp. 1562–7. Copyright © 1930 and renewed 1958 by William Faulkner. Reprinted from *Collected Stories of William Faulkner*, by permission of Random House Inc., and Curtis Brown Ltd.

4 Chaucer, *The Canterbury Tales*, trans. J. Nicolson (New York: Crown Publishing Group, 1934), pp. 120–3. Used by permission of the publisher.

5 Robert Frost, "Stopping by Woods on a Snowy Evening," from *The Poetry of Robert Frost*, ed. Edward Connery Lathem. Copyright 1923, © 1969 by Holt, Rinehart, & Winston. Copyright 1951 by Robert Frost. Reprinted by permission of Henry Holt and Company, Inc.

6 W. H. Auden, "Musée des Beaux Arts." Copyright © 1940 and renewed 1968 by W. H. Auden. Reprinted from *W. H. Auden: Collected Poems*, ed. Edward Mendelson, by permission of Random House, Inc., and Faber & Faber Ltd.

7 John Wesley, *God Brought Me Safe*.

8 Oliver Goldsmith, "The Benefits of Luxury, in Making a People more Wise and Happy."

CHAPTER NINE

1 Revised Standard Version Bible.

CHAPTER TEN

1 In each Greek tragic contest a playwright was required to present four plays in succession—three tragedies and a satyr play.

2 Peter D. Arnott, trans., in *An Introduction to the Greek Theatre* (Bloomington: Indiana University Press, 1963), pp. 76–7.

3 The chorus was a distinctive feature of Greek drama, portraying the dual function (in the same play) of narrator and collective character responding to the actors.

4 Hugh Honour and John Fleming, *The Visual Arts: A History*, 4th edn. (Englewood Cliffs, NJ, and New York: Prentice Hall and Abrams, 1995), p. 94.

5 Virgil, *The Aeneid*, trans. Theodore C. Williams (New York: Houghton Mifflin, 1938), p. 1.

6 John Garraty and Peter Gay, *A History of the World*, 2 vols. (New York: Harper & Row, 1972), p. 209.

7 "Rings around the Pantheon," *Discover*, March 1985, p. 12.

8 AOI: These three mysterious letters appear throughout the text. No one has ever adequately explained them, though every reader feels their effect.

9 *The Song of Roland*, trans. Frederick Goldin (New York: W. W. Norton, 1978).

10 Dante, *The Divine Comedy*, quoted in Cunningham and Reich, *Culture and Values*, vol. 1, 3rd edn., Harcourt Brace College Publishing, 1994, p. 366.

CHAPTER ELEVEN

1 Baldassare Castiglione, *The Book of the Courtier*, trans. George Bull. Copyright © 1967 George Bull, reprinted by permission of Penguin Books Ltd.

2 D. Redig de Campos, ed., *Art Treasures of the Vatican* (Englewood Cliffs, NJ: Prentice Hall, 1974), p. 7.

3 Lilian Hornstein et al., *World Literature*, 2nd edn. (New York: Mentor, 1973), p. 155.

4 Germain Bazin, *The Baroque* (Greenwich, CT: New York Graphic Society, 1968), p. 30.

5 Frederick Hartt, *Art*, 2 vols. (Englewood Cliffs, NJ., and New York: Prentice Hall and Abrams, 1981), p. 283.

6 Jonathan Swift, "A Modest Proposal," in *The Norton Anthology of English Literature*, vol. 1, 3rd edn. (New York: W. W. Norton, 1974), p. 2094.

7 Oliver Goldsmith, "The Deserted Village."

8 Samuel Johnson, "Idler Essays" in *A Johnson Reader*, E. L. McAdams, Jr. and George Milne, eds. (New York: Random House, 1964), p. 199.

CHAPTER TWELVE

1 Dominique-Rene de Lerma, *Reflections on Afro-American Music* (Kent, OH: Kent State University Press, 1973), p. 162.

2 William Allen, Charles Ware, and Lucy Garrison, *Slave Songs of the United States* (New York: A. Simpson, 1867), p. 50; in George R. Keck and Sherrill V. Martin, *Feel the Spirit* (New York: Greenwood Press, 1988), p. 3.

3 Keck and Martin, op. cit., pp. 4–5.

4 Keck and Martin, op. cit., p. 12.

5 Keck and Martin, op. cit., p. 10.

6 Bernard Katz, *The Social Implications of Early Negro Music in the United States* (New York: Arno Press and *The New York Times*, 1969), p. 26.

7 Katz, op. cit., p. 14.

8 Henry Edward Krehbiel, *Afro-American Folksongs* (New York: G. Schirmer, n.d. [c.1914]), p. 26.

9 Frederick J. Dockstader, *Indian Art of the Americas* (New York: Museum of the American Indian Heye Foundation, 1973), p. 14.

10 Ibid.

11 Susette la Flesche, "Nedawi." Copyright © 1989 The American Board of Regents. Reprinted from *The Singing Spirit*, ed. Bernd C. Peyer.

12 William Wordsworth, "Tintern Abbey," in *The Poetical Works of William Wordsworth* (New York: Houghton Mifflin, 1982), pp. 91–3.

13 Helen Gardner, *Art Through the Ages* (New York: Harcourt Brace Jovanovich, 1980), p. 760.

CHAPTER THIRTEEN

1 Zitkala-Sa (Gertrude Bonnin), "The Soft-Hearted Sioux." Copyright © 1989 The Arizona Board of Regents. Reprinted from *The Singing Spirit*, ed. Bernd C. Peyer.

2 Paula Gunn Allen, "Recuerdo." Reprinted from Joseph Bruchac, *Survival This Way* (Tuscon, AZ: University of Arizona Press, 1987), p. 3.

3 "Harlem Renaissance, Art of Black America." Exhibition book for the traveling exhibition under the auspices of the American Federation of Arts, 1989.

4 Ibid.

5 Ibid.

6 Ibid.

7 Langston Hughes, "Theme for English B." In *Selected Poems*. Reprinted by permission of David Higham Associates Ltd. Copyright © 1951 by Langston Hughes. Copyright renewed 1979 by George Houstan Bass. "Harlem." Copyright © 1951 by Langston Hughes. Reprinted from *The Panther and the Lash*, by permission of Alfred A. Knopf, Inc.

8 H. W. Janson, *A Basic History of Art*, op. cit., p. 682.

9 W. H. Auden, "In War Time," "Two's Company," and "The Composer." From *The English Auden*, ed. Edward Mendelson. Copyright © 1977 by Edward Mendelson, William Meredith, and Monroe K. Spears, as Executors of the estate of W. H. Auden. Reprinted by permission of Random House, Inc.

10 *New York Times*, January 18, 1998, Section 2, p.41.

11 Otto G. Ocvirk et al., *Art Fundamentals*, 7th edn. (Madison, WI, and Dubuque, IA: Brown & Benchmark, 1994), p. 309.

12 *New York Times*, May 30, 1997.

13 Ibid.

GLOSSARY

Cross-references are indicated by *italic* type.

a cappella. Choral music without instrumental accompaniment.

ABA. In music, a three-part structure that consists of an opening section, a second section, and a return to the first section. See also *ternary form*.

abacus. The uppermost member of the *capital* of an architectural *column*; the slab on which the *architrave* rests.

absolute music. Music that is free from any reference to nonmusical ideas, such as a text or program. See also *program music* and *tone poem*.

absolutism. The system or doctrine of government by which the ruler has unlimited powers; despotism.

abstract. *Nonrepresentational*; the essence of a thing rather than its actual appearance.

Abstract Expressionism. In art, a style of *nonrepresentational* painting that combines *abstract forms* with *Expressionist* emotional values.

abstraction. A thing apart; that is, removed from real life.

Absurdism. In drama and prose fiction, the view that the human condition is profoundly and unalterably absurd and indecipherable, giving rise to feelings of purposelessness and bewilderment. The movement arose after World War II in opposition to the beliefs and values of traditional culture and literature.

academic Neoclassicism. A style of the late eighteenth and early nineteenth centuries, particularly in France, and exemplified by the work of such painters as Jacques Louis David, who was not only influenced by *Classical* art but took Classical themes for his subject matter. See also *Neoclassicism*.

accelerando. In music, a gradual increase in *tempo*.

accent. (1) In music, a stress that occurs at regular intervals of time. (2) In the visual arts, any device used to highlight or draw attention to a particular area.

accentualsyllabic. A form of poetry in which the *rhythm* depends on there being a fixed number of syllables in each line.

acrylic. An artist's *medium* made by dispersing pigment in a synthetic medium.

action painting. A form of *Abstract Expressionism*, in which paint is applied with rapid, vigorous strokes or even splashed or thrown on the canvas.

adagio. A musical term meaning slow and graceful.

additive. (1) In sculpture, those works that are built. (2) In color, the term refers to the mixing of *hues* of light.

aerial perspective. The indication of distance in painting through the use of light and atmosphere. See also *linear perspective* and *perspective*.

aesthetic. Having to do with the pleasurable and beautiful as opposed to the useful.

aesthetics. A branch of philosophy dealing with the nature of beauty and art, and their relation to experience.

affective. Relating to feelings or emotions, as opposed to facts.

aleatory. Chance or accidental. Such music cannot be predicted beforehand, but depends for its form on statistical or computerized processes during the performance.

allegretto. A musical term denoting a lively *tempo*, but one slower than *allegro*.

allegory. Expression by means of symbols to make a more effective generalization or moral commentary about human experience than could be achieved by direct or literal means.

allegro. A musical term meaning brisk.

alliteration. A sound structure in which an initial sound is repeated for effect.

altarpiece. A painted or sculptured panel placed above and behind an altar to inspire religious devotion.

alto. In music, the lowest female voice.

ambulatory. A covered passage for walking, found around the *apse* or choir of a church.

amphora. A two-handled vessel for storing provisions, with an opening large enough to admit a ladle and usually fitted with a cover.

anapestic. One of the four standard feet in poetry. Two light syllables are followed by a stressed syllable. See also *foot* and *meter* (1).

andante. A musical term meaning a medium leisurely, walking *tempo*.

andantino. A musical term meaning a *tempo* a little faster than *andante*.

appoggiatura. In music, an ornamental note or series of notes above and below a tone of a *chord*.

apse. A large niche or niche-like space projecting from and expanding the interior space of an architectural form such as a *basilica*.

aquatint. An *intaglio* printmaking process in which the plate is treated with a resin substance to create textured tonal areas.

arabesque. A classical ballet pose in which the body is supported on one leg, and the other leg is extended behind with the knee straight.

arcade. A series of *arches* placed side by side.

arch. In architecture, a structural system in which space is spanned by a curved member supported by two legs.

architrave. In *post-and-lintel* architecture, the *lintel* or lowest part of the *entablature*, resting directly on the *capitals* of the *columns*.

arena theatre. A theatre in which the audience surrounds the stage.

aria. An elaborate solo song found primarily in operas, *oratorios*, and *cantatas*.

art brut. The name given by the French painter Jean Dubuffet to art created by anyone from outside the art world, such as children, prisoners, and the mentally ill.

art song. A vocal musical composition in which the text is the principal focus.

articulation. The connection of the parts of an artwork.

aryaballus. An Incan bottle-shaped pot with a pointed bottom, which fell over when empty. The word is also used for the round, narrow-necked container used in Greece, apparently to hold perfumed oil.

assemblé. In ballet, a leap with one foot brushing the floor at the moment of the leap and both feet coming together in fifth position at the finish.

assonance. A sound structure employing a similarity among vowels but not consonants.

atmospheric perspective. The three-dimensional space in a painting, especially when achieved through the use of *aerial perspective*.

atonality. The avoidance or tendency to avoid tonal centers in musical compositions.

avant-garde. French for "advanced guard." A term used to designate innovators, whose experiments challenge established values.

balance. In composition, the equilibrium of opposing or interacting forces.

ballad. A song or poem that tells a story in short *stanzas*; a narrative version of a folk song.

balletomane. A term used by ballet enthusiasts to refer to themselves. A combination of ballet and mania.

balloon construction. Construction of wood using a skeletal framework. See also *skeleton frame* and *steel-cage construction*.

Baroque. A seventeenth- and eighteenth-century style of art, architecture, and music that is highly ornamental.

barre. A wooden railing used by dancers to maintain balance while practicing.

barrel vault (tunnel vault). A series of *arches* placed back to back to enclose space.

bas relief. *See low relief.*

basilica. In Roman times, a term referring to building function, usually a law court; later used by Christians to refer to church buildings and a specific form.

battement jeté. A ballet movement using a small brush kick with the toe sliding on the floor until the foot is fully extended about two inches off the floor.

bay. A vertical division of the exterior or interior of a building, marked by piers, windows, *buttresses*, and so forth.

bearing-wall. A form of construction in which the wall supports itself, the roof, and floors. See also *monolithic construction*.

beats. In music, the equal parts into which a *measure* is divided.

bel canto. Italian for "beautiful singing." A style of singing in which beauty of tone and perfect technique are preeminent.

Be-bop. A style of *jazz*, popular between about 1945 and 1955, characterized by complex *rhythms* and instrumental virtuosity. Shortened to "bop."

binary form. The *form* of a piece of music with two sections.

biography. A written account of a person's life.

biomorphic. Representing life *forms* as opposed to geometric forms.

blues. Music of Black American folk origin, melancholy and often in 12-bar sequences.

bridge. In music, a passage of subordinate importance, played between two major *themes*.

bridging shot. In film, a shot inserted at editing to cover a break in continuity.

buttress. A support, usually an exterior projection of masonry or wood, for a wall, *arch*, or vault.

cadence. In music, the specific harmonic arrangement that indicates the closing of a phrase.

canon. In music, a type of *polyphony* in which a *melody* is repeated by each voice or instrument as it enters after a brief interval.

cantata. A short composition for *orchestra* and chorus, sometimes also with soloists.

cantilever. An architectural structural system in which an overhanging beam is supported at only one end.

capital. The transition between the top of a *column* and the *lintel*.

cast. See *sculpture*.

catharsis. The cleansing or purification of the emotions through the experience of art, the result of which is spiritual release and renewal.

cella. The principal enclosed room of a temple; the entire body of a temple as opposed to its external parts.

chaîné. A series of spinning turns in ballet utilizing a half turn of the body on each step.

changement de pied. In ballet, a small jump in which the positions of the feet are reversed.

character Oxfords. Shoes worn by dancers which look like ordinary street shoes but are actually specially constructed for dance.

chiaroscuro. Light and shade. In painting, the use of highlight and shadow to give the appearance of three-dimensionality. In theatre, the use of light to enhance *plasticity* of human and scenic form.

chord. Three or more musical tones played at once.

choreography. The composition of a dance work; the arrangement of patterns of movement in dance.

chroma. The degree of *saturation* or purity of a color or *hue*.

chromatic scale. A musical *scale* consisting of half steps or semitones.

cinematic motif. In film, a visual image that is repeated either in identical form or in variation.

cinéma verité. Candid camera; a television-like technique of recording life and people as they are. The hand-held camera, natural sound, and minimal editing are characteristic.

cire-perdue **(lost-wax).** A method of casting metal in a mold, the cavity of which is formed of wax, which is then melted and poured away.

Classic. Specifically referring to Greek art of the fifth century B.C.

Classical. Adhering to traditional standards. May refer to Greek and Roman art in which simplicity, clarity of structure, and appeal to the intellect are fundamental.

clerestory. The upper stage or portion of the *nave* walls of a church or *basilica*, located above an adjoining roof and admitting light through a row of windows.

coda. A passage added to the end of a musical composition to produce a satisfactory close.

cognitive. Facts and objectivity as opposed to emotions and subjectivity. See also *affective*.

collage. An artwork constructed by pasting together various materials, such as newsprint, to create *textures* or by combining two- and three-dimensional media.

colonnade. A row of *columns* usually spanned or connected by *lintels*.

color wheel. A circle or wheel in which the primary colors—yellow, red, and blue—are separated by secondary and tertiary colors, so that, for example, red and blue are separated by red-violet, violet, and blue-violet. The wheel shows the complementary color of each primary color—for example, green is opposite to red, yellow is opposite to violet, and blue is opposite to orange.

column. A cylindrical post or support, which often has three distinct parts—base, shaft, and *capital*.

complementary colors. Colors that lie opposite each other on a *color wheel*.

composition. The arrangement of line, *form*, *mass*, color, and so forth in a work of art.

compression. In architecture, stress that results from two forces moving toward each other.

compressive strength. The ability of a material to withstand crushing. See also *tensile strength*.

concerto. A composition for *orchestra* and, usually, one soloist.

concerto grosso. A composition for *orchestra* and a group of soloists.

conjunct melody. In music, *melody* consisting of notes close together in the *scale*. The opposite of *disjunct melody*.

consonance. The feeling of a comfortable relationship between elements of a composition. Consonance may be physical and/or cultural in its ramifications.

contrapposto **(counterpoise).** In *sculpture*, the arrangement of body parts so that the weight-bearing leg is apart from the free leg, thereby shifting the hip/shoulder axis.

conventions. The customs or accepted underlying principles of an art.

Cool jazz. A form of *jazz* playing characterized by a restrained, relaxed style.

Corinthian. A specific *order* of Greek *column* employing an elaborate leaf motif in the *capital*.

cornice. A crowning, projecting architectural feature.

corrales. Spanish for "playhouses."

Council of Trent. The council of the Roman Catholic Church, held at Trent in northern Italy, between 1545 and 1563. It condemned the Protestant Reformation and began the Counter- or Catholic Reformation.

counterpoint. In music, two or more independent *melodies* played in opposition to each other at the same time. See also *homophony*, *monophony*, and *polyphony*.

countersubject. In music, a subsidiary *theme* played at the same time as the subject (main theme) of a *fugue*.

crescendo. An increase in loudness.

crosscutting. In film, alternation between two independent actions that are related thematically or by plot to give the impression of simultaneous occurrence.

cruciform. Arranged or shaped like a cross.

Cubism. A movement and style of art of the early twentieth century in which objects are represented as assemblages of geometric shapes.

curvilinear. Formed or characterized by curved lines.

cutting. The trimming and joining that occurs during the process of editing film.

cutting within the frame. Changing the viewpoint of the camera within a shot by moving from a long or medium shot to a close-up, without cutting the film.

dactylic. One of the four standard feet in poetry. A stressed syllable is followed by two light syllables. See also *foot* and *meter* (1).

decrescendo. A decrease in loudness.

deësis. An artwork representing Christ in majesty seated between the Virgin Mary and John the Baptist.

demi-hauteur. A ballet pose with the leg positioned at a 45-degree angle to the ground.

demi-plié. In ballet, a half-bend of the knees in any of the five positions.

dénouement. The section of a play's structure in which events are brought to a conclusion.

depth of focus. In film, when both near and distance objects are clearly seen.

design. A comprehensive scheme, plan, or conception.

detachment. Intellectual as opposed to emotional involvement. The opposite of *empathy*.

development. In *sonata form*, the second section in which the *themes* of the *exposition* (1) are freely developed. See also *recapitulation*.

diatonic minor. The standard musical minor *scale* achieved by lowering, by one half step, the third and sixth notes of the diatonic or standard major scale.

differential focus. See *rack focus*.

diptych. (1) A painting or other artwork in two panels, hinged so that it can be closed like a book. (2) A painting consisting of two individual panels or canvases. See also *triptych*.

direct address. In film and theatre, when a character addresses the audience directly.

disjunct melody. In music, *melody* characterized by skips or jumps in the *scale*. The opposite of *conjunct melody*.

dissolve. In film, to make an object or person appear or disappear from view.

dissonance. The occurrence of inharmonious elements in music or the other arts. The opposite of *consonance*.

divertissement. A dance, or a portion thereof, intended as a diversion from the idea content of the work.

divisionism. The juxtaposition of tiny dots of unmixed paints, giving an overall effect of color when mixed optically by the viewer's brain. Also known as *pointillism*.

documentary. In photography or film, the recording of actual events and relationships using real-life subjects as opposed to professional actors.

dolly shot. In film, a shot taken by moving the camera, which is mounted on a "dolly," toward or away from an object or person.

dome. An architectural form based on the principles of the *arch* in which space is defined by a hemisphere used as a ceiling.

dominant. In music, the fifth note of the *scale* in relation to the *key* note. For example, in the scale of C (major or minor) the dominant note is G. See also *tonic*.

Doric. A Greek *order* of column having no base and only a simple slab as a *capital*.

drone. In music, a pipe or pipes sounding a note or notes of fixed *pitch*, continuing as a permanent bass, especially on various forms of bagpipe.

drypoint. An *intaglio* process in which the metal plate is scratched with a sharp needle-like tool.

dynamics. The various levels of loudness and softness of sounds; the increase and decrease of *intensities*.

eclecticism. In design, a combination of examples of several differing *styles* in a single composition.

editing. The composition of a film from various shots and sound tracks.

elevation. In dance, the height to which a dancer leaps.

embossing. The creation of raised designs in the surface of, for example, paper, leather, or metal.

empathy. Emotional and/or physical involvement in events to which one is a witness but not a participant.

empirical. Based on experiment, observation, and practical experience, without regard to theory.

engaged column. A *column*, often decorative, which is part of, and projects from, a wall surface.

engraving. An *intaglio* process in which sharp, definitive lines are cut into a metal plate.

en pointe. See *on point*.

entablature. The upper portion of a *Classical* architectural *order* above the *column capital*.

entrechat. In ballet, a jump beginning from fifth position in which the dancer reverses the legs front and back one or more times before landing in fifth position. Similar to the *changement de pied*.

ephemeral Transitory; not lasting.

epic. A long narrative poem in heightened *style* about the deeds and adventures of a hero.

episode. In music, a subordinate section occurring between entries of the subject in a *fugue*.

epistolary narrative. A work of *fiction* in which the narrative is conveyed wholly by the exchange of letters. Examples include *Clarissa* by Samuel Richardson and *Les Liaisons dangereuses* by Laclos.

esprit d'escalier. French, meaning "spirit of the stairs." Remarks, thought of after the fact, which could have been *bons mots* had they been thought of at the right moment; witty remarks.

essay. A short literary composition on a single subject, usually presenting the personal views of the author. Essays can be formal or informal.

establishing shot. In film, a long shot at the beginning of a scene to establish the time, place, and so forth. See also *master shot*.

etching. An *intaglio* process; lines are cut in the metal plate by an acid bath.

étude. French for "study." In music, an instrumental piece, usually solo, to train or demonstrate the performer's technique.

existentialism. The name given to a group of philosophies that hold that humans are completely free and wholly responsible for their actions, which is the reason for the sense of dread and anguish they feel.

exposition. (1) The first section of *sonata form*, in which the first subject (in the *tonic key*) and second subject (in the *dominant* key), also sometimes further subjects, are played and often repeated. See also *development* and *recapitulation*. (2) The first statement of the subject of a *fugue* by all players in turn.

Expressionism. A movement in art, literature, and drama of the early twentieth century, in which artists attempted to express emotional experience rather than impressions of the external world. It was characterized by the distortion of reality and the use of symbols and stylization.

façade. The front of a building or the sides if they are emphasized architecturally.

farce. A theatrical *genre* characterized by broad, slapstick humor and implausible plots.

Fauvism. A *style* of painting, developed in the early twentieth century, characterized by the vivid use of color.

fenestration. Exterior openings, such as windows and archways, in an architectural *façade*.

ferroconcrete (reinforced concrete). Concrete reinforced with rods or mesh of steel.

fiction. A literary work created from the author's imagination rather than from fact.

fluting. Vertical ridges in a *column*.

flying buttress. A semidetached *buttress*.

focal point (focal area). A major or minor area of visual attraction in pictures, *sculpture*, dance, plays, films, landscape design, or buildings.

foot. In poetry, a group of syllables forming a metrical unit. See also *anapestic, dactylic, iambic, meter* (1), and *trochaic*.

foreground. The area of a picture, usually at the bottom, that appears to be closest to the viewer.

form. The shape, structure, configuration, or essence of something.

form cutting. In film, the framing in a successive shot of an object that has a shape similar to an image in the preceding shot.

forte. A musical term meaning loud.

found object. An object taken from life that is presented as an artwork.

frame. In film, a single or complete image.

frame-tale. A literary device with a preliminary narrative in which one or more of the characters tells a tale. *The Arabian Nights Entertainments* was an early example.

fresco. A method of painting in which pigment is mixed with wet plaster and applied as part of the wall surface.

frieze. (1) The central portion of the *entablature* between the *architrave* and *cornice*. (2) Any horizontal decorative or sculptural band.

fugue. Derived from a Latin word meaning flight. A conventional musical composition, vocal or instrumental, in which a *theme* is developed by *counterpoint*, each voice or part entering successively and in imitation of each other. See also *exposition* (2).

full-round. See *sculpture*.

galliard. A lively court dance in 3/4 time of the sixteenth and early seventeenth centuries; usually associated with a *pavane*.

genre. (1) A category of artistic composition characterized by a particular *style, form,* or content. (2) A style of painting representing an aspect of everyday life, such as a domestic interior or a rural scene.

geodesic dome. A dome-shaped framework constructed from short, straight, lightweight bars that form a grid of polygons.

geometric. Based on man-made patterns, such as triangles, rectangles, circles, ellipses, and so on. The opposite of *biomorphic*.

Gesamtkunstwerk. A complete, totally integrated artwork; associated with the music dramas of Richard Wagner in nineteenth-century Germany.

gestalt. A whole; the total of all elements in an entity.

glyptic. Sculptural works emphasizing the qualities of the materials from which they are created.

gopura. The monumental gateway to a Hindu temple.

Gothic. A style of architecture based on a pointed-*arch* structure and characterized by simplicity, verticality, elegance, and lightness.

gouache. A *watercolor medium* in which gum is added to ground opaque colors mixed with water.

grande seconde. A ballet pose with the leg in second position in the air.

grand jeté. In ballet, a leap from one foot to the other, usually with a running start.

grand plié. In ballet, a full bend of the knees with the heels raised and the knees opened wide towards the toes. May be done in any of the five positions.

grave. In music, a *tempo* marking meaning slow.

Greek cross. A cross in which all arms are the same length.

Gregorian chant. See *plainchant*.

groin vault. The ceiling formation created by the intersection of two tunnel or *barrel vaults*.

ground. (1) A surface to which paint is applied. (2) The coating material in which lines are scratched to produce designs in such processes as *etching*.

guardian figure. A figure made by ancestor-worshiping societies to watch over (guard) the remains of dead tribe members.

hagiography. The written life of a saint or other religious figure.

harmony. The relationship of like elements, such as musical notes, colors, and repetitive patterns. See also *consonance* and *dissonance*.

Hellenistic. Relating to the time from Alexander the Great to the first century B.C.

heroic. Larger than life size.

hierarchy. Any system of people or things that has higher and lower ranks.

hieratic. (1) Of or used by priests. (2) Of or concerning Egyptian, Byzantine, or Greek traditional styles of art.

homophony. A musical *texture* characterized by chordal development supporting one *melody*. See also *counterpoint, monophony,* and *polyphony*.

horizon line. A real or implied line across the picture plane, which, like the horizon in nature, tends to fix the viewer's vantage point.

hue. The spectrum notation of color; a specific, pure color with a measurable wavelength. There are primary hues, secondary hues, and tertiary hues.

hypostyle. A hall with a roof supported by rows of *columns*.

iambic. One of the four standard feet in poetry. A light syllable is followed by a stressed syllable. See also *foot* and *meter* (1).

icon. Greek for "image." Used to identify paintings that represent the image of a holy person.

iconography. (1) A set of *symbols* conventionally associated with a subject, such as the iconography of Christianity. (2) The meaning assigned to a set of images or symbols according to a particular convention.

idée fixe. A recurring melodic *motif*.

identification. See *empathy*.

igneous rock. A very hard rock, such as granite, produced by volcanic or magmatic action and usually too hard to carve. See also *sedimentary rock* and *metamorphic rock*.

impasto. The painting technique of applying pigment so as to create a three-dimensional surface.

improvisation. Music and other art forms, produced on the spur of the moment or spontaneously.

inciting incident. In the theatre, an event or decision that creates a complication leading to the resolution of the drama.

intaglio. The printmaking process in which ink is transferred from the grooves of a metal plate to paper by extreme pressure.

intensity. (1) The degree of purity of a *hue*. (2) In music, theatre, and dance, that quality of *dynamics* denoting the amount of force used to create a sound or movement.

interval. The difference in *pitch* between two tones.

intrinsic. Belonging to a thing by its nature.

Ionic. A Greek *order* of *column* that employs a scroll-like *capital* with a circular base.

iris. In film and photography, the adjustable circular control of the aperture of a lens.

isolation shot. In film, the isolation of the subject of interest in the center of the frame.

jamb. The upright piece forming the side of a doorway or window frame.

jazz. Music of African American origins, characterized by *syncopation*, *improvisation*, and a regular rhythm.

jazz dance. A form of dancing arising partly from the African dance customs, and with a strong, improvisational nature, that developed into American social and entertainment dances, such as the Charleston, jive, and jitterbug.

jeté. In ballet, a small jump from one foot to the other, beginning and ending with one foot raised.

jump cut. In film, the instantaneous cut from one scene to another or from one shot to another; often used for shock effect.

key. A system of tones in music based on, and named after, a given tone—i.e., the *tonic*.

keystone. The central stone at the summit of an *arch*, rib, or vault, locking the whole together.

kouros. An archaic Greek statue of a standing, nude youth.

krater. A bowl for mixing wine and water, the usual Greek beverage.

kylix. A vase turned on a potter's wheel; used as a drinking cup.

Labanotation. A system of writing down dance movements.

lap dissolve. In film, the simultaneous fade in and fade out of two scenes so that they briefly overlap.

largo. In music, a *tempo* notation meaning large, broad, very slow, and stately movement.

Latin cross. A cross in which the vertical arm is longer than the horizontal arm, through whose midpoint it passes.

legato. In music, a term indicating that passages are to be played with smoothness and without break between the tones.

leitmotif. A "leading *motif*" used in music to identify an individual, idea, object, and so on. Associated with Richard Wagner.

lekythos. An oil flask with a long, narrow neck adapted for pouring oil slowly; used in funeral rites.

lento. A musical term indicating a slow *tempo*.

libretto. The words or text of an opera or musical.

linear perspective. The creation of the illusion of distance in a two-dimensional artwork through the convention of line and foreshortening. That is, the illusion that parallel lines come together in the distance. See also *aerial perspective* and *perspective*.

linear sculpture. Sculptural works emphasizing two-dimensional materials.

lintel. The horizontal member of a *post-and-lintel* structure in architecture.

lithography. A printmaking technique, based on the principle that oil and water do not mix, in which ink is applied to a piece of paper from a specially prepared stone.

lost-wax. See *cire-perdue*.

low relief (bas relief). Relief *sculpture* in which figures and forms project only slightly from the background.

madrigal. A secular part song, originating in Italy.

magnitude. The scope or universality of the *theme* in a play or film.

mambo. A South American dance, similar to the rumba.

manipulation. A sculptural technique in which materials such as clay are shaped by the skilled use of hands.

masonry. In architecture, stone or brickwork.

mass. (1) Actual or implied physical bulk, weight, and density. (2) The most solemn rite of the Roman Catholic liturgy, often set to music for liturgical use.

master shot. In film, a single shot of an entire piece of action. See also *establishing shot*.

measure. A division of music, marked by vertical lines (bar lines). See also *meter* (2).

medium. The process employed by the artist. Also, the binding agent that holds pigments together.

melisma. A group of notes sung to a single syllable.

melodrama. A theatrical *genre* (1), characterized by stereotyped characters, implausible plots, and emphasis on spectacle.

melody. In music, a succession of single tones.

metamorphic rock. A rock such as marble that is formed by natural forces such as heat, pressure, or chemical reaction. See also *igneous rock* and *sedimentary rock*.

metaphor. A figure of speech by which new implications are given to words.

meter. (1) Any form of poetic *rhythm*, determined by the number and length of feet in a line. See also *foot*. (2) In music, the regular succession of rhythmical impulses or *beats*.

metronome. In music, an electrical or mechanical instrument for sounding the number of *beats* per minute and thereby fixing the *tempo* of a composition.

microtone. In music, all *intervals* lying between the semitones of the 12-note tuning system.

mime. In dance or theatre, gestures and expressions that imitate human or animal activity, character, and so on without using words.

Minnesänger. A German lyric poet or singer of the twelfth to fourteenth centuries. See also *troubadour* and *trouvère*.

mise-en-scène. The complete visual environment in the theatre, dance, and film, including setting, lighting, costumes, properties, and physical structure of the theatre.

mobile. A constructed structure whose components have been connected by joints to move by force of wind or motor.

mode. A particular *form*, *style*, or manner.

modeling. The shaping of three-dimensional *forms*. Also the suggestion of three-dimensionality in two-dimensional forms.

modern dance. A form of concert dancing relying on emotional use of the body, as opposed to formalized or conventional movement, and stressing human emotion and the human condition.

modulation. A change of *key* or *tonality* in music.

monolithic construction. A variation of *bearing-wall* construction in which the wall material is not jointed or pieced together.

monophony. In music, a musical *texture* (2) employing a single *melody* line without harmonic support. See also *counterpoint*, *homophony*, and *polyphony*.

montage. The process of making a single composition by combining parts of others. A rapid sequence of film shots bringing together associated ideas or images.

monumental. Works actually or appearing larger than life size.

Moog synthesizer. See *synthesizer*.

motet. A short, unaccompanied, *polyphonic* work for choir.

motif (motive). In music, a short recurrent melodic or rhythmic pattern. In the other arts, a recurrent element.

musique concrète. A twentieth-century musical approach in which conventional sounds are altered electronically on tape to produce new sounds.

narthex. A porch or vestibule at the main entrance of a church.

nave. The great central space in a church. See also *transept*.

Neoclassicism. Various artistic *styles* in art, literature, music, and so forth, that borrow the devices or objectives of *Classical* art.

Neoplatonism. Any of the schools of philosophy based on modified Platonism, but especially that developed by the followers of Plotinus in the third century.

Neorealism. A movement, especially in Italian literature and film after World War II and in the tradition of *verismo*, in which superficially naturalistic works are informed by a degree of populism and sentimentality.

nirvana. In Buddhist philosophy, the state of perfect blessedness attained by the extinction of individual existence and the absorption of the soul into the supreme being.

nonobjective. Without reference to reality; may be differentiated from "abstract."

nonrepresentational. Without reference to reality; including *abstract* and *nonobjective*.

novel. A fictional prose narrative of considerable length, with a plot that unfolds through the actions, speech, and thoughts of the characters.

objective camera. A camera position based on a third-person viewpoint.

objet d'art. A French term meaning "object of art."

octave. In music, the distance between a specific *pitch* vibration and its double; for example, concert A equals 440 vibrations per second, one octave above that pitch equals 880 v.b.s., one octave below equals 220 v.b.s.

on point (*en pointe*). In ballet, a specific technique utilizing special shoes in which the dancer dances on the points of the toes.

opera buffa. A comic opera, dating from the eighteenth century, and depicting characters drawn from everyday life; the opposite of *opera seria*.

opéra comique. An opera with spoken dialogue. It is not necessarily humorous, as, for example, Bizet's *Carmen* and Beethoven's *Fidelio*.

opera seria. An opera, on a tragic or heroic theme, dating from the eighteenth century.

operetta. Light opera, with spoken dialogue and often a humorous or light-hearted theme.

opus. A single work of art.

oratorio. A semi-dramatic work, often on a religious *theme*, for *orchestra* (2), choir, and soloists.

orchestra. (1) The circular area in an ancient Greek theatre used by the chorus. (2) A large instrumental musical ensemble.

order. In architecture, one of the systems used by the Greeks and Romans to decorate and define their buildings. See also *Corinthian*, *Doric*, and *Ionic*.

overtones (overtone series). The sounds produced by the division of a vibrating body into equal parts. See also *sympathetic vibration*.

palette. In the visual arts, the composite use of color, including range and *tonality*.

pan. In film, to follow a moving object with the camera.

pantheon. A Greek word meaning all the gods of a people.

pao-chia system. In China, a system of mutual familial responsibility.

parallel development. The use in film of *crosscutting* between scenes of contemporaneous action, often for ironic effect.

pas. In ballet, a combination of steps forming one dance.

pas de deux. A dance for two dancers.

pathos. The "suffering" aspect of drama usually associated with the evocation of pity.

patina. The film, usually greenish, that forms on the surface of copper and bronze as a result of oxidation; also known as verdigris and aerugo. The word is also used for the gloss produced by age on wood and other surfaces.

pavane. A stately court dance in $\frac{3}{4}$ time; it usually follows a *galliard*.

pedal point. In music, a sustained note, usually in the bass, above or around which *harmonies* change.

pediment. The typically triangular roof piece characteristic of *Classical* architecture.

pendentive. A triangular part of the vaulting which allows the stress of the round base of a *dome* to be transferred to a rectangular wall base.

persistence of vision. The continuance of a visual image on the retina for a brief time after the removal of the object.

perspective. The representation of distance and three-dimensionality on a two-dimensional surface. See also *aerial perspective* and *linear perspective*.

Philosophes. The collective name given to a group of eighteenth-century writers and thinkers, who believed in the power of reason and disliked repressive traditions.

photojournalism. Photography of actual events that may have sociological significance.

piano. A musical term meaning soft or quiet.

picaresque novel. A style of literature dealing with the episodic adventures of a rogue.

pirouette. In ballet, a full turn on the toe or ball of one foot.

pitch. In music, the quality of a sound—its highness or lowness—which is governed by the number of vibrations per second emanating from the source of the sound.

plainchant (Gregorian chant). The liturgical chant to Latin texts, sung in unison and used since the Middle Ages; also known as plainsong,

plan. An architectural drawing of a building as seen from above that reveals in two dimensions the arrangement and distribution of interior spaces and walls, as well as door and window openings.

planographic process. A method of printing from a flat surface, such as *lithography*.

plasticity. The capability of being molded or altered. In film, the ability to be cut and shaped. In painting, dance, and theatre, the accentuation of dimensionality of form through *chiaroscuro*.

platemark. The ridged or embossed effect created by the pressure used in transferring ink to paper from a metal plate in the *intaglio* process.

poetry. A literary work designed to convey a vivid and imaginative sense experience through the use of condensed language selected for its sound and suggestive power and meaning, and employing specific technical devices, such as *meter* (1), *rhyme*, and *metaphor*. There are three major types of poetry—narrative, dramatic, and lyric.

pointillism. In art, a kind of French Impressionism in which color is applied in tiny dots or small, isolated strokes. Forms are visible only from a distance. Also known as *divisionism*.

polyphony. In music, the combination of two or more independent melodic lines. See also *counterpoint*, *homophony*, and *monophony*.

polyrhythm. In music, the use of contrasting *rhythms* at the same time.

porcelain. A variety of hard, non-porous, translucent ceramic ware, made from kaolin, feldspar, and quartz or flint.

port de bras. The technique of moving the arms correctly in dance.

portico. An open or partly enclosed roofed space, usually serving as an entrance and often the centerpiece of a *façade*.

post-and-lintel. An architectural structure in which horizontal pieces (lintels) are held up by vertical *columns* (posts).

post-Columbian. The word used to denote the history, architecture, culture, and so forth of the Americas after Columbus landed there. See also *pre-Columbian*.

post-tensioned concrete (prestressed concrete). Concrete using metal rods and cables under stress or tension to cause structural forces to flow in predetermined directions.

power figure. A figure regarded by tribal societies as a repository of magic, which could be activated by the insertion of nails.

precast concrete. Concrete cast in place using wooden forms around a steel framework.

pre-Columbian. The word used to denote the history, architecture, culture, and so forth of the Americas before Columbus landed there. See also *post-Columbian*.

presto. A musical term denoting a rapid *tempo*.

prestressed concrete. See *post-tensioned* concrete.

program music. Instrumental music that interprets, narratively and descriptively, a story or picture. See also *absolute music* and *tone poem*.

proportion. The relation, or ratio, of one part to another and of each part to the whole with regard to size, height, width, length, or depth.

proscenium. A Greek word meaning "before the *skene*." The plaster arch or "picture frame" stage of traditional theatres.

protagonist. The leading person or character in a work of literature, theatre, or film.

prototype. The model on which something is based.

putto (plural **putti**). A representation of a naked child, especially a cupid or cherub, particularly in Renaissance art.

pyramidal structure. In film and dance, the rising of action to a peak, which then tapers to a conclusion.

quadrille. (1) An American square dance. (2) A European ballroom dance of the eighteenth and nineteenth centuries.

rack focus (differential focus). In film, when an object is clearly shown while the remainder of the scene is out of focus.

ragtime. A kind of American music, mostly composed and popular from about 1890 to 1914, and characterized by fast, even time and strong *syncopation*.

Realism. A style of painting, sculpture, and theatre based on the theory that the method of presentation should be true to life.

recapitulation. In *sonata form*, the third section in which the *exposition* (1) is repeated, often with variations. See also *development*.

recitative. Sung dialogue in opera, *cantata*, and *oratorio*.

rectilinear. In the visual arts, the formed use of straight lines and angles.

register. A range or row, especially when one of a series.

reinforced concrete. See *ferroconcrete*.

relative major. In music, the sharing of a common *key* signature by a major and a minor key. For example, G major is the relative major of E minor (both have one sharp). Similarly, E minor is the relative minor of G major.

relevé. In ballet, the raising of the body to full height or half-height during the execution of a step or movement.

relief. See *sculpture*.

relief printing. The process in printmaking by which the ink is transferred to the paper from raised areas on a printing block.

representational. Objects that are recognizable from real life. See also *abstract* and *nonrepresentational*.

requiem. A *mass* (2) for the dead.

rest. In music, silence. The notation used in scores to indicate the absence of sound from a performer or group of performers.

rhyme. A sound structure coupling words that sound alike.

rhythm. The relationship, either of time or space, between recurring elements of a composition.

rib. In a vault system, a slender architectural support projecting from the surface.

rib vault. A structure in which *arches* are connected by diagonal as well as horizontal members.

ritardando. A musical term indicating a decrease in *tempo*.

ritornello. In a Classical *concerto*, the return of the full *orchestra* (2) after a solo passage.

Rococo. A style of architecture and design, developed in France from the *Baroque* and characterized by elaborate and profuse ornamentation, often in the form of shells, scrolls, and the like.

Roman cross. A cross with a long vertical arm and a shorter horizontal one; also known as a *Latin cross*.

rondo. A form of musical composition employing a return to an initial *theme* after the presentation of each new theme.

ronds de jambe à terre. In ballet, a rapid semicircular movement of the foot in which the toe remains on the floor and the heel brushes the floor in first position as it completes the semicircle.

round. In music, a vocal piece in which the same *melody* is sung at the same *pitch* but at different times by a group of singers. See also *canon*.

rubato. A style of musical performance in which the performer treats the *rhythm* of a piece with a degree of freedom.

satire. (1) The use of ridicule, irony, or sarcasm to hold up to ridicule and contempt vices, follies, abuses, and so forth. (2) A work of literature that uses satire (1).

saturation. In color, the purity of a *hue* in terms of whiteness; the whiter the hue, the less saturated it is.

scale. (1) In music, a graduated series of ascending or descending tones. (2) In architecture, the *mass* (1) of the building in relation to a given measurement, such as the human body.

sculpture. A three-dimensional art object. Among the types are: cast, which is created from molten material in a mold; relief, which is attached to a larger background; full-round, which is freestanding; and built or assembled, which is created by the addition of, often, prefabricated elements.

sedimentary rock. A rock such as limestone or sandstone that is formed by erosion and deposition. See also *igneous rock* and *metamorphic rock*.

sequence. In music, the repetition of a phrase at a higher or lower *pitch* than the original.

serial music. A twentieth-century musical style utilizing the tone row and serialization of *rhythms*, *timbres*, and *dynamics*.

serigraphy. A printmaking process in which ink is forced through a piece of stretched fabric, part of which has been blocked out; for example, silk-screening and stenciling.

sfumato. In oil painting, the creation of soft, delicately blended effects by the gradation of one tone into another.

shape. A two-dimensional area or plane with distinguishable boundaries.

short story. A short *fictional* work of prose, focusing on unity of characterization, theme, and effect.

silhouette. A form as defined by its outline.

silk-screening. See *serigraphy*.

skeleton frame. Construction in which a skeletal framework supports the building. See also *balloon construction* and *steel-cage construction*.

skene. The stage building of the ancient Greek theatre. See also *proscenium*.

sonata. In music, an instrumental piece, usually in three or four movements and usually for one or two players.

sonata form. A type of musical structure usually used in the first movement of a *sonata*. The three parts are the *exposition*, *development*, and *recapitulation*.

song cycle. A group of *art songs* combined around a similar text or *theme*.

sonority. In music, the characteristic of *texture* (2) resulting from chordal spacing.

spansion architecture. A style of architecture that takes to the extreme the horizontal distance between the supports of a bridge, *arch*, and so forth.

spine (superobjective). In the theatre, the motivating aspect of a character's persona that an actor seeks to reveal by physical means.

staccato. In music, the technique of playing so that individual notes are detached and separated from each other.

stanza. The group of lines of verse forming one of the divisions of a poem or song, usually consisting of four lines and having a regular arrangement of *rhyme* and *meter*.

static. Devoid of movement or other dynamic qualities.

steel-cage construction. Construction using a metal framework. See also *balloon construction* and *skeleton frame*.

stereotype. A standardized concept or image.

stippling. Applying small dots of color with the point of a brush.

stream of consciousness. A narrative form in fiction that attempts to capture the whole range and flow of a character's mental processes.

strophic form. Vocal music in which all *stanzas* of the text are sung to the same music.

stucco. A plaster used as a finishing and protective covering on walls. A mixture including lime and powdered marble was used extensively in Europe for relief decorations (see *sculpture*) from the sixteenth century.

Sturm und Drang. German for "storm and stress." The Romantic movement in late eighteenth-century German literature, developed in opposition to French *Neoclassicism* and characterized by the cult of genius and a return to "nature."

style. Those characteristics of a work of art that identify it with an artist, a group of artists, an era, or a nation.

stylization. Reliance on conventions, distortions, or theatricality; the exaggeration of characteristics that are fundamentally verisimilar.

stylobate. The foundation immediately below a row of *columns*.

substitution. A sculptural technique utilizing materials transformed from a plastic, molten, or fluid into a solid state.

subtractive. (1) In *sculpture*, referring to works that are carved. (2) In color, referring to the mixing of pigments as opposed to the mixing of colored light.

suspension construction. In architecture, the use of steel cables to suspend bridges, walkways, and the like.

suite. In music, a group of compositions, originally in dance style, to be played in succession.

superobjective. See *spine*.

Surrealism. A movement in art developed in the 1920s in which artists and writers gave free rein to the imagination, expressing the subconscious through the irrational juxtapositions of objects and *themes*.

Swing. A kind of *jazz* music, popular between about 1935 and 1945, characterized by strong, driving *rhythms*, and improvised *counterpoint*, and played by big bands.

symbol. A form, image, or subject, standing for something else.

symbolism. The suggestion through imagery of something that is invisible or intangible. In art and literature, the word refers especially to the French and Belgian writers and artists of the late nineteenth century who rejected realism and sought to express ideas, emotions, and attitudes by the use of symbolic words, objects, and so on.

symmetry. The balancing of elements in designs by placing physically equal objects on either side of a center line.

sympathetic vibration. The physical phenomenon of one vibrating body being set in motion by a second vibrating body. See also *overtones*.

symphony. A large musical ensemble; a symphony *orchestra* (2). Also, a musical composition for orchestra, usually consisting of three or four movements.

syncopation. In a musical composition the displacement of *accent* from the normally accented beat to the offbeat.

synthesis. The combination of independent factors or entities into a compound that becomes a new, more complex whole.

synthesizer (Moog synthesizer). An electronic instrument that produces and combines musical sounds.

systematic rationalism. In the seventeenth century, a system developed to explain the universe in both secular and religious terms.

tempera. An opaque *watercolor medium*, referring to ground pigments and their color binders, such as gum, glue, or egg.

tempo. The rate of speed at which a musical composition is performed. In theatre, film, or dance, the rate of speed of the overall performance.

tensile strength. The internal strength of a material that enables it to support itself without bending under tension. See also *compressive strength*.

ternary form. In music, the form of a movement in three sections. See also *ABA*.

terra-cotta. An earth-brown clay used in ceramics and *sculpture*.

tessitura. The general musical range of the voice in a particular composition.

texture. (1) In visual art, the two- or three-dimensional quality of the surface of a work. (2) In music, the melodic and harmonic characteristics of the composition.

theatricality. Exaggeration and artificiality. The opposite of *verisimilitude*.

theme. The general subject of an artwork, whether melodic or philosophical.

thrust theatre. A theatre in which the stage projects into the auditorium so that the audience is seated on three sides of the stage.

timbre. The characteristic of a sound that results from the particular source of the sound. The difference between the sound of a violin and the sound of the human voice is a difference in timbre; also called tone color.

tint. A color or *hue* that has been modified by the addition of a small amount of another color.

toccata. A composition, usually for organ or piano, intended to display technique.

tonality. (1) In music, the specific *key* in which a composition is written. (2) In the visual arts, the characteristics of *value*.

tondo. A painting in a circular format.

tone poem. An orchestral work, on a symphonic scale, written to interpret musically something non-musical, such as a work of literature; also called symphonic poem. See also *absolute music* and *program music*.

tonic. In music, the root tone or note (do) of a *key*; also sometimes called the keynote. See also *dominant*.

tracking. In film, when the camera is moving in the same direction and at the same speed as a person or object.

traditional jazz. In the style of the early twentieth century, as distinct from modern jazz, which developed from *Be-bop*.

tragedy. A serious drama or other literary work in which conflict between a protagonist and a superior force (often fate) concludes in disaster for the protagonist.

tragicomedy. A drama combining the qualities of *tragedy* and comedy.

transept. The crossing arm of a *cruciform* church, in contrast to the *nave*, to which it is at right angles.

transverse arch. In Romanesque and *Gothic* architecture, an *arch* separating one bay of a vault from another.

travertine. A hard limestone, found in Italy, used as a building material and for outdoor *sculpture*.

triad. A *chord* consisting of three tones.

triforium. An arcaded wall passage, above the *arcade* but below the *clerestory* and facing the *nave* of a Romanesque or *Gothic* church.

triptych. An artwork in the form of a set of three panels with related subject matter, often designed as an *altarpiece*. See also *diptych*.

trochaic. One of the four standard feet in poetry. A stressed syllable is followed by a light syllable. See also *foot* and *meter*.

trompe l'oeil. French for "trick of the eye" or "fool the eye." A two-dimensional artwork, executed in such a way as to make the viewer believe that three-dimensional subject matter is being perceived.

trope. In music, a type of interpolation into the traditional liturgical *plainchant*.

troubadour. A lyric poet or poet-musician who performed songs of courtly love and chivalry at the courts of southern France, Provence, Catalonia, and northern Italy in the eleventh to thirteenth centuries. See also *Minnesänger* and *trouvère*.

trouvère. A narrative poet, especially in northern France, between the eleventh and fourteenth centuries. See also *Minnesänger* and *troubadour*.

tunnel vault. See *barrel vault*.

tutu. A many-layered, short, stiff skirt worn by a ballerina.

twelve-tone technique. A twentieth-century *atonal* form of musical composition associated with Arnold Schoenberg.

two-shot. In film, a close-up of two people.

tympanum. The open space above the door beam and within the arch of a medieval doorway.

value (value scale). In the visual arts, the range of *tonalities* from white to black.

vanishing point. In *linear perspective*, the point on the horizon toward which parallel lines appear to converge and at which they seem to vanish.

variation. The repetition of a *theme* with minor or major changes.

verisimilitude. The appearance of reality in any element of the arts.

verismo. Italian for "realism." A word applied to late nineteenth-century Italian operas with contemporary, often violent, plots and everyday settings.

vivace. A musical term denoting a vivacious or lively *tempo*.

virtuoso. Referring to the display of impressive technique or skill by an artist.

waltz. A dance in ¾ time.

watercolor. (1) A pigment or coloring agent mixed with water for use as a paint. (2) An artwork produced with this medium.

wipe. In film, a line passes across the screen, eliminating one scene as it reveals the next.

woodcut. A relief printing executed from a design cut in the plane of the grain.

wood engraving. A relief printing made from a design cut in the butt of the grain.

ziggurat. In Mesopotamia, a stepped, rectangular tower, topped by a temple.

BIBLIOGRAPHY

Abcarian, Richard, and Marvin Klotz (eds.). *Literature, the Human Experience*. New York: St. Martin's Press, 1998.

Acton, Mary. *Learning to Look at Paintings*. London: Routledge, 1997.

Anderson, Jack. *Dance*. New York: Newsweek Books, 1974.

Andreae, Bernard. *The Art of Rome*, New York: Abrams, 1977.

Arnheim, Rudolph. *Art and Visual Perception: A Psychology of the Creative Eye*. Berkeley: University of California Press, 1997.

Arnheim, Rudolph. *Film as Art*. Berkeley: University of California Press, 1992.

Arnott, Peter D. *An Introduction to the Greek Theatre*. Bloomington: Indiana University Press, 1963.

Artz, Frederick. *From the Renaissance to Romanticism*. Chicago: University of Chicago Press, 1962.

Bacon, Edmund N. *Design of Cities*. New York: Viking Press, 1976.

Bazin, Germain. *The Baroque*. Greenwich, CT: New York Graphic Society, 1968.

Benbow-Pfalzgraf, Taryn. *International Dictionary of Modern Dance*. New York: St James Press, 1998.

Bobker Lee R. *Elements of Film*. New York: Harcourt Brace Jovanovich, 1979.

Booth, Michael. *Victorian Spectacular Theatre 1850–1910*. Boston: Routledge & Kegan Paul, 1981.

Bordwell, David, and Kristin Thompson. *Film Art: An Introduction*. Reading, MA: Addison-Wesley, 1996.

Braider, Christopher. *Refiguring the Real: Picture and Modernity in Word and Image: 1400–1700*. Princeton, NJ: Princeton University Press, 1993.

Brindle, Reginald Smith. *The New Music: The Avant-Garde Since 1945*. London: Oxford University Press, 1975.

Brockett, Oscar G. *History of the Theatre*. Boston: Allyn & Bacon, 1968.

Brockett, Oscar G.. *The Essential Theatre* (5th edn.). New York: Holt, Rinehart, & Winston, 1992.

Cameron, Kenneth M., and Patti Gillespie. *The Enjoyment of the Theatre* (4th edn.). Boston, MA: Allyn & Bacon, 1996.

Campos, D. Redig de (ed.). *Art Treasures of the Vatican*, Englewood Cliffs, NJ: Prentice Hall, 1974.

Canaday, John. *What Is Art?* New York: Alfred A. Knopf, 1990.

Cass, Joan. *Dancing Through History*. Englewood Cliffs, NJ: Prentice Hall, 1993.

Chadwick, Whitney. *Women, Art, and Society*. New York: Norton, 1991.

Ching, Frank D. K., and Francis D. Ching. *Architecture: Form, Space, & Order* (2nd edn.). New York: John Wiley & Sons, 1996.

Cook, David A. *A History of Narrative Film*. New York: Norton, 1996.

Le Corbusier. *Towards a New Architecture*. New York: Dover, 1986.

Corner, James S. *Taking Measures Across the American Landscape*. New Haven, CT: Yale University Press, 1996.

Davis, Phil. *Photography*. Dubuque, IA: William C. Brown, 1996.

Dean, Alexander, and Lawrence Carra. *Fundamentals of Play Directing*. New York: Holt, Rinehart, & Winston, 1990.

De la Croix, Horst, Richard G. Tansey, and Diane Kirkpatric. *Gardner's Art Through the Ages* (9th edn.). San Diego, CA: Harcourt, 1991.

De Lerma, Dominique-Rene. *Reflections of Afro-American Music*. Kent, OH: Kent State University Press, 1973.

Diehl, Charles. *Byzantium*. New Brunswick, NJ: Rutgers University Press, 1957.

Dockstader, Frederick J. *Indian Art of the Americas*. New York: Museum of the American Indian; Heye Foundation, 1973.

Ernst, David. *The Evolution of Electronic Music*. New York: Schirmer, 1977.

Finn, David. *How to Look at Sculpture*. New York: Harry N. Abrams, 1989.

Frampton, Kenneth. *Modern Architecture: A Critical History* (3rd edn.). London: Thames and Hudson, 1992.

Gardner, Helen. *Art Through the Ages* (9th edn.). New York: Harcourt Brace Jovanovich, 1991.

Garraty, John, and Peter Gay. *A History of the World* (2 vols.). New York: Harper & Row, 1972.

Giannetti, Louis. *Understanding Movies* (2nd edn.). Englewood Cliffs, NJ: Prentice Hall, 1996.

Giedion, Sigfried. *Space, Time and Architecture: the Growth of a New Tradition* (5th edn.). Cambridge, MA: Harvard University Press, 1967.

Gilbert, Cecil. *International Folk Dance at a Glance*. Minneapolis, MN: Burgess Publishing, 1969.

Gilbert, Creighton. *History of Renaissance Art Throughout Europe: Painting, Sculpture, Architecture*. New York: Abrams, 1973.

Glasstone, Victor. *Victorian and Edwardian Theatres*. Cambridge, MA: Harvard University Press, 1975.

Golding, John. *Visions of the Modern*. Berkeley, CA: University of California Press, 1994.

Grabar, André. *The Art of the Byzantine Empire*. New York: Crown Publishers, 1966.

Graziosi, Paolo. *Paleolithic Art*. New York: McGraw-Hill, 1960.

Griffiths, Paul. *A Concise History of Avant-Garde Music*. New York: Oxford University Press, 1978.

Grimm, Harold. *The Reformation Era*. New York: Macmillan, 1954.

Groenewegen-Frankfort and Bernard Ashmole. *Art of the Ancient World*. Englewood Cliffs, NJ: and New York: Prentice Hall and Abrams, n.d.

Grout, Donald Jay. *A History of Western Music* (rev. edn.). New York: W. W. Norton, 1973.

Hamilton, George Heard. *Nineteenth and Twentieth Century Art: Painting, Sculpture, Architecture*. New York: Abrams, 1970.

Hartnoll, Phyllis, and Peter Found (eds.). *The Concise Oxford Companion to the Theatre* (2nd edn.). New York: Oxford University Press, 1992.

Hartt, Frederick. *Art* (4th edn.). Englewood Cliffs, NJ, and New York: Prentice Hall and Abrams, 1993.

Hartt, Frederick. *Italian Renaissance Art* (3rd edn.). Englewood Cliffs, NJ, and New York: Prentice Hall and Abrams, 1987.

Hawkes, Jacquetta, and Sir Leonard Wooley. *History of Mankind: Prehistory and the Beginnings of Civilization*. New York: Harper & Row, 1963.

Held, Julius, and D. Posner. *17th and 18th Century Art*. New York: Abrams, n.d.

Helm, Ernest. *Music at the Court of Frederick the Great*. Norman, OK: University of Oklahoma Press, 1960.

Henig, Martin (ed.). *A Handbook of Roman Art*. Ithaca, NY: Cornell University Press, 1983.

Heyer, Paul. *Architects on Architecture: New Directions in America*. New York: Walker and Company, 1978.

Highwater, Jamake. *Dance: Rituals of Experience* (3rd edn.). New York: Oxford University Press, 1996.

Hitchcock, Henry-Russell. *Architecture; Nineteenth and Twentieth Centuries*. Baltimore: Penguin, 1971.

Honour, Hugh, and John Fleming. *The Visual Arts: A History* (4th edn.). Englewood Cliffs, NJ, and New York: Prentice Hall and Abrams, 1995.

Hornstein, Lilian, G. D. Percy, and Sterling A. Brown. *World Literature* (2nd edn.). New York: Mentor, 1973.

Hubert, J., J. Porcher and W. F. Volbach. *The Carolingian Renaissance*. New York: George Braziller, 1970.

Hyman, Isabelle, and Marvin Trachtenberg. *Architecture: From Prehistory to Post-Modernism/The Western Tradition*. New York: Harry N. Abrams, 1986.

Janson, H. W. *History of Art* (5th edn.). Englewood Cliffs, NJ, and New York: Prentice Hall and Abrams, 1995.

Jones, LeRoi. *Black Music*. New York: William Morrow, 1967.

Kamien, Roger. *Music: An Appreciation* (5th edn.). New York: McGraw-Hill, 1995.

Katz, Bernard. *The Social Implications of Early Negro Music in the United States*. New York: Arno Press and *The New York Times*, 1969.

Keck, George R., and Sherrill Martin. *Feel the Spirit*. Westport, CT: Greenwood Press, 1988.

Keutner, Hubert. *Sculpture: Renaissance to Rococo*. Greenwich, CT: New York Graphic Society, 1969.

Kjellberg, Ernst, and Gosta Saflund. *Greek and Roman Art*. New York: Thomas Y. Crowell, 1968.

Kramer, Jonathan, D. *Listen to the Music: A Self-Guided Tour Through the Orchestral Repertoire*. New York: Schirmer Books, 1992.

Krehbiel, Henry Edward. *Afro-American Folksongs*. New York: G. Schirmer, n.d. (c. 1914).

Lee, Sherman. *A History of Far Eastern Art* (4th edn.). Englewood Cliffs, NJ, and New York: Prentice Hall and Abrams, 1982.

Lippard, Lucy R. *Pop Art*. New York: Oxford University Press, 1966.

Lloyd, Seton. *The Archaeology of Mesopotamia*. London: Thames & Hudson, 1978.

Mango, Cyril. *Byzantium*. New York: Charles Scribner's Sons, 1980.

Marshack, Alexander. *The Roots of Civilization*. New York: McGraw-Hill, 1972.

Martin, John. *The Modern Dance*. Brooklyn: Dance Horizons, 1965.

McDonagy, Don. *The Rise and Fall of Modern Dance*. New York: E. P. Dutton, 1971.

McLeish, Kenneth. *The Theatre of Aristophanes*. New York: Taplinger Publishing, 1980.

Muthesius, Stefan. *The High Victorian Movement in Architecture 1850–1870*. London: Routledge & Kegan Paul, 1972.

Nesbitt, Kate (ed.). *Theorizing a New Agenda for Architecture: An Anthology of Architectural Theory 1965–1995*. New Haven, CT: Princeton Architectural Press, 1996.

Newton, Norman T. *Design on the Land: the Development of Landscape Architecture*. Cambridge, MA: Harvard University Press, 1971.

Nyman, Michael. *Experimental Music: Cage and Beyond*. New York: Schirmer Books, 1974.

Ocvirk, Otto G. et al. *Art Fundamentals* (7th edn.). Madison, WI, and Dubuque, IA: Brown & Benchmark, 1994.

Ostransky, Leroy. *Understanding Jazz*. Englewood Cliffs, NJ: Prentice Hall, 1977.

Pfeiffer, John E. *The Creative Explosion*. New York: Harper & Row, 1982.

Pignatti, Terisio. *The Age of Rococo*. London: Paul Hamlyn, 1969.

Politoske, Daniel T. *Music* (5th edn.). Englewood Cliffs, NJ: Prentice Hall, 1992.

Powell, T. G. E. *Prehistoric Art*. New York: Frederick Praeger Publishers, 1966.

Preble, Duane. *We Create, Art Creates Us*. New York: Harper & Row, 1976.

Rasmussen, Steen Eiler. *Experiencing Architecture*. Cambridge, MA: MIT Press, 1984.

Read, Benedict. *Victorian Sculpture*. New Haven, CT: Yale University Press, 1982.

Rice, David Talbot. *The Art of Byzantium*. New York: Abrams, n.d.

Richter, Gisela. *Greek Art*. Greenwich, CT: Phaidon, 1960.

Robertson, Martin. *A Shorter History of Greek Art*. Cambridge, MA: Cambridge University Press, 1981.

Roters, Eberhard. *Painters of the Bauhaus*. New York: Praeger Publishers, 1965.

Ryman, Rhonda. *Dictionary of Classical Ballet Terminology*. Princeton, NJ: Princeton Book Company, 1998.

Sachs, Curt. *World History of the Dance*. New York: W. W. Norton, 1937.

Savill, Agnes. *Alexander the Great and His Times*. New York: Barnes and Noble, 1993.

Schonberger, Arno, and Halldor Soehner. *The Rococo Age*. New York: McGraw-Hill, 1960.

Sherrard, Philip. *Byzantium*. New York: Time, 1966.

Sitwell, Sacheverell. *Great Houses of Europe*. London: Spring Books, 1970.

Sorell, Walter. *Dance in its Time*. Garden City, NY: Doubleday Anchor Press, 1981.

Sporre, Dennis J. *The Art of Theatre*. Englewood Cliffs, NJ: Prentice Hall, 1993.

Sporre, Dennis J. *The Creative Impulse* (5th edn.). Upper Saddle River, NJ: Prentice Hall, 2000.

Sporre, Dennis J., and Robert C. Burroughs. *Scene Design in the Theatre*. Englewood Cliffs, NJ: Prentice Hall, 1990.

Stanley, John. *An Introduction to Classical Music Through the Great Composers & Their Masterworks*. New York: Reader's Digest, 1997.

Stearns, Marshall, and Jean Marshall. *Jazz Dance*. New York: Macmillan, 1968.

Steinberg, Cobbett. *The Dancing Anthology*. New York: Times Mirror, 1980.

Steinberg, Michael. *The Symphony: A Listener's Guide*. New York: Oxford University Press, 1995.

Summerson, John Newenham. *Classical Language of Architecture*. Cambridge, MA: MIT Press, 1984.

Thompson, Kristin, and David Bordwell. *Film History: An Introduction*. New York: McGraw-Hill, 1994

Tirro, Frank. *Jazz: A History*. New York: W. W. Norton, 1977.

Trythall, Gilbert. *Principles and Practice of Electronic Music*. New York: Grosset & Dunlap, 1973.

Vacche, Angela Dalle. *Cinema and Painting: How Art Is Used in Film*. Austin, TX: University of Texas Press, 1996.

Van Der Kemp, Gerald. *Versailles*. New York: Vendome Press, 1977.

Wheeler, Robert Eric Mortimer. *Roman Art and Architecture*. New York: Praeger Publishers, 1964.

Yenawine, Philip. *How to Look at Modern Art*. New York: Harry N. Abrams, 1991.

Zarnecki, George. *Art of the Medieval World*. Englewood Cliffs, NJ: Prentice Hall, 1975.

Zorn. Jay D. *Listen to Music*. Englewood Cliffs, NJ: Prentice Hall, 1994.

INDEX

410